THE ARTISTS OF NORTHUMBRIA

Opposite:
Charles Napier Hemy, *Life*, 1913
Tryon and Swann Gallery

The Artists of
Northumbria

an illustrated dictionary
of Northumberland, Newcastle upon Tyne,
Durham and North East Yorkshire
painters, sculptors, engravers, stained glass
designers, illustrators, caricaturists and cartoonists
born between 1625 and 1950

Marshall Hall

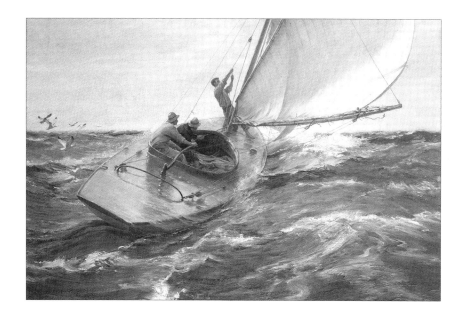

DICTIONARIES

Dedicated to the memory of
Byron Eric Dawson
Artist
my tutor in art
and friend for more than a decade

© Marshall Hall

First published 1973
Second edition 1982

This edition, revised and enlarged, first published in 2005 by
Art Dictionaries Ltd.,
81g Pembroke Road, Bristol BS8 3EA

ISBN 0 9532609 9 2

British Library Cataloguing-in-Publication Data.
A catalogue record for this book is available from the British Library.

Typeset by Datcon-Infotech, Frome, Somerset and
Stephen Morris, Bristol and Liverpool, smc@freeuk.com
Printed by HSW Print, Tonypandy, Rhondda

Contents

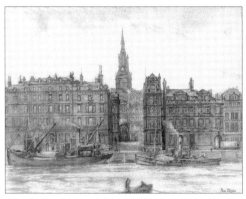

John Taylor, *Newcastle Quayside from Gateshead*,
watercolour 28 x 45 cm.
Private collection.

Note about place names:

All Northumbrian place names
mentioned in the Introduction, and
in artists' entries, have been set in
capitals for ease of identification,
thus: ALNWICK. For NEWCASTLE
wherever it appears in an artist's
entry read: NEWCASTLE UPON TYNE.

Acknowledgements

The assistance of the following in the preparation and illustration of this revised and enlarged edition of *The Artists of Northumbria* is hereby gratefully acknowledged:

Tyne & Wear Museums, Newcastle upon Tyne; Anderson & Garland, Newcastle upon Tyne; Darlington Borough Council, and Hartlepool Arts & Museum Service, for providing the bulk of the illustrations – other sources being individually identified in the captions.

The local studies librarians, reference librarians and county archivists throughout Northumbria for once again submitting to hundreds of enquiries, and the following publications and individuals for their special assistance in adding to my information on the work and biographical details of artists new to this edition: *The Dictionary of Artists in Britain Since 1945*, by David Buckman, (1998); *Public Sculpture of North-East England*, by Paul Usherwood, Jeremy Beach and Catherine Morris, (2000); *Shafts of Light – Mining Art in the Great Northern Coalfield*, by Robert McManners and Gillian Wales, (2002); Kenneth Richardson Adams, Alfred Marsden Alderson, John Anderson, Peter Andrews, J Archer Angus, Yvonne Armstrong, Frank Atkinson, Michael Bailes, Mareth Baker, Keith Bell, Mark Bicknell, Ralph Blacklock, Julian Brown, Joan Brownlow, Gwen Carr, Gerald Cordes, Clive Dawson, Lesley Dillow, Anne Dobson, Alan Dodds, Terence Dodds, Peter Doughy, Judith Douthwaite, Richard Dunford, Ronald Edgar, Nicolas Ekstrom, Phyl Evetts, Gillian Fairless, Leonard Franchetti, Lilian Fraser, Ronald French, Stephen Garbutt, John Gauld, Allan Graham, Frank and Vera Graham, Janice Hansen, Bernard Hemy, Peter Henzell, Jean Hepple, Nan Herbert, Andrew Herd, Eric Hollerton, June Holmes, Wilfrid Hudson, Doris Johnson, Michael Joicey, Peggy Kilbourn, Mary Kine, Elizabeth Law, Malcolm Lowson, Syl Macro, Chandra Masoliver, Peter Mather, Norman Macdonald, Colin McDermott, Winnie McPartlan, John Millard, Nicolas Moore, Steven Moore, Brian Morgan, Peter Muckle, Michael Neil, John Nichols, Peter Phillips, Lucio Pozzi, Terry Quinn, David Redpath, Sarah Richardson, Ann Ropner, Adam Rowntree, Anne Simmonds, Ronald Scott, Arthur Smelt, Helen Swain, Josephine Sykes, Phil Thirkell, John Todd, Michael Tooley, Tony Venus, Diana Villar, Richard Ward, Norman Watson, Hilary Wells, Mason Willy, Mara-Helen Wood, Walter Wood, Frank Wright, and Mary Yates.

The various galleries in Britain and abroad who provided catalogues and other material to assist in my researches into details of individual artists, and the many artists who responded to my questionnaires regarding themselves with up-to-date information, and illustrations of their work.

Finally my wife, Jennifer, for checking my text and transferring much of it onto disk for publishing, and also for giving me her unfailing support and encouragement in the completion of a monumental, but enjoyable, task.

Marshall Hall, 2005

Introduction

The area now popularly known as 'Northumbria' (see map page 386) stretches from a few miles beyond Berwick-upon-Tweed, Northumberland, in the north, to just short of Staithes, North Yorkshire, in the south; from the North Sea coast in the east, to the borders of Berwickshire, Roxburghshire and Cumbria in the west.

It is an area which has long been associated with some of the best known names in British Art – Thomas Bewick, Clarkson Stanfield, John Martin and Myles Birket Foster, to mention only four. But in addition to these well-known artists there are literally hundreds whose associations with the area have hitherto remained poorly documented.

Many are artists who remained in Northumbria throughout their careers, and though once well known, have faded into oblivion; some left the area of their birth to become leading painters elsewhere in the world and have long been regarded in their adopted countries as American … Canadian … Australian … South African, their connections with Northumbria little known. Surprisingly many belong to that universally underrated and therefore poorly recorded category of artist – the amateur.

This dictionary presents not only those artists whose connections with Northumbria are already well known, but the many more whom the author's long and wide-ranging research has brought to light. They total more than 1,000, and include some of the most talented painters, sculptors, engravers, stained glass designers, illustrators, caricaturists and cartoonists associated with any area of Britain.

These are some fields of art in which Northumbrian artists have notably distinguished themselves…

Marine painting

As one of Britain's earliest shipbuilding areas, and with a number of ancient and busy seaports strung along its coastline, it is not surprising that Northumbria has produced some of the finest marine painters in the country. Clarkson Stanfield and Charles Napier Hemy – both Royal Academicians – drew their earliest inspiration from the ship arrivals and departures, the shipbuilding activity, and talk of naval men which were a daily part of their early lives, the one at SUNDERLAND, the other at NEWCASTLE, and later NORTH SHIELDS.

But these were only two of Northumbria's many fine marine artists, outstanding as they undoubtedly were. Long before either of them was born the multi-talented Francis Place had turned down an offer of £500 a year from Charles II, to paint the King's Ships, and throughout their respective careers there were many other artists from the area whose work in marine painting was among the best the country could claim.

One of the earliest of these artists was John Wilson Carmichael, born a scant six years after Stanfield, yet destined to commence his career in marine painting at much the same time as his older contemporary; Stanfield after some years as a scenic painter for the theatre, Carmichael after an apprenticeship in the shipbuilding industry.

Stanfield then quickly made his name in London, while Carmichael remained on Tyneside, his struggle to establish himself as its leading marine painter initially challenged by the excellent work of fellow Northumbrians George Balmer and John Wilson Ewbank. These two men did not, however, have Carmichael's intimate knowledge of his subject, and his dogged determination to succeed in his chosen profession, and soon went their respective ways – Balmer to paint river and coastal scenes; Ewbank to flourish briefly at Edinburgh as one of its leading marine and landscape painters before succumbing to the temptations of drink.

But even Carmichael could not remain fully employed as a marine painter during his long period at NEWCASTLE. What he did produce in this field, however, helped to establish a local demand for ship portraits, and marine works generally, of which others were able to take advantage when he left for London in 1846. His pupil John Scott; contemporaries Mark Thompson, Robert F Watson, James Warkup Swift and James Stokeld, rapidly filled the vacuum left by his departure.

The shipping scene which Carmichael left behind him in Northumbria began to change rapidly in the immediately following years of the mid–19th century. Shipbuilding, mainly for the coaling trade, accelerated dramatically, and several Northumbrian seaports were developed considerably to accommodate the increasing number of ships engaged in this trade and in the expanding North Sea fishing industry. To this later scene along the rivers and coast of Northumbria were attracted the brothers of Charles Napier Hemy – Thomas Marie Madawaska staying several years before following his elder brother to the south of England; Bernard Benedict plodding away in the area until his death.

The second half of the 19th century inevitably witnessed a substantial increase in the number of Northumbria's marine artists, in line with this expansion in shipbuilding and seaport facilities, and each place of activity had its resident masters of the art, as well as a host of artists who occasionally turned their hands to painting ships and coastal scenes with shipping. NEWCASTLE had its Robert Jobling … SUNDERLAND its Stuart Henry Bell …

NORTH SHIELDS its John Chambers ... SOUTH SHIELDS its Robert F Watson ... BERWICK-UPON-TWEED its Frank Watson Wood, Senior ... HARTLE-POOL its John William Howey ... the tiny fishing port of CULLERCOATS, not only a surprising number of resident artists, but dozens of seasonal and other artist visitors, including the now famous American painter Winslow Homer. Indeed, from the late 19th century until the early decades of the last century a veritable colony of artists might be said to have flourished there – a conclusion explored in a major exhibition of their work at the Laing Art Gallery, NEWCASTLE, in 2003, with an accompanying book by Dr Laura Newton, *Cullercoats: A North-East Colony of Artists*, published by Sansom & Company/Art Dictionaries Ltd.

With the rapid decline in the use of sail which came with the beginning of the 20th century the number of Northumbrian marine artists dwindled rapidly. Steamships lacked the glamour of their predecessors, at least as far as the general public was concerned, and those marine artists who did continue to practise survived by either drawing on their earlier compositions featuring sailing ships, or were at pains to include examples of the relatively few that were still to be seen. Among these latter-day artists were Bernard Benedict Hemy and William Thomas Nichols Boyce – both of whom remained dedicated to the local shipping scene until their death – while among those who went on to paint the age of steam and motor vessel were Charles John de Lacy, John Chambers, Frank Watson Wood, Senior, Frank Henry Mason, Charles Herbert Nicholson, Fred Jay Girling, Odin Rosenvinge, and Alan Reid Cook. Recent years have seen further developments in the British shipping and shipbuilding scene with artists like Richard Hobson, Walter Holmes, Terence Storey and Peter Knox continuing the fine standard of work set in its portrayal by Stanfield and Carmichael. And apart from those who have distinguished themselves as painters of shipping and shipbuilding scenes there have also been some notable Northumbrian painters of pure seascapes – none so far distinguishing himself more prominently in this respect than John Falconar Slater, whose work compares favourably with that of many acknowledged masters of the subject.

Landscape painters

Although Northumbria has produced only a few landscape painters whose names are widely familiar it has over the centuries produced several fine practitioners of the art.

Francis Place of DINSDALE, near DARLINGTON, has been acknowledged as the first British artist whose main preoccupation was landscape, and among the first of those topographers who set out to explore and record the landscape of Britain in the 17th century; Thomas Bewick, of NEWCASTLE, towards the close of the 18th century produced watercolours of the local landscape for his wood engravings which are unique of their period for their scale, draughtsmanship and content; Myles Birket Foster born at NORTH SHIELDS, was the most prolific and successful landscape painter in Britain in the 19th century, and the work of George Edward Horton of NORTH SHIELDS is now being recognised as among the most distinctive produced by any British landscape artist in the last century.

For three-quarters of a century after Francis Place finally settled at York in 1692, almost the only landscapes painted in Northumbria, or of Northumbrian subjects, were those executed by visiting artists. Not until the last quarter of the 18th century did local artists begin to produce local views, and then ones mainly inspired by the vogue for the 'picturesque' which was then at its height. Notable among these early local landscape painters were Edward Swinburne, Luke Clennell, George Fennel Robson, and William Andrews Nesfield. But perhaps the best known Northumbrian view of this period, painted by a local artist, was by one usually devoted to animal and sporting painting. This was Joseph Atkinson, whose *Tanfield Arch* is familiar to students of the Industrial Revolution around the world. That there was little demand for the services of a full-time resident professional landscape painter in Northumbria in the early years of the 19th century is evidenced by the abruptness with which William Nicholson switched to portrait painting after only a brief time at NEWCASTLE painting local scenes. But with the changes which shortly afterwards came to the area via its industrial development there also came a demand to record these changes; town scenes showing the destruction of the old and the building of the new; river scenes showing the activity of shipyard and glassworks; landscapes pin-pointing the whereabouts of local mine and railway line; pastoral scenes incorporating the homes of those now rich through the industry of the area.

One of the first landscape painters to benefit from this demand was Thomas Miles Richardson, Senior, of NEWCASTLE, about whom the area's earliest landscape school grew, comprising himself, Henry Perlee Parker, John Wilson Carmichael, and later his sons George Richardson, Edward Richardson, and Thomas Miles Richardson, Junior. These were followed by the sons of his second marriage, Henry Burdon Richardson, Charles Richardson, and John Isaac Richardson; pupils James Burrell Smith and John Storey, and several young converts to land-

scape painting including John Henry Mole.

By the middle of the century the area could boast some three dozen accomplished landscape painters, several of whom had established reputations elsewhere in Britain. With Richardson's death in 1848, however, it lost the greatest of those landscape painters who had chosen to remain in the area of their birth, and interest in the art somewhat faltered until the arrival of William Cosens Way at the Government School of Design, NEWCASTLE, in 1862, when once again young local artists gained someone from whom they could learn the rudiments of art.

In the second half of the 19th century Northumbria experienced massive increases in the populations of its industrial towns, principally those on the Tyne, Wear and Tees, and with these increases came a demand from the middle classes comfortably ensconced in their town houses and suburban villas, for pure landscapes uncluttered by the products of the industrial development which had made their wealth possible. Belonging to this later period of landscape painting in the area were several artists who found their subject matter elsewhere in Britain; Edward Train and George Blackie Sticks travelled the Highlands of Scotland; John Surtees formed an attachment for the wild scenery of Wales; James Peel painted the Lake District and the lush pastures of the south of England, and John Atkinson made painting forays into the dales of North Yorkshire. But a surprising number of Northumbrian artists have found their inspiration in the river valleys, hill country and coastal stretches of their native area, and art exhibitions at NEWCASTLE have since never been without views of the upper Tyne, Tees, Wear and Coquet, the castles along the coast, and the sheep-dotted Cheviot Hills.

Those Northumbrian artists who distinguished themselves as landscape painters in this later period are too numerous to list. Outstanding, however, were Ralph Hedley, John Hodgson Campbell, Francis Thomas Carter, John Atkinson, Robert John Scott Bertram, Richard Jack, Frederick Charles Davison and Byron Dawson in the early part of the last century, while Kenneth Rowntree, Thomas Gamble, Edward Dawson, Brian Roxby, Walter Holmes, Harry Bell, Malcolm Gleghorn and Derwent Wise are among the many who have distinguished themselves as landscape painters more recently. These artists may be regarded as traditional landscape painters, while among the many Northumbrian artists who have produced abstract, semi-abstract and other modernist interpretations of landscape subjects are William Tillyer, Maurice Cockrill, Eric Atkinson, Peter Hicks, Derek Dalton and Pamela Malkin.

Portrait painting

It is perhaps significant that Northumbria's earliest portrait painter of note – Sir Ralph Cole – was a man of independent means who was able to indulge his artistic tastes unfettered by the need to earn a living from them. Northumbria in the middle of the 17th century, when Cole was in London receiving lessons from Van Dyck, could not have been a very encouraging place for a professional portrait painter, and it was not until almost half a century after Cole's death that the first Northumbrian artists were born who were able to practise as such. These men – Nicholas Farrer and William Bell – were fortunate, however, the former gaining the patronage of the Duke of Richmond; the latter that of Lord Delaval. It was not, in fact, until Northumbria in the later years of the 18th century, developed into one of the fastest growing industrial areas in Britain that opportunities for the portrait painter really began to present themselves, attracting first George Gray – ordinarily devoted to fruit painting – then a succession of able portraitists including William Nicholson, James Ramsay, and Henry Perlee Parker.

Nicholson, the first professional portrait painter to try his success in Northumbria, left NEWCASTLE about 1814, before its opportunities for his skills had fully ripened, and later made his name in Edinburgh. Ramsay, making his first professional visit to the area shortly after Nicholson's departure, was not immediately impressed by its prospects and did not, indeed, become so until much later in his life. Parker, on the other hand, deemed its prospects bright, and though obliged to paint many other types of work than portraits while at NEWCASTLE, dominated the local portrait painting scene for almost a quarter of a century. His dominance did not go unchallenged, however, several young Northumbrian artists returning to the area to paint portraits after periods in London – William Bewick, Andrew Morton and Edward Hastings, to name only a few.

With the foundation of the Northumberland Institution for the Promotion of the Fine Arts, at NEWCASTLE, a shop window was suddenly provided for the work of local portrait painters, its first exhibition in 1822 including work by both professionals such as Ramsay, and amateurs like Barrodail Robert Dodd. By the time that the Institution was succeeded by the Northern Academy of Arts in 1828 portraits of local celebrities and men of wealth had become regular features of local exhibitions, many also making their appearance at the Royal Academy, and its Scottish counterpart.

But while the demand for the services of portrait painters in Northumbria mushroomed in the first

half of the 19th century, keeping pace with its growth in prosperity, it was only in the later years of this period that Ramsay, after exploring his chances of success in Edinburgh, decided he could afford to settle here. His move came late in his career, however, and following his death at NEWCASTLE in 1854, portrait painting continued in the hands of artists trained in new ideas about art – those of the town's Government School of Design, under William Bell Scott. From this School in time emerged such portrait painters as Henry Hetherington Emmerson and Ralph Hedley, among many fine practitioners of the art.

The late 19th century saw the number of Northumbrian portrait painters reach its highest level, some settling elsewhere in Britain, or abroad, to further their careers; others like Thomas Bowman Garvie, William Irving and John Hodgson Campbell, working on Tyneside until photography virtually extinguished the art. Of those who have since practised successfully as portrait painters – albeit sometimes in addition to other types of work – none have distinguished themselves more than Richard Jack, who died in 1952, and John Thomas Young Gilroy, who died in 1985. More recently successful portrait painters have been Edwin Straker and Andrew Festing among the traditionalists, and Eric Scott among the modernists. Straker and Festing's work has embraced sitters ranging from middle-class men, women and children to royalty, while Scott's has seen him produce 'super-realist' portraits of pop musicians and film directors.

Historical, religious and subject painters

Probably no British artist is better known for his work as an historical, religious and subject painter than John Martin, of HAYDON BRIDGE. His work astonished his generation, was vilified in the half century following his death, and now stands higher in the esteem of art historians than ever before. But another such man was Sir Robert Ker Porter, of DURHAM, who, while his work has been consistently admired since his death, left so much of it that only today are we able to see that his accomplishment places him with Martin among the top half-dozen exponents of drama in art this country has produced.

Martin and Porter were Northumbria's most visibly successful painters of historical and religious themes; many other such artists from the area flourished less conspicuously. In the late 17th and early 18th centuries there was Thomas Whittle, who wandered the villages of south Northumberland painting altar pieces for local churches; in the late

18th century both William Bell and Robert Watson, of NEWCASTLE, achieved success with their exhibits at the Royal Academy; in the early 19th century poor Luke Clennell went mad in his efforts to portray a particularly difficult subject, while later in this same century William Bell Scott completed his magnificent series of scenes from Northumbrian history for Wallington Hall, near CAMBO, and Louisa Anne, Marchioness of Waterford, her biblical studies for the school she had built at FORD; later still, Frederic James Shields and Thomas Ralph Spence decorated churches throughout Britain, and John Charlton recorded some of the country's great state occasions.

The last century witnessed a sharp decline in the volume of historical, religious and subject paintings produced by Northumbrian artists, although several distinguished themselves as painters of contemporary history, particularly in the context of the First World War; John Charlton and Joseph Gray produced many moving images of land warfare, and Frank Henry Mason, and Frank Watson Wood, Senior, those at sea. In the more traditional line of history painting a rare opportunity was provided for several leading Northumbrian artists by Newcastle Corporation in 1930, to paint themes from the history of the area to decorate the Laing Art Gallery, NEWCASTLE, and this type of work was continued for many years subsequently by Byron Eric Dawson, Robert John Scott Bertram and Thomas William Pattison. Later commissions to paint history have arisen in connection with many other Northumbrian buildings other than art galleries, including Richard Ward's giant mural picturing the history of GATESHEAD, for the town's Queen Elizabeth Hospital, and Brian Brown's panels illustrating a fifty-year period of history of TRIMDON, near SEDGEFIELD, for the local community centre.

The Second World War attracted several Northumbrian artists to paint subjects associated with the bombing of Britain; the fight to protect it from attack, and the war at sea. John Brown Harrison's was the first painting exhibited at the Royal Academy picturing bombed buildings, while Frederick Gordon Crosby's air battle scenes and Frank Henry Mason's sea battle scenes rank as some of the most dramatic and skilfully painted images of the War. In religious and subject painting two of the area's most outstanding artists in the last century were Ernest Procter and Frederick Appleyard, while still today producing some distinguished subject works are Sheila Gertrude Mackie, and Pauline Bewick.

Sporting painters

Every major field of British sporting activity has been painted by Northumbrian artists down the centuries – some, indeed, producing among the earliest accomplished images of particular sports: Thomas Bewick's tiny watercolour 'rehearsals' for his wood engravings picturing angling; Thomas Marie Madawaska Hemy's Sunderland v. Aston Villa match of 1894, completed in the following year, and the first ever painting of Association Football, and Frederick Gordon Crosby's paintings of motor racing from the infancy of the sport, are only a few examples.

Foxhunting and horse racing appear to have been the two most enduringly popular subjects – the former inspiring some particularly fine work. One specialist in painting the sport in the early 19th century was John Wray Snow, whose *The Meet at Blagdon* is one of the largest and most frequently reproduced images of the sport in the world. But much fine work picturing foxhunting was later produced by artists who were also painters of many other subjects – among these John Charlton, Joseph Crawhall the Third, and John Atkinson. The scope for specialisation has continued from Snow right until the present time, however, a latter-day example being that of Thomas Carr, who painted almost every hunt in the North of England in the late 20th century.

Horse racing and racehorses have similarly remained attractive subjects for Northumbrian artists – from Thomas Fairbairn Wilson of early 19th century Tyneside, to Northumberland-born Lionel Hamilton-Renwick who practised until the early years of this century at Newmarket. Wilson's excellent work has remained among the least known of any Northumbrian sporting painter, while Hamilton-Renwick's has shared the distinction with that of the late Sir Alfred Munnings of joining the Royal Collection, and of being reproduced in a series of postage stamps.

The many Northumbrian artists who frequently turned to foxhunting and horseracing subjects are too numerous to mention, although no list would be complete without Wilson Hepple, Joseph Appleyard, and the Alderson twins in the last century, and Dennis Campbell Kirtley in the present century. Among the several Northumbrian artists who have produced accomplished paintings of other sports than those already mentioned must be counted Charles Napier Hemy, Frank Henry Mason and Arthur Winston Dale Megoran in yacht racing, and Frank Watson Wood, Senior and Kenneth Reed in golfing. The opportunity to specialise in particular sports has generally depended on the affluence of their supporters, football, for instance, having produced few specialist painters despite the millions who have continued to follow the sport, while foxhunting, even while under siege, still attracts a remarkable number.

Industrial painters

With Northumbria one of the most heavily industrialised areas in Britain, it is not surprising that many local artists have been tempted to paint its varied activities. The most lastingly popular subject has been its coalmining industry – initially in terms of its surface activity, as in the colliery watercolours of Thomas Harrison Hair, and the social lives of its workers in the oils of Henry Perlee Parker; more recently its underground activity, in the oils and watercolours of Norman Cornish, Thomas McGuinness, and Robert Olley. Leaving aside the sea and the Cullercoats artists' community, coalmining is, indeed, the only industrial activity of the area which has produced a distinct group of artists – the Ashington Group – and is further unique in that its painters have largely been drawn from the ranks of those employed within it.

The railways, shipbuilding and other industries co-existing with that of coalmining have certainly inspired a number of memorable, even famous images; William Bell Scott's superb combination of several of them in his masterpiece *Iron and Coal*, and John Dobbin's *Opening of the Stockton & Darlington Railway, 1825*, to name only two. But few other industrial scenes have attracted Northumbrian artists except as special commissions, or residencies – Byron Dawson capturing many images of turbine building at C A Parsons, WALLSEND, NEWCASTLE, and Thomas McGuinness, a nuclear power station on Teesside. The role of artist-in-residence, fulfilled by McGuinness in the latter connection, has created many other 'one-off' series of industrial paintings, but that of coalmining has proved so attractive that is has generated two major studies relating to its history (see bibliography). And it is an industry, as the more recent of these studies observes, which has not only inspired Northumbrian artists, but those of other coalmining areas around Britain.

Not many of those Northumbrian artists who have painted scenes from the coalmining industry reached a high professional standard, however. For every Norman Cornish or Thomas McGuinness there have been dozens whose work might be deemed amateurish. But the fascination with their subjects of many of those who painted them often developed from early fumblings with pencil or chalk, into well composed, colourful and dramatic paintings, and this must be regarded as incredible given that those responsible had also to contend with daily descents into one of the least hospitable

environments in industry.

The only other industries in Northumbria which have inspired more painted images than coalmining are farming and North Sea fishing. The former have mainly concentrated on harvesting, and the working of the land by heavy horses, while the latter have portrayed the comings and goings of fishing vessels at the region's ports, the unloading of catches and dramatic incidents at sea. Rarely has the painter been a worker in either industry. Robert Taylor of ALNMOUTH, is an early example but soon gave up painting cobles for sailing ships, while Andrew Craig Rutter of SEAHOUSES, alone was both fisherman and lifelong painter of fishing activities. A small number of artists have attempted to savour the industry at first hand to increase the realism of their work, a latter-day example being Albert Henry Herbert of NORTH SHIELDS.

Sculptors, stonemasons and woodcarvers

When George Bowes commissioned Christopher Richardson to sculpt a figure of *Liberty* for the park of his home at ROWLANDS GILL, near GATESHEAD, in the middle of the 17th century, Richardson had long been working outside Northumbria so little was the demand for his skills. The few commissions in sculpture in this period were handled by stonemasons – most sculptors, indeed, first serving an apprenticeship as such before branching out into statuary.

Not until the late 18th century, and with the expansion of many towns in Northumbria, was there enough work for the full-time sculptor, and then mainly on statues for the graves of the wealthy, and memorial tablets for churches. Among the earliest such professionals were Isaac Jopling, Junior, of GATESHEAD, John Priestman of DARLINGTON, and Christopher Tate of NEWCASTLE. All three were working at their respective places of birth when John Graham Lough, ambitious to develop the skills as sculptor acquired while working for a stonemason near his home at GREENHEAD, near CONSETT, came to NEWCASTLE to work on carvings for the façade of the town's new Literary and Philosophical Society building, and he quickly divined that there would be little work of other kinds for him should he remain.

Indeed, there was little work for the professional sculptor in Northumbria throughout the 19th century, though very much for the gifted stonemason, and even more for the woodcarver, in the train of the fashion for highly decorated furniture which blossomed in the 1840s, only to expire some twenty or so year later. In fact Northumbria produced some of Britain's most talented woodcarvers in this period, Gerrard Robinson, for instance, becoming recognised internationally for the excellence of his work. The area also produced a school of woodcarvers, based at ALNWICK, where John Brown, among several fine artists in wood worked on the interior decoration of Alnwick Castle under the supervision of Bulletti of Florence.

As the fashion for large, ornate pieces of furniture died, the interest in the neo-Gothic style of architecture quickened, providing work for many woodcarvers who would otherwise have become idle. Thomas Ralph Spence and Ralph Hedley – both gifted easel painters – did much distinguished work for the interiors of churches built in this style, others such as William Robinson and Henry Thomas Robinson carrying on this type of work well into the last century.

With the demand for war memorial work which came in the late 19th century through the Boer War, and the early 20th century through the First World War, several Northumbrian sculptors were able to find full employment, and to produce accomplished work – Thomas Eyre Macklin, Francis Doyle Jones, John W M Reid, and Roger Hedley, gracing several public places with their works in bronze. The Second World War also provided subjects for local sculptors, but it was the subsequent redevelopment of many Northumbrian and other British cities and towns which next provided the impetus to site works of sculpture in public places, examples by Murray McCheyne, Charles Sansbury, and others adding distinction to several otherwise mundane public spaces.

The clearance of former industrial, commercial and housing areas, too, offered opportunities to site sculptures, and none were grasped more eagerly than by GATESHEAD. The authority of the town in 1986 embarked on a programme of commissioning sculptures for sites all over the Borough, setting an example later followed by Newcastle City Council in its ambitious Quayside redevelopment. A publication listing and picturing these, along with earlier work in the region has been published under the title *Public Sculpture in the North-East of England* (see bibliography). Northumbrian sculptors' work has also graced many public spaces in Britain and abroad over the past quarter century, examples having been placed as far apart as the moors near Garrigill, Cumbria (Gilbert Ward), the banks of the Seine at Paris (Michael Noble), and a battlefield near the town of Badajoz, Spain (Gerald Laing).

Much of the sculpture produced has been representational, but several local authorities and other bodies have proved themselves admirably willing to commission pieces of a totally abstract nature employing modern materials ranging from ciment fondu to fibreglass and stainless steel. Woodcarving,

too, has seen a revival of interest in the last quarter of a century, particularly in its traditional context of church and other ecclesiastical buildings. Many examples rank among the best that have been produced by Northumbrian woodcarvers over the centuries – carvers like the late Maurice McPartlan, and the currently working Fenwick Lawson, proving worthy heirs to the tradition of excellence set by Gerrard Robinson and Ralph Hedley.

Engravers

Northumbria's engravers deserve a volume of their own so talented and numerous were those who practised as such, and could claim the area as their birthplace. But although the area produced many fine engravers on copper and steel, and several superb etchers, it is the field of wood engraving in which it unquestionably excelled. Indeed wood engravers born in the area dominated the book trade for more than a century – first through Thomas Bewick and his numerous workshop apprentices, later through 'The Brothers Dalziel' – Edward and George.

When Bewick took up wood engraving in the late 18th century as a means of illustrating his ground breaking book *The Quadrupeds* the art had reached its lowest ebb in Britain. Originally trained in copperplate engraving, then the dominant means of book and print illustration, he took the art and transformed it from a crude means of illustrating chapbooks and other simple publications into the most popular means of printing illustrations and moveable type simultaneously until the late 19th century.

Yet even as the technique of white line wood engraving developed by Bewick was spreading throughout Britain, the son of one of his closest friends was making his name as possibly the area's second most important wood engraver, using its earlier methods. This was Joseph Crawhall, the Second, who used the comparatively crude technique of the 'wood cut' to illustrate a succession of books which remain among the most unusual produced in the 19th century. In fact no greater contrast could be found than that between the closely finished reproductive illustrations of 'The Dalziel Brothers' using Bewick's techniques, and Crawhall's impressionist 'wood cuts' tracing their ancestry back to 8th-century Japan.

Stained glass designers

Few areas of Britain have produced more fine designers in stained glass, nor more prolific manufacturers, than that covered by modern Northumbria. Many of its early designers have gone unrecorded, and, indeed, even many later pieces of local design are still unattributed despite extensive research.

Those local designers who first became well known were inevitably associated with Northumbria's earliest large-scale manufacturer William Wailes, although a notable exception was Frederick James Shields, who successfully freelanced widely in the country.

The demand for Wailes' output largely derived from the Gothic revival in architecture spearheaded by Pugin, and most of it was for churches throughout Britain. Top class designers were recruited both from the ranks of locally practising artists, or further afield, from the ranks of already committed designers like Francis Wilson Oliphant. Some 360 windows a year were produced by such men under Wailes' supervision.

Wailes' business was carried on after his death by his grandson, William Wailes Strang, but not without some competition in its later years by a much differently inspired stained-glass manufacturer and artist. This was John George Sowerby, who employed the design services of Tyneside-based Thomas Ralph Spence and Arthur Hardwick Marsh. Like Wailes, Sowerby's main market was ecclesiastical stained glass much of which, however, remains largely unidentified. Spence is among the best known. He designed the north and south windows of St George's Church, JESMOND, NEWCASTLE, and a large window for the Unitarian Church at Monton Green, Eccles, near Manchester.

The services of stained glass designers continued in demand throughout the last century – particularly following the Second World War, when many churches required to be rebuilt after bombing. Several British designers rose to prominence during this period, and none more spectacularly than Leonard Charles Evetts, working on Tyneside. His work remained in demand long after this period of post-war reconstruction and he became the most prolific artist in Britain working in the medium. Later designers have followed the innovative lead in style and subject matter established by Evetts, among these Selwyn Smith Beattie, George Birtley Aris and Thomas McGuinness, many examples of whose work decorate churches and other buildings in Northumbria, and are widely admired.

Illustrators

No introduction to the work of Northumbrian illustrators would be complete without reference to the earliest of them, indeed England's first known artist, Eadfrith, Bishop of Lindisfarne, who died in 721. His work on the famous Lindisfarne Gospels produced on HOLY ISLAND in the late 7th century is one of the great triumphs of early European art, and his omission from this dictionary only justified on the grounds of the paucity of information about him,

and the vast lapse of time before any subsequent name can be identified. The first such name after Eadfrith is unquestionably that of Thomas Bewick – born some ten centuries after the creator of the Gospels had been laid to rest – and, like Eadfrith, his work has had an influence on other artists down the centuries. Bewick's pupils were among the earliest influenced – his brother John producing much which equalled his own, and pupil Luke Clennell's work for Scott's *Border Antiquities* owing a great deal to the simplified composition and style of his master. Yet another Bewick-influenced artist, Ebenezer Landells, distinguished himself by producing the first drawings for a newspaper to be made on the spot – covering Queen Victoria's first visit to Scotland for the *Illustrated London News*. And it was the latter newspaper which also gave another Northumbrian artist the opportunity to show his talents as an illustrator – John Wilson Carmichael becoming one of the country's first 'war artists' when he was sent to the Baltic during the Crimean campaign of the mid-century.

But Bewick's most lasting legacy has been in the field of bird illustration – one in which Northumbrian artists have continued to distinguish themselves until the present day. Prideaux John Selby and George Shield were among the earliest artists influenced by Bewick's example, while James Alder working today openly acknowledges a debt to Bewick for both his early interest in bird illustration, and his continuing preoccupation with it.

The Victorian era saw a rapidly increasing demand for illustrators which continued until the camera took over at the end of the 19th century. Illustrated books and magazines proliferated and literally dozens of Northumbrian artists like Myles Birket Foster and Frederic James Shields found themselves considerably in demand. But it was not only the leading book and magazine publishers of the day who drew on artists' services; Northumbrian artists such as William Irving worked for provincial newspapers covering every type of subject – much as today's press photographer. Indeed, the popularity of drawn illustrations persisted long after photography had been introduced, enabling illustrators like Byron Eric Dawson to present his drawings of buildings and street scenes in newspapers until the mid–1930s, and many other Northumbrian artists to distinguish themselves in book illustration throughout the last century. Among these have been Ernest Thompson Seton with his many drawings of North American wildlife; Sylvia Ismay Venus, her children's book illustrations; Elizabeth Blenkiron those of wild flowers, and Sheila Gertrude Mackie and Pauline Bewick, a range of subjects from early Christian history in Britain, to themes from the South Sea Islands.

Caricaturists and cartoonists

Although Northumbria has not yet produced a Gillray or a Rowlandson, the work of two of its humorous artists in print is perhaps better known to the general public than that of either of these famous British artists. John Thomas Young Gilroy's advertising images incorporating amusing caricatures of birds, animals, and sometimes himself, are known throughout Britain, while the antics of Reginald Smythe's Andy Capp are still entertaining tabloid readers throughout the world several years after his death. And the work of the area's cartoonists has not been confined to the static image, Charles Muir of SUNDERLAND having a hand in the early development of the world's most famous animated cartoon character – Mickey Mouse.

Thomas Bewick's 'tailpieces' are among the first humorous illustrations produced by a Northumbrian artist and unique in their day in terms of book decoration. Not all of course, qualify for the description of humorous, but those which do exemplify a wordless style far in advance of their time. His contemporary and friend Joseph Crawhall the First, by contrast couldn't have been less subtle in his approach to graphic humour. His *Grouse Shooting Made Quite Easy to Every Capacity* is full of 'private' though comparatively obvious jokes at the expense of fellow members of the Park House Club, while his son, Joseph Crawhall the Second, adopted an even broader sense of humour which he ably conveyed in his own 'wood cuts'. His capacities to illustrate his humour were admittedly limited, but his ideas sufficiently good to inspire many superb pieces by his friend and illustrator of *Punch*, Charles Keene. Later Northumbrian humorists in print – as cartoonists or caricaturists – have largely expressed their wit in magazines or newspapers. Little did one-time Bewick apprentice Ebenezer Landells know when he conceived the idea for *Punch*, how much work it, and its successors, would provide for many of his fellow Northumbrian artists!

Not all the successors to *Punch* were aimed at the intelligent and well off, however. Soon special 'funnies' like *Judy* and *Ally Sloper's Half Holiday* were presenting the comic activities of Northumbrian artist J R Brown's McNab, the wild Scotsman. Even respectable provincial newspapers and magazines began finding space for graphic humour, Ralph Hedley briefly in the 1880s excelling in political cartoons for his local press, and William Irving later contributing hundreds of superbly drawn general cartoons to the *Newcastle Weekly Chronicle*. In more recent years it has been Geordie humour, as with that of Smythe and Edward Scott Dobson, or football humour, as

with Richard Thompson's Fred the Fan, which have been the inspiration for much amusing work, although Henry Brewis's local farming humour through the person of Sep, and Norman Yendell Ward's early 20th-century stage and film celebrity-inspired comic strips are notable exceptions. In caricature Northumbria can claim several outstanding exponents, among these William Heath (Paul Pry), who not only made his own mark as a caricaturist but founded the first magazine in Europe devoted to the art; Joseph Foreman (Bos) in the mid-20th century caricaturing hundreds of Tyneside celebrities, and Geoffrey Laws today one of Britain's most accomplished caricaturists of political, film, television and other personalities.

Some important influences on the region's artists

Northumbrian artists have inevitably been influenced by artistic movements taking place elsewhere in the world, and, indeed, have influenced several such movements themselves. The first notable example of the former was perhaps that of the Pre-Raphaelites via William Bell Scott's teaching at the Government School of Design at NEWCASTLE. The effects of this on local artists were limited, however, compared with later influences. Scott's own work, and that of pupils Henry Hetherington Emmerson and Charles Napier Hemy stand out, but Impressionism later in the century was to exercise a much greater effect. Many Northumbrian artists fell under its spell, but none more outstandingly than John Falconar Slater, some of whose work must rank among the best produced by British Impressionists of the last century.

Such influences as were later exerted on the work of Northumbrian artists came as a combination of various circumstances; their visits to London, Paris and other European capitals; the example of teachers like Scott, in the region's multiplying number of art schools; their attendance of long established art schools elsewhere in Britain and abroad, and the sight of works by leading world artists of the past and present in the region's galleries.

The first dramatic examples of Northumbrian artists changing their style through the first of these circumstances were those of Henry William Phelan Gibb and Ralph Rumney. Gibb's visit to the Cézanne exhibition while visiting Paris in 1907 led to his adoption of the Fauve style of painting, and the production of his *Two Nudes*, 1908 – since described as 'the first painting of the twentieth century by a British Artist'; Rumney's visit also to Paris, but rather later, his meeting with Guy Debord, and through this influence the foundation of the Internationale Situationniste Movement.

Victor Pasmore's period of teaching at what is now Newcastle University during the middle 20th century exemplifies the continuing role of the region's art schools in exerting influence, as, indeed, does that of fellow tutor Richard Hamilton. Their time in Northumbria saw Pasmore become one of Britain's leading abstract painters, and Hamilton's seminal role in the birth of Pop Art, with enormous effects upon both their students and locally practising artists. The influences exerted by other art schools attended by Northumbrian students, and which later directed them towards particular subjects and styles must, however, rank as the greatest of them all, and are best identified in the pages of the dictionary. Britain's art schools are among the most numerous and best qualified of any country in the world, and have consistently attracted the full or part-time teaching skills of its leading artists. Some of these leading artists have, indeed, come from Northumbria itself, and have not only exerted their influences on students here in this country, but around the world.

The last, but by no means least, important influence – sight of works by leading world artists of the past and present in the region's galleries – has now been exercised for almost two centuries. Initially this was through the exhibitions of the Northumberland Institution for the Promotion of the Fine Arts, and the Northern Academy on their premises at NEWCASTLE, and later via the city's Laing, Hatton, and University of Northumbria galleries, and the Northern Gallery for Contemporary Art, SUNDERLAND. Now a major new influence has been created in the Baltic Centre for Contemporary Art, GATESHEAD, offering opportunities to the region's artists and art lovers to study some of the most important artworks being produced in the world today.

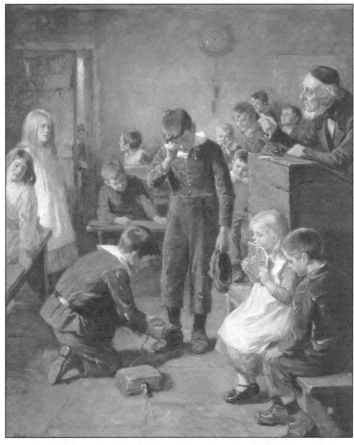

"The Truant's Log" by Ralph Hedley

DUNELM FINE ART

FINE 19TH & EARLY 20TH CENTURY BRITISH & EUROPEAN PAINTINGS

The leading gallery exhibitors in Northumbria, Dunelm Fine
Art hold several such events each year featuring the work of
Ralph Hedley and other well-known artists of the North East
of England. We also hold the largest stock of Hedley's work
in the region as well as a wide selection of works by other
19th and early 20th century British and European artists.

For appointments contact:

Malcolm Lowson BSc
Tel/Fax: 0191 375 0824
email:
MalcolmLowson@artworldwide.fsnet.co.uk

Alan Hedley-Dodd
Tel/Fax: 0191 285 2598
email:
alan@hedley-dodd.fsworld.co.uk

Established 1986

Walter Holmes

Since 1976 I have been painting and successfully exhibiting my work throughout the UK, including the Royal Society of Marine Artists, the Royal Institute of Oil Painters, and widely in my native North East. I have also over the years handled many special commissions, among these portraits of HMS Ocean and HMS Illustrious. If you or your company would like to commission a painting for an important presentation or occasion, to create a series for a calendar or simply decorate your premises or home, I should be delighted to discuss the project with you. Alternatively, I always have a wide selection of my work available for informal viewing at my workshop at

4 Queensway, Darras Hall, Ponteland, Newcastle upon Tyne, NE20 9RZ

(Tel no. 01661 820302)

or on my website **www.holmesart.co.uk**

shipyard commission

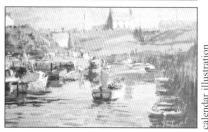

calendar illustration

private commission

JAMES ALDER FINE ART

Fine Victorian and early 20th century paintings

First incorporated in 1972 and now in conjunction with Ian Emmerson Paintings Ltd we can boast an unrivalled wealth of 60 years combined experience in all aspects of buying, selling, bespoke framing, restoration, valuation and advice on Victorian and 20th century paintings.

Now situated in the historic village of Corbridge our gallery is an integral feature within one of the North's finest antique centres, extending to 3000 sq ft, and boasting a free customer car park. Previews to exhibition evenings are by brochure invitation and we welcome your inclusion to our private database.

* Please direct your instructions and enquiries to James Alder or Ian Emmerson at:

James Alder Fine Art
Within Hedleys Antiques
Bishop's Yard, Main Street
Corbridge, Northumberland
NE45 5LA Tel: 01434 634458
email:
jimstell@btopenworld.com
web site: www.jamesalder.co.uk

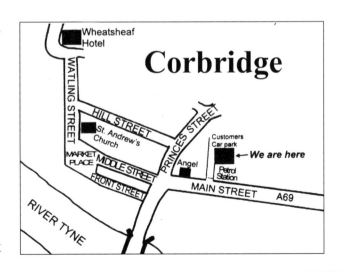

tallantyre gallery

Northumberland's premier contemporary art gallery

Established for almost 50 years the Tallantyre Gallery, Morpeth, is now the leading contemporary art gallery in Northumberland with a reputation for selling the work of well-known local, national and international artists' work.

Over the years the gallery has mounted several important exhibitions of work by Northumbrian artists represented in this dictionary, including James Alder, Walter Holmes, Peter Knox and Libby Orange, as well as by younger artists currently consolidating their reputations, such as Anthony Marshall, Rob Newton and Mary Ann Rogers.

The gallery offers customers five separate rooms to view the work of artists from around the world as well as an art location service to customers who wish to purchase works privately.

Tallantyre Gallery, 43-45 Newgate Street, Morpeth, Northumberland, NE61 1AT Tel. 01670 517214 Fax. 01670 519810.

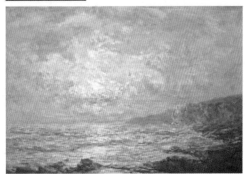
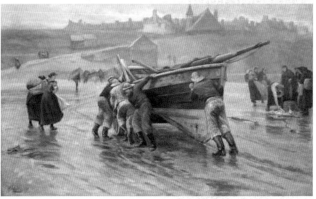

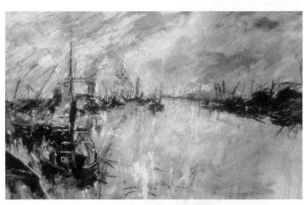

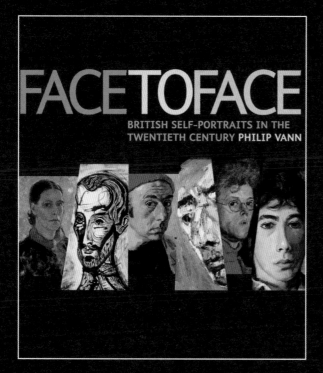

The Artists

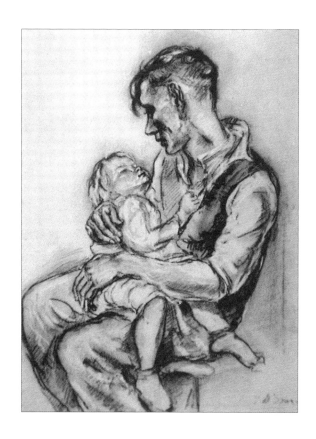

Thomas McGuinness, *Miner and Child*, 1949,
conté, 48 x 35cm. Tyne & Wear Museums,
Shipley Art Gallery.

A

ADAMS, Alan Henry (1892–1988)

Amateur sculptor; landscape and figure painter in oil and watercolour. Adams was born at Manchester, the son of businessman and talented amateur artist Moses James Adams (q.v.). He had taken a passionate interest in natural history from his childhood, and made meticulous drawings of plants and animals, but after his general education he joined Adamsez, the family sanitary ware business on Tyneside, only sculpting in his spare time. He remained with the company until its sale in 1972, meanwhile living at STOCKSFIELD, and exhibiting his sculptures widely in Britain. The group exhibitions in which he participated included the Royal Academy; the Royal Scottish Academy; the Society of Portrait Sculptors; the Artists of the Northern Counties exhibitions at the Laing Art Gallery, NEWCASTLE, and the Stocksfield Art Club, HEXHAM. After the sale of the family business he moved to London, and showed his work in a two-man exhibition at South End Green with Ingrid Barron, and in 1982 enjoyed his only one-man exhibition, at Burgh House, Hampstead. The latter exhibition, staged when he was ninety, featured recent landscapes painted in Suffolk. Although technically an amateur artist, Adams' work achieved a high professional standard and received critical acclaim in the press. His portrait sculpture *Sally*, shown at the Royal Scottish Academy

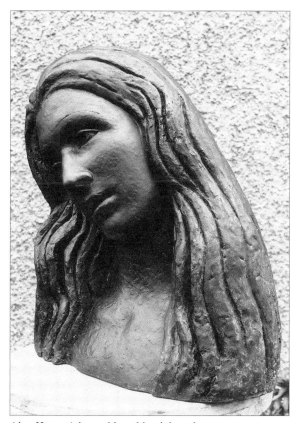

Alan Henry Adams, *Mary Magdalene*, bronze, 51 x 51 x 23cm. Private collection.

in 1956, was illustrated and commented upon in *La Revue Moderne* in that year for its style, modern thinking, and simplicity. He died in London and five of his works were featured in the exhibition 'Artists for Nuclear Disarmament', held at Swiss Cottage Library, in 1990. Adams was also a talented industrial designer and won the Gold Medal of the 12th Biennale di Milano for his work. His sisters GRACE ADAMS (1889–1976), DOROTHY ADAMS (1891–1952), and Ruth Adams (q.v.), were artistically talented. His son Kenneth Richardson Adams (q.v.) is a professional artist. Represented: Laing A G, Newcastle; Tyne & Wear Archives.

ADAMS, Kenneth Richardson ('Praveera') (b.1933)

Sculptor in bronze; figurative painter in oil and acrylic; art teacher. He was born at STOCKSFIELD, the son of businessman and talented amateur artist Alan Henry Adams (q.v.). After studying at Oxford University, where he was awarded a BA Hons degree in philosophy and psychology in 1956, he went on to study at the Slade School of Fine Art, graduating with a diploma in fine art in 1964. He first began exhibiting his work by showing his *Ziggurat and Ceramic Sculpture* at the Northern Sculptors exhibition at the Shipley Art Gallery, GATESHEAD, in 1967, and has since participated in many other group, two-man, and one-man exhibitions in Britain and on the Continent. The group exhibitions in which his work has been shown have included the O'Hana Gallery, London, in 1971; the Royal Academy in 1973, 1975, 1997 and 1998; the Galerie Voemel, Düsseldorf, Germany, in 1979; the Galerie Matthilde, Amsterdam, Netherlands, in 1980; Newcastle Polytechnic, NEWCASTLE, in 1982; the Beardsmore Gallery, London, in 1993, and the Peacock Theatre, London, in 2001. His two-man and one-man exhibitions have been mainly held in Britain, and have included the Grabowski Gallery, London, in 1972; the Alamo, London, in 1977; the Westleton Chapel Gallery, Suffolk, in 1987 and 1990; the Diorama Gallery, London, in 1996, and the Heifer Gallery, London, 2000 and 2001. From 1957 he held a variety of jobs in design research, business and teaching, culminating in a part-time teaching appointment as lecturer in sculpture at St Martin's School of Art. He then worked full-time in this capacity at Central St Martin's College of Art & Design, until his retirement from teaching in 1995 to become a full-time professional artist. During his period of teaching he also took a diploma in art therapy at Goldsmiths' College. In addition to being a talented sculptor mainly in bronze, Adams has also produced a substantial body of work as a painter, in both media initially as a figurative artist. He later turned to abstraction but has since returned to figurative work. He has also lectured and written on art, and is a gifted composer whose work has been performed in London and elsewhere. His commissions as a sculptor have included several private and corporate clients, and his work is represented in the Museum Sztuki, Lodz, Poland, and several private collections in Britain, the USA, and the Netherlands. He lives in London and signs his work

'Ken Praveera Adams', or 'KPA'. The name 'Praveera' is one which he adopted later in his professional career. [See colour plate]

ADAMS, Mrs Laura Gladstone (née Clark, Laura Annie) (1887–1967)

Miniature painter. The daughter of Joseph Dixon Clark, Senior (q.v.), and sister of Joseph Dixon Clark, Junior (q.v.), and John Stewart Clark (q.v.), she was born at BLAYDON, near GATESHEAD, and later practised as a successful painter of portrait miniatures. She exhibited her work at the Royal Academy; the Paris Salon; the Walker Art Gallery, Liverpool, and at various other provincial galleries, including the Laing Art Gallery, NEWCASTLE, whose Artists of the Northern Counties exhibitions she contributed to for many years. Her miniature on ivory portraying herself and infant son Dennis Gladstone Adams, *The Green Necklace*, was given the place of honour in the miniature section of the Royal Academy exhibition of 1923, between portraits of King George V and Queen Mary. She spent all of her life on Tyneside, marrying master photographer and inventor of the car windscreen wiper Gladstone Adams, and working as a colourist in her husband's studios at NEWCASTLE and WHITLEY BAY. In addition to being an accomplished artist she was a talented musician and composer; an operetta which she composed was recorded, Laura acting as pianist, Hubert Dunkerley of the Carl Rosa Opera Company providing the vocal accompaniment. She died at TYNEMOUTH, after living for many years at MONKSEATON.

ADAMS, Moses James (1856–1949)

Amateur landscape painter in watercolour; sculptor and wood-carver; potter; industrial designer. He was born in Suffolk and after moving to Tyneside by the early years of the 20th century was instrumental in founding Adamsez, eventually one of Britain's leading firms of sanitary ware manufacturers. Here he not only involved himself in its management but designed ornate sanitary ware for the firm, drawing on his abilities as a sculptor. He also took a keen spare-time interest in landscape painting, terracotta sculpture and woodcarving, and while living at STOCKSFIELD for many years exhibited examples of his work at the Artists of the Northern Counties exhibitions, at the Laing Art Gallery, NEWCASTLE. Some of his landscape work was produced on trips abroad, but mainly featured British subjects. About the start of the Second World War he moved to Cornwall with his wife and daughter Ruth Adams (q.v.), leaving his amateur artist son Alan Henry Adams (q.v.), to manage the family business. He died at Mousehole, Cornwall. The Laing Art Gallery has a small collection of his watercolours, including figure and architectural studies, and his landscape *Early Morning, Polperro*.

ADAMS, Ruth (1893–1948)

Landscape and figure painter in oil and watercolour. She was born at York, the daughter of Moses James Adams (q.v.), and sister of Alan Henry Adams (q.v.). After possibly receiving some private tuition she practised as an artist throughout her life, and exhibited her work on a number of occasions at the Artists of the Northern Counties exhibitions at the Laing Art Gallery, NEWCASTLE. She lived at STOCKSFIELD with her parents for many years until the outbreak of the Second World War, when she moved with them to Cornwall. Here she continued to paint until her tragic death in a cliff fall in 1948. The Laing Art Gallery has one of her watercolour landscapes, and an oil entitled *Sleeping Woman*.

ADAMSON, Charles Murray (1820–1894)

Amateur bird illustrator. He was born at NEWCASTLE, the son of solicitor, scholar, antiquary, author of the *Life of Camoens*, and translator of Portuguese sonnets, John Adamson. He also became a solicitor, later taking up the appointment of Clerk to the Commissioners of Taxes at NEWCASTLE, and developing in his spare time a keen interest in studying and sketching birds. He was a founder-member of the Tyneside Naturalists' Field Club, and became such an authority on birds that he was frequently consulted about the habits of different species, and had his observations published in the correspondence columns of *The Field*. He also published several books on bird life, among these *Sundry Natural History Scraps*, 1879; *More Scraps About Birds*, 1880–81; *Studies of Birds*, 1881, and *Some More Illustrations of Wild Birds*, 1887, illustrating all save the first named publication himself. He died at NEWCASTLE. He was the younger brother of William Adamson (q.v.). The Natural History Society of Northumbria, NEWCASTLE, has a large collection of his work.

ADAMSON, Dorothy RI ROI (1893–1934)

Animal and landscape painter in oil and watercolour. She was born at SUNDERLAND, and following her general education on Wearside studied under Lucy Kemp-Welch, the leading painter of equestrian and country subjects. Kemp-Welch had taken over the school at Bushey, Herts, of Sir Hubert von Herkomer, and Dorothy became one of her tutor's most promising pupils. She became a professional artist about 1915, and from this year onward specialised mainly in game-dog studies, exhibiting her work regularly until her early death at the age of forty-one. She exhibited at the Royal Academy from 1917 until 1933, showing a mixture of landscape and cattle studies, and also sent work for exhibition to the Royal Scottish Academy; the Royal Cambrian Academy; the Royal Institute of Oil Painters; the Royal Institute of Painters in Water Colours, and to various London and provincial galleries. During her career she lived in Cheshire and Dorchester, but made her eventual home at Bushey. She was elected a member of the Royal Institute of Oil Painters, and the Royal Institute of Painters in Water Colours, in 1929.

ADAMSON, William (1818–1892)

Amateur architectural and coastal painter in watercolour. He was born at NEWCASTLE, the son of solicitor, scholar, antiquary, author of the *Life of Camoens*, and translator of Portuguese sonnets, John Adamson. He succeeded to his father's business, and later took a keen interest in antiquarian and natural

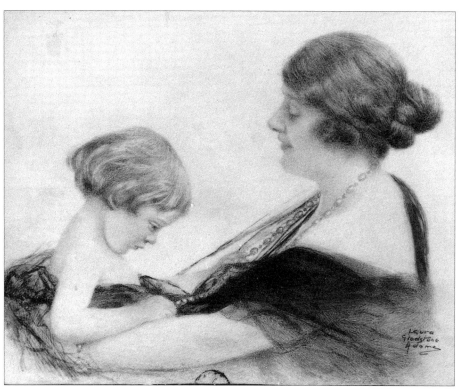

Laura Gladstone Adams,
The Green Necklace, 1923,
watercolour on ivory,
7.5 x 13cm.
Private collection.

history matters, becoming a member of the Society of Antiquaries, NEWCASTLE, and the town's Literary and Philosophical Society, as well as a close friend of the brothers Albany Hancock (q.v.), and John Hancock (q.v.). On his retirement he settled at CULLERCOATS, a place for which he had formed an attachment earlier in his life, and while visiting which, according to William Weaver Tomlinson, in *Historical Notes on Cullercoats, Whitley and Monkseaton*, 1893, he had 'made, about 1839 and 1842, a number of watercolour sketches of the village, of Sparrow Hall, Garden House, Whitley Rocks etc., which, though crude in execution, enable us to form a good impression of the place as it was half a century ago.' Tomlinson also noted that 'Mr. Adamson compiled and edited 'Notices of the Services of the 27th Northumberland Light Infantry Militia', to which corps he was appointed senior captain and honorary major in 1877'. He died at CULLERCOATS. He was the elder brother of Charles Murray Adamson (q.v.), and grandfather of Sophia Mildred Atkinson (q.v.).

ADYE, General Sir John (1819–1900)
Amateur landscape painter in watercolour; architectural draughtsman; illustrator. This artist was born at Sevenoaks, Kent, and enjoyed a distinguished military career, culminating in his promotion to General in 1884. He was a keen spare-time painter throughout his service, and in 1888 exhibited two of his works, described as portraying 'fortresses', at the New Water Colour Society (later the Royal Institute of Painters in Water Colours). In 1889, his daughter Winifreda Adye, married William Henry Armstrong Fitzpatrick Watson-

Armstrong, later First Baron Armstrong of Bamburgh and Cragside, and Adye, now having retired from the Army, joined his daughter at the Armstrong family home at Cragside, ROTHBURY. Here, and at BAMBURGH, he produced many watercolour and monochrome studies of local subjects, some of which are now on display at Cragside, courtesy of the National Trust. He also illustrated a volume of autobiographical reminiscences, and some of his Northumbrian work was sold in the form of prints. He died at ROTHBURY.

AINSLIE, Sam (b.1950)
Tapestry artist; art teacher. Ainslie was born at NORTH SHIELDS, and did an arts foundation course at the Jacob Kramer College of Art, Leeds, before going on to study art at Newcastle Polytechnic (now University of Northumbria). While studying at the latter she spent a period in 1975 in Japan, where her study of Sukiya architecture was to prove a big influence in her later work. In 1977 she moved to Edinburgh to study tapestry at the city's College of Art, later developing a style in the use of the medium, of abstract shapes and bright colours with a particular emphasis on challenging traditional perceptions of the female body. In 1983 she produced a large tapestry for General Accident's headquarters at Perth, this major work following a series of banners which she had designed and made for the Scottish National Gallery of Modern Art's new building at Edinburgh. Later work has included a Banner for Greenham (1985), and teaching at Glasgow School of Art. In 1986 she had an exhibition at Glasgow's Third Eye Centre.

ALDER, James (b.1920)

Bird, animal and flower painter in oil, pastel and watercolour; draughtsman; illustrator; sculptor. He was born at NEWCASTLE and showed such talent as an artist while still a schoolboy that he was encouraged to stage his first one-man exhibition at the age of thirteen. At the same age he also won a place at the evening classes in art held at King's College (now Newcastle University), where he studied for the next six years. When he was fifteen he joined the *Evening Chronicle*, NEWCASTLE, as a commercial artist, returning to the newspaper after two years' war service in the RAF, in the same capacity. He later became a freelance commercial artist, and received a commission from the *Chronicle* to provide a weekly series of illustrated articles on natural history which continued unbroken for twenty years. During this period he became Northumbria's best known wildlife artist, and in 1968 was given his second one-man exhibition, at the Shipley Art Gallery, GATESHEAD. This included various of his bird studies in watercolour, pastel, ink and scraperboard, as well as several posters which he had designed for the RSPB in his capacity as its first-ever publicity consultant. His increasing status as a wildlife artist led to other one-man exhibitions in Northumbria, including those at the Hancock Museum, NEWCASTLE, and the Bowes Museum, BARNARD CASTLE. It also led to his appointment as senior sculptor of birds and flowers for the Royal Worcester Porcelain Company, and the illustration of several books. His work for Royal Worcester has included several bird pieces, while his book illustration work has included *The Molecatcher*, by Henry Tegner, and *Bird Quest*, by Sir James Steel. In recent years he has produced a number of small bronzes, some of which he has exhibited at the Sladmore Gallery, London, and two major works of book illustration: *The Birds & Flowers of the Castle of Mey*, 1992, and *The Birds of Balmoral*, in 1997. The former was researched, written and illustrated for Her Majesty Queen Elizabeth the Queen Mother; the latter for Her Majesty Queen Elizabeth II, and are regarded as his most important works in book illustration. These two books were reprinted in 2003 by the University of Northumbria, NEWCASTLE, as a single volume. Alder is a member of several organisations associated with his interests in art and wildlife conservation, including the Pen & Palette Club, NEWCASTLE; the Tyneside Bird Club, the Northumberland Wildlife Trust, and the Natural History Society of Northumbria, serving in the latter as vice-chairman for many years. A major exhibition of his work, including his early illustrations for the *Chronicle*, later drawings, and his original illustrations for his two royal books, was held at the Tallantyre Gallery, MORPETH, in 2000, to mark his 80th birthday. A major preoccupation since the latter event has been the completion of what is probably the largest watercolour study of the wild cattle at CHILLINGHAM ever produced. The 89cm x 138.5cm painting, completed in 2002, has since been reproduced as a print to raise funds for the preservation of the cattle. In 2002 he was awarded an honorary doctorate of civil law by Northumbria University in recognition of his work as an artist and wildlife champion. He lives and

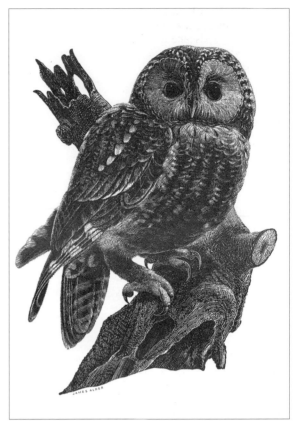

James Alder, *Little Owl*, scraperboard, 18 x 13.5cm. Private collection

works at PONTELAND, near NEWCASTLE, his home for many years. Represented: Natural History Society of Northumbria, Newcastle. [See colour plate]

ALDERSON, Alfred Marsden (b.1929)

Amateur landscape and animal painter in watercolour; illustrator; art teacher. He was born at NEASHAM, near DARLINGTON, the nephew of Elizabeth Mary, and Dorothy Margaret Alderson (q.v.), and worked most of his life in the farming industry, painting in his spare time. Since his retirement he has become increasingly active as a painter and has regularly exhibited his work with the Darlington Society of Arts, DARLINGTON, and carried out many commissions for private clients in North Yorkshire and South Durham. One of his major preoccupations as an artist has been a series of parish pictures for various villages in these areas, including Northallerton, and Hutton Rugby. He has also produced illustrations for aviation publications, and his landscape work has been the subject of a number of limited-edition prints. He lived most of his life with his aunts and received some of his initial tuition from them. He later moved to Northallerton, North Yorkshire, with his aunt Dorothy, and has continued to live there since her death in 1992. Alderson still actively paints and exhibits his work and teaches art locally.

ALDERSON, Elizabeth Mary (1900–1988), and Dorothy Margaret (1900–1992)
Animal and landscape painters in oil and watercolour. These twin sisters were born at NEASHAM, near DARLINGTON, descendants of Royal Academician William Etty, and without prior professional tuition, in 1919 began to collaborate in the production of paintings, usually featuring horses. Their first commissions of importance came from Sir William Nussey, of Melmerby, Cumbria, and they subsequently received hundreds of other commissions, many as a consequence of their regular attendance of the Harewood Trials, and other sporting events involving horses. The sisters also illustrated postcards with farming subjects, their tiny originals being among some of their most avidly collected works. Their unique artistic partnership involved one sister starting at one part of a painting, and the other at another, with a complete fusion of their talents in the finished work. This work was invariably exhibited combining both of their signatures, and shown widely throughout Britain including London, Edinburgh, and principally in Northumbria at the Artists of the Northern Counties exhibitions at the Laing Art Gallery, NEWCASTLE, and the Darlington Society of Arts exhibitions, DARLINGTON. The sisters painted well into their eighties, working at the family home at NEASHAM, and created something of a sensation when one of their paintings was accepted for hanging at the Royal Academy in 1984. Elizabeth shortly afterwards had to give up painting due to failing eyesight, and illness, and died in 1988. Dorothy continued painting on her own until just short of her death at Northallerton, North Yorkshire, in 1992, to which she and her artist nephew, Alfred Marsden Alderson (q.v.), had moved from the family home three years earlier. An Alderson Room displaying paintings by the sisters has since been established at Sion Hill Hall, Kirby Wiske, near Thirsk, North Yorkshire. Represented: Darlington A G; Middlesbrough A G. [See colour plate]

ALEXANDER, Hazel (b.1912)
Sculptor. Born at NEWCASTLE, Alexander developed a talent for art at an early age, and in 1936 attended Luton Art School. It was not until 1970, however, that she was able to pursue her studies further, working under Joan Armitage at the Camden Institute, and privately with Fred Kormis. She has exhibited her work at the Royal Festival Hall; the Ben Uri Gallery; the Mall Galleries, and on a permanent basis at the Sharon Hotel, Herzliya, Israel. Among her more important commissions have been a sculpture of singles champion Kitty Godfree, for the All-England Lawn Tennis Club, The Crouching Child, inspired by the NSPCC logo, and the politician Golda Meir for the Israeli Embassy's Hisdadrut Building, Tel-Aviv. Her work is in many private collections throughout the world. Her daughter, NAOMI ALEXANDER (b.1938), has also practised as a successful sculptor.

ALEXANDER, Joseph (born c.1754)
Landscape painter in oil; draughtsman. This artist practised at BERWICK-UPON-TWEED in the late 18th and early 19th centuries. His *View of the Barracks and Parade from the Walls above the Cow Port*, and *East View of the Governor's House &c of Berwick*, were engraved by R Scott, for *The History of Berwick upon Tweed*, by John Fuller MD, of BERWICK-UPON-TWEED, published in 1799. This work was reprinted by Frank Graham in 1973.

ALLAN, Griselda Norma (1905–1987)
Landscape painter in oil and watercolour; lithographer. She was born at SUNDERLAND into a prosperous shipping family and became a student at the town's School of Art in the mid–1920s. Here she studied under Richard Archibald Ray (q.v.), and contributed three flower studies to the library frieze painted by students in 1925. Her training continued at the Royal College of Art and on the Continent, and she attended the Ruskin School of Art 1935–9, under Albert Rutherston. During the Second World War she taught drawing for several years at the evacuated Slade/Ruskin Schools, continuing at the Ruskin following its conclusion. During the War she produced several notable works including her *New Shipyard at Southwick*, 1944, and several official purchases for the War Artists' Advisory Committee. She exhibited sparingly in her lifetime, among the few known examples being her oils *Running Shed, Camden*, and *The New Yard*, and watercolour *Tree Study*, shown at the 'Contemporary Artists of Durham County' exhibition, staged in 1951 at the Shipley Art Gallery, GATESHEAD, in connection with the Festival of Britain. She spent most of her life in the south of England, but eventually returned to live in SUNDERLAND. Represented: Sunderland A G.

ALLSOPP, Bruce (1912–2000)
Amateur landscape painter in oil and watercolour. Allsopp was born at Oxford and went on to graduate from Liverpool University with a first class honours degree in architecture. His subsequent post as lecturer at Leeds College of Art was briefly interrupted with the outbreak of the Second World War, when he was commissioned as a captain, serving in the Royal Engineers stationed in North Africa. After six years' war service he returned to Leeds, and in 1946 moved to Northumbria to lecture in architecture. He settled at STOCKSFIELD, where he continued his career as university lecturer and later reader, and also resumed his lifelong interest in painting. He joined the village art club, and for a number of years maintained a studio at STOCKSFIELD at which he staged exhibitions of various artists' work, including his own, and that of his talented artist wife Cyrilla (d.1991). Allsopp also wrote a series of successful books while living at STOCKSFIELD, and in 1962 founded Oriel Press Ltd, which published numerous books, often concerning architecture. He first exhibited his work in 1933, when living at Worthing, Sussex, showing one example at the Walker Art Gallery, Liverpool. A work entitled *Steyning High Street*, is in the collection of Worthing Art Gallery. He died at STOCKSFIELD.

ALMOND, Henry Nicholas (b.1918)
Landscape painter in oil and watercolour; art teacher. Almond was born at BISHOP AUCKLAND, and after studying at King's College (now Newcastle University), became an art teacher at STOCKTON-ON-TEES. He lived at MIDDLETON ST. GEORGE, near DARLINGTON, at which latter a major exhibition of his work was held in 1950. His oils *Gardens in Winter*, and *Tees-side Woods in Winter*, were included in the 'Contemporary Artists of Durham County' exhibition, staged in 1951 at the Shipley Art Gallery, GATESHEAD, in connection with the Festival of Britain, and he was also about this period a frequent exhibitor at the Artists of the Northern Counties exhibitions at the Laing Art Gallery, NEWCASTLE.

ALTSON, Meyer Daniel (1881–1965)
Portrait and decorative painter in oil; etcher; illustrator. He was born at MIDDLESBROUGH, and studied at the National Gallery of Victoria, Melbourne, Australia, where he was awarded a scholarship at the age of sixteen. He later studied at the École des Beaux-Arts, and at Colarossi's, Paris, settling in London by 1925. He spent the remainder of his life in London, and exhibited his work at the Royal Academy, the Paris Salon, and in the provinces. He also illustrated several books, newspapers and magazines. He died in London. His brother ABBEY ALTSON was a successful portrait painter and widely exhibited his work.

ANDERS, T (fl. early 19th cent.)
Landscape painter in oil. This artist painted a landscape featuring salmon netters on the Tyne, *Close House, Wylam, from Ryton Willows*, in the 1830s. An example of his work was included in the 'Exhibition of Paintings and other Works of Art', at the Town Hall, NEWCASTLE, in 1866, described as *Landscape and figures*. He is believed to have been a native of NEWCASTLE.

ANDERSON, Charles Goldsborough (1865–1936)
Portrait painter in oil. Born at TYNEMOUTH, Anderson studied at the Royal Academy Schools before practising as a professional artist. He first began exhibiting his work by sending three portraits to the Royal Academy in 1888. He sent a further sixteen works to the Academy before his death in 1936, and also exhibited at the Royal Institute of Oil Painters; the Royal Society of British Artists, and at various London and provincial galleries. In 1901 and 1904 exhibitions of his work were held at the Grafton Galleries, London. One of his major works was the panel which he painted for the Royal Exchange, in 1910. He worked most of his life in London, but appears to have spent his final years at Rustington, Sussex. The Laing Art Gallery, NEWCASTLE, has his portrait of his wife, which was exhibited at the Royal Academy in 1900.

ANDERSON, John (b.1778)
Wood engraver. The son of Dr James Anderson of Edinburgh, editor of *The Bee*, and a customer of Thomas Bewick (q.v.), he was an apprentice of Bewick from 1792 until 1799. He engraved the illustrations for

the first edition of Bloomfield's *The Farmer's Boy*, 1800, and Maurice's *Grove Hill*, 1799. After spending some time in London he is believed to have emigrated to South America, or Botany Bay, in 1803 or 4, and was lost to wood engraving.

ANDERSON, William S ('Jock') RE (1878–1929)
Amateur landscape, interior, flower and still life painter in watercolour; etcher. Born at Kilsyth, near Glasgow, Anderson painted from his early childhood, though frequently admonished by his parents for wasting time on this practice. Early in his life, however, he had the good fortune to meet Alexander Roche, the Royal Scottish Academician, who took an interest in his work and encouraged him to develop it further. By the end of the First World War Anderson had moved to HEXHAM, and began to exhibit his work, showing examples at the Royal Scottish Academy; the Royal Scottish Society of Painters in Water Colours; the Royal Society of Painter-Etchers (of which he was a member); the Goupil Gallery, London, and at the Artists of the Northern Counties exhibitions at the Laing Art Gallery, NEWCASTLE. He remained an exhibitor at NEWCASTLE all his life, in later years becoming a member of the city's Pen & Palette Club, and regularly showing at its exhibitions. His work encompassed a wide variety of subjects, but he was especially fond of interiors, and is said to have been greatly influenced by the work of the Dutch Masters in this field, particularly Vermeer of Delft. Represented: Laing A G, Newcastle; Pen & Palette Club, Newcastle.

ANDERTON, Mrs Mary Margaret (née East) RDS (d.1931)
Landscape, architectural and flower painter in watercolour. She was the daughter of Canon East, sometime Vicar of St Andrew's, NEWCASTLE, and trained as a teacher before becoming, in 1896, the first wife of Basil Anderton, City Librarian 1894–1935. While still unmarried she contributed two watercolour works to the Suffolk Street Gallery (1873/4); *A Dead Duck*, and *Wild Flowers and Nest*. She followed this by showing one work at the Arts Association exhibition, NEWCASTLE, in 1878, and thereafter showed her work regularly at the Bewick Club in the city, almost from its foundation. Following her marriage she continued to exhibit at the Bewick Club, and in 1899 sent one work to the Society of Women Artists' exhibition in London. She later became a frequent exhibitor at the Artists of the Northern Counties exhibitions at the Laing Art Gallery, NEWCASTLE, showing a wide range of British and Continental landscape and architectural subjects. She was a member of the Royal Drawing Society, and an occasional illustrator. Some of her work was reproduced in *Fragrance among old volumes*, written by her husband, and published by Kegan Paul in 1910.

ANDREWS, James (1824–1870)
Portrait and genre painter in oil. This artist practised at NEWCASTLE in the 1840s, listing himself in trade directories of this period, and exhibiting his work both here

and at Carlisle, Cumbria. He exhibited ten works at the North of England Society for the Promotion of the Fine Arts, NEWCASTLE, in 1842, which included portraits of the Rev J C Bruce, Mrs Bruce, and the Rev E Moises. He exhibited at the Society's exhibition in the following year, and in 1846 sent two works to Carlisle Athenaeum: *The Little Shepherdess*, and *Portrait of Thomas H. Graham Esq., Edmond Castle*. He may have been the 'John Andrews' who was an honorary exhibitor at the Royal Academy and the British Institution from the 1820s. The Literary & Philosophical Society, NEWCASTLE, has his portrait of the Reverend Edward Moises. It was presented to the Society in 1844 by Dr Headlam, in recognition of Moises' contribution to its establishment.

ANGAS, George French (1822–1886)
Topographical and natural history illustrator; lithographer. He was born at NEWCASTLE, the eldest son of George Fife Angas, Tyneside mahogany and wood merchant, and later one of the founders of South Australia. Following his general education his father placed him in a London office, but he left this employment after a year to study for a time under Waterhouse Hawkins, a natural history artist. At nineteen he toured the Mediterranean, and in 1842 published his first major illustrative work *A Ramble in Malta and Sicily in the Autumn of 1841*. The illustrations took the form of lithographs drawn by him on the stone. In 1843 he exhibited for the first time, showing a drawing, *West Side of the Quadrangle of the British Museum*, at the Suffolk Street Gallery. Shortly after this he went to Australia, spending a few months there in 1844, before moving on to New Zealand. In the following year he returned to Australia for six months, during this period showing at Adelaide and Sydney watercolours made during various trips into the Australian interior. After a tour of New South Wales he set sail for England via Cape Horn, stopping off briefly at Rio de Janeiro, where he made several watercolour drawings. In 1847 he exhibited in London a number of the watercolours from his Sydney exhibition, and in this year published three of his most important works: *South Australia Illustrated; The New Zealanders Illustrated* (both large folios), and *Savage Life & Scenes in Australia & New Zealand*. Most of the lithographs for the first two of these works were executed, and subsequently coloured, by Angas himself, and he was also responsible for much of the texts. He next travelled in South Africa, and in 1849 published in London the third of his large folios of hand-coloured lithographs, *The Kaffirs Illustrated*. In the same year he also published *Description of the Balarossa Range*; this was illustrated with six hand-coloured plates drawn 'from nature on the stone', by Angas. Some time later he was appointed naturalist to the Turko-Persian Boundary Commission, but caught a fever in Turkey and was invalided back to England. In 1849 he married, and in 1850 moved back to Australia, where in 1851 he published two works on the country's gold fields. In 1853 he was appointed secretary to The Australian Museum in Sydney, holding this position until 1860, when he retired to South Australia. In 1863 he left with

his family for London, where he remained until his death in 1886. He exhibited on only one further occasion following his return to London, this being when he sent his *Constantinople looking over the Sea of Mamora*, to the Royal Academy in 1873. He published two further works after his return to Britain: *Australia, a Popular Account*, 1865, and *Polynesia, a Popular Description*, 1866: His younger brother, JOHN HOWARD ANGAS (1823–1904), also practised as an artist, specialising in bird, flower and insect studies. Represented: British Museum; The Art Gallery of South Australia, Adelaide; The Australian Museum, Sydney.

ANGELICO – see CARMICHAEL, Herbert

ANT – see NORTH, Arthur

APPLEYARD, Frederick, RWA (1874–1963)
Landscape, genre and portrait painter in oil. Born at MIDDLESBROUGH, Appleyard studied art at Scarborough School of Art under Albert Strange. He later attended the Royal College of Art, and the Royal Academy Schools, at which latter he won the Creswick prize for landscape painting. He began exhibiting at the Royal Academy in 1900, showing *The Incoming Tide*, and a wall decoration, *Spring driving out Winter*. He left London in 1910 to work in South Africa, returning to the City in 1912, where he resumed exhibiting at the Royal Academy, and later began exhibiting at the Royal West of England Academy, and at various London and provincial galleries, including the Artists of the Northern Counties exhibitions of the Laing Art Gallery, NEWCASTLE. His work, *A Secret*, was purchased for the Tate Gallery by the Chantrey Bequest, in 1915, and in 1926 he was elected a member of the Royal West of England Academy. He died at Alresford, Hampshire, where he had lived for many years. The Laing Art Gallery, NEWCASTLE, has his oils, *Portrait of Lady*, and *Roses*. He may have been related to the artist Joseph Appleyard (q.v.).

APPLEYARD, Joseph (1908–1960)
Sporting and landscape painter in oil and watercolour; art teacher. He was born at MIDDLESBROUGH, the son of Frederick Appleyard, a local size and grease manufacturer. After education at Armley Church Schools, Leeds, he attended the city's College of Art evening classes under H H Holden and D S Andrews. He later taught art at Leeds, Keighley, and Swartmore Settlement in Leeds, and undertook numerous commissions for work on sporting themes, including *Dante*, the 1945 Derby winner; *Airborne*, the Derby and St Leger winner in 1946, and *The Finish at St Leger 1959* (won by *Cantello*). He painted most of the Yorkshire hunts in his lifetime and spent much of his time on the dales and moorlands around Grassington. He exhibited widely throughout his career, showing examples of his racing, hunting and polo subjects at the Royal Society of British Artists, and many provincial group exhibitions. The latter included the Yorkshire Artists, at which his *The Fourth Test Match at Headingley March/July 1953*, was exhibited in

Joseph Appleyard,
*Bramham Moor Open Race
- 3.50pm*, 1952,
oil, 30.5 x 46cm.
John Noot Galleries.

1953, and the Artists of the Northern Counties exhibitions at the Laing Art Gallery, NEWCASTLE. His work was also regularly reproduced in the *Yorkshire Observer*; *Yorkshire Dalesman*; *Yorkshire Illustrated*; *Field Sports*; *Sport & Country*; *Caxton Magazine*, and the *Yorkshire Magnet*. His studio was at Headingley, Leeds, where he lived for many years. He died in a road accident at Leeds in 1960. He may have been related to Frederick Appleyard (q.v.). Represented: Darlington A G; Doncaster Museum & A G.

ARCHER, John Wykeham (1806–1864)
Architectural draughtsman and painter in watercolour; animal and figure painter in oil; engraver; etcher. Born at NEWCASTLE, the son of a tradesman, Archer displayed a gift for drawing at an early age and was permitted by his family to enrol as a pupil of John Scott (q.v.), the well-known London engraver. Returning to his birthplace in his late teens, he became a partner of William Collard (q.v.), producing in 1827 a series of large etchings of Fountains Abbey, Yorkshire, after John Wilson Carmichael (q.v.), and four plates for Mackenzie's *Durham*. Also while at NEWCASTLE, he began exhibiting at the town's Northern Academy, showing as his first work in 1828, *Quagger pursued by a Lion*. A short period in Edinburgh followed, during which he made a large collection of drawings of old buildings in the city, then he returned to London to develop his skill as an engraver with the engraver and publisher brothers Finden. Archer spent the remaining thirty-odd years of his life mainly in London, and during this period became a regular exhibitor at the New Water Colour Society (later the Royal Institute of Painters in Water Colours), showing some sixty-three works from his election as member in 1842, until his death. He also in this period produced drawings of 'ruins, curios, and other objects of antiquarian interest' on the estates in Northumbria of the Fourth Duke of Northumberland, and thirty-seven etchings for his folio volume *Vestiges of Ancient London*, 1851. A few

more works in oil were produced while he was in London, but he was principally interested in drawing, later colouring his work or reproducing it in the form of engravings or etchings. Among his engraving work after others were many plates for *Views on the Newcastle to Carlisle Railway*, engraved on steel, after Carmichael, and wood engravings for the *Illustrated London News*, and Blackie's *History of England*. Following his death in London, a small volume of his poems was published by his son. Archer was a close friend of George Balmer (q.v.), during the latter's period in London, and contributed a lengthy tribute to the memory of his friend in the *Art Union*, October, 1846, a few months after Balmer's death. Represented: British Museum; Victoria and Albert Museum; Laing A G, Newcastle.

ARCHER, William, ARCA (b.1928)
Sculptor; landscape and portrait painter in oil; draughtsman. He was born at THORNLEY, near DURHAM, and studied at Sunderland College of Art in 1946, and again from 1949–1952, before attending the Royal College of Art. He first exhibited his work while living in London, showing his *Blossom Trees* at the Royal Academy in 1954. He continued to exhibit at the Academy for several years, and also contributed his work to the Royal Scottish Academy and various North of England exhibitions. One of his latter exhibits was his oil portrait *Maureen*, shown at the Artists of the Northern Counties exhibition at the Laing Art Gallery, NEWCASTLE, in 1955. He later returned to live at THORNLEY.

ARIS, George Birtley (b.1927)
Landscape painter in oil and watercolour; stained glass designer; illustrator; art teacher. Aris was born at SUNDERLAND, and studied at its College of Art & Crafts, and later at the College of Education, NEWCASTLE, before embarking on his career as an artist and later teacher. Following national service as a Bevin

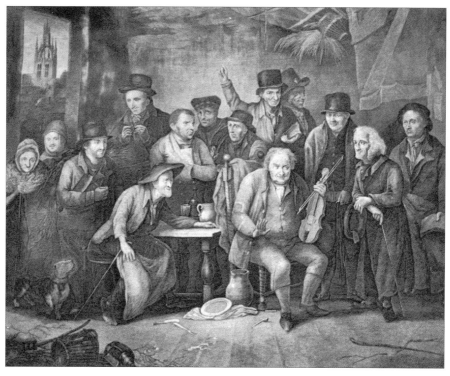

George Armstrong,
Principal Eccentric Characters of Newcastle,
engraving after Henry Perlee Parker.
Private collection.

Boy during the Second World War, he worked as a designer and craftsman in stained glass in NEWCASTLE, and London. On returning to Northumbria in 1962 he became head of art at a Tyne Valley High School, remaining there until 1982, before becoming a full-time painter. One of Northumbria's best known stained glass designers of the late 20th century, Aris has also produced a wide variety of other artistic work, including landscapes in oil and watercolour, and book and poster illustrations. He has also shown his work in many group and one-man exhibitions, including among the former, *Intimate Landscape*, HEXHAM, 1974; *Six British Watercolourists*, Berkeley, California, USA, 1983; *Celebration of the North*, Mall Galleries, London, 1988; *Durham Cathedral Artists & Images*, Durham Art Gallery, DURHAM, 1993; *Women of Music & Art*, Live Theatre, NEWCASTLE, 1994, and *Church Outing*, Customs House Gallery, SOUTH SHIELDS and touring, 2001–2, featuring rural chapels, churches and other places of worship. Among his one-man exhibitions have been those at the Bondgate Gallery, ALNWICK, 1974; Centre Cultural, Mitry-le-Neuf, France, 1974; Durham Art Gallery, 1985; Sunderland Arts Centre, 1996, and the Quaker Gallery, London, 1998. His illustrative work includes *Angerton Crossing*, Mid-Northumberland Arts Group (MidNAG), 1974; *Acknowledged Land*, with text by Linda France, 1974; Hans Christian Andersen's *Princess & The Pea*, 1997, and together with Gordon Highmoor (q.v.), *The Power of Place*, by Stan Beckensall, Tempus, 2001. His other activities in art have included lecturing for the Workers' Educational Association, and a period as artist-in-residence, Durham Cathedral. He lives at HEXHAM. His work is represented in many public and private collections in Northumbria, and on the Continent. [See colour plate]

ARMSTRONG, Charles, ABWS (b.1864)
Landscape painter in oil and watercolour. He was born at SUNDERLAND, and studied at the Royal College of Art, and at the Académie Julian, Paris, before serving at the former in the capacity of examiner for some eleven years. He later worked as headmaster of Peterborough School of Art, and the City of London School of Art, painting in his spare time. He painted several works in Switzerland and Italy, but exhibited sparingly. He exhibited two works at the Royal Hibernian Academy in the period 1901–2, and various works at the British Water Colour Society (of which he was an associate), and at miscellaneous London and provincial galleries in subsequent years. He also published a number of art-related textbooks, including *Light and Shade; Object Drawing*, etc. He lived for a number of years at Ramsgate, Kent.

ARMSTRONG, George (fl. early 19th cent.)
Engraver. This engraver practised at NEWCASTLE in the early 19th century, where one of his most notable works was the engraving of the *Principal Eccentric Characters of Newcastle upon Tyne, c. 1818*, of Henry Perlee Parker (q.v.). It was published by Emerson Charnley of NEWCASTLE, who had the painting exhibited to obtain subscribers. The popularity of the subject is said to have contributed much to Parker's later success in the town. Armstrong sometimes collaborated in his engraving work with James Walker (q.v.), and, indeed, is believed to have been in business with Walker for several years.

Marjorie Arnfield, *Hodbarrow Iron Mines and Collapsed Seawall*, acrylic, 33 x 46cm. Private collection.

ARMSTRONG, John (1772–1847)

Engraver. This engraver practised at NEWCASTLE in the early 19th century. He died at NEWCASTLE. Little is known of his work.

ARMSTRONG, John (fl. late 18th, early 19th cent.)

Wood engraver. Armstrong was the last apprentice of Thomas Bewick (q.v.), and probably carried out some of the less complicated wood engraving work in the Bewick workshop. He later practised as a wood engraver in London.

ARNFIELD, Marjorie (1930–2001)

Landscape and industrial painter in oil, acrylic and watercolour. She was born at SUNDERLAND into a community with long ties with the mining industry. When she was four she was struck by juvenile chronic arthritis, but notwithstanding its lifelong effects went on to study art and became a successful art teacher and artist, with a particular fondness for mining subjects in her later work. She obtained her design and art teacher's diplomas studying at Sunderland College of Art, and at King's College (now Newcastle University). She then took up a teaching post at her old school at SUNDERLAND before tutoring at various universities and other educational establishments in Cheshire, Cumbria, Scotland and Nottinghamshire, and several painting schools in Britain and abroad. She participated in many group exhibitions while working in this capacity and enjoyed several one-man exhibitions of her work. The former included the Northern Young Artists Exhibition; Huddersfield Art Gallery; the Royal Watercolour Society; the Lake Artists Society, Grasmere, Cumbria; Castle Museum,

Nottingham, and the Laing Art Gallery, NEWCASTLE. Among her one-man exhibitions were those held at the Bondgate Gallery, ALNWICK; Chesterfield Museum & Art Gallery; BBC Glasgow; Mansfield Museum & Art Gallery, and the Queen's Medical Centre, Nottingham. Her lifelong interest in the mining industry led her in the 1990s to record its virtual demise, and in 1994 British Coal toured her exhibition *Coal Mining in Nottinghamshire – a Tribute*, to produce work for which she went underground in her wheelchair. She subsequently showed work in various other mining theme exhibitions and enjoyed further one-man exhibitions, among these her *Images of Coal*, 1996. This exhibition initially toured Wales, subsequently visiting other parts of Britain, including Woodhorn Colliery Museum, ASHINGTON, and Sunderland Museum & Art Gallery, in 1997, and finally the Hutchinson Gallery, Town Hall, BISHOP AUCKLAND, and Bede's World, JARROW, near SOUTH SHIELDS, in 1999. She painted many other subjects than those related to mining but must nevertheless be counted among a handful of British women artists who have shown a particular fondness for them in their careers. Following her death in 2001 a major exhibition of her work was held at the Djanogly Art Gallery, University of Nottingham Arts Centre, Nottingham, entitled: *Marjorie Arnfield – a celebration of her Life and Art*. This included a wide range of her work, among this British and Continental landscapes and various of her industrial scenes. She died at Nottingham, having lived in the locality for some thirty years. Represented: Graves A G, Sheffield; Middlesbrough A G; Rotherham Museum Service; Sunderland A G; Woodhorn Colliery Museum, Ashington.

ARNOLD, Ann (b.1936)
Landscape painter in oil and watercolour; illustrator; art teacher. She was born at NEWCASTLE, and studied at Epsom School of Art before working as an art therapist in the south of England. Together with her husband, GRAHAM ARNOLD, she was one of seven artists who formed The Brotherhood of Ruralists in 1975, and held its first exhibition in the following year. Apart from participating in this, and later Ruralist exhibitions, she also showed her work in several mixed exhibitions, including those held at the Festival Gallery, Bath, in 1974; Bristol City Art Gallery, in 1975, and the Royal Academy from 1977. She held her first one-man exhibition at the Festival Gallery, Bath, in 1979, and has since mainly exhibited at the New Grafton Gallery. Arnold illustrated *Clare's Countryside*, published in 1981.

ARTHUR, Alice E (c.1885- after 1940)
Landscape and flower painter in watercolour. She was born at NEWCASTLE, the daughter of Samuel Arthur, chemist, and part owner of a firm of city druggists. Details of her early artistic education are not know, but by the age of about twenty she began exhibiting her work at the Artists of the Northern Counties exhibitions at the Laing Art Gallery, NEWCASTLE. She remained a regular exhibitor at these exhibitions for some thirty years, showing a wide range of English and Continental landscape and architectural studies, frequently of high standard in execution. She died at NEWCASTLE. Her sister GERTRUDE ARTHUR was also artistically gifted and showed her work at the Artists of the Northern Counties exhibitions.

ASH, Donald (1890–1964)
Amateur landscape painter in oil and watercolour. Ash was born at Leicester, but moved with his family from Birmingham to GATESHEAD at the turn of the century. On leaving school he went into engineering, becoming first a locomotive engineer, later a manufacturers' agent. Throughout his career in engineering Ash was a keen spare-time painter of landscapes, exhibiting many examples of his work at the Artists of the Northern Counties exhibitions at the Laing Art Gallery, NEWCASTLE, and showing three examples at the North East Coast Exhibition, Palace of Arts, in 1929. He shared an exhibition at the Shipley Art Gallery, GATESHEAD, with John Arthur Dees (q.v.), and contributed three examples of his work to this gallery's 'Contemporary Artists of Durham County' exhibition in 1951, in connection with the Festival of Britain; these comprised two views of Durham, and one view of the Cray Valley, Kent. Ash spent his early life on Tyneside at GATESHEAD and NEWCASTLE, later moving to MONKSEATON, where he died in 1964. He was the younger brother of John Willsteed Ash (q.v.) and Sidney Ash (q.v.). One of his spare-time interests was modelling sailing ships in bone, several examples of his work in this field finding their way into Tyneside public and private collections. Represented: Laing A G, Newcastle.

ASH, John Willsteed (1872–1946)
Landscape painter in oil and watercolour; decorative artist; art teacher. He was born at Leicester, and by the time that he was in his twenties had become a regular exhibitor at the Royal Birmingham Society of Artists, Birmingham. Following his move with his family from Birmingham to GATESHEAD, at the turn of the century, he maintained a studio at WYLAM for some years, but did not continue to exhibit his work. In the early 1920s he emigrated to New Zealand to take up the position of head of the School of Art, Auckland, remaining there until his retirement. He died at Auckland. He was the elder brother of Sidney Ash (q.v.), and Donald Ash (q.v.).

ASH, Sidney (1884–1959)
Amateur landscape painter in watercolour; architectural draughtsman. He was born at Leicester, the elder brother of Donald Ash (q.v.), and younger brother of John Willsteed Ash (q.v.). His family moved from Birmingham to GATESHEAD at the turn of the century, and here he embarked on a career in art by enrolling as a student at the School of Art, NEWCASTLE. At the outbreak of the First World War he enlisted in the Artists' Rifles, and on his demobilisation decided to become an architect, qualifying for the profession at Armstrong College (later King's College; now Newcastle University). He practised for some years with Thomas Harrison (q.v.), as his partner, continuing on his own after Harrison's retirement from the practice. Ash remained interested in painting and drawing throughout his life, and exhibited his work at the Artists of the Northern Counties exhibitions at the Laing Art Gallery, NEWCASTLE, for many years, showing a wide variety of North Country landscapes. He also showed two of his landscape works at the North East Coast Exhibition, Palace of Arts, 1929: *Durham*, and *Holy Island*. Much of his later work included bird and architectural studies, and he was also a skilled designer of jewellery. He lived at NEWCASTLE for much of his life, and was a member of the Newcastle Society of Artists, and the city's Pen & Palette Club. He died at NEWCASTLE.

ATKIN, William Park ('Gabriel') (1897–1937)
Landscape, architectural and figure painter in oil and watercolour; draughtsman; illustrator. Born at SOUTH SHIELDS, Atkin received his first artistic training at Armstrong College (later King's College; now Newcastle University), under Richard George Hatton (q.v.), and later at the Slade School of Fine Art and in Paris. He later lived in London for many years, showing one work at the London Salon in 1919, and regularly sending work to the Artists of the Northern Counties exhibitions at the Laing Art Gallery, NEWCASTLE. Although mainly a painter of landscapes in watercolour, he was a capable artist in line and prepared many book illustrations. He died suddenly at NEWCASTLE after living for some ten years in the JESMOND area of the city, and remaining a regular exhibitor at the Artists of the Northern Counties exhibitions, mainly showing Continental views. He was the husband of author Mary Butts, who also died in

Sidney Ash,
On Boulmer Beach,
Northumberland,
watercolour, 25.5 x 33cm.
Private collection.

1937. A major loan exhibition of his work was held at the Laing Art Gallery in 1940, for which his friend of many years, Osbert, later Sir Osbert Sitwell, wrote the foreword. Although christened William Park Atkin, he preferred to be called 'Gabriel Atkin', and signed his work using this name. The Laing Art Gallery, NEWCASTLE, has a large collection of his watercolours.

ATKINSON, Eric Newton ('Ricky'), NEAC RCA (b.1928)
Landscape painter in oil, and mixed media; print-maker; art teacher. Atkinson was born at WEST HARTLEPOOL (now HARTLEPOOL), and studied at the local College of Art, and the Royal Academy Schools, before taking up a teaching post at Leeds College of Art under his old tutor at the former, Henry Thubron (q.v.). After becoming head of fine art at the College in 1963 he moved to Canada in 1969 to take up a teaching post at Fanshawe College, London, Ontario, where he served as dean 1972–82. Here he created an innovative art education programme, where he succeeded in integrating television, film, music and advertising into the Basic Course. He expanded the art and applied art studios of the College by adding recording studios started by Tom Lodge on a Moog Synthesiser, vacuum-forming in plastics with Robin Hobbs in the Fine Art Machine Shop, and kinetic sculpture with Eric McLuhan and Michael Hayden. In addition to his innovative art teaching activities Atkinson has shown his work as a painter in many group exhibitions around the world. These have included the Royal Academy; Tate Gallery; British Council Tour, Tel-Aviv; Museum of Art, Carnegie Institute, Pittsburgh, USA, and the Artists of the Northern Counties exhibitions at the Laing Art Gallery, NEWCASTLE. He has also held a number of

one-man exhibitions including a series at the Redfern Gallery, from 1954. More recent such exhibitions have included those held at the Mendel Art Gallery, Saskatoon, in 1980, and at the Concept Gallery, Pittsburgh, in 1987. He was elected a member of the New English Art Club, in 1956, and the Royal Canadian Academy of the Arts, in 1978. His work is represented in many public collections, including the Arts Council; Contemporary Arts Society, and various provincial art galleries. Hartlepool Art Gallery staged a major exhibition of his paintings, drawings and prints in 2000 to mark the gift of some of his paintings to the town by his close friend Jack Reading, and the publication of a lavishly illustrated book on his work, *The Incomplete Circle: Eric Atkinson, art and education,* by David Lewis, Scolar Press. The event was attended by the artist from his home in Canada, where he is regarded as one of the country's important landscape painters. [See colour plate]

ATKINSON, George Clayton (1808–1877)
Topographical draughtsman. He was born at NEWCASTLE, the eldest son of Matthew Atkinson of Carr's Hill, GATESHEAD. His youth was spent at the family home, and at the vicarage at OVINGHAM at which Thomas Bewick (q.v.) had been educated, and following his own education at St Bees, Cumbria, and Charterhouse, he formed a close friendship with the great wood engraver. His association with Bewick led to a deep interest in natural history, and the encouragement to sketch birds and their habitats. Following Bewick's death in 1828, Atkinson divided his time between his natural history studies and the business to which his father had introduced him in 1831. In the year in which he joined this business – the Tyne Iron Company, at LEMINGTON, near NEWCASTLE – he under-

took the first of three major natural history expeditions, visiting the Hebrides and the Shetlands with his two brothers, and artist Edward Train (q.v.). On his subsequent expeditions, to the Shetlands in 1832, and Iceland in 1833, he travelled without the company of an artist to sketch to his request, and made his own sketches. These were later worked up into watercolours by Thomas Miles Richardson, Senior (q.v.), George Richardson (q.v.), Henry Perlee Parker (q.v.), and Train, for the purpose of illustrating Atkinson's manuscript work on his discoveries. Following his expeditions Atkinson lived in the WEST DENTON area of NEWCASTLE for some years, then lived at WYLAM for some twenty years. His final years were spent at NEWCASTLE, where he died in 1877. He is mainly remembered for being one of the earliest biographers of Bewick, his *Sketch of the Life and Work of the late Thomas Bewick* appearing in 1831. His only son Matthew Hutton Atkinson (q.v.), and granddaughter, Sophia Mildred Atkinson (q.v.), were both talented artists. His *Journal of an Expedition to the Feroe and Westman Islands and Iceland, 1833*, was published with colour illustrations in 1989, by the Bewick-Beaufort Press, NEWCASTLE.

ATKINSON, James (fl. 18th cent.)

Portrait painter. William Hylton Dyer Longstaffe (q.v.), in his *History and Antiquities of the Parish of Darlington*, published in 1854, records Atkinson as '. . . a young house-painter, the son of a woolcomber . . .' who '. . . painted portraits, strong likenesses, and at London published a series of letters on art addressed to Barry'. Longstaffe also tells us that a 'gentleman found him the means to become a surgeon, and secured him a post in India, where by the aid of his taste for the higher accomplishments in life he pushed his fortune, and sent his aged parents £200 a year for their lives'.

ATKINSON, John (1863–1924)

Animal and landscape painter in oil, tempera and watercolour; etcher; illustrator; inn-sign designer. Atkinson was born at NEWCASTLE, the son of a hostelry owner and freeman of the town, and it was not until he had spent many years as a telegraphist, draughtsman, and finally secretary to industrialist, art patron and father of Charles William Mitchell (q.v.), Dr Charles Mitchell, that he turned to a full-time career in art. Meanwhile, to advance his abilities as an artist, he had attended classes at the School of Art, NEWCASTLE, and is said to have studied briefly under Wilson Hepple (q.v.). In 1900, however, and after establishing something of a reputation for his work by frequently exhibiting at the Bewick Club, NEWCASTLE, he decided to become a full-time professional artist, and moved to an area which had increasingly attracted him in the immediately preceding years, North Yorkshire. From Sleights, North Yorkshire, in 1901, he sent his first work for exhibition to the Royal Academy, *A Winter's Morning*, subsequently deciding to make his home at nearby Glaisdale. Here he lived with his family until just before the First World War, forming many friendships with artists then painting in the area around Staithes, and becoming consider-

William Park Atkin, *Venice in August*, watercolour, 30 x 23cm. Private collection.

ably influenced in his style of painting, particularly in oil. On returning to NEWCASTLE about 1914 he took a studio in the city, and practised there almost uninterruptedly until his death ten years later. Atkinson's work both before and after turning professional was mainly animal portraiture, with a particular emphasis on horses (he was a lifelong supporter of the RSPCA, and supplied the Society with many illustrations for its publicity purposes). He also painted many landscapes, however, showing a special fondness for haymaking, hunting, and other countryside activities. In addition to showing his work at the Royal Academy, Atkinson also exhibited at the Royal Scottish Academy; the Royal Institute of Painters in Water Colours; and at the exhibitions of several provincial galleries, including the Laing Art Gallery, NEWCASTLE, whose Artists of the Northern Counties exhibitions he contributed to from their foundation, until his death. He also exhibited with the Yorkshire Union of Artists from 1898–1922, receiving a bronze medal in 1915 for his watercolour work. He was for some time an art teacher at Ushaw College, near DURHAM, and the Grammar School, at MORPETH. During the First World War years he also worked on the art staff of the *Newcastle Chronicle*. One of his most interesting commissions as a professional artist was that of painting the King's Drummer Horse, in 1911. After the War he increasingly turned to designing inn-signs, earning praise from the Duke of York for those which he designed for villages along the Thames. He was a member of the Bewick Club almost from its founda-

tion, and was also a member of the Newcastle Society of Artists, and the Pen & Palette Club, NEWCASTLE. He died at GATESHEAD, and was buried in the town's Saltwell Cemetery. A major exhibition of his work was held at the Moss Galleries, HEXHAM, in 1981. Represented: Hatton Gallery, NEWCASTLE; Laing A G, Newcastle; Middlesbrough A G; Pannett A G, Whitby; Shipley A G, Gateshead; South Shields Museum & A G; Sunderland A G. [See colour plate]

ATKINSON, Joseph (1776–1816)
Animal and landscape painter in oil and watercolour. Born at NEWCASTLE, Atkinson is principally known for his 1804 *View of Tanfield Arch*, near GATESHEAD, reproduced as an aquatint engraving by J C Stadler c. 1816. The subject was commissioned by his patron, Sir Matthew White Ridley, of Blagdon Hall, near SEATON BURN, after Atkinson's death, for the benefit of the artist's family. Thomas Oliver (q.v.), in his *A New Picture of Newcastle upon Tyne*, 1831, states that Atkinson 'excelled in animal painting'. Robert Robinson, in his *Thomas Bewick – his life and times*, 1887, notes that Thomas Bewick (q.v.), was responsible for two engravings on wood, and an etching on copper, after Atkinson's paintings, for *A Short Treatise on that Useful Invention called the Sportsman's Friend, or the Farmer's Footman . . .*, 1801, by Henry Utrick Reay of KILLINGWORTH, near NEWCASTLE. According to T Hugo, in *The Bewick Collector*, 1866–68, Reay was a 'patron of the famous Stubbs, and had several horses painted by him . . . The black pony, the bay and the white were all painted by Stubbs and from these paintings our 'Newcastle Atkinson' reduced the drawings for the engraver' The Science Museum, London, has Atkinson's watercolour of Tanfield Arch from which Stadler's aquatint was derived, and his oil of the same subject was on the London art market in 1964. He was possibly the 'J Atkinson, Painter', who contributed one work to the Royal Academy in 1796, *Portraits of a Horse and a Dog*.

ATKINSON, Marshall Forster, FRSA RG1 (1913–1990)
Amateur landscape, figure, industrial and abstract painter in oil, pastel and watercolour; collagist; silkscreen artist; cartoonist. He was born at GATESHEAD, and developed a talent for drawing and painting at an early age. His parents provided him with a studio and he later went on to study art at evening classes held at King's College (now Newcastle University). When the Second World War broke out he worked as a fireman in the land services, and trained as an engineer, painting in his spare time. This last activity led to his election in 1944 as Fellow of the Royal Society of Arts, but at the end of the War he joined the bakery trade, and remained in it for the rest of his working life, taking an active interest in union matters associated with the trade, and drawing cartoons for the Bakers' Union magazine. He first began exhibiting his work during the War, eventually showing examples at major venues throughout Britain and abroad, including the Royal Glasgow Institute of Fine Arts; the Pastel Society; the New English Art Club; the United Society of Artists; the Royal Society of British Artists; the Royal Society of Painters in Water Colours; the Royal Cambrian Society, and the Paris Salon. He was also a regular exhibitor with the Gateshead Art Society, of which he was a founder-member; the Univision Gallery, and the Park Road Group, of NEWCASTLE, and the city's Laing Art Gallery at its Artists of the Northern Counties exhibitions, and later those of the Federation of Northern Art Societies. He also enjoyed one-man exhibitions at the Little Theatre, and the Shipley Art Gallery,

Joseph Atkinson,
View of Tanfield Arch, 1804,
aquatint engraving,
41 x 61cm.
Private collection.

GATESHEAD, the latter also honouring him with a memorial exhibition in 1997, which was repeated at the Laing Art Gallery, NEWCASTLE, 1997/8. Atkinson was one of the best known amateur artists in Northumbria in the second half of the 20th century, the highlights of whose success were probably the acceptance by the Paris Salon in 1954 of three of his typical paintings (*The Pit Shaft; Backlanes and Rooftops*, and *Ravensworth Castle*), and his election in that year as a member of the Royal Glasgow Institute of Fine Arts. Represented: Shipley A G, Gateshead.

ATKINSON, Matthew Hutton (1843–1917)

Amateur landscape and figure painter in watercolour. The only son of George Clayton Atkinson (q.v.), he was born at NEWCASTLE, and after his education remained in business most of his life, only painting in his spare time. He served an apprenticeship as an engineer with Armstrong Mitchell & Co, and in his twenties went to Egypt as a torpedo instructor to the Egyptian Government. From 1891 until his death he was a director of the Newcastle & Gateshead Water Company, and took a keen interest in local affairs, but for some years prior to his death lived in virtual retirement, occasionally occupying himself by painting in watercolour. A considerable body of his work survives in the hands of his family, including examples of the watercolours which he produced while working in Egypt. He died at NEWCASTLE. His daughter, Sophia Mildred Atkinson (q.v.), was a talented painter in watercolour.

ATKINSON, Sophia Mildred (1876–1972)

Landscape painter in oil and watercolour; art teacher. She was born at NEWCASTLE, the daughter of Matthew Hutton Atkinson (q.v.), and grand-daughter of George Clayton Atkinson (q.v.), and William Adamson (q.v.). Following her general education she studied art under

Richard George Hatton (q.v.), at Armstrong College (later King's College; now Newcastle University), and later at Bushey, Herts, at the school of Sir Hubert Von Herkomer. After her training under Herkomer she practised as an artist at NEWCASTLE, and in 1905 showed one work at the Royal Institute of Painters in Water Colours, and three works at the Artists of the Northern Counties exhibition at the Laing Art Gallery, NEWCASTLE. She remained a regular exhibitor at the Laing Art Gallery until the First World War, in the middle of this period showing several oils and watercolours of the Island of Corfu, on which she had spent a year preparing notes and illustrations for her book *An Artist on Corfu*, published 1911. Between the outbreak of the War, and making her first trip to Canada in 1925, she painted in India, Denmark, England, Bavaria, the Southern Tyrol, and the Mission Country of California, USA, also enjoying a special one-man exhibition at the Hatton Gallery, at NEWCASTLE, in 1924. In Canada in 1925 she toured widely throughout British Columbia, taking a special interest in Rocky Mountain scenery, and in the following year staged her first exhibition in that country, at Montreal. A period of talks and exhibitions in Canada followed, after which she returned to England and was given a special section for her Canadian work at the North East Coast Exhibition, Palace of Arts, in 1929. She returned to Canada about 1932, and settling at Victoria, British Columbia, painted widely in the area under the sponsorship of the Canadian Pacific Railway. On leaving Canada some years later, she lived at Edinburgh until 1948, continuing to paint throughout her sojourn in the Scottish capital, and producing many studies of historic buildings and gardens. On returning to Canada in 1948 she settled at Revelstoke, British Columbia, where she lived for almost twenty years,

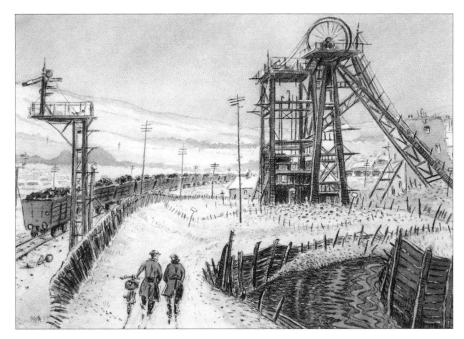

Marshall Forster Atkinson,
Norwood Pit, 1953,
crayon and watercolour,
34 x 48cm.
Private collection.

33

Sophia Mildred Atkinson, *Spring in the Rockies*,
watercolour, 36 x 25.5cm. Private collection.

AUGUST, Ian Lawrence (b.1940)
Amateur landscape painter in watercolour. He was
born at Sharpthorne, Sussex, but moved to NEWTON-
ON-THE-MOOR, near ALNWICK, with his family as a boy.
After leaving school he took up employment with
Northumberland Estates, ALNWICK, eventually becom-
ing clerk of works. Throughout his career in estate
management he has taken a keen interest in the arts.
He was chairman of the Bondgate Gallery, ALNWICK,
and in addition to regularly showing his work with
this gallery, also had a one-man exhibition at the
Kiehle Gallery, St Cloud, Minnesota, USA. As well as
holding the position of clerk of works at
Northumberland Estates he has served as director of
the Garden Project at Alnwick Castle – a multi-million
pound recreation of the former walled garden adjacent
to the building, headed by leading European garden
architects Jacques and Peter Wirtz. He lives at
ALNWICK.

teaching art, lecturing, painting, and running the
Revelstoke Art Club, which she had founded. In this
period, exhibitions of her work were held at Vernon,
British Columbia, in 1951, and at the Hatton Gallery,
NEWCASTLE, in 1953. In 1967 she left Revelstoke and
moved back to Edinburgh, where she died five years
later. Her work is highly regarded in Canada; several
examples have been included in the National Archives.

ATKINSON, William (1773–1839)
Architectural draughtsman. Born at BISHOP AUCKLAND,
Atkinson began life as a carpenter, but with the assis-
tance of Bishop Barrington was sent to London, and
became an apprentice of James Wyatt, the architect
and Royal Academician. He entered the Royal
Academy Schools, and first began to exhibit his archi-
tectural drawings in 1796, when he sent three designs
for buildings to the Royal Academy. He remained an
occasional exhibitor at the Academy until 1811, show-
ing designs for a variety of buildings ranging from
monuments to mansions. In 1797 he gained the
Academy gold medal for his designs for a Court of
Justice. He was 'both in theory and practice a clever
architect', it has been remarked, and held the office of
architect to the Board of Ordnance; he was also the
inventor of 'Atkinson's Cement', and in 1805
published *Views of Picturesque Cottages*. He died at
Cobham, Surrey.

B

BACKHOUSE, Edward (1808–1879)

Amateur landscape painter in watercolour. He was born at DARLINGTON, but about 1816 his parents moved to SUNDERLAND to establish a branch of the Backhouse banking firm. Here he later became a leading public figure, well known for his philanthropic work and wide cultural interests. He travelled extensively throughout his life, combining an interest in landscape painting with natural history. On his death at Hastings a large collection of seashells and butterflies which he had assembled on these travels was bequeathed to Sunderland Museum. His home at SUNDERLAND later became the premises of Sunderland School of Art & Design. Sunderland Art Gallery has his watercolour *Vevey, Lake Geneva*.

BACKHOUSE, James Edward (1845–1897)

Amateur landscape painter in watercolour. He was born at SUNDERLAND, and educated at University College, London, before entering the family banking business in the town. In 1869 he became a partner in the firm and moved from SUNDERLAND to CROFT, near DARLINGTON, living with his uncle until his own future home, Hurworth Grange, was completed. Backhouse was a keen spare-time painter from his youth and in later years frequently visited Italy, where he had a villa, to paint the local scenery. He exhibited his work at the New Water Colour Society (later the Royal Institute of Painters in Water Colours) from 1886 until 1891. He died at Hurworth Grange, DARLINGTON. Represented: Darlington A G.

BADENOCH, Thomas (d.1897)

Portrait and figure painter in oil. This artist practised as a portrait painter in NEWCASTLE, in the late 19th century. The *Newcastle Weekly Chronicle*, of 7th August, 1897, recording his death said that it had occurred 'while still promising' as a portrait painter. He showed his work at the Gateshead Fine Art & Industrial Exhibition, in 1883, and was an occasional exhibitor at the Bewick Club, NEWCASTLE, during his brief career in the city. His exhibits at the latter's inaugural exhibition in 1884 were his oils *After Culloden*, and *Welcome News*. He invariably described himself as 'Thomas Badenoch Junior' when entering his work for exhibition, although his work *The Bachelor*, included in the Loan Exhibition of Local Art, held at the Central Exchange Art Gallery, NEWCASTLE, in 1889, simply refers to him as 'Thomas Badenoch, Newcastle'.

BAGE, Oswald (1907–1963)

Illustrator; industrial, landscape and portrait painter in watercolour; art teacher. Bage was born at LEADGATE, near CONSETT, and began his working life as a miner. The under-manager of the colliery at which he worked was so impressed by his drawings that he contacted the *North Mail*, NEWCASTLE, and arranged for one of them to be reproduced in the newspaper. He was then only eighteen, and the under-manager also persuaded rising young local artist Frederick Charles Davison (q.v.) to give him some tuition. Bage's work quickly improved and his black and white drawings depicting various phases of mining from the coalface to the pithead were soon being used both locally and nationally. When the Second World War came he served in the RAF, and in 1942 was loaned to the American Design Division (US Navy Shore Patrol) to do special drawings for the US Marine Camp, and various poison gas posters, and in 1942–3 represented his squadron in an exhibition of work given by the Balloon Command. The exhibition toured Britain and was shown at the Laing Art Gallery, NEWCASTLE. Later in 1944 he was given an RAF station artist's job; this involved portraiture, designs and the organisation of art competitions, but he also painted watercolours in his spare time. Following his demobilisation he

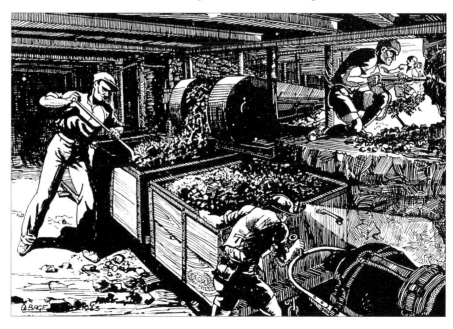

Oswald Bage,

The Coal Conveyor, 1943,

pen and ink, 10 x 15cm.

Private collection.

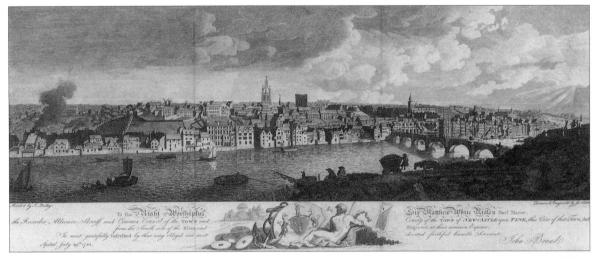

John Bailey, *Newcastle in 1781*, engraving after sketch by the artist in Brand's *History and Antiquities of Newcastle*, 1789.

married and settled at SHOTLEY BRIDGE, near CONSETT, and later took up employment with the Consett Iron Company. He also resumed painting and drawing and in 1946 formed the Consett Art Group. He held his first one-man exhibition and also began showing his work widely in the area, including the Artists of the Northern Counties exhibitions at the Laing Art Gallery, NEWCASTLE. Bage was a successful art teacher, and despite ill health continued to teach until his early death at SHOTLEY BRIDGE in 1963. Represented: Beamish Museum.

BAILEY, John (1750–1819)

Topographical painter in watercolour; draughtsman; engraver. Bailey was born at BOWES, and after showing a considerable talent for drawing as a child was placed as a pupil of the engraver Godfrey. On leaving Godfrey he went to live with his uncle by marriage, George Dixon, of COCKFIELD, near BARNARD CASTLE, acting as tutor to Dixon's children, and drawing and engraving in his spare time. His next employment was as a teacher at WITTON-LE-WEAR, near BISHOP AUCKLAND, but following his marriage to a local landowner's daughter he obtained a position as land agent to Lord Tankerville, at CHILLINGHAM, and here remained employed for most of his life. His interest in drawing led to his production of several topographical works, notable among which is his view of NEWCASTLE, for Brand's *History and Antiquities of Newcastle*, 1789, and the various views in Northumbria which he drew and engraved for Hutchinson's histories of the counties of Northumberland and Durham. In his later life Bailey became increasingly interested in agricultural matters, and published several works on this subject with George Culley, of Fowberry Tower, near BELFORD. Among these joint works was their *General View of the Agriculture of the County of Northumberland*, 1794, which contained several drawings of animals by Bailey, engraved by another hand. His most ambitious of these drawings portrayed the wild cattle of CHILLINGHAM, in a woodland setting. Other drawings were of agricultural implements, possibly engraved by

Bailey. He also illustrated and published several works independently. Bailey, George Culley, and his brother Matthew Culley, were friends of Thomas Bewick (q.v.), and Bewick refers to all three in his autobiographical *Memoir*, published posthumously in 1862. In addition to acting as land agent to Lord Tankerville, Bailey also farmed on his own account, and was for some years connected with a bank at BERWICK-UPON-TWEED. He died at GREAT BAVINGTON, near CAMBO. The Bowes Museum, BARNARD CASTLE, has his watercolour study of Egglestone Abbey.

BAILLIE, Edward (d.1856)

Stained glass designer; draughtsman. He was born at GATESHEAD, but appears to have spent most of his life living and working in the south of England. He exhibited at the International Exhibition of 1851 his *Shakespeare reading a play to Queen Elizabeth*. Nothing more is known of him except that he died in London in 1856.

BAINBRIDGE, Bertram ('Bert') (c.1900–after 1957)

Amateur draughtsman; etcher. Bainbridge was born on Tyneside and lived most of his life at WALKER, near NEWCASTLE. He is believed to have been a draughtsman in a local shipyard, and to have produced etchings and drawings of Northumbrian architectural subjects in his spare time. Some of the latter were used as newspaper illustrations, and sold as etchings. He was a regular exhibitor of his etchings at the Artists of the Northern Counties exhibitions at the Laing Art Gallery, NEWCASTLE, for many years from 1923, when his exhibits were *Newcastle from Gateshead*; *Delaval Hall*, and *The Black Gate*. Three of his etchings were also shown at the North East Coast Exhibition, Palace of Arts, in 1929. His work in etching when shown at Benwell Art Club, NEWCASTLE, in 1931 and comprising his *St Nicholas Cathedral, Newcastle*; *The Sandhill, Newcastle*, and *The Shambles, York*, earned the newspaper comment that they were 'striking in their freshness and wondrous in their deft handling

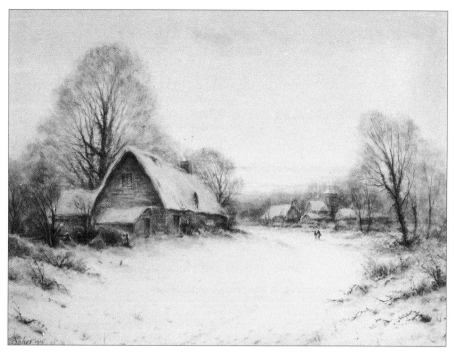

William John Baker,
Winter at Cleadon,
watercolour, 46 x 61cm.
Dean Gallery.

of light and shadow and power ...'. One of his last exhibits at the Artists of the Northern Counties exhibitions was *Miss Ramus*, a mezzotint engraving after Romney, shown in 1957.

BAKER, William John (1865–1938)
Landscape painter in oil and watercolour; draughtsman; illustrator; art teacher. He was born at SOUTH SHIELDS, and worked with his father at a draper's in the town before deciding at twenty-two to become a professional artist. Within a short time he had established a ready market for his work and was giving lessons in his studio. He travelled extensively in search of subjects for his landscapes, including Scotland, the English Lake District, and briefly in Holland, but the bulk of his work portrayed scenes around SOUTH SHIELDS, and in particular the nearby village of CLEADON, at which he died in 1938. In addition to practising successfully as a landscape painter Baker produced illustrations for local publications, an example being the 1895 edition of *The Banks of Tyne: A Christmas Annual*, published by the *South Shields Daily Gazette*. He also taught more than 100 pupils, including his son GEORGE BAKER (1901–1972), whose work is almost identical with that of his father. Baker's granddaughter, MARETH (RUHAMAH) BAKER (b.1944), is also a gifted artist and has exhibited her work.

BALDWIN, W T (fl. mid–19th cent.)
Marine painter in oil. Born at Dover, Baldwin practised as an artist in SUNDERLAND in the middle of the 19th century, specialising in marine subjects. A privately owned oil of the sailing barque *Meteor*, in a storm off SUNDERLAND, dated 1856, is known, while the National Maritime Museum, Greenwich, London,

has his *The Sarah Watson, off Dartmouth*. Some of his work was reproduced while he practised in Northumbria, an example being his *Screw Steamer Mary Lohden*, printed by J G Campbell & Co of SUNDERLAND.

BALMAIN, William (d.1976)
Animal, bird, and landscape illustrator in line and scraperboard. Balmain was born at NEWCASTLE and after training as a commercial artist worked as a poster writer and display designer for a city builders' merchant. He later worked for another such company at NEWCASTLE, then set up his own commercial design organisation. During this period in business he also published a magazine on Northumbrian wildlife and other topics, illustrating it himself with scraperboard

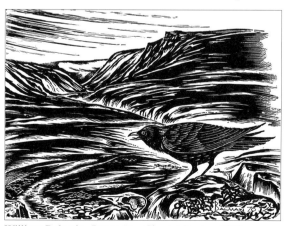

William Balmain, *Raven in a Cheviot Ravine*, 1970, scraperboard illustration from *The Wildlife of Northumbria*, 1971.

and other drawings. His main interest lay in animal and bird illustration and culminated in his publication of *The Wildlife of Northumbria*, in 1971, employing scraperboard illustrations reproduced from his articles in the *Evening Chronicle*, NEWCASTLE. He later worked as a graphic designer for Newcastle City Council. He died at NEWCASTLE after a long battle against cancer.

BALMER, George (1805–1846)

Landscape and coastal painter in oil and watercolour. Balmer was born at NORTH SHIELDS the son of a house painter, and deciding to follow his father's trade, had himself bound as an apprentice to Thomas Coulson (q.v.), who had established a thriving decorating business at Edinburgh. Once settled in the Scottish capital he soon became acquainted with the work of fellow Northumbrian, and Coulson apprentice, John Wilson Ewbank (q.v.), and inspired to try his own hand as a professional artist, returned to NORTH SHIELDS. In 1826 he sent his first work for exhibition from his home town, a *View of North Shields*, to the Northumberland Institution for the Promotion of the Fine Arts, NEWCASTLE. He again exhibited at the Institution in the following year, and showed no fewer than seven works at the first exhibition of the town's newly opened Northern Academy, in 1828. He continued to exhibit at NEWCASTLE for several years, and in the same period sent his first work for exhibition to the

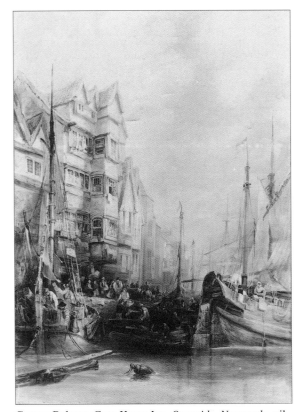

George Balmer, *Grey Horse Inn, Quayside, Newcastle*, oil, 85 x 62cm. Tyne & Wear Museums, Laing Art Gallery.

British Institution (1830), *Fishing Lodge near Inch Islay on the Tay – moonlight*, and several works to the Carlisle Academy. In 1831 he moved to NEWCASTLE, and in this year showed in the town one of his best known works, *The Juicy Tree Bit*, and collaborated in the production of another, *The Heroic Exploit of Lord Collingwood, when Captain of the Excellent at the Battle of Cape St Vincent*, with his close friend John Wilson Carmichael (q.v.). As far as can be determined Balmer remained at NEWCASTLE until late in 1833, when he decided to move to London. In 1834 he sent his first work for exhibition at the Suffolk Street Gallery, and also exhibited at NEWCASTLE. He then set off on a tour of Holland, thereafter proceeding up the Rhine, and travelling through Switzerland, making several studies of the Alps en route. Next he went to Paris, where he spent several months studying at the Louvre, and copied the works of Cuyp, Claude Lorraine, Paul Potter and Ruisdael. Back in London by 1835 he sought out his friend and fellow Northumbrian artist, John Wykeham Archer (q.v.), and announced his intention of practising in the capital. He remained in London until 1842, during which period he continued to exhibit at the British Institution and the Suffolk Street Gallery, showing Continental and Northumbrian scenes; among the former, *Scene near Dortrecht*, and *The Haarlem Mere – moonlight*, and the latter, *Entrance to the Port of Sunderland*, and *The Salmon Leap at Bywell*. Several of these works were bought by wealthy collectors, notably Harrison of Liverpool. In 1836 Balmer suggested to the engraver and publisher brothers Finden, a book on the *Ports and Harbours of Great Britain*. They accepted his proposal, and many of his views of such places along the Northumbrian coastline appeared in a volume published in 1842. A short while after its publication Balmer inherited some property near GATESHEAD, and retired there without, it seems, exhibiting his work again. He died at BENSHAM (now part of GATESHEAD), and was buried in the old cemetery, JESMOND, NEWCASTLE. Represented: Victoria and Albert Museum; Grace Darling Museum, Bamburgh; Laing A G, Newcastle; North Tyneside Public Libraries; Shipley A G, Gateshead; Sunderland A G Trinity House; Newcastle.

BANCROFT, Ernest James (c.1871–1936)

Amateur landscape painter in watercolour. He was a watchmaker and jeweller in DARLINGTON who later established himself as an optician. Darlington Art Gallery has his watercolour *Salutation Corner*, dated 1933.

BANKS, Peter (b.1950)

Multi-media sculptor; collagist; art teacher. Banks was born at NEWCASTLE, and studied at Leeds Polytechnic before becoming a technician at Lincoln College of Art. He later taught art at Salford and Southwark Colleges, and showed examples of his work employing photographs, wooden structures and ceramics at the Institute of Contemporary Arts, the Peterloo Gallery in Manchester, and in Summer Show 3 at the Serpentine Gallery, London. He also had a one-man

exhibition at Monks Hall, Eccles, in 1974; later ones included the Whitworth Art Gallery in Manchester, in 1980. Several of his works were created for galleries and the exterior walls of buildings. He lived in London for some time.

BARBER, Joseph, Senior (1706–1781)
Engraver. He was born near Dublin, but by 1738 had moved to NEWCASTLE, where in 1740 he was advertising the first copperplate print 'ever performed' in the town. He opened the first known circulating library at NEWCASTLE, before 1746, and his business according to local directories eventually grew to embrace not only engraving, and running a circulating library, but book, stationery, print, drug, and optical instrument selling. He was in partnership with his son Martin *c*. 1778, until his death, but the latter does not appear to have been interested in engraving. Barber died at NEWCASTLE, and was buried at the northeast corner of the churchyard of St Nicholas Cathedral, where his tombstone still rests today within a short distance of his workshop site from 1754–1781, Amen Corner. The proximity of this workshop to that of Ralph Beilby (q.v.). William Beilby (q.v.), and later Thomas Bewick (q.v.), led to some familiarity between Barber and these men, Bewick engraving a bookplate for him which has been described as 'of great artistic beauty not exceeded as a work of art by anything he (Bewick) afterwards produced of the same kind.' Barber's eldest son, Joseph Barber, Junior (q.v.), was a talented landscape painter in watercolour, and drawing master, and his grandson, Stephen Humble, 1793–1853 (q.v.), was an artist of considerable ability.

BARBER, Joseph, Junior (1757–1811)
Landscape painter in watercolour; drawing master. He was born at NEWCASTLE, the son of Joseph Barber, Senior (q.v.), engraver, bookseller, etc. After receiving some tuition in drawing at NEWCASTLE, possibly from William Beilby (q.v.), whose place of work was close to that of his father when Barber was a youth, he settled as a drawing master at Birmingham. Here he taught at the Grammar School, and achieved a considerable reputation for his instructive capabilities, his best known pupil being David Cox. Barber's work was little known until a group of twenty of his watercolours appeared at Sotheby's in February, 1934. Martin Hardie made a study of these works, and says of them in his *Water Colour Painting in Britain*, Vol. III p. 242: 'He has a kinship with John Laporte in colour, and William Payne in his handling of trees and foreground'. He also describes him as a 'studied and versatile painter'. He died at Birmingham. His sons CHARLES VINCENT BARBER (1784–1854), and JOSEPH VINCENT BARBER (1788–1838), were talented painters in watercolour. Represented: British Museum; Victoria and Albert Museum; Birmingham City A G; Dudley A G; Newport A G; Ulster Museum, Belfast.

BARCLAY, George (fl. late 19th cent.)
Landscape painter in oil and watercolour. He was born at Aberdeen, Scotland, but later moved to Tyneside where he practised as an artist for many years, based at NEWCASTLE. He mainly painted Northumbrian subjects, but returned to Scotland several times to paint. His son JOHN BARCLAY was also a talented artist, principally painting in watercolour. Both father and son exhibited their work in Scotland, mainly in Aberdeen.

BARKAS, Charles Edward (c.1856–1906)
Amateur draughtsman. He was the son of Thomas Pallister Barkas, bookseller, and later proprietor with Thomas Hall Tweedy (q.v.), of the Central Exchange News Room, NEWCASTLE. In his early years Charles Edward was associated with the art gallery which his father and Tweedy developed from their establishment, eventually becoming lessee of the gallery, and taking a keen spare-time interest in sketching. Many of his sketches of this period were later worked-up into illustrations for the *Newcastle Weekly Chronicle*, by George Hall (q.v.), with the credit 'From a sketch by C. E. Barkas'. He later went into the cycle business, then became an estate agent. He died at NEWCASTLE.

BARKAS, Henry Dawson, ARCA (1858–1924)
Landscape and architectural painter in watercolour; art teacher. Barkas was born at GATESHEAD, his family shortly after removing to St Helier in the Channel Islands. He was educated at Jersey, and later at Granville, France, following which he entered Bath School of Art. At Bath he obtained a scholarship to the Royal College of Art, and on leaving the College he taught at Warrington and Bradford Schools of Art. He later settled at Reading, Berkshire, where he served as headmaster of the School of Art & Science, before founding another school of art in the town about 1894. This school functioned until his death. Barkas is said to have spent all his summer vacations sketching, and while most of the resultant watercolours show a marked preoccupation with natural atmospheric effects he also produced many detailed architectural studies. He exhibited his work at the Royal Academy; the Fine Art Society, London (enjoying a special one-man exhibition in 1912 entitled 'English Pleasure Resorts'); the Royal Institute of Painters in Water Colours, and at various London and provincial art galleries. In 1892 he published *Art Students' Pocket Manual*. He was an associate of the Royal College of Art. His brother HERBERT ATKINSON BARKAS (1870–1939), was also a professional artist and art teacher. Represented: Reading A G.

BARLOW, Phyllida (b.1944)
Mixed-media sculptor; printmaker; art teacher. Barlow was born at NEWCASTLE, and studied at Chelsea School of Art and the Slade School of Fine Art, before returning to Chelsea to teach. She participated in a number of group exhibitions from early in her career, these including the Young Contemporaries; the London Group; The Artists' International Association; the Woodstock Gallery, and Camden Art Centre. She shared a two-man exhibition with Fabian Peake in 1976, at St Catherine's College, Oxford.

BARNES, John Wheeldon (1825–1893)
Amateur cartoonist. He was the son of Robert Barnes, of Durham. He was educated at Durham Grammar School, and began a career in business by joining the Backhouse Bank when he was about nineteen. A keen amateur artist from his youth, he later contributed a number of cartoons to *Punch*, and occasionally painted landscapes, two of which he exhibited in 1855. He was also a collector of work by the Pre-Raphaelites and their followers, and the wood engravings of Thomas Bewick (q.v.).

BARNETT, Harry V (fl. late 19th cent.)
Amateur draughtsman; illustrator; art critic. Barnett, who lived at HEATON, near NEWCASTLE, for many years in the late 19th century, was for some time an illustrator for the *Northern Weekly Leader*, under the pseudonym 'Impressionist'. In 1889, and after first making his name as a contributor to the *Magazine of Art*, he was appointed art commentator for the *Newcastle Daily Leader* and became an outspoken critic of the Bewick Club, NEWCASTLE, singling out Ralph Hedley (q.v.), and Henry Hetherington Emmerson (q.v.), for particularly vitriolic attacks. He showed several of his sketches for the *Northern Weekly Leader* at the 1889 Loan Exhibition of Local Art at the Central Exchange Art Gallery, NEWCASTLE. Some of the illustrations which appeared in the newspaper under his pseudonym were signed with his initials 'HVB', and an example of his work is believed to have hung at the library at HEATON for many years. Barnett's article *The Special Artist*, which appeared in the *Magazine of Art*, Vol 6, 1883, reveals him as a discerning critic of the art of illustration, and his own work for the *Northern Weekly Leader* as at least comparable with that of contemporaries Robert Jobling (q.v.) and William Irving (q.v.) for other local publications.

BARRASS, Dennis (1942–1995)
Amateur portrait, figure and landscape painter in oil and watercolour. Barrass was born at GATESHEAD, and after a boyhood spent in a local 'working boys' home joined the staff of the town's parks department as a gardener. His first attempts at painting pictured the flower-beds in Saltwell Park, and encouraged by G Nevin Drinkwater, curator of the Shipley Art Gallery, GATESHEAD, he decided to take his hobby seriously. Within a few years he had graduated from painting the scenery of Saltwell Park to more ambitious subjects, these including his portrait of Councillor Bill Collins, Mayor of GATESHEAD, painted in 1965, and his best known work *The Blue Lion*, painted in 1968, and later issued as a popular coloured print. In 1970 he enjoyed a large one-man exhibition at the Shipley Art Gallery, this being followed by yet another substantial showing of his work at the Gallery in 1976, as the first in its series of *Gateshead Artists Past & Present* exhibitions. By the latter year, however, he had virtually given up his 'hobby'. Barrass signed much of his work from 1960 'Sinned Ssarrab', this being his full name reversed. His later life was spent in some poverty, during which he subsisted on the sale of items

recovered from builders' skips. The Shipley Art Gallery has his mayoral portrait, *The Blue Lion*, and other examples of his work. The American Embassy, London, and Washington Old Hall, WASHINGTON, near SUNDERLAND, have his portraits of President Kennedy. [See colour plate]

BARRASS, Edward (fl. late 18th cent.)
Amateur engraver. Barrass practised as a mathematician at CHESTER LE STREET in the second half of the 18th century, also teaching drawing, and working as a surveyor. Several examples of his engraved work are known, including *The West Prospect of Lumley Castle*, and a study of 'a coal staith when the keels are loading'. Both were reproduced in *The London Magazine*, the former in December 1767, and the latter in January 1766. His Lumley Castle engraving also appeared in *Boswell, Historical descriptions of … the antiquities of England*, 1786, and in *Boswell, The antiquities of England and Wales displayed*, 1795.

BARTELS, Elizabeth Clayton (c.1905–after 1936)
Landscape and flower painter in watercolour; art teacher; print maker. She was born at NEWCASTLE, and studied art locally, in Cardiff, London and Newlyn before practising as a professional artist and art mistress mainly in the Yorkshire area. She exhibited her work at the Arts and Crafts Society, London; the Society of Women Artists; the Society of Graver Printers; the Societé des Artistes Français; the Paris Salon; the Royal Institute of Painters in Water Colours, and at various London and provincial galleries. She painted widely abroad, visiting the USA, the West Indies, East Africa, the Balearic Islands, and the Canary Islands, also producing colour prints from wood blocks of several of her subjects.

BARTLETT, Thomas W (b.1924)
Landscape painter in oil and watercolour. Bartlett was born at GATESHEAD, and studied at Sunderland College of Art. By 1952 he had commenced exhibiting his work at the Artists of the Northern Counties exhibitions at the Laing Art Gallery, NEWCASTLE. His work was included in an Arts Council Students' Travelling Exhibition, and he also exhibited in the Nine Painters

Thomas W Bartlett, *Pigeon lofts in snow*, oil, 38 x 51cm. Private collection.

in the North East exhibition, at the Hatton Gallery, NEWCASTLE, and at the Austen Hayes Gallery, York. In 1963 he and J A Temperley (q.v.) shared an exhibition at the Shipley Art Gallery, GATESHEAD. Bartlett became particularly well known for his paintings of pigeon lofts, and his bare tree studies. He lived at FRAMWELLGATE MOOR, near DURHAM, and commonly signed his work 'THOMAS'.

BATES, Robert William (c.1865–after 1929)
Landscape painter in oil and watercolour. He was born at GOSFORTH, near NEWCASTLE, the son of an engineer and studied at the city's School of Art before becoming a professional artist. He first began exhibiting his work while still living at GOSFORTH, showing examples at the Bewick Club, NEWCASTLE, by the early 1890s. He then moved to CHESTER LE STREET, from which he sent work to the Artists of the Northern Counties exhibitions at the Laing Art Gallery, NEWCASTLE, from their inception in 1905, until moving to Cheshire by the 1920s, when he mainly exhibited at the Royal Cambrian Academy and Manchester Art Gallery. His later life appears to have been spent in Cheshire.

BATTY, Joyce (b.1916)
Abstract painter in oil. She was born in Northumberland and educated at Penrhos College, Colwyn Bay, and Bedford College, London, where she displayed a marked talent for drawing and painting. Apparently without any further tuition she showed her work at various London exhibitions, her first abstracts making their appearance at the Group Show Artists' International Association, in 1958. Her work later joined the Travelling Exhibition II, in 1962, on which occasion she was quoted as saying: 'Since 1942 I have been rediscovering Northumberland at first hand by painting coast and harbour, but now my work is mainly abstract and grows out of the atmosphere of the coast or the idea of the Roman past of the region.' Her work is in private collections in England, the USA, and New Zealand.

BATY, Eleanor (c.1900 – after 1938)
Miniature painter. This artist practised at NEWCASTLE in the early 20th century. She first exhibited her work publicly when she sent *Joan* and *Winsome*, to the Royal Academy in 1919, also showing these two works, and a third, *Baby Belle*, at the Artists of the Northern Counties exhibition at the Laing Art Gallery, NEWCASTLE, in that year. She continued to exhibit at the Royal Academy and the Artists of the Northern Counties exhibitions until 1924. Between 1919 and 1938 she also showed work at the Royal Miniature Society, and the Walker Art Gallery, Liverpool. Several of her exhibits portrayed members of the Royal Family, and other prominent public figures.

BEALL, Robert (1837–1892)
Sculptor. He was born at Stamford, Lincolnshire, and moved to NEWCASTLE about 1860 to practise as a sculptor. His first work on Tyneside was stone carvings for St Mary's Church, Rye Hill, NEWCASTLE. Over the next thirty years he was responsible for a variety of work within a wide radius of his workshop near the city's High Level Bridge, including restoration work for St Nicholas' Cathedral; interior work for the offices of the *Chronicle*, and Hodgkin's Bank, NEWCASTLE, and monuments for churches and graveyards in the suburbs of the city, and throughout Northumbria, and Scotland. One of his most acclaimed works was the Caedmon Cross, at Whitby, North Yorkshire, unveiled by the Poet Laureate in 1897, although it must be presumed he was helped in its production by son ROBERT E BEALL, who had assisted his father from his youth. Beall senior died at NEWCASTLE after a short illness arising from a local influenza epidemic, and was succeeded in the business by his son. The Beamish Museum has his ornamental fountain, which was originally sited at CONSETT, but dismantled and re-erected at the museum. His Clock Tower, of 1861, still stands in Front Street, TYNEMOUTH. His son for many years employed the stone carving services of J Rogers (q.v.).

BEATON, Rev Malcolm A (b.1918)
Amateur landscape painter in oil. Born at Inverness, Scotland, Beaton was ordained in 1947, and moved to DARLINGTON in 1953, where he became a member of the Darlington Society of Arts. His work mainly consisted of local views, several of which he exhibited with the Society. Darlington Art Gallery has his oil of the town's Tubwell Row, dated 1971.

BEATTIE, Basil James (b.1935)
Abstract painter in oil; muralist; art teacher. Beattie was born at WEST HARTLEPOOL (NOW HARTLEPOOL), and studied at the town's College of Art before moving to the Royal Academy Schools. On concluding his studies at the latter he took up a teaching appointment at the Goldsmiths' College School of Art, and began to actively show his work in group exhibitions, notably the Artists of the Northern Counties exhibitions at the Laing Art Gallery, NEWCASTLE, where examples in 1957 were his oils *Abingdon* and *Ponte Vecchio*. He later went on to exhibit at the John Moores Exhibition at Liverpool, in 1965; the Museum of Modern Art, *Four Painters*, Oxford, 1971, and at the Royal Academy's *British Painting 1952–1977*, in 1977, and in 1976 won a major Arts Council Award. His first one-man exhibition was at Greenwich Theatre Art Gallery, in1968, and apart from the group exhibitions referred to earlier, he also showed his work at several galleries in London, and elsewhere in Britain, including the Bede Gallery, JARROW, near SOUTH SHIELDS. In 1986 there was a substantial exhibition of his work at the Gray Art Gallery, HARTLEPOOL, and in 1987 he completed an abstract mural for Manors Metro Station, NEWCASTLE. Beattie was second prizewinner in the 1989–90 John Moores Liverpool Exhibition and in 2001 shared an exhibition at Hartlepool Art Gallery with Anthony Heywood and Paul Wager. He has lived in London for a number of years. The Arts Council and Hartlepool Arts & Museum Service hold several examples of his work and he is represented in the collection of the Laing Art Gallery. [See colour plate]

BEATTIE, Selwyn Smith (b.1937)
Architectural and landscape painter in oil and water-colour; draughtsman; stained glass designer; art teacher. He was born at JARROW, near SOUTH SHIELDS, and studied art at King's College (now Newcastle University), under Leonard Charles Evetts (q.v.), Victor Pasmore and Richard Hamilton before taking up a career in teaching. He taught art at various secondary and comprehensive schools in County Durham from 1960, until his retirement in 1997, meanwhile retaining a keen interest in painting, and showing his work at a number of mixed exhibitions. He has also undertaken a number of stained glass commissions for churches in Northumbria, including St Andrews Church, STANLEY, and Holy Trinity Church, PELTON, near CHESTER LE STREET. In 1984 he wrote and illustrated a booklet on the architecture of Durham Cathedral to accompany the *Craftsmen for Christ* exhibition for schools. Several of his pen and ink drawings of the Cathedral were included in the *Durham Cathedral Artists and Images* exhibition, at Durham Art Gallery, DURHAM, in 1993. He lives at STANLEY. [See colour plate]

BEILBY, Mary (1750–1797)
Enamel painter on glass. She was born at DURHAM, the daughter of William Beilby, the silversmith and jeweller. Following the failure of her father's business at DURHAM she moved with her family first to GATESHEAD, later to NEWCASTLE, where she was instructed in enamel painting on glass by her brother William Beilby (q.v.). She later assisted her brother in much of his work in enamel painting on glass, principally handling the simpler styles of decoration. Thomas Bewick (q.v.), during his apprenticeship to another of her brothers, Ralph Beilby (q.v.), formed a strong emotional attachment to Mary, and would have married her had her family not discouraged his interest in the girl. Some time following her departure from NEWCASTLE for London with William in 1779, she suffered a paralytic stroke. About 1788 she moved with William and his wife to East Ceres, Fife, Scotland, to live on the estate owned by the father of her sister-in-law, dying there in 1797. The work of William and Mary Beilby in glass enamelling has been superbly documented and illustrated by James Rush, in his *The Ingenious Beilbys*, 1973, and his *A Beilby Odyssey*, 1987.

BEILBY, Ralph (1743–1817)
Engraver; draughtsman. He was born at DURHAM, the son of William Beilby the silversmith and jeweller, and joined his father's business on leaving school. When the business failed he moved with his family to GATESHEAD, where he learnt seal-cutting under his brother Richard before following this trade himself at NEWCASTLE by 1760, in premises shared with his elder brother William Beilby (q.v.), and sister Mary Beilby (q.v.). In addition to seal-cutting he was soon handling many other tasks of the jobbing engraver, including engraving for reproduction. Indeed, as Beilby's apprentice from 1767, Thomas Bewick (q.v.), records in his *Memoir*, published posthumously in 1862: 'At

this time a fortunate circumstance, for my future master, happened which made an opening for him to get forward in his business unopposed by anyone in Newcastle – An Engraver of the name of Jameson, who had the whole stroke of the business in Newcastle to himself, having been detected in committing a Forgery upon the old Bank, was tried for the crime, but his life was saved by the perjury of a Mrs. Gray . . . and Jameson left the town'. According to Bewick, Beilby's engraving in the reproductive field included 'writing engraving of Bills, bank notes, Bills of Parcels, shop bills & cards – these last, with Gents Arms for their Books . . .' and this '. . . he executed as well as most of the Engravers of the time . . .' Towards the close of Bewick's apprenticeship, however, Beilby began to aspire to more ambitious work in reproductive engraving, and left for London 'for the purpose of taking lessons in etching & engraving & practising upon large copperplates'. Beilby found little demand for his new found skills immediately upon his return to NEWCASTLE, but this situation evidently changed in the late 1780s when the Rev John Brand (for whom, as early as *c.* 1770, he had engraved a vignette book-plate), commissioned him to engrave plates for *History and Antiquities of Newcastle*, published in 1789. Notable among Beilby's work for this book by Brand is his *Thornton's Monument, All Saints' Church, Newcastle*, in which his ability as an heraldic draughtsman and engraver are seen to perfection. He later handled other engraving for reproduction, but this mainly related to maps and plans. In 1798 he retired from the business in which he had been partner with Bewick from 1777, and joined Langlands & Robertson in establishing a watch-glass manufactory in the town. He retired from this business some time after 1806, and died at NEWCASTLE in 1817. Bewick's *Memoir* contains much interesting information about Beilby as artist and man, which despite the acrimony in which they eventually ended their partnership in 1798, may be taken to be largely objective and fair.

BEILBY, Thomas (d.1826)
Drawing master. He was born at DURHAM, the son of William Beilby, the silversmith and jeweller, and joined the family in their move to GATESHEAD, and thence to NEWCASTLE, following the failure of his father's business at DURHAM. At NEWCASTLE he received tuition from his brother William Beilby (q.v.) in glass enamelling and painting in the premises shared by William, his brother Ralph Beilby (q.v.), and sister Mary Beilby (q.v.). Although evidently trained in the skills which were later to make William and Mary famous, Thomas appears to have preferred giving instruction in drawing, to enamelling glass, and later obtained a position as drawing master at Grimshaw's Academy, Leeds. He died at Leeds in 1826.

BEILBY, William (1740–1819)
Enamel painter on glass; landscape painter in watercolour; draughtsman; drawing master. He was born at DURHAM, the eldest son of William Beilby, the silversmith and jeweller. As a young man he

William Beilby,
*Landscape with classical
ruins and shepherds*, 1774,
watercolour, 22.5 x 32cm.
Victoria and Albert Museum.

was apprenticed to John Haseldine, of Bilston, Birmingham, under whom he learnt the art of enamelling on snuffbox lids. When his father's business failed at DURHAM the family moved first to GATESHEAD, later to NEWCASTLE, where William and his younger brother Ralph Beilby (q.v.), set up as engravers etc, about 1760. Here, within a short period William cultivated a demand for his skills as an enamel painter on glass, also involving his sister Mary Beilby (q.v.), in this type of work. The work of brother and sister is now highly prized, and was extensively illustrated in *The Ingenious Beilbys*, 1973, by the late James Rush. Less well known, however, are William's capabilities as a landscape painter in watercolour, draughtsman and drawing master. He would appear to have been one of the first drawing masters to advertise his services in NEWCASTLE, in the *Newcastle Journal* of 14th February 1767, stating 'Drawing. William Beilby proposes teaching young ladies and gentlemen in the several branches of drawing …'. This skill as a draughtsman also found expression in the production of a number of topographical and other drawings, including technical illustrations, and local scenery. Notable amongst these was his drawing *The Assembly House*, reproduced in Brand's *History and Antiquities of Newcastle*, 1789. Research by Rush for his second book on the Beilbys, *A Beilby Odyssey*, 1987, confirms that William continued his interest in drawing when he and Mary moved to London in 1779. Here he continued to draw and paint landscapes, showing three examples at the Royal Academy between 1780 and 1782. While in London it appears the couple did not resume their glass enamelling, William instead concentrating on running his 'Battersea Academy', where Latin and Greek were taught to young lady and gentleman boarders. After five years in the capital William married a London girl named Ellen Turton, and three years later moved with his wife and sister Mary to Ceres, Fife, where his father-in-law owned a large estate. William evidently acted as manager of the estate, sometimes using his spare time to draw and paint local scenery. For reasons which even Rush's patient research could not explain, in 1810 William, his wife and three children decided to leave Scotland and moved to Hull. Again no evidence exists of his resumption of glass enamelling, only of occasional watercolours for new found friends in the area. He died at Hull in 1819, his otherwise flattering obituary in a local newspaper making no mention of his abilities as an artist. Rush's two books on the work of William and Mary Beilby contain many illustrations of their work in glass enamelling, the second also illustrating many of his watercolours. Many examples of these were included in a special commemorative exhibition at the Laing Art Gallery, NEWCASTLE, in 1980. Represented: Victoria and Albert Museum.

BELL, HARRY (b.1947)
Townscape and landscape painter in oil and acrylic. Bell was born at GATESHEAD and did not become a full-time professional painter until he was fifty, and after a long career as an executive officer with the DSS, NEWCASTLE. He first began painting seriously after enrolling on the Open College of the Arts painting course in 1989, and was soon exhibiting his work, showing examples at the British Painters exhibition at the Westminster Galleries, London, in 1990. He has since participated in a number of other group exhibitions, and enjoyed two, one-man exhibitions. His group exhibitions include the John Laing Art Competition, NEWCASTLE, in 1993, 1994 and 1995; the Journal Art Competition, NEWCASTLE, in 1997 (in which he won first prize); Art in the North East, ING Barings, London, in 1998, and the Royal Scottish Academy, 2000. Exhibitions of his work have

Harry Bell, *The Sunday Market II*, 1994, oil, 122 x 70cm. Seaham Hall Ltd.

been held at the Samling Foundation, Dovenest, Windermere, Cumbria, in 1999, and the Gallagher & Turner Gallery, NEWCASTLE, 2000. Titled *Aphrodite's Island*, the latter exhibition represented a departure from his usual preoccupation with Northumbrian urban scenes to include subjects painted in Western Cyprus. Bell's work is represented in a number of corporate collections and in 1997 he was commissioned to produce two large paintings for the A & E Waiting Room of the Opthalmic Department of the Royal Victoria Infirmary, NEWCASTLE. He lives at GATESHEAD.

BELL, John (fl. late 18th, early 19th cent.)

Portrait painter in oil. Born on Tyneside, the son of Joseph Bell (q.v.), he was possibly taught by his father before practising as a portrait painter in NEWCASTLE. He was a playmate in his youth of the children of Thomas Bewick (q.v.): Jane Bewick (q.v.), Robert Elliot Bewick (q.v.), Elizabeth Bewick, and Isabella Bewick, his portrait of Bewick's son as a boy being one of the few examples of his work which have survived. This portrait is in the possession of the Natural History Society of Northumbria, NEWCASTLE, and shows Robert Elliot playing the Northumbrian pipes. Commenting on this work, Bewick's daughter Jane wrote: 'John Bell ... painted a portrait of my Brother when a boy – playing on the North[d] pipes, the likeness very good'. She also wrote that Bell was '– Very dissipated – died in his prime'. A 'John Bell' is listed in the *Newcastle Directory*, for 1811, under portrait and landscape painters, who may have been this artist. Represented: Natural History Society of Northumbria, Newcastle.

BELL, Joseph (1746–1806)

Portrait painter in oil. Bell was born on Tyneside, and became a close friend of Thomas Bewick (q.v.), in consequence of their mutual interest in art. Bewick refers to Bell in his autobiographical *Memoir* as 'Joseph Bell, Painter, he also displayed considerable abilities as a painter, poet, & a Man of talents in other respects – but with keeping much company he became also much dissipated – he died 26 April 1806 aged 60 & was buried at St Andrews'.[‡] Bewick's daughter, Jane Bewick (q.v.), wrote of Bell: '... painter & decorator – He painted portraits occasionally – & was a talented but somewhat dissipated man ... He painted a portrait of my Father – he could not please himself with it and threw down the brush with an oath saying: 'nobody can paint you''. He was the father of John Bell (q.v.), and is described by Robert Robinson in his *Thomas Bewick – his life and times*, 1887, as a 'portrait painter of some ability' who lived in the town's 'High Bridge', in a house 'decorated with great taste'. It is evident from directories of NEWCASTLE that Bell was a dealer in colours, in addition to practising as a 'painter in general'. He died at NEWCASTLE.

BELL, Stuart Henry (1823–1896)

Marine and scenic painter in oil. Born at NEWCASTLE of a family which could trace its descent from the Royal Stuarts of Scotland, Bell became connected with Tyneside theatres in his boyhood, and is said to have become a scene painter at an early age. His first commission was to paint scenery for the Theatre Royal, NEWCASTLE, following which he was engaged in this line by almost every metropolitan and provincial theatre, from 1850 achieving special recognition for his marine back-drops. In 1855 he moved to SUNDERLAND to decorate the town's Theatre Royal, subsequently becoming lessee of this theatre, and of the nearby Drury Lane Theatre, which he later developed into a music hall. He remained associated with theatres at SUNDERLAND for many years, and at one time could boast of considerable affluence because of his flair for sensational scenic effects, and general management ability. Eventually, however, he was obliged to give up his theatre interests, and to devote himself increasingly to painting marine subjects,

‡ *See p. 113. A Memoir of Thomas Bewick, Written by Himself*, edited and with an introduction by Ian Bain. Oxford University Press. 1975.

Stuart Henry Bell,
Sunderland Harbour,
oil, 40 x 76cm.
Tyne & Wear Museums,
Sunderland Art Gallery &
Museum.

achieving such accomplishment that it is said that Queen Victoria regarded him as the best painter of these since Clarkson Stanfield (q.v.). It is commonly supposed that Bell never exhibited his work, but a scrutiny of fine art exhibition records relating to Tyneside shows that this was not the case. From 1870, until his death just over a quarter of a century later, he exhibited several times at NEWCASTLE, and on at least one occasion at GATESHEAD. In 1870, at the 'Central Exchange News Room, Art Gallery, and Polytechnic Exhibition', NEWCASTLE, he showed *Tynemouth, Flood Tide during a North East Gale*, and *Entrance to Sunderland Harbour* (his favourite subject); in 1878, at the town's exhibition of works by local painters at the Central Exchange Art Gallery, he showed three marine works and one genre painting, and he was an exhibitor at the Bewick Club, NEWCASTLE, in 1885, and the year before his death, on which latter occasion he showed *Fisher Life in the North Sea – A Sudden Gale*, and *Saved by the Whitburn Fisherman – The Rocket Apparatus in 1860*. Bell remained at SUNDERLAND until close to his death, his painting activities in later years severely hampered by failing eyesight. He died at GATESHEAD. Sunderland Art Gallery has an excellent collection of his marine paintings, dated 1857–1896.

BELL, William (1740- c.1804)

Portrait and landscape painter in oil; drawing master. Bell was born at NEWCASTLE, the son of a bookbinder, and was one of the first students to be enrolled in the Royal Academy Schools. In 1770 the Council of the Academy offered a gold medal to the student who painted the best historical picture. Bell's entry was not successful, but in the following year he received a gold medal from Sir Joshua Reynolds for his *Venus Soliciting Vulcan to forge armour for her son Aeneas*. Several Northumbrian characters sat for Bell's huge canvas of this historical subject, amongst these Willie Carr, a blacksmith, who sat for the portrait of Vulcan. By the time that Bell painted his medal-winning work

he had already come to the notice of Lord Delaval, and was giving lessons in drawing to the young ladies at Seaton Delaval Hall, near BLYTH. He had also started to paint full-length portraits of various members of the family, including Lord and Lady Delaval, their son John, and several of their six daughters. In 1775 he exhibited two landscapes at the Royal Academy, describing them as north and south views of *Seaton Delaval, built by Sir John Vanbrugh, the seat of Sir J. H. Delaval, Bart*, and giving as his address 'At Sir John Delaval's' – his patron's London home at Grosvenor House. The last work which he painted, and exhibited while in London, was his *Susannah and the Two Elders*, shown at the Free Society of Artists, in 1776. This was another large historical painting. Bell then returned to NEWCASTLE, where he opened a drawing school, and resumed portrait painting. His portraits of this period have been described as 'all extremely accurate and beautifully finished'. One of these works portrayed his friend Thomas Bewick (q.v.), and came into the possession of William Bewick (q.v.), who wrote of it in 1864: 'The portrait of Thomas Bewick that I possess was painted by Bell, in the style of Rembrandt ... it is artistical, but not a domestic picture by any means, and no one would like a family likeness to be so treated. But it is well painted and I am often asked if it is by Rembrandt.' Also in this period he painted a self portrait; a work, *Two Children with a Lamb*, and portraits of stage performers Joseph Austin and his wife, who frequently appeared in NEWCASTLE between 1774 and 1778. His portrait painting did not, however, earn him much of a living, and he was obliged to continue giving drawing lessons, and later restored pictures, including those damaged by a fire at the Guildhall, NEWCASTLE, in 1791. His final years were spent in obscurity at NEWCASTLE, where he died about 1804. An excellent account of Bell's life and work appears in *Eighteenth Century Newcastle*, by P M Horsley, Oriel Press, 1971. Several examples of his work may be seen at Seaton Delaval Hall.

BENNET, George Montagu, 7th Earl of Tankerville (1852–1931)
Amateur miniature painter. He was born in London, the son of Charles Bennet, 6th Earl of Tankerville, and Olivia Montagu, daughter of the 6th Duke of Manchester. He enlisted in the Navy in 1865, and served as a midshipman 1867–9, before resuming his education by attending Radley public school. He was commissioned a lieutenant in The Rifle Brigade in 1872, and later served as aide-de-camp to the Lord Lieutenant of Ireland 1876–80. He was styled Lord Bennet 1879–99, succeeding his father as Earl of Tankerville, in 1899, and taking up permanent residence at the family home of Chillingham Castle, CHILLINGHAM, in that year. He was a talented artist from his youth, and in 1885 commenced exhibiting his work at the Royal Academy, contributing some thirty portrait miniatures between that date and 1900. Most of his exhibits portrayed members of the nobility. He died at Chillingham Castle. His wife, LEONORA SOPHIA, COUNTESS OF TANKERVILLE (née Van Marter), was also a talented artist, and exhibited her work.

BENNET, Lady Mary Elizabeth – see MONCK, Lady Mary Elizabeth

BENNETT, Christopher (1892–1970)
Amateur genre and industrial painter in oil. Bennett worked as a miner in the area around SUNDERLAND for most of his life and became increasingly interested in painting towards his retirement. He became a regular exhibitor with the Art Club founded at WASHINGTON, near SUNDERLAND, in 1957, and also showed work at the Artists of the Northern Counties exhibitions at the Laing Art Gallery, NEWCASTLE. Some of his subjects were local mining and everyday scenes recreated from the past; others, genre works like his Laing Art Gallery exhibit of 1962 – an oil entitled *The Pawnshop's Bleezing*. Also in 1962 he exhibited at the Laing Art Gallery an oil of the Blaydon Races in connection with the centenary celebrations of the event. Later work included many scenes along the Quayside, NEWCASTLE.

BERTRAM, Charles Neville, ARBS (1908–1999)
Sculptor; landscape painter in oil and watercolour; art teacher. He was born at CULLERCOATS, the son of Robert John Scott Bertram (q.v.), and studied art at Armstrong College (later King's College; now Newcastle University). At the conclusion of his studies he entered and submitted work for the Rome School, following this with a short period of teaching on Tyneside during which he studied modelling and potting, and carried out some stone carving. In 1933 he moved to Liverpool as trainee and assistant to Herbert Tyson Smith, helping Smith with some commercial sculpture, and marrying one of the sculptor's daughters. In 1936 he returned to Tyneside, where he lived first at OVINGHAM, and later at TYNEMOUTH, and undertook sculptural and painted work for local architects. This ceased when he joined the Air Transport Auxiliary at Bristol with the outbreak of the Second World War, and it was not until 1945, when he joined the staff of Liverpool College of Art, that he was able to resume his career. This initially part-time work in the College's painting and sculpture departments led to a full-time appointment by 1950, and he taught at Liverpool until his retirement in 1973. During this period he joined the Liverpool Academy, and was elected an associate of the Royal Society of British Sculptors. Bertram exhibited throughout his career, initially at the Artists of the Northern Counties exhibitions at the Laing Art Gallery, NEWCASTLE, and later at the Liverpool Academy; the Walker Art Gallery, Liverpool; The Sandon Studios; The Blue Coat Gallery; The Williamson Gallery, Birkenhead, and at Port Sunlight. His exhibits included wood-carvings, watercolours, drawings and wood engravings. On his retirement he moved from Merseyside to Cheshire, where he died in 1999. He was the younger brother of Robert Bryan Bertram (q.v.). The Walker Art Gallery, Liverpool, has his *Quadripartite Form*, of 1959.

BERTRAM, Robert Bryan (1906–1986)
Landscape painter in watercolour; art teacher. He was born at NEWCASTLE, the son of Robert John Scott Bertram (q.v.), and spent all his working life as an art teacher at the Royal Grammar School, NEWCASTLE. He initially lived at NEWCASTLE, but after service with the Border Regiment during the Second World War, lived at nearby PONTELAND. Bertram was a keen spare-time painter, and exhibited his work mainly at the Artists of the Northern Counties exhibitions at the Laing Art Gallery, NEWCASTLE, showing Northumbrian, Scottish and South Country landscapes. He was the elder brother of Charles Neville Bertram (q.v.).

BERTRAM, Robert John Scott (1871–1953)
Landscape and historical painter in oil and watercolour; muralist; draughtsman; art teacher. Bertram was born at NEWCASTLE, the son of a ship's chandler and showed talent as an artist from an early age. At the end of his general education, however, his parents decided that he should enter the coal trade, and it was only later when he joined a local furniture store as a designer of interiors, woodwork and furniture that he was able to pursue his ambition to become an artist. He attended evening classes in art, and won a scholarship to the art school of the Durham College of Science & Art, at NEWCASTLE, proving so successful that in 1895 he was appointed part-time assistant. In 1902 he was appointed full-time assistant, and in 1920 he became master of design at what was by then Armstrong College (later King's College; now Newcastle University), retaining this position until his retirement in 1937. His outstanding abilities as a draughtsman made him in demand by publishers from his early twenties and in 1893 his drawings were used for the first volume of the *Northumberland County History*. He also illustrated guidebooks to the East and North Ridings of Yorkshire, and Northumberland, and a succession of books by local authors, including *A Fisher's Garland*, by John Harbottle (1905), and *A Northumbrian Decameron*, by Howard Pease (1927).

Apart from illustrating the works of others he also in 1908 produced drawings for a set of fifteen lithographs entitled *Old Newcastle*, published by Mawson Swan & Morgan, NEWCASTLE, and in 1914 and 1920 respectively, his *Newcastle upon Tyne Sketch Book*, and his *Durham Sketch Book*. Meanwhile he had become a prolific painter of local scenery, usually with an historic theme, and exhibited at the Bewick Club, NEWCASTLE, and later the Artists of the Northern Counties exhibitions at the city's Laing Art Gallery. He also in 1908 sent one work to the Royal Academy, entitled *Warkworth*, and in 1930 was one of several local artists selected to paint a lunette for the Laing Art Gallery. His subject was *The River Tyne during the great flood of 1771* – one of his many depictions of the city as it once looked, in both oil and watercolour. Apart from his First World War Service in the Territorial OTC attached to the Durham Light Infantry, Bertram lived mainly at CORBRIDGE throughout his career as an academic and painter on Tyneside. His later life in the area saw him become deeply involved in the preservation of old buildings, and membership of several organisations devoted to this activity, including the Society of Antiquaries, NEWCASTLE. He was also member of a number of art clubs, including the city's Pen & Palette Club. On his retirement he moved to Whitby, North Yorkshire, where he continued to take an interest in local buildings, paint, and exhibited his work at the town's Pannet Art Gallery. He died at Whitby. Bertram was one of Northumbria's most outstanding draughtsmen, painters and art teachers of the early 20th century, and was also a prolific muralist and designer of heraldic and ornamental work for reproduction. He was the father of Robert Bryan Bertram (q.v.), and Charles Neville Bertram (q.v.). Represented: Laing A G, Newcastle; Pen & Palette Club, Newcastle, and various scholastic and public buildings in Northumbria. [See colour plate]

BEVERLEY, William Roxby (1811–1889)

Marine, coastal and landscape painter in watercolour; scenic painter. He was born at Richmond, Surrey, the son of actor and theatrical manager William Roxby Beverley. It is popularly believed that he received his early training in art from Clarkson Stanfield (q.v.), but this is not the case. Indeed, on eventually moving to London to practise as a scenic painter he was, in his own words, 'somewhat cold-shouldered by Clarkson Stanfield and other brothers of the brush'. His first association with Northumbria came in 1831, when his family took over the management of the Northern Theatrical Circuit, including theatres at STOCKTON-ON-TEES, DURHAM, SUNDERLAND, NORTH SHIELDS and SOUTH SHIELDS. At the opening of the Drury Lane Theatre, SUNDERLAND, on 31st October of that year, one of the principal announcements on the bill referred to a new act-drop by 'William Beverley, jun.' He remained based at SUNDERLAND for several years from 1831, combining his duties as scenic painter to the family circuit with those of actor, and in his leisure moments painting a number of local views. Notable among these views are his *Shipping*, 1831; *North*

Shields, 1833, and *Tynemouth*, 1834, all three of which are in Northumbrian public collections, and represent some of his earliest and least known work. On leaving SUNDERLAND, Beverley worked as a scenic painter at Edinburgh, and later London, at which latter he established a reputation in his profession second only to that of Stanfield. Throughout his hectic life as a scenic painter, however, he never lost his interest in watercolour painting, though not until 1865 did he evidently think enough of his work to exhibit it publicly. From that date until 1880 he exhibited at the Royal Academy; the Dudley, and various other London galleries; the Glasgow Institute of Fine Arts, and the Arts Association, NEWCASTLE, many of his exhibits reflecting his involvement in this period in managing the family theatrical interests in Northumbria, by portraying North East coastal views. Towards the end of his life Beverley's eyesight failed and he was obliged to give up scenic painting, and his spare-time relaxation of watercolour painting. He died at Hampstead. Represented: British Museum; National Gallery of Scotland; Victoria and Albert Museum; National Maritime Museum; Bridport A G; Fitzwilliam Museum, Cambridge; Laing A G; Newcastle; Leeds A G; Leicester A G; Newport A G; Portsmouth City Museum & A G; Sunderland A G; Ulster Museum, Belfast.

BEWICK, Jane (1787–1881)

Amateur landscape painter in watercolour. The eldest daughter of Thomas Bewick (q.v.), she was born at NEWCASTLE, and later assisted her father with much of the administrative work associated with the various publications which he illustrated. She occasionally painted in her spare time, and executed two views of the Ouseburn, NEWCASTLE, which were later reproduced in monochrome in *An Account of Jesmond*, by F W Dendy, 1904. The originals are in the possession of the Society of Antiquaries, NEWCASTLE, and show her to have been a capable amateur watercolourist, though by no means as accomplished as her father, her brother Robert Elliot Bewick (q.v.), or uncle, John Bewick, The First (q.v.). She died at GATESHEAD.

BEWICK, John, The First (1760–1795)

Wood engraver; landscape painter in watercolour; draughtsman; illustrator; drawing master. He was born at CHERRYBURN, near OVINGHAM, the younger brother of Thomas Bewick (q.v.). In 1777 he joined Bewick at NEWCASTLE as his brother's first apprentice and soon made an impression in the workshop run by Bewick and partner Ralph Beilby for his cheerfulness and industry. After five years in the workshop, during which he worked with his brother on the woodcuts for such works as *The Fables of the late Mr Gay*, 1779, he expressed a wish to try out his skills as an engraver in London. Bewick released him two years short of his time for this purpose, and arriving in the capital aged twenty-two he soon found a demand for his skills from the city's leading publishers and booksellers. His health quickly deteriorated, however, and he was forced to return to Tyneside to recover. As

John Bewick, The First, *The Sad Historian*, wood engraving from *The Deserted Village*, Goldsmith & Parnell's Poems, 1795.

soon as he was well enough he returned to London, and after making contact with printer Thomas Hodgson became involved in designing the blocks for *Emblems of Mortality*. This book – a reproduction of Holbein's *Imagines Mortis*, representing upwards of fifty woodcuts of death claiming people of all social positions and circumstances – was published in 1789. John's subsequent work on the Rev Dr Trusler's *Proverbs Exemplified*, 1790, and *Progress of Man in Society*, 1791, saw a considerable advance in the artistic treatment of his illustrative work, but the long hours involved, even ameliorated by occasional escapes to teach drawing at Hornsey Academy, took their toll and he fell violently ill. He had recovered by the autumn of 1792 sufficiently to attempt work, but by the following spring was writing to his brother that his illness might never entirely leave him. He resisted the temptation to return home to recuperate and began work for Francis Newbery, the publisher, on *Looking Glass for the Mind*, and *Tales for Youth in Thirty Poems*, both of which were published in 1794 and represented some of his best wood engraving to date. Indeed, of those produced for the second publication John Bell, who exhaustively catalogued his work remarked: 'Many of them are the equal of the highest effort of his genius; that of the prowling cat, at page 55, has been pronounced the most natural likeness of that animal ever produced.' In April 1794 a prospectus was issued by London publisher William Bulmer announcing a 'splendid' edition of Goldsmith and Parnell's poems for the following January, comprising *The Traveller*, *The Deserted Village*, and *The Hermit*.

He produced a wood engraving for *The Deserted Village* entitled *The Sad Historian*, which is deemed one of his finest works, but his fame as an illustrator in the medium chiefly rests on his work for William Somerville's poem of the *Chase*, published by Bulmer, in 1796. He was not to live long enough to engrave the designs he had so beautifully drawn onto the wood. He fell ill soon after completing his designs, and became so worried about his health that he immediately returned to Tyneside to be nursed by his sister Ann, at OVINGHAM. He died there in the December of 1795 and it was left to his brother, Thomas, to engrave all but one of his designs for the *Chase*, published in the year following his death. This he did so beautifully that George III could not be persuaded that such delicate effects were obtained by 'woodcuts'. In addition to being a talented wood engraver John Bewick was an able watercolourist, many examples of whose work survive in public and private collections. These include landscapes, bird studies, and preparatory sketches for his book illustrations. A book which attempts to give Bewick due credit for his abilities, *Life & Illustrations of John Bewick*, by Nigel Tattersfield, was published by the British Library, in 2001. Represented: British Museum; Laing A G, Newcastle; Natural History Society of Northumbria, Newcastle.

BEWICK, John, The Second (1790–1809)
Draughtsman; engraver. The nephew of Thomas Bewick (q.v.), and John Bewick The First (q.v.), he was born at CHERRYBURN, near OVINGHAM, the son of William Bewick. He was apprenticed to his uncle Thomas at NEWCASTLE, as a copperplate printer, but showed considerable promise as a draughtsman in a series of drawings which survived for many years at his birthplace. He died at nineteen, before completing his apprenticeship.

BEWICK, Pauline, RHA (b.1935)
Figure and landscape painter in oil and watercolour; illustrator; sculptor; etcher; ceramicist. She was born at CORBRIDGE, the daughter of Corbitt Bewick, a great-great-nephew of Thomas Bewick (q.v.), and artist ALICE MAY GRAHAM. When only a child she, her mother and sister left CORBRIDGE, and shortly after settled in County Kerry, Ireland. A fascinating account of her early life in Ireland may be found in *A Wild Taste* (Peter Davies, 1958), by her mother under the pseudonym 'Harry Bewick'. After about five years in Kerry they then went to live in Wales and England, occupying houseboats and caravans before taking up residence in a city house in Dublin. Here she enrolled at the National College of Art at the age of fifteen after demonstrating precocious talents as an artist, but left before taking her teaching certificate examinations. Her early work after leaving the College involved designing costumes and sets for the Pike Theatre, Dublin, and drawing for Trinity College's magazine *Icarus*. In 1954 she contributed to the Irish Living Art exhibition, and in the following year illustrated the cover for Thomas Kinsella's translation of *Thirty Three Triads*, part of *The*

Robert Elliot Bewick,
Elizabethan House in the
Forth, Newcastle,
pen and ink, 14.5 x 22.5cm.
Tyne & Wear Museums,
Laing Art Gallery.

Dolmen Chapbook. In 1956 she had her first of many works accepted for hanging at the Royal Hibernian Academy, Dublin, and in 1957 enjoyed her first one-man exhibition at the Clog Gallery, Dublin. Two followed at the Parkway Gallery, 1959–60, and she has since enjoyed several more including her major retrospective *Two Years to Fifty Years*, at the Guinness Hop Store, Dublin, in 1986, which subsequently toured the museums of Ireland, and *The Yellow* Man, at the Royal Hibernian Academy, in 1996. The former exhibition included some 1,500 works painted from the age of two until fifty; both attracted huge attendances. In addition to being a successful painter she has also illustrated many books and periodicals, including *Irish Tales and Sagas* (Townhouse, 1993), and *People* (Collins Press, 2001), and her own books: *Ireland: An Artist's Year* (Methuen, 1990); *The Yellow Man*, (Wolfhound Press, 1995), and *The South Seas and a Box of Paints*, (Art Books International, 1996). She was elected an associate of the Royal Hibernian Academy in 1981, and a member in 1986, and her work has been the subject of a number of books and television productions, notably *Pauline Bewick, Painting a Life* by Dr James White, former director of the National Gallery of Ireland (Wolfhound Press, 1985); *A Painted Life* shown on RTE and Channel 4, at the Pompidou Centre, Paris, and at the Los Angeles and Chicago film festivals, and *Kelly reads Bewick* (Arlen House, 2001) containing some fifty large-format illustrations of her work with interpretations by award winning poet and writer Rita Kelly. One of the leading contemporary artists in Ireland, she has lived in County Kerry with her psychiatrist husband Patrick Melia for many years, and her daughters POPPY MELIA (b.1966), and HOLLY MELIA (b.1970), are also successful artists. Represented: Arts Council of Ireland; Arts Council of Northern Ireland, and many other public and private collections. [See colour plate]

BEWICK, Robert Elliot (1778–1849)
Architectural and natural history painter in watercolour; draughtsman; engraver; etcher. The only son of Thomas Bewick (q.v.), he was born at NEWCASTLE, and after serving an apprenticeship (1804–1810) with his father, was partner in the Bewick engraving business from 1812 until the latter's death in 1828. Later, he continued the business on his own account. Skilful as a watercolourist, copperplate engraver and etcher, but only moderately accomplished as a wood engraver, Robert Elliot never quite fulfilled his father's hopes for him, confessing to a friend that he felt unable to follow in Bewick senior's footsteps with credit. He is best known for his watercolour preparatory drawings for the *History of British Fishes*, which his father and he proposed to publish, but he shows in several drawings of an Elizabethan house at NEWCASTLE, which he prepared in the early years of the nineteenth century, and a drawing of Ovingham Church produced six years before his death, that he was a sensitive and capable handler of architectural perspective. *The History of British Fishes* was never published, but he exhibited a number of his drawings for the work at the First Exhibition of the Northumberland Institution for the Promotion of the Fine Arts, NEWCASTLE, in 1822, and several of them were reproduced in the form of wood engravings in a supplementary section of his father's autobiographical *Memoir*, published posthumously in 1862. Robert Elliot was, of course, together with his father, and several other well-known Northumbrian artists, on the committee of the Northumberland Institution, having taken an active part in its foundation. He died at GATESHEAD, and was buried in the graveyard of the Parish Church at OVINGHAM. The British Museum has about 150 of his drawings, three of which were included in the 'Thomas Bewick' exhibition, Laing Art Gallery, NEWCASTLE, Summer, 1978. Represented: British Museum; Laing A G, Newcastle; Natural History Society of Northumbria, Newcastle.

BEWICK, Thomas (1753–1828)
Wood engraver; bird, animal, landscape and genre painter in watercolour; illustrator; draughtsman. The most celebrated artist ever produced by Northumbria, Thomas Bewick was born at CHERRYBURN, near OVINGHAM, the son of a farmer and colliery lessee. He was educated at the Vicarage school at OVINGHAM, under the Rev Gregson, and after displaying a marked interest in drawing throughout his childhood, was placed as an apprentice of Ralph Beilby (q.v.), at NEWCASTLE, at the age of fourteen. Here he was first put to copying *Copelands Ornaments*, later being introduced to all sorts of metal engraving, and at the instigation of local mathematician Dr Hutton, wood engraving. His first work of note on wood was for Hutton's *Treatise on Mensuration*, which began publication in parts in 1768. Hutton obtained the blocks of boxwood and tools necessary for his commission, and showed Beilby and Bewick how to handle the work which he required. Thus, by chance, Bewick – though later to excel in metal engraving – happened early in his career on a type of work for which he had a natural liking and ability, and through which his name was to become first nationally, then internationally famous. The Beilby workshop's commission from Hutton was followed by many other commissions to execute wood engravings, mainly from local printers, and Bewick, having by now displayed something of his talents in this direction, found himself cutting everything from bill heads, to illustrations for childrens' books. Some of his cuts for the latter were submitted by Beilby in Bewick's name, to the Society of Arts, and just before completing his apprenticeship in 1774 he received an award for seven guineas which he promptly presented to his mother. Bewick remained with Beilby for a few weeks after the termination of his apprenticeship, then went to CHERRYBURN, where he did work for his friend Thomas Angus, printer at NEWCASTLE, Beilby, and others, until the summer of 1776. He then went on a long walking tour of Scotland, and on returning to NEWCASTLE, stayed there only long enough to earn his passage to London. The capital had little attraction for him, however, and although he could easily have obtained work there, he was back on Tyneside by June, 1777. After some months working on commissions which he had brought back with him, he rejoined his former master as partner, taking as his first apprentice his younger brother John Bewick The first (q.v.). For the next seven years the partners concentrated mainly on the large volume of metal and wood engraving which their skills attracted, then Bewick one day proposed to Beilby that they should go into publication with a book illustrating and describing various types of four-legged animals, as most other works of this kind which he, Bewick, had studied, were poorly presented in these respects. After consultation with local bookseller, and editor of the *Newcastle Chronicle*, Solomon Hodgson, who thought it a good idea, Bewick began on the 15th of November, 1785, to cut the figure of a dromedary. The work eventually published in 1790, as *A General History of Quadrupeds*, with illustrations by Bewick, and the text largely by Beilby, was an immediate success, encouraging the partners to produce several successive editions, and almost immediately to commence work on yet another natural history publication, the first volume of a book on British birds. This work appeared in 1797, as *A History of British Birds, Volume 1, Land Birds*. Like the *Quadrupeds*, it also was well received, but unfortunately the partners disagreed over the authorship of the book (Bewick feeling it should be regarded as joint; Beilby, his alone), and the partnership was ended in the following year. Bewick then set about illustrating and writing the second volume entirely on his own, and spent some time correcting and adding illustrations to the earlier volume, most of this work being done in the evenings after the workshop closed, much as he had worked on the *Quadrupeds*. Published in 1804, as *A History of British Birds, Volume 2, Water Birds*, it set the seal on his reputation as a wood engraver, and together with the first volume, became the most popular of his illustrated books. His accurate and lifelike representations of birds contributed much to this popularity, but it was the tailpieces which excited particular delight by encompassing within the smallest spaces, nevertheless telling observations on contemporary rustic life and attitudes. Almost all of his illustrations for the *Birds* – both figure and tailpiece – were first prepared as watercolours, and in them it has been said, can be seen the true source of his genius as an engraver; his painter's eye, and dexterity as an engraver on wood, enabled him to produce unique work as an illustrator, and to exercise a lasting influence on all subsequent book illustration. His last published work of note was *The Fables of Aesop*, which was embarked upon following a serious illness in 1812. He had by then taken his only son, Robert Elliot Bewick (q.v.), into the business as partner, and now settled at GATESHEAD, he began to draw his Fables' designs direct on to the wood, leaving their cutting to apprentices. This work duly appeared in 1818, and hardly had it been published when he set about producing with his son a history of British fishes. Prospectuses were issued stating that it would be 'put to the press' in 1826, but Bewick was by then beginning to feel the effects of old age, and this circumstance, coupled with the difficulty of obtaining suitable specimens for illustration, and his son's diffidence in proceeding with the work, led to its abandonment. In his final years Bewick spent much time writing his autobiographical *Memoir*, which has remained a prime source of information about his life and his work as an artist since it was published in an abridged form some thirty-four years following his death.‡ It was started at TYNEMOUTH in November, 1822, and occupied him until close to his death. He died at GATESHEAD, and was interred in the graveyard

‡ The first edition of Bewick's 'Memoir' to give the complete text was not published until 1975, all its predecessors being based on the version published in 1862 by his daughter, Jane Bewick (q.v.). Edited and with an introduction by Iain Bain, it was published by Oxford University Press.

Thomas Bewick, *The Chillingham Bull*, 1789, wood engraving, 18.5 x 25cm. Pease Collection, Newcastle Central Library.

Thomas Bewick, *The Newfoundland Dog*, wood engraving, 6 x 8cm, from *The History of Quadrupeds*, 1790.

Thomas Bewick, *Sparrow Hawk*, watercolour, 30 x 20.5cm. Natural History Society of Northumbria, Newcastle.

of the Parish Church at OVINGHAM. Bewick has been the subject of more portraits, biographical studies and articles, than any other artist of Northumbria, and deservedly enjoys a truly international reputation as one of the world's greatest wood engravers and book illustrators. Bewick's work as a watercolourist was until recent years little known. With the publication in 1981 of *The Watercolours & Drawings of Thomas Bewick and his Workshop Apprentices*, by Ian Bain, recognition of his abilities in this field has now been made possible. In addition to his small-scale wood and copper engravings for illustrative purposes, and his large volume of watercolours, Bewick also produced a number of larger scale wood engravings for publication as prints. Notable amongst these were his famous *Chillingham Bull*, of 1789, and *Waiting for Death*, of 1828. He also produced a single lithograph, *Cadger's Trot*, 1823. His work has been the subject of many important exhibitions since his death (he only exhibited once while alive, and this at the Northumberland Institution for the Promotion of the Fine Arts, NEWCASTLE, in 1822), these coinciding with various anniversaries connected with his life, and culminating in 2003 with the 250th anniversary of his birth. The latter anniversary was also marked by the reproduction in metal on a pavement in Bewick Street, NEWCASTLE, of his Chillingham Bull, and the naming of an adjacent area as Thomas Bewick Square. There is a permanent exhibition of his work at CHERRYBURN, acquired by the National Trust in 1990, and opened to the public in 1991. Represented: British Museum; Victoria and Albert Museum; Hatton Gallery, Newcastle; Laing A G, Newcastle; Natural History Society of Northumbria, Newcastle; Newcastle Central Library.

Thomas Bewick, *Old Woman chasing Geese*, wood engraving, 5 x 9cm, from *The History of British Birds*, 1797-1804.

BEWICK, William (1795–1866)

Portrait, historical, biblical, genre and landscape painter in oil; draughtsman. Bewick was born at DARLINGTON, the son of an upholsterer, and served an apprenticeship with his father before deciding on a career in art. While still an apprentice he began experimenting with drawing and painting, receiving his first lessons from itinerant artists, later from George Marks (q.v.), in the latter's studio in the town.

By the age of twenty he had accumulated a portfolio of his drawings, and with £20 raised by the sale of these works he left for London in 1815. Here he met by chance the rapidly rising historical and genre painter Benjamin Robert Haydon, who accepted Bewick as a pupil, and with whom he remained for about three years. At Haydon's studio he met many famous men of the day, including Wordsworth, Hazlitt, Keats and Scott. Bewick worked hard under Haydon's influence, and besides working in his master's studio, attended the Royal Academy Schools, and the dissecting rooms of Sir Charles Bell. His health suffered from overwork, however, and he returned briefly to DARLINGTON to recuperate before resuming work in London by completing a series of drawings of the Elgin marbles for the poet Goethe. He first began exhibiting his work in 1820, at the Old Water Colour Society (later the Royal Society of Painters in Water Colours). His first exhibit of note, however, was his *Jacob meeting Rachel*, which he sent to the British Institution in 1822, and later showed at DARLINGTON. In that year also he showed four examples of his work at the First Exhibition of the Northumberland Institution for the Promotion of the Fine Arts, NEWCASTLE. For the next seventeen years he confined his exhibiting activities to the provinces, where he showed work at NEWCASTLE, Glasgow and Carlisle. During the early part of this period he returned briefly to DARLINGTON to paint portraits, then in the autumn of 1823 he visited Edinburgh, where he was warmly received by the city's leading artists and citizens. He formed an anatomical drawing class in the Scottish capital, and spent much time producing life-sized likenesses of the celebrities he met, including Sir William Allan, Sir John Malcolm, and Lord Jeffrey. He next went to Glasgow, where he held an exhibition of his works, and again attracted portrait commissions. The same success attended his subsequent visit to Dublin in 1824, and returning to Scotland shortly afterwards he stayed with Sir Walter Scott, whose portrait he painted while the great author sat for Sir David Wilkie. On leaving Scotland Bewick returned to DARLINGTON, where he married and is said to have 'painted several landscapes for different parties, to enable him to see the works of the Italian Schools'. Sir Thomas Lawrence, the Royal Academician, became aware of Bewick's interest, and offered him 100 guineas for a large copy of Michelangelo's *Prophets and Sybils*, in the Sistine Chapel. This commission was later extended to encompass other works in the Chapel, which Bewick was in the course of completing when Sir Thomas suddenly died. He was recompensed for his work by Sir Thomas's executors on his return to London after his four-year stay in Rome, and here resumed portrait painting before once again returning to DARLINGTON, where he stayed until the late 1830s. Back in London by 1839, he resumed exhibiting at the British Institution, and sent his first work to the Royal Academy, and the Suffolk Street Gallery. He continued to exhibit at the major institutions in

William Bewick, *Sir David Brewster*, chalk drawing, 52.7 x 37.5cm. Scottish National Portrait Gallery.

London throughout this, his final stay in London, and also exhibited his work for Sir Thomas, at his London home in 1840. After returning to DARLING- TON in 1842 he exhibited in the capital on only one further occasion, this being when he sent his *The Historian Platina in Prison*, to the British Institution in 1848. He spent the last twenty-odd years of his life at his home at HAUGHTON-LE- SKERNE, near DARLINGTON, his efforts in the early part of this period being confined to the production of a cartoon of the *Triumph of David* as a competi- tion entry for the decoration of Westminster Hall, and the painting of portraits and 'fancy pictures'. He died at HAUGHTON-LE-SKERNE, and is buried in the churchyard there. Much interesting information about Bewick, and several of his acquaintances among Northumbrian artists, including William Davison (q.v.), is contained in *The Life and Letters of William Bewick (Artist)*, edited by Thomas Landseer, 1871. A more recent account of his life and work, containing many illustrations, may be found in *William Bewick of Darlington*, by J R Kirkland and M R Wood, 1989. He was not a member of the family of Thomas Bewick (q.v.), as is sometimes believed.Represented: British Museum; National Portrait Gallery; Scottish National Portrait Gallery; Darlington A G; Laing A G, Newcastle.

BICKLE, Herbert W (b.1911)
Landscape and figure painter in oil and watercolour; draughtsman; printmaker; art teacher. Bickle was born at STANLEY, and studied art at Armstrong College (later King's College; now Newcastle University) under Robert Lyon (q.v.). After leaving the College he exhibited a number of works at the Artists of the Northern Counties exhibitions at the Laing Art Gallery, NEWCASTLE, but during the 1940s spent most of his time working as an aircraft design draughtsman. Following the Second World War he resumed his inter- est in painting by enrolling at the Southampton College of Art, and later went on to exhibit at the Royal Society of British Artists. His Royal Academy exhibits included his *Beekeeping*, of 1935, and *The Swarm*, of 1965. Bickle spent most of his life at Southampton.

BICKNELL, Phillis Ellen (née Lovibond) (1877– 1958)
Landscape, architectural and flower painter in water- colour. She was born at Lewisham but moved to Tyneside as a girl when her father took up a position with a local brewery. After education at GATESHEAD she studied under artist Arthur G Bell, and at Armstrong College (later King's College; now Newcastle University). In 1900 she sent one work to the Royal Institute of Painters in Water Colours, and four works to the Alpine Club, London, following this by becoming a regular exhibitor at the Artists of the Northern Counties exhibitions at the Laing Art Gallery, NEWCASTLE. Her first contributions in 1905 were entitled *Corner at Hesleyside*, and *New Christ Church*. During her career as an artist she lived at NEWCASTLE, ROWLANDS GILL, near GATESHEAD, and HEXHAM. She died at NEWCASTLE. Several other members of her family were also artistically gifted, including her daughter, ELLEN PHILLIS BICKNELL (b.1902), and sons PETER BICKNELL (b.1907), and NIGEL BICKNELL (b.1919). Her early works were signed 'Phillis Ellen Lovibond'.

BIGGE, Charles John (1803–1846)
Amateur landscape painter in watercolour; draughts- man. He was born at NEWCASTLE, the son of Charles William Bigge. He later took a prominent part in local council affairs, painting and drawing in his spare time. He was an alderman of NEWCASTLE, and in 1835 became the first mayor to be elected under the Municipal Corporation Reform Act. In 1836 he was made a freeman of the town. He occasionally exhibited his work at NEWCASTLE commencing in 1831, when he showed four Italian views at the Northern Academy. Among his later exhibits were the *Bamborough Castle from the North . . .*, and *Pass in the Maritime Alps*, which he showed at the First Water Colour Exhibition of the Newcastle Society of Artists, 1836, after serving as mayor. An example of his draughtsmanship is his drawing of Brinkburn Priory, 1833, reproduced as an engraving by William Collard (q.v.), in Hodgson's *History of Northumberland*, Vol III, part III. He died in London.

BIGLAND, Mary Backhouse (b.1844)
Amateur landscape and flower painter in oil and water-colour. She was born at DARLINGTON, the daughter of Jane Backhouse, and Hodgson Bigland. Nothing is known of her early artistic training, but by 1869 she was exhibiting in London, from Birkenhead in Cheshire, showing one work at the New Water Colour Society (later the Royal Institute of Painters in Water Colours). She later became a regular exhibitor in London and the provinces, showing works at Liverpool and NEWCASTLE. Amongst her earliest exhibits at NEWCASTLE were the three works which she showed at the Arts Association in 1878, following her return to DARLINGTON. She showed other works at the Arts Association in the next three years, and later became a regular exhibitor at the Bewick Club, NEWCASTLE, show-ing landscapes and flower studies. Typical of the former was her *Harvest Time*, shown at the Club's exhibition in 1893. In her later years she was an occasional exhibitor at the Society of Women Artists' exhibitions.

BIRD, James Lindsay (1905–1972)
Landscape and portrait painter in oil and watercolour; etcher. He was born at CROOK, but moved to MIDDLES-BROUGH with his family as a boy. He studied art at King's College (now Newcastle University), then went on to the Royal College of Art, where he won a travelling scholarship to Italy. On his return he taught at Batley School of Art for twelve years before moving to DARLINGTON in 1946 to teach at the Queen Elizabeth Grammar School. Here he taught until his retirement in 1965, when he moved to Scorton, near Richmond, North Yorkshire. Bird painted, and exhib-ited his work throughout his life, showing examples at the Royal Academy; leading London galleries; the Artists of the Northern Counties exhibitions at the Laing Art Gallery, NEWCASTLE; the Shipley Art Gallery, GATESHEAD, and elsewhere in the provinces. One of his most important portrait commissions was that of Her Majesty Queen Elizabeth the Queen Mother, which he received from the Old Boys of the Queen Elizabeth Grammar School in 1964. A bronze medal winner in Paris for his work *The Fallen Tree*, and a member of the Industrial Art Design Panel, Bird also illustrated books, and contributed drawings to *The Dalesman* under the name 'Rara Avis'. A founder-member of 'Three Teesside Artists', he was also a frequent contributor to Darlington Society of Arts exhibitions. Retrospective exhibitions of his work were held at Darlington Art Gallery in 1976, and at Rippon Contemporary Art Gallery, Oakham. Represented: Darlington A G. [See colour plate]

BIRD, Robert (b.1921)
Landscape painter in oil; muralist; art teacher. He was born at Birmingham and at eighteen was runner-up in a *Punch* competition won by Ronald Searle. He later took up a post as head of the art department at the Newcastle College of Art & Industrial Design, and began to exhibit his work widely in Northumbria, including the Artists of the Northern Counties exhibi-tions at the Laing Art Gallery, NEWCASTLE; the Gulbenkian Gallery, People's Theatre, NEWCASTLE, and

at various other venues in the provinces. He also exhibited at the Royal Society of British Artists; the Mayor Gallery, London, and elsewhere in the capital, and enjoyed one-man exhibitions at the Midland Group Gallery, Nottingham. His paintings were mainly landscape-inspired but he also interpreted a wide range of other subjects in paint including still life and birds. The Laing Art Gallery has his oil *Spanish Gold (A)*, and he is also represented in several other public collections.

BLACK, Albert Ernest (1882–1963)
Landscape, portrait, flower and street scene painter in oil and watercolour. He was born at NORTH SHIELDS, the second eldest son of Alderman Isaac Black J P. He sketched from his boyhood, taking special pleasure in visits to ROTHBURY for this purpose, with his mother who was also interested in art. He attended boarding school at NEWCASTLE, subsequently joining the staff of a shipowner in the city. At twenty-four he left his job at NEWCASTLE, and following his marriage in 1907, became book-keeper to his father, who owned several tailoring and outfitting shops on Tyneside. About 1933 he retired from business to devote his life to painting, having throughout his book-keeping employment exhibited his work frequently at SOUTH SHIELDS, and at the Artists of the Northern Counties exhibitions at the Laing Art Gallery, NEWCASTLE, in an amateur capacity. Many of the works which he exhibited at South Shields Art Club were later purchased by South Shields Museum & Art Gallery, and an exhibition of thirty-nine of his works was held by this establishment in 1956, proving so popular that it was extended. Most of his work featured local landscape, street and river scenes, some of these based on photographs. He died at SOUTH SHIELDS. He was the elder brother of Joseph Wallace Black (q.v.). Represented: South Shields Museum & A G.

BLACK, Joseph Wallace (1884–1945)
Coastal painter in watercolour; illustrator. He was born at NORTH SHIELDS, the son of Alderman Isaac Black J P, and younger brother of Albert Ernest Black (q.v.). He followed a variety of occupations from his youth, principally connected with the publication of periodicals, some of which he illustrated himself. His best known publication was the *Shields Hustler*, an advertising freesheet which he published and edited from 1905–1937. In his later life he took an increasing interest in the tailoring and outfitting shops owned by his father. He died at NORTH SHIELDS. Represented: North Tyneside Public Libraries.

BLACKLOCK, William Kay, ARCA (1872–1924)
Landscape and genre painter in oil and watercolour; art teacher. Born at SUNDERLAND, Blacklock studied at the Slade School of Fine Art, and at the Royal College of Art, before practising as a professional artist and art teacher. On leaving the College he returned to SUNDERLAND, where he established a studio, and began exhibiting his work at the Bewick Club, NEWCASTLE. After several years exhibiting with the Club he sent his first work for exhibition at the Royal Academy, show-

ing *The home of a fisherman, Whitby*, and *Study*, in 1897. In the following year he moved back to London where he studied anatomy at the London Teaching Hospitals. He again exhibited at the Academy in 1900 and 1901, then moved to Edinburgh, where in 1902 he took up a position as headmaster at the Edinburgh Institute of Art. However, never in robust health he decided he wished to freelance, and work in the open air, and resigned his position in 1908. In 1909 he married his former model and fellow artist Nellie. They set up home in Chelsea, London, but shortly after moved to Walberswick, Suffolk, where they remained until the early years of the First World War. From there they moved to Hemingford Gray, Huntingdonshire, on the banks of the River Ouse where Blacklock began varying his portrait and teaching work by painting rustic genre scenes, finding a ready market among local industrialists. The couple later moved to Leicester, renting a cottage on the Ouse. After this cottage was burnt to the ground in 1921, they decided to travel abroad to sketch, mainly in France. Blacklock's health later deteriorated badly, and he was recommended to seek a warmer climate. They settled at Polperro, in Cornwall, and here he began work on what he regarded as his finest painting, *Checkmate*, featuring a chess game in a local pub. He died shortly after completing it, in 1924. In addition to exhibiting his work frequently at the Royal Academy, Blacklock also exhibited many works at the Royal Scottish Academy; the Royal Institute of Painters in Water Colours, and sent some six works to the Royal Institute of Oil Painters. He also exhibited widely in the provinces, including the Artists of the Northern Counties exhibitions at the Laing Art Gallery, NEWCASTLE, from their inception in 1905, and produced illustrations for Ward Lock, the publishers. He was an associate of the Royal College of Art, and had been nominated for election as an associate of the Royal Academy at the time of his death. His wife, Nellie, who featured in many of his paintings, later became well known for her flower pictures, several of which were shown at the Royal Academy. Represented: Sunderland A G. [See colour plate]

BLAKELOCK, Clive Vernon (1880–1955)

Amateur landscape and coastal painter in watercolour. Born at SUNDERLAND, Blakelock studied at the town's Technical College, and later became assistant park superintendent at nearby SOUTHWICK. He became the first park superintendent at WHITLEY BAY, in 1914, and during his thirty-one years in this capacity was responsible for the planning of many of the town's beauty spots. He was a pupil and friend of John Atkinson (q.v.), a lifelong acquaintance of David Thomas Robertson (q.v.), and showed his work at Sunderland Art Gallery, and the Artists of the Northern Counties exhibitions at the Laing Art Gallery, NEWCASTLE. Blakelock was one of Atkinson's most accomplished pupils, his work in watercolour the equal of much that was produced by the latter artist. Following his retirement in 1946 Blakelock spent five years at HEXHAM, then returned to WHITLEY BAY, where he died in 1955.

BLENKIRON, Edith (1904–1992)

Flower painter in watercolour; draughtsman; illustrator. She was born at EBCHESTER, near CONSETT, and studied at Goldsmiths' College School of Art. Here she met, and in 1929 married fellow artist and student Rowland Hilder (1905–1993), soon after collaborating with him in painting pictures for which she supplied the flowers and he the landscape details. This combination reached fruition in the early fifties when *The Shell Guide to the Flowers of the Countryside* was given to them as an illustrative commission. Her affectionately drawn and botanically accurate watercolours, with landscape backgrounds in her husband's by now highly distinctive style made their illustrations extremely popular when serialised in the colour magazines of the day, and led to an equally successful book published in 1955. In 1957 her *British Wild Flowers* widened her public still further, and in another collaboration with her husband, *Sketching and Painting Indoors*, was published in the same year. Blenkiron exhibited her work at the Royal Academy and the Royal Society of Painters in Water Colours. She also exhibited jointly with her husband on a number of occasions, notably in Britain and the USA following their work on *The Shell Guide*, and at the Edward Read Gallery, Johannesburg, South Africa, to which latter country they went every winter for several years. Notwithstanding her collaborative work with her more famous artist husband she established a considerable reputation in her own right as a meticulously accurate botanical draughtsman. She died of cancer in London, her home for all of her married life and work as a professional artist. Their son ANTHONY FLEMMING (b.1936) is a professional artist. [See colour plate]

BOAG, George (fl.1864–1902)

Animal painter in oil. This artist practised in NEWCASTLE in the late 19th century, where he was a regular exhibitor at the Bewick Club from 1884, until his death. He also exhibited at the 'Gateshead Fine Art & Industrial Exhibition', in 1883, where he showed his *Ready For the Fair*. His studio was for many years in the city's Scotswood Road.

George Boag, *A Black Greyhound*, 1900, 47 x 59.5cm. Anderson & Garland.

BODYCOTE, Nellie (fl. early 20th cent.)

Portrait, figure and flower painter in watercolour. She practised as a portrait miniature painter in SOUTH SHIELDS, showing one work at the Royal Academy in 1936, and several works at the Artists of the Northern Counties exhibitions at the Laing Art Gallery, NEWCASTLE, from 1935 until the middle of the century. Her Royal Academy exhibit was entitled *Marjorie*.

BOLAM, Cyril Thompson (b.1908)

Amateur landscape painter in oil and watercolour. Bolam was born at NEWCASTLE, and became a self-taught painter before exhibiting his work at the Artists of the Northern Counties exhibitions at the Laing Art Gallery, NEWCASTLE, and the Federation of Northern Art Societies, at the Shipley Art Gallery, GATESHEAD. He held official positions with the Federation, and with the West End Art Club, NEWCASTLE. Typical of his Laing Art Gallery exhibits were his watercolour *Gatehouse of Fleet*, and oil *Concert Spa Pavilion, Whitby*, of 1952.

BOLTON, Elaine – see GILMOUR, Elaine

'BOS' – see FOREMAN, Joseph

BOUET, Joseph Sébastien Victor Francois ('Nicolas') (1791–1856)

Genre, portrait and landscape painter in oil; draughtsman; caricaturist; lithographer. He was born in Paris, and following artistic training in the French capital, settled at DURHAM to practise as a professional artist, art teacher, and later teacher of French. He soon became well known for his artistic abilities at DURHAM, and later NEWCASTLE, at which latter he exhibited at the Northumberland Institution for the Promotion of the Fine Arts, from 1823, and the town's Northern Academy, from its inaugural exhibition in 1828. His exhibit at the Northern Academy in 1829, *The Bird's Nest*, earned from W A Mitchell in the *Tyne Mercury*, the remark: 'As a pencil drawing this is in Bouet's usual excellent style'. Bouet exhibited little in his later life, apart from showing a few works in pencil, chalk, etc., at the Polytechnic Exhibition held at the Durham Mechanics' Institute in 1843. He was, however, very active artistically, producing many pencil drawings of local landscape and architectural subjects, and works in lithography. One of his major works in pencil was his series of drawings of the tapestries at Durham Castle, which were later drawn on the stone by James Dickson, and published as a volume of lithographic illustrations. Among his own work in lithography were his *Gateway to the Old Gaol at Durham* (taken down in 1821), printed by W Day, and a *View of Durham from the lower Gilesgate area, with figures*, printed by G Hullmandel. In his later years Bouet increasingly relied on teaching French and drawing for his living, in the former activity having some connection with the University at DURHAM, and later the city's Grammar School. In his final years he preferred to be called 'Nicolas Sébastien Bouet'. He died at DURHAM. Represented: Durham University: Sunderland A G.

BOULLEMIER, Lucien Emile (1877–1949)

Portrait and genre painter in oil and watercolour. He was born at Stoke, the son of Antonin Boullemier, one of Mintons best-known French painters in the 19th century, and a spare-time painter of miniatures. He eventually took up his father's profession, working at the Lennox china factory in New Jersey, USA, from 1900–1906 before returning to England to work first for Mintons, and later at the Soho Pottery at Cobridge. In 1926 he joined the Ford Potteries of Maling, NEWCASTLE, to take charge of the decorating departments, later distinguishing himself as their best-known designer. During his period in this capacity, which ended with his departure in 1936, he painted as a relaxation a number of genre works in watercolour, and portraits in oil. However, he is only known to have exhibited his work on one occasion, this being when he sent his watercolour *The Street Watchman*, and portrait plaque *Councillor A. W. Lambert M.C. ex Lord Mayor of Newcastle*, to the Artists of the Northern Counties exhibition at the Laing Art Gallery, NEWCASTLE, in 1927. On leaving Maling he returned to the Staffordshire area to work for the potteries, initially for a company, and later as a freelance. His portrait plaque of Lambert is in the collection of the Mansion House, NEWCASTLE. An account of Boullemier's years with Maling is contained in *Maling – The Trade Mark of Excellence*, by Steven Moore and Catherine Ross, Tyne & Wear Museums Service, 1989.

BOWEY, Olwyn, RA RBA (b.1936)

Figure, portrait and landscape painter in oil and watercolour; draughtsman; art teacher. Bowey was born at STOCKTON ON-TEES, and attended the School of Art at HARTLEPOOL, and the Royal College of Art, at which latter she was awarded a travelling scholarship. After completing her studies she taught for some time at Waltham Forest School of Art, then became a full-time professional artist. She exhibited her work at the Royal Academy from the age of twenty-four showing a wide variety of work over many years, including in 1964, among several portraits, a portrait sketch of L S Lowry RA, which was purchased by the Academy under the terms of the Chantrey Bequest. She also showed her work at the New Grafton Gallery, London, and elsewhere, and was elected associate of the Royal Academy in 1970, and full academician in 1974. She was also a member of the Royal Society of British Artists. She lived in London for many years, and later at Heyshott, Midhurst, Sussex. Represented: Royal Academy; Tate Gallery; Arts Council; Ministry of Public Buildings and Works, and various provincial art galleries.

BOWLT, William (b.1822)

Marine and coastal painter in oil. Born at GATESHEAD, Bowlt exhibited his work at NEWCASTLE at the North of England Society for the Promotion of the Fine Arts, in 1839 and 1841. In 1839 he showed *The Mouth of the Tyne, Morning*, and in 1841 *The Herd Sands from the Mouth of the Tyne*, and *Rocks near Cullercoats*. Nothing more is known of this artist

except that he was a member of a well-known family at GATESHEAD, of which several members were tradesmen in the town.

BOWMAN, George G (fl.1890–1920)
Landscape and genre painter in oil and watercolour; illustrator; engraver. This artist practised at NEWCASTLE in the early 20th century, and first exhibited his work publicly when he sent a coloured print, *On the Tyne*, and a drawing, *Death of an Old Man*, to the Artists of the Northern Counties exhibition at the Laing Art Gallery, NEWCASTLE, in 1910. In 1913 he exhibited work at the Royal Scottish Academy, and the Artists of the Northern Counties exhibition, at the latter showing an oil, *Tootie after the bath*, and two drawings. He exhibited three further works at the Royal Scottish Academy in the next four years, and also exhibited at NEWCASTLE, but he appears to have ceased exhibiting entirely shortly after the conclusion of the First World War.

BOWMAN, Thomas Stanton (c.1840- after 1886)
Landscape painter in oil. This artist practised at NEWCASTLE in the second half of the nineteenth century, following a period in London during which he sent one work to the British Institution, and four works to various other exhibitions in London, 1866–67. His British Institution exhibit, contributed in 1867, was *A Revolt in the Kitchen*. He occasionally exhibited at NEWCASTLE, notably at the exhibitions of the Arts Association. He may have been related to George G Bowman (q.v.).

BOYCE, Albert Ernest (1886–1956)
Amateur landscape painter in watercolour. Born at SOUTH SHIELDS, one of the nine sons of William Thomas Nichols Boyce (q.v.). Albert Ernest Boyce was a keen amateur artist in his early manhood, but is believed to have virtually abandoned painting about 1920. Prior to this he painted a number of local landscapes, such as his *Near Hartley*, shown at the Artists of the Northern Counties exhibition at the Laing Art Gallery, NEWCASTLE, in 1913. He died at SOUTH SHIELDS. He was the brother of Herbert Walter Boyce (q.v.), and Norman Septimus Boyce (q.v.).

BOYCE, Herbert Walter (1883–1946)
Amateur seascape and landscape painter in watercolour. Born at SOUTH SHIELDS, one of the nine sons of William Thomas Nichols Boyce (q.v.), Herbert Walter Boyce was a keen amateur artist throughout his life. Like his father, and brothers Albert Ernest Boyce (q.v.), and Norman Septimus Boyce (q.v.), he exhibited almost exclusively at SOUTH SHIELDS, and at the Artists of the Northern Counties exhibitions at the Laing Art Gallery, NEWCASTLE. He worked predominantly on a small scale, and exhibited at NEWCASTLE such titles as *A Mill Stream* (1906); *By the Harbour Cliffs of Tynemouth* (1911), and *To the Rescue* (1912). He died at SOUTH SHIELDS. Represented: South Shields Museum & A G.

BOYCE, Norman Septimus (1895–1962)
Amateur seascape, landscape and miniature painter in watercolour. One of the nine sons of William Thomas Nichols Boyce (q.v.), he was born at SOUTH SHIELDS, and began his working life as an engineering apprentice, but left his employer for the drapery trade. After service with the Royal Artillery in the First World War he took up the profession of artist for some twenty years, only abandoning it at the outbreak of the Second World War, when he went to Swindon, to work once more in engineering. After the War he settled at Derby, remaining there until he retired, when he returned to SOUTH SHIELDS. Like his father, and brothers Albert Ernest Boyce (q.v.), and Herbert Walter Boyce (q.v.), he exhibited almost exclusively at SOUTH SHIELDS, and at the Artists of the Northern Counties exhibitions at the Laing Art Gallery, NEWCASTLE, showing his first work at the latter in 1913, *Seascape*. His work is very similar to that of his father, and was painted mainly in watercolour, though a few oils are known. In later years he worked increasingly in monochrome. Represented: South Shields Museum & A G.

BOYCE, William Thomas Nichols (1857–1911)
Marine and landscape painter in oil and watercolour. Boyce was born in Norfolk, the son of a master mariner, but moved to SOUTH SHIELDS in 1872 with his parents. Here he became first an apprentice joiner, and later an employee in a draper's shop in the town, before becoming a full-time professional artist. His work from this point forward consisted mainly of watercolours of steam tugs, brigs, schooners and steam colliers, portrayed in a wide range of climatic conditions, and providing a valuable, and artistically accomplished record of the transition from sail to steam before the First World War. He also painted these subjects in oil, showing an equal degree of accomplishment in the use of this medium, but examples are quite rare. Boyce is not known to have exhibited his work outside Northumbria. He exhibited at South Shields Art Club; the Bewick Club, NEWCASTLE, and from 1905 until his death at SOUTH SHIELDS, the

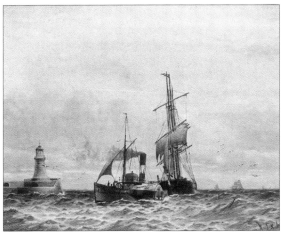

William Thomas Nichols Boyce, *Entering the Tyne*, watercolour, 39 x 86cm. Private collection.

Artists of the Northern Counties exhibitions at the Laing Art Gallery, NEWCASTLE. Three examples of his work were included in the 'Wearmouth 1300th Festival - 19th Century Artists' exhibition at Sunderland Art Gallery, in 1974. These comprised *Brig off the Tyne; Homeward Bound*, and *Sunderland Harbour 1905*. His sons Albert Ernest Boyce (q.v.), Herbert Walter Boyce (q.v.), and Norman Septimus Boyce (q.v.), were all artistically gifted. Represented: Laing A G, Newcastle; South Shields Museum & A G; Sunderland A G.

BOYD, Alice (1825–1897)

Amateur landscape and figure painter in oil and watercolour. She was born at Penkill Castle, Ayrshire, of an ancient Scottish family. Following the death of her father, her mother married a Mr Mayhew, and she and her brother Spencer went to live in Wharfedale, Yorkshire, near the village of Arncliffe. Alice and her brother later moved to Tyneside, where she began to take a keen interest in painting after meeting William Bell Scott (q.v.), in 1859, while he was working on his murals for Wallington Hall, near CAMBO. He was then painting his Bernard Gilpin subject, and in addition to encouraging her interest in art, asked her to pose for the main figure of his Grace Darling mural. She later settled at NEWCASTLE, and became a pupil of Scott. Scott and his wife asked her to join them when they moved to London late in 1864, but she was detained by the illness of her brother at their home at TYNEMOUTH, and did not join the Scotts until 1865. From then on she spent every winter with the Scotts in London, while they spent their summers and autumns with her at Penkill Castle. While on one of her stays in London she showed her only work at the Royal Academy, *A Scottish Glen*. This work was shown in 1880, and was followed by the exhibition of several works at the Royal Scottish Academy, including her *The Incantation of Hervor*, and *The Wild Huntsman*. She was also an exhibitor at NEWCASTLE for several years, showing examples of her work at the Arts Association from 1878, and the Bewick Club from 1884. Scott continued to visit Penkill until his final years, dying there after a long illness throughout which he was nursed by Alice. She also died at Penkill, and was buried in the same grave there as Scott. Much interesting information on their relationship, together with Scott's etching of her portrait after Dante Gabriel Rossetti, is contained in his *Autobiographical Notes etc.* 1892. She was not related to the family of Edward Fenwick Boyd (q.v.). Represented: Kyle & Carrick District Libraries, Ayr; Penkill Castle, Girvan, Ayrshire.

BOYD, Edward Fenwick (1810–1889)

Amateur landscape painter in watercolour; draughtsman. Boyd was born at NEWCASTLE, the son of a banker, and was educated at WITTON-LE-WEAR, near BISHOP AUCKLAND, and later Edinburgh University. He subsequently became a professional mining engineer, and for many years served several bodies in Northumbria as mine agent and supervisor. He was an acquaintance in his youth of Thomas Bewick (q.v.), and while at WITTON-LE-WEAR produced some sketches which came to the attention of Edward Swinburne (q.v.). Swinburne persuaded Boyd's father to place his son as a pupil of Thomas Miles Richardson, Senior (q.v.), at NEWCASTLE, and Boyd remained throughout his career in mining a keen spare-time painter and sketcher of local scenery, amassing over the years several portfolios of his work. He died at his home for many years, Moor House, LEAMSIDE, near DURHAM. He was the father-in-law of Janet Augusta Boyd (q.v.). His daughter was the well-known Bewick collector, Julia Boyd, author of *Bewick Gleanings*, 1886, which work she dedicated to her father.

Alice Boyd,
From the window of Balcony House, Tynemouth, 1864,
oil, 25 x 35cm.
Private collection.

BOYD, Francis (b.1931)
Landscape, portrait and still life painter in oil and watercolour; lithographer. Boyd was born at WINLATON, near GATESHEAD, and studied at South Shields School of Art, and King's College (now Newcastle University), at which latter he was awarded the John Bell Simpson Prize for Drawing, and Bronze Medal for Painting. From 1955–1960 he was unable to paint due to ill health, but at thirty he was able to turn professional.In 1962 he exhibited with the London Group, and atthe Federation of Northern Art Societies exhibition on Tyneside. In 1965 he held a large one-man exhibition of his work at his studio in NEWCASTLE, comprising watercolours, pencil drawings and lithographs of landscapes, portraits and still life subjects.

BOYD, Mrs Janet Augusta (1850–1928)
Amateur miniature painter. The daughter-in-law of Edward Fenwick Boyd (q.v.), she first exhibited her work while living with her husband George Fenwick Boyd, at WHITLEY BAY, showing portraits at the Bewick Club, NEWCASTLE, in 1886. She continued to exhibit at the Bewick Club for some years subsequently, and in 1895 sent her first works to the Royal Academy. Some years after her father-in-law's death at Moor House, LEAMSIDE, near DURHAM, she moved with her husband to his father's former home, and from this address exhibited at the Royal Academy, the Royal Miniature Society; the Society of Women Artists, and the Walker Art Gallery, Liverpool, from 1896. Most of her exhibits were portraits of friends in Northumbria. She died at the home of her daughter, near Cheltenham, Gloucestershire.

BRANNAN, Noel (b.1921)
Industrial and landscape painter in oil and watercolour; draughtsman; art teacher. Brannan was born at TYNEMOUTH and studied at Lincoln School of Art, then Leicester College of Art before working as an art teacher for some twenty-eight years. Although he had begun painting in 1940 it was not until 1980 that he became a full-time professional artist, this despite the fact that he was one of the painters chosen for Jack Beddington's book *Young Artists of Promise*, 1957. He became a member of the Artists International Association and also showed his work at the Royal Academy; the Royal Society of British Artists; the London Group, and elsewhere, including the Lincolnshire and South Humberside Artists' Society. He also had a one-man exhibition at the Willoughby Memorial Trust Art Gallery, Corby Glen, in 1985. Brannan has shown a preference for working on the spot using felt pen and wash, and with a strong attraction to industrial subjects. He lived at Burbage, Leicestershire. Represented: Nuneaton A G; Usher Gallery, Lincoln.

BRASON, John (b.1924)
Landscape and figure painter in oil and watercolour; draughtsman; art teacher. He was born at SOUTH SHIELDS and attended the town's School of Art, and later the Royal College of Art, before teaching at St Martin's School of Art, and Camberwell School of Arts and Crafts. He has exhibited his work at the Royal Academy; the Arts Council, and elsewhere, while living for many years in London.

BREWIS, Henry (1932–2000)
Cartoonist; illustrator. He was born at SHILBOTTLE, near ALNWICK, and followed the occupation of farmer for most of his life, eventually settling at HARTBURN, near MORPETH, in 1958. His talent for illustration first came to light when he sent personally drawn Christmas cards to friends, and led to his publication of some fourteen books, many of which poked fun at bureaucrats taking over farming. One of his earliest creations was a rustic character named *Sep*, who regularly featured in his books, and on mugs, sweatshirts and in figurines exported to many countries. He was a regular contributor of articles to the *Northumbrian* magazine, illustrated by himself. This magazine published a collection of his humorous articles under the title *A Stroll in the Country*, in 1999, and his usual publisher, Farming Press, a posthumous collection of his best cartoons over twenty-five years: *Last Round-up*, in 2000. Brewis also produced cartoons for *Farming Livestock*, and a number of local companies. He died at HARTBURN. An exhibition of his work was held at Middleton and Todridge Village Hall, near HARTBURN, following his death.

Henry Brewis, *Sep*, pen and ink, illustration from *Northumbrian* magazine.

BROADFIELD, Robina Margaret (b.1906)
Imaginative and landscape painter in oil and watercolour. She was born at HEBBURN, near GATESHEAD, and apart from six weeks of evening classes at Leicester College of Art developed as a self-taught artist. She became a leading member of the Leicester Society of Artists, and showed her work in public galleries at Leicester and Nottingham, and in Germany and Italy. Much of her exhibited work was 'from memory, or imagination', and signed with her initials. She was married to the art teacher Aubrey Broadfield.

BROBBEL, John Christopher, ARBA (b.1950)
Landscape and figure painter in oil and watercolour; art teacher. Brobbel was born at HARTLEPOOL and stud-

ied at the local College of Art; the Byam Shaw School of Drawing and Painting, then the Royal Academy Schools before embarking on a career in teaching art. He taught for a time at Hartlepool College of Further Education and later at Cleveland College of Art, and during this period began exhibiting his work at the Royal Academy, the New English Art Club, and the Royal Society of British Artists. He also staged a joint exhibition with Lionel Charlton, at the Gray Art Gallery, HARTLEPOOL, in 1980, and later held several one-man exhibitions. He is the author of *Pencil Drawing* and *Drawing with Ink*, a freeman of the Worshipful Company of Painter Stainers, and an associate of the Royal Society of British Artists. He lives in Dublin where he practises as a professional artist, and teaches prisoners at the city's Mountjoy Prison 'to use their time creatively, and develop new confidence and skills'. Represented: Hartlepool Arts & Museum Service.

John Christopher Brobbel, *The Journeyman*, c.2000, watercolour, 46 x 71cm. Private collection.

BROMLY, Thomas ('Tom'), OBE (b.1930)

Abstract and portrait painter in oil; photographer; art teacher. Bromly was born at Los Mochis, Mexico, and studied at Canterbury College of Art, and then Leeds College of Art before taking up a teaching position in painting at the College of Art & Industrial Design, NEWCASTLE, in 1955. He then went on to serve as dean of the faculty of arts and design at what was then Newcastle Polytechnic (now University of Northumbria), meanwhile becoming a founder-member of the Newcastle Group, and later secretary. He was an exhibitor with the Group at its inaugural show at the Laing Art Gallery, NEWCASTLE, in 1965, and in the following year was represented in the Belfast Open Exhibition. His main exhibits with the Group were initially large hard edge pictures but restrictions in his time because of his varied teaching commitments later resulted in a change of scale and subject matter for his work. Bromly was closely associated with the development of art and design education throughout Britain and awarded an OBE in recognition of his work. In 1992 he was co-author of *Capability Through Art & Design*, and in that year also retired from the University. As well as mixed shows at the Laing Art Gallery, NEWCASTLE; London;

Leeds; Nottingham, and SUNDERLAND, he has had a number of one-man exhibitions, the first of which was held at the Laing Art Gallery in 1966. A retrospective exhibition of his work was also held at the University Gallery, University of Northumbria, in 1993–4, the earlier part of which included his paintings and drawings; the latter, his photographs and portraits. Since his retirement he has had a number of photographic exhibitions but has maintained his interest in painting. Recent work in the latter field has included a number of portrait commissions. For several years following his retirement he lived at Callaly Castle, WHITTINGHAM, near ALNWICK, but now lives at CORNHILL. Represented: Laing A G; University Gallery, University of Northumbria, Newcastle.

BROUGH, Derek (born c.1930)

Abstract painter in oil; sculptor; art teacher. Born at WALLSEND, near NEWCASTLE, Brough studied at the Slade School of Fine Art, and the Institute of Education, London University, before taking up a national service commission in the Northumberland Fusiliers. On leaving the Regiment in 1957 he taught in a Tyneside secondary modern school, and evening classes at the College of Art and Industrial Design, NEWCASTLE, before taking up a position as senior lecturer at the College of Education, ALNWICK. Just before taking up his appointment he shared an exhibition at the Westgate Gallery, NEWCASTLE, with Albert Henry Herbert (q.v.) consisting of oils and sculptures.

BROWN, Brian (b.1939)

Sculptor; landscape, seascape and figure painter in various media. Brown was born into a mining family at SUNDERLAND. Following the family tradition he went to work at a local colliery on leaving school, but thanks to a chance discovery of his drawing talents by the manager was encouraged to attend Sunderland College of Art. On leaving the College he taught art at schools around CONSETT until his retirement in 1991. He then took up a career as a full-time artist, and freelance art teacher locally, and at summer schools in France. Brown exhibited his work both before and since turning professional and completed a number of commissions both as sculptor and painter. Among the former has been his *Putting it Back on the Way*, for the Durham Miners' Association, DURHAM, and the latter, a six-panel narrative of fifty years of the history of TRIMDON, near SEDGEFIELD, for Trimdon Community Centre. He is currently working on other important sculptural commissions, including an approximately 4 metres high statue of Bede for St Peter's Church, SUNDERLAND. He lives at WITTON GILBERT, near DURHAM.

BROWN, Forster (d.1878)

Drawing master. He was born at DURHAM, the son of William Brown (q.v.), drawing master. He was apprenticed as a bookbinder and followed this trade at DURHAM for most of his later life, also serving for some years as drawing master at the Mechanics' Institute. He retired from business about 1871, and later moved to SUNDERLAND, where he died at the home of his son in 1878. It is said that he excelled as

an 'artistic penman'. One of his pupils at the Mechanics' Institute was Clement Burlison (q.v.).

BROWN, James (c.1870- after 1922)

Landscape painter in oil and watercolour; lithographer. This artist practised at GATESHEAD in the late 19th and early 20th centuries, from which he regularly sent work for exhibition to the Bewick Club, NEWCASTLE, and later the city's Laing Art Gallery, whose Artists of the Northern Counties exhibitions he contributed to from their inception in 1905, until the 1920s. Three of his Bewick Club exhibits of 1893 were described in the local press as: 'a drawing of the Tyne at Stella, with quaint buildings and old coal staiths; a picture of Whittle Dene, and a sketch on the Derwent. They are all excellent'. Brown painted widely throughout Britain, but the majority of his works featured Northumbrian coastal, river and village scenes. The Shipley Art Gallery, GATESHEAD, has his oil *Windsor Castle*, and his watercolours, *Street Scene*, 1899, and *Stalls in Bigg Market*, 1894. He may have been related to engraver JAMES BROWN (fl. late 19th cent.), who practised at NEWCASTLE until c.1880.

BROWN, James Miller (fl. late 19th, early 20th cent.)

Landscape and coastal painter in oil and watercolour. This artist practised at SOUTH SHIELDS, and briefly at NEWCASTLE, in the late 19th and early 20th centuries. He was an exhibitor at the 'Gateshead Fine Art & Industrial Exhibition', in 1883, contributing his *View on the Tees*, and later became a regular exhibitor at the Bewick Club, NEWCASTLE, showing a variety of Northumbrian landscapes in oil and watercolour. South Shields Museum & Art Gallery has two of his oils, a number of his local watercolours painted 1877–92, and a book of sketches.

BROWN, J Gillis (fl. late 19th, early 20th cent.)

Genre and landscape painter in oil and watercolour; caricaturist: illustrator. He was born at SUNDERLAND, and worked much of his life as a baths superintendent in the town, painting and drawing in his spare time. He exhibited his work at the Bewick Club. NEWCASTLE, from its foundation, and later at the Artists of the Northern Counties exhibitions at the city's Laing Art Gallery. He was an acquaintance of John Atkinson (q.v.), and David Thomas Robertson (q.v.), and sometimes accompanied these artists on sketching trips. His best known work was in caricature, and he supplied many illustrations in this field to local publications, including the *Newcastle Weekly Chronicle*. Represented: Sunderland A G.

BROWN, Dr John (1715–1766)

Portrait painter in oil and crayon. He was born at ROTHBURY, the son of the Rev Brown, who was then a curate in the town. Following his education under his father, and at public school at Wigton, Cumbria, he went to St John's, Cambridge, leaving there in 1735. He returned to Cambridge in 1739 to take his master's degree, when he was also admitted into priest's orders,

J Gillis Brown, *John Atkinson at work*, pastel, 19 x 16.5cm. Private collection.

and made minor canon and lecturer of Carlisle Cathedral. He subsequently obtained the living of Morland in Cumbria. In 1745 he was presented with the living of Great Horkesley, in Essex, but resigned it; later he was presented to the vicarage of St Nicholas, NEWCASTLE, where he was also Chaplain in Ordinary to the King. Brown was an avid writer all his life, and according to Hutchinson's *History of Cumberland* (Volume II. p. 471), also a musician and a painter. 'Those who have seen his pictures of his father and mother, painted in crayons by him, allow that they have great merit; and that if that portrait of himself, which is now in the vicarage house at Wigton was also painted by him, as some have thought it was, it clearly evinces the hand of a master.' Brown's father was Vicar of Wigton, and according to some authorities (Carrick, in his *History of Wigton*, 1949), the self portrait referred to by Hutchinson is more likely to be a portrait of the artist's father. Brown died by his own hand at the age of fifty-one.

BROWN, John (c.1812– c.1895)

Landscape painter in oil and watercolour; decorative painter. Brown was born on Tyneside, and as a young man became a member of an art society at NEWCASTLE, comprising John Henry Mole (q.v.), Thomas Henry Tweedy (q.v.), and other artists then seeking to

John Brown,
Old Kepier Hospital,
Durham, 1881,
oil, 36 x 58.5cm.
Private collection.

develop their talents. This society flourished about 1830–35, and held its first exhibition at T Bamford's Long Room at Amen Corner in the town. It later moved its meeting place and exhibition venue to the Old Tower, Pink Lane, where Mole began to assume a leading role in encouraging his fellow members in their progress. Brown's first attempt to seek wider exposure for his work occurred in 1834, when he sent two works, *Scene near Askew's Quay*, and *View near Winlaton Mills*, to the Newcastle upon Tyne Institution for the General Promotion of the Fine Arts, NEWCASTLE. From 1834 until 1878 he remained a regular exhibitor in the town, showing a large number of landscapes painted in the North East of England. He exhibited outside Northumbria on only one occasion in this period, showing two works at the 1850 exhibition of Carlisle Athenaeum. Soon after he first began exhibiting at NEWCASTLE, he moved to neighbouring GATESHEAD. In 1838 he exhibited at NEWCASTLE from a London address, but by 1841 he was back at GATESHEAD, and after returning to NEWCASTLE a few years later, he practised in the town until his death, in his later years also working as a decorative painter for J Richardson & Co, of 42, Dean Street. He died at NEWCASTLE. His watercolour, *The Ouseburn at Heaton*, 1860, appears opposite page 288 in Volume XIII, of *The Northumberland County History*. St Andrew's Church, NEWCASTLE has his oil showing the interior of the building in 1861.

BROWN, John (c.1829- c.1894)

Woodcarver. Brown was born in Scotland, but moved to ALNWICK to take up employment as a woodcarver with a cabinet maker in the town following his marriage in 1849. In 1854, the Fourth Duke, Algernon decided on a scheme of alteration for Alnwick Castle, which he placed in the hands of the Italian architect Canina, with the intention of remodelling it along the lines of an Italian castle. Woodcarvers were engaged from Italy, under the superintendence of Bulletti, of Florence, in the belief that only they could execute the

carving satisfactorily, but when Brown was observed one day carving a capital in his workshop he was asked to join the team as foreman. The main alteration work to the castle was completed in ten years, at a cost of £$\frac{1}{4}$ million, but at the end of it Brown was retained by the Duke, eventually serving him for some forty years. During this period Brown became the central figure of what has since become known as the 'Alnwick School of Wood Carvers'. His studio in the Abbot's Tower of the castle was frequently visited by the Duke's guests, one of whom, Lord Beaconsfield, was so impressed by Brown's work that he remarked: 'If I were a wood carver and could do work like that, I should be as proud of it as I am to be Prime Minister of England'. Examples of his work outside Alnwick Castle may be seen in the town's St Michael's Church, which contains several fine pieces of his foliage carving. Brown was also something of a writer, and wrote a handbook to Alnwick Castle, which was published by Davison, the town printer. He died at ALNWICK. He was the father of J R Brown (q.v.), and grandfather of Paul J Brown (q.v.). An account of his life and work, written by the latter, appeared in the *Newcastle Journal*, 8th July, 1938, under the title *'The Abbot's Tower, and the carver's shop in Alnwick Castle'*.

BROWN, John George (1831–1913)

Genre and portrait painter in oil and watercolour. Brown was born at GATESHEAD, but spent his boyhood at NEWCASTLE, where his father practised law. At the age of fourteen he became an apprentice in the glass trade on Tyneside, attending art classes in his spare time. On concluding his apprenticeship he moved to Edinburgh, where he worked for the Holyrood Glass Company. Determined to become an artist, however, he studied whenever possible at the Royal Scottish Academy, making such good progress that he won a prize for his drawings of the Antique. In 1853 he decided to leave the Scottish capital for London to take up the profession of portrait painter. But he did

J R Brown, *Grey Street, Newcastle*, engraving after sketch by artist for *Illustrated London News*.

not remain long in London, for after scarcely three months he fell under the spell of the emigrant songs of the USA then being sung by Henry Russell, and resolved to try his fortunes there. On arriving at New York he thought it wise to work in his old trade while looking for commissions to paint. He obtained a position with William Owen, the leading glass maker in Brooklyn, meanwhile studying at the National Academy of Design. In 1855 he married his employer's daughter, and encouraged by Owen, he once more became a professional painter. His father-in-law died in 1856, however, and when the glass firm collapsed in the financial panic of the following year he was obliged to depend entirely on his income as a painter to support his family. Brown's first success in portraiture was a commission from a business associate of his late father-in-law, and several other commissions soon followed. But it was his early love of painting street urchins which eventually earned him fame, and following his move to New York City to practise his progress was rapid. In 1862 he was elected an associate of the National Academy, and in the following year he became a full member. His street urchin pictures – bootblacks and newsboys – sold well

throughout his career, and he became one of the best known and loved artists on the East Atlantic Coast of the USA, indeed, the most celebrated painter of genre scenes in that country in the late 19th century. In 1906 the *American Art News* wrote 'No painter has ever been as happy in the delineation of the street boys of American cities.' Other honours followed Brown's election as a member of the National Academy, including its vice presidency from 1899 until 1903, and presidency of the American Watercolour Society. He exhibited frequently throughout his career in the USA showing his work at the National Academy from 1858; the Boston Athenaeum, and the Pennsylvanian Academy. His work has also been the subject of several major exhibitions since his death at New York in 1913, among the more recent, *Country Paths and City Sidewalks: The Art of J G Brown*, held at the George Walter Smith Museum, Springfield, Massachusetts, USA, in 1989. This was accompanied by an excellent account of his life and work by Martha J Hoppin. His work is represented in numerous important collections, including those of the Metropolitan Museum, New York; Concoran A G, Washington DC; Museum of Fine Arts, Boston; National Museum of

American Art, Washington DC, and the Peabody Institute, Baltimore. [See colour plate]

BROWN, John W (1842–1928)

Portrait, genre and landscape painter in oil and water-colour; stained glass designer. Brown was born at NEWCASTLE, and received his early training in art at the Government School of Design in the town, under William Bell Scott (q.v.), later serving as assistant master at the School. In 1866 he sent a landscape work, *Newburn from the East*, to the 'Exhibition of Paintings and other Works of Art', at the Town Hall, NEWCASTLE, while still at the School, following which he left the town for London. In the immediately following years he formed a close association with William Morris, later taking up a position with the stained glass firm of James Powell of London, where his work was greatly admired by John Ruskin. He later left Powell and set up a studio at Stoke Newington. However, ill health eventually obliged him to leave the country for Australia. During his career as a stained glass designer windows by him were placed in Salisbury Cathedral; Liverpool Cathedral; St George's Church, in the JESMOND area of NEWCASTLE, as well as in many cathedrals in Australia and the USA. He never abandoned his love of painting, however, exhibiting three genre works in London between 1876 and 1878, and sometimes painting portraits. He died at Salisbury. Represented: Laing A G, Newcastle.

BROWN, J R (d.1918)

Illustrator. He was born at ALNWICK, the son of John Brown (q.v.), and following his education in the town was apprenticed to a local architect. On completing his apprenticeship he studied at South Kensington School of Art, and began contributing illustrations to *The Builder*, and other technical papers. He worked for a period as an art master at a boys school in Yorkshire, then was commissioned by *The Graphic* to go as a special artist to the USA, and to Ireland during the Fenian rising. Together with his brother JAMES BROWN, he originated the humorous character of *Wild Scotchman, McNab*, the first of a series of comic drawings featuring their creation appearing in *The Graphic*. Later on Brown's sketches featuring *McNab* appeared in *Judy*, proving so popular that they were transferred to *Ally Sloper's Half Holiday*, where they ran for almost thirty years until the suspension of the paper at the beginning of the First World War. In partnership with his brother he did a considerable amount of decorative work in London, and designed the greater part of the popular shows *Venice*, and *Constantinople*. On the death of his brother he joined the firm of Goodall's, of Manchester, to supervise their restoration of large houses, hotels, castles, etc., meanwhile continuing to contribute illustrations and humorous articles to various periodicals, including the *Newcastle Weekly Chronicle*. His work for *The Graphic* spanned the years 1874–77, and 1885–88. He also exhibited his work during these years, notably at Liverpool and Manchester. Probably his best known illustration was his *Common Lodging House*, 1888. His son. Paul J Brown (q.v.), was also a talented illustrator.

Paul J Brown, *Trinity House, Newcastle*, illustration from *The Friday Book*, 1934.

BROWN, Keith (b.1947)

Sculptor; art teacher. Brown was born at HEXHAM. He won a scholarship to Michigan University, in the USA, in 1969, then studied at the Royal College of Art before taking up a teaching post at Manchester Polytechnic in the early 1980s. One-man exhibitions of his work have been held at the Serpentine Gallery, London, in 1977, and Leeds Polytechnic, in 1979. His multi-piece work *Untitled*, of 1981, in wood, is held by South Hill Park Arts Centre, Berkshire.

BROWN, Paul J (d.1950)

Illustrator. He was the son of J. R. Brown (q.v.), and grandson of John Brown (q.v.), and practised as an artist and author in NEWCASTLE in the first half of the 20th century. He first worked as a reporter for the *Newcastle Daily Leader*, but became increasingly involved in commercial art and writing for newspapers in his spare time. He was a regular contributor of articles on local history to the *Newcastle Journal*, many of these articles, and his accompanying illustrations, later appearing in a series of publications called the *Friday Books*. He also took a lifelong interest in the Roman Wall, and published a work *The Great Wall of Hadrian in Roman Times*. He was a member of the Society of Antiquaries, NEWCASTLE, among several bodies concerned with the study and preservation of old buildings. He died at NEWCASTLE.

BROWN, William (1775–1854)
Drawing master; landscape painter in oil and watercolour. This artist practised as a drawing master at DURHAM in the early 19th century following some years as a landscape painter in NEWCASTLE. An oil entitled *Prudhoe Castle, Northumberland*, and a large watercolour of the River Tyne with NEWCASTLE in the distance from this period are known. The latter is said to have been engraved by Thomas Bewick (q.v.), and published tinted by Brown. His etchings with aquatint of *Durham from the Lower End of Framwell Gate*, and *Durham, From the Upper Part of Claypath*, both of 1809, were included in the *Durham Cathedral Artists & Images* exhibition at Durham Art Gallery, in 1993. He died at DURHAM in 1854, and was buried in St Oswald's churchyard. He was the father of Forster Brown (q.v.). Represented: Durham University Library; The Dean & Chapter of Durham.

BROWNLOW, George (1869–c.1915)
Amateur landscape, genre, and animal painter in oil. Brownlow was born at NEWCASTLE, the son of Stephen Brownlow (q.v.), and nephew of George Washington Brownlow (q.v.). After some tuition from his father he attended the art school at South Kensington, where in 1881 he passed the Second Grade Art Examination in Freehand & Model Drawing. He later worked as a painter of crests on railway carriages, painting pictures in his spare time, and exhibiting his work mainly at the Bewick Club, NEWCASTLE. He was a capable amateur artist, whose work is sometimes confused with that of his uncle, George Washington Brownlow. [See colour plate]

BROWNLOW, George Washington (1835–1876)
Genre, portrait, landscape and religious painter in oil. He was born at NEWCASTLE, the son of a cordwainer, and received his first tuition in art at the town's Government School of Design under William Bell Scott (q.v.). At the age of twenty he was awarded a gold medal for his work as a student, and as a result of his achievement came to the notice of his future principal patron, the Rev J St Clere Raymond, of Belchamp Hall, Belchamp Walter, in Essex. St Clere Raymond was then Vicar of DINNINGTON, near NEWCASTLE, and on inheriting the Belchamp estate took Brownlow with him and set him up in a studio there. His patron also encouraged him to enrol as a student at the Royal Academy Schools, where he made such good progress that by 1858 he was exhibiting at both the British Institution and the Suffolk Street Gallery. In 1859 he exhibited at the Royal Scottish Academy, and in 1860 at the Royal Academy, remaining a regular exhibitor at the latter, and the Suffolk Street Gallery, until the year before his death. His exhibited work included many genre subjects, with such titles as *Daddy's Coming, The Mother's Lesson*, and *The First Tiff*, but he also exhibited many homely Scottish and Irish cottage scenes, and occasionally showed portraits and pure landscapes. As a relaxation during his some twenty years based at Belchamp Walter, Brownlow was especially fond of painting children at play. His main occupation, however, was painting pictures for his patron and relations, among these an approximately 4 metres × 2 metres mural of the Rev Oliver Raymond and wife, for the former Middleton Rectory. He also painted a series of panels for the pulpit and the front of the altar of the local church, and contributed illustrations to books published by his patron and others, including Fulcher's *Pocket Book and Miscellany*, the latter publication using as its frontispiece an engraving of his last work: *The Moorhen's Nest*. One of his best known works was his *Early Days of the Ettrick Shepherd*, which was exhibited at NEWCASTLE in 1866, at the 'Exhibition of Paintings and other Works of Art', at the Town Hall, and again in 1878, at the exhibition of work by local painters, at the town's Central Exchange Art Gallery. Brownlow died at Sudbury, in Suffolk, but was buried at Belchamp Walter. A window was erected to his memory in the church there by the stained glass manufactory of William Wailes (q.v.). Brownlow's work has become increasingly appreciated over the past half century; his *Cadogan Pier, Chelsea*, was singled out for comment and illustration in Satcheverell Sitwell's *Victorian Narrative Pictures*, 1969. He was the younger brother of Stephen Brownlow (q.v.). The two occasionally painted together, a notable occasion being when Brownlow was in his early thirties and painted his *All but Lost*, at CULLERCOATS. Represented: Sudbury Old Town Hall; Boston Guildhall Museum; Burns' House, Dumfries; The Bishop's Palace, Dumfries. [See colour plate]

BROWNLOW, Stephen (1828–1896)
Landscape, genre and portrait painter in oil and watercolour. Brownlow was born at NEWCASTLE, the son of a cordwainer, and showed a talent for painting from an early age. He followed his general education by receiving some tuition from William Bell Scott (q.v.), at the Government School of Design at NEWCASTLE, and soon after became a full-time professional artist. He made his first major appearance at an exhibition in 1878, when he showed several works at the exhibition of works by local painters, at the Central Exchange Art Gallery, NEWCASTLE, including *The Shrimp Girl*, a marine work and two landscapes, also showing one work, *Sunset on the Tyne*, at the Arts Association exhibition in that year. From 1878 he was a regular exhibitor in the city, notably at the Bewick Club, of which he was a member from its foundation until his death. Works shown at the Bewick Club included *The Poacher* (1884), and *The Busy Tyne* (1893), amongst a wide range of local genre and landscape subjects. Brownlow was a friend, and portrait subject of Ralph Hedley (q.v.), the latter's portrait of Brownlow showing the artist in his studio close to Hedley's in the city's New Bridge Street. His greatest friend, however, was Robert Jobling (q.v.), with whom he travelled widely to paint. He was the elder brother of George Washington Brownlow (q.v.). His son, George Brownlow (q.v.), was a capable amateur artist. Represented: Laing A G, Newcastle.

Ralph Bullock,
The Mischief Makers,
oil, 49 x 74cm.
Anderson & Garland.

BUCHANAN, Evelyne Oughtred, MSSA MSSWA (1883–1979)

Landscape painter in oil and watercolour. She was born at STOCKTON-ON-TEES, and after some tuition from Stanhope Forbes moved to Edinburgh, where she practised as an artist until after the middle of the last century. She exhibited her work at the Royal Academy; the Royal Scottish Academy; the Royal Institute of Oil Painters; the Society of Women Artists, and widely in the provinces. Three of her works were included in the 'Contemporary Artists of Durham County' exhibition staged at the Shipley Art Gallery, GATESHEAD, in 1951, in connection with the Festival of Britain. She was a member of the Society of Scottish Artists, and a member of the Scottish Society of Women Artists, also serving on the Council of the latter. Her daughter ELSPETH BUCHANAN (b.1915), has also practised as an artist, and exhibited her work. Represented: Glasgow Museums & A G.

BUCKLE, Sydney H (b.1912)

Landscape and figure painter in oil; printmaker; art teacher. He was born at STOCKTON-ON-TEES and attended the School of Art at DARLINGTON; the Northern Polytechnic, and Garnet College, before holding a number of teaching posts in Northumbria. He was a member of Darlington Society of Arts, and principally exhibited with the Society, while living at STOCKTON-ON-TEES.

BULLOCK, Ralph, MA (1867–1949)

Portrait, landscape, animal and flower painter in oil and watercolour. Bullock was born at MORPETH, the son of a well-known local sportsman and greyhound breeder, and subsequently moved to nearby KILLINGWORTH, before attending the School of Art, NEWCASTLE. Here he soon became recognised as an outstanding pupil, and on completing his studies was asked to remain as a member of staff, eventually receiving the designation Master of Painting when the

School became absorbed into Armstrong College (later King's College; now Newcastle University). During his period of teaching at the College, Bullock established a reputation as one of Northumbria's most respected artists and teachers. Among his pupils were Byron Eric Dawson (q.v.), and John Thomas Young Gilroy (q.v.), as well as dozens of amateurs who attended evening classes under his tutelage. He first began exhibiting his work at the Bewick Club, NEWCASTLE, later becoming a regular exhibitor at the city's Laing Art Gallery, whose Artists of the Northern Counties exhibitions he contributed to for many years. In 1927 and 1928 he exhibited at the Royal Academy; in the first year contributing *Northumberland*, and in the second, *Portrait of the Rev J Mackenzie*. In 1930 he was one of several leading local artists commissioned to paint a lunette for the Laing Art Gallery, his subject being *The Entry of Princess Margaret into Newcastle upon Tyne c. 1503*. Bullock was a friend of Arthur Heslop (q.v.), John Atkinson (q.v.), and many other local artists, and frequently shared exhibitions with them. He also took a keen interest in artistic activities outside the College, and in 1923 received an honorary Master of Arts degree from Durham University in recognition of his contribution to art in Northumbria. He was a member of the Pen & Palette Club, NEWCASTLE, and a founder-member of the Newcastle Society of Artists. He died at his home for many years, FOREST HALL, near NEWCASTLE. Represented: Hatton Gallery, Newcastle; Laing A G, Newcastle; Pen & Palette Club, Newcastle.

BURLISON, Clement (1815–1899)

Portrait, landscape and allegorical painter in oil; copyist. He was born at EGGLESTON, near MIDDLETON-IN-TEESDALE, the son of William Burlison, joiner and later clerk of works to leading architect at DURHAM, Ignatius Bonomi. Early in his boyhood he was encouraged by the example of his elder brother, John Burlison (q.v.), to draw and paint, and when his family later

moved to DURHAM, he was allowed to attend the art classes at the Mechanics' Institute one evening a week, under Forster Brown (q.v.). His first employment as an artist was as an heraldic painter to a coach-builder at DARLINGTON, with whom he served an apprenticeship c.1828-c.1835. On completing this apprenticeship, however, he turned to portrait painting and with money saved from commissions obtained at STOCKTON-ON-TEES and HARTLEPOOL, paid for his first visit to London, about 1837. Here he made copies of works in the National Gallery and carried out portrait commissions, shortly afterwards returning to Northumbria, where he remained for the next six years. In 1843 he sent his first work for exhibition, showing several portraits, and copies of works in the National Gallery, at the Polytechnic Exhibition at the Mechanics' Institute, DURHAM. Shortly after this he went to London, staying there briefly to make further copies of works in the National Gallery before visiting Paris, Rome, Florence, and Venice, where he also made copies, and painted several original works. It would appear that on all or part of this two-year stay on the Continent he was accompanied by his brother John, as on returning to London in 1846 both men exhibited at the Royal Academy, showing Italian subjects. Clement showed his *Portrait of an Italian Girl*; his brother two landscapes. In the following year he again visited Italy to paint copies of work in public and private collections, then settling at DURHAM, he quickly established his reputation as a portrait painter, and remained based there for the rest of his life. He exhibited at the Royal Academy and the British Institution until 1863, and also showed his work at NEWCASTLE, notably at the exhibitions staged by the North of England Society for the Promotion of the Fine Arts and the Government School of Design in 1850, and 1852; the 'Exhibition of Paintings and other Works of Art', at the Town Hall, in 1866, and at the exhibitions of the Arts Association, and the Bewick Club, later in the century. Probably his finest work was his large group portrait of the Parker family exhibited at the Royal Academy in 1855 under the title: *The 12th of August on Wellhope Moors*. On his death at DURHAM in 1899 Burlison bequeathed many of his copies of works in famous public collections, and a number of his own compositions, to the Corporation at DURHAM, which are now housed in part of the Old Town Hall known as the *Burlison Art Gallery*. The gallery also has a portrait of Burlison attributed to his son CLEMENT BOOTH BURLISON (b.1866). His widow and daughter also set aside a sum of money to provide *Clement Burlison Art Prizes*, to be competed for annually by pupils at Durham High School. An interesting account of Burlison's early life is contained in his *The Early Life of Clement Burlison, artist*, published by J H Veitch & Sons, DURHAM, in 1914. Represented: Burlison Gallery, Old Town Hall, Durham; Darlington A G; Hartlepool Arts & Museum Service. [See colour plate]

BURLISON, John (c.1812- after 1846)
Landscape, figure and animal painter in watercolour; draughtsman. He was the son of William Burlison, joiner and later clerk of works to leading architect at DURHAM, Ignatius Bonomi, and was possibly born at EGGLESTON, near MIDDLETON-IN-TEESDALE. He was a talented artist from his youth, his younger brother Clement Burlison (q.v.), clearly recalling in later years watercolours of sawyers in a saw pit, and a horse, painted by him as early as *c*. 1822. Indeed, it was these same watercolours which provided Clement's first attraction to drawing. John later assisted his father in the supervision of building work for Bonomi, one of the last works in which they were involved together being the construction of St Paul's, WINLATON, near GATESHEAD, when John was about sixteen. He later worked for a builder at DARLINGTON, after which nothing is known of him except that he possibly accompanied Clement on part of the latter's first tour of the Continent, for at the Royal Academy in 1846, he exhibited two Italian views: *Sorrento, Bay of Naples*, and *Grand Canal, Venice*.

BURN, George (1834–1883)
Sculptor. This sculptor practised at NEWCASTLE for many years in the middle of the 19th century, and is believed to have been of local birth. He had premises on Neville Street, and later Corporation Street in the town, and executed several important local memorial statues, including those of well-known Tyneside rowers Harry Clasper, James Renforth and Robert Chambers; Charles Larkin, the orator; John Pritchard, the tragedian, and J P Robson, the poet. He also executed figures for the Corporation Fish Market, and the Free Library, NEWCASTLE. Probably his best-known work is that of James Renforth, which he executed in 1871, following the rower's death in Canada. It originally stood in the East Cemetery at GATESHEAD, but was relocated to its present site beside the town's Shipley Art Gallery in 1992, because of vandalism. His work varied greatly in quality, his statue to Colonel Moseley Perkins (1874), at BIRTLEY, near GATESHEAD, being described in the first edition of Pevsner for the County of Durham (1953), as 'perhaps the funniest monument in the County'. His head of Garibaldi, originally part of a statue commissioned by Tyneside MP and newspaper magnate Joseph Cowen, and erected at the latter's home at BLAYDON, near GATESHEAD, in 1868, has since 1977 been kept in a glass case in the village library. Burn died at NEWCASTLE at the early age of forty-nine, and was buried in the city's Elswick Cemetery. [See colour plate]

BURRELL, Mrs H Théonie (c.1870- after 1920)
Portrait painter in oil and watercolour. This artist practised at newcastle in the late 19th and early 20th centuries. She first exhibited her work at the Bewick Club, NEWCASTLE, later showing examples at the Royal Academy, the Royal Society of British Artists and the Society of Women Artists, of which last named body she was elected an associate in 1905. She also exhibited her work at the Artists of the Northern Counties exhibitions at the Laing Art Gallery, NEWCASTLE, from their inception in 1905. She last exhibited at the Royal Academy in 1920.

BURROW, Mary Grace Elizabeth (1886–1969)
Amateur portrait and figure painter in oil and water-colour. She was born at NEWCASTLE, the daughter of civil engineer Adam Burrow, and showed a talent for drawing and painting at an early age. She enrolled in the day classes held at Armstrong College (later King's College; now Newcastle University) at the age of sixteen, but although very talented she virtually gave up painting towards the end of the First World War. She died at GATESHEAD in 1969, having long retired from a teaching post which she had held in the town from her early twenties. Several of her portraits and figure studies are in private collections on Tyneside. [See colour plate]

BUTCHART, Theresa Norah – see COPNALL, Mrs Theresa Norah

BUTLER, Canon George (1819–1890)
Amateur landscape painter in watercolour. He lived at Ewart Park, near FORD, and was a neighbour and acquaintance of Louisa Anne, Marchioness of Waterford (q.v.). Little is known of his work except that he was a capable amateur landscape painter.

BYNON, Herbert Stanley (1898–1982)
Landscape and portrait painter in oil and watercolour; etcher. He was born at Macclesfield, Cheshire, but moved in his infancy to Tyneside. Here he trained as an artist following service in the First World War, attending Armstrong College (later King's College; now Newcastle University), under Richard George Hatton (q.v.). He later worked in the art department of Mawson Swan & Morgan, NEWCASTLE, but after service in the Second World War he turned to picture restoration on his own account, and eventually established a reputation as one of the leading practitioners in his field. Throughout his life he took a keen spare-time interest in painting and etching, showing his first work in the latter medium at the Artists of the Northern Counties exhibition at the Laing Art Gallery, NEWCASTLE, in 1916. He later exhibited his work on many occasions locally, and produced several limited edition etchings of Northumbrian subjects, some of them with theaddition of colour. He died at NEWCASTLE.

C

CAFFREY, John (b.1938)

Natural history and landscape painter in acrylic, tempera and watercolour; illustrator. He was born at NEWCASTLE but has spent most of his life at MORPETH, employed in the telecommunications industry. As a young man he made the acquaintance of George Jude McLean (q.v.), then director of the Bondgate Gallery, ALNWICK, who encouraged him to develop his skills as an artist. This led him to become a keen spare-time painter who has since exhibited his work widely in Britain. His main interest as an artist both during his working life, and since retiring at the age of fifty-five, has been natural history. This interest has involved him in spending many hours observing wildlife out of doors, and undertaking sketching trips to Europe and North America. Examples of his work have been included in mixed exhibitions at the Tryon Gallery, London; the Bladon Gallery, Hurstbourne Tarrant; the Bondgate Gallery, ALNWICK; the Coquetdale Gallery, ROTHBURY; the Hancock Museum, NEWCASTLE, and the Dean Gallery, NEWCASTLE. He has also had one-man exhibitions at the Bondgate and Coquetdale galleries, and he has regularly participated in the Northumbrian Artists' Summer exhibition at NEWTON-ON-THE-MOOR, near ALNWICK, in the company of Malcolm Gleghorn (q.v.), and others. A keen supporter of the Northumberland Wildlife Trust he has contributed illustrations to its official journal *Roebuck* on a number of occasions. He continues to live and paint at MORPETH, mainly working on private commissions. [See colour plate]

CALDECOTT, H S (1870–1942)

Landscape painter in oil. Born at SUNDERLAND, this artist practised in the town in the late 19th and early 20th centuries. Sunderland Art Gallery has his oil: *Tree Study*.

CALLIS, Mary Eleanor, ABWS (b.1877)

Flower and landscape painter. She was born at SOUTH HYLTON, near SUNDERLAND, the daughter of the Rev William Callis, and studied at Farnham Art School and privately before practising as an artist in London. She exhibited her work with the British Water Colour Society, of which she was elected an associate in 1926, mainly showing flower paintings and Italian Lake scenes. She also exhibited in the provinces.

CALVERT, John Smales (1836–1926)

Amateur landscape and architectural painter in watercolour. He was born at Staithes in North Yorkshire, but moved to MIDDLESBROUGH with his parents while still a child. He later spent a short period of time with his family in France, where his father was employed on the construction of the first French railway, then returning to MIDDLESBROUGH he attended the only school then in the town, later becoming a pupil teacher there. On qualifying as a teacher he taught for some twenty years, later becoming secretary to the School Board at MIDDLESBROUGH, and ultimately Director of Education. He was a keen spare-time painter throughout his life, and painted many views in North Yorkshire, France, Belgium, Norway and Germany. He was a member of the town's Literary and Philosophical Society, and a foundation member of the Cleveland Field Club, and the Cleveland Sketching Club. He died at MIDDLESBROUGH. Middlesbrough Art Gallery has several of his works, together with his life-size portrait by Frank Stanley Ogilvie (q.v.).

CALVERT, Samuel (fl.19th cent.)

Marine and coastal painter in oil. This artist practised in Northumbria in the middle of the 19th century, where a strong connection with SUNDERLAND is claimed. Two of his seascapes were included in the exhibition of works by local painters, at the Central Exchange Art Gallery, NEWCASTLE, in 1878, the catalogue notes of which describe him as: 'Calvert, a clear but little known artist who excelled at seascapes'. He was also described in the notes as deceased. The Laing Art Gallery, NEWCASTLE, has a view, *Tynemouth Bar*, attributed to this artist, and a view of the High and Low Lights at NORTH SHIELDS is known.

CAMPBELL, John Hodgson (1855–1927)

Portrait and genre painter in oil; landscape painter in watercolour; illustrator. The eldest son of John Thompson Campbell (q.v.), he was born at NEWCASTLE and received his early training in art from William Cosens Way (q.v.), at the town's School of Art. At the age of fourteen he was apprenticed to William Wailes (q.v.), in the Wailes stained glass manufactory at NEWCASTLE, meanwhile continuing his studies at the School of Art. He remained with Wailes for a year after completing his apprenticeship, but deciding that he did not like being a stained glass designer, left his trade with the intention of becoming a professional artist. With this object in mind he went to Edinburgh, and entered himself as a student at the Statue Gallery in the city. On the death of his father about 1880, however, he felt obliged to return to NEWCASTLE, and was only able to continue his studies at Edinburgh sporadically over the next few years by visiting the city for a month or two at a time. By 1878 he was exhibiting at the Arts Association, NEWCASTLE. He was an exhibitor at the 'Gateshead Fine Art & Industrial Exhibition', in 1883, and in the following year he began exhibiting at the Royal Academy, showing: *Ovingham, the burial place of Thomas Bewick*. In 1884 he also began exhibiting at the New Water Colour Society (later the Royal Institute of Painters in Water Colours), and at the Bewick Club, NEWCASTLE, remaining a regular exhibitor at the latter for the rest of his life. He also exhibited at the Royal Scottish Academy, and several provincial exhibitions, including the Artists of the Northern Counties exhibitions at the Laing Art Gallery, NEWCASTLE. Although Campbell's main profession was that of portrait painter, he was by preference a painter of landscapes in watercolour, and in recognition of this a major exhibition of his work in this medium was held at NEWCASTLE in 1924. He was a lifelong member of the Pen & Palette Club, NEWCASTLE, and frequently

exhibited with the Club. He died at WHICKHAM, near GATESHEAD, where he had lived for some years prior to his decease. Represented: British Museum; Laing A G, Newcastle; Shipley A G, Gateshead; South Shields Museum & A G.

John Hodgson Campbell, *Winlaton Mill, from the South*, watercolour, 56 x 38cm. Dean Gallery.

CAMPBELL, John Thompson (1822- c.1880)

Stained glass designer; genre, portrait and landscape painter in oil, watercolour and crayon. He was born at Edinburgh, and studied under Sir William Allan, later president of the Royal Scottish Academy, and at the Royal Institution in the city, where he was a successful student. About 1840 he joined the design staff of William Wailes (q.v.), in the Wailes stained glass manufactory at NEWCASTLE, with fellow Scotsmen James Sticks (q.v.), and Francis Wilson Oliphant (q.v.). Together with these two artists he visited the Continent to study the best examples of stained glass in cathedrals and other buildings, subsequently becoming one of Wailes' most distinguished designers. He occasionally painted in his spare time, exhibiting this work at NEWCASTLE, where in 1848 he showed his *Academy Study of the Laacoon*, and *Portrait in Crayons*, at the 'Exhibition of Arts & Manufactures & Practical Science'. He followed this by exhibiting his *Gossips at the Well; The Letter; Asleep in the Wood; An Anxious Moment*, and a stained glass study, at the 'Exhibition of Paintings and other Works of Art', in 1866, and showed two Scottish landscapes at the 'Central Exchange News Room, Art Gallery, and

Polytechnic Exhibition', in 1870. He last exhibited when he sent two landscapes to the Arts Association exhibition at NEWCASTLE, in 1878: *Glenlochy, Killen, Perthshire*, and *Swalwell from Whickham Bank*. He was the father of John Hodgson Campbell (q.v.).

CANNON, William (b.1840)

Marine painter in watercolour. Cannon is said to have been born at NEWCASTLE, and to have studied under Thomas Bush Hardy before practising as a marine painter. He lived and worked for some time in France and Italy, but is said to have returned to England in his later years, dying at NEWCASTLE. He exhibited his work at the Royal Institute of Painters in Water Colours, and the Royal Water Colour Society, and in 1877 received a gold medal in Paris. He appears to have produced little work in Northumbria, although a watercolour *Off Whitley Bay*, is known.

CARMICHAEL, Herbert (née Schmalz, Herbert Gustave) ('Angelico') (1856–1935)

Portrait, landscape, religious, classical and flower painter in oil. He was born at RYTON, the son of merchant, and later Prussian Consul at NEWCASTLE, Gustave Schmalz, and Margaret Carmichael, eldest daughter of John Wilson Carmichael (q.v.). He first began painting as a child of eight during an illness caused by a burn sustained at his boarding school at NEWCASTLE, and is believed to have been encouraged in this respect by the sight of his grandfather's paintings in the drawing room of his home, The Tower, at RYTON. He subsequently spent two years at school at DURHAM, then was sent to Gothic House College, London, where he won every drawing prize available. Following his education he returned to Tyneside to study at the School of Art at NEWCASTLE, under William Cosens Way (q.v.), but at seventeen he went back to London, first to attend South Kensington Art School, later the Royal Academy Schools. He then spent the remainder of his life in the south of England, though visiting Northumbria frequently while his parents were still alive. He first began exhibiting his work in 1879, as Herbert Gustave Schmalz, showing two works at the Royal Academy: *Light and Shade*, and *I cannot mind my wheel mother* . . . He retained this name while exhibiting at the Royal Academy, the Royal Hibernian Academy, the Fine Art Society, the Leicester Gallery, and widely in the provinces, until 1918, whereafter he contributed his work as 'Herbert Carmichael', having adopted his mother's maiden name because, it is said, of prevailing anti-German feeling in Britain. Schmalz's work was well appreciated in his lifetime and in 1911 encouraged Trevor Blakemore to publish *The Art of Herbert Schmalz*, illustrating many of his works. His *Zenobia's Last Look at Smyrna* was acquired for The Art Gallery of South Australia, Adelaide, and his *Too Late*, for the Bendigo Art Gallery, Victoria, while his *Rabboni* is in a chapel at Stockport. He retained an interest in the artistic activities of his native Tyneside throughout his professional career, exhibiting many works at the Bewick Club, NEWCASTLE, and later the city's Laing Art Gallery, whose Artists of the Northern Counties

exhibitions he contributed to from their inception in 1905, until several years after he changed his name to Carmichael. A major exhibition of his work was held in the year following his death, at Robertson's Gallery, London, comprising some thirty-two paintings. Among these were examples of his flower works signed 'Angelico'. Represented: Middlesbrough A G, and various provincial and overseas art galleries. [See colour plate]

CARMICHAEL, John Wilson (1799–1868)

Marine, landscape and figure painter in oil and water-colour; draughtsman; illustrator; drawing master. He was born at NEWCASTLE, the son of a shipwright, and after some years at sea as a boy, was himself apprenticed to this trade with Tyneside shipbuilders Richard Farrington and Brothers. Here he soon began to display a talent for drawing, and was occasionally allowed to work in the drawing office of the firm. Later one of his employers, amateur artist JOSEPH FARRINGTON, gave him his first box of watercolours, and from then on he both drew and painted his compositions. On concluding his apprenticeship he was at first undecided whether to become a professional artist, but encouraged by his employers, and later mining engineer Nicholas Wood, he established a studio at NEWCASTLE by his early twenties, and in 1825 began exhibiting his work, showing at the Northumberland Institution for the Promotion of the Fine Arts, in the town, *A Seventy-four in a heavy sea*, and *Outward and homeward-bound Indiamen passing the Downs*. In the following year (20th March, 1826), he married at Holy Cross Church, RYTON, a girl from his own background, Mary Sweet, and living at various places on Tyneside over the next twenty years, remained a regular exhibitor at NEWCASTLE, also sending work to the Carlisle Academy from 1828, the Royal Academy from 1835, the Suffolk Street Gallery from 1838, and the British Institution from 1846. Carmichael's twenty-odd year period at NEWCASTLE as a professional artist saw him develop from a painter of miniatures and drawing master, into one of the best liked and respected landscape and marine artists of Northumbria. It also saw him take an active interest in the promotion of art in his native town, and the development of a style in marine painting considerably influenced by the work of the many famous artists whose work was thereby exhibited. He received his first major commission in the year of his marriage, *The Bombardment of Algiers, 1816*, for Trinity House, NEWCASTLE. Three years later, and exhibiting some nine works at the Northern Academy, NEWCASTLE, he began attracting praise from local critics, and in 1831, working from sketches provided by his friend and fellow artist George Balmer (q.v.), he consolidated his position as one of the area's most promising marine painters by executing, *The Heroic Exploit of Lord Collingwood when Captain of the Excellent at the Battle of Cape Vincent* (1797), for Trinity House. Much work followed the production of this popular painting; a series of drawings of the construction of the Newcastle and Carlisle Railway, commenced in 1835, and issued as engravings 1836–1838, before their

presentation as a volume in 1839; his collaboration with Henry Perlee Parker (q.v.) in painting *William and Grace Darling going to the Rescue of the Forfarshire Survivors*, also of 1839; colouring and figure drawing for the compositions of local architect John Dobson (q.v.); tuition in drawing and painting for pupils such as John Scott (q.v.), and the production of a number of views of towns and buildings, including towards the end of his period at NEWCASTLE, its High Level Bridge as it would look when later completed. At the age of almost forty-seven Carmichael felt the need to test his abilities more fully, and moving to London in 1846, he practised there with considerable success until 1862. His work there soon became popular with influential patrons, and at times he was completing a picture a day while advancing more elaborate work. By 1852 he was able to record, 'Hard at work as usual, with better results this year . . .', and three years later the *Illustrated London News* was proudly announcing to its readers that it had secured the services of 'Mr J. W. Carmichael, the celebrated marine painter' to sketch the events of the 'coming campaign in the Baltic'. During his stay in London he came increasingly to regard himself as a marine painter, and apart from his trip with the Baltic Fleet for the latter assignment, made trips to Portsmouth, the Isle of Wight, Calais and Dunkerque, to handle commissions in this field. Others also viewed him in this light. Winsor & Newton engaging him to write *Marine Painting in Water Colours* 1859, and four years later, *Marine Painting in Oils*. By the time that the second book appeared, however, ill health had driven him to Scarborough, and here he remained until his death on 2nd May, 1868. Carmichael is popularly supposed to have given up painting when he moved to Scarborough, but research ('John Wilson Carmichael – the missing years at Scarborough', Marshall Hall, *Art & Antiques Weekly*, 15th, October, 1977) has revealed that he painted until close to his death. He was the grandfather of Herbert Carmichael (q.v.). Major exhibitions of Carmichael's work were held at the Laing Art Gallery, NEWCASTLE, in 1982 in connection with the Newcastle Festival, and in 1999 to mark the bicentenary of his birth. An excellent account of his life and work was published in 1995 by his great-great-granddaughter Diana Villar, by Carmichael & Sweet. Represented: British Museum; National Maritime Museum; Victoria and Albert Museum; Carlisle A G; Grace Darling Museum, Bamburgh; Hartlepool Arts & Museum Service; Laing A G, Newcastle; Natural History Society of Northumbria, Newcastle; Newcastle University; Sunderland Museum & A G. [See colour plates]

CARR, Dorothy (1902–1986)

Landscape, portrait and figure painter in oil, pastel and watercolour; muralist. Carr was born at NEWCASTLE, and studied art at Armstrong College (later King's College; now Newcastle University), and St John's Wood Art School, London before practising as a professional artist on Tyneside. Her early work included portraiture in oil and pastel but she gradually developed a preference for landscape painting in water-

Thomas Carr,
In hot pursuit, 1976,
oil, 61 x 91.5cm.
Anderson & Garland.

colour, and also handled mural work for Alexanders, the Tyneside decorators, mainly for restaurants and cinemas. She became a regular exhibitor of mainly Northumbrian and Scottish scenes at the Artists of the Northern Counties exhibitions at the Laing Art Gallery, NEWCASTLE, and with the Newcastle Society of Artists, commencing at the former in 1923 with her *Roofs, Robin Hood's Bay*. She also showed one work at the Royal Academy in 1934; one work at the Royal Scottish Academy in 1951, and three works with the Society of Women Artists in Manchester and Bournemouth. She was still practising at NEWCASTLE when she exhibited at the Royal Academy, but later moved to WARKWORTH. Here she continued to paint for several years, and exhibited her work at the Hatton Gallery, and the People's Theatre, Green Room, NEWCASTLE, before finally turning to colour photography. One of her best known murals was for the Tyne Room of the coffee restaurant for many years associated with the News Theatre in Pilgrim Street, NEWCASTLE. The mural was painted in the 1930s and covered all four walls of the room with well-known Northumbrian scenes. In her final years she helped collect information for the Cambridge University five-year survey of flora of the British Isles. She died at WARKWORTH. Represented: Laing A G.

CARR, Thomas ('Tom') (1912–1977)
Sporting and landscape painter in oil and watercolour; etcher. Carr was born at ALLENDALE COTTAGES, near CONSETT, and worked as a colliery blacksmith and later in a forge producing ships' anchors, before deciding to prepare himself for a career in art. His artistic ability enabled him to attend King's College (now Newcastle University), where he studied under the direction of Lawrence Gowing, and gained a certificate of fine art, in 1950. He later studied dry point etching under George Vernon Stokes (1873–1954),

but finding it too time consuming, concentrated instead on working in a variety of media producing paintings and illustrations of a range of sporting subjects, including fox-hunting, otter-hunting, stag-hunting, polo, beagling, shooting, racing, golf, etc. Most of his subjects were initially sketched on the spot or at his home in an armchair, but increasing problems with his spine made him unable to ride, and he instead used a car as a means of following hounds and getting to remote locations. He spent his final years at Southdean, Roxburghshire, where he became well known as a local sporting painter. Carr occasionally showed his work at the Artists of the Northern Counties exhibitions at the Laing Art Gallery, NEWCASTLE, where typical exhibits in 1957 were his oils: *Hunters at Grass, Allensford*, and *Fishing on the River Derwent*. It was also regularly displayed at art dealers Mawson Swan & Morgan, NEWCASTLE. A major loan exhibition of his work was held at the Bondgate Gallery, ALNWICK, in 1987 to mark the tenth anniversary of his death. Among his illustrative work was that for *A Hunting Man's Rambles*, by Stanislaus Lynch. An example of his work hangs in Durham Cathedral, and he is represented in many private collections throughout the North of England.

CARTER, Mrs Eva (née Lawson) (1885–1963)
Landscape, flower, fruit and portrait painter in oil and watercolour. She was born at NEWCASTLE, and appears to have become a largely self-taught artist before setting up a studio in the city alongside other professionals such as Byron Eric Dawson (q.v.), and Thomas William Pattinson (q.v.). She first began exhibiting her work shortly after her marriage to schoolmaster John Carter, sending *A Study in Colour*, to the Artists of the Northern Counties exhibition at the Laing Art Gallery, NEWCASTLE, in 1908. Three years later she commenced exhibiting outside Northumbria, sending

five works to the Royal Academy between 1911–16. She later exhibited almost exclusively on Tyneside, sending work regularly to the exhibitions of the Artists of the Northern Counties; the Federation of Northern Art Societies' exhibitions at the Laing Art Gallery, and those of Gateshead Art Club, at the Shipley Art Gallery, GATESHEAD. She was a talented writer, and in addition to contributing articles to the *Evening Chronicle*, NEWCASTLE, 1935–51, wrote and illustrated a book, *Tales of the North Country*, 1947. Two of her more important works as an artist were her memorial to the 43rd and 49th Tank Regiments, *Rhine Crossing*, unveiled at the Territorial Army Centre, NEWCASTLE, in 1948, and her portrait of Captain E G Swan, honorary curator of the Museum of Science & Engineering, NEWCASTLE. Represented: Laing A G, Newcastle; Shipley A G, Gateshead.

CARTER, Francis ('Frank') Thomas (1853–1934)
Landscape painter in oil. Carter was born at WARK-WORTH, the son of the local stationmaster. He later moved to NEWCASTLE, where he began a career in business with station newsagents W H Smith, abandoning this employment some years subsequently to join his father, who had become lessee of the Pineapple Grill & Restaurant in the city's Nun Street. Later his father, his brother Charles and himself, took over the Nag's Head in the same street, this public house soon becoming widely known throughout Tyneside, as 'Carter's'. His first introduction to painting came about by accident, he once claimed. A friend had asked him to dispose of 'a painter's outfit', and experimenting with it he found he could paint passably well. Following this experiment he spent an increasing amount of time on his new hobby, and became so accomplished an artist that he was soon selling his work. He first began exhibiting his work at the Bewick Club, NEWCASTLE, and by 1898 had sent his first work to the Royal Academy, *Vale of Aln*. He later became a regular exhibitor at the Academy, also sending his work to the Royal Scottish Academy; the Royal Hibernian Academy; the Royal Cambrian Academy; the Suffolk Street Gallery; the Royal Institute of Oil Painters, and to various London and provincial galleries, including among the latter the Laing Art Gallery, NEWCASTLE, whose Artists of the Northern Counties exhibitions he contributed to from their inception in 1905. In 1934 he shared a loan exhibition at the last named establishment with Thomas Bowman Garvie (q.v.), George Edward Horton (q.v.), and John Falconar Slater (q.v.). It is said that for six days a week Carter conducted his business as an inn-keeper, while on Sundays he took out his palette and brushes at his studio at GATESHEAD, and painted pictures from his sketches made during the summer months. His establishment in Nun Street, NEWCASTLE, from its early days was a resort of the 'intelligentsia' of the city, fellow artists, writers, and professional men crowding its picture hung rooms to discuss their mutual interests. When asked for a price for one of his works he quickly fixed a sum, and if that figure were not accepted no further negotiations would be entertained. His accomplishment as an artist was considerable, and all the more remarkable because it was entirely self-developed. His favourite subject matter was the hills, lakes and streams of the

Francis Thomas Carter, *Eighton Banks, Gateshead*, oil, 43 x 76.5cm. Dean Gallery.

English Lake District, but he also painted many Northumbrian landscapes and was no stranger to Scotland. He died at GATESHEAD. Represented: Laing A G, Newcastle; Shipley A G, Gateshead; South Shields Museum & A G.

CATHRAE, Percy Gerald (b.1900)
Amateur landscape painter in watercolour; draughtsman; illustrator. He was born at NEWCASTLE, and worked in the accounts department of the London North Eastern Railway Company, painting in his spare time. While working on Tyneside he was a member of several local art groups, notably the Benwell Art Club, the West End Art Club, and the Park Road Group, and also exhibited his work at the Artists of the Northern Counties exhibitions at the Laing Art Gallery, NEWCASTLE. He lived near York for many years, where he continued to take a keen interest in drawing and painting. He was a member of York Art Society.

CHAMBERS, George William (1859–1942)
Marine and landscape painter in oil and watercolour. He was born at WEST HARTLEPOOL (now HARTLEPOOL), the son of William Henry Chambers (q.v.), and grandson of George Chambers (1803–1840), the well-known marine painter. He is believed to have spent periods of time living away from his birthplace, but was resident at EAST HARTLEPOOL when he sent his *The Rescue of the 'Streonshalh', of Newcastle, at Hartlepool, Oct 15th, 1894,* to the Bewick Club, NEWCASTLE, in 1895, and is recorded as having lived in the area from 1913 until his death. Most of the work he produced throughout his career was in watercolour. An example of his work in oil portraying Hartlepool Harbour was on the art market in 1994, revealing a style and choice of subject matter similar to that of contemporary, and fellow townsman, Ralph Marshall (q.v.).

CHAMBERS, John (1852–1928)
Landscape, seascape and portrait painter in oil, tempera and watercolour; etcher; illustrator. Chambers was born at SOUTH SHIELDS, and educated at the Union British Schools in the town. Drawing was taught at the Schools, and pupils were particularly encouraged to draw ships and other nautical subjects. Chambers found that he liked drawing, and although he entered the Tyne Pilot Service soon after leaving school he had even then decided that he would one day become an artist. Before reaching manhood he left the Pilot Service, and enrolled in the Government School of Design at NEWCASTLE, under William Cosens Way (q.v.), later studying in Paris in the ateliers of Professors Boulanger and Fevre, before settling at NORTH SHIELDS as a professional artist. He first began exhibiting his work by showing several examples at the South Shields Fine Art & Industrial Exhibition in 1877. He followed this by showing his *Parton Hall, and Harbour*, at the exhibition of works by local painters, at the Central Exchange Art Gallery, NEWCASTLE in 1878, and was subsequently an exhibitor at the Arts Association exhibition, NEWCASTLE, in 1879, 1881 and 1882, and the Gateshead Fine Art & Industrial Exhibition in 1883. In the following year he began an association with the exhibitions of the Bewick Club, NEWCASTLE, which lasted just over a decade, and in 1886 sent his first of three works to the exhibitions of Royal Institute of Painters in Water Colours, showing *The Deserted Mill*. Chambers mainly exhibited on Tyneside for the remainder of his career. Exhibitions to which he regularly sent examples of his work included those of the art clubs of SOUTH SHIELDS and TYNEMOUTH, and from their inception in 1905, the Artists of the Northern Counties exhibitions at the Laing Art Gallery, NEWCASTLE. Most of his work was executed in watercolour and predominantly featured nautical and landscape subjects. His most important work, however, was in oil and pictured *HMS Victoria*, which was accidentally sunk off Tripoli during

George William Chambers,
Hartlepool Harbour,
oil, 21.5 x 32.5cm.
Anderson & Garland.

manoeuvres in 1893. He had painted the vessel as it looked leaving the Tyne following its completion at Sir William Armstrong's Elswick Yard, in 1888, and after its loss spent a year preparing a 9ft x 12ft canvas which proved so successful an interpretation of the scene that is was exhibited all over Tyneside, and was also engraved. Chambers maintained a succession of studios at NORTH SHIELDS at which he held exhibitions of his work, and occasionally those of fellow artists. It was also shown prior to its disposal in large quantities at Bainbridge & Co, the auctioneers at NORTH SHIELDS, and featured in several local loan exhibitions. Despite frequent favourable comment on his work, Chambers remained a quiet, diffident artist, who died at his home and studio at Borough Road, NORTH SHIELDS, without ever having extended his reputation beyond his native Northumbria. Although much of this reputation rested on his nautical and landscape paintings he also etched subjects for sale locally and was an occasional illustrator of Tyneside publications. Among his less typical works were a number of portraits in watercolour, among these one of Henry Hetherington Emmerson (q.v.), now in the possession of the Laing Art Gallery. [See colour plate]

CHAMBERS, William Henry (1834–1890)
Marine and landscape painter in oil and watercolour. He was born in London, the son of George Chambers, Senior (1803–1840), the well-known marine painter, but spent the last more than thirty years of his life at WEST HARTLEPOOL (now HARTLEPOOL). Here he painted a number of oils and watercolours of local marine and landscape subjects, the former much in the style of his elder brother GEORGE CHAMBERS, JUNIOR (b.1830). Hartlepool Arts & Museum Service has examples of his work, and his copy of his father's watercolour *The Dart* was used as the front cover illustration to *Ship Portrait Painters*, by C H Ward-Jackson, published by the Trustees of the National Maritime Museum, London, in 1978. The Dart was the vessel on which Chambers Senior was sent on a voyage to Madeira in the summer of 1840 in the hope that it would improve his health, but he died in the following October. A lithograph of the subject is also illustrated in the publication.

CHANCER, Thomas (1761–1819)
Sculptor; stonemason. Chancer was a well known stonemason and occasional sculptor at RYTON in the late 18th century. He was responsible for the production of the Village Cross erected in 1795. He is buried in the churchyard of Holy Cross Church, RYTON.

CHAPMAN, Abel, MA (1851–1929)
Amateur bird and animal painter in watercolour; illustrator. He was born at Silksworth Hall, SUNDERLAND, the son of a brewery owner, and following his general education joined the family business as a director. Part of his responsibility as a director was to travel abroad, and many of these trips he combined with hunting and natural history expeditions which eventually took him throughout Europe, and into North, South and East Africa. He wrote prodigiously of his experiences

and observations on these expeditions, illustrating some of his books with his own watercolours, or drawings. Notable amongst these were *Bird Life of the Borders*, 1907, and *The Borders & Beyond*, 1924, which latter he illustrated with W H Riddell, providing 170 sketches himself. Chapman remained director of the brewery for some thirty years, at the end of this period retiring to WARK, on the North Tyne. Here he stayed for the rest of his life, occupying much of his time writing his autobiographical *Retrospect: Reminiscences 1851–1928*, and the two books mentioned earlier. In 1922 his contributions to literature were recognised by Durham University, and an honorary Master of Arts degree was conferred upon him. Many of his drawings, and natural history specimens form part of the collection of the Hancock Museum, NEWCASTLE. He was a cousin of Joseph Crawhall, The Third (q.v.).

CHAPMAN, William (1817–1879)
Engraver; landscape and architectural painter in watercolour. He was born at SUNDERLAND, and became a pupil of William Miller, a well known Edinburgh engraver, before setting up himself in that city as an engraver. He later moved to London, where in 1866 he sent to the Royal Academy an engraving of Henry Dawson's *Westminster Palace and Abbey*. By 1869 he had moved to York, from which in that year he sent to the Academy a second engraving, *Tynemouth Pier*, after A W Hunt. After settling at York he mainly concentrated on producing views of the city, and its various architectural landmarks. He died at York. He was related to the family of Joseph Crawhall, The Second (q.v.), and received considerable help from this artist at one stage in his career. He also contributed work in the form of etchings to some of Crawhall's publications. Represented: British Museum; Laing A G, Newcastle; Leeds A G; Sunderland A G; York City A G.

CHARLES, Edward (b.1930)
Sporting, animal and landscape painter in oil, pastel and watercolour; art teacher. He was born at SOUTH SHIELDS and studied at

Edward Charles, *A Huntsman and Pack*, oil, 30.5 x 39.5cm. Anderson & Garland.

the town's School of Art and at King's College (now Newcastle University) before taking up the profession of art teacher. He taught at Sunderland College of Art; King's College, and the College of Art & Industrial Design, NEWCASTLE, but gave up teaching in 1960 to take up farming at STOCKSFIELD, and spend more time painting. One of the specialities of the farm was the breeding of Cleveland Bay horses, and these famous carriage horses became a regular subject amongst his varied studies of local hunting and equestrian activities. His proficiency as a horse painter was also helped by his knowledge of horses in the course of riding them as an amateur jockey, and he held a large number of exhibitions of his work at various private venues in the 1960s, 1970s and 1980s. This exhibition activity continued selectively following his move from STOCKSFIELD to CRAWCROOK, near GATESHEAD, in the early 1990s and also included briefly his own Phoenix Gallery, located at the latter. His later work has included many private, and some corporate commissions including one from Newcastle Breweries to paint the Lord Mayor of Newcastle's coach being drawn by Cleveland Bays. His other work has consisted of landscapes, mainly of the Lake District. He is also a skilled potter, and maker of Northumbrian small pipes.

CHARLETON, Robert John (1849–1925)

Amateur landscape and architectural painter in watercolour. He was born at HEXHAM, but at the age of five moved with his parents to NEWCASTLE. Here he later worked for a hardwareman before branching out on his own account in this line, but adding electrical lighting to his business. Charleton lived at NEWCASTLE throughout his career in business, from his earliest years taking a keen interest in writing. He published three historical novels as well as several books on local history, of which latter the best known is his *Newcastle Town*, 1885, with illustrations by Robert Jobling (q.v.). He was also interested in painting and drawing and was friendly with many leading Northumbrian artists of his day, among these Jobling, and Ralph Hedley (q.v.). His *Newcastle Town* devotes several pages to artists of the area. Charleton occasionally exhibited his work at NEWCASTLE, notably at the exhibitions of the Arts Association. His first exhibit at the Association was his *On the Derwent*, shown in 1878. He died at NEWCASTLE.

CHARLTON, Alan Bengall (1913–1981)

Landscape painter in oil, pastel and watercolour; draughtsman; inn sign painter. Charlton was born at NORTH SHEILDS, and first worked in his father's butcher's shop, as a seaman, and later as a bookkeeper, before studying art at King's College (now Newcastle University), and with the Press Art School, London. During the Second World War years which followed he worked as an assistant repair manager at a shipyard at WALLSEND, near NEWCASTLE. About 1950 he took over a smallholding at NINEBANKS, near ALLENDALE, to raise poultry and pigs, continuing to earn his living from this until becoming warden at the Youth Hostel at CATTON, near ALLENDALE, about 1956. A keen painter through-

Alan Bengall Charlton, *Loch Faskally, Perthshire*, oil, 40 x 59cm. Anderson & Garland.

out his adult life, Charlton first exhibited his work at the Artists of the Northern Counties exhibition at the Laing Art Gallery, NEWCASTLE, in 1935, while still living at NORTH SHIELDS. He remained a regular contributor to these exhibitions throughout his various occupations in Northumbria and also sent his work to Manchester City Art Gallery in 1938, and later to the Royal Institute of Painters in Water Colours exhibitions, in London. His work was also continuously on display at the Mawson Swan & Morgan Gallery, at NEWCASTLE, and other private galleries in the area. Although best known for his North Country and Scottish landscapes Charlton also produced a substantial body of work related to Scandinavia, and a number of marine works. He died at CATTON.

CHARLTON, John, RBA, ROI (1849–1917)

Animal, sporting, battle scene and figure painter in oil and watercolour; illustrator. Charlton was born at BAMBURGH, and received his first drawing lessons from his father. At an early age he obtained employment in the bookshop at NEWCASTLE, of Robert Robinson, later biographer of Thomas Bewick (q.v.). Here he displayed a keen interest in painting and drawing, and when he subsequently took up an engineering apprenticeship with Sir Isaac Lowthian Bell, his master gave him one day off a week to attend the Government School of Design under William Cosens Way (q.v.). He decided after some time that he would prefer a career in art to that of engineering, and after studying at South Kensington for some weeks he returned to NEWCASTLE to establish himself as a full-time professional artist. In 1870 he confirmed the wisdom of his choice by having accepted for showing at the Royal Academy his *Harrowing*, and also exhibited at the 'Central Exchange News Room. Art Gallery, and Polytechnic Exhibition' at NEWCASTLE, in that year. In the following year he showed his first of many works at the Suffolk Street Gallery, *Head of a Fox Terrier*, and by 1875 he had decided to establish himself in London. Here he first shared a studio with John Dawson Watson, from whom he is said to have received much valuable instruction, and the encouragement to concentrate on figure painting. The two artists collaborated in the painting of a work shown at the Suffolk Street Gallery

in 1876/7, *A Check*, and remained friendly for many years. Following the showing of *A Check*, Charlton set up his own studio in the capital, and with his Royal Academy exhibit of 1878, *Gone Away*, established himself as one of the foremost sporting painters of his day. He continued to exhibit at the Royal Academy, and the Suffolk Street Gallery over the next three years, and also sent work to the Arts Association exhibitions at NEWCASTLE. He next attracted attention with his 1883 exhibit at the Academy, *The British Artillery entering the enemy's lines at Tel-el-Kebir*, this impressive work possibly paving the way to his commission to paint for Queen Victoria four years later the Royal Procession in connection with her Jubilee, and a similar commission in connection with her 1897 Jubilee. Interestingly, he received news of the first commission while holidaying at CULLERCOATS, a village which he had visited regularly from his childhood. His second royal commission typified his method when painting ceremonial occasions. He is said to have positioned himself at St Paul's Cathedral, where a short service of thanksgiving was to be held on the steps, as the queen was too infirm to go inside without difficulty. From this position he made thirty or so hurried sketches on the spot, relying for the remainder of the scene on his memory. He then made careful portrait studies and sketches of the uniforms and horses, and when his design was completed, submitted it to the queen with three large cartoons. The approved work took fourteen months to complete and was shown at the Royal Academy in 1899. He brought such a degree of accuracy to the work that many of the dozens of figures included – among these the artist himself – can be identified. Charlton continued to exhibit at the Royal Academy until the year of his death, and at the Suffolk Street Gallery until 1891. He also exhibited his work at the Royal Society of Portrait Painters, and at various other London and provincial establishments, including the Bewick Club, NEWCASTLE, and later the city's Laing Art Gallery, whose Artists of the Northern Counties exhibitions he contributed to from their inception in 1905. In addition to practising as a highly successful painter, Charlton was a popular illustrator, working for *The Graphic* 1876–95, and illustrating at least two books: *Twelve Packs of Hounds*, 1891, and *Red Deer*, 1896. He was elected a member of the Royal Society of British Artists in 1882, and a member of the Royal Institute of Oil Painters in 1887. Following his death at Lancercost, Cumbria, in 1917, the Laing Art Gallery held a major memorial exhibition of his work. One of his two sons, HUGH VAUGHAN CHARLTON (1884–1916) was a talented landscape and bird painter and exhibited his work. Represented: Victoria and Albert Museum; Hartlepool Arts & Museum Service; Hatton Gallery, Newcastle; Laing A G, Newcastle; Natural History Society of Northumbria, Newcastle; Royal Collection; Shipley A G, Gateshead; South Shields Museum & A G. [See colour plate]

CHARLTON, William Henry (1846–1918)
Landscape and coastal painter in oil and watercolour; lithographer. He was born at NEWCASTLE, and began his studies in art at the town's Percy Street Academy, under Charles Richardson (q.v.). He later studied at

the Académie Julian, in Paris, and on his return to NEWCASTLE commenced exhibiting widely throughout Britain, showing examples of his work at the Royal Academy; the Royal Scottish Academy; the Glasgow Institute of Fine Arts; the Walker Art Gallery, Liverpool; the Bewick Club, NEWCASTLE, and later the city's Laing Art Gallery, whose Artists of the Northern Counties exhibitions he contributed to from their inception in 1905, until his death at nearby GOSFORTH, in 1918. Charlton painted and exhibited several Continental subjects, in addition to his many Northumbrian subjects, and frequently worked on a small scale. He sometimes worked in chalk, and experimented with lithography. The Hatton Gallery, NEWCASTLE, has a large collection of his work and in 1998 held a major exhibition combined with the amateur work of author Catherine Cookson (q.v.). Represented: British Museum; Laing A G, Newcastle; North Tyneside Public Libraries.

CHARNLEY, Emerson Junior (1820–1881)
Amateur draughtsman. He was born at NEWCASTLE, the grandson of the town's leading 18th century bookseller, William Charnley (1727–1803), and son of Emerson Charnley, Senior (1781–1845). He was a keen amateur artist until succeeding to the family bookselling business, and at the age of nineteen produced an album of drawings which showed considerable competence. Signed and inscribed *Bigg Market, April 11th 1839*, this appeared on the art market, at NEWCASTLE, in 1995. His father was a friend of Thomas Bewick (q.v.), and in 1820 printed *Select Fables*, with 'cuts designed and engraved' by Bewick and his brother, John Bewick The First (q.v.).

CHASE, Peter (b.1921)
Industrial, townscape and landscape painter in oil and watercolour; printmaker; muralist; art teacher. Chase was born at NEWCASTLE, and later studied art at King's College (now Newcastle University). In 1941 he was called up for naval service, and spent five years as a seaman radar-operator before returning to the College to resume his studies. After graduating in 1951 with an honours degree in fine art (painting) he showed his work at various London galleries, following this with his first one-man show at Leazes Terrace, NEWCASTLE, in 1953. In 1954 he sent his first of several works to the Artists of the Northern Counties exhibitions at the Laing Art Gallery, NEWCASTLE, and after joining the city's Park Road Group in 1956, exhibited with the Group at NEWCASTLE and SOUTH SHIELDS. Before his move to London in 1961 two further one-man exhibitions of his work were held in NEWCASTLE, these being at the People's Theatre, Green Room, in 1957, and the Univision Gallery, in 1959. Between these years he also completed murals for King's College, NEWCASTLE, and the County Hotel, ROTHBURY. After moving to London he spent four years as a studio assistant at the Slade School of Fine Art, and resumed exhibiting in the capital. His first one-man exhibition was held there at the Chiltern Gallery in 1961, following which he taught printmaking at Burslem School of Art and Bournemouth College of Art. Pathé made

a film of his work in this field in 1966 entitled *Lithography on Stone*, and he later devoted much time to printmaking. Chase continued to exhibit his work widely throughout his later career, most of which was spent living in the south of England.

CHILTON, Elizabeth (b.1945)
Landscape, portrait and abstract painter in oil and watercolour; sculptor. She was born at DARLINGTON, and studied at the Ruskin School of Drawing, Oxford, before practising as a professional artist. She later exhibited her work at the Royal Academy; the New English Art Club; the Royal Institute of Oil Painters, and at the Paris Salon. Her work has included landscapes, portraits and abstracts, and bronzes. Examples are held by several Oxford Colleges. She has lived at Toot Baldon, Oxfordshire, for a number of years.

CHISHOLM, Peter, ARCA (1875–1962)
Landscape painter in oil and watercolour; draughtsman; art teacher. Chisholm was born at Selkirk, in Scotland, but in his youth moved to NEWCASTLE, where he attended the city's Rutherford College. On completing his studies at the College he practised as an artist for some time at NORTH SHIELDS, from which in 1897 he sent his only work to the Royal Academy, *November*. Following this he enrolled as a student of the Royal College of Art, but remained a regular exhibitor at the Rutherford College Art Club for a number of years, until his appointment as senior art master at the Douglas School of Art, Isle of Man. After this appointment he exhibited only at the Royal Scottish Academy, and at Liverpool. He later retired from the School of Art and taught art at Douglas High School. He died at Douglas. He was an associate of the Royal College of Art. The Manx Museum, Douglas, has examples of his work in oil, watercolour and pen and ink.

CHURNSIDE, Thomas Edward (fl. late 19th, early 20th cent.)
Amateur landscape painter in watercolour. Churnside worked as a hairdresser at SOUTH SHIELDS for much of his life, painting in his spare time. He exhibited his work from 1901, showing one work at the Royal Cambrian Academy; one work at the Royal Hibernian Academy, and one work at the Glasgow Institute of Fine Arts. He also exhibited at the Artists of the Northern Counties exhibitions at the Laing Art Gallery, NEWCASTLE, in 1908, showing *On Bellingham Moors*. He later moved to NEWCASTLE, where in trade directories published just before the First World War, he was listing himself as a professional artist. Represented: Shipley A G, Gateshead.

CLARK, Anthony, ARCA (b.1942)
Thematic painter in various media; art teacher. Born at SUNDERLAND, Clark studied at Sunderland College of Art, and later at the Royal College of Art, before taking up a career in teaching. He became head of fine art at Monkwearmouth College, SUNDERLAND, remaining in this position until taking early retirement in 1997. He exhibited his work throughout his career in teaching,

and has continued this practice since moving to WHORLTON, near BARNARD CASTLE, following his retirement from the College. Among the group exhibitions in which he has participated are those of the Royal Academy; the Royal College of Art Gallery; the Laing Art Gallery, and the Hatton Gallery, NEWCASTLE, and the Hyde Park and Edith Snow galleries, London. He has also had one-man exhibitions of his work at the University of Surrey; Durham Arts Centre, DURHAM; the Moot Hall, HEXHAM, and the Piers Feetham Gallery, London. Clark undertook a number of ecclesiastical commissions between 1967–1971, including *The Risen Christ*, for St Mary's Church, Alton; *The Crucifixion*, for St Paul's Church, Harefields, and a ceramic mural for St James's Church, HEBBURN, near GATESHEAD. His paintings have been presented as civic gifts to President Carter and the late Cardinal Basil Hume, and were collected by the late L S Lowry. As an artist he has always reflected his sense of painting as a journey or pilgrimage – from his *Ecumenical Pilgrimage* while a student at the Royal College of Art through the *Lyke Wake Dirge*, and *Landscape of the Pilgrim* pastels produced on the northern fells. His work is represented in the collections of the universities of Durham and Surrey. [See colour plate]

CLARK, James, RI ROI NEAC (1858–1943)
Portrait, figure, genre, biblical, landscape and flower painter in oil, watercolour and pastel; muralist; illustrator; stained glass designer. Clark was born at WEST HARTLEPOOL (now HARTLEPOOL), and after studying at the local School of Art, went on to study at South Kensington, where he gained the Gold Medal for Watercolour Studies. Later he went to Paris, where he worked in the studio of Bonnat, and afterwards at the Ecole des Beaux Arts, under Gérôme. On leaving Paris he returned to his native town, where he practised as an artist until settling in Chelsea in 1877. In 1881 he sent his first work to the Royal Academy, *Hagar and Ishmail*. He returned to WEST HARTLEPOOL in the following year and while working here for some three years continued to exhibit at the Royal Academy, and also sent work for exhibition widely in the provinces, including the Bewick Club, NEWCASTLE, at which in 1884 he showed an oil: *A Fisherman's Cottage*. On moving back to London by 1885, Clark began exhibiting at the Suffolk Street Gallery; the Royal Institute of Painters in Water Colours; the Royal Institute of Oil Painters; the Royal Society of Portrait Painters, and several London galleries, including the Fine Art Society. He was elected a member of the New English Art Club in 1886; the Royal Institute of Oil Painters in 1893, and the Royal Institute of Painters in Water Colours in 1903, and apart from occasional professional visits to Northumbria, appears to have spent most of his later life in London. Here, in addition to practising as a highly succesful artist patronised by the Royal Family, he also served as examiner and inspector of art for the Board of Education, and an examiner in art for the University of Cambridge. He continued to exhibit his work widely until late in life, from 1908 regularly sending works to the Artists of the Northern Counties exhibi-

James Clark,
The Bombardment of Hartlepool,
watercolour, 23 x 38cm.
Hartlepool Arts & Museum Service.

tions at the Laing Art Gallery, NEWCASTLE, and in 1926 enjoying a one-man exhibition of his work at the Gray Art Gallery, WEST HARTLEPOOL, at which some eighty-eight examples of his work were shown. He died at Reigate, Surrey. His son JOHN COSMO CLARK (1897–1967), was also a distinguished artist. Hartlepool Arts & Museum Service has a fine collection of his work, including a self portrait. Represented: Hartlepool Arts & Museum Service; Laing A G, Newcastle; Pannett A G, Whitby; Shipley A G, Gateshead; Sunderland A G.

CLARK, James Waite (fl. late 19th, early 20th cent.)

Landscape and coastal painter in oil and watercolour. This artist practised at NORTH SHIELDS in the 1880s, from which he regularly sent work for exhibition to the Bewick Club, NEWCASTLE, and to the Art Club at TYNEMOUTH, of which latter he was for some time treasurer. By 1899 he had moved to SOUTH SHIELDS, from which in the following eight years he sent work to the Royal Academy; the Royal Institute of Painters in Water Colours, and to various London and provincial galleries, including the Laing Art Gallery, NEWCASTLE, whose Artists of the Northern Counties exhibitions he contributed to in 1905 and 1908. His Royal Academy contribution of 1900, was *On Whitley Sands*. Clark's name was sometimes misprinted in catalogues of his period as 'Waiteclark': trade directories, however, confirm his correct name as shown above. He was for several years a picture framer and artists' colour man while practising at SOUTH SHIELDS, frequently framing work for fellow artists in the town as well as supplying them with materials.

CLARK, John Stewart (STEWART, Ian) (1883–1956)

Portrait, landscape and fruit painter in oil and watercolour; miniaturist; etcher. The second son of Joseph Dixon Clark, Senior (q.v.), and younger brother of Joseph Dixon Clark, Junior (q.v.), he was born at BLAYDON, near GATESHEAD, and began exhibiting at the Royal Academy at the age of eighteen, showing a portrait miniature, *Miss Brown*. Following this early success he became a frequent exhibitor at the Academy, mainly showing portraits in miniature of Northumbrian clients, and acquaintances, but also in a freelance capacity portraying many famous personalities, among these, members of the Royal Family, Sir Winston Churchill, and Queen Salote of Tonga. For much of his early professional life he ran a photographic studio at GATESHEAD, where he also tinted photographs in colour; this work led to commissions from many other photographic houses, for which he both coloured photographs, and interpreted them in a variety of media including crayon and etching. He exhibited at the Royal Academy until 1937, one of his exhibits in 1918, *Miss Katherine Vincent*, earning from *The Studio* the comment: 'John Stewart Clark has a shrewd perception of present day necessities. In his examples of miniatures which are reproduced it can be clearly seen that there is no necessity to impose the snapshot manner for the sake of securing a definitely characteristic likeness.' Clark spent most of his life on Tyneside, and formed several friendships among brother artists, including Harry James Sticks (q.v.), a portrait of whose son Harry, he exhibited at the Artists of the Northern Counties exhibition, at the Laing Art Gallery, NEWCASTLE, in 1914. Most of the works which he sent to the Artists of the Northern Counties exhibitions at NEWCASTLE, and to the Walker Art Gallery, Liverpool, were portrait miniatures, but he occasionally showed full-size portraits in oil. As relaxations from his portrait work he also painted, but rarely showed publicly, watercolour studies of gardens, fruit, etc. In his later years Clark lived and worked in the Midlands and south of England, dying in London in 1956. He sometimes sent work to exhibitions signed 'Ian Stewart', several of these works being accepted for showing at the Royal

Academy; the Royal Scottish Academy, and in London galleries. His sister, Laura Annie Clark (q.v.), was also a talented painter of portrait miniatures.

CLARK, Joseph Dixon, Senior (1849–1944)

Animal, landscape and portrait painter in oil and watercolour: sculptor; woodcarver; furniture designer. One of Northumbria's best known animal painters of the last century. 'Dixon Clark', as he preferred to sign himself for the greater part of his long career as a professional artist, was born at NORTH SHIELDS. Details of his early artistic training are not known, but by 1884, and exhibiting at the first exhibition of the Bewick Club, NEWCASTLE, two works, *O Ye Dales*, and *The Turnip Field*, he had taken a studio in the city, and was living at nearby BLAYDON, and supporting a family of four children, of whom Joseph Dixon Clark, Junior (q.v.), John Stewart Clark (q.v.), and Laura Annie Clark (q.v.), were also to become artists. Clark continued to live at BLAYDON until the turn of the century, meanwhile consolidating his reputation as an artist by exhibiting at the Royal Academy; the Royal Scottish Academy, and at various London and provincial exhibitions, mainly showing cattle pictures. He also continued to exhibit at the Bewick Club of which he remained a member throughout its existence. By 1900 Clark's success as an artist was such that he was able to purchase a large house at WHICK-HAM, near GATESHEAD, and build a studio at the bottom of his two and a half acre garden. He thereafter confined his exhibiting activity to Tyneside, however, where his works were often the centre of attraction at the Bewick Club exhibitions, and later the Artists of the Northern Counties exhibitions at the Laing Art Gallery, NEWCASTLE. Clark lived at WHICKHAM for many years before settling finally at WHITLEY BAY, where he died at the age of ninety-five. In addition to being an accomplished animal painter, Clark was an able landscape and portrait painter, a sculptor and woodcarver of considerable ability, and designed and made his own furniture. He painted until close to his death, his last exhibits being the two works which he sent to the Artists of the Northern Counties exhibition in 1944: *Incoming Tide, Whitley Bay*, and *Pilot's Lover*. Represented: Shipley A G, Gateshead; Sunderland A G. [See colour plate]

CLARK, Joseph Dixon, Junior (1878–1966)

Landscape painter in oil and watercolour. The first son of Joseph Dixon Clark, Senior (q.v.), and brother of John Stewart Clark (q.v.), and Laura Annie Clark (q.v.), he was born at BLAYDON, near GATESHEAD, and later qualified as an architect. While studying architecture he became a keen amateur painter, and evidently travelled to the Middle East, for by 1911 he was exhibiting Egyptian scenes at the Artists of the Northern Counties exhibitions at the Laing Art Gallery, NEWCASTLE. He continued to exhibit at NEWCASTLE until the outbreak of the First World War, when he enlisted in the Royal Flying Corps. At the end of the war he returned to NEWCASTLE, sending one work to the Royal Academy as 'Dixon Clark Jun.', in 1919, *In Fancy Dress*, and resuming exhibiting at the Artists of the Northern Counties exhibitions by sending two oils: *Bamburgh Castle*, and *Barnard Castle*. Clark spent his later years in the south of England, dying in London in 1966.

CLARK, Laura Annie – see ADAMS, Mrs Laura Gladstone

CLARKSON, George Henry (fl. early 20th cent.)

Landscape painter in watercolour; enamel painter; sculptor. This artist practised at SUNDERLAND in the early 20th century. He exhibited his work at the Royal Academy, and at the Artists of the Northern Counties exhibitions at the Laing Art Gallery, NEWCASTLE, at the former mainly showing enamels; at the latter enamels and occasional works in watercolour.

CLAUGHAN, E W (fl.1894–1922)

Landscape painter in watercolour. Claughan was reputedly an architect at DURHAM, who also painted local landscapes and for some time assisted Clement Burlison (q.v.) with his portrait work. He occasionally exhibited his work, showing examples at the Bewick Club, NEWCASTLE, and later at the Artists of the Northern Counties exhibitions at the city's Laing Art Gallery. His first exhibits at the latter in 1908 were his *Sunderland Bridge*; *The Neville's Tomb*, and *On the River Wear*; his final exhibit in 1922: *Old Kepier*. Sunderland Art Gallery has his 1884 watercolour: *Kepier Hospital*.

CLEET, James (1840–1913)

Marine painter in oil and watercolour. Cleet was born at SOUTH SHIELDS, the son of a well-to-do family which owned several ships. Its fortunes suffered a reverse in his youth and he became a shipwright, painting only in his spare time. With some tuition from John Scott (q.v.), he developed a fair level of competence in his work and exhibited examples with South Shields Art Club, of which he was for some time honorary treasurer, and at the Bewick Club, NEWCASTLE. His work is sometimes confused with that of his son James Henry Cleet (q.v.). Represented: South Shields Museum & A G.

CLEET, James Henry (1877–1959)

Amateur landscape and marine painter in watercolour. He was born at SOUTH SHIELDS, the son of James Cleet (q.v.), and apart from a period of service in the Royal Naval Air Service during the First World War, he practised as a photographer in the town. He was a keen spare-time painter of watercolour views of SOUTH SHIELDS and its neighbouring coast, approximately forty examples of which are held by South Shields Museum & Art Gallery. His work as a watercolourist does not compare with that of photographer, the latter now being recognised as of high documentary quality, particularly in relation to the changing face of SOUTH SHIELDS in the 1930s. His work as a painter is sometimes confused with that of his father, but is readily distinguishable by his signature: 'J. H. Cleet'.

CLENNELL, Luke (1781–1840)

Landscape, portrait and genre painter in oil and water-colour; wood engraver; illustrator. Clennell was born at ULGHAM, near MORPETH, and worked in his uncle's grocery and leather tanning business at the latter before becoming an apprentice of Thomas Bewick (q.v.), at NEWCASTLE, in 1797. He joined Bewick in the year in which his master published the first volume of the *Birds*, and soon became involved in cutting many tailpieces for the second volume, which appeared in the last year of his apprenticeship, 1804. While working with Bewick, Clennell appears to have received instruction in watercolour painting from his master, and followed Bewick's practice of producing studies in this medium for his subsequent engravings. Many of his watercolours were, however, completely unrelated to known engravings, suggesting that at this early stage he was already attracted to their painting for purely personal reasons. Bewick was obviously impressed by Clennell's abilities as an illustrator and wood engraver, and worked with him in the last two years of his apprenticeship on *The Hive of Ancient and Modern Literature*, published by Solomon Hodgson in 1806. The two also worked together after the expiry of Clennell's apprenticeship, on Hume's *History of England*, Clennell later being invited by the publisher to continue the commission in London. Settled in the capital by the end of 1804, Clennell soon began to receive many other commissions as wood engraver, reproducing his own, or other artists' designs. In 1806

he was awarded the gold palette of the Society of Arts, and in 1809 a gold medal for his large engraving from a design by Benjamin West, for the diploma of the Highland Society. The turning point in his career came in 1810, with the publication in that year of his most successful commission to date; engravings for Samuel Roger's *Pleasures of Memory*. At this time he began to forsake engraving for watercolour painting, and became a member of the Associated Artists, exhibiting his work at their Bond Street Gallery. In 1811 he showed his first work at the British Institution, and was commissioned to produce the bulk of the illustrations for *The Border Antiquities of England & Scotland*, by Scott; in the following year he consolidated his success by sending his first work to the Royal Academy, and becoming an associate of the Old Water Colour Society. By this time he was experimenting with compositions for oil paintings, his cartoon for *The Charge of the Life Guards at Waterloo*, gaining a premium of 150 guineas from the British Institution. In 1813 he showed his first major oil painting, *Sportsmen taking refreshment at the door of a country ale house*, at the British Institution, and in 1814 received his first important commission for an oil — a group portrait of the allied sovereigns and their generals at the Guildhall, London, for the Earl of Bridgewater. Unfortunately, this work proved so difficult to complete that in 1817 Clennell lost his reason, and was never wholly himself again. A compositional sketch for this work in the Laing Art

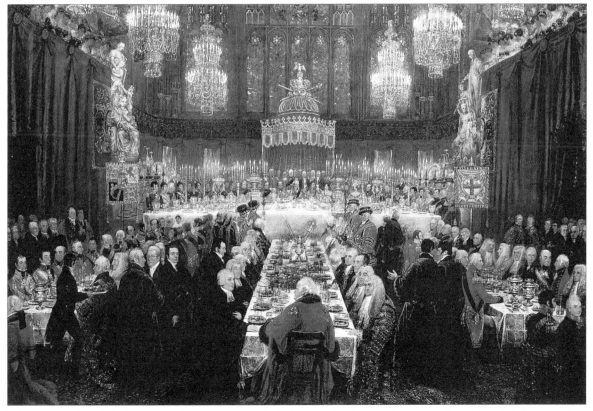

Luke Clennell, *The Allied Sovereigns' Banquet at Guildhall, June 18, 1814*, oil, 127 x 191cm. Guildhall Art Gallery, London.

Gallery, NEWCASTLE, shows that he was able to cope with its basic artistic requirements, and he is known to have completed portrait sketches of the almost 400 personages present, but the total work involved so taxed his capacities that he fell into a state of complete dejection and was admitted to an asylum in London. His wife died shortly afterwards, and in an effort to provide for Clennell and his three young children the Earl purchased the picture in its unfinished state, and it is said to have been completed by Edward Bird R A. Clennell last exhibited in London in 1818, showing *The Day after the Fair*, at the British Institution. This painting was purchased by Mark Lambert (q.v.), and was included in the First Exhibition of the Northumberland Institution for the Promotion of the Fine Arts, NEWCASTLE, in 1822. In the following year Clennell, still living in London, it seems, exhibited two works at the Northumberland Institution, *Dover Pier*, and *The House in which Robert Burns was born*, and one work at the Carlisle Academy in 1826, and in the following year moved to TRITLINGTON, near MORPETH, where it was thought he had made a good recovery from his illness until in 1831 he suddenly became violent, and was placed in the asylum at NEWCASTLE. He spent the remainder of his days at NEWCASTLE, sometimes in the asylum, sometimes at relatives in the town. He exhibited his last work at NEWCASTLE in 1836, showing his watercolour *Turnpike Gate*, at the First Water Colour Exhibition of the Newcastle Society of Artists. His *The Day after the Fair* was also shown in that year, at the Second Annual Exhibition of the Society, courtesy of Lambert, whereafter Clennell lived several years 'beguiling the weary days in drawing, music, and writing poetry', before ending his days in the town asylum. Four years after his death a handsome monument to his memory, by Richard George Davies (q.v.), was placed in St Andrew's Church, NEWCASTLE. Clennell is today regarded as Bewick's most gifted pupil, and might have emerged as a major figure in British watercolour painting had his career not been cut short by mental illness. A large exhibition of Clennell's work was held at the Laing Art Gallery in 1981, accompanied by an excellent catalogue detailing his life and work. Represented: British Museum; Victoria and Albert Museum; Carlisle A G; Dundee A G; Guildhall Art Gallery, London; Laing A G, Newcastle; Natural History Society of Northumbria, Newcastle; Newcastle Central Library; Newport A G; Ulster Museum, Belfast.

CLOSE, Val (b.1949)

Abstract painter in oil and acrylic; collagist; art teacher. She was born at SUNDERLAND, and studied at Sunderland Polytechnic, and Syracuse University in the USA, before becoming a professional artist and part-time art teacher. She first taught part-time when still a student at Syracuse, and on returning to Britain continued at various polytechnics, universities and colleges in the North East of England for the next ten years. She also in the same period was visiting artist at a number of educational institutions in North America, New Zealand and Australia. She first participated in group exhibitions by showing her work at the New Contemporaries, Institute of Contemporary Arts, London, in 1979/80. She has since shown her work in many other such exhibitions, including the Five British Artists, Fairbank Gallery, New York 1982; the Tyne Tees Northern Open, 1985; Richard Demarco Gallery, Edinburgh, and Centrum Beeldende Kunst, Groningen, Holland, 1988; Four British Contemporaries, Bede Gallery, JARROW, near SOUTH SHIELDS, 1993, and 'Art to Atlanta', King Plow Art Centre, Atlanta, Georgia, USA, 1996. Her one-man exhibitions have included those at the Rome Arts Centre, Rome, New York, in 1982; Washington Arts Centre, WASHINGTON, near SUNDERLAND, in 1984; the Laing Art Gallery, NEWCASTLE, in 1988; the Oriel Gallery, Mold, Clwyd, Wales, 1992, and the Collins Gallery, Strathclyde University, Glasgow, in 1995. Two-man exhibitions of which she has been part have been held at the Isis Gallery, Melmerby, Cumbria, in 1995, and the Vardy Gallery, Sunderland University, 2002. Close has received a number of awards in her career as an artist and art teacher, notably the Backhouse Drawing Prize, in 1981; a Syracuse University Scholarship, in 1981–83; a Northern Arts Major Bursary, in 1987; the British Council Travel Awards (Russia and the USA), in 1992, and the British Council Exhibition Award (Atlanta, Georgia, USA), in 1993. She was also appointed artist-in-residence with Northumbria Police, 1984/85, and had her work included in the Inaugural Exhibition of the Design Works Foundation, GATESHEAD, opened by HRH The Prince of Wales, in 1989. Her work is represented in university, education authority and corporate collections in Britain, the USA and Australia.

COATSWORTH, John (b.1947)

Landscape and portrait painter in oil, acrylic and watercolour; illustrator; cartoonist. Born at NEWCASTLE Coatsworth first worked as a craftsman printer for a Tyneside photography business. He later left this employment and after taking a foundation course in graphic art at college worked briefly at the Hancock Museum, NEWCASTLE, designing and illustrating displays. His next employment was with the *Evening Chronicle* and the *Journal*, NEWCASTLE, where he worked for some ten years as an illustrator and cartoonist. In 1986 he left the newspapers to paint full time. Since becoming a professional artist he has exhibited his work widely in Northumbria, often with the River Tyne, its bridges and nearby buildings as themes. He has also illustrated publications for various local authorities and received commissions from the Tyne & Wear Development Corporation and major companies in Britain. In 2003 a major exhibition of his work was held at the Collier Gallery, NEWCASTLE.

COCKRILL, Maurice, RA (b.1936)

Romantic expressionist in oil and watercolour; art teacher. Cockrill was born at HARTLEPOOL, but moved with his family to South Wales in his infancy. His teenage years were spent in North Wales, however,

Val Close,
Crochet Silk, 2002,
oil, 61 x 61cm.
Private collection.

where he began full-time study at Wrexham School of Art in 1960. He subsequently studied fine art at the University of Reading, then moving to Liverpool in the middle 1960s he taught first at St Helen's School of Art, and later in the Faculty of Art, Liverpool Polytechnic. In the same year (1967) as he took up the latter appointment he participated in the first of many group exhibitions by showing work in *Art in a City*, at the Institute of Contemporary Arts, London. In 1969 he burnt much of his work, and two years later embarked on his photo-realist period, enjoying major one-man exhibitions at the Peterloo Gallery, Manchester, and the Serpentine Gallery, London, by 1971. Since then he has participated in many group exhibitions and enjoyed further one-man exhibitions, among the former those held at the Royal Academy; the Neptune and Everyman theatres, Liverpool; the Bluecoat Gallery, Liverpool; the Portal Gallery; the Royal Cambrian Academy, and the Edward Totah Gallery. His many one-man exhibitions since 1971 have included those at the Bluecoat Gallery in 1980, and the same gallery in 1982 at the time of his move to London to set up a studio at Clerkenwell; the University of Nottingham Art Gallery, 1984; the Kuntsmuseum, Düsseldorf, 1985; the Bernard Jacobson Gallery, London, 1987, 1990, 1992 and 1994; the Bernard Jacobson Gallery, New York, 1988,

and the Walker Art Gallery, and Djanogly Art Gallery, University of Nottingham Arts Centre, 1995. The latter exhibition, comprising paintings and drawings executed by Cockrill 1974–1994, was his first major retrospective, and was organised by the National Museums and Galleries on Merseyside, Liverpool, and the University of Nottingham Arts Centre. A loan exhibition of some seventy works, it showed Cockrill's transition from the photo-realism of his early Liverpool years to the romantic expressionism of his later London period. Cockrill returned to teaching soon after moving to the capital, working at St Martin's School of Art in a part-time capacity. He continues to live and work in London, where two important exhibitions of his work have been held since his election as member of the Royal Academy in 1999. These were held in 2002 at the Belgrave and Archeus galleries. A book was also published on his work in 2002: *Maurice Cockrill*, by Marco Livingstone and Nicholas Alfrey, (Merrell). Represented: Arts Council Collection; Atkinson A G, Southport; British Museum; National Museums and Galleries on Merseyside; Walker A G, Liverpool; Museum of Reading; Ulster Museum, Belfast; University of Liverpool A G; Welsh Arts Council. [See colour plate]

COLE, Elizabeth Ann ('Lillie') (b.1871)

Landscape and genre painter in oil and watercolour; sculptor. She was born at NEWCASTLE, the daughter of amateur artist William Cole (q.v.), and received tuition from her father before exhibiting her work from the family home at GATESHEAD at the age of eighteen. She first exhibited at Liverpool, Manchester and NEWCASTLE, at the latter showing examples at the Bewick Club, and later the Artists of the Northern Counties exhibitions at the Laing Art Gallery. She practised successively at GATESHEAD, WHITLEY BAY, and Hinderwell, North Yorkshire, and was living at the last named place when she exhibited at the Royal Academy in 1911, showing *A Rugged Pasture*, and in 1913, *April at Runswick*. She last exhibited at the Artists of the Northern Counties at the Laing Art Gallery, in 1916, showing a watercolour, *The Mill beside the Linn*, and an oil, *Golden Harvest*. She was then still living at Hinderwell. Her watercolour *Runswick Bay, Yorks*, was included in the North East Coast Exhibition, Palace of Arts, in 1929.

COLE, Sir Ralph (1625–1704)

Amateur portrait painter in oil; engraver. He was the son of Sir Nicholas Cole, of Brancepeth Castle, near DURHAM, who was created a baronet in 1640. On his father's death Sir Ralph inherited a considerable fortune, and spent the greater part of it on art, and the patronage of artists. He took lessons from Van Dyck, and painted several portraits, among these a portrait of Thomas Wyndham, which was later mezzotint engraved by R Tompson. He also produced a portrait of Charles II, which he engraved himself. His own portrait was painted by Lely, and mezzotint engraved by Francis Place (q.v.), a friend and brother dilettante of Cole. He is said to have retained several Italian painters in his employment, but his extravagant expenditure in this, and other directions, later obliged him to sell the family castle. He died three years later and was buried close to the castle.

COLE, William (1843–1923)

Amateur landscape and genre painter in oil and watercolour. Cole was born at HEXHAM, and after moving to NEWCASTLE followed the occupation of commercial traveller, painting in his spare time. He first exhibited his work while living at GATESHEAD, showing examples at the Bewick Club, NEWCASTLE, but later moved to MONKSEATON, from which he showed his work at the Artists of the Northern Counties exhibitions at the Laing Art Gallery, NEWCASTLE, from their inception in 1905. His first exhibits at the latter were a watercolour, *After a storm, Dunstanborough*, and an oil, *A Rustic Park*. He continued to exhibit at the Artists of the Northern Counties exhibitions following his retirement to WHITLEY BAY, and later Hinderwell, North Yorkshire, where he had joined his artist daughter Elizabeth Ann ('Lillie') Cole (q.v.). Some of his best work was produced while visiting, and later living at Hinderwell, an excellent example being his oil *Dalehouse Mill, Staithes*, shown at the Laing Art Gallery in 1906. He died at Hinderwell and is buried in the local churchyard. [See colour plate]

COLLARD, William (1792–1847)

Engraver; etcher; lithographer; draughtsman. Collard was one of the most prolific engravers at NEWCASTLE in the early 19th century, and was also an accomplished draughtsman. His work embraced the engraving or etching of many illustrations for publications associated with Northumbria, including Hodgson's *History of Northumberland*, and *Architectural and Picturesque Views in Newcastle*, for both of which publications he also provided drawings. He also occasionally exhibited his drawings, his exhibits at the Northern Academy, NEWCASTLE, in 1829, earning from W A Mitchell, in the *Tyne Mercury*, several favourable comments; of his *View in Ouseburn; near West Jesmond*: '. . . a clear, fresh spirited drawing; carefully done, and highly creditable to Mr Collard, who has seldom come before the public except as an engraver . . .', and of his *Rocks at Cullercoats*: '. . . a beautiful drawing . . .'. Collard collaborated in some of his engraving work with Mark Lambert (q.v.), and taught his skills to George Finlay Robinson (q.v.). His work outside pictorial engraving for reproduction consisted of the usual work of the jobbing engraver, plus the engraving of a number of railway plans. He died at GATESHEAD, where he had lived for some years prior to his decease.

COLLEY, Andrew (c.1868- after 1910)

Genre, landscape and industrial painter in oil. He was born on Tyneside, the son of a local twine merchant, and is believed to have studied art in the town while working in his father's business at NEWCASTLE. He remained in this business throughout his stay in the city, during which period he began exhibiting at the Bewick Club, NEWCASTLE, in 1891, showing two genre works in oil: *Morning Studies*, and *Waiting for Dad*. Two years later he commenced exhibiting at the Royal Academy, showing an industrial scene, *Glass Blowing: lamp chimney making*, and in this year (1893) became a member of the Bewick Club committee, describing himself as 'a merchant'. He remained at NEWCASTLE until the turn of the century, continuing to exhibit at the Royal Academy, and at the Bewick Club, as well as at various London and provincial galleries. Working in London from 1904, he exhibited at the Royal Academy in 1905, 1907, and 1909, and at the New English Art Club in 1909, at both of these institutions showing Continental subjects among his several genre and landscape works. He last exhibited in 1910, when living at Chelsea, London, after which nothing is known of him. The Laing Art Gallery, NEWCASTLE, has his Royal Academy exhibit of 1905: *Venetian Embroidery Makers*.

COLLS, Bernard (fl. early 20th cent.)

Dog painter in watercolour. Colls practised as an artist at DARLINGTON in the early 20th century, and exhibited his work at the Artists of the Northern Counties exhibitions at the Laing Art Gallery, NEWCASTLE, on a number of occasions from the late 1920s to the mid-1930s. All of his exhibits were of dogs, painted with considerable accomplishment in watercolour. His watercolours *Alsatian* and *Wire-Haired Terrier* were included in the North East Coast Exhibition, Palace of Arts, in 1929.

Bernard Colls, *Wire-haired Terrier*, watercolour,
21 x 19cm, oval. Private collection.

CONNELL, William (fl. late 19th, early 20th cent.)

Landscape and coastal painter in oil and watercolour; stained glass designer. This artist practised at GATESHEAD in the late 19th and early 20th centuries, from which he regularly sent work for exhibition on Tyneside. His first exhibit of note was his *Jesmond Old Mill*, shown at the 'Gateshead Fine Art & Industrial Exhibition', in 1883. He later exhibited at Laing Art Gallery, NEWCASTLE whose Artists of the Northern Counties exhibitions he contributed to from their inception in 1905, until the 1920s. He mainly exhibited local landscape and coastal views, but his Laing Art Gallery exhibits included several examples of his skill as a stained glass designer. Represented: Laing A G, Newcastle; Shipley A G, Gateshead; Sunderland A G.

CONNOLLY, Therese (b.1932)

Sculptor. She was born at JARROW, near SOUTH SHIELDS, and developed into a talented sculptor whose work was first shown publicly at the People's Theatre Art Group exhibition of North Country Sculpture, at the Gulbenkian Gallery, People's Theatre, NEWCASTLE, in 1963. Her exhibits were a companion pair of plaster abstracts entitled *Uninhabited Towers*. These were inspired by her visit to Italy and to the studio of Marino Marini, which was seminal in encouraging her concern with sculpture as a complex of hidden passages. She shortly afterwards enjoyed her first one-man show at Middlesbrough Art Gallery, evoking the observation from art critic W E Johnson, of the *Northern Echo*, DARLINGTON: 'Here is a remarkably sensitive sculptress of considerable creative power and one in whom the North East can feel justly proud.' She produced work in a variety of materials including plaster, alabaster and terracotta, initially in realist style, but later in abstract and semi-abstract form. She was also an able draughtsman who frequently exhibited her drawings for her sculptural compositions alongside her finished work. Little is known of her subsequent career except that she was an exhibitor at the Works '64 exhibition at the Laing Art Gallery, NEWCASTLE, in 1964.

COOK, Alan Reid, RSMA PS (1920–1974)

Marine and landscape painter in oil, pastel and watercolour; art teacher. Cook was born at GATESHEAD and was educated at the town's grammar school and later at York College. At the outbreak of the Second World War he became an RAF navigator, receiving part of his training in Canada. After his demobilisation he decided to become an art teacher and trained at Canterbury Art School, and under leading contemporary artists. On completing his studies he taught art at the Ralph Gardiner School, TYNEMOUTH, and North Tyneside College of Further Education, WALLSEND, near NEWCASTLE. He first began exhibiting his work by showing examples at the Royal Society of Marine Artists, and the Artists of the Northern Counties exhibitions at the Laing Art Gallery, NEWCASTLE. He later exhibited with the Newcastle Society of Artists; the Triangle Art Club, NORTH SHIELDS; St Oswald's Art Club, CULLERCOATS, and on the premises of art dealers Mawson Swan & Morgan, NEWCASTLE, which latter also gave him a one-man exhibition in 1967. In 1973 he received his greatest honour by being the only artist in that year elected as a member of the Royal Society of Marine Artists (an organisation with whom he exhibited until the year of his death). In the same year he was also elected a member of the Pastel Society. He died of cancer at WHITLEY BAY. A substantial exhibition of his work was held at the Central Library, NORTH SHIELDS, in 1976. One of his best known works was his oil of the *Esso Northumbria*, launched on May 2nd, 1969, at Swan Hunter's shipyard, WALLSEND, near NEWCASTLE. Represented: National Maritime Museum; Shipley A G, Gateshead.

COOKSON, Dame Catherine, OBE MA (1906–1998)

Amateur flower and landscape painter in oil, pastel and watercolour; illustrator. She was born at EAST JARROW, near SOUTH SHIELDS, and although best known as a prolific and successful novelist dabbled in drawing and painting long before the publication of her first book in 1950. According to a broadcast she gave on *Woman's Hour*, in August, 1949, she first learned to draw at the age of thirty. However, her first real drawing lessons appear to have been taken at a college at St Albans, Hertfordshire, where she had moved temporarily with her husband at the outbreak of the Second World War. She was then thirty-four and abandoned them after three sessions, disillusioned with her progress. The urge to draw did not return until she was subsequently living at Hereford. She was walking across the green of Hereford Cathedral when she said she heard a voice saying: 'You can draw that,' and buying the necessary materials completed what she later regarded as one of her first successful drawings.

Alan Reid Cook,
Neville Street, Newcastle,
in the rain,
oil, 51 x 76cm.
Dean Gallery.

During the war years Christmas cards were difficult to buy and she took her drawing of the Cathedral to a local printer to be reproduced for this purpose. Woolworths, and several shops in Hereford agreed to sell them, and her printer recommended her to talk to Thomas Vaughan Milligan, of Herefordshire School of Art, about developing her artistic talents further. Milligan told her that she was capable of taking a third-year exam, and that there was no reason why she should not later study at the Slade School of Fine Art. She declined his offer of help, despite the encouragement of work from an Isle of Wight publisher as an illustrator, and the inclusion of three of her drawings in a local exhibition. Instead she became fond of visiting the studio of Hereford-based Dutch artist André van der Meersch, under whom she studied until his death in 1944. Catherine bought his paints, brushes and easel from his widow, and used them for the next forty years. Few oils of her Hereford period are known and her next burst of painting activity does not appear to have taken place until she moved to Northumberland in 1976. In that year she began a series of sea paintings based on her recollections of Hastings and these were shown at the Metal Art Precinct, SOUTH SHIELDS, in 1979, in an exhibition entitled *Women Artists of the North East*, along with her Hereford and other drawings. Despite further activity in painting right up until failing eyesight in the mid–1980s made it difficult to work, her paintings and drawings were not shown publicly again until after her death at NEWCASTLE, in 1998. In late 1998 they were included in an exhibition at the Hatton Gallery, NEWCASTLE, of work by William Henry Charlton (q.v.), to illustrate connections between the life of Catherine and this local artist, and in 1999 as part of this gallery's *A Legacy* exhibition to acknowledge 'her generosity to the University of Newcastle Hatton Gallery, Robinson Library and Medical School'. A substantial collection of her paintings was sold by auctioneers T N Miller, NEWCASTLE, in 1998, several of which fetched four figure sums. Although initially interested in landscape, Catherine increasingly turned to flower and still life painting in her later years with considerable accomplishment. Several illustrations of her work and revealing insights of her attitudes toward painting are contained in her autobiographical anthology *Let me make myself plain*, 1988. Represented: South Shields Museum & A G; Newcastle University Robinson Library; Newcastle University.

COOPER, Herbert (1911–1979)

Amateur painter of social and industrial scenes. Born at LANGLEY PARK, near DURHAM, Cooper was the son of a colliery locomotive driver, and at the age of sixteen went to work in a North Durham mine just after the ending of the 1926 strike. After losing his right foot in an accident aged nineteen he left the mine and during the Second World War worked as its canteen secretary. He later left this employment and ended his working life at the Central Stores, PHILADELPHIA, near SUNDERLAND. He then began to paint recollections of Durham mining and social scenes and entered his work in local exhibitions, many of which were organised by the National Coal Board in Miners' Halls and Institutes. As well as attending the Workers' Educational Art Class at ESH WINNING, near DURHAM, Cooper also painted at Durham Technical College. Although not an accomplished painter his work was sufficiently interesting as a record of social life around the mining communities of North Durham in the 1920s and 1930s to merit an exhibition at the DLI Museum & Art Gallery, in 1976. It also proved of interest when offered by Cooper to guide film directors Ken Loach and Tony Garnett when they were preparing to make *Days of Hope*.

COPLAND, Elijah (1846–1916)

Woodcarver; draughtsman. Copland was born at NEWCASTLE, and received his education at the town's St Andrew's Charity School, having early lost his father. He left school at the age of twelve to become a milk delivery boy, but showed such promise as an artist that he was taken on as an apprentice by Thomas

Hall Tweedy (q.v.), the Tyneside woodcarver. At the conclusion of his apprenticeship with Tweedy he went to London, where he obtained employment in a carver's shop at Bloomsbury. He remained there some four months, then returning to NEWCASTLE, he secured an engagement in the studio of Gerrard Robinson (q.v.). He worked for Robinson for two years, afterwards moving to ALNWICK, where he was employed by Robertson & Sons for four years. On leaving ALNWICK, he next worked for Whitty, of Princess Street, NEWCASTLE, then in 1875 decided to try his fortune again in London. He worked for various carving shops in the capital for three years. Then, after a serious accident, he returned to NEWCASTLE, where, after a long convalescence, he set-up his own carving shop. He quickly became successful as his own master, and attracted considerable praise for his work, which consisted of 'solid figures, character pieces in alto relievo, friezes, finials, and designs for art furniture and ornaments'. He died at NEWCASTLE. He was well known throughout his adult life for his interest in politics, and at one time was considered as a Labour candidate for NEWCASTLE.

COPNALL, Theresa Norah (1882–1972)
Flower and portrait painter in oil. She was born at HAUGHTON-LE-SKERNE, near DARLINGTON, and studied at the Slade School of Fine Art under Tonks, Brown and Steer; at Bushey, Herts, at the School of Sir Hubert Von Herkomer, and in Brussels. Following her training she practised as an artist at Barrow-in-Furness, and Liverpool, before settling at Hoylake, Cheshire, with her artist husband Frank T Copnall, where she spent the remainder of her life. She exhibited her work widely throughout Britain, showing examples at the Royal Academy; the Royal Scottish Academy; the Royal Cambrian Academy, and at various overseas, London and provincial galleries. She first exhibited at the Royal Academy in 1927, showing *A mixed bowl*, and sent her final exhibit in 1954: *Flowers in a crystal bowl*. Her work was reproduced by the Medici Society, and Raphael Tuck. Represented: Walker A G, Liverpool.

CORDES, Bernard (1888–1974)
Amateur landscape painter in watercolour. He was born at NEWCASTLE, and later became a solicitor's clerk in the city, painting in his spare time. He subsequently became chief financial officer at Castle Ward Rural District Council, based at PONTELAND, near NEWCASTLE, remaining here until his retirement. Cordes exhibited his work at the Artists of the Northern Counties exhibitions at the Laing Art Gallery, NEWCASTLE, for some thirty years, and for several years with The Tyneside Art Club. He remained a keen amateur painter until his final years, when increasing problems with his eyesight eventually rendered him almost blind. He died at St Dunstan's Hospital, WHITLEY BAY, after having spent most of his life at NEWCASTLE. His son GERALD CORDES (b.1917) is an accomplished professional artist who exhibits his work.

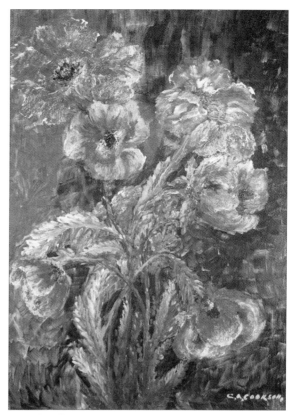

Catherine Cookson, *Still life with red poppies*, oil, 56 x 43cm. T N Miller.

CORLETT, Alfred (b.1921)
Portrait and landscape painter in oil; art teacher. He was born at STOCKSFIELD, and following his general education joined an advertising agency at NEWCASTLE which permitted him to attend art classes at King's College (now Newcastle University). During the Second World War he became a conscientious objector, and was sent to do various jobs on the land. Following the War he decided to take a degree in art at King's College, to enable him to teach the subject, and on concluding his studies taught at various schools in the south of England. He later attended the Courtauld Institute, London, where he took a degree in art history, and thereafter taught the subject at Croydon and Chesterfield, before taking up a post at the College of Art & Technology, NEWCASTLE. While teaching there he also became a partner with Vincent Rea (q.v.), in the Bede Gallery, JARROW, near SOUTH SHIELDS, and helped to organise many of its exhibitions. On his retirement from the College after some twenty years teaching he moved to Ringmer, near Lewes, East Sussex, where he has now lived for many years. Corlett has painted and exhibited his work intermittently throughout his life, showing examples at the Artists of the Northern Counties exhibitions at the Laing Art Gallery, NEWCASTLE, and once only at the Royal Academy in 1958, when his exhibit was a portrait entitled *Mrs Ridge*. Since his retirement he has resumed painting on a more active scale and

87

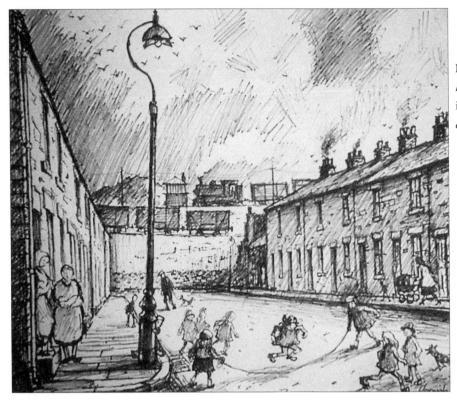

Norman Cornish,
Bishops Close Street,
illustration from *Cornish and Spennymoor*, 1999.

exhibited with the Paddock Studios Group at Lewes. Although strongly attracted to landscape he is particularly interested in portraiture and figure painting. He was a friend of Laurie Wheatley (q.v.), and wrote an introduction to Wheatley's exhibition at SOUTH SHIELDS, in 2000, describing their first meeting at the Wheatley family home in the town.

CORNER, Frank W (d.1928)
Landscape and coastal painter in watercolour and pastel; etcher. Born at NORTH SHIELDS, Corner practised as an artist in the town throughout his career. He was particularly fond of working in pastel, and produced a substantial number of etchings. He exhibited his work at the Bewick Club, NEWCASTLE, and later at the city's Laing Art Gallery, whose Artists of the Northern Counties exhibitions he contributed to for the last eighteen years of his life. He lived for many years at WILLINGTON, near NORTH SHIELDS, but returned to his birthplace shortly before his death in 1928. The Laing Art Gallery has his pastel: *A Northumbrian Village*. Represented: Laing A G, Newcastle; North Tyneside Public Libraries; Sunderland A G.

CORNISH, Norman (b.1919)
Mining, landscape, figure and portrait painter in oil, pastel and watercolour; draughtsman; art teacher. He was born at SPENNYMOOR, and although artistically gifted from his childhood, at fourteen went to work down a local coal-mine. The following year, however, he joined the Sketching Club at The Spennymoor Settlement and by 1940 had begun exhibiting his work at the Artists of the Northern Counties exhibitions at

the Laing Art Gallery, NEWCASTLE, showing a portrait. At the outbreak of the Second World War, coal-mining being deemed essential war work he continued to draw and paint between mining and fire-watching duties, and in 1946 enjoyed his first one-man exhibition at the People's Theatre, Green Room, NEWCASTLE. He next exhibited at the 'Contemporary Artists of Durham County' exhibition, staged at the Shipley Art Gallery, GATESHEAD, in 1951, in connection with the Festival of Britain, and in 1959 began a more than twenty-year association with the Stone Gallery, NEWCASTLE, which resulted in several joint and other exhibitions and his eventual reputation as the 'Pitman Artist'. In 1962 he was invited to execute what has remained his largest work to date, a 24-metres mural for Durham County Council's headquarters at DURHAM, and a year later was asked to appear with fellow-artist Sheila Fell in a BBC documentary, *Two Border Artists*, directed by Melvyn Bragg. In 1966 Cornish left coal-mining after thirty-three years in the industry, due to ill health. In the same year he made a film for Tyne Tees Television featuring drawings which he had completed in Paris, entitled *Cornish in Paris*, and now a full-time professional artist (and occasional art teacher at Sunderland Art College) was able to devote more of his time to depicting his native town and its characters. In 1974 he received an honorary Master of Arts degree from Newcastle University and his career as an artist has since been punctuated by many other recognitions of his skill. In 1989 Melvyn Bragg's film was relaunched after twenty-five years, and in the same year a major retrospective of his work was shown at the University

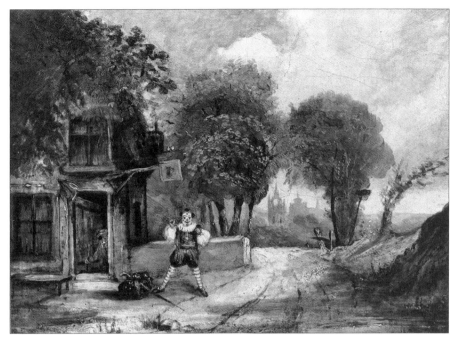

Edward Corvan,
The Bundle,
oil, 29.5 x 46.5cm.
Anderson & Garland.

Gallery, University of Northumbria, to celebrate his 70th birthday, and the launching of his autobiography: *A Slice of Life*. This was followed by a second one-man exhibition at the University Gallery in 1992, and a regional touring one-man exhibition by this gallery in 1994/5. In 1995 he received an honorary doctorate in civil law from the University of Northumbria, and in 1996 exhibited twenty-five of his works at the Town Hall, SPENNYMOOR, as part of the UK Year of Visual Arts. A further one-man exhibition of his work was held at the University Gallery in 1999, to mark its acquisition two years earlier of a large collection of his oils, watercolours, etc, from his studio. This exhibition also coincided with the publication of his second autobiographical work *Cornish and Spennymoor*, containing many drawings of people and places around his birthplace. A more recent exhibition has been his *A Shot Against Time*, held at the University Gallery in 2003. Apart from attending the Sketching Club at SPEN-NYMOOR Cornish is entirely self-taught, and has emerged as one of the most outstanding artists of Northumbria of his period. His work in depicting coal-mining has tended to bracket him as the 'Pitman Artist', but he has proved himself much more versatile than this term implies. He has spent all of his life at SPENNY-MOOR, and there can have been few places more minutely and lovingly depicted by any other British artist. A major exhibition of his work was held at ING Bank NV, London, in 2003, following its partial showing at the Red Box Gallery, NEWCASTLE, in that year. Represented: Laing A G, Newcastle; Sunderland A G; Shipley A G, Gateshead; University Gallery, University of Northumbria, Newcastle. [See colour plate]

CORVAN, Edward ('Ned') (1829–1865)
Amateur religious and figure painter in oil. Corvan was born at NEWCASTLE, and became a sail maker on Tyneside before falling under the spell of the theatre. He joined the dramatic company of famous local comic actor Billy Purvis, turning his hand to everything from bill sticking to playing the violin, but was best known for his singing in the manner of his employer. He later toured on his own, and spent some time as a publican at NORTH SHIELDS, but his voice began to fail and he came to rely on his skills as an artist to redeem his acts. One of his practices was to produce a piece of chalk from his pocket and draw a succession of life-like portraits of then living celebrities, but he is best remembered for his several portraits of his one-time master Purvis performing one of the music hall star's 'bundle' acts, in a Tyneside or Scottish landscape setting. He is also said to have painted a number of religious scenes in the style of John Martin (q.v.). He died at NEWCASTLE.

COULSON, Henry Major (b.1880)
Landscape painter in oil and watercolour; etcher. He was born at SOUTH SHIELDS, and later practised as a painter and etcher, mainly in the Midlands. He exhibited eight works at the Royal Scottish Academy, and nine works at the Walker Art Gallery, Liverpool, between 1921 and 1937. He also exhibited at the Artists of the Northern Counties exhibition at the Laing Art Gallery, NEWCASTLE, in 1927, showing three etchings.

COULSON, Thomas (fl. late 18th, early 19th cent.)
Landscape and decorative painter in oil. He was born at NEWCASTLE, and served an apprenticeship as a watchmaker before placing himself as a pupil under Thomas Miles Richardson, Senior (q.v.), in the hope of becoming a landscape painter. He later became interested in decorative and house painting, however, and was soon receiving commissions from as far afield as Edinburgh. By 1814 he had become recog-

nised as one of the leading practitioners in decorating in his native town, with a special skill in imitating the effects of wood, marble etc., and decided to move to Edinburgh, taking with him apprentice John Wilson Ewbank (q.v.), and possibly Thomas Fenwick (q.v.). Coulson is said to have revolutionised the art of house painting in Scotland, and to have attracted apprentices from all over the North of England, and Southern Scotland. One of the apprentices whom he engaged shortly after setting-up in Edinburgh was George Balmer (q.v.). Thomas Bewick (q.v.), called on Coulson when visiting Edinburgh in August, 1823, after which little is known of his activities, except that he advertised his services at Edinburgh for several years after this date, sometimes under the heading of landscape painter, etc. Bewick was, of course, familiar with Coulson from the latter's days at NEWCASTLE, and cut a business card for him featuring a view of the Tyne, and the castle in the town, together with cherubs and a shield bearing particulars of his name and trade.

COZENS, Kenneth (1920–2000)

Landscape, industrial and seascape painter in oil and watercolour; draughtsman. He was born at GUISBOROUGH, but later moved to MIDDLESBROUGH, where he became an assistant in a grocer's shop. Between 1937 and 1939 he attended evening classes in art at the Constantine College, MIDDLESBROUGH, then joined the RAF to serve during the Second World War. On leaving the RAF he joined the Cleveland Sketching Club, and took up part-time art classes again. In 1947 he commenced work with the Tees Conservancy Commissioners, later becoming fine arts officer for Teesside Museums Service, then on local government reorganisation in 1974, fine arts officer for Middlesbrough Council Museums Service. Both before and after taking up his arts appointments Cozens remained actively interested in painting, and in 1955 enjoyed his first one-man exhibition at Middlesbrough Art Gallery. Between 1962 and 1979 he held other one-man exhibitions, both in Northumbria, and further afield, including the Edinburgh Festival Fringe Club, and the Alwin Gallery, London. He also took part in a number of group exhibitions, including *Artists with North Country Associations*, Manchester City Art Gallery, 1955; *Industrial Britain*, London and the provinces, 1956, and *Society for Education through Art*, Laing Art Gallery, NEWCASTLE, 1956. After his retirement in 1985 he continued to paint, and in 1988 had a one-man exhibition at Middlesbrough Art Gallery. In the same year he also had five drawings and watercolours selected by the Japanese Art Council for an international art exhibition at Beijing and Hebei, China, and at the Gefu Art Museum, Japan. He contributed work to an *Invited Artists Exhibition*, at Billingham Art Gallery, BILLINGHAM, in 1991, and subsequently enjoyed several further one-man exhibitions including one at the Hutchinson Gallery, Town Hall, BISHOP AUCKLAND, in 1998. He died in 2000 and a major retrospective was held at the latter gallery in 2002 in recognition of his long service to the arts in Northumbria. He spent most of his

life at MIDDLESBROUGH. Represented: Middlesbrough A G; Shipley A G, Gateshead, and the Society for Education Through Art.

CRAWHALL, Joseph, The First (1793–1853)

Amateur landscape, figure and animal painter in oil and watercolour: caricaturist: lithographer; etcher; wood engraver. The first member of the old Northumbrian family of Crawhall to distinguish himself artistically, he was born at NEWCASTLE, where he was apprenticed to a ropemaker at sixteen. Eventually he bought his employer's ropery, and by 1830 had become one of the town's more prosperous businessmen. Before becoming deeply involved in his business affairs Crawhall had taken a considerable interest in painting and drawing, indeed his friend Thomas Bewick (q.v.), remarked: 'Joseph . . . excelled as a painter, for which nature had furnished him with the requisite innate powers – but in this he was taken off by his business of a Rope maker.'‡ Little of Crawhall's work as a painter has survived; his *On 'Change'*, is in a collection of the Literary and Philosophical Society, NEWCASTLE; a landscape with cattle and figures is owned by Charles S Felver, USA, author of a book on Joseph Crawhall, The Second (q.v.), and a self portrait painted in the year of his death is in another private collection. We know that Crawhall exhibited alongside fellow committee member Bewick, at the First Exhibition of the Northumberland Institution for the Promotion of the Fine Arts, NEWCASTLE, showing a watercolour copy of *The marriage of St Catherine*, by Parmigianino, and two dog portraits, and showed work at later exhibitions at NEWCASTLE, but what has become of these works is uncertain. His best known work of his pre-1830 period is, however, easily accessible: the lithographic portrait of himself, and the several drawings wittily portraying sporting incidents, contained in his *Grouse Shooting made Quite Easy to Every Capacity*, published in 1827 under the pseudonym 'Jeffrey Gorcock'. Although hard pressed in later years by his business and civic commitments (he was elected Sheriff of NEWCASTLE in 1846, and served as Mayor 1848–50), he never, indeed, lost his love for drawing, often filling his account books with sketches, and frequently dashing off satirical drawings and etchings for the amusement of his friends and family. He died at STAGSHAW, near CORBRIDGE. His sons Joseph Crawhall. The Second (q.v.), GEORGE EDWARD CRAWHALL, and Thomas Emerson Crawhall (q.v.), and daughter MARY ELIZABETH CRAWHALL, were also artistically gifted, only the second named, however, developing skill as an artist to a marked degree. His family had connections with that of William Chapman (q.v.). Represented: Literary and Philosophical Society, Newcastle.

CRAWHALL, Joseph, The Second (1821–1896)

Wood engraver; figure and genre painter in watercolour; caricaturist; commercial artist; book designer.

‡ See p. 180, *A Memoir of Thomas Bewick, Written by Himself*, edited and with an introduction by Iain Bain. Oxford University Press, 1975.

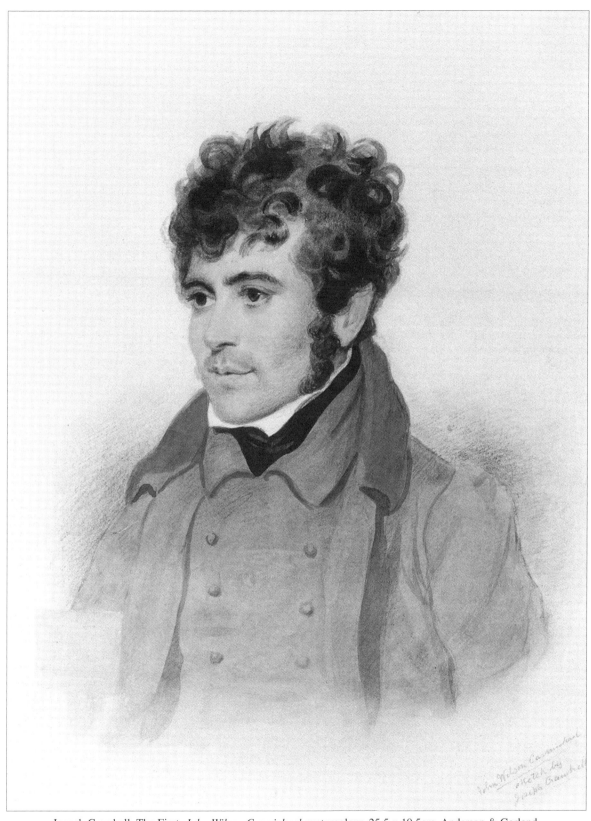

Joseph Crawhall, The First, *John Wilson Carmichael*, watercolour, 25.5 x 19.5cm. Anderson & Garland.

The eldest son of Joseph Crawhall, The First (q.v.), he was born at West House, NEWCASTLE, and joined his father's ropery business as soon as he left school. Like his father he became keenly interested in art and probably received some guidance in painting and drawing from Crawhall, Senior, before embarking on his own activities in these fields. Early in life he became fascinated by wood engraving, later producing many books to which he contributed his own illustrations in this medium. His first such publication of note was *The Compleatest Angling Booke That Ever was Writ*, published in 1859, and both illustrated and printed by him entirely independently. This was followed by a succession of books until 1889, when his *Impresses Quaint* was published at NEWCASTLE containing a collection of his choicest wood engravings, including some of his earliest and latest work. According to his biographer Charles S Felver (p. 115, *Joseph Crawhall, The Newcastle Wood Engraver*, Frank Graham 1972), his 'most brilliant and best known book' was his *Chapbook Chaplets*, published under the imprint of Field & Tuer, in 1883. Crawhall was a close friend of Charles Keene, the famous illustrator of *Punch*, and sent sketches to Keene which Keene re-drew for this publication. Glasgow Art Gallery has twenty-one albums of these drawings, and Adrian Bury, who studied them in connection with his book on Crawhall's son, Joseph Crawhall, The Third (q.v.), describes them as showing 'an inexhaustible sense of fun, characterisation of human types of all classes, and adequate feeling for composition. As a whole, they make an amusing social document of the time. For one who had no formal training in figure-drawing they are surprisingly good'. Although Crawhall's wood engraving was treated with some amusement by his contemporaries, for its crudity compared with that of the highly skilled reproductive engraving of such engravers as the Dalziels,* it has since been recognised that his influence on the work of later engravers was considerable, and that it was boldly original. His interest in art outside his own self-expression was considerable, and he was one of the founders of the Arts Association, NEWCASTLE, formed in 1878, serving as joint secretary, and later secretary. He is also said to have offered much encouragement to his relative William Chapman (q.v.), when Chapman was still struggling to succeed as a professional artist. He was a close friend of the descendants of Thomas Bewick (q.v.), and as one of the executors of the will of Isabella Bewick, last surviving daughter of Bewick, was responsible for the presentation of hundreds of the artist's original watercolours, and drawings to what is now the Natural History Society of Northumbria. He died in London. His brothers GEORGE EDWARD CRAWHALL and Thomas Emerson Crawhall (q.v.), and sister MARY ELIZABETH CRAWHALL, were also artistically talented. Another sister, Jane Ann Crawhall, became the mother of Abel Chapman (q.v.). Represented: British Museum; Glasgow A G; Newcastle Central Library.

* See George Dalziel (q.v.), and Edward Dalziel (q.v.): 'The Brothers Dalziel'.

92

CRAWHALL, Joseph, The Third, RSW (1861–1913)

Amateur animal, bird and sporting painter in oil and watercolour; illustrator. Born at MORPETH, the son of Joseph Crawhall, The Second (q.v.), Crawhall received his first artistic instruction from his father. His father introduced him to the practice of always drawing from memory, and never correcting or erasing his work, a practice which remained with the artist all his life and contributed greatly to the distinctiveness of his later work. Early in his boyhood the Crawhall family moved to NEWCASTLE, where Joseph was sent to school. Later he attended King's College, London, then went to Paris to study under Aimeé Morot. His stay with Morot was brief and had little influence on his subsequent artistic development, and returning to Britain he rejoined his family at NEWCASTLE, where at seventeen he exhibited for the first time, showing two works at the 1878 exhibition of the Arts Association: *Fox Hounds – Morpeth*, and *A Collie Dog*. In the following year an event occurred which was to have a lasting effect on his career in art; his sister had married the brother of Scottish artist Edward Arthur Walton, and this resulted in Joseph's first visit to Scotland, where he was soon painting in the countryside around Glasgow with Walton, and fellow artist James

Joseph Crawhall, The Second, wood cut illustration of angler from *The Compleatest Angling Booke*, 1859.

Guthrie. In the 1880 Spring Loan & Sale Exhibition of the Arts Association, NEWCASTLE, Joseph and the latter artist exhibited a joint work, *Bolted*, and in 1882, in the company of Guthrie, he painted what was to become his only Royal Academy exhibit, *A Lincolnshire Pasture*, shown in 1883. Crawhall's later artistic associations were almost exclusively with Glasgow, where he became a leading member of the Glasgow School, and regularly exhibited his work at the Royal Scottish Academy; the Royal Scottish Society of Painters in Water Colours (of which he was elected a member); the New English Art Club, and at various international, London and provincial exhibitions. Despite his attachment to Glasgow, however, he chose to spend much of his later life in Tangier and elsewhere abroad, finally settling at Brandsby, near York. His period in Yorkshire was one of intense artistic activity during which he would shut himself up in his studio and disregard sleep and food in his creative frenzy. Any work which did not please him was immediately destroyed. He died in London, but was buried in the graveyard of St Mary's Church, MORPETH, alongside his father. In addition to his work in oil and water-colour Crawhall was an accomplished illustrator in line. His first productions in this field were for his father's publications, such as *Border Notes & Mixty Maxty*, 1880. He also contributed illustrations to *Unexplored Spain*, by his cousin, Abel Chapman (q.v.), and to many other publications, including *The Yellow Book*. His most outstanding illustrations were probably those done for binding into a copy of the *Fables of Reynard the Fox*, in 1896–7. These were prepared as drawings, from which hand-coloured wood blocks were later produced. The publication of the volume did not proceed, however, and the ten illustrations involved were reproduced in facsimile in 1906 in a limited edition of 200 copies by W B Paterson, the Glasgow dealer who had long handled Crawhall's work. An important exhibition of Crawhall's work was held at Paterson's Gallery, London, in 1912, and there have been several others since his death a year later. The most outstanding of these was that held by Glasgow Museums & Art Galleries in 1990, drawing upon the some 140 Crawhall works in the Burrell Collection. This was shown at the Burrell Collection, Glasgow, and at the Fine Art Society, London, coincidentally with the publication earlier in that year of *Joseph Crawhall – One of the Glasgow Boys*, by the collections' assistant keeper of fine art, Vivien Hamilton. Lavishly illustrated with examples of Crawhall's work from a variety of sources, the book published by John Murray in association with Glasgow Museums & Art Galleries amply demonstrates his entitlement to be regarded as one of Britain's most outstanding water-colourists and illustrators of his period. Represented: British Museum; Burrell Collection, Glasgow; Tate Gallery; Victoria and Albert Museum; Berwick Museum & A G; Hatton Gallery, Newcastle; Laing A G, Newcastle. [See colour plate]

CRAWHALL, Thomas Emerson (1820–1892)
Amateur painter in oil and watercolour. The elder brother of Joseph Crawhall, The Second (q.v.), he was born at West House, NEWCASTLE, and became a skilled amateur artist and art collector. He also served on the executive committee of the Newcastle Arts Association. Most of his working life was spent in the Crawhall family ropery in NEWCASTLE.

CRAWHALL, William (c.1825- after 1878)
Marine and landscape painter in oil. He was probably the son of William Crawhall, brother of Joseph Crawhall, The First (q.v.), and farmer, at STAGSHAW, near CORBRIDGE.* It is possible that he received some tuition in art from his uncle after moving to NEWCASTLE in the later 19th century, where he took a studio in the premises occupied by Thomas Hall Tweedy (q.v.), the woodcarver and gilder, at 44, Grainger Street. He first exhibited his work publicly when he sent a *Sea View* to the Suffolk Street Gallery in 1860. In 1863, and 1864, he exhibited at the British Institution, showing a total of three works: *Wreck, Sunrise; Morning After the Storm*, and *A Calm Evening at Sea*. He was an exhibitor at NEWCASTLE from 1866 until 1878, at the first of these exhibitions, 'The Exhibition of Paintings & Other Works of Art', at the Town Hall, in 1866, showing one of his British Institution exhibits of 1864; at the second exhibition, 'The Central Exchange News Room, Art Gallery, and Polytechnic Exhibition', in 1870, showing his *Ship on Shore, South Shields*; and *Small Breeze at Sea*, and at the last of these exhibitions, the exhibition of works by local painters, at the Central Exchange Art Gallery, in 1878, showing two landscapes and a 'sea-piece'. Nothing is known of him after 1878, in which year the catalogue of the last named exhibition indicated him as a living artist. The Laing Art Gallery, NEWCASTLE, has his *Mouth of the Tyne*, and a *View of St Nicholas with figures* is known.

CRISP, John (1914–1983)
Abstract painter in oil; art teacher. Crisp was born at Rocky Island, SEATON SLUICE, near BLYTH, and began his working life as a seaman in the merchant navy. He returned home after two years, however, and taking up painting at his family's home at St Mary's Island, near WHITLEY BAY, soon became popular as a painter of impressionistic local scenes. During the Second World War he served as a gunner in the RAF and was later commissioned. He painted a few portraits while serving in the RAF, including that of the Duke of Hamilton, but immediately after the War turned to abstract painting in a style which anticipated the Tachiste technique. His earliest one-man exhibition was at the People's Theatre, NEWCASTLE, in 1953, but he first won local acclaim as a painter when he was commissioned to paint a huge modern mural for the Church of England pavilion at the Newcastle Royal Agricultural Show in 1956. Teaching positions followed, as an extramu-

* Before his retirement to become a farmer he was chief lead mining agent at ALLENHEADS, for many years.

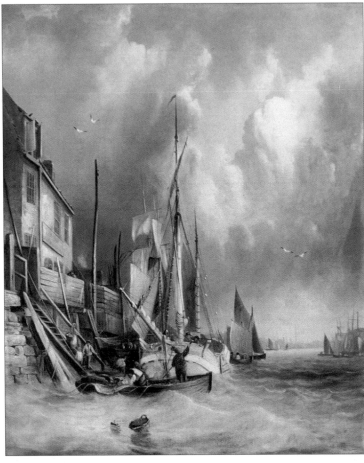

William Crawhall, *On the Tyne*, 1859,

oil, 75 x 62cm.

Anderson & Garland.

ral tutor at King's College (now Newcastle University), and full-time tutor at Newcastle Polytechnic (now University of Northumbria) but he continued to exhibit his own work at a variety of venues including the Hatton, Univision, Westgate and Laing art galleries, NEWCASTLE; the Artists International Association, London; the Royal Scottish Academy, and at various exhibitions in England and Northern Ireland. A major retrospective of his work 1959–1979, was held to coincide with his retirement from the Polytechnic in the latter year. His later work has been described as 'fiercely abstract, yet with a striking suggestion of the rocky landscape of his island home'. Crisp spent his summers on St Mary's Island, and his winters on the mainland. He died at Agadir, Morocco, while on holiday just as the Laing Art Gallery, and the Bede Gallery at JARROW, near SOUTH SHIELDS, were simultaneously planning retrospective exhibitions of his work. Said his friend and fellow artist Gilbert Ward (q.v.) in a posthumous appreciation, published in *Aspects*, Spring 1983: 'When these exhibitions take place they will mark the climax of his painting power and should establish his position as a major British Painter.' Represented: Laing A G, Newcastle; Hatton Gallery, Newcastle. [See colour plate]

CROSBY, Frederick Gordon (1885–1943)

Motoring, aviation and marine painter in oil and watercolour; illustrator; sculptor. Crosby was born at SUNDERLAND, the son of a shipowner and shipbroker, and worked as a draughtsman in a Tyneside shipyard, and the Daimler Car Company's drawing office, before becoming an illustrator for *The Autocar*, and other publications for some thirty years. His main forte was the production of lively motoring scenes, but he also distinguished himself as a painter and illustrator of aeronautical subjects from the two World Wars. His first Royal Academy exhibit in 1916 was, in fact, the first aeronautical subject accepted by the Academy: *The glorious achievement of Lieut. Warneford, V.C., RNAS, shooting down the Zepplin L37 over Ghent in 1915*. Crosby was by then in the Royal Flying Corps, serving from 1915–1919. Following this he resumed working full-time for *The Autocar*, to tight deadlines to meet its weekly publication, but this pressure relaxed with the outbreak of the Second World War, and he turned his talents to producing what his biographer Peter Garnier (*The Art of Gordon Crosby*, Hamlyn Publishing, 1978) has described as among his finest work: *The Roads of War*. This was a series of paintings illustrating the War in all its aspects. Although Crosby's aeronautical subjects from this series involved several combat scenes which are highly valued for their accuracy, he

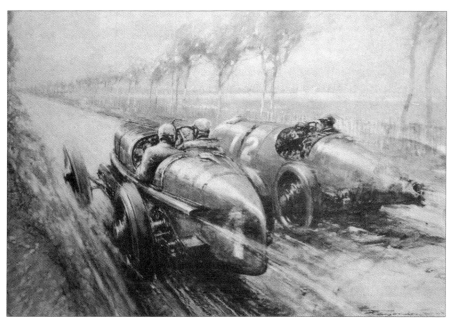

Frederick Gordon Crosby,
*The French Grand Prix
of 1922*,
watercolour, 46 x 72cm.
Brooks.

did not himself have actual experience of combat while serving in the Royal Flying Corps. However, his son, Peter, was a fighter pilot who was killed in action, and it was depression resulting from this which contributed to Crosby's suicide in 1943. Although he was an exhibitor at the Royal Academy early in his career Crosby does not appear to have followed this by exhibiting elsewhere. This may have been due to the intense pressure of his illustrative work but he was nevertheless able to find time to produce a number of small bronze sculptures, among these the original leaping cat which became the mascot of the Jaguar car. A substantial exhibition of his work was held at the Institution of Mechanical Engineers, London, in 1994, and it is represented in the Imperial War Museum, London, and the RAF Museum, Hendon. Crosby is today regarded as one of the most outstanding artists of the early days of motor racing and motoring generally, his work commanding thousands of pounds when it is sold at auction. His son PETER CROSBY was also a talented artist. [See colour plate]

CROSBY, William (1830–1910)
Portrait, genre, landscape and seascape painter in oil and watercolour. Crosby was born at SUNDERLAND, the son of Stephen Crosby, an inn-keeper in the town. At fourteen he was apprenticed to the same painter and glazier as James Stokeld (q.v.), and like his fellow apprentice he decided to abandon his trade soon after completing his indentures. An exhibition of paintings in the town about this time is said to have 'fanned the flame of his artistic ambition', and after succeeding in selling several of his paintings he decided to use the money to stay in Antwerp for two or three years making copies of the Old Masters, in the company of John Reay (q.v.). On his return to SUNDERLAND he soon established himself as one of the town's leading artists, mainly concentrating on portraiture, and producing likenesses of many local celebrities,

including Edward Backhouse (q.v.), whose wife was one of the artist's patrons. Crosby also painted many genre, landscape and seascape subjects, exhibiting eight such works at the Royal Academy, and five works at the Suffolk Street Gallery, between 1859 and 1873. Following this period he increasingly concentrated on exhibiting his work in Northumbria, where he showed work at several major exhibitions at NEWCASTLE, including the exhibition of works of local painters shown at the Central Exchange Art Gallery, in 1878, and subsequently at the annual exhibitions of the Bewick Club in the city. A landscape and a seascape were on show at the Stanfield Art Exhibition, SUNDERLAND, at the time of his death in the town in 1910. Sunderland Art Gallery has several examples of his work, including his portrait of Edward Backhouse (q.v.).

CROWTHER, Stephen, RBA (b.1922)
Portrait and landscape painter in oil and pastel; draughtsman; art teacher. He was born at Sheffield, Yorkshire, and studied at the College of Art there, and later the Royal College of Art, resuming his studies after service in the Second World War. After leaving the College he was from 1950–1987 a lecturer in drawing and painting at the Cleveland College of Art & Design, HARTLEPOOL, but continued to take a keen interest in painting. In 1957 he was included in Jack Beddington's volume *Young Artists of Promise*, and in the following year became a member of the Royal Society of British Artists. He was for some time president of Hartlepool Art Club and in addition to exhibiting at the Club showed examples at the Royal Academy; the Royal Society of Portrait Painters; the Leicester Galleries, and elsewhere in mixed exhibitions. He has received a number of important commissions in his career as an artist, notably a Higgs & Hill Bursary in 1989, to paint Port Solent Marina, Portsmouth, for this company, and in 1992 two oils

for the Sultan of Oman. He has also had a number of one-man exhibitions notably at the Gray Art Gallery, HARTLEPOOL, from 1967; Billingham Art Gallery, 1970, and Middlesbrough Art Gallery, 1984, and the English Martyrs Art Gallery, HARTLEPOOL, in 2002. His wife SHEILA MARIA CROWTHER (1930–2003) was also a talented artist. Their studio sale was held at Anderson & Garland, NEWCASTLE, in 2004 following his move from their home of many years at SEATON CAREW. Hartlepool Arts & Museum Service has a number of his works, and he is represented in several public, educational and other collections, including those of the Abbot Hall Art Gallery, Kendal, Cumbria, and Derbyshire and Hartlepool Education Committees. [See colour plate]

CURRY, Denis Victor, RCamA (b.1918)
Painter of various subjects in oil and watercolour; sculptor; art teacher. Curry was born at NEWCASTLE and was a compulsive draughtsman from his childhood. After studying architecture he attended the Slade School of Fine Art, winning numerous prizes and the praise from one of his teachers, A H Gerrard, that he was 'one of the most outstanding thinkers since Leonardo'. Gerrard also used him as his assistant on some of his large commissions, including Hemel Hempstead Town Centre. His first full-time teaching position was that of head of sculpture at Exeter College of Art. He then moved to Bristol where he served as head of the department of foundation studies from 1962–1976 before deciding to settle on a remote hill farm at Llanycefn, Clynderwen, Pembrokeshire, to pursue his own work as a painter and sculptor. The first comprehensive exhibition of his work was held at the Pelter Sands Gallery, Bristol, in 1976, entitled *Shapes of Flight*. Curry had been interested in animal flight for many years, and in 1967 had been granted a patent on a novel variable-geometry ornithopter which, in 1978, he was invited to place in the Historic Aircraft Museum. His later work was much inspired by the wildlife of Pembrokeshire, but in the 1990s he also worked on a series of earth paintings incorporating tractor wheel patterns. He has also in recent years completed a number of large-scale bronze sculptures, examples of which were shown at the Heifer Gallery, London, in 1999 and 2002, in joint exhibitions with Elizabeth Haines. Curry was elected a member of the Royal Cambrian Academy in 199?, and also showed his work at the Royal Academy; the Walker Art Gallery, Liverpool; the Royal West of England Academy; the Watercolour Society of Wales; the West Wales Centre at Fishguard, and the National Eisteddfod of Wales. His work is said to combine 'a profound knowledge of nature's engineering structure with a poetic vision', and is represented in the collection of the National Museum of Wales, Cardiff; Pembrokeshire Museum & Art Gallery, and the Tunnicliffe Museum, Anglesey. He has also published a book in conversation with John Sansom: *Denis Curry Painting Sculpture Images* (1985). [See colour plate]

CUTHBERT, Alfred Edward (1898–1966)
Amateur landscape and seascape painter in water-colour. He was born at SOUTH SHIELDS and after study at the local School of Art became a keen spare-time painter while working in the insurance business. He was a founder-member of the South Shields Art Club, a member of Sunderland Art Club, and regularly exhibited with both, and at the Artists of the Northern Counties exhibitions at the Laing Art Gallery, NEWCASTLE. He was also a contributor of work to the exhibitions of the Royal Institute of Painters in Water Colours, and in 1962 enjoyed a joint exhibition with fellow artist Alfred Ainslie O'Brien (q.v.), at the People's Theatre, Green Room, NEWCASTLE. Many of his works were offered as prizes in the National Savings Campaign during the Second World War. Represented: Sunderland A G; South Shields Musuem & A G. [See colour plate]

James Alder, *Great Tit and Rhododendron*, illustration from *The Birds of Balmoral*, 1997.

Kenneth Richardson Adams,
Charioteer, 1996,
ceramic, 53 x 46 x 15cm.
Private collection.

Eric Newton Atkinson,
Coastline, Hartlepool, 1998,
oil and sand, 71 x 91.4cm.
Hartlepool Arts & Museum Service.

George Birtley Aris, *Durham Cathedral, Cross from Choir Triforium*, 1988, watercolour, 76 x 56cm. Private collection.

Elizabeth Mary and Dorothy Margaret Alderson, *The Harvesters*, 1974, watercolour, 38 x 56cm. Private collection.

John Atkinson, *A Busy Horse Fair*, watercolour, 54 x 76.5cm. Private collection.

Dennis Barrass,
The Matador's Dream,
oil, 60 x 106cm.
Tyne & Wear
Museums, Shipley
Art Gallery.

James Lindsay Bird,
*The Fleece,
Darlington*,
watercolour, 66 x
84cm. Borough of
Darlington Art
Collection.

Basil James Beattie,
Cornucopia, 1981,
oil and collage,
133 x 98cm.
Private collection.

Selwyn Smith Beattie, *Lindisfarne Window, St Andrew's Church, Stanley.*

Pauline Bewick,
Heron and Tadpoles, 1998,
watercolour, 157.5 x 119.5cm.
Private collection.

Edith Blenkiron and Rowland Hilder,
Flowers wake in the April Sun,
illustration from
The Shell Country Book, 1962.

George Brownlow,
Hounds following a scent,
oil, 44.5 x 59.5cm.
Anderson & Garland.

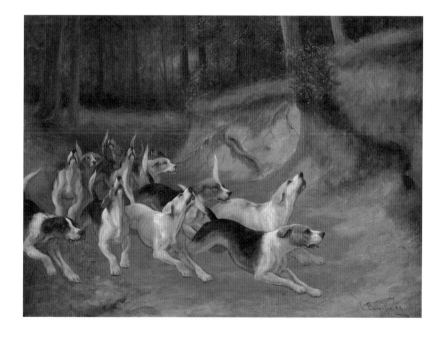

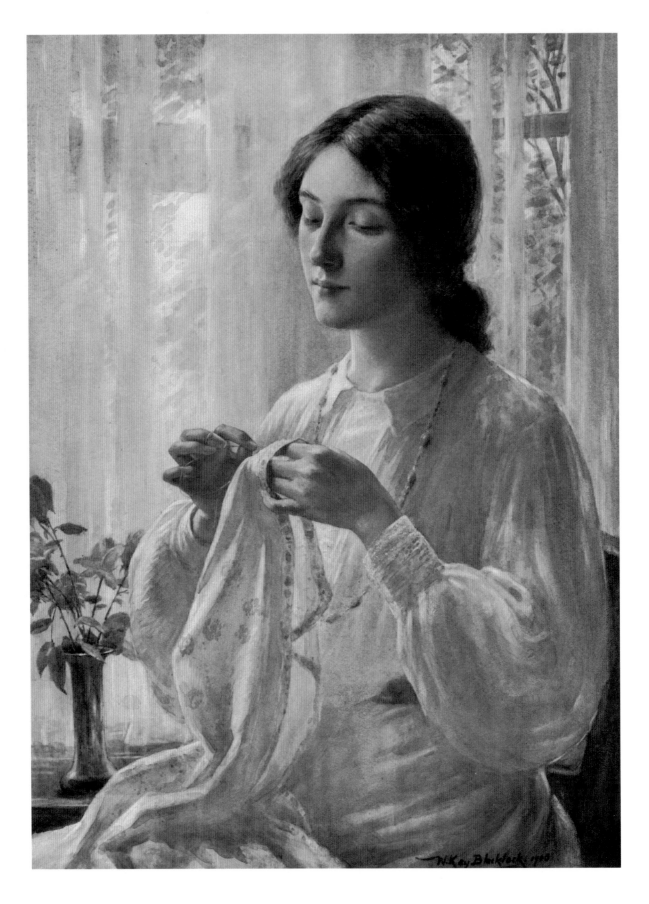

William Kay Blacklock, *At the Window – the Artist's Wife*, 1910, watercolour, 50 x 36cm. Anderson & Garland.

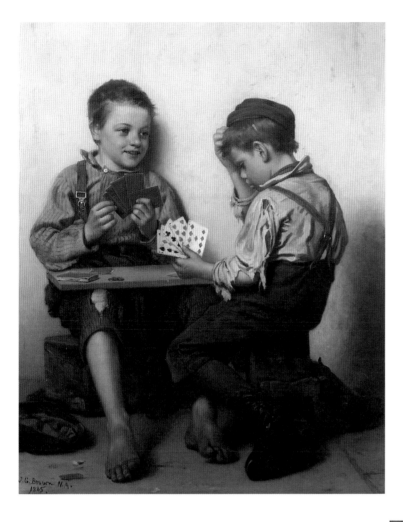

John George Brown,
Bluffing, 1885,
oil, 64 x 52cm.
Spanierman Gallery, New York.

George Washington Brownlow,
The Moorhen's Nest,
oil, 43 x 29cm.
Private collection.

Robert John Scott Bertram,
Steam Train crossing High Level Bridge, Newcastle,
watercolour, 74 x 53cm.
Private collection.

John Wilson Carmichael,
Newcastle from St Ann's, 1835,
watercolour, 60.5 x 97.5cm.
Tyne & Wear Museums, Laing Art Gallery.

John Wilson Carmichael, *An Opium Trader and British Schooners off Hong Kong*, oil, 59.7 x 90.2cm. Christies.

John Chambers, *Outward bound from the Tyne*, oil, 34 x 57cm. Anderson & Garland.

George Burn, *James Renforth*, c.1871,
sandstone, figures and base, 80 x 185 x 100cm.
Gateshead Metropolitan Borough Council.

Mary Grace Elizabeth Burrow, *The Green Hat*, 1916,
watercolour, 47 x 32cm. Private collection.

John Caffrey, *Avocets*,
gouache and watercolour,
47 x 63.5cm.
Private collection.

Herbert Carmichael, *A Morning in Galilee*, 1910, oil, 106.7 x 106.7cm. Anderson & Garland.

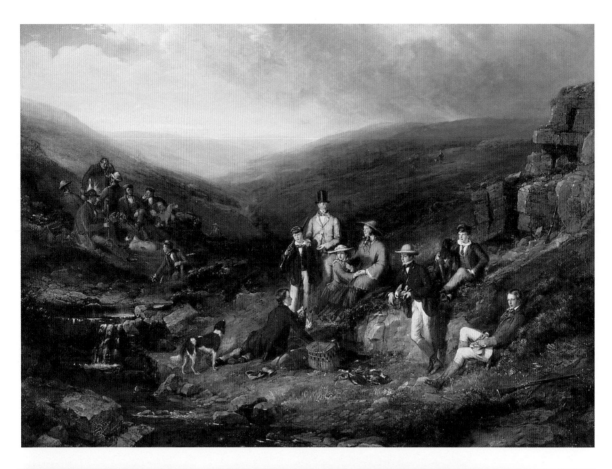

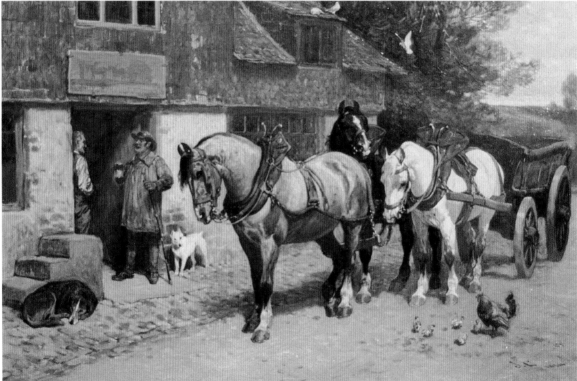

Clement Burlison, *The 12ᵗʰ of August on Wellhope Moors, Weardale, Durham*, oil, 89 x 121cm. Sothebys.

John Charlton, *A Welcome Stop*, oil, 61 x 91.5cm. Private collection.

Anthony Clark,
Altar Piece,
St James's, Hebburn,
ceramic mural,
92 x 170cm.

John Crisp,
Untitled,
oil, 153 x 153cm.
Private collection.

Maurice Cockrill, *Magenta Column*, c.2002, oil and acrylic, 80 x 100cm. Archeus Fine Art.

D

DACK, Thomas ('Tom') (b.1933)
Marine, aeronautical and landscape painter in oil. He was born at NEWCASTLE, and attended the city's College of Art & Industrial Design before starting a career in advertising agencies and commercial art studios as an illustrator and designer. Throughout this career he has remained keenly interested in painting, and has exhibited his work at galleries throughout Northumbria. These include Darlington Art Gallery; the Bede Gallery, JARROW, near SOUTH SHIELDS; the Sally Port Gallery, BERWICK-UPON-TWEED, and the Trinity Maritime Centre, NEWCASTLE. A major exhibition of his work was held on the Earl of Zetland floating public house and restaurant NORTH SHIELDS, in 2002. This was followed by a further major exhibition at the DLI Museum & Art Gallery, DURHAM, in 2003, inspired by the North East's industrial traditions. [See colour plate]

DALRYMPLE-SMITH, Edith Alexandra (1897–1958)
Amateur landscape painter in oil and watercolour. She was born at SUNDERLAND, and was a keen spare-time painter and calligrapher. She was a member of Sunderland Art Club. Sunderland Art Gallery has her oil *Mowbray Park, Sunderland*, and several examples of her work in calligraphy.

DALTON, Derek (b.1929)
Landscape and architectural painter in watercolour; art teacher. Dalton was born at Blackpool, Lancashire, and studied at Blackpool and Hornsey Colleges of Art. By the age of twenty he was exhibiting his work in London, showing examples at the Artists of Tomorrow, and Young Contemporaries. After military service in a map reproduction unit, with attendance at Guildford Art School, he spent some time as a consultant with WPM, then was appointed lecturer at the College of Art & Industrial Design, NEWCASTLE. Here he taught a foundation course and began to actively exhibit his work on Tyneside, showing examples at the Artists of the Northern Counties exhibitions at the Laing Art Gallery, NEWCASTLE, and later with the Newcastle Group. He held his first major exhibition at the Décor Gallery, NEWCASTLE, in 1970, and in the same year was appointed by Newcastle Polytechnic (now University of Northumbria) as head of painting. Over the years until his retirement from the position in 1987 he showed extensively in group exhibitions, and held several two-man and one-man exhibitions. His group exhibitions included the John Moores Exhibition, Liverpool, 1972; the Tom Caldwell Gallery, Belfast, 1978; Ukrainian Institute of Modern Art, Chicago, 1986; Washington Arts Centre, 1989, and the Newcastle Group's 'Northern Lights' exhibition at the DLI Museum & Art Gallery, DURHAM, 1990 and tour. One-man exhibitions included the Hoya Gallery, London, 1975; the Hopper Williams Gallery, NEWCASTLE, 1980, and the Galerie La Charbonniere, St Laurent en Grandvaux, France, 1996. Among the several awards which he has received for his work was that of first prize in the Tyne Tees Northern Open 1985. He was also honoured by his selection to

paint several pictures of CULLERCOATS for inclusion in the Winslow Homer exhibition at the Northern Centre for Contemporary Arts, SUNDERLAND, in 1988, to 'illuminate' the American artist's work on show, 'in today's light'. This came about as a result of his long-time preoccupation with a scheme he calls 'In the Footsteps of Turner', which has involved him in trying to find the exact places in the North of England where Turner painted, and recording the views as they exist now. He remains a member of, and exhibitor with, the Newcastle Group, and in recent years has shown his work extensively in Cumbria – an area which has provided much inspiration for his paintings. He has lived at CORBRIDGE for many years, and is a regular participant in the Tynedale Artists' Network annual opening of members' studios. In 2001 his work from 1969–1999, was shown at his studio and gallery at CORBRIDGE, and in the same year he held a one-man exhibition entitled *Mountains, Canyons and Castles*, at the Shire Pottery Gallery & Studios, ALNWICK. His work is represented in a number of corporate collections.

DALZIEL, Alexander, Senior (1781–1832)
Portrait, still life, animal, genre and fruit painter in oil. He was born at WOOLER, and was a horticulturist, and commissioned officer in the Northumbria Militia, before taking up art as a profession. While still living at WOOLER, Dalziel married, and fathered eleven of his twelve children. Just before the birth of his twelfth child, however, and in his forty-second year, he moved to NEWCASTLE to further his career as an artist, remaining there for the rest of his life. Dalziel exhibited his work at NEWCASTLE from 1824 until his death, and also exhibited at the Carlisle Academy in 1825 and 1826. Most of the works he exhibited were still life subjects, typical of which were his fish paintings, shown at the Northumberland Institution for the Promotion of the Fine Arts, NEWCASTLE, in 1824, and *The Sideboard*, and *Group of Musical Instruments*, shown at the Carlisle Academy in 1826. He died at NEWCASTLE. He was the father of William Dalziel (q.v.), Robert Dalziel (q.v.), Alexander Dalziel, Junior (q.v.), George Dalziel (q.v.), Edward Dalziel (q.v.), Margaret Jane Dalziel (q.v.), John Dalziel (q.v.), and Thomas Bolton Gilchrist Septimus Dalziel (q.v.).

DALZIEL, Alexander, Junior (1814–1836)
Draughtsman. He was born at WOOLER, one of the eight sons of Alexander Dalziel, Senior (q.v.), and moved with his family to NEWCASTLE at an early age. It was said of him by his brothers George Dalziel (q.v.), and Edward Dalziel (q.v.), in their autobiographical *The Brothers Dalziel*, 1901, that had he lived he 'must necessarily have made a great name for himself as a designer and draughtsman in black and white', but he caught a chill which terminated in consumption, and returning to NEWCASTLE to his mother's home, he died there in his twenty-third year. He was the brother of William Dalziel (q.v.), Robert Dalziel (q.v.), George Dalziel (q.v.), Edward Dalziel (q.v.), Margaret Jane Dalziel (q.v.), John Dalziel (q.v.), and Thomas Bolton Gilchrist Septimus Dalziel (q.v.).

Derek Dalton,
Interrupted Space, 1989,
watercolour,
76 x 107cm.
Private collection.

DALZIEL, George (1815–1902) and DALZIEL, Edward (1817–1905), 'The Brothers Dalziel'

Wood engravers; draughtsmen. They were born at WOOLER, two of the eight sons of Alexander Dalziel, Senior (q.v.), and following a brief period with their family at NEWCASTLE, went to London. At the age of nineteen George became a pupil of Charles Gray, the wood engraver. He remained with Gray for four years, and on the completion of his engagement with his master commenced wood engraving on his own account. Within a few weeks, however, he joined his brother Edward Dalziel (q.v.), who was also working in London as an engraver, in founding their own wood engraving establishment, this eventually becoming the most famous and prolific such establishment in Britain in the 19th century. These two, 'The Brothers Dalziel', not only engraved for the publications of others, but printed and published their own publications, acted as editors, and commissioned illustrations for books and magazines. Among the books which they illustrated – sometimes in association with their brother Thomas Bolton Gilchrist Septimus Dalziel (q.v.) – were some of the most popular publications of the Victorian era, such as Tenniel's *Alice*, and Houghton's *Arabian Nights*, while one of their typical trade assignments was the engraving of the prospectus for *Punch*, of which one of the original projectors and proprietors was fellow Northumbrian, Ebenezer Landells (q.v.). The Brothers were distinctive among the reproductive wood engravers of their day in being able to actually improve on the original designs from which they worked, and which were frequently prepared by leading artists of the time. Tenniel's *Alice*, for instance, owes much to the artistry of 'The Brothers Dalziel' for its attractiveness. Most of their work in wood engraving simply carried the name 'Dalziel', as the brothers collaborated so much in the work of their establishment. All their contributions to the Royal Academy between 1861 and 1870 were entered as 'Dalziel Brothers, Wood Engravers', and consisted of their interpretations on wood of paintings by leading contemporary artists such as Sir John Everett Millais, and Myles Birket Foster (q.v.). Edward is said to have been more seriously interested in illustration than his brothers George and Thomas Bolton Gilchrist Septimus; he studied at the Clipstone Academy alongside Charles Keene, and Sir John Tenniel, and exhibited his paintings at the Royal

'The Brothers Dalziel', wood engraving after drawing by Myles Birket Foster (qv), for Thomas Pringle's *Come awa', Come awa'*.

98

Academy, and the British Institution, between 1841 and 1871. An excellent account of the work of the wood engraving establishment which George and Edward ran from 1840 until 1890, together with much interesting biographical information and many illustrations, is their joint work *The Brothers Dalziel*, 1901, while a comprehensive listing of the various works to which they contributed illustrations throughout their entire careers may be found in *The Dictionary of British Book Illustrators and Caricaturists, 1800–1914*, by Simon Houfe, Antique Collectors' Club, 1978. Edward's sons, EDWARD GURDEN DALZIEL (1849–1888), and GILBERT DALZIEL (1853–1930), also practised as artists, and exhibited their work.

DALZIEL, John (1822–1869)

Wood engraver. He was born at WOOLER, one of the eight sons of Alexander Dalziel, Senior (q.v.), and following some years at NEWCASTLE, where he is believed to have received some tuition from the pupils of Thomas Bewick (q.v.), he joined his brothers George Dalziel (q.v.), Edward Dalziel (q.v.), and Thomas Bolton Gilchrist Septimus Dalziel (q.v.), in their wood engraving establishment in London. He worked with his brothers from 1852 until 1868, when ill-health forced him to retire to Drigg, in Cumbria, where he died in 1869. He was the brother of William Dalziel (q.v.), Robert Dalziel (q.v.), Alexander Dalziel, Junior (q.v.), George Dalziel (q.v.), Edward Dalziel (q.v.), Margaret Jane Dalziel (q.v.), and Thomas Bolton Gilchrist Septimus Dalziel (q.v.).

DALZIEL, Margaret Jane (1819–1894)

Painter; illustrator. She was born at WOOLER, one of the four daughters of Alexander Dalziel, Senior (q.v.), and moved with her family to NEWCASTLE at an early age. She received tuition in art from her father, and later moved to London to join her brothers George Dalziel (q.v.), and Edward Dalziel (q.v.), to assist them in their engraving establishment. She worked mainly as a painter, however, though she is not known to have exhibited her work. She died in London. She was the sister of William Dalziel (q.v.), Robert Dalziel (q.v.), Alexander Dalziel, Junior (q.v.), George Dalziel (q.v.), Edward Dalziel (q.v.), John Dalziel (q.v.), and Thomas Bolton Gilchrist Septimus Dalziel (q.v.).

DALZIEL, Robert (1810–1842)

Portrait and landscape painter in oil; modeller. He was born at WOOLER, one of the eight sons of Alexander Dalziel, Senior (q.v.). He received his first tuition in art from his father, and later under Thomson of Duddingston, and after practising successfully at Glasgow and Edinburgh, moved to London. He first began to exhibit his work publicly in 1831, while practising at NEWCASTLE, showing two works alongside those of his father at the town's Northern Academy. Leaving NEWCASTLE some time after 1834, however, he did not apparently exhibit again until 1840, when he sent work to both the British Institution and the Suffolk Street Gallery, showing landscapes and genre paintings. He continued to exhibit at

both these venues until his death at London in 1842. A bust of his father which he modelled in the classical manner, together with portraits in oil of his mother Elizabeth, and brothers George Dalziel (q.v.), and Edward Dalziel (q.v.), are illustrated in *The Brothers Dalziel*, 1901, written and illustrated by the two last named artists. He was the brother of William Dalziel (q.v.), Alexander Dalziel, Junior (q.v.), George Dalziel (q.v.), Edward Dalziel (q.v.), Margaret Jane Dalziel (q.v.), John Dalziel (q.v.), and Thomas Bolton Gilchrist Septimus Dalziel (q.v.).

DALZIEL, Thomas Bolton Gilchrist Septimus (1823–1906)

Landscape and figure painter; illustrator; copper engraver; wood engraver. He was born at WOOLER, one of the eight sons of Alexander Dalziel, Senior (q.v.). After some time at NEWCASTLE with his family, and possibly receiving some tuition there in copper engraving, he moved to London, where by 1846 he was exhibiting at the Suffolk Street Gallery, showing a genre work *Thieves Alarmed*. In 1856 he began exhibiting at the Royal Academy, showing *A Triton*, and in 1858 sent his only work to the British Institution, *On the Shore*. In 1860, and with an already impressive record of book illustrating behind him, he joined his brothers George Dalziel (q.v.), and Edward Dalziel (q.v.), in their wood engraving establishment in London, subsequently carrying out much fine illustrative work for various of their publications. Among the many widely popular works to which he contributed illustrations was *Houghton's Arabian Nights*, 1865. He rarely exhibited his paintings after 1866, when he last showed at the Suffolk Street Gallery, though he did show two works at the Royal Hibernian Academy, and two works at Manchester, in 1881. He was the youngest of the brothers comprising the Dalziel wood engraving establishment, and remained associated with it until his death in 1906. He was the brother of William Dalziel (q.v.), Robert Dalziel (q.v.), Alexander Dalziel, Junior (q.v.), George Dalziel (q.v.), Edward Dalziel (q.v.), and Margaret Jane Dalziel (q.v.). His sons HERBERT DALZIEL (1853–1941), and OWEN DALZIEL (1861–1942), also practised as artists, and frequently exhibited their work.

DALZIEL, William (1805–1873)

Still life painter in oil; heraldic and ornamental book decorator. He was born at WOOLER, one of the eight sons of Alexander Dalziel, Senior (q.v.). He moved with his family to NEWCASTLE in his teens, and following some tuition from his father practised as a painter of still life subjects. He spent some time in London with his brothers George Dalziel (q.v.), and Edward Dalziel (q.v.), possibly assisting them in the preparation of book illustrations, but later moved to Penarth, Wales, where he died in 1873. He was the eldest brother of Robert Dalziel (q.v.), Alexander Dalziel, Junior (q.v.), George Dalziel (q.v.), Edward Dalziel (q.v.), Margaret Jane Dalziel (q.v.), John Dalziel (q.v.), and Thomas Bolton Gilchrist Septimus Dalziel (q.v.).

Richard George Davies and Christopher Tate, *Monument to 3rd Duke of Northumberland*, Master Mariners' Homes, Tynemouth, 1841, stone, figure 2m high.

North Tyneside Council.

DAVIES, Jean Elizabeth (1918–1984)

Landscape, portrait and still life painter in oil; art teacher. She was born at West Kirby, Cheshire, and studied at the Belvedere Art School, and Liverpool Art School, before practising as a professional artist, initially in London. Here her work included commercial commissions such as book-jackets, but following her marriage in 1946, and subsequent move to live at PONTELAND, near NEWCASTLE, in 1950, she became a keen painter of landscapes, portraits, etc, and exhibited her work widely on Tyneside. She also taught at evening classes and helped to organise local art exhibitions. One of her favourite subjects for her paintings was the Diamond Inn, and Old Smithy, viewed from above the bridge at PONTELAND, but she was also fond of Durham Cathedral and Bamburgh Castle. The Dean Gallery, NEWCASTLE, regularly exhibited her work in the final years of her life. She lived at PONTELAND until her death in 1984.

DAVIES, Richard George (c.1790- after 1857)

Sculptor; marble mason. Davies practised as a sculptor and marble mason in Northumbria from the early years of the 19th century, until about 1860. Eneas Mackenzie, in his *History of Newcastle*, says that Davies' predecessor in his profession was 'The late John Jopling ... a good sculptor' who also had 'a fine taste in miniature painting', but whether this implies that Davies took over the business of John Jopling (q.v.), or was merely taught by him, is not clear. Davies married at St Andrew's Church, NEWCASTLE, in 1812, and was soon busy enough in his studio to take on Christopher Tate (q.v.). Among his early work are monuments to Phillis Craster (d. 1813) – a sarcophagus and obelisk; and Winefrid Haggerston (d. 1815) – a draped urn and obelisk; both at St Maurice's Church, ELLINGHAM. Most of his later work lay in the field of producing monuments,

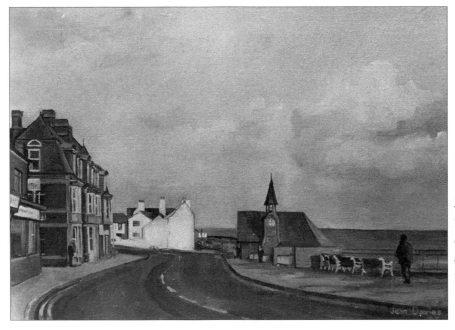

Jean Elizabeth Davies, *The Lookout Tower, Cullercoats,* oil, 25.5 x 36cm. Private collection.

examples of which may be found in churches throughout Northumbria, but he did occasionally aspire to more demanding work, some of which he sent for exhibition. In 1844, at the Westminster Hall, London, he exhibited his *Actaeon Devoured by his Hounds*, but this work was scathingly remarked upon by the *Literary Gazette* (1844 – page 482), which said: 'We wish the unfortunate hunter had been entirely devoured, so that we might have been spared the sight of so disgusting a group.' The *Illustrated London News* of the same year implied a better appreciation of his work, however, when it published wood engravings of his newly erected monuments to Grace Darling, at St. Cuthbert's Chapel, FARNE ISLANDS, and Luke Clennell (q.v.), at St Andrew's Church, NEWCASTLE. In 1846, Davies, then evidently working at Carlisle, sent eleven works to the exhibition in that year of Carlisle Athenaeum, but after returning to Northumbria some time after this event, he established himself at CHESTER LE STREET, after which nothing is known of him. His monument to Luke Clennell, consisting of a garlanded palette, with maulstick, once occupied a prominent place at the entrance to the chancel of St Andrew's, but has now been removed to a position high on the inside right-hand wall. An example of his work in statuary is the figure of the Duke of Northumberland which he finished for his former pupil Tate, and which was later erected outside the Master Mariners' Asylum, TYNEMOUTH.

DAVISON, A Scott (fl. late 19th cent.)

Landscape painter in oil and watercolour. She practised at SUNDERLAND, in the late 19th century and exhibited her work at the Royal Institute of Painters in Water Colours; the Society of Women Artists; the Walker Art Gallery, Liverpool, and the Bewick Club, NEWCASTLE, in its final years. A relative, MAY DAVISON, also exhibited from the same address in this period, showing work at the Society of Women Artists, and the Walker Art Gallery, Liverpool. The College of St Hild and St Bede, DURHAM, has two of May's views of the city.

DAVISON, Frederick Charles, RBA (1902–1989)

Landscape painter in watercolour; art teacher. He was born at CONSETT, and after studying art at King's College (now Newcastle University), was appointed art master at Dame Allan's School, NEWCASTLE. He first began exhibiting by showing his work at the Artists of the Northern Counties exhibitions at the Laing Art Gallery, NEWCASTLE, in 1922, while still living at CONSETT. On leaving his teaching post and setting up a studio at Gosport, Hants, however, he began exhibiting at the Royal Society of British Artists and the New English Art Club, becoming elected a member of the former in 1935. By 1936 he had returned to Northumbria, and settling at TYNEMOUTH, resumed exhibiting at the Laing Art Gallery, showing mainly English and Continental watercolours. He remained an exhibitor at NEWCASTLE for more than twenty years, and showed three of his watercolours at the 'Contemporary Artists of Durham

County' exhibition, staged at the Shipley Art Gallery, GATESHEAD, in 1951, in connection with the Festival of Britain. These were entitled: *Near Nyons S. France*; *Stockholm*, and *Cullercoats*. He also taught widely in the area. His final home was at WALL, near HEXHAM, where he died in 1989. Davison's work was noted for its fine architectural draughtsmanship and he was for many years a member of the Architectural Association. The Shipley Art Gallery, GATESHEAD, has his watercolour *Stockholm*.

Frederick Charles Davison, *Petite Marie Claude Douarnez*, watercolour, 36 x 49cm. Private collection.

DAVISON, John (born c.1896)

Portrait painter in oil. This artist practised at GATESHEAD in the early years of the last century, following five years' art training at Hospital Field House, Arbroath. He exhibited at the Royal Hibernian Academy in 1917, and at the Artists of the Northern Counties exhibitions at the Laing Art Gallery, NEWCASTLE, from 1918.

DAVISON, William (c.1805–c.1870)

Amateur marine, coastal and landscape painter in oil and watercolour. This artist lived at SUNDERLAND, and later HARTLEPOOL, in the 19th century, and first began exhibiting his work publicly from the former, sending his *Moonlight; Fishing Boat off Hartlepool*, and *A Calm*, to the Northern Academy, NEWCASTLE, in 1829. In the following year he exhibited at both the Northern Academy, and the Carlisle Academy, and in this year also became a member of the Northern Society of Painters in Water Colours, NEWCASTLE, along with Thomas Miles Richardson, Senior (q.v.), and others. He thereafter exhibited little at NEWCASTLE, and on only one further occasion at Carlisle, following which he left SUNDERLAND for HARTLEPOOL, where he worked as Chief Clerk to Hartlepool Dock & Railway Company. Davison was a close friend of William Bewick (q.v.), many of Bewick's letters to him c.1845–1864 appearing in *The Life and Letters of William Bewick (Artist)*, by Thomas Landseer, 1871. Several of these letters discuss Davison's artistic activities, one such letter dated 7th December, 1850, stating that much rather than look at his friend's

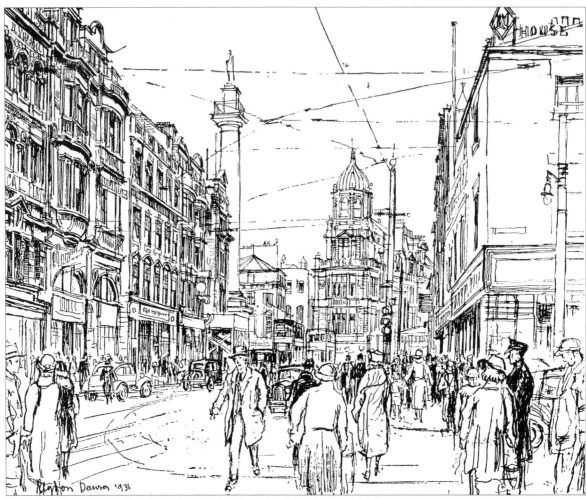

Byron Eric Dawson, *Blackett Street, Newcastle*, illustration from the *North Mail*.

copies of Rembrandt's work 'I cannot but long that you should be doing what in your own peculiar line you do so well, those delightful bits of seaside scenes.' Two of Davison's coastal views were included in the exhibition of works by local painters, at the Central Exchange Art Gallery, NEWCASTLE, in 1878, the catalogue describing them as by 'W. Davison of Hartlepool, an amateur whose paintings are full of truth of feeling, with marked truthfulness to nature.' According to Clement Burlison (q.v.), in his *The Early Life of Clement Burlison*, Davison had been a pupil of Copley Fielding and had taken a few lessons from David Cox. He also said of Davison that he had learnt more from him than any other.

DAWSON, Byron Eric (1896–1968)

Landscape, architectural and subject painter in oil, tempera and watercolour; draughtsman; illustrator; art teacher. Dawson was born at Banbury, Oxfordshire, but moved to NEWCASTLE following the death of his parents to serve an engineering apprenticeship. His skill at drawing was soon noticed by his employers, however, and he was encouraged to become an art student at the city's Armstrong College (later King's

College; now Newcastle University). At the conclusion of his studies he was asked to remain at the College as assistant master of painting, working in this capacity until 1927, when he embarked on his career as a professional artist by preparing for submission to the Royal Academy a work entitled *Panel for Morning Room*. This was exhibited at the Academy in 1928, and enabled him to attract several commissions for his work, among these one to paint a large lunette for the Laing Art Gallery, NEWCASTLE, depicting *John Baliol paying homage to Edward the First at Newcastle, in 1292*. In 1928 he exhibited his first of three works at the Royal Scottish Academy, and in 1929 sent one work to the North East Coast Exhibition, Palace of Arts. He exhibited one further work at the Royal Academy in 1931, entitled *Shepherd and Three Graces*, but by 1933 he had ceased exhibiting outside Northumbria altogether, contenting himself by showing his work at the Artists of the Northern Counties exhibitions at the Laing Art Gallery, and the city's private galleries. Some measure of his reputation as an artist by the Second World War may be gained from his selection in 1940 to prepare drawings for the Recording Britain scheme funded by

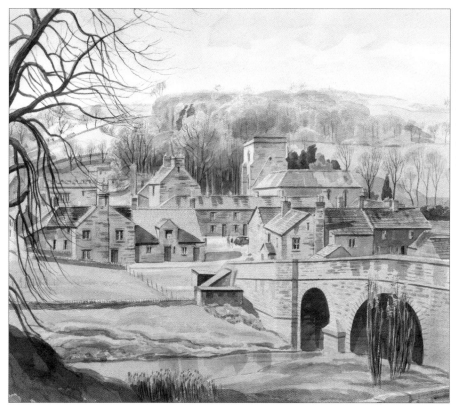

Byron Eric Dawson,
Blanchland,
watercolour,
46 x 61cm.
Private collection.

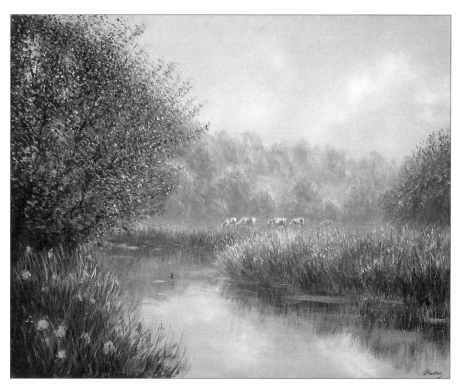

Edward Dawson,
*Cattle grazing, early
morning, River Stour,
Dorset*, 1999,
oil, 61 x 76cm.
Lincoln Joyce Fine Art.

103

the Pilgrim Trust. These were later published by the Oxford University Press in a book entitled *Recording Britain*, along with the work of other leading British contemporary artists. Most of Dawson's later life was taken up with architectural painting and drawing. He drew and painted street scenes, historic buildings, landscape, seascapes and industrial scenes. Two of his favourite subjects were the cathedrals of DURHAM and NEWCASTLE, of which he probably produced more watercolour studies than any other artist in history. In oil he preferred to produce works of the imagination, and sometimes on a large scale. The lunette referred to earlier was his largest work in this medium, but he also produced several other canvases of massive proportions, including his *North Tyne* commissioned for the refreshment room of the Central Station, NEWCASTLE, (now re-hung in its Centurion Bar). Dawson was for many years from 1925 a newspaper illustrator, many of his pen and ink drawings appearing in the *North Mail*, later amalgamated with *The Journal*, NEWCASTLE. This made him one of the best-known artists of Northumbria of his period, but his final years were spent in poverty, with only a small income from the tuition of private pupils and the occasional sale of his watercolour work to enable him to survive. Two of the finest exhibitions of his work in his lifetime are said to have been those mounted by the Laing Art Gallery, in 1932, and the Shipley Art Gallery, GATESHEAD, in 1955. At the earlier of these Sir David Y Cameron, the Royal Scottish Academician said his work possessed '... a delicate beauty ... a sensitive architectural draughtsmanship'. He died in a sanatorium in the Tyne Valley following an operation, and lies in an unmarked grave in St Andrew's Cemetery, NEWCASTLE. A major exhibition of his work was held at the Dean Gallery, NEWCASTLE, in 1993 to mark the 25th anniversary of his death. Represented: Victoria and Albert Museum; Laing A G, Newcastle; Shipley A G, Gateshead; Pen & Palette Club, Newcastle.

DAWSON, Edward, NEAC (1941–1999)

Landscape and figure painter in oil, pastel and watercolour; art teacher. He was born at STAMFORD, near EMBLETON, and after education at ALNWICK, attended King's College (now Newcastle University), where one of his tutors was Victor Pasmore. Following his graduation with a BA in fine art he initially taught at the College of Art & Industrial Design, NEWCASTLE, but shortly after took up an appointment on the staff of the Epsom and Ewell School of Art. During this period he began to re-evaluate his early interest in abstract painting and became increasingly influenced by Impressionism. In 1971 he began an association with the Furneaux Gallery, Wimbledon, and in the following year was featured in this gallery's *Ten Years and Ten Artists* exhibition, showing a variety of landscapes in his newly adopted style of painting. This was followed by two further one-man exhibitions at the gallery in 1973 and 1974, and in the latter year his first of two successive appearances at the Royal Academy. In 1977, he was elected a member of the New English Art Club and by 1978 had given up his teaching commitments and moved to Wiltshire

to devote more of his time to painting. In 1980 and 1981 he exhibited at the Frost & Reed Gallery, London, and from then on enjoyed several one-man exhibitions and participated in various group shows. His further one-man exhibitions included those at the Edwin Pollard Gallery, London, in 1983, and 1985, and from 1989–1991; the Kingsmead Gallery, Surrey, in 1998 and 1999, and The Guggleton Farm Arts Project, Stalbridge, Dorset, in 1998. Group and other showings of his work were those at the New English Art Club, the Royal Society of British Artists, and various galleries in London and the provinces; the Algarve, Portugal; New England, USA; Abu Dhabi; Austin, Texas, USA, and Monflanquin, France. After living in Wiltshire Dawson lived in France for several years, before finally returning to Dorset, where he died in 1999, at the early age of fifty-eight. Although mainly a painter in the final years of his life Dawson also did some part-time teaching, notably at the adult education art classes at the Guggleton Farm Arts Project, Dorset. A memorial exhibition of his work was held at the Lincoln Joyce Gallery, at Great Bookham, Surrey, in 2000, showing work loaned by his widow, the artist Gillian Dawson (née Furlong). Dawson's work included a number of commissioned paintings, and images for reproduction. The former included that by the All-England Tennis Club, for the first official painting of the Centre Court (1983); the latter, greetings cards for the Medici Society, posters for the American market, and a limited edition print for Henstridge Aero Park, Dorset, entitled *Seafire over Henstridge*. Dawson was the great-nephew of Ralph Bullock (q.v.).

DEAN, Donald (b.1930)

Still life and landscape painter in oil. Born near STOCKTON-ON-TEES, Dean studied first at West Hartlepool College of Art, and then at Sunderland School of Art under Henry Thubron (q.v.). He then continued at the Slade School of Fine Art under William Coldstream and Claude Rogers. On leaving the Slade he returned to Northumbria and began exhibiting his work showing examples using a low-keyed clotted brushwork bearing affinities in style with that of Rogers. However, he later changed into a painter of larger than life still life groups with a breakfast table theme, and often with the use of the palette knife. A substantial exhibition of his work was held at the Shipley Art Gallery, GATESHEAD, in 1961, by which time Dean had begun a hermit-like existence in a cottage at Egton, near Whitby, North Yorkshire. Represented: Hartlepool Arts & Museum Service; Shipley A G, Gateshead.

DEES, Herbert Bewick (1892–1965)

Amateur genre, landscape and cattle painter in oil and watercolour. He was born at GATESHEAD, the younger brother of John Arthur Dees (q.v.), and studied art under amateur artist JACK EVANS (1871–1967), while training as a painter and decorator. After service in the 'Pals' regiment during the First World War he began in business as a painter and decorator at SPENNYMOOR, and resuming his interest in art, shortly

John Arthur Dees,
Evening, Alnmouth,
oil, 30.5 x 41cm.
Dean Gallery.

afterwards began exhibiting his work at the Artists of the Northern Counties exhibitions at the Laing Art Gallery, NEWCASTLE. He also contributed work to the North East Coast Exhibition, Palace of Arts, NEWCASTLE, in 1929, and having become the first member to join the Sketching Club set up by The Spennymoor Settlement in 1931, sent many works to its annual exhibitions. The Club was later affiliated to the Federation of Northern Art Societies, and he participated in several exhibitions held by this organisation at the Shipley Art Gallery, GATESHEAD. Like many artists associated with SPENNYMOOR, Dees was strongly attracted to the local mining scene and from 1936 began making small tempera and watercolour studies of abandoned industrial workings around the town – some of which were interpreted as satirical comments on Durham life. Several of these were included in the *Art of the People* travelling exhibition. Dees retired from business in 1962, and died three years later at SPENNYMOOR.

DEES, John Arthur (1875–1959)

Amateur landscape, cattle and portrait painter in oil and watercolour. Dees was born at NEWCASTLE, a member of a family connected with that of John Graham Lough (q.v.). He studied at the School of Art at GATESHEAD, winning gold medals in 1895, and 1896, but decided on a career in commerce, and thereafter painted mainly in his spare time. He first exhibited his work at the Bewick Club, NEWCASTLE, where he soon won a reputation for the quality of his landscapes and formed friendships with several local professional artists, among these John Atkinson (q.v.). He was an exhibitor at the Artists of the Northern Counties exhibitions at the Laing Art Gallery, NEWCASTLE, from their inception in 1905, and

as a member of the city's Pen & Palette Club, was associated with various of its exhibitions. He first exhibited outside Northumbria in 1911, when he sent one work to the Royal Institute of Painters in Water Colours. In 1913 he sent the first of two works to the Royal Academy, *A North Country Valley*, having by this time moved to GATESHEAD, where he lived until just short of his death. He was given his first one-man show by the town's Shipley Art Gallery in 1927, and was a contributor to its 'Contemporary Artists of Durham County' exhibition, staged in 1951, in connection with the Festival of Britain. He exhibited at the Royal Academy on only one further occasion, contributing *An Autumn Afternoon*, in 1915, but remained a regular exhibitor on Tyneside all his life, sending two works to the North East Coast Exhibition, Palace of Arts, in 1929, and enjoying a special retrospective exhibition of his work at the Shipley Art Gallery, in 1954. Towards the close of his life he exhibited mainly with the Newcastle Society of Artists. He died at Scunthorpe, Lincolnshire, while staying with his daughter. He was the elder brother of Herbert Bewick Dees (q.v.). Represented: Laing A G, Newcastle; Shipley A G, Gateshead.

DE LACY, Charles John (c.1860–1936)

Landscape, coastal and marine painter in oil and watercolour; illustrator. He was born at SUNDERLAND, the son of Robert de Lacy, photographer and music teacher, and trained as an engineer and had some experience in the Army and Navy before deciding on a career in art, and studying at Lambeth, and later South Kensington Museum, and the National Portrait Gallery. Following his studies he settled in London, where he first began to exhibit his work publicly when he sent his *The Thames from Greenwich*, to the Suffolk Street Gallery in 1885.

In 1889 he commenced exhibiting at the Royal Academy, showing: *Near the Commercial Docks: end of a Winter's Day*. He exhibited at the Suffolk Street Gallery until 1894, and the Royal Academy until 1918, and occasionally sent work to provincial exhibitions, including those of the Bewick Club, NEWCASTLE, at which his exhibit in 1892, *Cony hole derrick at Bugsby's Hole, near Woolwich*, was described in the Tyneside press as an 'extremely realistic and picturesque rendering of a busy scene'. From 1890 De Lacy increasingly concentrated on illustrative work, contributing to the *London Illustrated News*, and *The Graphic*, and also illustrating for the Admiralty and the Port of London Authority. He also produced illustrative work for *A Book About Ships*, by A. O. Cook, 1914, and *Our Wonderful Navy*, by J. S. Margerison, 1919. He is believed to have died at Cheam. Represented: Imperial War Museum; National Maritime Museum; Whitehaven Museum. [See colour plate]

DELLOW, Jeffrey ('Jeff') (b.1949)

Abstract imagist in oil and acrylic; art teacher. Dellow was born at NEWCASTLE, and studied at St Martin's School of Art; Maidstone College of Art, and the Slade School of Fine Art, following this with a Cheltenham Fellowship in the mid–1970s. He then went on to appear nationally in numerous group exhibitions, including the John Moores exhibitions at Liverpool in 1976, 1989, and 1991–2, when he was a prize-winner; the Hayward Gallery, 1980; the Whitechapel Gallery for several years up to 1991; the Curwen Gallery, in 1993, and the Sun and Doves Gallery, in 1999. He has also had one-man exhibitions at the Castlefield Gallery, Manchester, in 1988 (also in that year becoming an Athena prize-winner); the Todd Gallery, in 1989; Calder Fine Art Centre, Grand Valley State University, Michigan, USA, in 1996; the Standort Gallery, Frankfurt, Germany, in 2000, and the DeliArt exhibition, London, in 2001. Dellow began his career as a painter by joining a group of artists who worked in a cluster of studios at Greenwich from the mid–1970s, until the mid–1990s. He then moved to a more conventional studio warehouse where he has latterly become preoccupied with images he has been processing through Photoshop. In the catalogue of his one-man exhibition at Frankfurt Chris Horrocks defined the works on show by stating: 'Jeff Dellow exploits recent advances in computer technology in order to introduce new processes to his painting. His work can therefore be seen as contributing to the unfolding story of abstract painting in response to the impact of digital tools.' Dellow has since completing a two-year period teaching at Hull College of Art in 1988, been principal lecturer in painting at Kingston University (formerly Kingston Polytechnic). He lives in London. His work is represented in the collections of the Arts Council, and several university and corporate bodies in Europe and the USA. [See colour plate]

DENYER, Edwin Ely (c.1840- after 1905)

Landscape painter in watercolour; art teacher. Denyer practised as an artist and art teacher at WEST HARTLEPOOL (now HARTLEPOOL), in the second half of the 19th century, serving as headmaster of the town's School of Art until 1905. He was succeeded as headmaster by Alfred Josiah Rushton (q.v.). Hartlepool Arts & Museum Service, HARTLEPOOL, has Denyer's sepia wash: *West Hartlepool at the time of granting of the Charter of Incorporation, 1887*.

DICKINSON, John (1852–1885)

Portrait painter in oil. Dickinson was born at Merthyr-Tydfil, South Wales, where his father, an engineer from ALLENDALE, was temporarily employed on the construction of a railway. His father shortly afterwards fell ill and the family moved back to ALLENDALE, and here Dickinson remained until the age of fourteen, when he left home to become an apprentice to an engraver at NEWCASTLE. He did not like the work, however, and in 1870 left for London, where he began studying at South Kensington Museum. In 1873 he entered the Royal Academy Schools, where he received the Silver Medal for the best painting of a portrait in oil. He began exhibiting at the Royal Academy in 1876, showing a portrait study, *Contemplation*, and remained a regular exhibitor at the Academy for the rest of his life, also showing one work at the Suffolk Street Gallery, *Study of a head*. Almost all of his Royal Academy exhibits were portraits, these including artists John Charlton (q.v.), and Dickinson's cousin, Thomas Dickinson (q.v.). Although he practised in London during this period he returned to NEWCASTLE each year to carry out portrait commissions, and was an occasional exhibitor in the town. One of his works, *The Sultana*, was shown at the exhibition of paintings by local artists, at the Central Exchange Art Gallery, in 1878, a catalogue note stating: 'This, his last painting, is one of the most refined and exquisite female studies we have seen. The whole pose, tone, colour and feeling of the painting are admirable and we heartily congratulate Mr Dickinson on the lovely life-like and refined beauty of the subject.' Dickinson last exhibited at a major exhibition in 1882, showing four works at the Royal Scottish Academy. He died of consumption at the early age of thirty-two.

DICKINSON, Thomas (1854- after 1902)

Amateur portrait and landscape painter in oil. He was born at ALLENDALE, and studied art at the Government School of Design, NEWCASTLE, and under his cousin, portrait painter John Dickinson (q.v.). He did well in his examinations at the School, but decided against a career as a professional artist because of the precarious state of his health. Dickinson is best remembered for his work in promoting and organising art in Northumbria, amongst his most notable achievements being his work in helping to found the Bewick Club, and the Pen & Palette Club, at NEWCASTLE, and his association with the organisation of several major exhibitions in the city.

DICKMAN, George (born c.1898)

Landscape and coastal painter in oil and watercolour. He was born at NEWCASTLE, and practised as an

artist in the city throughout the first half of the last century. He exhibited his work at the Bewick Club, NEWCASTLE, and at the Artists of the Northern Counties exhibitions at the city's Laing Art Gallery, from 1919, until they were replaced by the Federation of Northern Art Societies' exhibitions many years later. He was for some time honorary secretary of the Benwell Art Club, in the West End of NEWCASTLE. He died at NEWCASTLE.

DIX, Harrison (b.1940)

Abstract artist in various media. He was born at NEWCASTLE, and studied art at King's College (now Newcastle University), before taking up a teaching post at Dartmouth College. During his period on Tyneside he participated in several group exhibitions, including the Artists of the Northern Counties exhibitions at the Laing Art Gallery, NEWCASTLE. This gallery has his wood relief *48 Point Regress*.

DIXON, Dudley (c.1900- after 1948)

Landscape and still life painter in oil. He was born at GATESHEAD, the son of solicitor and clerk to the County Justices, Dr J A Dixon. After completing his general education he studied at Armstrong College (later King's College; now Newcastle University), and later under Frank Spenelove-Spenelove, before practising as a professional artist, mainly in London. He first began exhibiting his work publicly in 1919, at the Artists of the Northern Counties exhibition at the Laing Art Gallery, NEWCASTLE, later sending work to the Royal Academy; the Royal Scottish Academy; the Royal Hibernian Academy; the Royal Institute of Oil Painters, and Walker's Gallery, London. The Shipley Art Gallery, GATESHEAD, has his oil: *Still-Life*, 1927. He was the brother of Joyce Deighton Dixon (q.v.).

DIXON, Elsie M, SWA (1894–1972)

Landscape and flower painter in watercolour. She was born in India, but later settled in Northumbria, near DARLINGTON. She was a founder-member of the Darlington Society of Arts, and in addition to serving on its committee was elected president in 1969. She is said to have exhibited her work at the Royal Institute of Painters in Water Colours; the Society of Women Artists (of which she was a member); the Royal Water Colour Society, and the annual exhibitions of the Darlington Society of Arts. Darlington Art Gallery has her watercolour: *Rhododendron Farges II*.

DIXON, George Pelham (1859–1898)

Seascape and landscape painter in oil and watercolour. The eldest son of George Dixon, first Librarian of TYNEMOUTH, Dixon was a self-taught artist who quickly became so proficient that he was able to offer instruction to brother artists no older than himself. He later, in fact, devoted much of his life to teaching art, serving as head master of Turton Hall College, Leeds, Yorkshire, and the Collegiate School, Morley, Derbyshire, and issuing in a private capacity an advertising card stating: 'Lessons given in sketching, oil and watercolours, practical geometry and pencil and chalk drawing'. He practised as an artist both

before and after his teaching appointments, producing many local seascapes and coastal views, usually in watercolour, and frequently in vignette form of small proportions. He was a member of both North Shields Art Club, and South Shields Art Club, and appears to have exhibited his work exclusively in Northumbria, mainly at the exhibitions of the aforementioned clubs, but also occasionally at the Bewick Club, NEWCASTLE. At South Shields Art Club in 1892, he exhibited an oil, *Frenchman's Bay*, and at the Bewick Club in 1894, a watercolour, *Twixt Tyne and Wear*. South Shields Museum and Art Gallery has several of his works in watercolour, including *Tynemouth; North Shields in the distance*, painted in the year of his death at SOUTH SHIELDS.

DIXON, John, MA (1835–1891)

Amateur marine painter in watercolour. He was born at NEWCASTLE, and following his education at Dr Bruce's School in the town, served an engineering apprenticeship with Robert Stephenson & Co. On leaving Stephenson's he obtained an appointment as an engineer to the Derwent Iron Co., at CONSETT, leaving the company some time later to go into partnership with a Mr Mounsey, at BEDLINGTON, in an attempt to revive the prestige of the iron works long associated with the town. Their attempt failed, and in 1867 Dixon moved to London to work as a civil engineer and contractor. His success in his chosen new profession was phenomenal, and in the next twenty-four years he was responsible for major civil engineering works in various parts of the world, including a bridge across the Nile at Cairo, piers in Mexico, and in 1874 the construction of the first railway in China, between Shanghai and Woosung. He also handled projects in Portugal, Gibraltar, and Britain, but perhaps his most famous undertaking was the transportation from Alexandria to London of Cleopatra's Needle. Dixon was evidently a keen spare-time painter throughout his life, though not until he was working in London did he seriously begin to exhibit his work. In the period 1880–87, he sent four works to the Suffolk Street Gallery, one work to the Royal Institute of Painters in Water Colours, and three works to the Dudley Gallery. Most of these works were marine paintings, some of which were executed while he was working abroad on his civil engineering projects. Towards the end of his life failing health sent him to South Africa to recover. His health did not improve there, however, and returning to London, he died at East Croydon in 1891. Dixon received several honours in his lifetime; he was Deputy Lieutenant of the City of London, and received an honorary Master of Arts degree from Durham University. His name appears on the bronze tablet at the foot of Cleopatra's Needle, in London.

DIXON, John (1869- after 1937)

Landscape, portrait and flower painter in oil and watercolour. Dixon was born at SEATON BURN, and received his tuition in art at NEWCASTLE, and later St. John's Wood, London, and the Royal Academy Schools. On returning to Northumbria he settled at MORPETH, and began exhibiting his work at the

Bewick Club, NEWCASTLE. At the age of thirty he sent his first work to the Royal Academy, *Wild Roses*, and in 1905 contributed the first of his many works to the Artists of the Northern Counties exhibitions at the Laing Art Gallery, NEWCASTLE: *Autumn Gold*, and *Wind in the Valley*. He did not resume exhibiting at the Royal Academy until 1926, when he contributed a portrait, *Mrs Duncan*. He last exhibited at the Academy in 1937, when his contribution was *Mrs Dorothy M Osborne*. Dixon continued to contribute to the Artists of the Northern Counties exhibitions until close to his death, mainly showing landscapes. Represented: Laing A G, Newcastle.

DIXON, John Turnbull (c.1846- after 1921)

Amateur landscape painter in oil and watercolour; illustrator. He was the son of William Dixon, village draper at WHITTINGHAM, near ALNWICK, and brother of David Dippie Dixon (1842–1929), author of *The Vale of Whittingham*, and *Upper Coquetdale*, published in NEWCASTLE. Both brothers worked for their father's business of Dixon & Sons, ROTHBURY, from its opening in 1862, David spending much of his spare time preparing the texts for his books, John, the illustrations, most of which were in line. John also painted considerably in his spare time, contributing work to several exhibitions at NEWCASTLE, notably the Bewick Club exhibition of 1891, at which he showed an oil, *St Mary's Isle, near Whitley; a storm in the offing*, and the Artists of the Northern Counties exhibition at the Laing Art Gallery in 1921, at which he showed a watercolour, *An incoming tide*. Both works were contributed to these exhibitions from ROTHBURY, his home for most of his life. Several examples of his work may be seen at Cragside, the former home of the Armstrong family at ROTHBURY, courtesy of the National Trust.

DIXON, Joyce Deighton (c.1899- after 1950)

Landscape, portrait and flower painter in oil and watercolour. She was born at GATESHEAD, the daughter of solicitor and clerk to the County Justices, Dr J A Dixon. After completing her general education she studied art at Armstrong College (later King's College; now Newcastle University), and later under Frank Spenelove-Spenelove, before practising as a professional artist, mainly in London. She first began exhibiting her work publicly in 1919, when she sent examples to the Artists of the Northern Counties exhibition at the Laing Art Gallery, NEWCASTLE, and to several other provincial exhibitions. She subsequently exhibited widely in Britain, showing her work at the Royal Scottish Academy; the Royal Hibernian Academy; the Royal Cambrian Academy; the Royal Institute of Oil Painters; the Society of Women Artists, and in 1950, at the Royal Academy, at which her *Snow in Chelsea*, was shown. She also exhibited at the Paris Salon in 1923. She shared a studio for some years in London with her brother, Dudley Dixon (q.v.). Represented: Shipley A G, Gateshead; South Shields Museum & A G.

DIXON, William (died c.1830)

Portrait and landscape painter in oil and watercolour. This artist first came to prominence in Northumbria about 1816, when jointly with Thomas Miles Richardson, Senior (q.v.), he embarked on the publication of a series of aquatint illustrations of places of interest in NEWCASTLE. He published further illustrations in this form in 1819 and 1820, covering Northumberland, and showing his address as London, but by 1822, and exhibiting at the First Exhibition of the Northumberland Institution for the Promotion of the Fine Arts, NEWCASTLE, he was describing himself as a resident of both NEWCASTLE, and London. His exhibit at the Institution was a portrait of Francis Humble, newspaper proprietor of DURHAM, Dixon not only contributing to the exhibition, but serving on its committee, along with Richardson, Senior, Thomas Bewick (q.v.), Henry Perlee Parker (q.v.), John Dobson (q.v.), and others. These circumstances, coupled with the type of work which he subsequently exhibited at NEWCASTLE, suggest that he may have been the William Dixon who commenced exhibiting at the Royal Academy in 1796, and the British Institution in 1808, while working in London. Certainly Dixon was known to have been a member of the Kensington Gravel Pits Colony in London, and a protégé of Mulready. He was also a friend of John Linnell (1792–1882), and received a visit from Linnell at NEWCASTLE in 1817 during which he introduced this former pupil of Varley to Richardson, Senior. Dixon's involvement in the artistic activities of the area were not to last long, however. He continued to exhibit at the Institution at NEWCASTLE, for a number of years, and also exhibited at the town's Northern Academy in 1828, but must have died shortly after the latter exhibition, as he did not show his work again. Dixon lived successively at NEWCASTLE, DURHAM and SUNDERLAND, during his exhibiting period at NEWCASTLE, and showed mainly portraits and landscapes, among the former a portrait of Joseph Sébastien Victor Francois Bouet (q.v.), and the latter, the *Ruins of Finchdale Priory*, and *View on the River Wear*. He also in this period collaborated with John Dobson (q.v.), in producing a stage drop-scene for the old theatre at NEWCASTLE. His work was occasionally exhibited at NEWCASTLE after his death, notably at the exhibition of the Newcastle Society of Artists, in 1836, in the catalogue of which he was described as 'Dixon, Wm., the late', and the exhibition of works by local painters, at the Central Exchange Art Gallery, in 1878, comprising a portrait of John Dobson, and a landscape.

DIXON, William (1881–1964)

Figure and portrait painter in watercolour; draughtsman; cartoonist and caricaturist. Born on Tyneside, Dixon became a largely self-taught artist who worked principally for the *Newcastle Weekly Chronicle*, NEWCASTLE. He was a keen spare-time painter, however, and exhibited examples of his watercolours and drawings at the Artists of the Northern Counties exhibitions at the Laing Art Gallery, NEWCASTLE, from 1909 until the late 1940s. Dixon produced hundreds of political and sporting cartoons during his professional

career, and claimed to be the originator of the famous Magpie figure in its man-like form (it had previously appeared as the symbol of the Newcastle United Football Club, as a black and white bird). He also produced a series of Tyneside characters and illustrated local songs. Failing eyesight eventually obliged him to give up drawing and painting.

DOBBIN, John (1815–1888)
Landscape and architectural painter in oil and watercolour; mosaic artist. Dobbin was born at DARLINGTON, the son of a weaver, and at the age of fourteen was apprenticed to a town cabinet-maker. While serving his time he took some lessons in watercolour painting from George Richardson (q.v.), who was then teaching in the town, but appears to have received no further tuition in art before exhibiting his first work at NEWCASTLE in 1836, at the Newcastle Society of Artists exhibition. By 1842 he had moved to London, where he commenced exhibiting at the Royal Academy, showing a landscape, *Loch Catrine, Scotland*. In the following year he sent his first work to the Suffolk Street Gallery, (three watercolours of Northumberland scenery), and in 1851 commenced exhibiting at the British Institution, showing *On the Skerne, Darlington*. He remained a regular exhibitor at the Royal Academy until 1875, and showed work at the British Institution for four years. He mainly exhibited at the Suffolk Street Gallery, however, showing some 102 works between 1843, and four years before his death. Most of his exhibited work was in watercolour, and included subjects painted in Holland, France, Spain and Germany, as well as in Scotland and his native Northumbria. Most of Dobbin's professional life was spent in London, but he made frequent visits to his home town, one of these resulting in a commission to paint probably his best known work: *Opening of the Stockton and Darlington Railway, A.D.1825*. This large watercolour, painted in 1871, was first exhibited at DARLINGTON in 1875, and has since become one of the most widely reproduced images of railway history in the world. The painting has an intriguing history, however, which is fully explored in *Tracking the history of railway's greatest painting*, Marshall Hall, *Durham Town & Country Magazine*, Winter, 1999. In the late 1860s Dobbin began making a large mosaic of the *Last Supper*, cutting all the pieces himself. It is believed that he intended to offer it to Westminster Abbey but that after its rejection by the dean, he offered it to St Cuthbert's Church, DARLINGTON. Here it was duly installed as a reredos to the Church in 1875, followed three years later by two smaller mosaics featuring *The Three Marys*, and *The Walk to Emmaus*, which now form side panels to this work. His use of hand shears to cut the pieces of the mosaics is said to have seriously affected the use of his right wrist, and may account for the relative infrequency with which he exhibited work in the period after 1875. He died in London, and was buried in Brompton Cemetery. A large exhibition of Dobbin's work was held at the Myles Meehan Gallery, DARLINGTON, in 1996, accompanied by an excellent account of his life and work by then curator of the Darlington Museum & Art Collections, Allan Suddes BA, under the title *A Grand Tour*. Represented: Victoria and Albert Museum; Cartwright Hall, Bradford; Darlington A G; Shipley A G, Gateshead; Sunderland A G.

DOBSON, Alexander Ralph (1826–1854)
Architectural draughtsman. He was born at NEWCASTLE, the youngest son of John Dobson (q.v.), and received his first tuition in drawing from his father. He later decided to follow his father's profession as architect, and was placed as a pupil under Sydney Smirke (his brother-in-law, and later Royal Academician), in London. He worked diligently at his studies under Smirke, and gained the First Prize for Architecture (Fine Arts), and First Prize for Architecture (Construction), from University College, London. In 1852 he returned to NEWCASTLE and joined his father's practice. He died two years later in an explosion at GATESHEAD. It is said that he was 'favourably known in his profession for some clever drawings'.

DOBSON, Edward Scott (1918–1986)
Representational and abstract painter in oil and watercolour; printmaker; collagist; cartoonist; art critic. He was born at BLYTH, and studied art at Armstrong College (later King's College; now Newcastle University); at Freckleton in Lancashire, and Leeds College of Art, before becoming a teacher of art at Manchester Grammar School. On returning to Northumbria he taught at various local authority schools and began to exhibit his work extensively, showing examples at the Redfern Gallery; the New Vision Gallery; the Chenil Gallery; the Royal Society of British Artists; the New English Art Club; the Royal Institute of Painters in Water Colours; the Royal Scottish Academy; the Artists of the Northern Counties exhibitions at the Laing Art Gallery, NEWCASTLE, and the city's Westgate Gallery, founded by himself in 1960. In addition to teaching in the North East of England Dobson also lectured on art for the Workers' Educational Association. He also served as art critic for the *Evening Chronicle*, NEWCASTLE, and the *Arts Review*, London, for a number of years, and from 1970 wrote and illustrated a succession of books under the title *Larn Yersel Geordie*. He travelled widely throughout his life, visiting the Far East, Africa, France, Germany, Italy, Spain, Greece, Poland and Norway. He was particularly fond of the island of Gozo, off the tip of Malta, and spent most of his final years living there, and at his home at SOUTH SHIELDS. He died on Gozo and was buried there. Dobson was one of the most colourful and best known artists of Northumbria of the mid–20th century, an outspoken art critic, and energetic gallery owner who brought the work of many fellow artists to the attention of a wider public. Represented: Laing A G, Newcastle; Shipley A G, Gateshead.

Edward Scott Dobson, *David Hinge*, 1962, oil, 73 x 49cm. Private collection.

DOBSON, Eric (1923–1992)

Representational and abstract painter in oil; art teacher. Dobson was born at TUDHOE, near SPENNYMOOR, and after gaining a scholarship to Dame Allan's School, NEWCASTLE, went on to study art at King's College (now Newcastle University). His studies were interrupted by service in the Royal Navy during the Second World War, and after completing them in 1950 he stayed on at the College as a tutorial student under Lawrence Gowing, Roger de Grey and Christopher Cornford. He later became a full-time member of staff at Newcastle University, remaining there until 1989, and running a virtually one-man education course. In addition to his work as one of the most influential art teachers of his period Dobson was a keen painter who regularly throughout the 1950s and 1960s, participated in group exhibitions in London, Paris, and at the Artists of the Northern Counties exhibitions at the Laing Art Gallery, NEWCASTLE. An accidental head injury in 1988 resulted in surgery, and his retirement from the University. He died in 1992, and a memorial exhibition of his work both representational and abstract was held at the University of Northumbria Gallery, NEWCASTLE, in 1994. The Euston Road Group, and especially the work of Victor Pasmore are said to have been the principal influences evident in the work included. [See colour plate]

DOBSON, Mrs Isabella (née Rutherford) (1795–1846)

Amateur miniature painter. She was born at GATESHEAD, the eldest daughter of Alexander Rutherford of Warburton House, and in 1816 became the wife of John Dobson (q.v.). Details of her early artistic training are not known, but by 1828, and exhibiting portraits at the Northern Academy, NEWCASTLE, and the Carlisle Academy, she had obviously achieved some competence as an artist. She exhibited little after 1828, though a miniature of her sister, Anne Rutherford (shown at the Northern Academy, in 1828), was included in the exhibition of work by local painters, at the Central Exchange Art Gallery, NEWCASTLE, in 1878. Her daughter, Margaret Jane Dobson, in a memoir of Dobson published in 1885, refers to her as 'a lady of great artistic talent, her miniature painting being far beyond ordinary amateur work'. Her son, Alexander Ralph Dobson (q.v.), was also talented artistically. She died at NEWCASTLE.

DOBSON, John (1787–1865)

Architectural and landscape painter in watercolour; draughtsman. Born at NORTH SHIELDS, the son of a gardener, Dobson is best known as one of Northumbria's most outstanding architects of the 19th century. He was, however, also a superb architectural draughtsman, and one who showed a talent for drawing from his earliest years. Indeed, at the age of eleven he was appointed 'Honorary Draftsman' to a well-known local damask weaver, and four years later we find him being welcomed as a pupil of architect and builder David Stephenson, at NEWCASTLE, and taking lessons in drawing from Boniface Muss (q.v.), along with John Martin (q.v.). He also had ambitions as a watercolourist, and on completing his studies with Stephenson by 1810, he went to London to study under no less a master of the art than John Varley. He remained with Varley for several months and developed a close friendship with his master, and several other leading artists of the day, including Robert Smirke, the painter Royal Academician, whose son was later to marry Dobson's eldest daughter. Back at NEWCASTLE no later than 1811, Dobson did not pursue his ambitions as watercolourist, but set-up in the town as an architect. That he remained attached to his early love of drawing and watercolour painting, however, is evidenced by the many works which he subsequently exhibited, albeit sometimes assisted in the latter respect by other artists. His first exhibit of note was his *Perspective View of Seaton Delaval House*, sent to the Royal Academy in 1818, this work attracting considerable attention because of its novelty as a coloured perspective drawing. He again chose Seaton Delaval Hall, when he next exhibited his work, this time as a founder and committee member of the Northumberland Institution for the Promotion of the Fine Arts, at its first exhibition at NEWCASTLE, in 1822. At the First Exhibition of the Northern Academy, NEWCASTLE, in 1828, he showed his design for one of his earliest important ecclesiastical commissions, *The Chapel of*

John Dobson,
Seaton Delaval Hall,
watercolour, 56.5 x 90cm.
Tyne & Wear Museums,
Laing Art Gallery.

St. Thomas, for the Haymarket area of the town, and at the Carlisle Academy, in the same year, two of his other designs for buildings. He continued to exhibit at NEWCASTLE throughout his rise to prominence as the town's most respected architect, and again in the Royal Academy in 1850, showing *The Arcades and Portico, Central Station, Newcastle upon Tyne*. The most notable occasion on which he exhibited at NEWCASTLE was in 1838, when he showed no fewer than fifteen of his drawings, mainly of buildings which he had designed. In some of his exhibited work he collaborated with John Wilson Carmichael (q.v.), the latter providing the figures, and frequently the colouring. In another instance of artistic collaboration he worked with William Dixon (q.v.), in the production of a stage drop-scene for the old theatre, NEWCASTLE, which was so successful that a copy of it was used at Drury Lane, London, for many years. Dobson took an active interest in art promoting activities at NEWCASTLE for much of his life, and as one of the area's most respected architects, and fellow of the Royal Institute of British Architects, was the natural choice as first president of the Northern Architectural Association. He suffered a stroke in 1863, and retired to RYTON. He later returned to NEWCASTLE, where he died at his home in the town's New Bridge Street in 1865. His wife Isabella Dobson (q.v.), and son Alexander Ralph Dobson (q.v.), were also talented artistically. An exhibition to celebrate the bicentenary of Dobson's birth was held at the Laing Art Gallery, NEWCASTLE, in 1987, accompanied by an excellent account of his life and work by Tom Faulkener and Andrew Greg. A further exhibition containing many examples of his watercolours was held in 2001–2002, to coincide with the publication of a revised edition of the book by Tyne Bridge Publishing, under the title *John Dobson, Architect of the North East*. Represented: British Museum; Laing A G, Newcastle; National History Society of Northumbria, Newcastle.

DODD, Barrodail Robert (fl. early 19th cent.)
Amateur portrait painter; copyist. Dodd was born on Tyneside, and practised as a civil engineer, engineer and architect at NEWCASTLE in the early 19th century. He was evidently a keen painter of portraits in his spare time, at the First Exhibition of the Northumberland Institution for the Promotion of the Fine Arts, NEWCASTLE, in 1822, showing two such works, *The Late Henrietta A. Dodd*, and *Portrait of a Lady, after Sir Thomas Lawrence*, and at the Institution's exhibition in the following year, *The Misses Ella, Eliza and Mary Ann Dodd*. Thomas Miles Richardson. Senior (q.v.), was once occasioned to defend Dodd in a letter to the *Tyne Mercury* (29th November, 1823), when Dodd's visit to an exhibition of the Institution to make notes of colours in the paintings on view was criticised in the press as copying. He does not appear to have exhibited his work after this criticism, concentrating instead on his work as civil engineer, etc. He may have been the son of Robert Dodds (q.v.), despite the different spelling of this artist's name.

DODDS, Robert (fl. late 18th, early 19th cent.)
Amateur portrait painter. Mackenzie, in his *History of Newcastle*, Volume II. p. 585, states that 'a portrait of Mr Bewick, when in the prime of life, by the late Robert Dodds, engineer, is now in the possession of his son, R B Dodds, of Newcastle, civil engineer'. The 'R B Dodds' referred to in connection with this portrait of Thomas Bewick (q.v.), may have been Barrodail Robert Dodd (q.v.).

DOWDEN, Edward (b.1950)
Landscape painter in oil and watercolour; art teacher. Born at London, Dowden moved to NEWCASTLE in 1969 to read architecture at Newcastle University. On leaving the University in 1972 he became a full-time professional artist with a studio in the Tyne

Valley, near HEXHAM, holding his first one-man exhibition at Wallsend Arts Centre, WALLSEND, near NEWCASTLE, in 1975. Following this he spent three years preparing some 138 paintings and pencil drawings depicting views of the River Tyne from its mouth to its sources. These were shown at the Hatton Gallery, NEWCASTLE, in 1978. He later moved to Wiltshire where he continued to practise as a professional artist, and occasional part-time art teacher, showing his work widely in Britain in a number of one-man and group exhibitions. He has also worked extensively on commissions, and illustrated a number of books. He has since moved to live in North Yorkshire.

DOWELL, Samuel (fl. early 20th cent.)
Amateur landscape painter in oil and watercolour. This artist was a regular exhibitor at the Artists of the Northern Counties exhibitions at the Laing Art Gallery, NEWCASTLE, from 1922–1939, showing a variety of local landscapes. These included views along the Wansbeck and Tyne valleys and were contributed while he lived successively at WHITLEY BAY and MONKSEATON.

DOXFORD, James, ARWA ATD (1899–1978)
Landscape, portrait and flower painter in oil and watercolour; art teacher. Doxford was born at NORTH SHIELDS and studied art at Armstrong College (later King's College: now Newcastle University), under Richard George Hatton (q.v.), and E M O'Rorke Dickey, before practising as a professional artist in his native town until the early 1930s. During this period he became a regular exhibitor at the Artists of the Northern Counties exhibitions at the Laing Art Gallery, NEWCASTLE, showing a wide variety of work in oil and watercolour. He was later appointed principal of Bridgwater (and later) Barnstaple Art and Technical Schools, and in 1945 took up the post of head of the art department of the Grammar School at GATESHEAD, remaining there until his retirement in 1964. He exhibited his work at the Royal Academy on five occasions from 1939, and also showed his work widely in the provinces. Three of his works in oil, *Myself, Vera Gomez* and *Asters*, were included in the 'Contemporary Artists of Durham County' exhibition at the Shipley Art Gallery, GATESHEAD, staged in 1951, in connection with the Festival of Britain. He was an associate of the Royal West of England Academy, and was a holder of the Art Teachers' Diploma. Following his retirement he moved to Canterbury. He died at Canterbury. Represented: Shipley A G, Gateshead.

DRESSER, Alfred B (d.1939)
Landscape and architectural painter in watercolour; draughtsman: art teacher. He was born at DARLINGTON, the son of William Dresser, well-known printer and stationer in the town. He was a talented artist from his youth, and after training at the Slade School of Fine Art taught art at Darlington Grammar School, and the town's Ladies' Training, and Technical colleges. Throughout much of his life as a teacher he maintained a studio at Blackwellgate, DARLINGTON, and

James Doxford, *Vera Gomez*, oil, 76 x 51cm.
Tyne & Wear Museums, Shipley Art Gallery.

regularly showed his work at the exhibitions of the Darlington Society of Arts. He died at DARLINGTON. He was the elder brother of George Cuthbert Dresser (q.v.). His grandfather WILLIAM DRESSER was also artistically talented. Represented: Darlington Public Library.

DRESSER, George Cuthbert (1872–1951)
Amateur landscape painter in watercolour. He was born at DARLINGTON, the son of William Dresser, well-known printer and stationer in the town. Although a talented artist from an early age, Dresser preferred to become a structural draughtsman with a local firm rather than paint and draw for a living, and thereafter pursued these activities only as a relaxation. He occasionally exhibited his work at the Royal Institute of Painters in Water Colours, and was a regular exhibitor at the exhibitions of the Darlington Society of Arts, of which he was also a lifelong member. He died at DARLINGTON. He was the younger brother of Alfred B Dresser (q.v.). Represented: Darlington A G.

DRINKWATER, F H C (1862–1949)
Landscape painter in oil. He was the son of Northwich artist JAMES FREDERICK DRINKWATER (1820–1893) and practised at SUNDERLAND in the latter part of the 19th century, and the early years of the 20th century, mainly producing oils of scenes along the River Wear. He was the great-uncle of G Nevin Drinkwater, sometime chief assistant curator of Sunderland Museum. Sunderland Art Gallery has his *Girdle-Cake Cottage on the River Wear*, dated 1899.

DUCKETT, Lewis, ARCA (b.1892)

Landscape painter in oil and watercolour. He was born at SUNDERLAND and after studying at the Royal College of Art, became principal of the Northampton School of Art. He later moved to Yelverton, Devon, where he became a member of the Plymouth Art Society. In 1950 he exhibited five works with the Society, including a horse portrait and some watercolour views of Dartmoor.

DUNBAR, David, Senior (1782–1866)

Sculptor. Dunbar was born at Dumfries, the son of a stonemason, and became an apprentice to his father at the age of fourteen. By the age of seventeen he had become so proficient as a sculptor that he was carrying out the carving of capitals and other decorative parts of Lowther Castle in Cumbria. Later he entered the studio of Sir Francis Chantrey in London, remaining there some nine years and beginning to exhibit at the Royal Academy. Moving to Carlisle by 1822 he became one of a small group of local artists responsible for founding the Carlisle Academy. He sculpted a figure for a niche above the archway of the building, and showed twelve works at its opening exhibition in 1823. He remained a regular exhibitor at the Academy until exhibitions ceased in 1833, and also in this period showed his work at NEWCASTLE, Dumfries, Birmingham and Leeds. In 1830 he decided to move to NEWCASTLE, and here over the next decade became one of Northumbria's best known sculptors – notwithstanding an early embarrassment in having his *Musidora* rejected by Thomas Miles Richardson, Senior (q.v.) and Henry Perlee Parker (q.v.), from the town's Northern Academy on the grounds of its 'indecency'. This prompted him to mount his own exhibition at his studio in NEWCASTLE: 'Mr Dunbar's Exhibition of the Works of Foreign and British Sculptors'. Comprising some 160 works including ones reputedly by Canova, Pisano and Michelangelo, as well as by leading contemporary British sculptors (among these himself) it proved so successful that later in the year he staged another exhibition in DURHAM, and in 1832, a third at the Royal Arcade, NEWCASTLE. By the middle 1830s Dunbar had patched up his differences with Richardson and Parker and had become a regular exhibitor at their exhibitions. In fact by 1835 he had become so reconciled with them that, as a member of the Newcastle Society of Artists, he produced a leaflet publicising the Society's exhibitions. Controversy seemed to dog him, however, and in the same year he became embroiled in a dispute with the town's Westgate Hill Cemetery Committee over their rejection of his proposed bust of local schoolmaster John Bruce, in favour of one by Benjamin Green (q.v.), which led to success for the latter, and Dunbar's condemnation as 'a disappointed and misanthropic Plaster of Paris Face Maker'. This was followed by something of a downturn in his career on Tyneside, and he showed fewer examples of his work locally. By 1842 he had left NEWCASTLE, and spent the remainder of his career 'travelling the length and breadth of Britain to carry out commissions' before dying in Dumfries in 1866. Dunbar was one of the most accom-

David Dunbar, Senior, *Grace Darling*, 1838, marble, 63.5cm high. National Portrait Gallery, London.

plished sculptors working in Northumbria in the early 19th century, his main *forte* being the production of busts of local celebrities, notable among which was his bust of Grace Darling, of 1838. Dunbar was one of the several Northumbrian artists who sought sittings for portraits of Grace and her father immediately after the famous rescue of the crew of the Forfarshire, on 7th September, 1838, and by the 27th October was advertising plaster busts of both, cast from his marble originals sculpted shortly after the event. He was the only sculptor among the local artists who produced likenesses, and his bust of Grace is in the collection of the National Portrait Gallery. Another and larger likeness of note is his life-size marble figure of Robert Hooper Williamson, Recorder of Newcastle, which stands in St Nicholas Cathedral, NEWCASTLE, and was executed following Williamson's death in 1837. For part of the time that Dunbar worked in NEWCASTLE he was accompanied by his son DAVID DUNBAR, JUNIOR. Father and son occasionally showed work together at local exhibitions, the latter subsequently moving to London to pursue his career. Represented: National Portrait Gallery; Carlisle A G; Literary & Philosophical Society, Newcastle; University College, University of Durham.

DUNCAN, John (c.1846- after 1898)

Bird painter in oil and watercolour; illustrator; lithographer; glass painter. He was the son of Robert Duncan, taxidermist, of NEWCASTLE, and at the age of fourteen was apprenticed to William Wailes (q.v.), at his stained glass manufactory in the town. Like many

John Duncan, *The Magpie*, watercolour, 33 x 23cm. Private collection.

of Wailes' apprentices he attended the Government School of Design in the town under William Bell Scott (q.v.), later working for his master, and for the firm of Wailes & Strang, for more than forty years. Duncan was interested in making studies of birds in oil and watercolour from his teens, this leading to a commission from the *Newcastle Weekly Chronicle*, about 1888, to produce a series of pen and ink drawings of British birds for reproduction in its pages. The series ran for almost ten years, proving so successful that his drawings and accompanying texts were published as a limited edition book entitled *Birds of the British Isles*, in 1898 (many of these drawings and texts also appeared in the locally printed *Monthly Chronicle of North Country Lore and Legend*, 1887–1891). Duncan occasionally exhibited his work at NEWCASTLE, one of his earliest exhibits being the chalk study of a Greenland Falcon which he sent to the 'Exhibition of Paintings and other Works of Art', at the Town Hall, in 1866. In addition to his illustrative work in pen and ink, he produced work in lithography. His work for Wailes was widely used in Britain, and the USA. The Natural History Society of Northumbria, NEWCASTLE, has examples of his work.

DUNKLEY, Keith (b.1942)
Landscape painter in oil and watercolour; art teacher. He was born at CORBRIDGE, and studied at Kingston School of Art, then the Royal Academy Schools, before teaching at Sheridan College, in Canada. He exhibited at the Royal Academy in 1966 and 1969, and at the Royal Water Colour Society during his period of membership of that body. He also showed elsewhere in Britain and from 1978 had a series of one-man exhibitions with John Davies, in Stow-on-the-Wold. He painted in the Scottish Borders, France, and elsewhere on the Continent, and lived at Edinburgh.

DUNNING, John Thomson, RBA (1851–1931)
Landscape and figure painter in oil and watercolour. Dunning was born at MIDDLESBROUGH, and was educated at Ackworth Quaker School in Yorkshire, before studying art at Heatherley's School, and in Exeter. On completing his art training he settled in London, and commenced exhibiting his work at various London and provincial exhibitions, including among the latter those of the Bewick Club, NEWCASTLE. He later exhibited mainly at the Suffolk Street Gallery, also sending works to the Royal Academy; the Royal Scottish Academy; the Royal Hibernian Academy; the Royal Institute of Painters in Water Colours, and to a wide range of London and provincial galleries. He was elected a member of the Royal Society of British Artists in 1899, and appears to have spent most of his professional life based in London, while painting landscapes widely throughout southwest England, and other parts of Britain. Dunning was an occasional illustrator in his early years, and published *Middlesbrough in 1885*, containing many of his drawings. He also illustrated *The Fairyland of Dartmoor*, and *The Two Pools*. Represented: Middlesbrough A G.

John Thomson Dunning, *A Stitch in Time*, oil, 49 x 34cm. James Alder Fine Art.

DYSON, John William (1855–1916)
Landscape and figure painter in oil and watercolour; architectural draughtsman. Dyson was born at Addingham, in Wharfedale, and was trained as an architect under William Vickers Thompson, of BISHOP AUCKLAND. On completing his training he set up practice at NEWCASTLE, later becoming a founder-member of the Bewick Club in the city, and serving in various capacities on its committees. He was a keen spare-time painter when not involved in his architectural design work for local public and private buildings, and exhibited his work regularly at the Bewick Club until his death at NEWCASTLE in 1916.

E

EAST, Mary Margaret – see ANDERTON, Mrs Mary Margaret

EASYDORCHIK, Edwin (b.1949)
Abstract artist in mixed media; art teacher. Easydorchik was born in Northumberland and studied at the Central School of Art, London. In 1971 he won a James Knott Travelling Scholarship, travelling to Italy, following which he was a postgraduate painter at Newcastle University. From 1974 he held several part-time lectureships, and from 1982 lectured in painting full time at the University. Easydorchik early displayed an interest in abstract compositions using a variety of materials and from 1970 took part in many group shows, including the Young Contemporaries in that year; Sunderland Arts Centre and tour, 1975; the XI Paris Biennale, 1980, and Six Artists from the Coast, Laing Art Gallery, NEWCASTLE, 1983. He also enjoyed a one-man exhibition at Sunderland Art Gallery in 1978, entitled *The Eight Passions* (or Eight Painted Panels) which represented the most important showing of his work while he was living in Northumbria. Produced specially to fit the exhibition space of the gallery the wholly abstract 'paintings' (based on allusions to the Marquis de Sade) were executed in a combination of 'thick graphites and chalks with fine cement, oxides and acrylics – together with rich and savage colours', and attracted considerable publicity. A two-man exhibition with Duncan Newton was held at the Waterloo Gallery, London, in 1979, and Easydorchik later went on to enjoy one-man exhibitions at Sunderland Arts Centre, and the Atlantis Gallery, in 1983. He spent much of his life in Northumbria based at TYNEMOUTH, but has since lived in Australia. The Arts Council holds several of his drawings.

EBDON, Christopher (d.1824)
Topographical artist. Ebdon practised as a topographical artist and architect after working as a pupil of James Paine. He produced several drawings of work executed by his master, including Paine's design for the principal front of Gibside Chapel, reproduced in the architect's *Plans, elevations and sections of noblemen and gentlemen's houses*, 1767, and 1783. He mainly practised in County Durham.

ECKHARDT, Oscar, RBA (1872–1904)
Landscape painter in oil; illustrator. He was born at SUNDERLAND, but early in his life moved to London. Here he practised as a professional artist until his death at the early age of thirty-two, establishing considerable success in his brief career as painter and illustrator. He exhibited at the Royal Society of British Artists' exhibitions from the age of twenty-four, showing some eighteen works prior to his death. He also exhibited at the Royal Institute of Oil Painters, and at the Walker Art Gallery, Liverpool. He worked for numerous publications as a pen and ink illustrator between 1893–1900, including: *The Butterfly*, 1893; *The Daily Graphic*, 1895; *The St. James's Budget*, 1898, and *Illustrated Bits*, 1900. He was elected a member of the Royal Society of British Artists in 1896. Represented: Victoria and Albert Museum.

EDDOWES, W K (fl. early 19th cent.)
Amateur religious and landscape painter in oil. Eddowes practised in Northumbria in the early 19th century, and was evidently a man of some means who painted in his spare time. He exhibited two examples of his work at the Northern Academy, NEWCASTLE, while living at SOUTH SHIELDS, these being *A Magdalen*, in 1828, and a *Landscape*, in 1829. He later moved to TYNEMOUTH, but does not appear to have continued exhibiting while there, although he remained keenly interested in the exhibitions at NEWCASTLE, buying from one of these the *Tynemouth* exhibited by George Balmer (q.v.). He was a collector of works of art, and owned examples by Dürer, and Van Huysum. It is said that he spent his later life at SOUTH SHIELDS.

EDEN, Sir Timothy Calvert, 8th Baronet, West Auckland (1893–1963)
Amateur flower and still life painter in oil and watercolour. The son of Sir William Eden (q.v.), he was born at Windlestone Hall, near BISHOP AUCKLAND, and received his education at Eton, and later Christ Church College, Oxford. In the period 1914–16 he was interned as a prisoner at Ruhleben, Germany, in the middle of this period succeeding to the Baronetcy, on the death of his father. On returning to England he enlisted in the Army, serving until the end of the First World War. He also served in the Second World War, 1939–43, as a staff captain. Like his father, Sir Timothy was a talented amateur artist and may, indeed, have received some tuition from Sir William, as a young man. He exhibited his work mainly at Arthur Tooth & Sons' Gallery, in London, also sending several works to the Alpine Club Gallery, and to the Artists of the Northern Counties exhibitions at the Laing Art Gallery, NEWCASTLE. He also wrote several books, among these *Five Dogs and Two More*, 1928; *The Tribulations of a Baronet* (a biographical work concerning his father), 1933, and *Durham*, 1952. He was the elder brother of Sir Anthony Eden, later 1st Earl of Avon.

EDEN, Sir William, 5th Baronet Maryland, North America, 7th Baronet, West Auckland (1849–1915)
Amateur landscape painter in watercolour. He was born at Windlestone Hall, near BISHOP AUCKLAND, son of SIR WILLIAM EDEN (1803–1873), 4th BARONET OF MARYLAND, NORTH AMERICA, and 6th BARONET OF WEST AUCKLAND, a talented amateur artist. He was educated at Eton, where his early attempts to draw and paint were encouraged by Sam Evans. It was not, however, until some thirteen years after leaving Eton to prepare for the Army that he began to paint seriously, and then only because an ankle injury kept him from his duties as a lieutenant in the 8th Hussars. He began taking lessons from Nathaniel Everett Green, later painting

much in the company of this artist, David Green, Alfred East, and others. He also went to Paris, where he spent time in the studios of James Abbott McNeill Whistler, and Jacques Blanches. Sir William sketched widely around the world, touring Europe at the age of seventeen, and later visiting among many countries, Egypt, Algeria, India, China, Japan, and the USA. He exhibited his work in London and Paris, showing some 133 examples at the Goupil Gallery, more than 100 at the Dowdeswell Gallery, and twenty-two at the New English Art Club, apart from sending occasional works for exhibition at the Royal Institute of Painters in Water Colours; the International Society, and the London Salon. On the conclusion of his service in the Army as Colonel in Command of the 2nd V.B. Durham Light Infantry 1889–96, he took an increasing interest in the sporting life of his county, adding to his already established reputation as a boxer, that of fox-hunter and field sportsman. His son, Sir Timothy Calvert Eden (q.v.), was also a talented amateur artist, and wrote a number of books, among these one about his father, *The Tribulations of a Baronet*, 1933, in which reference is made to Sir William's famous legal battle with Whistler, which became known as the 'Baronet and the Butterfly' lawsuit. Represented: Laing A G, Newcastle.

ELGOOD, Thomas Scott (fl. late 19th, early 20th cent.)

Landscape painter in watercolour. This artist practised in Northumbria for several years in the last quarter of the 19th century. He later practised at Birmingham, where he occasionally exhibited his work at the city's Royal Birmingham Society of Artists exhibitions. Darlington Art Gallery has four of his North Yorkshire and Durham views. Sunderland Art Gallery has his *Sunderland Bridge*. He may have been related to George Samuel Elgood (1851–1943), the painter and architect of gardens.

ELLIOT, George (fl. 19th cent.)

Portrait and imaginative painter in oil. Little is known of Elliot except that he spent many years in Bensham Asylum, GATESHEAD, and that he painted several pictures in which he portrayed himself grandiosely robed and bejewelled in regal surroundings. One of his pictures, dated 1856, hung for many years in the Davy Inn, WALLSEND, near NEWCASTLE, and portrays Elliot crowned and robed, in a fantastic architectural setting with dozens of surrounding figures in biblical clothing. In a lengthy inscription on this picture, written by Elliot, he tells us that it is 'Dedicated to the World', and that it portrays 'George Elliot, Emperor of the World and True Live God, George the Fifth of Great Britain'. This picture was sold at Sotheby's Belgravia saleroom on February 1st, 1972, for £160. A self portrait in pen and wash is in the possession of Gateshead Central Library.

ELLIOTT, Robinson (1814–1894)

Genre, portrait, figure and landscape painter in oil. The son of a prosperous hatter at SOUTH SHIELDS, Elliott showed an aptitude for drawing from an early age and was sent by his father to study at the school of Henry Sass, where one of his fellow pupils was Sir John Everett Millais, afterwards President of the Royal Academy. On returning to SOUTH SHIELDS after his training he established a studio in the town, and shortly afterwards sent his first work for exhibition, showing three works at the Newcastle upon Tyne Institution for the General Promotion of the Fine Arts, 1833. Two years later, and living briefly in London, he exhibited for the first time outside Northumbria, showing *Smuggler on the Watch*, at the Suffolk Street Gallery. He continued to exhibit at NEWCASTLE until late in his life after taking up residence in the town by 1841. One of his earliest exhibits after this event was his *The Finding of the Cup in Benjamin's Sack*, shown at the North of England Society for the Promotion of the Fine Arts Exhibition, in 1842, and thought to have been connected with his entry as a competitor in the Houses of Parliament decorations competition in the following year. In 1844 he sent his first work to the Royal Academy, *A morning call*, and *Children in the wood*, and in the following year sent his first work to the British Institution: *The Ascension; sketch for an altar-piece*. He continued to exhibit at the Suffolk Street Gallery until 1868; the British Institution until 1852, and the Royal Academy until 1881, also exhibiting his work at NEWCASTLE, and on two occasions at Carlisle Athenaeum: 1846 and 1850. Several of his later Academy works were coastal scenes near SOUTH SHIELDS, to which he returned to practise by the late 1850s. Elliott was a popular teacher of painting and attracted many pupils to his studios at SOUTH SHIELDS and NEWCASTLE. He was also a poet of considerable ability, whose work was collected and published in his lifetime. One of his less characteristic works was the designing of the Coat of Arms, and Seal, of his native town. Elliott continued to paint vigorously into his late life. He died at SOUTH SHIELDS. Represented: South Shields Museum & A G; Sunderland A G.

ELTON, Edgar Averill (1859–1923)

Landscape painter in watercolour; art teacher. The son of Samuel Averill Elton (q.v.), he was probably born at DARLINGTON after his father had taken up residence in the town. He studied art at the schools of South Kensington Museum, and in 1886 succeeded his father as professor at the School of Art, at DARLINGTON. Elton appears to have exhibited exclusively in Northumbria, amongst his few known exhibits being the three works which he sent to the Bewick Club, NEWCASTLE, in 1893: *Still Life; Piercebridge, near Darlington*, and *Kate*. Soon after the First World War he was forced to retire from his teaching post due to ill health. He died at DARLINGTON: Darlington Art Gallery has his watercolour: *Whitby*.

ELTON, Samuel Averill (1827–1886)

Landscape and coastal painter in oil and watercolour; art teacher. Elton was born at Newnham, Gloucestershire, but spent most of his life at DARLINGTON, where he was for many years professor at the School of Art. While living at DARLINGTON he

exhibited at the Royal Academy and at the Suffolk Street Gallery. He also sent work to various other London exhibitions, and was an exhibitor at the Arts Association, and Bewick Club exhibitions, at NEWCASTLE, from their foundation. His Royal Academy exhibits were, *Mousehold Heath, Norwich* (1874), and *Purple Iris* (1884); those at the Suffolk Street Gallery, *A study near Rokeby* (1860), and *Whitby Sands* (1880). His exhibits at NEWCASTLE consisted of Northumbrian, south of England, and Continental landscape and coastal views. He died in London. His son Edgar Averill Elton (q.v.), was also a talented landscape painter. Represented: Victoria and Albert Museum; Bowes Museum, Barnard Castle; Darlington A G.

EMERY, John (1777–1822)

Coastal, landscape, animal and genre painter in oil. He was born at SUNDERLAND, the son of a country actor, and later followed his father in this profession, achieving considerable critical acclaim for his performances in comical roles. He was originally trained as a musician, however, following a rudimentary education at Ecclesfield, Yorkshire, by playing in an orchestra at Brighton at the age of twelve. He continued to play fiddle for several years, occasionally taking the part of country boys in provincial theatrical productions. His first important engagement as an actor came in 1798, when he was engaged to replace T Knight at Covent Garden, London, as Frank Oakland, in Morton's 'A Cure for the Headache'. A number of other parts followed, then from 1801 until his death he acted almost exclusively at Covent Garden, and from that year until 1817 sent no fewer than nineteen works to the Royal Academy. Most of these works were coastal, landscape, animal or genre studies, among these *View of part of the town of Liverpool after sunset* (1804); *Portrait of an Irish Mare* (1808), and *View of the North Pierhead and Lighthouse, Sunderland* (1817). From 1803 he was described as 'An Honorary Exhibitor'. Emery continued to act until a month before his death but is not known to have produced any work in painting after 1817. His masterly portrayal of comic figures on the stage, notably 'Tyke', in Morton's 'School of Reform', made him a popular portrait subject for other artists, and no less than seven portraits of him in various characters were painted, apart from an unknown number of conventional portraits, such as Samuel Raven's miniature in the National Portrait Gallery, London. He died in London.

EMMERSON, Frederick (born c.1864)

Amateur landscape painter in oil and watercolour. This artist worked as an agent, and later a clerk, at NEWCASTLE, in the late 19th century painting in his spare time. He exhibited his work at the Bewick Club, NEWCASTLE, from 1886, and later the city's Laing Art Gallery, whose Artists of the Northern Counties exhibitions he contributed to from their inception in 1905. He later moved from NEWCASTLE, to STOCKSFIELD.

EMMERSON, Henry Bewick (1861/2–1897)

Animal, sporting and landscape painter in oil and watercolour. He was born at STOCKSFIELD, one of the artist sons of Henry Hetherington Emmerson (q.v.), and first began exhibiting his work after the family had moved to CULLERCOATS in the early 1880s. At the 'Gateshead Fine Art & Industrial Exhibition' in 1883, he showed his *Horse & Paddock*, and at the first exhibition of the Bewick Club, NEWCASTLE, in 1884, alongside his father, and brother Hugh Percy Emmerson (q.v.), his *Ram's Head; Throwing off Hounds*, and *Return to the Meet*. He also exhibited at the Bewick Club in the following year, but later emigrated to South Africa, where he died at Bulawayo in 1897.

EMMERSON, Henry Hetherington (1831–1895)

Genre, portrait and landscape painter in oil and watercolour; muralist; illustrator. He was born at CHESTER LE STREET, and came to NEWCASTLE at the age of thirteen to study at the Government School of Design, under William Bell Scott (q.v.). Scott is said to have taken a special interest in Emmerson, and had tutored him for some two years, when a clergyman who had heard of the boy's talent sent him to Paris for six months so that he could spend time copying works in the Louvre. At the end of his stay in Paris, Emmerson went to London, where he was successful in gaining entry to the Royal Academy Schools. While studying at the Schools he had to support himself entirely unaided, but found his special gift for painting children brought him more than enough commissions to meet this require-

Henry Hetherington Emmerson, *A Cullercoats Fisherwoman at a Cottage Door*, 1863, 89 x 70cm. Dean Gallery.

Henry Hetherington Emmerson, *Scandal*, illustration from *Afternoon Tea*, 1880.

ment. In 1851 his oil *The Village Tailor* (portraying his father), was accepted for exhibition at the Royal Academy, and was honoured with a position on the line. Emmerson decided to leave London, however, and back in Northumbria by 1856, he lived briefly at WHICKHAM, near GATESHEAD, then marrying in 1857, he moved first to EBCHESTER, then to STOCKSFIELD, where he remained for several years. About 1865 he moved to CULLERCOATS, retaining a home there for the rest of his life, although he spent a number of years living mainly near ROTHBURY, under the patronage of Lord Armstrong. Emmerson continued to exhibit at the Royal Academy until two years short of his death, showing a total of fifty-eight works, and establishing a considerable reputation as an artist. He also exhibited his work at NEWCASTLE, notably at the exhibitions of the Arts Association, and later at the Bewick Club, at which latter his work was sometimes to be seen accompanied by that of his two artist sons: Henry Bewick Emmerson (q.v.), and Hugh Percy Emmerson (q.v.). Emmerson frequently painted on a large scale, amongst his largest works being the four murals which he executed for the banqueting hall of the Crown Hotel, NEWCASTLE. These murals, each measuring about twenty feet in length, had as their subjects *Pastimes – Past and Present*, and are said to have earned him 400 guineas. In his later life Emmerson became increasingly interested in illustration. In 1878 he illustrated along with John George Sowerby (q.v.), Joseph Crawhall, The Third (q.v.), and Robert Jobling (q.v.), notes on the Arts Association exhibition at NEWCASTLE in that year, and two years later, with Sowerby alone, he produced illustrations for *Afternoon Tea*. This highly successful book was followed by a work dealing with the childhood of Queen Victoria, which Emmerson illustrated entirely on his own. A major exhibition of his oils and watercolours was opened at NEWCASTLE shortly after his death at CULLER-COATS, in 1895. A large selection of his work may be seen at the one-time home of Lord Armstrong at

Cragside, ROTHBURY, courtesy of the National Trust, which together with the several works now in public collections, show Emmerson to have been one of Northumbria's outstanding artists of the nineteenth century. This fact was widely recognised in his life-time, resulting in his election as first president of the Bewick Club, and his service in this capacity until his death. Represented: Laing A G, Newcastle; Natural History Society of Northumbria, Newcastle; Shipley A G, Gateshead; Sunderland A G. [See colour plate]

EMMERSON, Hugh Percy (1865/6–1919)
Portrait and landscape painter in oil. He was one of the two artist sons of Henry Hetherington Emmerson (q.v.), and received his early tuition in art from his father, in the company of his brother Henry Bewick Emmerson (q.v.). He was an exhibitor along with his father and brother at the 1884 exhibition of the Bewick Club, NEWCASTLE, sending a bird study and a flower study from the family home at CULLERCOATS. He remained a regular exhibitor at the Bewick Club until the outbreak of the Boer War, when he enlisted in the Army and went to South Africa. It is believed that he remained in South Africa following the end of the War, and became a member of the military police, painting portraits in his spare time. One of the best works which he produced before leaving for South Africa was the portrait of his father shown at the Grainger Street Gallery of Mawson Swan & Morgan on the occasion of their showing of his father's *God's Nursery*, in the 1890s. 'It is an exceedingly interesting work of art', commented the local press at the time 'and is evidence of Mr Percy Emmerson's ability in portraiture . . .'. Among his portrait subjects while painting in South Africa was Cecil Rhodes.

ENGELBACH, Mrs Florence A (née Neumegen) ROI NS (1872–1951)
Portrait, figure and flower painter in oil. She was born at Jerez de la Frontera, Spain, of English parents, and studied at Westminster School of Art, the Slade School of Fine Art, and in Paris, before becoming a profes-sional artist. Following her marriage in 1902 she settled at NEWCASTLE, remaining in the city for many years, and establishing a considerable reputation as an artist. She first began exhibiting her work publicly in 1892, showing at the Royal Academy; the Royal Scottish Academy; the Royal Institute of Oil Painters; the Royal Society of British Artists, and various lead-ing London galleries. She also exhibited her work at several provincial galleries, including the Laing Art Gallery, NEWCASTLE, at which she showed a large number of portrait and figure studies both before and after her stay in the city. Her first one-man exhibition was held at the Beaux Arts Gallery, in 1931, and a memorial exhibition was held at the Leicester Galleries in 1951, following her death in London, her home for many years after leaving NEWCASTLE. She was a member of the Royal Institute of Oil Painters, and the National Society of Painters, Sculptors and Gravers. The Laing Art Gallery has her *Old Woman Knitting*, exhibited at the Paris Salon in 1910, and for which she was awarded the bronze medal at the Women's

International exhibition in London. The Tate Gallery has her oil *Roses*, 1939, reflecting her increasing preoccupation with flower painting in her later life.

EQUI, Enrico (b.1936)
Landscape, portrait and interior painter in oil; illustrator; art teacher. He was born at Loppia-de-Sutto, near Barga in Tuscany, Italy, but emigrated with his parents to Britain as a boy. After study at the College of Art, HARTLEPOOL, under Stephen Crowther (q.v.), and Ron Storr, he became a teacher of art, working at a succession of schools and colleges in Northumbria, until his retirement from the Henry Smith Comprehensive School, HARTLEPOOL, in 1996. Equi was a keen spare-time painter throughout his career in teaching and participated in many mixed and group exhibitions in both London and the provinces from 1960. These included the Royal Society of British Artists, in 1960, 1961, and 1962; the Royal Society of Portrait Painters, in 1960; the Northern Young Artists, Huddersfield, 1961; the '67 Group, Gray Art Gallery, HARTLEPOOL, in 1967; the DLI Museum & Art Gallery, in 1974, and Darlington Art Gallery, in 1992. He has also held a number of joint and one-man exhibitions of his work, including among the former, the Westgate Gallery, NEWCASTLE, and Sunderland Art Gallery, in 1965; and the latter, the Gray Art Gallery, HARTLEPOOL in 1961 and 1975, and the Information Centre, PETERLEE, in 1975. He has received a number of prizes and awards for his work, including the Turner Gold Medal for Landscape Painting; the Richard Jack Prize for an interior, and on two occasions the David Murray Travelling Scholarship. His published work includes a calendar for Easington District Council; a record cover for *Repercussions*; poetry illustrations, and posters. Hartlepool Arts & Museum Service has examples of his work. He lives at PETERLEE.

ERRINGTON, Isabella (1806–1890)
Portrait and genre painter in oil and watercolour. She was born at TYNEMOUTH, but practised as a professional artist at NORTH SHIELDS, from her early twenties until her death. She first began exhibiting her work at NEWCASTLE, where, in 1835, she showed her *St. Cecilia at the organ*, at the First Exhibition of the Newcastle Society of Artists. She continued to exhibit exclusively at NEWCASTLE until 1846, when she sent work to both the Suffolk Street Gallery, and to Carlisle Athenaeum, at the former showing *A Boy carrying Bait – from life*, and *A Cullercoats Girl with Fish*, and at the latter, *A Sea Swallow fallen after a shot*; *A Travelling Besom Seller*, and *The New Ribbon for a Sunday Bonnet*. Following this she exhibited outside Northumbria on only one further occasion, this being when she again sent work to Carlisle Athenaeum. She exhibited at NEWCASTLE until late in her life, and evidently became quite well known for her portrait work in the area around NORTH SHIELDS. She died a spinster in the town, at the age of eighty-four. Some exhibition records show her as 'J Errington'; her full name was Isabella Cecilia Errington. Some of her work is reproduced in Hodgson's *History of Northumberland*.

ETCHELLS, Frederick (1886–1973)
Figure and landscape painter in oil; draughtsman; architect. Etchells was born at NEWCASTLE, and studied at the Royal College of Art and later in Paris, at which latter he became interested in Fauve and Cubist painting. He exhibited his work with Roger Fry's Post Impressionist exhibitions in London, then became involved in the Omega Workshops. Etchells accompanied Wyndham Lewis when he left to found the Rebel Art Centre, and participated in the Vorticist movement. He also showed work with the X Group, and the London Group. His best known work as an easel painter was that produced when he was a war artist; this was his *Armistice Day*, for the Canadian War Memorial. Some of his drawings appeared in the Vorticist publication *Blast*. He later abandoned painting for architecture, and became a fellow of the Royal Institute of British Architects in 1931. He died at Folkestone, Kent. The Tate Gallery has a small number of his works painted just before the First World War.

EVANS, John Dixon (fl. 19th cent.)
Landscape painter in oil. Evans was a 'Plain and Ornamental Painter', who set up in business at BERWICK-UPON-TWEED in 1831, after gaining experience in these fields in London and Edinburgh. He had, however, before setting up in business in the town sent one work from it to the Northern Academy, NEWCASTLE, in 1828, titling it: *Berwick from the Car (sic) Rock*, and had even earlier been responsible for a *View of Berwick upon Tweed, its Suburbs & Bay in 1822*, which was published by Robert Good, elder brother of Thomas Sword Good (q.v.), as an engraving in 1829.

EVETTS, Leonard Charles, ARCA (1909–1997)
Landscape painter in watercolour; stained glass designer; calligrapher; art teacher. Evetts was born at Newport, Monmouthshire, and after displaying a talent for drawing at an early age, studied at Newport College of Art while working in his father's building firm. When working for his father he also won a Berger Paint Scholarship to the Royal College of Art for three months, and two years later won a national scholarship enabling him to return to the College for a further three years. Amongst his tutors there were Martin Travros for glass and Edward Johnston for lettering, the latter employing him as demonstration student in his final year. In 1933 he joined Edinburgh College of Art to teach drawing, lettering and related subjects, remaining there until 1937 when he became head of the design school at King's College (now Newcastle University). Throughout his thirty-seven year tenure of this post he not only taught at the school but also practised as a stained glass designer. Without ever advertising his abilities in this capacity he became the most prolific artist working in Britain in the medium, completing over 400 examples. Among these were several multiple commissions, outstanding amongst which were his forty-six individual windows for St Nicholas' Church, BISHOP-WEARMOUTH, SUNDERLAND, which has been described as 'an achievement unparalleled in modern times'. In addition to his prodigious output in glass he also handled

dozens of commissions for lettering and heraldry, Books of Remembrance, illuminated addresses, memorial tablets, and a wide variety of ecclesiastical work, including altar frontals, processional crosses, organ pipe covers and banners, often for nationally famous cathedrals. Shortly after taking up his position at the school he also published a book on Roman lettering which ran into ten editions. His watercolours were largely produced as a relaxation from his varied commitments as teacher and designer and mainly consisted of Northumbrian, and Continental landscapes, which he exhibited at the Artists of the Northern Counties exhibitions at the Laing Art Gallery, NEWCASTLE; the city's Pen & Palette Club, and Stone Gallery, for many years following his service in the RAF Camouflage Section during the Second World War. He also had a number of one-man exhibitions on Tyneside, and occasional joint shows with his second wife PHYL DOBSON (b.1926). Evetts had a number of honours and awards conferred upon him in recognition of his artistic skills, including honorary membership of the York Art Workers' Association, and in 1990 the Northern Electric Award for outstanding lifetime service to the arts. A major exhibition of his varied work as designer and artist was held at the Hatton Gallery, NEWCASTLE, in 2001, to coincide with the private publication of a lavishly illustrated account of his life: *Leonard Evetts – Master Designer*. The Laing Art Gallery has a small collection of his watercolours. [See colour plate]

EWART, William (c.1820- after 1863)
Portrait, landscape and genre painter in oil. This artist first began exhibiting his work publicly while practising at WOOLER, showing work at the North of England Society for the Promotion of the Fine Arts, NEWCASTLE, in 1841 and 1843. In 1841 he showed *The Exhausted Mendicant*, and *The Pet Lamb*; in 1843 *The Destitute Mother's Prayer*. Shortly after last exhibiting at NEWCASTLE he moved to London, where he exhibited at the Royal Academy from 1846 until 1850, showing portraits, and the British Institution from 1847 until 1863, showing landscape and genre works. Represented: Berwick Museum & A G.

EWBANK, John Wilson, RSA (1799–1847)
Landscape, coastal and marine painter in oil; architectural and topographical draughtsman. Ewbank was born at DARLINGTON, the son of an inn-keeper who later moved to GATESHEAD. Before his parents moved to Tyneside, in 1804, Ewbank was adopted by a wealthy uncle at WYCLIFFE, near BARNARD CASTLE, and later sent by his guardian to Ushaw College, near DURHAM, to train for the Roman Catholic priesthood. He absconded from the College after only a short period of study, however, and rejoining his parents, had himself bound as an apprentice to house painter Thomas Coulson (q.v.), at NEWCASTLE, in 1813. In the following year Coulson left Newcastle to set up business in Edinburgh, and took his apprentice with him. Here Ewbank began to display such a talent for painting that his master allowed him time to study under Alexander Nasmyth, one of the leading Scottish

landscapists of the day. He first exhibited his work publicly at Edinburgh in 1821, while still working for Coulson, showing *Newcastle upon Tyne from the Byker Hill*, and two black lead drawings, at the city's Institution for the Encouragement of the Fine Arts in Scotland. In the following year, and now in his own studio, he again exhibited at the Institution, and sent five works to the First Exhibition of the Northumberland Institution for the Promotion of the Fine Arts, NEWCASTLE. He continued to exhibit at Edinburgh, and NEWCASTLE, for the next eleven years, also in this period sending his only work to the Royal Academy, *Alexander's triumphal entry into Babylon*, (1826), and showing some twenty-seven works at the Carlisle Academy. These years saw his reputation as an artist in Edinburgh reach dizzy heights, then plunge into the mediocre. In 1823, a series of views of the city by Ewbank were engraved by Lizars; in 1826 he became a founder-member of the Scottish Academy, and following his showing at the Academy's first exhibition in 1827, of his *View of Edinburgh from Inchkeith*, and *The Entry of George IV into Edinburgh*, he became the city's wealthiest teacher of painting, earning £2,500 in one year alone. Towards the end of his Edinburgh period he began to paint larger and more ambitious works, then suddenly overwhelmed by his success, he took to drinking, and careless behaviour, and his work deteriorated rapidly. In 1834 he left the Scottish capital in disgrace, and returning to NEWCASTLE, took a 'squalid lodging in Denton Chare' and 'worked mostly at lead pencil drawings ... executed from recollections of the fine works of his best days'. He exhibited at NEWCASTLE in the year of his return, and continued to exhibit in the town until the early 1840s, but his work attracted little attention. Much of his later work was executed on pieces of tin, his daughters assisting him in their painting, and afterwards hawking the pictures around the town, and sometimes as far afield as NORTH SHIELDS and SOUTH SHIELDS. He also did many lead pencil drawings on scraps of cardboard, which were disposed of in a similar manner, or by Ewbank himself, when on visits to nearby villages with his friend of later years, William Weddell (q.v.). In 1838 he was obliged to forfeit his status as a Royal Scottish Academician. Some time after 1841 he moved to SUNDERLAND, where he died in extreme poverty in Bishopwearmouth Infirmary. Ewbank's early marine paintings are becoming increasingly recognised for their quality, his *Shipping in the harbour, South Shields* shown posthumously at the Royal Scottish Academy in 1863, and the Royal Academy in 1903, selling for a record price of £41,825, when it was sold in Scotland in 2002. Represented: British Museum; National Gallery of Scotland; Dundee A G; Laing A G, Newcastle; North Tyneside Public Libraries; Shipley A G, Gateshead; Sunderland A G. [See colour plate]

F

FAIRLESS, Thomas Kerr (1825–1853)

Landscape, coastal and genre painter in oil and water-colour; drawing master. He was born at HEXHAM, the son of Joseph Fairless, 'perpetual churchwarden' to the town's Abbey Church, and well-known local antiquary. He was interested in drawing from his boyhood, and keenly studied the work in engraving of Thomas Bewick (q.v.), later becoming a pupil of one of Bewick's apprentices, Isaac Nicholson (q.v.), at NEWCASTLE. He soon became dissatisfied with wood engraving, however, and went to London to develop his skill as a painter. Here his progress was rapid. By 1848 he had commenced exhibiting at the Royal Academy, showing a coastal view, *Vessel Ashore*, and in the following year he began exhibiting at the British Institution, and the Suffolk Street Gallery, at the former showing a landscape, *Gordale*, and at the latter a coastal view, *Sunset at Sea – Tynemouth Castle*. He exhibited at all three establishments until 1851, and sent three works to Carlisle Athenaeum, in 1850, his exhibits being well enough received to enable him to establish a considerable practice as a teacher of drawing and painting in London. It was his ambition eventually to practise in Scotland, and on the Continent, but ill-health forced him to return to HEXHAM in August, 1851, and here he died two years later, at the age of twenty-eight. In the year of his death his father published *A Guide to the Abbey Church at Hexham*, containing illustrations which may have been his work.

FALLAW, Thomas Penman (1875–1922)

Landscape and seascape painter in oil and water-colour. Born at GATESHEAD, Fallaw practised in the town as an estate agent until 1918, painting in his spare time. He was largely a self-taught artist, although he did receive some assistance in improving his work from his friend for many years, John Falconar Slater (q.v.). He occasionally exhibited at the Artists of the Northern Counties exhibitions at the Laing Art Gallery, NEWCASTLE, until his retirement due to ill health, at the end of the First World War, when he moved to Torquay. He painted a number of coastal scenes in watercolour while living at the resort, dying there in 1922.

FARRELL, William George (1895–1971)

Amateur landscape, still life and abstract painter in oil and watercolour. Farrell was born at Liverpool and later became a professional actor, painting in his spare time. In 1930 he moved to SPENNYMOOR to become the first and only warden of what by the following year had been established as The Spennymoor Settlement. This was an experimental organisation, established by The Pilgrim Trust to help the local mining community cope with the effects of the economic depression then affecting the country and its objectives were 'to encourage tolerant neighbourliness and voluntary social service and give its members opportunities for increasing their knowledge, widening their interest and cultivating their creative powers in the friendly atmosphere'. In these it proved so successful that in addition to a wide range of social activities it quickly established a Sketching Club, and by 1939 a theatre-

Thomas Kerr Fairless,
Pedlars resting in the square of St Andrews, Fife, Scotland,
oil, 30.5 x 44.5cm.
Private collection.

William Fawcus, *Road West of Gilsland*, 1945, watercolour and collage, 24 x 31.5cm. Anderson & Garland.

art gallery. A series of art exhibitions at The Settlement was started in 1933 which were responsible for inspiring many local miners, including Norman Cornish (q.v.), to paint, and exhibit their work. Tisa von Schulenburg (q.v.) was for some years retained to teach drawing and woodcarving, and The Settlement later became affiliated to the Federation of Northern Art Societies, encouraging members to show their work with that organisation's annual exhibitions at the Shipley Art Gallery, GATESHEAD. Farrell, himself an enthusiastic painter, also showed work at The Settlement's exhibitions, and at the Artists of the Northern Counties exhibitions at the Laing Art Gallery, NEWCASTLE. He retired from The Settlement in his fifties and went to live at Cambridge with his wife and longtime assistant Elizabeth Ceridewen. They returned to Northumbria in the 1960s to live at Ormesby Hall, near MIDDLESBROUGH, as guests of a lifelong friend. Farrell died at Teesside Hospital in 1971 after a long illness. The Settlement still survives today, although greatly changed in terms of its services to the local community, and an exhibition was held at the Hutchinson Gallery, Town Hall, BISHOP AUCKLAND, in 2001, to celebrate its 70th anniversary. This was followed by an exhibition devoted to the work of Tisa von Schulenburg, who died in that year.

FARRER, Nicholas (1750–1805)
Portrait painter in oil. Farrer was born at SUNDERLAND, and studied art under Robert Edge Pine, the historical and portrait painter, and in the schools of the Society of Artists, London. He was befriended by Reynolds and Northcote, and painted portraits much in the style of the former. His main patron was the Duke of Richmond, for whom he painted a number of family portraits.

FAWCUS, William (1906–1994)
Landscape painter in oil and watercolour; art teacher. He was born at SOUTH SHIELDS, and studied art at King's College (now Newcastle University) before teaching at various schools and colleges in Northumbria. He eventually joined the teaching staff of the Institute of Education in NEWCASTLE, where he remained until his retirement. During the Second World War and after he painted extensively in Cumbria, and exhibited his work principally at the Artists of the Northern Counties exhibitions at the Laing Art Gallery, NEWCASTLE. Most of these works were based on objective observation, but some of his most distinguished work portrayed the dramatic transformation of the fell landscape during cloudy and stormy weather. He also experimented with abstraction. A large collection of his work reflecting all these various characteristics, consisting of oils, watercolours and drawings, was shown at the Hatton Gallery, NEWCASTLE, 1992/3. He died at NEWCASTLE. The Hatton Gallery has a substantial collection of his work.

FEATHERSTONE, R – see ROBSON, Featherstone

FEENEY, Hilary (b.1947)
Figure painter in various media; art teacher. She was born in Yorkshire and originally trained in dress design at St Martin's School of Art, London, and Newcastle Polytechnic (now University of Northumbria). After a successful career as a dress designer she lectured at the Polytechnic and became a member of the Society of Industrial Artists & Designers. Her interest in the human form led her to pursue an honours degree in fine art at Newcastle

University, where she specialised in painting. Her degree show provided an impetus for a style which has since become distinctive in its handling of mixed media and a preoccupation with people and how they interact with each other and the environment. Since her graduation she has exhibited her work widely in Britain in a number of group and one-man exhibitions. The former have included the Cleveland Open Arts Exhibition, Middlesbrough Art Gallery, 1992/3; *Five Women Artists*, the Vicarage Cottage Gallery, NORTH SHIELDS, 1993; *Drawn to the Figure*, the Sally Port Gallery, BERWICK-UPON-TWEED, 1996; the Coningsby Gallery, London Art House, London, 1998, and *Signpost* – Tynedale Artists' Network, Queen's Hall, HEXHAM, 2000. Her one-man exhibitions have included *Moving Through the Glass*, Gulbenkian Gallery, People's Theatre, NEWCASTLE, 1993; *Across the Wire*, The Samling Foundation, Dovenest, Cumbria, 1996, and at Brown's Gallery, NEWCASTLE, in 1998. She has also shown her work at various exhibitions abroad, among these *British Artists*, Tokyo, 1994, and at the Workit Gallery, Washington DC, USA, 1997. She has also acted as artist-in-residence at schools and hospitals in Northumbria and taken an active interest in the Tynedale Artists' Network, which annually provides opportunities to the public to visit members' studios to see their work. She has lived and worked for a number of years at STOCKSFIELD. Her work is represented in a number of public, private and institutional collections throughout Britain.

FENTON, William (born c.1880)
Landscape painter in oil and watercolour; art teacher. This artist practised at NEWCASTLE in the first half of the 20th century, from which he first sent his work for exhibition in 1916 to the Walker Art Gallery, Liverpool, and the Artists of the Northern Counties exhibitions at the Laing Art Gallery, NEWCASTLE. He remained a regular exhibitor at the latter for more than forty years, and for some time taught art at NEWCASTLE. He later lived at CULLERCOATS, and WHITLEY BAY, from which he continued to exhibit his work until his final years, at the annual exhibitions of the Benwell Art Club, NEWCASTLE, as well as at the city's Laing Art Gallery.

FENWICK, Thomas (d.1850)
James L Caw, in his *Scottish Painting, 1620–1908*, published 1908, describes Fenwick as a friend, and fellow apprentice of John Wilson Ewbank (q.v.), under Thomas Coulson (q.v.), at Edinburgh. He also states that Fenwick shared 'North of England birth' with Ewbank.

FERGIE, William (1893–1971)
Landscape painter in watercolour; cartoonist. He was born at BERWICK-UPON-TWEED and became a self-taught artist, painting in his spare time and contributing illustrations to a local newspaper while working in the clerical profession on Tweedside. In the 1930s he moved to Tyneside to work as a timekeeper at the Swan Hunter shipyard, but continued to paint and exhibit his work widely in the North East of England, notably at

the Artists of the Northern Counties exhibitions at the Laing Art Gallery, NEWCASTLE. Following his retirement from the shipyard he devoted himself exclusively to painting, producing a wide range of landscape and coastal views. He died at WALKER, near NEWCASTLE.

FERGUSON, Kenneth (b.1937)
Landscape painter in oil; draughtsman; printmaker in various media. Born at WEST SLEEKBURN, near BEDLINGTON, Ferguson did not start painting until he had served an apprenticeship as a house painter and decorator, and spent twelve years as a professional soldier. He initially painted while working in a factory, but after developing an interest in graphics he attended a course in etching, engraving and relief printing with the Charlotte Press, NEWCASTLE, and in 1978 became a full-time artist and printmaker with his own etching press. His first project in this capacity was a series of studies of sea coal gatherers on the Northumbrian coastline which he published as forty limited edition wood engravings and multi-block coloured lino cuts, and showed in a Mid-Northumberland Arts Group (MidNAG) touring exhibition in 1979. This was followed in 1982 by another MidNAG touring exhibition, based on a trip to Appleby Horse Fair, and employing relief and intaglio techniques. In 1983 he set up his first print workshop at ASHINGTON, later moving this to nearby CRAMLINGTON, where he has continued with other themed series of limited edition prints, and since 1993 produced a number of handmade limited edition books using his own images. These books have included: *Fair View Farm*; *Helen*; *The Newspaper Sellers*; *My Friend John*; *Trip to the Seaside*; *Day at the Races*; *Spring*, and *Trip to Tunisia*. Although mainly preoccupied with his handmade book productions, Ferguson has taken a continued interest in painting and has shown his landscapes widely in Northumbria. He was for several years a keen exhibitor at the

Kenneth Ferguson, *Collecting Prayer Stones*, linocut, 7 x 7cm. Private collection.

annual exhibitions held at NEWTON-ON-THE-MOOR, near ALNWICK, by Malcolm Gleghorn (q.v.), and others, and has also shown his work at many private galleries in the North of England, including the Tallantyre Gallery, MORPETH, and the Gossipgate Gallery, Alston, Cumbria. An exhibition of his Tunisian and other linocuts, woodcuts and metal engravings was held at the Bondgate Gallery, ALNWICK, in 2003, under the title 'Near and Far'.

FESTING, Andrew Thomas, RP (b.1941)

Portrait painter in oil. He was born at Chalford, Gloucestershire, the son of Field Marshall Sir Francis Festing, of TARSET, near BELLINGHAM. He followed in his father's footsteps by joining the Rifle Brigade, serving some eight years before taking up a position in the English Picture Department of Sotheby's, the auctioneers. On leaving Sotheby's in 1980 he decided to become a professional portrait painter, and although entirely self-taught, quickly obtained commissions. One of the first of these was the Bishop of Ely, since when he has completed portraits of several famous people, including Her Majesty Queen Elizabeth II, and

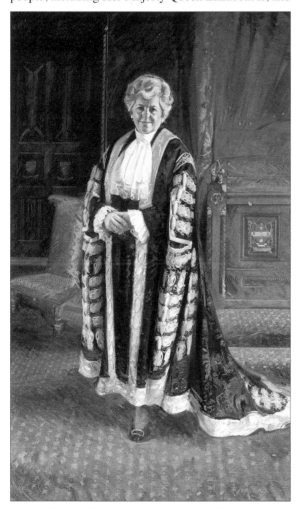

Andrew Thomas Festing, *Betty Boothroyd*, oil, 254 x 110cm. Collection of the Palace of Westminster.

Her Majesty Queen Elizabeth the Queen Mother. One of his portraits of the former, commissioned by the Royal Hospital, Chelsea, was filmed in the course of its execution for the TV documentary *Elizabeth R*, in 1993. An unusually large commission was that to paint a huge cross-section of the House of Commons Smoking Room, including 160 MPs. This now hangs in the Strangers Dining Room, and later led to a commission to paint a portrait of then Speaker of the House, Betty Boothroyd, MP. He has been a member of the Royal Society of Portrait Painters since 1990, and vice-president from 2000. His portrait of Northumbrian huntsman Owen Balding was included in the Society's 'People's Portraits' exhibition which toured Britain 2000–2001, visiting the DLI Museum & Art Gallery, DURHAM. He has lived at COLWELL, near HEXHAM, for many years while maintaining a studio in London. Represented: National Portrait Gallery; National Gallery of Ireland; Royal Collection; Palace of Westminster.

FINCH, Thomas ('Tom') (1918–2003)

Landscape painter in watercolour; sculptor; cartoonist; art teacher. Finch was born at WINLATON, near GATESHEAD, and began painting as a self-taught artist at the age of fifteen. He opted to become a sign writer, however, and although he exhibited his watercolours from an early point in his career it was only after his retirement from his own business in 1982 that he was able to devote himself fully to his art. He held his first one-man exhibition at South Shields Museum & Art Gallery, SOUTH SHIELDS, in 1953, while working as a sign writer for the National Coal Board, and subsequently enjoyed several other such exhibitions both at SOUTH SHIELDS, and NEWCASTLE. The most important of these were his *A Northern Tour in Watercolour*, at Bede's World, JARROW, near SOUTH SHIELDS, in 1994, and a show of fifty Highland and Lake District scenes at the Customs House Gallery, SOUTH SHIELDS, in 1997. Finch participated in many group exhibitions throughout Britain and Europe, among these the annual Great British Art Show, Manchester, and the Artists of the Northern Counties exhibitions at the Laing Art Gallery, NEWCASTLE. He also produced occasional works of sculpture, (notably

Thomas Finch, *Sailing Boat at the mouth of the Tyne*, watercolour, 26 x 38cm. Private collection.

his life-size work *Christ & St Lawrence the Martyr*, 1989, for the Church of St Lawrence, SOUTH SHIELDS), and for a period in the middle of the last century drew cartoons for the *Shields Gazette*, SOUTH SHIELDS. Finch lived for many years at SOUTH SHIELDS where he became a popular teacher of oil and watercolour painting with local art groups. A major retrospective exhibition of his work was held at the Customs House Gallery, SOUTH SHIELDS, following his death.

FLEMING, Ken (b.1944)

Printmaker; designer; illustrator. Fleming was born at MIDDLESBROUGH, but grew up in London. On leaving school in 1963 he decided to reject formal training and obtained work in an advertising agency. He later worked for other agencies and began experimenting with printmaking using lithography. In 1968 he moved back to Teesside where he ran his own design business for some four years. After returning to London in the late 1970s he became a freelance illustrator. He has since concentrated on printmaking with considerable success.

FLINTOFF, Thomas (1809–1891)

Portrait and landscape painter in oil, watercolour and crayon; photographer. Flintoff was born at NEWCASTLE, and practised in the town as a professional artist until the middle of the century, when he emigrated first to Texas, USA, later to Ballarat, near Melbourne, Australia. Prior to leaving Britain, Flintoff established a moderate demand for his work at NEWCASTLE, and also gave lessons in dancing. He occasionally exhibited his work in the town from his early thirties, among this work the *Fruit Piece* which he showed at the North of England Society for the Promotion of the Fine Arts, in

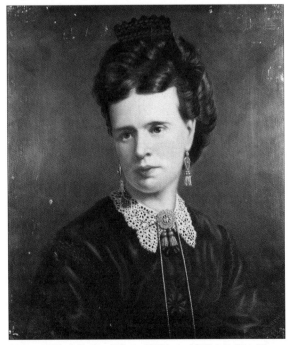

Thomas Flintoff, *Mrs Edward White*, c.1873, oil, 81 x 71cm. La Trobe Collection, State Library of Victoria, Australia.

1839, and the *Portrait of a Lady*, at the 'Exhibition of Arts, Manufactures & Practical Science', in 1848. About 1850 he left Britain for the USA and by 1851 was painting in Texas, where one of his portrait subjects was Senator Sam Houston; he also painted portraits of other members of the State Legislature, and leading dealers in cattle and slaves. After leaving Texas he painted his way through Mexico, possibly California, and the Society Islands. In Australia by 1856, he set up practice at Ballarat, where he undertook to make portraits in oil, crayon and watercolour. After leaving Ballarat he established himself in Melbourne in 1872, and for the next nineteen years took commissions for portraits of mayors, Members of Parliament, farmers and their prize bulls, and worthy matrons. At the age of eighty-two he died during the 1891 influenza epidemic at Melbourne, by swallowing a glass of ammonia in mistake for a tonic. Flintoff was evidently highly successful as a portrait painter in Australia, judging by his impressive list of sitters. Several examples of his work in this field are in the La Trobe Collection in the State Library of Victoria, Melbourne, Australia. Information on his career in the USA is contained in *Painting in Texas*, by Pauline Pinckney, University of Texas, 1967, while his career in Australia, omitting, however, the above detail of his work at NEWCASTLE, appeared in the *Age*, 28th July, 1979. Examples of his work were included in *Australian Colonial Fine Arts* at the Lauraine Diggers Gallery, Melbourne, 1986, and the Bicentennial exhibition, *The Face of Australia*. Represented: Ballarat Fine Art Galleries; La Trobe Collection, State Libraries of Victoria.

FOREMAN, Joseph ('Bos') (1894–1970)

Sporting cartoonist. Foreman was born at BEARPARK, near DURHAM, the son of a colliery engineer, and became interested in drawing at an early age. He was commissioned in the Green Howards during the First World War, but as a result of being twice wounded was unable to take up farming in Rhodesia as he had planned. Instead he trained at the Liverpool School of Art and became a freelance cartoonist. He first earned his reputation touring English conference centres drawing personalities, but after acceptance as a freelance cartoonist for the *Evening Chronicle*, NEWCASTLE, and its associated newspapers, worked for them for some thirty years. His work included both sporting and general cartoons. However, his best known work was in the former line for which he originated the locally famous *Magpie* cartoons celebrating the activities of Newcastle United Football Team. For much of his professional life he was based at WHITLEY BAY, where he died in 1970, aged seventy-six.

FORMAN, Robert (b.1912)

Illustrator in pen and wash; interior designer. Born at BERWICK-UPON-TWEED, Forman became a largely self-taught artist with a particular interest in interior decoration and commercial design. He wrote several books including *The Art of Scraperboard*, and *Design for Commercial Artists*. Some of his design work was produced in line and wash. He lived at Redland, Bristol.

126

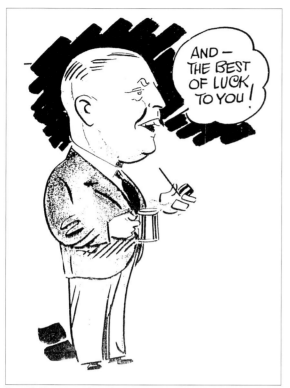

Joseph Foreman ('Bos'), *Peter Doig*, 1951, caricature from *Evening Chronicle*, Newcastle.

FORREST, Eric Lancelot (1926–1993)

Landscape painter in watercolour. He was born at ALLENDALE and showed such artistic talent while at school that a local businessman paid for him to attend the Newcastle College of Art & Industrial Design. After his national service in the RAF he worked for a paint company at HALTWHISTLE, then taught at Gateshead College of Art before joining a commercial design studio at NEWCASTLE. He later became self-employed as a commercial artist, and began to paint Northumbrian, Lake District and Scottish views, which he subsequently turned into colour prints, and sold throughout the North of England as part of his *Forrest Collection*. He is not known to have exhibited his work during his brief career as a landscape painter. He died at NEWCASTLE.

FORSTER, Noel (b.1932)

Abstract painter in oil and acrylic; art teacher. Forster was born at SEATON DELAVAL, near BLYTH, and studied at Newcastle University, before practising as a professional artist, and later art teacher. During the 1960s he had one-man exhibitions at the Ikon Gallery, Birmingham, and the University of Sussex. He also began showing his work at the John Moores Exhibitions, at Liverpool, gaining several prizes. In 1970–1, he taught at Minneapolis College of Art and Design, USA, following this with a period of teaching at the Slade School of Fine Art. In 1975–6 he won an Arts Council Major Bursary in recognition of his work and became artist-in-residence at Balliol College,

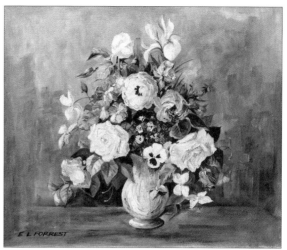

Eric Lancelot Forrest, *Still life, with flowers*, oil, 50 x 60.5cm. Anderson & Garland.

Oxford. While serving in this capacity he showed work at the Museum of Modern Art there. In the mid–1970s he also won the Gulbenkian Award. From the mid–1980s Forster taught at Camberwell School of Arts and Crafts, and mainly showed his work at the Anne Berthoud Gallery.

FORSTER, Percy, HRSA (c.1800–after 1858)

Sporting, animal, genre and still life painter in oil and watercolour. Born at ALNWICK, the son of a former gamekeeper to the Duke of Northumberland, Forster practised as a professional artist in Northumbria, the Scottish Borders, and Cumbria, until the late 19th century. He first began exhibiting his work publicly at NEWCASTLE, while practising at ALNWICK, sending two works to the Northumberland Institution for the Promotion of the Fine Arts, in 1826: *Dead Game*, and *Fruit*. He was still at ALNWICK when he exhibited at the Carlisle Academy in 1828, and at various exhibitions at NEWCASTLE 1829–42. In 1828 he was elected an honorary member of the Scottish Academy, and exhibited a mixture of still life, and animal paintings there over the next three years. In addition to this honour one of his exhibits shown at the Northern Academy in 1828 earned from W A Mitchell, in the *Tyne Mercury*, the praise that it would 'bear comparison with almost any fruit piece ever painted'. After leaving ALNWICK c.1843, Forster settled briefly at Kelso, in the Tweed Valley, later moving eastward to Coldstream, from which latter, in 1845, he sent one work to the Royal Academy, *The leading hounds*, and in 1846, three works to Carlisle Athenaeum. From 1850–55 he was working in NEWCASTLE, from which in 1854 he sent two works to the British Institution, *The Domestic Scavengers*, and *Minnow Fishing on the Tweed*, in addition to showing several works in the town. When he next exhibited in London he was working at Keswick, Cumbria, from which he sent his bird study *The Greenland Falcon* to the Suffolk Street Gallery in 1858. Nothing is known of him after that date, except that his work now commands high prices.

127

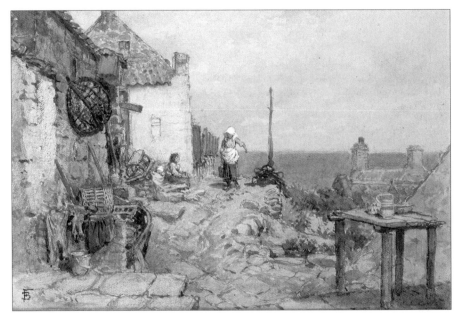

Myles Birket Foster,
Cullercoats,
watercolour,
26 x 39cm.
Private collection.

A mezzotint after his *Portrait of the Celebrated Short horned Cow, Bracelet*, engraved by Thomas Landseer, was auctioned at Phillips, Leeds, in November 1994 for several hundred pounds.

FOSTER, Myles Birket, RWS (1825–1899)

Landscape and figure painter in oil and watercolour; illustrator; wood engraver; etcher. One of the most popular British artists of the 19th century, Foster was born at NORTH SHIELDS, the son of a Quaker. When he was five his family moved to London, and here he received his first formal tuition in drawing while attending an academy at Tottenham. Later he attended school at Hitchin, Hertfordshire, where he received instruction in painting, as well as drawing, from Charles Parry. He left this school at fifteen, and joining the beer bottling company which his father had established in the capital, spent some ten months there before deciding that he would prefer a career in art. Foster's father persuaded an engraver named Stone to accept his son as an apprentice, but Stone committed suicide before the indentures were completed, and the boy was apprenticed instead to Ebenezer Landells (q.v.). Landells introduced him to the technique of wood engraving, but quickly recognising that his talents lay in the direction of drawing on wood for reproduction, increasingly employed him in this field. By the close of his apprenticeship in 1846, his work as an illustrator was beginning to attract attention, and when he left Landells he obtained an appointment in this capacity under Henry Vizetelly. His first success in illustrating came with his work for Longfellow's *Evangeline*, 1850, and in this year also, he married his cousin Ann Spence – a member of the well-known Spence family of NORTH SHIELDS, several members of which later became artists (see entries). Over the next nine years his work for *Evangeline* led to his receiving many other illustrative commissions, notably for the clas-

sics, and books of modern poetry. Some of this work came from George Dalziel (q.v.), and Edward Dalziel (q.v.) – 'The Brothers Dalziel', who employed him from 1851. Although moderately prosperous as an illustrator by the late 1850s, Foster became increasingly ambitious to succeed as a landscape painter in watercolour. He had painted in the medium as a relaxation for many years, and much like Thomas Bewick (q.v.), frequently composed his illustrations in watercolour before interpreting them in line on the wood. In 1859 he commenced exhibiting his work, showing examples at the Royal Academy, and the Old Water Colour Society (later the Royal Watercolour Society). In the following year he was elected an associate of the latter body, and with his election as a full member of the Society in 1862, he committed himself fully to his new career. His wife had meanwhile died, and when, in 1863, he came into a handsome fortune by the death of his uncle, he built a house at Witley, near Godalming, Surrey, for which the interior was designed with the help of William Morris, and Dante Gabriel Rossetti, and decorations provided by Edward Burne-Jones. In 1864 he remarried, choosing as his second wife Fanny Watson, sister of painter and illustrator John Dawson Watson, and over the next thirty years at Witley produced literally thousands of watercolours, and occasional oils, depicting scenery in Britain and on the Continent. His work became so popular that he could scarcely meet the demand, and publishers clamoured to reproduce his work by chromolithography. Meanwhile, he continued to exhibit at the Royal Academy, and the Old Water Colour Society, and contributed examples of his work to many leading London and provincial exhibitions. He also exhibited at NEWCASTLE, notably at the Arts Association in 1878, the Bewick Club in 1884, and the Royal Jubilee Exhibition in 1887. Most of Foster's work was executed in watercolour, working with as fine and dry a brush as possible, and in a

minutely stippled style which was in marked contrast to that of most earlier British watercolourists. He could, however, paint in a much looser and spontaneous style, as in the work reproduced. He mainly worked on the small scale to which he had become accustomed in book illustration, but sometimes produced quite large works in watercolour, such as his *Ben Nevis*, in the collection of the Laing Art Gallery, NEWCASTLE, which measures 79 × 118 cm. He also worked in oil, and was a skilful etcher on steel and copper. The high prices paid for his watercolours in his lifetime inevitably led to widespread forgery of his work, this once prompting him to write to his brother-in-law Robert Spence, at NORTH SHIELDS (31st January, 1880): '... I am constantly having pictures brought to me for recognition – all forgeries. One man the other day gave 150 gns, for a little oil picture sold to him as mine. It was a copy of a small drawing which had been forged several times.' Forgers were, of course, considerably helped by the fact that his work could easily be studied in colour reproduction. Indeed, Foster's work was among the first by any artist to be reproduced in colour, and its reproduction continues unabated to the present time. He painted vigorously until just short of seventy, when ill health drove him to retire to Weybridge, Surrey, where he spent the final years of his life. He died at Weybridge and was buried at Witley. An excellent account of his life and work, together with many colour plates of his watercolours, is contained in *Birket Foster R.W.S.*, by H M Cundall, 1906. A special loan exhibition of his work was held at the Laing Art Gallery in 1925, at which many of his Northumbrian, south of England, and Continental watercolours were shown. Important exhibitions to mark the centenary of his death were held by London art dealers Polak, and Frank T Sabin, in 1999. His son, WILLIAM FOSTER (1853–1924), was also a talented painter and illustrator. Represented: British Museum; Victoria and Albert Museum; Laing A G, Newcastle; Middlesbrough A G; North Tyneside Public Libraries; Shipley A G, Gateshead, and various provincial and overseas art galleries.

FOTHERGILL, George Algernon (1868–1945)

Sporting, landscape and architectural painter in oil and watercolour; draughtsman; illustrator. He was born at Leamington, Warwickshire, and received his education at Uppingham School, Rutland, where he received first prize for his drawings from the antique and life three years in succession. He later studied medicine at Edinburgh University, qualifying as Bachelor of Medicine and Master of Surgery in 1895. About three years after receiving these qualifications he commenced practice as a doctor at DARLINGTON, and within a short time began to take a keen interest in the sporting and artistic life of the surrounding area, contributing many articles on these topics to the national and regional press of the day, including *Bailey's Magazine of Sports and Pastimes*, and the *County Monthly*. He also wrote and illustrated several books while in practice at DARLINGTON, notable among which are his *Notes from the Diary of a Doctor, Sketch*

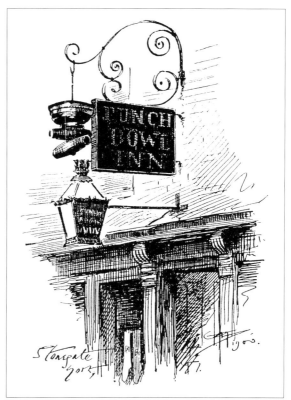

George Algernon Fothergill, illustration from *North Country Album*, 1901.

Artist and Sportsman, 1901; *North Country Album . . .*, 1901; *Darlington in Silhouette*, 1902; *Fothergill's Sketch Books*, 1901–3, and *A Pictorial Survey of St Cuthbert's Darlington*, 1905. By 1904 more than 1000 of his drawings and sketches had been published, and such was his reputation as an artist that his collection of engraver's proofs, together with original drawings and the books and magazines themselves, was purchased for £200 by seventy leading Darlingtonians, and presented to the town. He had also widely exhibited his work, showing examples at the Dudley Gallery, London, and the Walker Art Gallery, Liverpool. Just before the First World War, and having by then moved to Cramond Bridge, near Edinburgh, and commenced exhibiting at the Royal Scottish Academy, he decided to give up medicine to become a full-time professional artist. It was not, however, until after the War, and service as Medical Officer in charge of the 1st Cavalry Brigade, that he fully achieved this ambition, and returning to Cramond Bridge, practised as an artist until his death. While at Cramond he continued to exhibit at the Royal Scottish Academy, and in 1938 enjoyed a major exhibition of his work at Walker's Gallery, London. He also continued to write and illustrate sporting and other works, one of the last of these being *Hunting, Racing, Coaching and Boxing Ballads*, published in 1926. In addition to being a superb, if little known, sporting illustrator, Fothergill was keenly interested in experimenting with various methods of reproducing his work, these including auto-

John Gauld Fullerton,
Circus Horses,
oil, 30 x 46cm.
Private collection.

lithography, collotype and tri-colour process printing. He also dabbled in wood engraving, and painted pottery. Fothergill signed many of his works with his initials, 'GAF'. His small paintings of terriers ratting are in consequence sometimes confused with those of George Armfield (1811–1887), or occasionally those of Edward Armfield (1817–1896). Darlington Art Gallery has a large collection of his work.

FRASER, Ian (1933–1987)
Landscape painter in oil; etcher; art teacher. Born at NEWCASTLE, Fraser studied at Leeds College of Art, then at the Royal College of Art, before going on to teach at Hornsey College of Art. He was also head of the BA Hons Fine Art course at Middlesex Polytechnic, and for some thirteen years during his teaching career was a regular exhibitor at the Royal Academy showing oils, colour etchings and aquatints largely consisting of landscape subjects. His first exhibit in 1956 was his colour etching and aquatint *By the River*; his last, in 1967, an oil, *High Street, Colchester*. He initially lived in London, but later moved to Shepperton, Middlesex.

FREIGHT, Frances E (fl. early 20th cent.)
Amateur landscape painter in watercolour. This artist painted a substantial number of local coastal scenes while living at NORTH SHIELDS in the early 20th century, and showed her work at the Royal Society of Women Artists, London, and later the Artists of the Northern Counties exhibitions at the Laing Art Gallery, NEWCASTLE, and the North East Coast Art Club, WHITLEY BAY. Her first exhibit at the Laing Art Gallery in 1910 was entitled *St Mary's Island*. Her work is occasionally mistaken for that of Robert Jobling (q.v.).

FULCHER, Raf (b.1948)
Sculptor; art teacher. Born in Essex, Fulcher studied at Newcastle University before taking up a teaching post at Sunderland Polytechnic (now Sunderland University), and settling near BISHOP AUCKLAND. He has worked in a variety of materials and was included in the Serpentine Gallery, South Bank Centre's *The Sculpture Show*, in 1983. While living in Northumbria he has continued to exhibit his work and has executed a number of prominent sculptural commissions in the area. He exhibited at the Chelsea Flower Show in 1985 and 1987; the Garden Festivals in Liverpool, 1984, Stoke, 1986, Glasgow, 1988, and Gateshead, 1990. His commissions have included his *Garden Front*, of 1981, sited at Jesmond Metro Station, NEWCASTLE, and *The Swirle Pavilion*, of 1998, Quayside, NEWCASTLE. One of his more ambitious works, the latter is both a work of sculpture and architecture, incorporating a large gilded orb within a spherical framework of metal, set upon a stone and concrete pavilion opening towards the River Tyne, beside the Gateshead Millennium Bridge. His non-sculptural work has included landscape design for Easington District Council in 1996. Fulcher was appointed reader in fine art practice at Sunderland University, where he continues to teach. [See colour plate]

FULLERTON, John ('Jock') Gauld (1894–1967)
Circus and fairground painter in oil and watercolour; poster and inn-sign designer. Fullerton was born at Liverpool, of Scottish parents, and after early displaying a talent for drawing and painting took the Scottish Highers in art. After his art training, however, he studied as an engineer and joined the family forge and engine works at Paisley, only returning to his artistic interests in the 1920s. He found work with a

Nottingham printer, but later moved to CORBRIDGE, having obtained a design position with the Robert Sinclair tobacco company, NEWCASTLE. He first began exhibiting his work while living at CORBRIDGE, showing examples at the Artists of the Northern Counties exhibitions at the Laing Art Gallery, NEWCASTLE. During the period 1929–1932, and apparently living back on Clydeside he also showed work at the Glasgow Institute of Fine Arts, and at the Royal Scottish Society of Painters in Water Colours. In 1939 he began a long association as a designer with Davidson's Glassworks, GATESHEAD, remaining there until 1954 when he decided to become a freelance designer on Tyneside. Among his commissions were posters for British Rail, and inn-signs for Newcastle Breweries. One of the latter, which he produced for the Bedlington Terrier Public House, BEDLINGTON, became famous because lovers of the breed of dog from all over the world came to see it and have themselves or their dogs photographed beside it. As a relaxation from his commercial work Fullerton was a keen painter of circuses and fairs held on the Town Moor, NEWCASTLE, and two of his circus studies form part of the Fenwick Collection of Circus and Fairground Material held by the Laing Art Gallery. These were included in an exhibition featuring the material, held at the Gallery in 1970, and it also held an exhibition of his design and artwork in 1994 to celebrate the centenary of his birth. Much of his work is signed 'Jock Fullerton'.

G

GAHAN, George Wilkie (1871–1956)

Landscape painter in oil and watercolour; etcher. He was born at NEWCASTLE, and studied at Dundee School of Art before practising as a professional artist in Scotland. He exhibited his work at the Royal Scottish Academy, and at several provincial exhibitions. His home was for many years at Broughty Ferry, Angus. Dundee Art Gallery has two examples of his work in oil: *Landscape with Sheep*, and *The Old Vault, Dundee, Saturday Afternoon*.

GAMBLE, Thomas ('Tom'), RWS (b.1924)

Landscape painter in watercolour; art teacher. He was born at NORTON, near STOCKTON-ON-TEES, and was apprenticed at fourteen to a local sign-writer. He served in the Royal Navy during the Second World War, and on his demobilisation received part-time education in art at MIDDLESBROUGH and STOCKTON-ON-TEES while continuing his career in sign writing and later exhibition design. In 1952 he was appointed teacher of design and drawing at Loughborough College of Art & Design, remaining there until his retirement as senior lecturer in 1984. Encouraged by his paternal grandmother, herself an amateur painter in watercolour, Gamble had been interested in the medium from his youth and even while teaching had exhibited his work widely in Britain and enjoyed a successful one-man exhibition at Middlesbrough Art Gallery in 1962. It was not until his retirement, however, that he was able to concentrate fully on his interest, proving so successful that in 1989 he was elected to membership of the Royal Water Colour Society. During his career as teacher and later full-time professional artist he has exhibited his work at the Royal Academy; the Royal Water Colour Society; the Mall Galleries, London, and at a number of provincial and overseas galleries. His work has been featured at Royal Water Colour Society exhibitions and he has also tutored courses for the Society, as well as acting as its honorary secretary. He has painted abroad for many years, his interest in 'detecting and emphasising the spirit of places' taking him to Italy, France, Germany, among several European countries. His work is represented in many private and public collections, including those of Her Majesty Queen Elizabeth II, and Her Majesty Queen Elizabeth the Queen Mother; Middlesbrough Art Gallery; Lloyds of London, and Leicester and Nottingham County Councils. His home for many years has been at Huntingdon, Cambridgeshire. [See colour plate]

GARBUTT, James ('Putty') (c.1815–1895)

Coastal, seascape and landscape painter in oil and watercolour. Born at SUNDERLAND, Garbutt was working as a painter and glazier at SOUTH SHIELDS by 1850, with an address in Thrift Street. Most of his paintings appear to have been produced in his later years, when local trade directories were listing him as both artist and painter, and include a self portrait of 1870; a *Sea Scene with Castle in Background*, 1872; *Going to the Wreck*, 1875; *Dolly Peel*, 1880, and *Coach and horses outside the Old County Hotel, Westoe*, 1884. He died at SOUTH SHIELDS in 1895. Although he is described in trade directories as 'James Garbutt', there are other records which refer to him inaccurately as 'Joseph Garbutt'. The name 'Putty' obviously derived from his trade as glazier. South Shields Museum and Art Gallery has several of his works.

GARTHWAITE, William (1821–1889)

Marine painter in oil. Garthwaite was a pupil of John Wilson Carmichael (q.v.), and is believed to have studied under Carmichael in the years immediately preceding the latter's departure for London in 1846. Examples of his work are extremely rare, but show considerable ability. Denys Brook-Hart in his *British Marine Painting*, 1974, (page 348), writes most flatteringly of Garthwaite based on sight of several examples, but there are no records of this artist having had his work exhibited, apart from a single example at the Loan Exhibition of Local Art staged at the Central Exchange Art Gallery, NEWCASTLE, in 1889. His exhibit was entitled *Hauling the Nets*, and was loaned by J A D Shipley, after whom the Shipley Art Gallery, GATESHEAD, was named. This Gallery has two examples of his work, these being entitled *Entrance to a River*, 1854, and *Herring Fishing*, 1852. The latter work is possibly Garthwaite's exhibit at NEWCASTLE, under a different title. Represented: National Maritime Museum; National Museums & Galleries on Merseyside; Shipley A G, Gateshead.

GARVIE, Thomas Bowman (1859–1944)

Portrait, genre and landscape painter in oil and watercolour. Garvie was born at MORPETH, and studied art at the evening classes of the local Mechanics' Institute before attending Calderon's School in London. While at Calderon's he won a scholarship to the Royal Academy Schools, where he won a first silver medal for his painting of a head, and an extension of his scholarship by three years. On leaving the Schools he studied at the Académie Julian, Paris, under Fleury and Bouguereau, then returning to Britain he practised briefly in London before settling at MORPETH. He first began exhibiting his work publicly in 1884, sending a portrait of the Rev F R Grey, Rector of MORPETH, to the inaugural exhibition of the Bewick Club, NEWCASTLE. In 1886 he exhibited the same work at the Royal Academy, and for the next twenty years remained a regular exhibitor at both the Academy, and the Bewick Club, also sending two works to the Royal Society of British Artists' exhibitions. During the first ten of these years he practised at MORPETH, later moving to ROTHBURY, where he remained until c. 1920, although spending several long periods in Italy in the early years of the century. While practising at ROTHBURY, Garvie was considerably patronised by Lord Armstrong, for whose home at nearby Cragside he painted several family portraits, and a number of landscape and other works, several of which can still be seen there today, courtesy of the National Trust. He also exhibited widely throughout Britain, showing work at the Royal Academy; the Royal Scottish Academy; the Glasgow Institute of Fine Arts; the Walker Art Gallery,

Thomas Bowman Garvie, *Self Portrait*, oil, 73 x 51cm.
Private collection.

Liverpool, and various other provincial art galleries, including the Laing Art Gallery, NEWCASTLE, whose Artists of the Northern Counties exhibitions he contributed to from their inception in 1905. He last exhibited outside Northumbria in 1914, from that date onwards exhibiting almost exclusively at the Artists of the Northern Counties exhibitions, and the Pen & Palette Club, NEWCASTLE, of which latter he was a member 1914–44, and for some time Master of Paintings. On leaving ROTHBURY, Garvie practised briefly at CULLERCOATS, then moving to FOREST HALL, near NEWCASTLE, he remained there until his death in 1944. Garvie was one of Northumbria's most successful portrait painters of the last century, and included some of the best known local men of his day among his sitters. He also painted many genre subjects, and was particularly fond of interiors with figures. Many of the works which he exhibited both locally and in London from 1900 reflected his keen interest in Italy, in which he is said to have painted some of his finest works. In 1934 he shared a loan exhibition of his work at the Laing Art Gallery with Francis Thomas Carter (q.v.), George Edward Horton (q.v.), and John Falconar Slater (q.v.). Represented Hatton Gallery, Newcastle; Laing A G, Newcastle; Pen & Palette Club, Newcastle; Sunderland A G.

GAULD, John Richardson, ARCA (c.1886–1962)
Landscape and portrait painter in oil and watercolour; muralist; illustrator. Born at GATESHEAD, Gauld stud-

ied art at evening classes in the town, and later at Armstrong College (later King's College; now Newcastle University). Between 1910 and 1914 he studied at the Royal College of Art, after which he attended the London County Council School of Lithography. He first began exhibiting his work publicly in 1905, showing *The Cottage on the Cliff*, at the first exhibition of the Artists of the Northern Counties at the Laing Art Gallery, NEWCASTLE. He continued to exhibit at NEWCASTLE, and in 1911 sent his first work to the Royal Academy, *Newcastle upon Tyne*. Following his training as an artist he was appointed chief assistant at the Huddersfield School of Art. He remained based in the Manchester area for the rest of his life, and in addition to establishing a high reputation as an art teacher, was widely recognised for his abilities as an artist, serving as president of the Manchester Academy of Fine Arts, and from 1930–51, the Bolton Art Circle. Besides exhibiting at the Royal Academy, Gauld showed work at the Goupil Gallery, London, and in the provinces, and enjoyed one-man shows at NEWCASTLE, Huddersfield, Halifax and Bolton. Examples of his work were included in the 'Contemporary Artists of Durham County' exhibition staged at the Shipley Art Gallery, GATESHEAD, in 1951, in connection with the Festival of Britain. His work was also reproduced, examples appearing in *Colour Magazine; The Yorkshire Evening Post*; the *Leeds Mercury* and the *Newcastle Chronicle*. He was an associate of the Royal College of Art. A relative, ALEXANDER GAULD, was a talented amateur artist and was a regular exhibitor at NEWCASTLE early in the last century. Represented: British Museum; Victoria and Albert Museum; Bolton A G; Darlington A G; Laing A G, Newcastle; Rochdale A G; Salford A G.

GEORGE, Charles (1872–1937)
Landscape and marine painter in oil and watercolour; art teacher; decorator. He was born at TYNEMOUTH, the son of John Reed George (q.v.), a well-known local decorator and spare-time artist. He showed a talent for art from his teens and became a protégé of a Tyneside shipping chief, who sent him to Brussels to study art for a time. On his return to TYNEMOUTH he set up a studio, but on the death of his father in 1890 he was obliged to give up art as a full-time occupation and devote himself to the family decorating business, painting in his spare time, and teaching art at local evening classes. George painted prolifically throughout his life, forming many friendships with local artists such as John Falconar Slater (q.v.), George Edward Horton (q.v.), and John Davison Liddell (q.v.), and developing considerable skill as a painter, particularly in watercolour. He is not known to have exhibited his work outside Northumbria, but was a regular exhibitor at the Bewick Club, NEWCASTLE, mainly showing examples of his marine work. The Laing Art Gallery, NEWCASTLE, has his oil *Seascape with Storm*, and the Tynemouth Volunteer Life Brigade Museum & Watch House, the watercolour illustrated overleaf. He died at TYNEMOUTH.

Charles George,
The Wrecking of the Stanley and the Friendship, at the Mouth of the Tyne, 1864, watercolour, 41 x 61cm. Tynemouth Volunteer Life Brigade Museum & Watch House.

GEORGE, John Reed (1832–1890)

Amateur coastal and landscape painter in watercolour; decorator. George was born at TYNEMOUTH, a member of a well-known local family. He worked all his life in the family painting and decorating company in the town, painting in his spare time. He mainly painted local coastal views, in many of which he displayed considerable ability as an artist. He died at TYNEMOUTH. He was the father of Charles George (q.v.).

GIBB, Henry William ('Phelan') (1870–1948)

Figure, landscape and abstract painter in oil and watercolour; pottery decorator. He was born at ALNWICK, the son of Thomas Henry Gibb (q.v.), and brother of Sadie Gibb (q.v.). He received his early artistic training under his father, and later at NEWCASTLE and Edinburgh. While based at ALNWICK he exhibited his work at the Royal Scottish Academy in 1894; Carlisle Art Gallery in 1896, and the Bewick Club, NEWCASTLE, between 1893 and 1896. Until 1895 he exhibited his work as 'H. W. Gibb', but in that year began using his grandmother's maiden name of 'Phelan', after the initials 'H.W.', later describing himself as 'Henry Phelan Gibb', or simply 'Phelan Gibb'. During his period based at ALNWICK Gibb travelled to Paris and Antwerp before settling for a time at Munich, where he had been offered a scholarship. On completing his course there he returned to Paris, where he attended the Académie Julian under the tutelage of J D Laurens and A W Bouguereau. After a brief return to ALNWICK, during which he married, he then travelled to Spain, Venice and Antwerp before settling back in Paris once more. Most of the works which he had exhibited before finally leaving ALNWICK were similar to those painted by his father and sister – a typical example being his *Far o'er those hills my longing fancy flies*, shown at the first Artists of the Northern Counties exhibition at the Laing Art Gallery,

NEWCASTLE, in 1905. Following a chance visit to the posthumous Cézanne exhibition at the Salon d'Automne, in Paris, in 1907, however, he became inspired to paint in a much more avant-garde style. This led to friendships with Matisse and Braque, and at one point he shared a studio with them. Gertrude Stein also became a friend, and supporter of his changed style, and in 1909 he was made a Sociétaire of the Salon d'Automne. By then he had painted the first important of the many nudes he was to complete by the early 1920s, his *Two Nudes*, of 1908. It was a work which has since been described as probably 'the first painting of the twentieth century by a British artist'. Gibb first exhibited his new style of painting in Britain at the Baillie Gallery and the South Gallery, RAH, London, in 1909, following this in 1910 by showing at the American Art Association, Paris; again at the Baillie Gallery, and the Leavenritts Gallery, New York. One-man exhibitions followed at the Baillie Gallery, in 1911; the Carfax Gallery, London, in 1912, and Bernheim-Jeune, Paris, in 1913. His Carfax Gallery exhibition was badly received and closed early, while that at the Bernheim-Jeune was an enormous success. Transferred to Dublin soon after, however, all ninety-seven of his pictures from this exhibition were confiscated and locked away for thirty years. At the outbreak of the First World War he returned to London, where, undaunted by the Dublin fiasco, he continued with his enigmatic nudes and shortly after fell under the spell of abstraction. Some ninety of his paintings reflecting his recent changes of style were shown at the Alpine Gallery in 1917, along with fifty items of pottery which he had decorated, but despite the exhibition's success he did not show his work again for the next ten years. He made a brief visit to Paris in 1920, but finding it not to his liking returned to England and in 1921 settled in Exmoor. Financial hardship followed due to his obsession with

Henry William ('Phelan') Gibb, *Staward, near Allendale*, 1905, oil, 49.5 x 67.5cm. Anderson & Garland.

fishing, but after another exhibition at the Baillie Gallery in 1927, participation in an exhibition at the London Pottery in 1928, and the Betty Joel Gallery, in 1928 and 1929, he felt sufficiently well off to take a studio in Chelsea. In 1931 Lucy Wertheim was shown a large body of his work and agreed to support him financially. With her first cheque he travelled to La Rochelle in France to paint and she gave him three one-man exhibitions at her London gallery in 1931, 1935 and 1939. Until 1943 Gibb divided his time between his Chelsea studio and a small cottage in Devon. Two exhibitions at the Mid-Day Studios in Manchester followed in 1941 and 1943, but towards the end of the Second World War he finally settled at Great Missenden, Buckinghamshire, where he died after several heart attacks, in 1948. A posthumous retrospective was held at the Galerie Apollinaire, London, in 1949, for this remarkable but largely forgotten Northumbrian artist whose early work in Paris anticipated some of the most important trends in 20th century French art. Represented: Tate Gallery. [See colour plate]

GIBB, Sadie (1869- after 1916)
Landscape painter in oil. The daughter of Thomas Henry Gibb (q.v.) and sister of Henry William Phelan Gibb (q.v.), she was born at ALNWICK, and received her early artistic training under her father.

She first began to exhibit her work publicly when she sent a work, *In the gloaming*, to the Bewick Club, NEWCASTLE in 1893. She continued to exhibit her work at the Bewick Club for some years, but later moved to Glasgow, from which she began to exhibit at the Walker Art Gallery, Liverpool, sending nineteen works between 1913 and 1916.

GIBB, Thomas Henry (1833- after 1893)
Landscape and animal painter in oil; modeller. He was born at ALNWICK, the son of Henry Gibb, County Court official, house agent, and one-time proprietor of the celebrated *Northern Liberator*. Nothing is known of his early artistic training, but by 1864 he had already achieved something of a reputation by exhibiting at NEWCASTLE a full-size model, *The Fox caught in a trap*, and in 1866 this reputation as a modeller was further enhanced by two works which he sent to an exhibition at the Agricultural Hall, Islington, London. These two works were *Otter and Salmon*, and *The Biter Bitten*. The former model was considered so attractive that the *Illustrated Exhibitor*, a publication devoted to the exhibition, honoured him by illustrating it by means of a specially commissioned wood engraving. In 1870 he sent examples of his work in both modelling and painting to the 'Central Exchange News Room, Art Gallery, and Polytechnic Exhibition,' NEWCASTLE. These included a

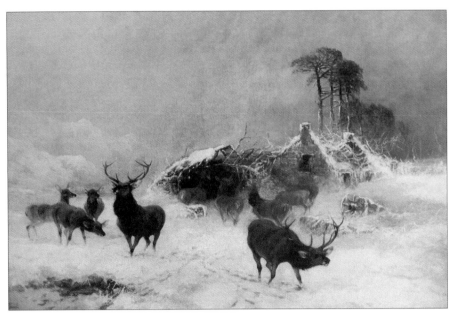

Thomas Henry Gibb,
Old Homes, new Tenants,
oil, 51 x 81cm.
Private collection.

Dutch Scene, and two coastal scenes. He sent four landscapes to the exhibition of works by local painters, at the Central Exchange Art Gallery, NEWCASTLE, in 1878, and also showed work at the Arts Association exhibition, NEWCASTLE, in 1881, and the Alnwick Mechanics' Institute 'Exhibition of Art & Science', 1882. From the latter date until 1885, however, he appears to have exhibited mainly outside Northumbria, showing two works at the Royal Scottish Academy; one work at the Royal Hibernian Academy, and one work at Tooth & Sons Gallery, London. He subsequently resumed exhibiting at NEWCASTLE, on one occasion showing work alongside that of his daughter Sadie Gibb (q.v.), and son Henry William Phelan Gibb (q.v.), at the Bewick Club exhibition of 1893. His works were entitled *In Alnwick Park; Evening*, and *The Peace of an Autumn Evening*. In addition to painting and modelling, Gibb carried on his father's business as house agent, and was also a taxidermist of note. He died at ALNWICK. Represented: Darlington A G; Shipley A G, Gateshead.

GIBBS, John Binney (1859–1935)
Portrait and landscape painter in oil and watercolour; art teacher. He was born at DARLINGTON, and later studied at the town's School of Art. On leaving DARLINGTON he studied at South Kensington School of Art, and the Académie Julian, Paris. Returning to Britain in his twenties, he accepted a teaching appointment at Liverpool College. While teaching at the College he established a studio in the city and became a regular exhibitor at its Walker Art Gallery. Some time in the late 1890s he returned to DARLINGTON, but left after a short while to become art master and director of technical studies at an establishment at Congleton, Cheshire, remaining there for almost thirty years. Following his retirement in 1928 he returned to DARLINGTON, where he mainly exhibited at the Darlington Society of Arts, also

serving as secretary for some years. He was the elder brother of Thomas Binney Gibbs (q.v.). Darlington Art Gallery has his oil *High Row, Darlington*, dated 1896. Represented: Imperial War Museum; Darlington A G. [See colour plate]

GIBBS, Thomas Binney (1870–1947)
Landscape and portrait painter in oil; art teacher. He was born at DARLINGTON, the younger brother of John Binney Gibbs (q.v.), and received his artistic education at Liverpool North-West School of Art and Liverpool University, before studying briefly in London. Following this he practised in Manchester and Chapel-en-le-Frith, Derbyshire. He followed this with a spell as art master at New Mills, then in 1910 moved to Whistler's old art studio at Chelsea. Here, and having already exhibited several family portraits at the Royal Academy, he began to concentrate on portraiture for a living, proving modestly successful. He continued to exhibit at the Royal Academy until 1938 showing a mixture of portraits, figure studies and landscapes, and also showed examples of this type of work at the Royal Institute of Oil Painters; the International Society of Sculptors, Painters, and Gravers; the London Group, and the Paris Salon. In 1939 he settled at Stunts Green, Sussex, where he painted local people and landscapes until his death in 1947. Jeremy Wood Fine Art, Cranleigh, had an exhibition of his work in 1975.

GIBSON, Ethel Kate – see MANVILLE, Mrs Ethel Kate

GIBSON, John (1794–1854)
Landscape, portrait and genre painter in oil; stained glass designer; ornamental and house painter. Gibson was born at NEWCASTLE, and practised as an 'ornamental and house painter' for many years before devoting himself to stained glass designing. During

his early years he frequently painted landscape and other works in his spare time, showing the first of these, *View of the Shot Tower from Thornton Street*, at the 1823 exhibition of the Northumberland Institution for the Promotion of the Fine Arts, NEWCASTLE, at the age of twenty-nine. He next exhibited at NEWCASTLE in the early 1830s by sending three works to the 1833 exhibition of the Newcastle upon Tyne Institution for the General Promotion of the Fine Arts, and exhibited at the Institution in 1834, and at the Newcastle Society of Artists in 1835 and 1836, showing such works as *Gipsies* (1834); *Evening* (1835), and *Bywell Ferry* (1836). Also in this period he acquired a considerable reputation for his taste in art, and is said to have played an important part in its promotion in NEWCASTLE. He later spent much time on his stained glass work, many churches in NEWCASTLE still displaying examples of his skill. Gibson was elected a town councillor for North St Andrew's Ward, and in 1854 served the office of Sheriff of NEWCASTLE. He died shortly after vacating his office.

GIBSON, Leslie Donovan, ARCA (1910–1969)

Landscape, portrait and still life painter in oil and watercolour; etcher. He was born at NEWCASTLE and educated in the city. In 1926 he was awarded the John Christie Scholarship to Armstrong College (later King's College; now Newcastle University), taking the Education Drawing Certificate in 1928, the Diploma BA in Fine Art, English and French in 1929, and the Painting Certificate in 1930. He was awarded a Royal Exhibition, studying at the Royal College of Art from 1930–1934, following which he was appointed as the Board of Education Visitor to Art Schools in Germany and Italy, 1936–38. During the 1930s he travelled extensively in Europe, visiting and painting in France, Belgium, Spain, Finland, Norway, Sweden and Greece. He also exhibited his work at the Royal Scottish Academy; the National Gallery of Canada, and at many London and provincial group exhibitions. His studios during the early part of this period were in London. In 1940, however, he worked in Rydal, Cumbria, returning to London in 1945, where he based his studio at Kensington. In 1950 he again moved from London, establishing the Stapleford Studio, near Salisbury, Wiltshire, and painting extensively in the West Country until his death. A major exhibition of his work was held at the Hatton Gallery, NEWCASTLE, in 1993, which included many of his North of England subjects, including his *Sheep Dipping, Bellingham, Northumberland*, 1934. Represented: Hatton Gallery, Newcastle. [See colour plate]

GIBSON, Thomas (1810–1843)

Portrait and landscape painter in oil and watercolour. Gibson was born at NORTH SHIELDS, the third son of James Gibson, and appears to have become a largely self-taught artist before practising in his native town by the age of twenty. He first exhibited his work at NEWCASTLE, showing examples at the Newcastle upon Tyne Institution for the General Promotion of the Fine Arts in 1833. He again exhibited at this Institution in the following year, and after moving to NEWCASTLE early in 1836, was a regular exhibitor in the town for the next four years, showing examples of his work at the exhibitions of the Newcastle Society of Artists, and the North of England Society for the Promotion of the Fine Arts. He last exhibited at NEWCASTLE in 1840, when he contributed two local landscapes and a *Lake Scene, near Penrith*, to the 'Exhibition of Arts, Manufactures & Practical Science' in the town. In 1841 he went to London, where he exhibited at the Suffolk Street Gallery exhibition of that year showing four Westmorland landscapes. Much of his two remaining years of life was spent at Carlisle, Cumbria, where he established a considerable reputation as a portrait painter. He last exhibited in the year of his death, showing examples of his work at Carlisle Athenaeum. He died in London, where according to Carlisle newspaper reports of his death he was 'pursuing his professional studies'. Seventy of his paintings were sold at Carlisle in the year following his death.

GIBSON, William Sidney, MA (1814–1871)

Amateur landscape and coastal painter in watercolour; architectural and antiquarian draughtsman. He was born at Fulham, the son of a merchant, and after studying for the Bar for some time was admitted to Lincoln's Inn in 1839. Four years later he moved to NEWCASTLE to take up the appointment of registrar of the Newcastle upon Tyne District Court of Bankruptcy, retaining this title until the Bankruptcy Act of 1869 abolished the Court. Throughout his period in Northumbria, Gibson took a keen interest in antiquarian matters, and in addition to writing dozens of articles for magazines and newspapers on these and other topics, published many books, several of which were associated with TYNEMOUTH, where he lived after moving from NEWCASTLE *c*.1856, until just short of his death. Notable among these books were his *The History of the Monastery founded at Tynemouth*, Two Volumes, 1846 and 1847, and *A Descriptive & Historical Guide to Tynemouth*, 1849. He was, however, the author of many other books on the archaeology of the North, and in recognition of his contributions to the literature of this subject received an honorary Master of Arts degree from Durham University in 1857. Gibson led a reclusive existence while living at NEWCASTLE, and later TYNEMOUTH, and the fact that he was in addition to being a scholarly writer on a miscellany of subjects, an accomplished spare-time painter in watercolour appears to have gone entirely unnoticed. He died at London, and in accordance with a wish long and frequently expressed during his lifetime, was buried in the disused grounds of the old Priory at TYNEMOUTH. He is interred in a vault close to the Lady Chapel. The Laing Art Gallery, NEWCASTLE, has a rare example of Gibson's watercolour work: *At Newhaven*.

GIBSONE (GIBSON), George (1762–1846)

Seashell, plant and mineral specimen painter in watercolour; draughtsman; drawing master. Gibsone was born at Deptford, Kent, the son of an architect, and joined his father's practice on leaving school. Like his

George Gibsone, *Murex Lyratus, South Seas*, watercolour, 27.5 x 21.5cm. Natural History Society of Northumbria, Newcastle.

father, he travelled Italy before commencing practice, later designing several London residences and country mansions. In 1796 he married, and shortly afterwards moved with his wife and the rest of his family to NEWCASTLE, where local lead works owner Richard Fishwick wished father and son to help design and erect an iron works at nearby LEMINGTON. A company was formed in 1800 in which Fishwick and the two Gibsones were partners, but in June, 1803, the enterprise collapsed, ruining all three. Gibsone then became manager of his brother John's colour works at BILL QUAY, near GATESHEAD. However, his wife later opened an 'upper class girls' school' at NEWCASTLE, and with Gibsone's help as drawing master this enterprise proved so successful, that the couple were able to retire in 1831 to a house which they had erected at LOW FELL, near GATESHEAD. For many years after first moving to NEWCASTLE, Gibsone had taken a keen interest in the natural sciences, and was a member of what is today the Natural History Society of Northumbria. He was also a keen spare-time painter in watercolour, painting 'coins, plants, minerals, shells, etc., etc.,', and acquiring 'great dexterity in illustrating conchology'. Before his retirement from the school he had begun to concentrate on the last named activity, and to obtain specimens for illustration travelled the coasts of England, Scotland and France, also obtaining specimens from other collectors. When he

died at LOW FELL in 1846 he left behind him a vast number of watercolours depicting his collection. Some 4,000 passed into the hands of local vicar, the Rev E H Adamson, and were later presented to the Natural History Society of Northumbria, NEWCASTLE. A further quantity, numbering some 7,260, in sixteen portfolios, were purchased by public subscription in 1890, and presented to Newcastle Public Library. Altogether, they represent a monumental work, and one of the most unusual preoccupations of any Northumbrian artist. Gibsone was also a keen gardener, and at the Northumberland Institution for the Promotion of the Fine Arts, NEWCASTLE, 1827, exhibited a watercolour portraying *Wilmot's superb strawberry, forced at Fenham 10.5.27*.

GILLIE, Ann (1906–1995)
Landscape and still life painter in oil; abstract painter; collagist. She was born at NEWCASTLE and studied art at Armstrong College (later King's College; now Newcastle University), finishing with a scholarship to study further in Paris. She subsequently worked as a stage designer at NEWCASTLE, and then as an interior designer in London, designing interiors for churches, public buildings and private houses. In 1934 she returned to the North East to marry, and live at TYNEMOUTH, from which in 1939 she first began exhibiting her work by showing two designs for cathedral kneelers at the Artists of the Northern Counties exhibition at the Laing Art Gallery, NEWCASTLE. She continued to exhibit at NEWCASTLE for several years, and in 1948 sent her first works to the Royal Academy: *Seashells*, and *Flotsam*. By 1951 she had also exhibited at the Royal Scottish Academy, and in that year contributed three works to the 'Contemporary Artists of Durham County' exhibition held at the Shipley Art Gallery, GATESHEAD, in connection with the Festival of Britain. She subsequently exhibited at NEWCASTLE for many years, showing work at the Laing, Univision and Westgate Galleries, and the exhibitions of the Newcastle Society of Artists, and the Federation of Northern Art Societies. She also exhibited widely abroad, including the Numero Gallery, Florence; the Salon European, Nancy, and the Mortimer Borne Gallery, New York. In 1965 a one-man exhibition of her work was held at the Laing Art Gallery of which its then director B Collingwood Stevenson wrote: 'Her works are inspired by a diversity of objects but have a single theme – the feeling of oneness in the whole of life … Her aim is always to explore the unity which lies behind the apparent diversity of life.' This was followed by a one-man exhibition at Middlesbrough Art Gallery in 1968. She was a founder-member of Tyneside's *Triangle*, and *63* groups, with which latter she continued to work until she was eighty-five when she had a severe stroke. She was also director of the Calouste Gulbenkian Gallery at the People's Theatre, NEWCASTLE, for many years, where she arranged and participated in a number of exhibitions. She died at TYNEMOUTH in 1995, in her ninetieth year. A major retrospective exhibition of her work was held at the Hatton Gallery, NEWCASTLE, in 1999, including paint-

ings, collages and constructions from her Euston Road influenced period of the early 1950s, to her highly individual later abstracts and collages using a variety of media. Several of her NORTH SHIELDS and other local landscape subjects were also featured. Represented: Laing A G, Newcastle; Shipley A G, Gateshead; Sunderland A G; Middlesbrough A G. [See colour plate]

GILMOUR, Albert Edward (b.1923)

Amateur railway and landscape painter in oil; illustrator; cartoonist. Gilmour was born at WEST HARTLEPOOL (now HARTLEPOOL), and at the age of sixteen began an almost fifty year career in the railways which saw him qualify first as a fireman, and later as a driver of steam and diesel locomotives. Interested in art from an early age, however, he studied at evening classes held at the Shipley Art Gallery, GATESHEAD, and King's College (now Newcastle University), and attended day classes at Ormesby Hall, Yorkshire, and the Slade School of Fine Art. By 1949 he was exhibiting his work at the Artists of the Northern Counties exhibitions at the Laing Art Gallery, NEWCASTLE, showing *A Locomotive Fireman*, later going on to become a regular exhibitor of railway and other subjects there, and at the annual exhibitions of the Gateshead Art Club, held at the Shipley Art Gallery. He also exhibited with the West End Art Club, NEWCASTLE, and showed his work elsewhere in Northumbria. Two of his works were included in the 'Contemporary Artists of Durham County' exhibition, held at the Shipley Art Gallery in 1951, in connection with the Festival of Britain, and in 1961 he shared an exhibition with his artist wife Elaine Gilmour (q.v.), at the People's Theatre, Green Room, NEWCASTLE. Since his retirement from the railways he has continued to take an interest in painting and exhibited his work at the Federation of Northern Art Societies' annual exhibitions at the Shipley Art Gallery, and the Laing Art Gallery, and with the West End Art Club. While working on the railways he contributed cartoons to magazines related to the industry. In 1959 he illustrated *Old Inns & Taverns of Northumberland*, and in 1967, *Old Inns & Taverns of Northumberland & Durham*, both published by Frank Graham. Gilmour lived at GATESHEAD when he began his railway career, but has now lived at NEWCASTLE for many years. Most of his work is signed simply 'Gilmour'. [See colour plate]

GILMOUR, Elaine (née Bolton) (1931–1990)

Amateur still life painter in oil; collagist; art teacher. She was born at HETTON-LE-HOLE, near SEAHAM, and did not take up painting seriously until after she had gained her teacher's certificate with art distinction at Durham University. She then attended art classes at Neville's Cross College, DURHAM, and Sunderland College of Art, and began exhibiting her work under her maiden name of 'Elaine Bolton'. Following her marriage to artist Albert Edward Gilmour (q.v.), she exhibited under her married name, showing her work at the annual exhibitions of the Gateshead Art Club, held at the Shipley Art Gallery, GATESHEAD; the Artists of the Northern Counties exhibitions at the Laing Art

Gallery, NEWCASTLE, and the Federation of Northern Art Societies' exhibitions at both galleries. She was also an exhibitor with the West End Art Club, and Sunderland Art Club, and in 1961 shared an exhibition with her husband, at the People's Theatre, Green Room, NEWCASTLE. She lived for many years at NEWCASTLE. Represented: Laing A G, Newcastle; Sunderland A G.

GILROY, John Thomas Young, MA(HON) ARCA FRSA (1898–1985)

Portrait and landscape painter in oil and watercolour; poster designer; art teacher. Gilroy was born at NEWCASTLE, the son of John William Gilroy (q.v.), and received some tuition from his father before studying art at Armstrong College (later King's College; now Newcastle University) under Richard George Hatton (q.v.). In 1916 he enlisted in the Royal Field Artillery serving in the First World War in France, and later in Palestine on the staff of Lawrence of Arabia. After the War he took up a scholarship at the Royal College of Art and won a further travelling scholarship to study in France and Italy. Returning to England, he taught at the Royal College of Art and worked on his first of many Royal portrait commissions: Edward, Prince of Wales, later Edward VIII, Duke of Windsor. In 1928 he entered the commercial art world, joining the well-known Benson's Advertising Agency. The agency soon after won the Guinness account and with Dorothy L Sayers as one of the principal copywriters on the account Gilroy commenced a productive career in devising advertisements and posters for the brewers which was to last for the next thirty-five years. Over these years he produced some of the most memorable images in British advertising, such as the man with the girder (Guinness for Strength), and the Toucan (Guinness is Good for You). He developed the Guinness menagerie, drawing the animals from life in London Zoo, and sometimes using them in his designs with a zookeeper caricaturing himself. Several of his designs were also based on visits to Bertram Mills Circus, the series which he produced for his posters becoming amongst the most famous of the 20th century. During the Second World War he further contributed to this reputation by producing for the Ministry of Information the *Careless Talk Costs Lives*, and *Dig for Victory* posters, examples of which can now be seen in Churchill's Cabinet War Rooms, London. Notwithstanding his considerable activity as a commercial artist Gilroy was much in demand as a portrait painter throughout his life. Her Majesty Queen Elizabeth II, Her Majesty Queen Elizabeth the Queen Mother, The Duke of Edinburgh, Princess Margaret, Princess Anne and Prince Charles have all been painted by him for various institutions. Other sitters have included Lord Mountbatten, Lord Hailsham, Edward Heath, Winston Churchill, Pope John XXIII, and Field Marshall Alexander of Tunis. He also as a relaxation painted many landscapes, some of these while on holidays in Spain, Portugal and other European countries. Gilroy exhibited widely in his career, from 1927 participating in many group exhibitions, including the Fine Art Society; the Royal

139

Academy; the Royal Institute of Oil Painters, and several provincial galleries, among these the Laing Art Gallery, NEWCASTLE, whose Artists of the Northern Counties exhibitions he contributed to for several years. His first one-man exhibitions were held at Cheltenham Art Gallery, and Sunderland Museum & Art Gallery in 1941. Others included Mawson Swan & Morgan, NEWCASTLE, in 1964; the Upper Grosvenor Gallery, London, 1970, and the Laing Art Gallery, in 1984. Retrospectives were also held following his death at Guildford, Surrey, in 1985. The first of these was held in London in the year of his death, the second following at the Laing Art Gallery in 1998 to celebrate the centenary of his birth. The latter exhibition, which later toured Britain, was sponsored by the History of Advertising Trust and majored on Gilroy's outstanding posters from his Guinness days – posters which became so recognised for their distinctive design that he became the first British designer to devise one which didn't require words. This was his Guinness poster produced in 1953, to coincide with the coronation of Her Majesty Queen Elizabeth II. Gilroy, who was an associate of the Royal College of Art, and a fellow of the Royal Society of Arts, received an honorary Master of Arts degree from Newcastle University in 1975. Represented: National Portrait Gallery; Belfast A G; Leeds A G; Laing A G, Newcastle; Walker A G, Liverpool, and various British and overseas art galleries. [See colour plate]

GILROY, John William (1868–1944)

Landscape, marine, portrait and genre painter in oil and watercolour. He was born at NEWCASTLE, and became a largely self-taught artist before setting up practice in the city. He first began exhibiting his work publicly at the Bewick Club, NEWCASTLE, in his early twenties. He exhibited one work at the Royal Academy in 1898, *Trawlers Resting*, but thereafter exhibited almost exclusively in the provinces, and mainly at the Artists of the Northern Counties exhibitions at the Laing Art Gallery, NEWCASTLE, from their inception in 1905, until only a few years short of his death. Typical exhibits at the Laing Art Gallery during this period were his *Pittenweem Harbour, Fifeshire* (1910); *Aquatania in the Tyne* (1920); *Passing Ships*, and *Corner of the Stackyard* (1940). He also painted and exhibited a substantial number of portraits. Glory practised at NEWCASTLE until the early 1920s, when he moved to WHITLEY BAY. He was still living at WHITLEY BAY when he last exhibited at the Artists of the Northern Counties exhibition of 1940. He was the father of the distinguished portrait painter and poster designer John Thomas Young Gilroy (q.v.). Represented: Laing A G, Newcastle; Shipley A G, Gateshead.

GIPPS, Lucy (fl. mid–19th cent.)

Amateur landscape painter in watercolour. She was the daughter of the Rev Henry Gipps, Vicar of CORBRIDGE during the middle of the 19th century, and while living there with her family produced a number of watercolours of local subjects including various old buildings. Her view of the Smithy and other buildings

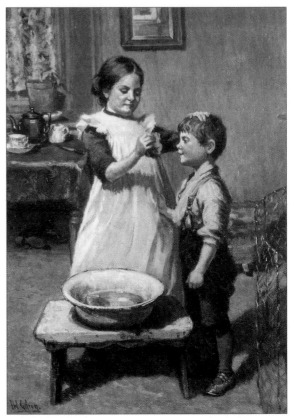

John William Gilroy, *Close your eyes*, oil, 20 x 16cm. Private collection.

at the north end of the bridge at CORBRIDGE, c.1846, was used as the front cover illustration of *Corbridge – the last 2000 years*, by Gillian Dickinson, Spredden Press, 2000.

GIRLING, Fred Jay (c.1894–1964)

Marine and landscape painter in watercolour. This artist practised for many years in Northumbria in the first half of the 20th century, mainly selling his work through Mawson Swan & Morgan, art dealers at NEWCASTLE. He is believed to have been a naval architect or draughtsman, and to have mainly painted as a relaxation. After his retirement he moved from Northumbria to Northampton. [See colour plate]

GLASGOW, Edwin (1874–1955)

Amateur landscape painter in oil and watercolour; draughtsman; illustrator. Born at Liverpool, Glasgow was educated at University College, Liverpool, and Wadham College, Oxford. On leaving College he took a post as sixth form master, Forest School, and became a keen spare-time painter in watercolour and pen and ink artist, exhibiting examples of his watercolours at the Walker Art Gallery, Liverpool, from 1896, and publishing books of his drawings in 1900 and 1901. By the early years of the last century he had exhibited his work widely throughout the provinces and handled several illustrative commissions, this activity, allied to his experience as a

Edwin Glasgow,
Warkworth Castle, 1919,
watercolour, 33 x 53.5cm.
Tyne & Wear Museums,
Shipley Art Gallery.

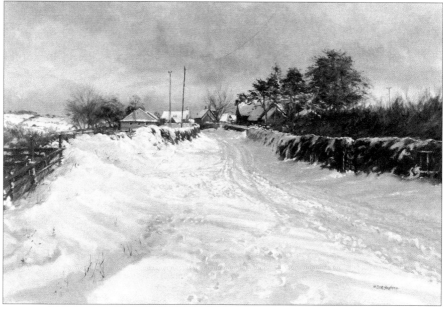

Malcolm Scott Gleghorn,
Village under snow,
oil, 61 x 91.5cm.
Private collection.

teacher, securing for him an appointment as Inspector under the Board of Education. He first worked in this capacity at NEWCASTLE, in 1909, later acting as HMI for the City, Northumberland County and Boroughs 1912–26. During his period in Northumbria he continued to take an active interest in painting and drawing, becoming a member of the Pen & Palette Club, NEWCASTLE, and exhibiting his work at the Royal Academy; the Royal Institute of Painters in Water Colours; the Paris Salon, and widely in the provinces, including the Artists of the Northern Counties exhibitions at the Laing Art Gallery, NEWCASTLE, and enjoying several one-man exhibitions of his work at various London and other galleries. On leaving NEWCASTLE he worked in Warwickshire and at Gibraltar for some

years, then took the post of Secretary and Keeper of the National Gallery, London, 1933–35. He retired on reaching Civil Service pensionable age, and devoted himself in the immediately following months to the completion of his book *The Painter's Eye*, published in 1936. He remained a keen painter and draughtsman until his death at Charlbury, Oxford, in 1955. Represented: Cheltenham A G; Laing A G, Newcastle; Shipley A G, Gateshead.

GLEGHORN, Malcolm Scott, ARCA (b.1932)
Landscape painter in oil and watercolour. He was born at NEWCASTLE, and was first taught art while attending the city's Royal Grammar School, under Cecil Marfitt-Smith (q.v.), and Robert Bryan Bertram (q.v.).

141

He later studied at King's College (now Newcastle University) under Lawrence Gowing and Roger de Grey; Sunderland College, under Henry Thubron (q.v.), and the Royal College of Art, under Carel Weight, before taking up a career as an art teacher in Northumbria. After working in this capacity from 1959–1974, at various schools and colleges in the area, he became a full-time painter. Gleghorn began exhibiting his work widely in Northumbria from 1968, when his first one-man exhibition was held at the Bondgate Gallery, ALNWICK. Subsequent one-man and group exhibitions have included, among the former, Ashington Technical College, 1969, and the Coquetdale Gallery, ROTHBURY, 1975 and 1980, and among the latter a three-man exhibition at the Town Hall, MORPETH, 1969, and the Vicarage Cottage Gallery, NORTH SHIELDS, 1991. Much of his later work, consisting of Northumbrian landscape and coastal studies, has been shown at the annual exhibitions at NEWTON-ON-THE-MOOR, near ALNWICK, instigated by George Jude McLean (q.v.). Gleghorn lives at NEWTON-ON-THE-MOOR.

GLEGHORN, Thomas ('Tom') (b.1925)

Abstract expressionist in oil and gouache; sculptor; art teacher. He was born at THORNLEY, near DURHAM, but moved with his family to Australia in the following year. Here he initially trained as an engineer at Newcastle, New South Wales, and later worked as a commercial artist, but after seeing the work of William Dobell in a Sydney gallery in the late 1950s he decided he wanted to paint. He had by now moved to Sydney, and while still working in display design and directing the city's Blaxland Galleries, spent increasing time on painting and exhibited his work. He first exhibited in Sydney in 1956, other showings of his work quickly following in Melbourne, Tokyo, Perth, Adelaide, Sao Paulo, Brisbane and London. In 1961 he was appointed as lecturer at the National Art School, Sydney, and after winning the coveted Helena Rubinstein Travelling Art Scholarship was able to travel to the Continent and Britain, painting en route. While in Britain he travelled to NEWCASTLE, where the city's Stone Gallery was so impressed by his work that it was shown as part of its *Critics Choice* exhibition in 1962. His section of the exhibition was a sell-out, and in the following year the gallery gave him his first one-man exhibition in Europe, in association with the Galerie du Fleuve, Paris. Again his work proved popular and the gallery continued to represent him for several years after his return to Australia. Gleghorn made a return visit to NEWCASTLE in 1970, having meanwhile exhibited at the Stone Gallery, elsewhere in Britain and in Australia, on a number of occasions. He later continued to teach in his adopted country, notably at the Bedford Park Teacher's College, Adelaide, from 1973. Although an eclectic painter, and occasional sculptor, he has always remained particularly attracted to the Australian landscape. He has qualified this by stating: 'I'm passionately fond of everything about Australia – its landscapes, its people, the lot – and I don't want to work anywhere but in Australia. This doesn't mean I want to paint represen-

Thomas Gleghorn, *The Passion*, 1958, oil, 136 x 61cm. Private collection.

tations of these things. I've never walked into a landscape and said 'That's nice, I'll paint that!' I'm concerned with experiences triggered by the sight of the landscape or people as such. But everything I've ever painted has been completely Australian.' His work is represented in all the state collections of Australia, and examples are also held in Britain by the Laing Art Gallery, NEWCASTLE; Middlesbrough Art Gallery; Manchester City Art Gallery, and the Shipley Art Gallery, GATESHEAD.

GLOVER, Kenneth (1887–1966)

Amateur landscape, portrait and still life painter in oil and watercolour; sculptor. Glover was born at NEWCASTLE, and later practised as an architect, living successively at CORBRIDGE, NEWCASTLE, and BEADNELL. He was a keen spare-time painter and exhibited almost exclusively at the Artists of the Northern Counties exhibitions at the Laing Art Gallery, NEWCASTLE, showing his first exhibits in 1916. Over the next thirty-odd years he showed a wide variety of subjects, including local landscapes, portraits, still lifes, and on at least one occasion a work of sculpture. During the Second World War years he built a house at BEADNELL, initially using it as a holiday home, but finally settling permanently there some years later. In addition to producing paintings he was for two years scenic artist to the

Newcastle Drama Club, and lectured on art history. He was an expert on early English watercolours and exhibited his own collection at the Hatton Gallery, NEWCASTLE. He was a member of the Society of Architects, later absorbed into the Royal Society of British Architects. He died at BEADNELL. Represented: Laing A G, Newcastle. [See colour plate]

GODDARD, Alan (b.1940)

Figure, portrait and still life painter in oil; art teacher. He was born at DARLINGTON, and first studied art under Douglas Pittuck (q.v.), at Barnard Castle School, BARNARD CASTLE. He later studied at the Ruskin School of Art, Oxford, before becoming a teacher of art to both children and adults. He has exhibited on a number of occasions at the Artists of the Northern Counties exhibitions at the Laing Art Gallery, NEWCASTLE, and in 1966 shared an exhibition at the Shipley Art Gallery, GATESHEAD, with Michael Ingham.

GOFTON, William ('Billy') (b.1945)

Sculptor. Gofton was born at SOUTH SHIELDS and initially worked as a shot blaster, painting and sculpting in his spare time. He later became a marine engineer, doing contract work which allowed him long periods to work on his sculpture. Much of his work is assembled from scrap materials and liberally deco-

William Gofton, *Dolly Peel, South Shields Waterfront*, 1987, ciment fondu, figure 1.8m high.
South Tyneside Metropolitan Borough Council.

rates his home and garden at SOUTH SHIELDS, but he has also handled other pieces requiring more conventional materials, including his statue of Dolly Peel (1782–1857), for South Tyneside Borough Council. Made of ciment fondu this stands facing the Tyne at SOUTH SHIELDS, and portrays a local fishwife of the early 1800s who was also a smuggler. It was commissioned by a distant relative, Reg Peel, and unveiled in 1987. The subject's life story is told on metal plates fixed to the sculpture's concrete pedestal.

GOOD, Thomas Sword, HRSA (1789–1872)

Portrait, genre and landscape painter in oil and watercolour; draughtsman; etcher. Good was born at BERWICK-UPON-TWEED, and first found employment for his artistic talents as a house painter. After a brief stay in London in this occupation c.1810–1811 and possibly seeing the work of other artists in the capital he began to paint coastal and landscape works in his spare time, exhibiting the first of these at the Edinburgh Exhibition Society in 1815, comprising, *Fishermen going out: Morning; Landscape*, and *Sea-Beach: Fresh Breeze*. Two years later he was engaged to draw and illustrate a map for Johnsone's history of BERWICK-UPON-TWEED, and in1820 he showed his first work at the Royal Academy: *A Scotch Shepherd*. In the following year he again exhibited at the Academy, and sent two portraits and one genre work to the Institution for the Encouragement of the Fine Arts in Scotland, Edinburgh, and heartened by his success to date decided to represent himself as a professional artist in London. Using an address in the capital from 1822 until 1824, he exhibited at the Royal Academy; the British Institution, and the Suffolk Street Gallery. He remained a regular exhibitor at the Royal Academy and the British Institution over the following nine years using both his London and home addresses, also in this period exhibiting at the Scottish Academy; the Suffolk Street Gallery; the Carlisle Academy, and the Northumberland Institution for the Promotion of the Fine Arts, NEWCASTLE, and later the town's Northern Academy. Perhaps his most noteworthy success during this period was his *A Fisherman with a gun*, which created a sensation when shown at the Northumberland Institution in 1825. In 1828 he was made an honorary member of the Scottish Academy. He exhibited little after 1834, though what work he did exhibit contradicts the popular belief that he gave up painting entirely about that year. In 1838 he showed at the First Exhibition of the North of England Society for the Promotion of the Fine Arts, NEWCASTLE, *The Industrious Mother*; at Carlisle Athenaeum, in 1846, a genre work; at the Royal Scottish Academy in 1850, *Boy Fiddling*, and *The Sleeping Fisherman*, and at 'The Exhibition of Paintings and other Works of Art', at the Town Hall, NEWCASTLE, in 1866, *The Sailor Boy*. Good was a contemporary and imitator of Sir David Wilkie (1785–1841), the Royal Academician, and chose to paint many of Wilkie's favourite subjects – fishermen, rustics in the field, and ordinary people about their everyday lives. Like Wilkie he also painted many

portraits, among these at least two of Thomas Bewick (q.v.), with whom he was evidently on terms of some familiarity. Bewick's daughter, Jane Bewick (q.v.), writing of one of these portraits in not very flattering terms, remarked of Good: '... a painter of some eminence he got out of his depths by painting in Wilkie's style; as soon as these would not sell he threw by the brush & married a Woman with money – & now enjoys the fruit of his industry ...'. Good married in 1839, and his output of work certainly dropped considerably after this event, but as evidenced by the exhibiting activity detailed above, he did not give up painting entirely. He died at his home on the Quay Walls, BERWICK-UPON-TWEED, at the age of eighty-two. On her death two years later, his widow Mary Evans Good, bequeathed three examples of his work to the National Gallery, London. Good's work was the subject of two important exhibitions in the last century, apart from its inclusion in a number of theme exhibitions. In 1906 an exhibition of twenty-eight of his works was held by art dealers Mawson Swan & Morgan, NEWCASTLE, and a major exhibition of his work was shown at Berwick Museum & Art Gallery, in 1989; this was accompanied by an excellent account of his life and work: *In a Strong Light*, by P Edwin Bowes. Represented: National Portrait Gallery; Scottish National Portrait Gallery; Victoria and Albert Museum; Tate Gallery; Hartlepool Arts & Museum Service; Laing A G, Newcastle; Natural History Society of Northumbria, Newcastle; Newcastle Central Library; North Tyneside Public Libraries. [See colour plate]

GORDON, Thomas Watson (c.1863- after 1893)
Landscape painter in watercolour. This artist practised at NEWCASTLE in the late 19th century. He first exhibited his work publicly at the 'Gateshead Fine Art & Industrial Exhibition', in 1883, showing a watercolour, *Misty Morning*, and a charcoal study, *Bill Sykes*. He later became a regular exhibitor at the Bewick Club, NEWCASTLE, and in 1892 was one of the signatories to the incorporation of the Club as the Northumbrian Art Institute, describing himself as a lithographic artist. He painted and exhibited a number of watercolour studies of scenery along the River Derwent.

GOWDY, William (1827–1877)
Portrait painter. Two examples of this artist's work were included in the exhibition of works by local painters, at the Central Exchange Art Gallery, NEWCASTLE, in 1878. These works were both head studies.

GRAHAM, Allan Price (1934–2003)
Landscape painter in watercolour; draughtsman. He was born at SOUTH SHIELDS, and after encouragement to pursue a career in art while at school attended St Michael's Art School in the town. While there, he won a *Sunday Pictorial* art competition, and completed his studies with many accolades for his work, and again encouragement to pursue a career in art. However, following his two years' national service in Egypt he felt obliged to help support his family and

Allan Price Graham, *My Father, William Price Graham*, conté drawing, 17 x 17cm. Dean Gallery.

instead applied to join an advertising agency in NEWCASTLE as a graphic artist. During this time he also attended evening classes at King's College (now Newcastle University), and was much influenced by tutors Victor Pasmore and Roger de Grey, but had little opportunity to indulge his early love of painting and drawing. He later worked in many other graphics studios and eventually opened his own such establishment. This was later expanded to encompass the Dean Gallery, NEWCASTLE, and to eventually absorb most of his time as gallery director. For many years only an occasional painter, following the closure of the gallery in 2002 he became a full-time professional artist. He died at NEWCASTLE. His work is represented in numerous private collections around the world.

GRAHAM, Anthony (1828–1908)
Landscape painter in oil. He was the son of William Graham of ALNWICK, a carrier between the town and NEWCASTLE in the days before the railways. Little is known of Graham's artistic career except that he was for some years drawing master at the Rev Canon Moore's School, ALNMOUTH, and that he was well known for his landscape and coastal works in his day. Several views of Bamburgh Castle are known.

GRAHAM-THOMPSON, Eva (c.1898- after 1955)
Amateur landscape painter in watercolour. This artist painted on Tyneside from the early years of the last century, until the late 1950s and exhibited her work at the Artists of the Northern Counties exhibitions at the Laing Art Gallery, NEWCASTLE, and later the Federation of Northern Art Societies' exhibitions at this gallery. She married in the early 1950s, and thereafter exhibited her work as Mrs Eva Graham-Wood. Her work included many Tyne Valley views painted near her home at STOCKSFIELD in the

early years of the century, and Lake District views painted after she had moved to NEWCASTLE c.1922. She appears to have spent most of her later life at NEWCASTLE.

GRAHAM-WOOD, Eva – see GRAHAM-THOMPSON, Eva

GRAY, Ethel (1879–1957)
Landscape painter in oil and watercolour; etcher; woodcut artist; art teacher. She was born at NEWCASTLE, and studied at York; Leeds; the Royal College of Art, and under Leonardo Garrido, and Stanhope Forbes, before practising as a professional artist. She later served as art mistress at York and Leeds Schools of Art, and Leeds Training College. She exhibited her work at the Royal Academy 1935–50, showing such titles as *The Old Bridge, Richmond*, and *A Coniston Waterfall*, and also sent work for exhibition to the Society of Women Artists; the Royal Water Colour Society, and the Paris Salon. Most of her life was spent at Leeds, but she finally lived in Johannesburg, South Africa. She also exhibited her work while living there.

GRAY, George (1758–1819)
Fruit, still life and portrait painter in oil and crayon; drawing master. Gray was born at NEWCASTLE, the son of a bookbinder, and received his education at the town's Grammar School. He showed an interest in drawing from an early age, and on completing his education was placed as an apprentice to an 'eminent fruit painter' named Jones, who had temporarily settled at NEWCASTLE. Before completing his apprenticeship, however, Gray's master decided to move to York, taking his apprentice with him, and when Jones decided to move on again, Gray returned to NEWCASTLE. On returning to his native town he began to take a keen interest in botany, mineralogy and chemistry, and having acquired a considerable knowledge of the first named subject, resolved to go to North America on a 'botanizing expedition'. He sailed from Whitehaven, Cumbria, in 1787, and after

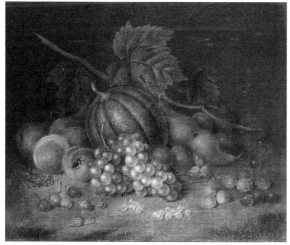

George Gray, *Fruit Study*, oil, 41 x 48.5cm. Dean Gallery.

'traversing the northern wilds of the New Continent, and observing the modes of savage life', returned to NEWCASTLE. In 1791, he was engaged with a Mr McNab, by Prince Pontiatowsky, to examine and report upon the geology of Poland, but his companion's extravagances of behaviour so offended Gray that he decided to abandon his commission at Cracow. A Major Anderson later asked him to accompany an expedition through Iceland as botanist, geologist and draughtsman, but he eventually declined this offer because of the subordinate position he would have had to accept, and in 1794 opened a shop in Dean Street, NEWCASTLE, as 'portrait, fruit, house, and sign painter'. His lack of capital, and inability to organize his business activities, soon caused him to abandon his shop, and he thereafter occupied himself with his chemical and other researches, only following his profession of painter and drawing master as much as needed to pay for the necessities of life. Gray's talents as a fruit painter were highly regarded in his day, and his portraits show him to have been as capable in this type of work. Two of his sitters, of whom portraits still exist, were Thomas Bewick (q.v.), of whom he painted the earliest known portrait, and Bewick's brother John Bewick, The First (q.v.), whose portrait in crayon by Gray is one of the very few known to have been executed. Gray's eccentricities of behaviour and general popularity made him a popular subject of portraits himself, both Henry Perlee Parker (q.v.), and William Nicholson (q.v.), taking his likeness. Gray lived briefly at SUNDERLAND, and in London, in the early nineteenth century, and was working in the latter when he sent a fruit painting to the Royal Academy in 1811. He spent his final years in NEWCASTLE, however, dying at his home in Pudding Chare in 1819. Gray was a close friend of Thomas Bewick and is referred to in the latter's autobiographical *Memoir*, published posthumously in 1862. Represented: Laing A G, Newcastle; Natural History Society of Northumbria, Newcastle; Shipley A G, Gateshead.

GRAY, Joseph (1890–1963)
Portrait and landscape painter in oil; draughtsman; illustrator; etcher. Gray was born at SOUTH SHIELDS, the son of a sea captain, and trained as a seagoing engineer before enrolling as a student at South Shields Art School under John Heys (q.v.). At the conclusion of his studies he received an appointment as an illustrator with the *Dundee Courier*, remaining with the paper until the outbreak of the First World War, when he enlisted in the Black Watch Regiment. He was invalided out of the Regiment before the end of the War, and obtained an appointment as a war illustrator with *The Graphic*. At the end of the War he turned to etching French, Dutch and Belgian subjects, many of which he had sketched on holidays before the outbreak of hostilities. He also began portrait painting, taking over the old studio of John Singer Sargent in Chelsea, London, and quickly establishing a demand for this type of work, and for his War memorial paintings. During the Second World War he once more enlisted in the Army, first as an artist attached to the Camouflage Department of the War Office and

Ministry of Supply; later as an officer in the Royal Engineers. Following the War he practised at Marlow, Norfolk, Bath, Deal, Suffolk, Dorset, and for some years at Broughty Ferry, Angus, producing paintings, drawings and etchings, and exhibiting his work at the Royal Scottish Academy, and at various London and provincial art galleries. He also exhibited in Europe and the USA. Represented: British Museum; Victoria and Albert Museum; Imperial War Museum; Dundee A G; South Shields Museum & A G.

GRAY, Joyce (1923–1998)

Amateur coastal scene and landscape painter in watercolour and pastel. She was born (née Carlisle), at MONKSEATON, and later lived at SEATON SLUICE, near BLYTH. She did not begin painting seriously until 1974, but quickly developed a skill in watercolour and pastel painting which enabled her to exhibit at the Guildhall, London, and at various North East art galleries. She was also a regular exhibitor at the Federation of Northern Art Societies' exhibitions at the Laing Art Gallery, NEWCASTLE, and the Shipley Art Gallery, GATESHEAD, receiving several commendations for her work. She died at WHITLEY BAY, on the eve of an exhibition of her work at HEXHAM together with fellow artists Walter Holmes (q.v.), and Penny Ward (q.v.).

GREEN, Arthur (1894–1988)

Amateur landscape, portrait, cattle, still life and flower painter in oil and watercolour. Green was born at Nottingham, the son of an officer in the 33rd Sussex Regiment, but moved in his infancy to GATESHEAD, with his family. While receiving his general education at Gateshead Secondary School he won a scholarship to the town's School of Art, where he studied for several years under William Fitzjames White (q.v.). On leaving the School he began to dabble on his own account in building motor cycles, attending classes at King's College (now Newcastle University) under Ralph Bullock (q.v.), in his spare time. Following service in the First World War as a technical sergeant-major in the Royal Flying Corps, however, he decided on a full-time career in the aircraft industry, remaining in this field until his retirement as works manager for De Havilland, at the age of seventy-one. Green remained interested in painting throughout his life, and although frequently called by his employment to spend long periods outside Northumbria, always made his home here, and took a keen interest in local artistic activities. He exhibited his work at the Royal Academy, he was an exhibitor for several years at the Artists of the Northern Counties exhibitions at the Laing Art Gallery, NEWCASTLE, and enjoyed several exhibitions at the city's Mawson Swan & Morgan gallery, in association with leading local professional artists, such as Thomas William Pattinson (q.v.), and Robert Leslie Howey (q.v.).

GREEN, Benjamin (1811–1858)

Architectural draughtsman. He was the son of John Green (q.v.), and trained under the Elder Pugin in London before joining his father's practice as architect and civil engineer at NEWCASTLE. While still in

Arthur Green, *Two calves by a fence*, oil, 28 x 38cm. Private collection.

London he exhibited at the Northern Academy, NEWCASTLE, in 1829, showing one of his designs. By 1833, and exhibiting his *Interior of the Literary and Philosophical Society*, at the Newcastle upon Tyne Institution for the General Promotion of the Fine Arts, NEWCASTLE, he had joined his father's practice in the town. He later exhibited at NEWCASTLE on several occasions, showing his designs for buildings, one of these works being the *Suggested Appearance of Grey Street*, with colour and figures added by Thomas Miles Richardson, Senior (q.v.), shown in 1838. He collaborated much with his father in designing local buildings, amongst these joint works the street front of the Theatre Royal, NEWCASTLE, and part of the south side of neighbouring Market Street. A later joint work was their Penshaw Monument, which stands on a small hill overlooking PENSHAW, near CHESTER LE STREET. He died in a mental home at Dinsdale Park, near DARLINGTON. The Metropolitan Museum of Art, New York, has the designs produced by John Green, Senior, and Benjamin Green, for the Theatre Royal. The Laing Art Gallery, NEWCASTLE has Green's *Suggested Appearance of Grey Street*.

GREEN, Ernest (d.1960)

Amateur landscape painter in oil. Green was born at Keighley, Yorkshire, and moved to SUNDERLAND in 1900 in connection with his work as a railwayman. He was a keen spare-time painter, and occasionally exhibited in the town while living there, and later at EAST BOLDON, near SOUTH SHIELDS. He retired to his place of birth, dying there in 1960. Sunderland Art Gallery has his *Corner of Silksworth Lane, and Durham Road, Sunderland, 1920*.

GREEN, John (1787–1852)

Architectural draughtsman. Green was born at NAFFERTON, near OVINGHAM, the son of a carpenter and agricultural implement maker. Shortly after his coming of age he joined his father's business, helping to make it so successful that it was soon found necessary to establish larger premises at nearby CORBRIDGE. Here they extended the business to include general

146

building, and after taking responsibility for this department for some time, Green moved to NEWCASTLE to practise as an architect and civil engineer. By 1822 he had established himself well enough in the town to receive the prestigious commission of designing new headquarters for its Literary and Philosophical Society. He later designed many other important structures in Northumbria, amongst these the Scotswood Suspension Bridge, opened just west of the town in 1831, and a miscellany of public and private buildings, bridges, etc. Like many architects, Green exhibited his designs, showing his first such work at the Northern Academy, NEWCASTLE, in 1828. In the following year, and with scenery painted by Thomas Miles Richardson, Senior (q.v.), he exhibited his Scotswood Bridge design. He exhibited at NEWCASTLE on several occasions subsequently, and in 1837 sent his first exhibits to the Royal Academy; these consisted of his Scotswood Bridge design, and his design for Grey's Monument, NEWCASTLE. Green increasingly collaborated with his son Benjamin Green (q.v.), in his later architectural and civil engineering projects, having taken his son into the practice about 1833. He exhibited little work produced by the practice under his own name after 1837, preferring to exhibit it jointly with his son, or under the latter's name alone. Among the works for which they jointly produced designs were the street front of the Theatre Royal, NEWCASTLE, and part of the south side of neighbouring Market Street. A later joint work was the Penshaw Monument, which stands on a small hill overlooking PENSHAW, near CHESTER LE STREET. He died at NEWCASTLE. His son, JOHN GREEN, JUNIOR (c.1807–1868), also practised as an architect at NEWCASTLE, and exhibited his designs, but does not appear to have become as involved in his father's practice as his brother Benjamin. The Metropolitian Museum of Art. New York, has the designs prepared by John Green, Senior, and his son Benjamin, for the Theatre Royal.

GREENWELL, J J (b.1897)
Amateur painter in various media; draughtsman. Born at ASHINGTON, Greenwell worked at nearby Woodhorn Colliery for some fifty-one years before retiring in 1962. He regularly exhibited his work at the Coal Industry Social Welfare Organisation's exhibitions, receiving praise for his work on a number of occasions, and a special prize for his *Bringing up the Family*. His ink wash drawing *Miner's Bath*, 1967, in the collection of Woodhorn Colliery Museum, reveals an artist of accomplished draughtsmanship and considerable sensitivity.

GREY, Edith F (c.1865- c.1914)
Landscape, portrait and flower painter in oil and watercolour. She was born on Tyneside, and studied at the School of Art, NEWCASTLE, and privately in London, before practising as a professional artist in Northumbria. She first began exhibiting her work publicly when she sent four works to the Royal Jubilee Exhibition, NEWCASTLE, in 1887, while living at MONKSEATON. Encouraged by the sale of three of these works she moved her studio to NEWCASTLE, remaining in the city throughout her career, and establishing a considerable reputation as a painter of a wide variety of subjects. She was very successful in selling her work from exhibitions, her first contribution to the Royal Institute of Painters in Water Colours being bought by a south country patron at the private view, and all but one of her sixteen contributions to the Royal Academy between 1891 and 1911 enjoying a similar fate. She also exhibited her work at the Suffolk Street Gallery; the Royal Miniature Society, and widely in the provinces, including the Bewick Club, NEWCASTLE, and the Artists of the Northern Counties exhibitions at the city's Laing Art Gallery. She died at NEWCASTLE.

GRIBBIN, Lancelot Benedict (b.1927)
Landscape and figure painter in oil; printmaker; sculptor; art teacher. Gribbin was born at GATESHEAD, and studied at Sidcup School of Art, then Goldsmiths' College School of Art, where his teachers included Ruskin Spear. He then studied art history at the Courtauld Institute, gaining an Italian government scholarship for postgraduate studies in Venice. A series of educational appointments followed, including work in the education department of the Victoria and Albert Museum; head of the history of art and design department of the London College of Printing, then a lectureship at Sotheby's in its educational studies section. Gribbin maintained a strong interest in painting from his first years as an art student and exhibited his work at the New English Art Club from 1946. He later went on to exhibit at the Royal Academy, showing his *Woman Writing*, in 1949, and showed examples of his work at the London Gallery and the Paris Salon. He had two, one-man exhibitions in London in 1952–3, but shortly after last exhibiting at the Royal Academy in 1961, decided that although his acknowledgement as a painter had been rewarding to his self-esteem, it would not provide a satisfactory living. He thereafter concentrated on his skills as a photographer, and lecturing on art history. He has lived for many years at St Albans, Hertfordshire.

GRIMES, John (fl. late 19th cent.)
Coastal artist in watercolour; draughtsman. This artist practised at SOUTH SHIELDS in the late 19th century. South Shields Museum & Art Gallery has a book of his sketches picturing various local coastal scenes, dated 1884–1893.

HADDOCK, Edwin Aldridge ('Fin') (1931–1996)

Amateur painter of various subjects in mixed media. He was born at THORNLEY, near DURHAM, and attended university at the latter, where he graduated as a bachelor of medicine and surgery in 1922. He was later granted a diploma in obstetrics from the Royal College of Obstetricians and Gynaecologists and went on to become house surgeon and house physician at a number of hospitals at NEWCASTLE and MIDDLESBROUGH. Haddock was a self-taught artist who painted throughout his career in medicine and showed his work widely throughout Britain. This included group exhibitions at the Laing Art Gallery, and the Westgate Gallery, NEWCASTLE, and one-man exhibitions at Hull, Sheffield, and Henley-on-Thames. He lived at Grimsby, Lincolnshire, for a number of years, and was a member of Lincolnshire Artists' Society and Free Painters and Sculptors. Represented: Doncaster City A G; Ferens A G, Hull; Laing A G, Newcastle.

HAIR, Thomas Harrison (1810–1875)

Landscape, industrial and marine painter in oil and watercolour; engraver; etcher. He was born at what was then the village of SCOTSWOOD, near NEWCASTLE, the son of John Hair, a lampblack manufacturer. Details of his early artistic training are not known, but it is possible in view of his early accomplishment in engraving and etching that he received training in these activities soon after receiving his general education, and possibly at NEWCASTLE, in the workshop of Mark Lambert (q.v.). His earliest known work is a watercolour of *Hebburn Colliery*, dated 1828, in the collection of the Hatton Gallery, NEWCASTLE, and is interesting because it demonstrates how early he became interested in the Northumbrian industrial scene which he was later to depict so superbly in his *Sketches of the Coal Mines of Northumberland & Durham*, 1839, and *Views of the Collieries of Northumberland & Durham*, 1844. While working on the watercolours upon which the etchings for the latter were based, however, he frequently painted more conventional works, among these his *Prudhoe Castle*, and *Cottage at Paradise*, exhibited at the Newcastle upon Tyne Institution for the General Promotion of the Fine Arts, in 1833, and the *Mill in Blagdon Burn*, and *River Scene*, which he showed at the Institution in the following year. Hair remained at NEWCASTLE until early in 1838, by which time he had completed most of the watercolours for his coal mines' publication, and in many cases executed the etchings. Also before leaving the town he had executed two engravings of the drawings of John Wilson Carmichael (q.v.), for *Views on the Newcastle and Carlisle Railway*, commenced by this artist in 1835, and issued as engravings between 1836–8, as each section of the line was completed. It is interesting that Hair and Carmichael were working on their respective industrial illustrative works simultaneously. Shortly after arriving in London from NEWCASTLE, by 1838, Hair exhibited at the Suffolk Street Gallery for the first time, and sent work to the First Exhibition of the North of England Society for the Promotion of the Fine Arts, NEWCASTLE. It appears that he spent most of the succeeding twelve years in the capital, during which time he continued to exhibit at the Suffolk Street Gallery, and also showed work at the Royal Academy; the British Institution, and back briefly at NEWCASTLE in 1842, the North of England Society for the Promotion of the Fine Arts. Most of the works he showed in London consisted of Northumbrian and Lake District views. His movements after 1849, when he last exhibited in London, are uncertain, but it is evident from the substantial number of Northumbrian subjects which he painted between 1850 and 1875, that he was a frequent visitor to the area. These works include his view of NEWCASTLE, after the construction of the High Level Bridge, in 1851 (later engraved for use in Fordyce's *History of Coal, etc., in the North of England*, along with many etchings pirated from Hair's earlier work on the mines); *The Barque 'Bomarsund', off Tynemouth*, 1857; *Hartley Colliery after the Disaster*, 1869, and *The Bigg Market, Newcastle*, 1875. He died at NEWCASTLE. A book on Hair's watercolour sketches for his mining publications, lavishly illustrated with examples from the collection of the Hatton Gallery, was published in 2000 by Douglas Glendinning under the title *The Art of Mining*. Represented: British Museum; Hatton Gallery, Newcastle; Laing A G, Newcastle; Shipley A G, Gateshead. [See colour plate]

HALFNIGHT, Richard William (1855–1925)

Landscape painter in oil and watercolour. He was born at SUNDERLAND, and following his general education went to work for the architects Jos. Potts & Son, where he soon gained a reputation for his colouring of plans, etc. He quickly tired of this occupation, however, and decided to join his father's painting and decorating business. During the evenings he attended classes at the School of Art, NEWCASTLE, under William Cosens Way (q.v.), and in spare moments copied works from his father's extensive collection of paintings. Later, an artist visiting SUNDERLAND saw his work and recommended him to adopt painting as a profession. A legacy from a relative happily made this possible, and at the age of twenty-five he went to London. His progress here was not immediately satisfactory, but following the acceptance of his first work by the Royal Academy in 1884 – a colossal watercolour entitled *Dredging* – he began to achieve success. Later in the same year he joined Yeend King in a studio at St John's Wood, benefiting considerably from this artist's three years' sojourn in Paris, and in the following year he had two works accepted by the Academy. One of these exhibits, an oil, *Streatley – Late Afternoon*, was purchased by the Art Union of London. In 1886 he made his first attempt to have his work published, choosing one of his best pictures, *Still Waters*. Within a month of its issue 300 copies were sold, and in the next few years he achieved many other notable successes in having his work published. Halfnight exhibited widely throughout his career. Prior to his move to London about

Bentham Hall,
Stewart Tea Company,
figures, etc,
lithograph.
Beamish Museum.

1880, he began exhibiting at the Suffolk Street Gallery, eventually showing more than forty works; he exhibited at the Royal Academy on eight occasions, and was a frequent exhibitor at the Royal Institute of Oil Painters; the Royal Institute of Painters in Water Colours, and at various London and provincial art galleries, including the Laing Art Gallery, NEWCASTLE, whose Artists of the Northern Counties exhibitions he contributed to from their inception in 1905, until 1923. He was also a regular exhibitor at NEWCASTLE throughout the late 19th century, sending works to the various exhibitions of the Arts Association, and later the Bewick Club, while working at SUNDERLAND. Halfnight returned to SUNDERLAND in the mid 1890s, later moving to NEWCASTLE, where he maintained studios until the outbreak of the First World War. During the remainder of his life he worked at both NEWCASTLE, and London, dying at the latter in 1925. Represented: Laing A G, Newcastle; Pen & Palette Club, Newcastle; Sunderland A G.

HALL, Arthur Henderson RWS RE ARCA (1906–1983)

Landscape painter in oil and watercolour; etcher; illustrator. Hall was born at SEDGEFIELD, and studied at Accrington and Coventry schools of art, and the Royal College of Art. In his final year at the latter he commenced exhibiting at the Royal Academy, showing an etching, and in the following year (1931), received the Prix de Rome in Engraving, enabling him to study at the British School in Rome. On returning to Britain he continued to exhibit his work showing further examples at the Royal Academy; also the Royal Institute of Painters in Water Colours; the Royal Society of Painter-Etchers and Engravers, and various

London galleries. During this period he was appointed head of the school of graphic design at Kingston School of Art, and later went on to illustrate children's educational and gardening books. Most of his life was spent at East Molesey, Surrey. Represented: British Museum; Cambridge University.

HALL, Bentham (1775–1859)

Woodcarver. He was born at WEST ACOMB, near HEXHAM, and served his apprenticeship with Richard Farrington Brothers, shipbuilders, cabinet-makers, upholsterers, carvers and gilders, NEWCASTLE. He subsequently set up in business as a carver and gilder on his own account and became well known for his ship figureheads, and other ornamental pieces in wood. Probably his best known work was his series of Oriental figures etc, and name sign for the Stewart Tea Company's shop façade on Grainger Street, NEWCASTLE, in the production of which he may have been assisted by Robert Sadler Scott (q.v.). This became one of the curiosities of the city and was illustrated in a lithograph issued in the late 19th century. He also carved items of furniture, amongst which is an oak settle in the abbey at HEXHAM. The Beamish Museum, BEAMISH, near STANLEY, has his name letters from the tea company's shop façade, which were carved in the form of Chinamen. His son James Hall (1825–1904) became a prominent Tyneside shipowner, and collector of Pre-Raphaelite paintings, as well as a member of the Newcastle Arts Association, and the Bewick Club, NEWCASTLE.

HALL, George (1852- after 1918)

Amateur illustrator in pen and ink. He was born at GATESHEAD, the son of a pawnbroker, and trained as an

George Lionel Hamilton-
Renwick,
Aureole, c. 1957,
oil, 51 x 61cm.
Royal Collection.

accountant before joining his father's business in the town. Later he became a regular contributor of illustrations in pen and ink to the *Newcastle Weekly Chronicle*, mainly specialising in countryside and architectural views. Many examples of his work were later reproduced in the *Monthly Chronicle of North Country Lore & Legend*, 1887–1891. He died at GATESHEAD.

HALL, Joseph (b.1890)
Landscape, genre and marine painter in oil, pastel and watercolour; draughtsman. He was born at THORNABY-ON-TEES, near MIDDLESBROUGH, and studied at Goldsmiths' College School of Art under E J Sullivan and Clive Gardiner before practising as a professional artist in the south of England. He eventually settled at Bromley, Kent, and exhibited his work at the Royal Academy; the Royal Society of British Artists; the Royal Institute of Painters in Water Colours; the National Society of Painters, Sculptors and Gravers; the Pastel Society, and the Royal Society of Marine Artists. Typical exhibits at the latter were his *Quiet River*, 1950, and *Thames Barges*, and *Grey River*, 1951. HRH The Duke of Edinburgh bought examples of Hall's work.

HALLWOOD, Dudley (1904–1991)
Cartoonist; draughtsman; portrait painter in oil and watercolour. He was born at Cambridge, and later moved to Ipswich, where he completed his general education. He then attended Holborn School of Art, London, later taking up a position in public relations for the Imperial Tobacco Company although he had had his first cartoon published in the *Ipswich Evening Star*, when only fifteen. Hallwood continued to work for the tobacco company throughout his life, apart from service as an officer during the Second World War, when he is said to have amused himself by producing portraits and caricatures of men serving with the BAOR. Several leading military figures of the day were included among his sitters, including Montgomery, Eisenhower and Zhukov. He also attended the Lüneburg war trials, painting portraits of several Nazi war criminals. Although he was made several tempting offers to become a full-time cartoonist by newspapers, Hallwood returned to his tobacco job after the War and contented himself by working as a part-timer for the *Journal*, NEWCASTLE, from 1946 until the mid–70s. During this period his whimsical sense of humour was deployed as a sports cartoonist for the paper's back page, which became required reading for post-war generations. Countless of his originals have pride of place in clubhouses throughout Northumbria, thanks to his coverage of various sporting events, and in 1961, a large collection of his work was published in NEWCASTLE. Hallwood lived at MONKSEATON, when he first moved to Northumbria, but spent much of his later life at CRAWCROOK, near GATESHEAD, dying there in 1991 after a retirement during which he continued to draw cartoons, mainly to accompany his letters on various topics to the local press. He also did occasional portraits, and other works, although sadly many of these, together with his newspaper work, were destroyed by fire at his home. Hallwood is only known to have exhibited his work on a few occasions, and these at the Artists of the Northern Counties exhibitions at the Laing Art Gallery, NEWCASTLE, soon after resuming civilian life following the Second World War.

HAMILTON-RENWICK, George Lionel (1917–2003)

Equestrian painter in oil. He was born at WARKWORTH, but spent his boyhood on his grandfather, Sir George Renwick's estate at Newminster Abbey, near MORPETH, surrounded by racehorses, pedigree stock and a variety of dogs which his family had a long interest in breeding. He moved to Suffolk in his teens and was sent from there to be educated in Switzerland before taking up farming in that county. While working as a farmer he received a weekly commission from the publication *Rally* to draw a famous horse. The commission proved so challenging that he enrolled as a student at Heatherlys, London, following this with further studies at the Byam Shaw School of Art, and with leading sporting artists of the day, including Frederic Whiting (1874–1962), and Gilbert Scott Wright (1880–1958). In 1953 he had the first of several one-man exhibitions at the Walker Galleries in London. This exhibition resulted in several commissions to paint the racehorses of leading owners, and his move to Newmarket a few years later to further his career in this capacity. One of his commissions by this time had included the painting of *Aureole* for Her Majesty Queen Elizabeth II, and this was quickly followed by commissions to paint equestrian portraits for Her Royal Highness, the Princess Royal; His Highness, the Maharajah of Jaipur; His Highness, Sultan Mahommed Bey, and many other leading owners both in Britain and abroad. Other exhibitions which included his work were at the Fores Gallery, and Frost & Reed, but much of his later life was taken up by his interest in the breeding at his Newmarket home of miniature Shetlands, and prize-winning dogs, and his work as a leading judge at Crufts and other dog shows. This latter represented the culmination of a lifelong interest in breeding dogs and other animals which began on his grandfather's estate as a boy. A late honour in the field of his main career as an artist was the inclusion of his portrait of *Red Rum* in a series of equestrian theme stamps issued by the Isle of Man Post Office in 2001 – a distinction which he shared with the late Sir Alfred Munnings. His portrait of *Aureole*, painted in 1957, hangs at Buckingham Palace. He signed his work 'Hamilton-Renwick'.

HAMMOND, Hermione (b.1910)

Portrait and cityscape artist in oil, pastel and watercolour; etcher. She was born at HEXHAM, and studied at Chelsea Polytechnic, with Henry Moore and Graham Sutherland, and at the Royal Academy Schools, with Walter Russell and Thomas Monnington. She also studied etching at evening classes although she appears to have done little work in the medium in her later career. After winning the competition to decorate the ceiling of the New Senate House of London University in 1937, she won the Rome Scholarship in painting in 1938. In the latter year she also commenced exhibiting at the Royal Academy (showing *The White Frock*), a practice which she was to continue for more than thirty years, showing mainly landscapes and flower pieces. Her time in Rome on her scholarship was cut short by the outbreak of the Second World War, and after war service she took the opportunity to record many views of London exposed by the Blitz which had previously been obscured. Several of these were included in her Royal Academy exhibits of the period. She next decided to pursue her career in Canada, the USA, Europe, and the Near East, and on returning to Britain became a successful portrait painter, eventually including several well-known academics amongst her commissions. She painted Professor Francis Wormald for the Society of Antiquaries, and Dr Kate Bertram for Lucy Cavendish College in Cambridge. Much of her later work, however, consisted of oil, chalk and watercolour architectural studies, among these St Paul's Cathedral and Gloucester Cathedral. In addition to exhibiting at the Royal Academy she has also shown her work at the Royal Society of British Artists; the New English Art Club; in the provinces, and abroad. One-man exhibitions of her work have been held at the Bishopgate Institute, in 1956; Colnaghi's, in 1957; Arthur Jeffries, in 1961; All Hallows, London Wall, in 1965; the New Grafton, in 1973; Hartnoll & Eyre, Iran & Cyprus, in 1978, and the University of Hull, in 1993. She has spent much of her professional life in London. Represented: Fitzwilliam Museum, Cambridge; The Museum of London; University of Hull.

HANCOCK, Albany (1806–1873)

Amateur seashell illustrator; flower, fruit and fish painter in watercolour; modeller. He was born at NEWCASTLE, one of the three sons of John Hancock, saddler and ironmonger, and practised as an attorney in the town before devoting his life to the study of natural history, like his brother John Hancock (q.v.). During the period immediately following the end of his legal career in 1832, he became interested in modelling in clay and plaster, and drew and painted flowers, fruit and fish with some success, these skills in art later proving of much value to him in his natural history researches. He subsequently became interested in the study of seashells, and during the period 1845–1855 was co-author with Joshua Alder, of *Monographs of the British Nudibranchiate Mollusca*. This work was described as having 'Figures of the Species by Joshua Alder and Albany Hancock', but most of the drawings and the whole of the anatomy were by Albany alone. This work brought the two men a world-wide reputation, and soon after its completion Albany commenced work alone on *The Organisation of the Brachiopoda*, which appeared in the Philosophical Transactions of the Royal Society for 1858, and further enhanced his reputation as an authority on his subject as well as an 'accomplished artist'. Altogether, either alone or in collaboration with friends, he published some seventy-four scientific works, and had many honours conferred upon him by learned societies, not only for his knowledge of the mollusca and brachiopoda, but of several other groups of invertebrates. He died at NEWCASTLE. He was the brother of Mary Jane Hancock (q.v.), and the uncle of Thomas Archibald Hancock (q.v.). Represented: Natural History Society of Northumbria, Newcastle.

HANCOCK, John (1808–1890)

Bird illustrator in line; sculptor; wood engraver. He was born at NEWCASTLE, one of the three sons of John Hancock, saddler and ironmonger, and later joined the family business with his brother Thomas. He soon found business irksome, however, and came to an arrangement with Thomas whereby he would be free to devote his life to the study of natural history, like their brother Albany Hancock (q.v.). John had been an acquaintance in his youth of Thomas Bewick (q.v.), and from his earliest years had collected specimens of birds, insects, shells and plants. He had also formed a friendship with taxidermist at NEWCASTLE, Richard Wingate, this leading to a lifelong interest in this art himself, and eventually the reputation of Britain's finest practitioner. In 1851 he contributed a series of mounted birds to the Great Exhibition, London, two years later publishing a series of lithographic plates of these groups, drawn on the stone himself. This work was followed in 1875 by the publication of his *Catalogue of Birds of Northumberland and Durham*, with fourteen photographic copper plates from drawings by the author, and published as Volume VI of *The Natural History Transactions of Northumberland and Durham*. He also wrote and published many other works on birds, taking a special interest in birds of prey. Some of his finest work in taxidermy was devoted to mounting specimens of these birds, modelling them in clay, and illustrating them by means of wood engravings. He was a member of many Northumbrian bodies associated with natural history study, and served as vice-president of what is today the Natural History Society of Northumbria, NEWCASTLE. It was largely through his influence that the natural history museum at NEWCASTLE which bears his name, was opened in 1884. He died at NEWCASTLE. He was the brother of Mary Jane Hancock (q.v.) and uncle of Thomas Archibald Hancock (q.v.). Represented: Natural History Society of Northumbria, Newcastle.

HANCOCK, Mary Jane (1810–1896)

Amateur landscape painter in oil and watercolour. She was born at NEWCASTLE, the younger sister of Albany Hancock (q.v.), and John Hancock (q.v.). The Natural History Society of Northumbria, NEWCASTLE, has a large collection of her watercolour sketches of local buildings, villages and landscapes painted 1841–1887, and other examples of her work. The Society also has a portrait of her drawn by William Bell Scott (q.v.), dated 1847.

HANCOCK, Thomas Archibald (1858–1916)

Landscape and coastal painter in watercolour. He was born at NEWCASTLE, the son of ironmonger Thomas Hancock, and nephew of Albany Hancock (q.v.), John Hancock (q.v.), and Mary Jane Hancock (q.v.). He practised as a professional artist at NEWCASTLE until 1900, when he moved to TYNEMOUTH. He was a member of the Bewick Club, NEWCASTLE, occasionally exhibiting his work with the Club from 1890, on which occasion he showed his *Cornfield near Kenton*. He was also an exhibitor at the Artists of the Northern Counties exhibitions at the Laing Art Gallery, NEWCASTLE, showing *Promontory Point, Cullercoats*, in 1906. He died at TYNEMOUTH. Represented: Natural History Society of Northumbria, Newcastle.

HARLE, George (b.1771)

Drawing master. Harle was born at DURHAM and practised as a drawing master at his birthplace throughout the first half of the 19th century. One of his pupils was George Fennel Robson (q.v.).

HARMAN, Gill – see HOLLOWAY, Gill

HARPER, Thomas (1820- c.1889)

Landscape painter in watercolour; drawing master. Harper was born at EIGHTON BANKS, near GATESHEAD, but at an early age moved to NEWCASTLE, where he became a pupil of Thomas Miles Richardson, Senior (q.v.). At the age of sixteen he exhibited two landscapes at the Newcastle Society of Artists. He again exhibited at NEWCASTLE in 1838 and 1839, showing work at the North of England Society for the Promotion of the Fine Arts, but from the latter date until 1841 he is believed to have worked in London, where in 1840 he showed his only works at the Royal Academy: *Distant View of the Cheviot, Northumberland*, and *Ruins of Dunstanborough Castle, Coast of Northumberland, by Moonlight*. On returning to NEWCASTLE he resumed exhibiting in the town, mainly showing Lake District views. He did not exhibit again in London until 1856, when he sent three Northumbrian coastal views to the Suffolk Street Gallery. By the time that he next exhibited at the Suffolk Street Gallery, in 1875, he had moved to SOUTH SHIELDS, following a brief spell at NORTH SHIELDS, and it appears that he spent the rest of his life at the former town, dying there some time after 1888. Harper exhibited little in his later life, among his few known exhibits being the two coastal views which he sent to the exhibition of works by local painters, at the Central Exchange Art Gallery, NEWCASTLE, in 1878. Represented: Laing A G, Newcastle; North Tyneside Public Libraries; Shipley A G, Gateshead.

HARRISON, Amy (d.1956)

Landscape painter in watercolour. She was the daughter of Ewbank Harrison, goldsmith at DARLINGTON, and great, great-grand-daughter of John (Longitude) Harrison, inventor of the chronometer. In her late teens, or early twenties, she left DARLINGTON to study under the Cornish Group of Painters, and further developed her art under Sir Frank Brangwyn. She later settled permanently at DARLINGTON, where she became well known for her studies of local churches, and Northumbrian views. She exhibited her work at the Royal Institute of Painters in Water Colours, and the Society of Women Artists from 1920, and was a frequent exhibitor at the Artists of the Northern Counties exhibitions at the Laing Art Gallery, NEWCASTLE, from 1911, her first exhibits being *Old Pilchard Curing House, Newlyn*, and *Croft Church, with Hunlaby Pew*. Three examples of her work were shown at the North East Coast Exhibition, Palace of Arts, in 1929, and she was a regular exhibitor with the

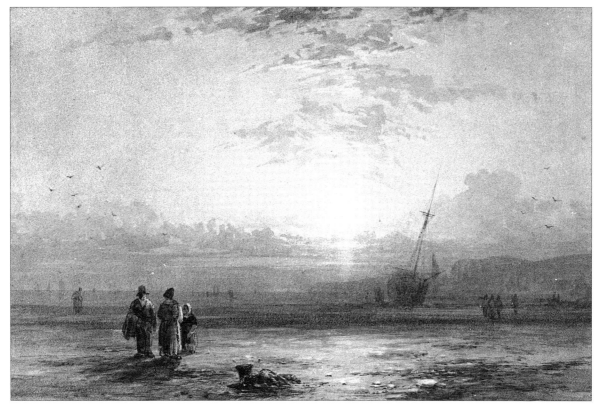

Thomas Harper, *Figures on a Northumberland Beach, Sundown*, 1888, watercolour, 19.5 x 28.5cm. Private collection.

John Brown Harrison,
A Pool on the Swale, 1926,
watercolour,
48 x 58.5cm.
Borough of Darlington
Art Collection.

Darlington Society of Arts throughout her life. Darlington Art Gallery has several of her large watercolour studies of local churches. She was the sister of John Brown Harrison (q.v.).

HARRISON, Daphne (b.1940)
Landscape and wildlife artist in watercolour; illustrator. She was born at ROWLANDS GILL, near GATESHEAD, and studied at the College of Art & Industrial Design, at NEWCASTLE, under Thomas Bromly (q.v.), before practising as an artist at her birthplace, and later at EMBLETON, near CRASTER. Her book, *Northumberland in Watercolour*, with text by John Taylor, was published by Ansis, ALNWICK, in 1997. A second volume was printed in 2000.

HARRISON, James (b.1873)
Marine draughtsman. Harrison was born at HARTLEPOOL, the son of a master mariner. His first attempts at drawing sailing ships were made in his very early years, encouraged by his father, who assisted him with the technical details of the masting, sparring and rigging. In later years his own experience at sea intensified his desire to draw ships under varying conditions of wind and weather, and to help develop his capabilities in this direction he studied under Richard George Hatton (q.v.) at Armstrong College (later King's College; now Newcastle University). A major exhibition of his work, comprising more than sixty ink and pencil drawings of sailing ships, was staged at Sunderland Art Gallery in 1950.

HARRISON, John Brown (1876–1958)
Landscape painter in oil, watercolour and pastel. He was the son of Ewbank Harrison, goldsmith at DARLINGTON, and great-great grandson of John (Longitude) Harrison, inventor of the chronometer. On concluding his general education he was allowed to enrol as a pupil at the School of Art, DARLINGTON, under Edgar Averill Elton (q.v.), where he soon distinguished himself as a talented painter in watercolour and pastel. After leaving the School, however, Harrison was introduced into the family business, remaining a spare-time painter until his retirement about 1931. He exhibited his work widely, showing examples at the Royal Academy; the Paris Salon; the Royal Cambrian Academy; the Royal Institute of Painters in Water Colours; the Pastel Society, and at various London and provincial galleries. He also took an active interest in local artistic matters, in 1922 helping to found the Darlington Society of Arts, and serving as secretary for almost thirty years. Under the nom-de-plume 'Xamon', he also wrote art criticisms for the *Darlington & Stockton Times*. One of his Royal Academy exhibits was *The morning after*. A study of a bombed area of the North East Coast, it was a chief exhibit at Burlington House in 1941 because of its novelty as the Academy's first bombed building scene of the Second World War. Much of his other work received special attention for its accomplishment, or unusual subject matter. He died at DARLINGTON. He was the brother of Amy Harrison (q.v.). Darlington Art Gallery has a substantial collection of his watercolours, including *Pool on the Swale*, 1926, and *The Meadows, High Coniscliffe*, 1936. Represented: Darlington A G; Middlesbrough A G.

HARRISON, Thomas (d. 1945)
Landscape, architectural and coastal painter in watercolour; architectural draughtsman. Harrison was born at NEWCASTLE, and practised as an architect in the city in partnership with Sidney Ash (q.v.), following an apprenticeship in London, and some time as assistant of J H Morton of SOUTH SHIELDS. He went to France with the Artists' Rifles in the First World War, and on his return rejoined the partnership, retiring in 1936 to take a post as borough architect at WALLSEND, near NEWCASTLE. From his early days he had been a keen student of architecture and spent most of his spare time sketching and making drawings of historical and interesting buildings. In this way, it has been said, he acquired a vast knowledge of architectural details which was of great value to him in his career as an architect. Later he became an enthusiastic painter in watercolour, and frequent exhibitor of his work at the Artists of the Northern Counties exhibitions at the Laing Art Gallery, NEWCASTLE, and the city's Pen & Palette Club. He was also an exhibitor at the North East Coast Exhibition, Palace of Arts, in 1929. Harrison was a member of the Newcastle Society of Artists, and as a member of the Pen & Palette Club served as honorary secretary from 1919 until 1931. He was the son-in-law of John Atkinson (q.v.), having married Atkinson's daughter Mabel, in 1923. Represented: Pen & Palette Club, Newcastle.

HARVEY, William (1796–1866)
Wood engraver; draughtsman. Born at NEWCASTLE, the son of the keeper of the town's public baths, Harvey showed a remarkable talent for drawing from an early age, and was apprenticed to Thomas Bewick (q.v.), at the age of fourteen. He made remarkable progress under Bewick, and was soon allowed to give up the drudgery of engraving bar bills, invoice headings, etc., for the more demanding work of engraving with fellow apprentice William Temple (q.v.), cuts for Bewick's *Fables of Aesop* published in 1818. On completing his apprenticeship in 1817, Harvey decided to develop his skills as an artist yet further, and moving to London placed himself as a pupil of the rapidly rising historical and genre painter Benjamin Robert Haydon. Like Haydon's other Northumbrian pupil, William Bewick (q.v.), he also attended the dissecting rooms of Sir Charles Bell. At Haydon's studio he worked with the Landseers and others, maintaining himself meanwhile by 'furnishing designs for the engravers, and labouring with the burin on his own account'. One of his most outstanding works in wood engraving while with Haydon, was his interpretation of his master's *Death of Denatus*, later described by Chatto in his *The History of Wood Engraving*, 1848, as one of the most elaborately engraved wood cuts, for a large subject, that had ever appeared. Harvey went on to become the successor of John Thurston as the principal designer for the wood engraving trade in London. His work appeared in

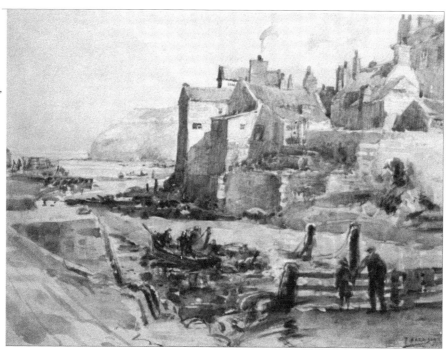

Thomas Harrison, *Staithes,*
North Yorkshire,
watercolour, 26 x 37cm.
Private collection.

innumerable books, but is seen to its best advantage in only a few of these, notably *Northcote's Fables*, 1828 and 1833; Lane's *Arabian Nights*, 1838–40, and *The Gardens and Menagerie of the Zoological Society*, 1829. In addition to designing and engraving for a wide range of books, Harvey also contributed to a number of popular periodicals of his day, including *The Observer*, 1828; *Punch*, 1841–2; the *Illustrated London News*, 1843–59, and *The Illustrated London Magazine*, 1854. Like several of Bewick's pupils, Harvey prepared watercolour designs for several of his book illustrations. Some of this work survives in public collections. He exhibited on only one occasion, this being when he showed his 'Impressions from Wood Cuts, chiefly illustrative of the History of Bacchus. Designed and engraved for Dr. Henderson's 'History of Wines'', at the Northumberland Institution for the Promotion of the Fine Arts. NEWCASTLE, 1824. He died at Richmond, Surrey. He was the last of Bewick's major pupils to die, his passing later being commemorated just inside the north porch of St. Nicholas' Cathedral with a stone carved with the design of a palette, and a set of engraver's tools. Represented: British Museum; Victoria and Albert Museum; Fitzwilliam Museum, Cambridge; Natural History Society of Northumbria, Newcastle; Newcastle Central Library.

HASTINGS, Edward (Edmund) (1781–1861)

Portrait, genre and landscape painter in oil and watercolour. He was born at ALNWICK, but received his education at BAMBURGH. He was later taught painting under the patronage of Archdeacon of Northumberland, Reynold Gideon Bouyer, probably before Bouyer's attainment to this position in 1812, as Hastings was then working as a professional artist in London. By 1804 he had commenced exhibiting at the Royal Academy, showing his *Portrait of a Lady*, and in 1807 he exhibited his first work at the British Institution: *South West View of Durham Cathedral*. In the next twenty-three years he continued to exhibit at the Academy and the Institution, also sending work to the Suffolk Street Gallery, and the Old Water Colour Society. His exhibits at the first two of these establishments were contributed as 'Edward Hastings', while those to the second two were contributed as 'Edmund Hastings'. Some confusion has arisen as a consequence of this practice, but all available evidence supports the conclusion that Edward and Edmund Hastings were one and the same artist. Hastings' exhibits at the Royal Academy were all portraits, entered as the work of 'Edward Hastings', and it is significant that the obituary of 'Edmund Hastings', when he died at DURHAM in 1861, described him as a portrait painter; also, most of the Suffolk Street exhibits entered as by 'Edmund Hastings', were portraits. Hastings' early association with DURHAM, (as evidenced by his British Institution exhibit of 1807) was developed following his marriage to a local girl, and by 1829 he was describing his address as 'London and Durham'. By that date he had become a regular exhibitor at NEWCASTLE, where he had shown portraits, animal, coastal and landscape paintings at the Northumberland Institution for the Promotion of the Fine Arts, from 1823. In 1829 he commenced exhibiting at the town's Northern Academy, and from that date until the early 1840s he remained a regular exhibitor at NEWCASTLE, from 1834 showing his address as DURHAM. His work attracted considerable interest among fellow artists in Northumbria, and he painted several portraits of these men, including Thomas Miles Richardson, Senior

155

Edward Hastings, *Prideaux John Selby*, oil, 76 x 56cm.
Private collection.

(q.v.), Prideaux John Selby (q.v.), and Henry Perlee Parker (q.v.). He also took a prominent part in various of the art promoting ventures of the period, and chaired the first meeting of The Northern Society of Painters in Water Colours, held at NEWCASTLE, 24th November, 1830. In the last twenty-five years of his life Hastings appears to have concentrated mainly on painting portraits of well-known people at DURHAM, among these the famed Count Boruwalski, the three-feet-high son of a Polish nobleman, who spent the last seventeen years of his life in the city. But he also produced occasional informal portraits, such as his *Houghall Milk Boy*, painted on wood in 1855. He died at DURHAM. Several examples of his work were included in the *Durham Cathedral Artists & Images* exhibition at Durham Art Gallery, DURHAM, in 1993, among these his *Cathedral Choir Assize Sunday*, 1835. His elder brother, CAPTAIN THOMAS HASTINGS, and his eldest son W A HASTINGS (1808–1837), were both talented artists, and exhibited their work. Represented: Durham Cathedral Library; University College, Durham University.

HASWELL, John (1855–1925)

Amateur landscape painter in oil. Haswell was born at SUNDERLAND, the eldest son of a clergyman, and later practised as a solicitor in the town, taking a keen spare-time interest in painting and writing. He did not begin to exhibit his work widely until quite late in life, sending two works to the Royal Academy, one work to the Royal Scottish Academy, and various works to London and provincial exhibitions, between 1908 and 1914. His two Royal Academy contributions were *Mountain Torrent: melting snow* (1908), and *After the Storm* (1909). His exhibits at the Artists of the Northern Counties exhibitions at the Laing Art Gallery, NEWCASTLE, 1909–14, included his two Royal Academy exhibits, and a wide range of Lake District views. Haswell was president of the Stanfield Art Society in 1908, and wrote a book: *Pages from my past*. He was also a poet, musician, astronomer, and photographer of some ability. He died at Leamington Spa. Sunderland Art Gallery has his two Royal Academy exhibits in its collection. His daughter, VIOLET M HASWELL, was also a talented amateur artist, and showed one work at the Royal Academy in 1911, and several works at the Artists of the Northern Counties exhibition in 1912; her work was in portraiture.

HATTON, Richard George, ARCA (1865–1926)

Landscape, genre and portrait painter in oil and water-colour; art teacher. Hatton was born at Birmingham and received his early training in art at Birmingham School of Art. In 1890 he was appointed to the position of second art master at the College of Physical Science, NEWCASTLE, becoming headmaster five years later, on the retirement of William Cosens Way (q.v.). He remained with the College until its absorption into Armstrong College (later King's College; now Newcastle University), and in 1912 received the appointment of director of the school of art at King's College, becoming professor of fine art five years later. He was responsible for encouraging and instructing many Northumbrian artists during his long period of association with the city's schools of art, and was himself an accomplished artist, though he did not frequently exhibit his work. He exhibited at the Royal Birmingham Society of Artists, Birmingham, between 1887 and 1895; the Bewick Club, NEWCASTLE, for a few years after his move to Northumbria, and he was an occasional exhibitor at the Artists of the Northern Counties exhibitions at the city's Laing Art Gallery, from 1906. In addition to teaching art, Hatton published several books of use to the art student, these including *Perspective for Art Students*, 1902; *Figure Drawing* 1905, and *Principles of Decoration*, 1925. He was an associate of the Royal College of Art, and was president of the National Society of Art Masters in 1911. He died at NEWCASTLE. The Hatton Gallery at Newcastle University was named in memory of his great contribution to the teaching of art on Tyneside. Represented: Laing A G, Newcastle.

HAVELOCK-ALLAN, Sir Henry Spencer Moreton, Bart (1873–1953)

Amateur landscape painter in oil and watercolour. He was born at Dublin, the son of General Sir H M Havelock-Allan, Baronet, VC, and grandson of General Havelock of Indian Mutiny fame. He succeeded to the Baronetcy in 1897, and after taking up residence at Blackwell Grange, DARLINGTON, became intimately involved in the civic and cultural life of the

town, also painting in his spare time. He held several offices connected with the judiciary at DARLINGTON during his many years at Blackwell Grange, and also served as MP for BISHOP AUCKLAND 1910–18. He was a leading member of Darlington Society of Arts for many years, and was an enthusiastic patron of music, literature and painting.

HAVERY, Isabella Horton (b.1911)

Landscape, flower and still life painter in oil and watercolour; art teacher. She was born at NORTH SHIELDS, a relative of George Edward Horton (q.v.), and studied art at King's College (now Newcastle University) before taking up a teaching post at her birthplace. She next taught art at Sheffield and Doncaster, then returning to Tyneside in the early 1950s, settled at TYNEMOUTH. From this base she continued her work teaching art as occupational therapy, at hospitals at GATESHEAD, and NORTH SHIELDS until her retirement in 1971. Throughout her teaching career she continued to take a keen interest in painting, and exhibited her work widely, including the Artists of the Northern Counties' exhibitions, and later the Federation of Northern Arts Societies' exhibitions, at the Laing Art Gallery, NEWCASTLE, and the Shipley Art Gallery, GATESHEAD; the 63 Group, NEWCASTLE; the Bondgate Gallery, ALNWICK; Doncaster Art Gallery, and various other North of England galleries. She still paints and exhibits her work, and was winner of the Federation of Northern Arts Societies' Staniland Award in 1982 and 1985.

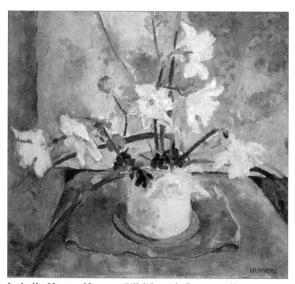

Isabella Horton Havery, *Sill life with flowers*, oil, 40 x 44cm. Private collection.

HAWARD, Arthur (1857–1937)

Landscape painter in watercolour. Born and educated in London, Haward moved to DARLINGTON in 1874 to assist in his father's cabinet making and upholstery business, eventually becoming senior partner. He was a keen spare-time painter, and frequently contributed work to the exhibitions of the Darlington Society

of Arts from its foundation in 1922, until his death fifteen years later. He was also an occasional exhibitor at the Artists of the Northern Counties exhibitions at the Laing Art Gallery, NEWCASTLE, and had two examples of his work accepted for showing at the North East Coast Exhibition, Palace of Arts, in 1929. He died at his home for many years at EGGLESTON, near MIDDLETON-IN-TEESDALE. Represented: Darlington A G.

HAWKING, Edwin J (b.1926)

Sculptor; art teacher. Hawking was born at Keynsham, Somerset, and after studying at the West of England College of Art, at nearby Bristol, taught at the College of Art at MIDDLESBROUGH from 1952–1986, eventually becoming its director of studies. He mainly exhibited his work locally, and carried out a number of commissions in MIDDLESBROUGH. Among the latter was his untitled abstract bas-relief attached to the police station at Dunning Street, MIDDLESBROUGH, installed in 1962. This was the first public sculpture commissioned in MIDDLESBROUGH for half a century.

HAY, Charles William (fl. 19th cent.)

Landscape and portrait painter in watercolour. He was born at NEWCASTLE, the son of a schoolmaster. He was an acquaintance from his youth of Thomas Miles Richardson, Senior (q.v.), and may have had some tuition from this artist before taking up the profession of watercolour painter at NEWCASTLE. He occasionally exhibited his work here in the 1840s, examples being the *Portrait*, and *Cottages near Gosforth*, which he showed at the North of England Society for the Promotion of the Fine Arts, in 1843. The Laing Art Gallery, NEWCASTLE, has his *Landscape with river and bridge*.

HAYES, Joseph (b.1904)

Amateur portrait and figure painter in oil. Hayes was a bricklayer by occupation, at NEWBIGGIN-BY-THE-SEA, near BLYTH, but was a keen draughtsman and painter from his youth. He was entirely self-taught but developed sufficient skill to have a work accepted by the Royal Academy in 1936, entitled *The Last Pitch*. The scene portraying boys playing marbles was also shown at the Artists of the Northern Counties exhibition at the Laing Art Gallery in 1937, but he thereafter exhibited little of his work.

HEALER, George, ARBS (b.1936)

Sculptor in various materials; art teacher. He was born at CHESTER LE STREET, and after education locally attended Sunderland College of Art under Henry Thubron (q.v.), and Robert Jewell. Following national service in the Army he pursued a number of occupations, including working in the family business; commercial and church furniture design; ceramics restoration for the Beamish Museum, BEAMISH, near STANLEY, and commercial sculpture for the Swanbridge Art Company, SUNDERLAND. He also taught sculpture and casting design, including adult education evening classes, and at Sunderland College of Art, and with Peterlee and Aycliffe Development Corporation. In 1974 he was elected an associate of the

William Heath ('Paul Pry'), *Where Are You Going, My Pretty Maid?*, hand-coloured engraving, c.1825.

Royal Society of British Sculptors, and in that year also gained the Society's Diploma for Distinction. He has exhibited his work at the Royal Academy; the Royal Glasgow Institute of Fine Arts; the Commonwealth Institute, London, and in Northumbria, at the Westgate Gallery, and the Gulbenkian Gallery, People's Theatre, NEWCASTLE, and Durham University, DURHAM. The Bowes Museum, BARNARD CASTLE, has his specially commissioned life-size figures of its founders, John and Josephine Bowes. He has lived at CHESTER LE STREET for many years. His son REUBEN JOHN HEALER (b.1963), is a successful professional artist.

HEATH, William ('Paul Pry') (1795–1840)
Genre, landscape and subject painter in watercolour; caricaturist; engraver. This artist was born in Northumbria, and started his professional career as an artist working as a draughtsman, later claiming to be 'Portrait and Military Painter'. His main claim to fame rests on his having produced the first caricature magazine in Europe, *The Glasgow*, later *Northern Looking Glass*, 1825–6, but he enjoyed considerable popularity as a caricaturist throughout the years 1809–34, under the pseudonym of 'Paul Pry'. Heath was reputed to have spent his early years as a captain of the Dragoons, but is not recorded in the Army List. His movements after his early years in Northumbria are uncertain, but he was working at NEWCASTLE, in 1827, when he contributed six genre, landscape and other works to the Northumberland

Institution for the Promotion of the Fine Arts, in the town. Following his fall from popularity as a caricaturist about 1834, Heath concentrated on topographical work, and straight illustration. His works in illustration include *The Looking Glass*, 1830; *The Life of a Soldier*, 1823; *Minor Morals*, (Bowring 1834–39), and *The Martial Achievements of Great Britain and Her Allies and Historical Military and Naval Anecdotes*. He died in London. His watercolour, *Merry Wives of Windsor*, was included in the exhibition of works of local painters, at the Central Exchange Art Gallery, NEWCASTLE, in 1878. Represented: British Museum; Victoria and Albert Museum; National Gallery of Scotland.

HEAVISIDE, John Smith (1812–1864)
Wood engraver. He was born at STOCKTON-ON-TEES, the son of a builder, and did not become an artist until the age of twenty-six. Following this he spent a short time in London, then settled at Oxford, where he mainly worked on cutting illustrations for archaeological works, many of them by John Henry Parker. He died at Kentish Town. Two of his brothers also practised as engravers; one of these was Thomas Heaviside (q.v.).

HEAVISIDE, Thomas (fl. early 19th cent.)
Wood engraver. He was the brother of John Smith Heaviside (q.v.), and also practised as a wood engraver. Among his best known work in this field was his portrait of Thomas Bewick (q.v.), after William Nicholson (q.v.); this portrait, with a short

memoir by William Howitt, appeared in *Howitt's Journal*, No 38, Vol II, September, 1846. He also engraved other portraits, and contributed work to the *Illustrated London News*, 1849–51. Another brother was also a wood engraver.

HEDLEY, Johnson (1851–1913)

Amateur landscape and genre painter in oil and water-colour. The younger brother of Ralph Hedley (q.v.), he was born at NEWCASTLE shortly after his family's move there from Gilling West, in Yorkshire. In the 1870s and 1880s he ran a newsagent and confectionery shop owned by his brother at GATESHEAD, and first began exhibiting his work by sending two genre works to the Arts Association, NEWCASTLE, in 1880: *The Rosary*, and *Past Redemption*. He again exhibited at the Arts Association in 1881 and 1882 and contributed a view of the River Tyne at Dunston to the 'Gateshead Fine Art & Industrial Exhibition', in 1883, and several landscapes and genre works to the Bewick Club, NEWCASTLE, in 1885 and 1886. From 1903 he lived with his family at FULWELL, near SUNDERLAND, where his daughters ran a stationery shop while he spent more time painting. In about 1907 he took a studio in SUNDERLAND, and in 1908 became a founding member of the town's Stanfield Art Society. He also became a member of the Bewick Club and in 1906 was on its executive committee. At the time of his death at FULWELL he was also president of the Benwell Art Club, NEWCASTLE. He appears to have exhibited at the Stanfield Art Society, and the Benwell Art Club exclusively in his final years as an artist. Represented: Sunderland A G.

HEDLEY, Ralph, RBA (1848–1913)

Genre, portrait and landscape painter in oil, pastel and watercolour; illustrator; sculptor; woodcarver. Born at Gilling West, near Richmond, North Yorkshire, Hedley began his career in art as an apprentice to Thomas Hall Tweedy (q.v.), wood-carver at NEWCASTLE. Prior to working as an apprentice, however, he attended the evening classes at the Government School of Design in the town, where he received tuition in drawing and painting under William Bell Scott (q.v.), and William Cosens Way (q.v.). Before his apprenticeship was complete he left Tweedy to work with Gerrard Robinson (q.v.) for a few months before starting, in 1869, his own wood-carving business in partnership with another Tweedy apprentice JAMES WISHART, who died two years later. His first tentative steps towards becoming a professional artist were about 1875 with some election posters, and in 1876 he produced portraits each week for the *North of England Review*. From this date onwards he continued to develop his wood-carving workshop as a dual source of income which would support his embryonic career as a painter. He quickly established a demand for his work and in 1878 sent eight works to the exhibition of works by local painters, at the Central Exchange Art Gallery, NEWCASTLE, and three works to the first exhibition of the town's Arts Association. In the following year he commenced exhibiting at the Royal Academy, showing his *News Boy*, between that date and his death

in 1913, contributing some fifty-two works, and also exhibiting at the Royal Scottish Academy; the Royal Institute of Painters in Water Colours; the Royal Society of British Artists, and widely in the provinces. He was a regular exhibitor at the Bewick Club, NEWCASTLE, and later the Artists of the Northern Counties exhibitions, at the city's Laing Art Gallery, and illustrated several local publications, some under the pseudonym 'Pendennis'. The woodcarving firm he founded at the start of his career became one of the best known in the area, although he only occasionally handled its commissions himself. A notable example of his work is the misericord carvings incorporated in the choir stalls which his workshop made for St Nicholas Cathedral, NEWCASTLE, as well as virtually all the wood-carving added since 1882. The firm employed William Robinson (q.v.), and JAMES TAYLOR OGLEBY (d.1909) for over thirty years, both master craftsmen in their own right. The firm worked to the commission of the leading local architects of the day, including Robert James Johnson (q.v.), William Serle Hicks, Henry Clement Charlewood, George Edward Charlewood, Frank Thorman, William Henry Knowles (q.v.), Thomas Ralph Spence (q.v.), John William Dyson (q.v.), and Arthur Benjamin Plummer, contributing designs to some of their important schemes. Apart from the work in Newcastle Cathedral other notable projects were: St Andrews, NEWCASTLE; St Chads, GATESHEAD, and St Oswalds, HARTLEPOOL. Hedley's sons Roger Hedley (q.v.), and FREDERICK HEDLEY (1884–1952), who were also talented wood-carvers, carried on the family business well into the twentieth century. Hedley was one of the most popular and well-respected local artists of his day, and in addition to enjoying membership of the Royal Society of British Artists from 1899, served as president of the Bewick Club from 1895, in succession to Henry Hetherington Emmerson (q.v.), and was the president or vice-president of several other Northumbrian art clubs. His work is today particularly valued for the record it provides of everyday life on Tyneside in the late 19th and early 20th centuries, as well as for its excellence of execution. He died at NEWCASTLE. He was the elder brother of Johnson Hedley (q.v.). A major loan exhibition of Hedley's work was staged at the Laing Art Gallery in 1938, including examples of his work in oil, watercolour, and wood-carving. On this occasion more than twenty of his surviving models took tea at the gallery with the establishment's committee chairman, and the artist's sons. In 1990 the gallery staged another exhibition of his work, entitled *Ralph Hedley Tyneside Painter*, which broke attendance records for a loan exhibition. A biography and catalogue accompanying this exhibition by John Millard was published by the Tyne & Wear Museums Service. In 2001 the Victoria and Albert Museum included three of his works in its major exhibition, *The Victorian Vision*, marking the centenary of Queen Victoria's death – the only Northumbrian artist to be so honoured. The Laing Art Gallery has a large collection of his work. Represented: Hartlepool Arts & Museum Service; Laing A G, Newcastle; Shipley A G, Gateshead; South Shields Museum & A G; Sunderland A G. [See colour plate]

HEDLEY, Roger (1879–1970)

Carver in wood and stone; modeller. Born at NEWCASTLE, the son of Ralph Hedley (q.v.), Hedley joined his father's wood-carving firm in the city on completing his general education. For some six years from 1907 he worked on his own, rejoining the family firm on the death of his father in 1913, in partnership with his elder brother FREDERICK HEDLEY (1884–1952). The partnership was dissolved in 1939, at the outbreak of the Second World War, when Frederick left to carry out war work for the local council (although he did resume work for the firm at the conclusion of the War). During the First World War Roger had also done war work, serving as a foreman at an aircraft factory in NEWCASTLE, where he introduced many improvements in woodworking technique. He invented a wood-carving easel on which he would carve wood while sitting upright without bending over a bench, and taught wood-carving at classes in various Northumbrian parishes which resulted in significant decorative additions to local churches. His sister FLORENCE HEDLEY (1877–after 1938), was a talented wood-carver, and also taught wood-carving. The workshop under the direction of Roger and Frederick carried out hundreds of wood-carving commissions throughout Northumbria and Cumbria, these including many churches and public buildings too numerous to mention. In 1948 Roger was also commissioned to make a new head for Grey's Monument, NEWCASTLE, to replace the original, struck off by lightning in 1939. In addition to his work in wood and stone Roger was

Roger Hedley, *Alnwick War Memorial*, 1922, bronze, 2m high (figures only). Alnwick District Council.

responsible for two major First World War memorials including bronze figures: ALNWICK, unveiled 1922, and WALLSEND, near NEWCASTLE, unveiled 1925. The former stands in the town centre; the latter occupies a niche in Wallsend Memorial Hall, and is dedicated to fallen staff members of Swan Hunter & Wigham Richardson, the shipbuilders. He also produced works in plaster, exhibiting several of these at the Artists of the Northern Counties exhibitions at the Laing Art Gallery, NEWCASTLE, shortly before and after his father's death. He died at STANNINGTON, near MORPETH.

HEMY, Bernard Benedict (1845–1913)

Marine and coastal painter in oil and watercolour. He was born at NEWCASTLE, the second son of Henri F Hemy, music teacher and composer. At the age of seven he travelled with his family to Australia, where they remained some two and a half years, and his father worked in the goldfields at Ballarat, near Melbourne. When the family returned to NEWCASTLE he studied for some time at the School of Art in the town under William Cosens Way (q.v.), then decided to lead a seafaring life while preparing for the priesthood. Neither seafaring, nor the priesthood, retained his interest, however, and he returned to his first love of painting. He first practised as a professional artist at NORTH SHIELDS, from which in the period 1875–7 he sent his first work for exhibition, showing *A boat builder's shop on the Tyne*, and *On the Tyne, South Shields*, at the Suffolk Street Gallery, and two works at the Dudley Gallery, London. He next showed his work at the exhibition of works by local painters, at the Central Exchange Art Gallery, NEWCASTLE, in 1878, and on finding his six marine and coastal views so well received there, decided to return to his native town. He remained at NEWCASTLE until the late 1880s, when he again settled at NORTH SHIELDS, meanwhile exhibiting at the 'Gateshead Fine Art & Industrial Exhibition', in 1883, and showing his first work at the Bewick Club, NEWCASTLE: *Shipping on the Tyne*. He remained a regular exhibitor at the Bewick Club throughout his stay at NORTH SHIELDS, and later SOUTH SHIELDS, also sending work to the art club at the latter, and for some years the Walker Art Gallery, Liverpool. He spent his final years at SOUTH SHIELDS, dying there in 1913. He was the younger brother of Charles Napier Hemy (q.v.), and the elder brother of Thomas Marie Madawaska Hemy (q.v.). Represented: Bootle A G; Laing A G, Newcastle; North Tyneside Public Libraries; South Shields Museum & A G; Sunderland A G.

HEMY, Charles Napier, RA RWS (1841–1917)

Marine, coastal and landscape painter in oil and watercolour; illustrator. He was born at NEWCASTLE, the eldest son of Henri F Hemy, music teacher and composer. Here he attended the Grammar School, and took lessons in art at the town's School of Art, under William Cosens Way (q.v.), before leaving with his family for Australia, where they spent some two and a half years. In this period Hemy's father worked in the goldfields at Ballarat, near Melbourne, Charles Napier helping him as a rough digger in this

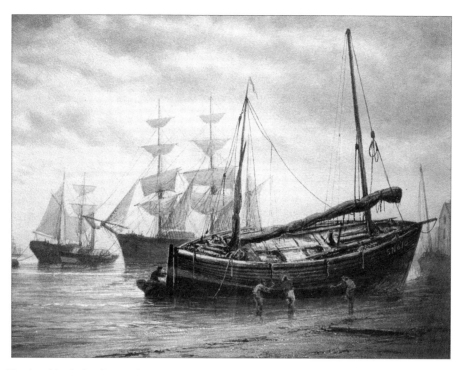

Bernard Benedict Hemy,
Mending the boat,
watercolour,
51 x 76cm.
Private collection.

work. On the return trip to England he helped man the ship on which the family travelled, this activity infecting him with a lifelong love of the sea, and a desire later to paint it in all its moods. On arriving back at NEWCASTLE, however, he decided to enter the priesthood, and was sent to Ushaw College, near DURHAM, but his love of the sea was too strong, and he left the College to work until the age of nineteen on a collier brig. At the end of this period he again felt a strong urge to become a priest and spent the next two years in a Dominican House at NEWCASTLE, and in a monastery of the same Order, at Lyons, France. His health proved too precarious for his calling, and he abandoned it to become a full-time professional artist. Hemy claimed that it was about 1854 that the sight of paintings by his uncle, Isaac Henzell (q.v.), gave him his first wish to paint, but it was not until 1863, and living at GATESHEAD, that he sent his first work for exhibition, showing four coastal views and a landscape at the Suffolk Street Gallery. He next practised at NORTH SHIELDS, sending his first work to the Royal Academy from this town in 1865: *The lone sea shore . . .*, and *Among the Shingles at Clovelly*, this latter work, painted in 1864, indicating a period in North Devon, and stylistically, the influence of the Pre-Raphaelite movement in its attention to detail, and general handling. In 1865 Hemy married a woman of independent means, and in the next five years spent much time studying at the Antwerp Academy of Arts, under Baron Leys, meanwhile continuing to exhibit in London, and showing work at the 'Exhibition of Paintings and other works of Art', at the Town Hall, NEWCASTLE, in 1866. In 1867 he sent his only contribution to the British Institution: *Tynemouth, Low Water*. After settling in London in 1871, he continued to exhibit at the Royal Academy and the Suffolk Street

Gallery, and began to show his work widely in London and the provinces, mainly showing river and coastal scenes. By the beginning of the 1880s, however, he was starting to feel the need of different inspiration for his work, and after visiting Venice, and touring the coastal resorts of the south coast of England, settled at Falmouth, where he converted a forty-foot, broad beamed fishing boat into a floating studio, christening it the 'Vandervelde'. From this vessel and its successor, the 'Vandermeer', he painted the sea and sailing studies for which he is now most famous. The vivid realism of these paintings attracted considerable attention, and in 1897 his *Pilchards* was purchased by the Chantrey Bequest for the Tate Gallery, and in the following year he was elected an associate of the Royal Academy, and a member of the Royal Society of Painters in Water Colours. In 1904 his *London River* was the subject of a second Chantrey purchase for the Tate, and in 1910 he was elected a full member of the Royal Academy. Although Hemy showed his work at all the leading exhibiting establishments in Britain from early in his career, he never forgot his native Tyneside, and was an exhibitor at NEWCASTLE until close to his death, showing many works at the Artists of the Northern Counties exhibitions at the city's Laing Art Gallery. Indeed, the last work which he exhibited was shown at NEWCASTLE in 1916: *The Black Flag*. He died at Falmouth. A memorial exhibition entitled *Life on the Sea*, was held at the Fine Art Society, London, in the year following his death, and the Laing Art Gallery, NEWCASTLE, and the City Art Gallery, Plymouth, held a major exhibition in 1984, accompanied by an excellent account of his life and work, by curator of the former, Andrew Greg. In 1999 a then record price of £110,000 was paid at auction for his oil *Life*, exhibited

161

at the Royal Academy in 1913. Many today regard Hemy as the greatest marine painter of his era. He was the elder brother of Bernard Benedict Hemy (q.v.), and Thomas Marie Madawaska Hemy (q.v.). Another younger brother, OSWIN BEDE HEMY (1856–1916), was also artistically gifted but became a professional musician. Represented: British Museum; Tate Gallery; National Maritime Museum; Hartlepool Arts & Museum Service; Laing A G, Newcastle; South Shields Museum & A G; Sunderland A G; Walker A G, Liverpool; Pen & Palette Club, Newcastle. [See colour plate]

HEMY, Thomas Marie Madawaska (1852–1937)

Marine and coastal painter in oil and watercolour. He was born on the passenger ship 'Madawaska', the sixth son of Henri F Hemy, music teacher and composer, while his family were en route from NEWCASTLE to Australia. His family remained in Australia for some two and a half years, his father working for part of this time in the goldfields at Ballarat, near Melbourne. On his family's return to NEWCASTLE he was sent to school in the town, and when he later moved to NORTH SHIELDS, he received some tuition in art from his uncle, Isaac Henzell (q.v.). About the age of fourteen, however, he became 'fed up' with life ashore, and spent the next seven years at sea, travelling widely throughout the world. At the end of this period, and having suffered a shipwreck on his way back to England from San Francisco, he decided to return to NEWCASTLE, where he enrolled as a pupil at the town's School of Art, under William Cosens Way (q.v.). While still at the School he exhibited for the first time, showing his *Old Houses on the Tyne*, at the Suffolk Street Gallery, in 1873. In the following year his works were hung on the line at the Dudley Gallery, London, and in 1874 he showed his first work at the Royal Academy: *The herring fishery at North Shields*. At this point in his career he came to the attention of John George Sowerby (q.v.), who sent him to Antwerp for two years to study drawing under Verlat. On returning to Tyneside he found some difficulty in living from his art, but shortly after showing an Irish coastal view at the exhibition of works by local painters, at the Central Exchange Art Gallery, NEWCASTLE, in 1878, he moved to SUNDERLAND, and from then on his fortunes steadily improved. While on a visit to London from SUNDERLAND, he received his first major commission – a picture in commemoration of 'Lord Charles Beresford and Engineer Benbow's gallantry up the Nile'. His work was titled, *Running the Gauntlet*, and after its purchase by Lord Beresford, was despatched on a tour of the provinces, and widely reproduced as an engraving. His career from this point forward suffered few reverses. Many other commissions followed his move to London, about 1883, several of which were also reproduced as engravings. He continued to exhibit at the Royal Academy until 1915, when one of his final exhibits was *The Ard Lects o' Shields*, and also showed work at the Royal Institute of Painters in Water Colours, and widely in the provinces, including the exhibitions of the Bewick Club, NEWCASTLE, and later the Artists of the Northern Counties exhibitions at the

city's Laing Art Gallery. Although most of his later life was spent in London he frequently spent time working away from the capital on commissions, and pursuing his personal interests in painting. These interests included the painting of a variety of sporting events, an example being his 1894 oil of a football match between Sunderland and Aston Villa, played at SUNDERLAND. This now hangs at the city's Stadium of Light, and is the world's oldest painting of Association Football. Towards the end of his life he settled at St Helen's, Isle of Wight, where he died in 1937. Much interesting information about Hemy's early life at sea, his later periods at sea on painting expeditions, and several of his more important works, are contained in his *Deep Sea Days – The Chronicles of a Sailor and Sea Painter*, 1926. This book also contains twelve monochrome illustrations by him. He was the younger brother of Charles Napier Hemy (q.v.), and Bernard Benedict Hemy (q.v.). His daughter, GWENYTTH HEMY (b.1884), was also a talented artist, and exhibited her work at the Royal Academy, and the Artists of the Northern Counties exhibitions. Represented: Laing A G, Newcastle; Shipley A G, Gateshead: Sunderland A G. [See colour plate]

HENDERSON, William (fl. 19th cent.)

Portrait and landscape painter. Henderson practised as a professor or teacher of portraiture at BERWICK-UPON-TWEED in the first decades of the 19th century after some tuition from Thomas Sword Good (q.v.). He later moved to London, but returned annually to BERWICK-UPON-TWEED on professional visits. Before his departure from the town some time after 1833, to practise in London, he published two lithographic views of the town which he had drawn. In addition to his portrait work he also produced a number of figure studies similar in style to those of his one-time master, Good. Henderson exhibited several times in NEWCASTLE, notably at the exhibitions of the Northumberland Institution for the Promotion of the Fine Arts, and later the town's Northern Academy.

HENRICKSON, Frank Watson (1915–1955)

Amateur landscape, industrial and still life painter in watercolour. He was born at WALLSEND, near NEWCASTLE, and after leaving school worked for a short time at the Post Office. However, a progressive muscular complaint led to his confinement to his home for the remainder of his life, and he used his time to paint so successfully that he was soon exhibiting his work at the Artists of the Northern Counties exhibitions at the Laing Art Gallery, NEWCASTLE, and the Federation of Northern Art Societies' exhibitions at the Shipley Art Gallery, GATESHEAD. He also had a one-man exhibition at the People's Theatre, NEWCASTLE, in 1948, and showed three works at the 'Contemporary Artists of Durham County' exhibition, at the Shipley Art Gallery, staged in 1951, in connection with the Festival of Britain. These consisted of two pencil studies, *Creeping Plant*, and *Gauging Instruments*, and a gouache, *Shell Rampant*. Although his confinement to his home led Henrickson to paint mainly still lifes, he also painted a number of local

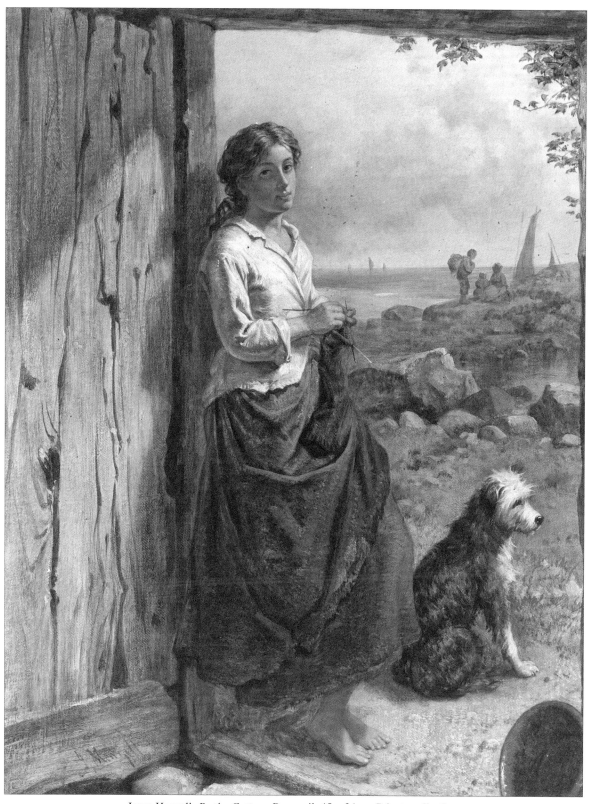

Isaac Henzell, *By the Cottage Door*, oil, 45 x 34cm. Private collection.

industrial subjects. Represented: Hatton Gallery, Newcastle; Laing A G, Newcastle; Shipley A G, Gateshead.

HENZELL, Isaac (1815–1876)
Genre, landscape and portrait painter in oil. Although Henzell was born at Sheffield, Yorkshire, there is little doubt that he was descended from the De Henzell, or Hensey, Huguenot family brought to Tyneside in 1619 from Lorraine, France, to help found a local glass industry. He is first recorded as an artist at NEWCASTLE in 1841, where he practised as a portrait painter in the town's Grainger Street. He appears to have spent the next eleven years on Tyneside before, in the summer of 1852, emigrating to Australia with his family. They evidently found it difficult to survive there and by 1854 had returned to England, where they settled in London. Henzell remained in London until 1865, then moved back to Tyneside for some six years. He spent his final years in London, dying there in 1876. Henzell first began exhibiting his work publicly in 1841, when he sent three portraits to the North of England Society for the Promotion of the Fine Arts, NEWCASTLE. These were among his few known portrait works, however, as the work which he subsequently showed at the Royal Academy; the British Institution; the Suffolk Street Gallery; and at NEWCASTLE, were almost all genre and other works, with such titles as *The Seaside Rustics* (Royal Academy, 1854); *The Prawn Fishers* (British Institution, 1862), and *R. Lambton and his Hounds* ('Central Exchange News Room, Art Gallery, and Polytechnic Exhibition' NEWCASTLE, 1870). Indeed, all but six of the some sixty-one works which he showed at the Suffolk Street Gallery from the year before his election as member of the Society of British Artists in 1855, could be firmly classed as genre paintings. One of his major works, *The Fishergirl*, was included in the exhibition of work by local painters, at the Central Exchange Art Gallery, in 1878. Isaac Henzell was the uncle of Charles Napier Hemy (q.v.), Bernard Benedict Hemy (q.v.), and Thomas Marie Madawaska Hemy (q.v.). Represented: Laing A G, Newcastle; Shipley A G, Gateshead; York A G, and at various provincial art galleries.

HEPPER, George (1839–1868)
Portrait, genre, landscape and animal painter in oil. He was born at NEWCASTLE, and after practising as an animal painter in the town for some years, went to London, where he quickly established himself as a professional artist. In 1866 he began to exhibit his work at the British Institution, and the Suffolk Street Gallery, at the former showing *Uncle Charlie's Favourites*, and *Auntie Peggie's Pets*, and at the latter, *The Young Anglers*. He again exhibited at the British Institution in 1867, and at the Suffolk Street Gallery in 1868. He died in London. Three of his works were included in the exhibition of works by local painters, at the Central Exchange Art Gallery, NEWCASTLE, in 1878; these comprised *Showing the way; Sheep*; and *View of the Thames*. He was the elder brother of William James Hepper (q.v.).

HEPPER, William James (d.1882)
Portrait and animal painter in oil. He was born at NEWCASTLE, the younger brother of George Hepper (q.v.), and practised as an artist in the town from his early twenties. He exhibited two works at the exhibition of works by local painters, at the Central Exchange Art Gallery, NEWCASTLE, in 1878: *Moonlight after the storm*, and *Humble Life*. He appears to have exhibited in the town on only one further occasion before his death, this being at the Arts Association exhibition, NEWCASTLE, in 1881, showing his *Ten Miles from Home*. He died at NEWCASTLE. Two examples of his work were included posthumously in the inaugural exhibition of the Bewick Club, NEWCASTLE, in 1884: *Dog's Head*, and *Frenchman's Bay*.

HEPPLE, John Wilson (1886–1939)
Amateur landscape painter in oil and watercolour. The son of Wilson Hepple (q.v.), he was born at WHICKHAM near GATESHEAD, and although a talented artist from an early age, chose to enter the teaching profession. He became an English master at Atkinson Road Technical School, NEWCASTLE, and remained in the teaching profession until his death. Throughout his teaching career Hepple was a keen amateur painter in watercolour, exhibiting his work almost exclusively on Tyneside, and mainly at the Artists of the Northern Counties exhibitions at the Laing Art Gallery, NEWCASTLE. He spent much of his life at GATESHEAD, but about 1928 moved to CULLERCOATS, where he lived with his family until his death while on holiday at his father's former home at ACKLINGTON, in 1939. His son, Reginald Watson Hepple (q.v.), was also a talented amateur artist, and art teacher.

HEPPLE, Reginald Watson (1920–1993)
Amateur sporting and landscape painter in oil and watercolour; art teacher. He was born at GATESHEAD, the son of John Wilson Hepple (q.v.), but moved with his family to CULLERCOATS at the age of six. After education at Tynemouth High School he attended art classes at King's College (now Newcastle University), and after later taking his art teacher's diploma taught at his former school (later the Sixth Form College at TYNEMOUTH) until his retirement in 1983. He then pursued his lifelong interest in painting until his death ten years later. Like his father, and grandfather Wilson Hepple (q.v.), he was particularly attracted to landscape and animal painting, and carried out a number of commissions in these fields, although rarely exhibiting his work. [See colour plate]

HEPPLE, Wilson (1853–1937)
Landscape, animal, sporting and historical subject painter in oil and watercolour; illustrator. He was born at NEWCASTLE, and is said to have received his early tuition in art from William Cosens Way (q.v.), who was visiting art master at Hepple's school, and later taught him at evening classes. At thirteen he was apprenticed to a grocer, but his artistic inclinations were such that he quickly left the grocery trade and entered the service of Gerrard Robinson (q.v.), to learn woodcarving. After less than a year, however, he tired

of woodcarving and decided to become a full-time professional painter. Helped in his early efforts in this direction by John Blower, of Gallowgate, NEWCASTLE, he quickly established himself in his profession, and by the age of twenty-two had produced his first major work: *Gallowgate Hoppings*. This work is said to have 'astounded the art world of Newcastle', and led Hepple to devote himself to genre painting for some time, only later specialising in the type of animal painting for which he is now best known. In 1878 he contributed work to two major exhibitions at NEWCASTLE, the first exhibition of the Arts Association, and the exhibition of works by local painters, at the Central Exchange Art Gallery. From this point forward he remained a regular exhibitor in the city, showing many examples of his work at the Bewick Club, and later the Artists of the Northern Counties exhibitions at the Laing Art Gallery. Until 1895 Hepple lived and worked on Tyneside, living for some years at WHICKHAM, near GATESHEAD. His increasing preoccupation with animal painting, however, made him wish to work in the country, and while he maintained a studio in the city for some years after this date, his home for the rest of his life was a small cottage on the banks of the River Coquet, near ACKLINGTON. Hepple's work varied widely throughout his career, and although he never exhibited outside Northumbria he was able to establish a considerable reputation as an artist in the area of his birth. He made drawings for Dr Bruce's work on the Roman Wall; executed many paintings for local hunts; painted several major works portraying incidents in the history of Tyneside (some of which were reproduced by lithography), and produced hundreds of horse, dog and kitten paintings. One of his most unusual works was the highland cattle scene which he painted jointly with George Blackie Sticks (q.v.), for the Royal Jubilee Exhibition at NEWCASTLE in 1887. Hepple painted the cattle, Sticks the landscape. He personally considered that his best work was his painting of the visit in 1906 of King Edward VII to NEWCASTLE to open the new infirmary, and Armstrong College (later King's College: now Newcastle University). He died at his cottage near ACKLINGTON, at the age of eighty-four, and is buried in the village churchyard. His brothers JOHN ROBERT HEPPLE (1846–1914), and WILLIAM THOMAS HEPPLE (d.1925), were both talented amateur artists, while his brother, ROBERT WATSON HEPPLE (1865–1946), was a professional commercial artist and accomplished watercolourist. Hepple's son, John Wilson Hepple (q.v.), grandson Reginald Watson Hepple (q.v.), and nephew ROBERT NORMAN HEPPLE (1908–1994), were also artistically talented, the latter achieving membership of the Royal Academy in 1961. Represented: Laing A G, Newcastle; Shipley A G, Gateshead. [See colour plate]

HERBERT, Albert Henry (1914–1982)
Marine, landscape and industrial painter in oil and watercolour. Herbert was born at York and developed an interest in art at an early age. During the Second World War he served in the RAF as a Sgt PTYI, and for some years was posted to NORTH SHIELDS, where he met and married his wife Nan. After the War he became a sub-postmaster in Manchester, and after studying at the Manchester College of Art exhibited his work at the Manchester Fine Arts Academy. In 1960 he and his wife moved to NORTH SHIELDS so that he could take up a position as sub-postmaster in the town, and while working in this capacity he began exhibiting his work at the Royal Scottish Academy; the Royal Scottish Society of Painters in Water Colours, and the Artists of the Northern Counties exhibitions at the Laing Art Gallery, NEWCASTLE. He also held his first one-man exhibition at the City Hotel, DURHAM, in 1964, and a two-man exhibition with Derek Brough (q.v.), at the Westgate Gallery, NEWCASTLE, in 1965. Heartened by his exhibition successes he gave up his work with the Post Office in 1968, and opened a gallery with his wife at Nile Street, NORTH SHIELDS, in which to show his own, and other local artists' work. He continued to take part in group exhibitions held elsewhere, however, and in 1972 had two of his watercolours shown at the Royal Academy. After closing his gallery he continued to paint regularly along the banks of the Tyne at NORTH SHIELDS, with a particular interest in the activities of the local sea fishing industry, shipping on the Tyne and areas of dereliction following town clearance schemes. The Vicarage Cottage Gallery, NORTH SHIELDS, held a major retrospective of his work seven years after his death consisting of thirty-seven oils, watercolours, gouaches, pencil drawings and prints. Represented: Glasgow A G; Shipley A G, Gateshead.

HESKETH, Richard (1867–1919)
Landscape painter in oil. This artist practised on Tyneside in the late 19th and early 20th centuries, where he became an acquaintance of several leading local artists, including Ralph Bullock (q.v.), David Thomas Robertson (q.v.), Francis Thomas Carter (q.v.), and J Edgar Mitchell (q.v.). He exhibited his work at the Bewick Club, NEWCASTLE, and later at the Artists of the Northern Counties exhibitions at the city's Laing Art Gallery, from their inception in 1905, until a year before his death. Hesketh lived for many years at RIDING MILL, but spent his final years in NEWCASTLE. The Shipley Art Gallery, GATESHEAD, has his *Harter Fell, Eskdale*. He died at NEWCASTLE.

HESLOP, Arthur (1881–1955)
Landscape and marine painter in oil and watercolour; etcher; art teacher. Heslop was born at NEWCASTLE, but spent his early years living in Egypt with his parents and sisters. At the age of ten he was sent to a private school in Jersey, remaining there until he was seventeen, when he became an art student at Armstrong College (later King's College; now Newcastle University), under Richard George Hatton (q.v.). At the end of his studies he remained as a member of staff, subsequently becoming master of engraving and design at the School of Art at King's College. Heslop was one of the finest etchers produced by Northumbria, and in addition to teaching many young local artists his skills, exhibited his work at the Royal Scottish Academy; the Walker

Art Gallery, Liverpool, and the Laing Art Gallery, NEWCASTLE, whose Artists of the Northern Counties exhibitions he contributed to for many years. Many of his etchings and paintings were based on Continental subjects, several of his annual holidays being spent abroad. He was also extremely fond of marine subjects, and was an active member of the Society for Nautical Research, Greenwich, London, which showed a warm appreciation of his accurate drawings of boats and ships. One of his sketch books of cobles, each sketch of which was carefully annotated by Heslop, is in the collection of this Society, and has been used as a source of valuable information on the history and development of this type of craft. Heslop continued to etch, sketch and paint following his retirement from the College. In 1953, two years before his death at NEWCASTLE, he shared an exhibition of his work with Sophia Mildred Atkinson (q.v.) – one-time fellow pupil at Armstrong College – at the city's Hatton Gallery. Represented: Laing A G, Newcastle; Natural History Society of Northumbria, Newcastle.

HESLOP, B H (fl. late 19th, early 20th cent.)
Landscape and genre painter in watercolour. This artist practised at STOCKTON-ON-TEES in the late 19th and early 20th centuries, and exhibited his work at the Bewick Club, NEWCASTLE, and later the Artists of the Northern Counties exhibitions at the city's Laing Art Gallery.

HESLOP, Robert John (1907–1988)
Amateur landscape and industrial painter in oil and watercolour; printmaker. Born at SPENNYMOOR, Heslop worked as a 'puller' at various collieries around his home town, painting in his spare time. He is believed to have received some tuition from another amateur artist JACK EVANS (1871–1967), and first exhibited his work in 1933, when he showed several local scenes at the inaugural exhibition of The Spennymoor Settlement in that year. He was a member of The Settlement's Sketching Club, and in addition to showing work at its later exhibitions also showed examples at the Artists of the Northern Counties exhibitions at the Laing Art Gallery, NEWCASTLE, for many years. Most of his exhibits at both venues were landscapes or colliery scenes, but at the former in 1941 he submitted a starkly realistic picture of an industrial area illuminated by searchlights and in the background exploding bombs, which is thought to be one of the first war pictures of its type exhibited. In 1970 he enjoyed his first one-man exhibition, showing some sixty works depicting landscapes and colliery scenes, and in 1973 was commissioned by Durham County Museum Service to record Durham County's mining history both contemporaneously, and retrospectively. As a teenager Heslop designed some of the earliest safety posters in Britain, after his artwork had been seen by the colliery manager on roadway walls, but this early recognition of his artistic ability, and success as an exhibitor from his twenties, did not attract him to leave mining and he remained associated with it for most of his life. Although Heslop mainly painted watercolours he was one of the first Northumbrian artists to

experiment with silkscreen printing. One of his well-known works in this medium is his *Domino Players*, produced in collaboration with Norman Cornish (q.v.) in the 1940s, while another is one entirely of his own production shown at the Artists International Association Exhibition, London, 1952, entitled *The Dean & Chapter Colliery at Night*.

HESLOP, T R (fl. early 19th cent.)
Landscape, architectural, coastal and figure painter in oil and watercolour; illustrator; etcher. This artist practised at TYNEMOUTH in the early 20th century, and was a regular exhibitor at the Artists of the Northern Counties exhibitions at the Laing Art Gallery, NEWCASTLE, from 1914. He mainly exhibited Northumbrian views in watercolour, but also showed designs for book illustrations, etchings, and examples of needlework and embroidery. Among his last exhibits at the Artists of the Northern Counties exhibitions were the oil painting *Punch and Judy*, and the embroidery work *At the Zoo*, which he showed in 1935, while still living at TYNEMOUTH.

HESS, Tisa – *see* **SCHULENBURG, Countess Elisabeth von der**

HEWISON, William (1925–2002)
Painter of various subjects in oil and watercolour; illustrator; cartoonist. Hewison was born at SOUTH SHIELDS, and studied at the local school of art; Regent Street Polytechnic School of Art, and London University before practising as a professional artist. In 1960 he was appointed art editor of *Punch*, retaining this position for almost quarter of a century. He exhibited his work both before and following his appointment, showing examples in 'Young Contemporaries', Whitechapel Art Gallery, and Arts Council exhibitions. He also had four one-man exhibitions at the National Theatre; published a number of books related to cartooning; designed book jackets for publishers, and contributed illustrations and cartoons to a wide range of publications. He lived in London. Represented: British Museum; Victoria and Albert Museum.

HEWITT, Geoffrey, ARCA RBSA (b.1930)
Landscape and sporting artist in oil and watercolour; art teacher. Hewitt was born at HORDEN, near EASINGTON, and after studying at the Royal College of Art under Carel Weight, John Minton and Ruskin Spear, went on to teach at Sunderland College of Art. He first began exhibiting his work while still studying at the Royal College of Art, showing examples at the Royal Academy, and the Artists of the Northern Counties exhibition at the Laing Art Gallery, NEWCASTLE, in 1952. His exhibit at the former was his *Trials at the White City* – one of the several sporting pictures he painted in his career; other examples are his *North Eastern League*, and *Junior Trial Match*, shown at the Arts Council of Great Britain/Football Association Exhibition, in 1953. Hewitt continued to exhibit at the Royal Academy, and the Laing Art Gallery, for several years, mainly showing landscapes, and also showed work at the Royal Scottish Academy; the Royal

Society of British Artists; the Royal Birmingham Society of Artists; the Walker Art Gallery, Liverpool, and overseas. The Univision Gallery, NEWCASTLE, and the Shipley Art Gallery, GATESHEAD, held one-man exhibitions of his work. After teaching at Sunderland College of Art he went on to lecture at Birmingham College of Art, and illustrated a wide range of books and magazines. Birmingham City Art Gallery has examples of his work. He was a member from 1964 of the Royal Society of Birmingham Artists, and is believed to have died some time after 1995.

HEWITT, May R (c.1940–1960)

Amateur landscape, figure and flower painter in oil and watercolour. Hewitt was born at NEWCASTLE and became a keen spare-time painter after studying part-time at King's College (now Newcastle University). She exhibited her work exclusively in Northumbria, showing examples at the Artists of the Northern Counties exhibitions at the Laing Art Gallery, NEWCASTLE, and with the Gateshead Art Society, and Federation of Northern Art Societies, at the Shipley Art Gallery, GATESHEAD. She was for much of the 1950s secretary to the latter Society.

HEYS, John (1864–1952)

Landscape painter in oil and watercolour; art teacher. Heys' place of birth is not known, but by 1880 he was a pupil teacher at the Old Friends School, SOUTH SHIELDS. He was appointed art teacher at South Shields High School in 1889, and later became first principal of South Shields Art School, retiring in 1929. Throughout his career as a teacher Heys was an enthusiastic painter, and regularly exhibited his work at the Bewick Club, NEWCASTLE, and later at the Artists of the Northern Counties exhibitions at the city's Laing Art Gallery. He married three times, his first wife, ANNIE E HEYS, also being a gifted landscape painter, and exhibitor alongside her husband at the Laing Art Gallery. Heys continued to live at SOUTH SHIELDS for some eleven years following his retirement, then moved to Sussex, where he became a member of the Association of Sussex Artists.

HICKLING, Ross (b.1918)

Amateur landscape and figure painter in oil, pastel and watercolour. He was born at Swinton, in Yorkshire, and did not settle in Northumbria until marrying after service in the Second World War. On moving to Tyneside he joined the Fire Service, remaining a fireman until his retirement thirty years later. A member of a family of artists, Hickling had taken an interest in painting and drawing from his youth and throughout his career in the Fire Service exhibited widely throughout Britain, showing examples at the Royal Academy; the Royal Scottish Academy, and other major venues. He also exhibited his work extensively on Tyneside, enjoying several one-man exhibitions at the Univision Gallery which he had founded together with fellow artists Harry Bennett Lord (q.v.), and William Smith (q.v.), in the 1950s. He was an exhibitor for several years at the Artists of the Northern Counties exhibitions at the

Laing Art Gallery, NEWCASTLE, and also showed examples of his work at the Federation of Northern Art Societies' exhibitions at the Shipley Art Gallery, GATESHEAD. Since moving to WHITLEY BAY following his retirement he has occasionally exhibited his work with the North of England Art Club, at NEWCASTLE. [See colour plate]

HICKS, Peter Michael (b.1937)

Landscape painter in watercolour and acrylic; art teacher. Although born at Osgaby, Selby, East Yorkshire, Hicks spent much of his life working as a teacher of art in Northumbria, following training at Scarborough School of Art; Middlesbrough College of Art, and Leeds School of Art. After receiving his art teacher's diploma from the latter in 1960 he taught in secondary education for several years, then at the school of art at Darlington College of Technology. He then went on to serve as head of department at the Queen Elizabeth College, DARLINGTON, for twenty-one years until leaving in 1991 to become a full-time professional painter. He also before and after his appointment at DARLINGTON taught at extramural classes at Durham University, Hull University, and numerous weekend schools, and art societies in Northumbria and Yorkshire. He held his first one-man exhibition at Picardy, France, in 1988, since when his work has been shown in a substantial number of other one-man, and group shows in London, Yorkshire, Northumbria, Scotland, and elsewhere in the UK, enjoying considerable critical acclaim. His work is principally landscape, in which he says he attempts 'to celebrate the values of the visionary as many 19th century landscapists did, but in the context of 20th century painting practice'. Hicks was awarded an MA with distinction by the University of Northumbria in 1990, and is the author of a short biography of Staithes, North Yorkshire artist Lilian Colbourn. He lives at Danby, Whitby, North Yorkshire. A major exhibition of his work was held at the Gossipgate Gallery, Alston, Cumbria, in 2003. His work is represented in collections held by Darlington Borough Council, and West Yorkshire Education Authority. [See colour plate]

HIGGINBOTTOM, William Hugh (1881-after 1936)

Landscape, portrait and figure painter in oil and watercolour. He was born at NEWCASTLE, the son of wine and spirit merchant Albert H Higginbottom, and received his training in art at the Royal Academy Schools, and at the Académie Julian, Paris. He first began to exhibit his work publicly in 1908, when he showed a portrait in oil, *Elsie*, at the Royal Academy, and subsequently at the Artists of the Northern Counties exhibition at the Laing Art Gallery, NEWCASTLE, of that year. He did not exhibit at the Royal Academy again until 1926, meanwhile continuing to exhibit at the Artists of the Northern Counties exhibitions, and on one occasion at the Royal Institute of Oil Painters. He last exhibited at the former venue in 1936, when he showed two oils: *Jevington*, and *Sussex Downs*. Higginbottom lived at Chiswick, London, for much of his later life, and

Gordon Highmoor,
Northumbrian Landscape,
oil, 46 x 61cm.
Private collection.

published *Frightfulness in Modern Art*, in 1928. His father was a keen collector of Japanese objects and prints, and bequeathed his collection to the Laing Art Gallery, NEWCASTLE. Represented: Pen & Palette Club, Newcastle.

HIGHMOOR, Gordon (b.1935)

Landscape and archaeological painter in various media; illustrator; art teacher. Highmoor was born at NEWBIGGIN-BY-THE-SEA, near BLYTH, and studied at the Newcastle College of Art (now University of Northumbria), under Thomas Bromly (q.v.), John Crisp (q.v.), and Peter Bottomley, before becoming first a senior lecturer and later head of the art and design department of New College, DURHAM. He participated in a number of group exhibitions and enjoyed several one-man exhibitions both before and after his retirement from this position in 1995, among the former the Federation of Northern Arts Societies' exhibitions at the Laing Art Gallery, NEWCASTLE; the Durham Art Teachers' exhibitions at the DLI Museum & Art Gallery, DURHAM; the Friends of the Hatton Gallery, NEWCASTLE, and the Small Works exhibitions, University of Northumbria, NEWCASTLE. One-man exhibitions of his work have included those at Northumberland Technical College, ASHINGTON: *Work in Progress*, 1964; the City Hotel Gallery, DURHAM, 1970; the Playhouse Theatre, NEWCASTLE, 1973; Kielder Castle Gallery, KIELDER, near BELLINGHAM: *Northern Landscape II*, 1988, and at the Gulbenkian Gallery, People's Theatre, NEWCASTLE, under a variety of titles, in 1990, 1992, 1996 and 1998. Several of the latter took as their subject archaeological features of Northumbria, a subject in which he has become increasingly interested since his retirement from teaching and which in 2001 led to his illustration with George Birtley Aris (q.v.), *The Power of Place*, by Stan Beckensall, and in 2002 a showing of his work in the *Art on the Rocks* exhibition at The Old Fulling Mill Museum of Archaeology, DURHAM. He has also remained interested in teaching art and has organised schools in painting and drawing, and various workshops and seminars, in Northumbria and Scotland. His wife, PAMELA HIGHMOOR (b.1941), is also a talented artist, and exhibits her work. Both are members of the North of England Art Club. They live at NEWCASTLE.

HILDER, Edith – see BLENKIRON, Edith

HILL, Ernest Edward (c.1860–c.1945)

Landscape and coastal painter in oil and watercolour. This artist was born on Tyneside and practised for many years at GATESHEAD, painting mainly Northumbrian landscapes and coastal scenes. He exhibited one example of the latter at the 'Gateshead Fine Art & Industrial Exhibition', in 1883, entitled *Misty Sunset, Low Lights*, but little else is known of his work except that his oil *The Black Middens, North Shields*, hung in a public house in the Bigg Market, NEWCASTLE, for many years. The Shipley Art Gallery, GATESHEAD, has one of his less typical oils: *Terrier & Hedgehog*.

HILL, Howard (d.1957)

Amateur architectural and landscape painter in watercolour; draughtsman. Hill practised as an architect at SOUTH SHIELDS for many years in the early part of the last century, drawing and painting in his spare time. His drawings show close affinities in style with those of contemporary and fellow architect William Henry Knowles (q.v.).

HINDMARSH, William Brack (b.1942)

Mining, landscape and figure painter in oil, watercolour and pastel. He was born at SEDGEFIELD, but spent his childhood and formative years in rural Northumberland. On leaving school he served an electrical engineering apprenticeship at Linton

Howard Hill, *Old York*, 1899, pen and ink, 14 x 9cm. Private collection.

Colliery, near ASHINGTON, later working some twelve years in mines in Northumberland and Durham County. While working in the mines he began to develop his boyhood interest in drawing and painting and won a National Coal Board prize as a result of his work. He also had his work reproduced in *Iron & Coal*, and the civil service publication *Anglia*. Despite this encouragement, and contact with members of the Ashington Group while living at WIDDRINGTON, near ASHINGTON, he did not, however, choose to develop his interest further, and it was only after his early retirement as a production engineer in 2000 that he became a full-time professional artist. His work was quickly recognised, and in that year he enjoyed one-man exhibitions at the Botanic Gardens, DURHAM; the National Coal Mining Museum for England, Wakefield, and the Hutchinson Gallery, Town Hall, BISHOP AUCKLAND. More recent such exhibitions have been held at the Customs House Gallery, SOUTH SHIELDS, and the DLI Museum & Art Gallery, DURHAM, in 2002, and he has regularly shown his work at the Glass Gallery, CONSETT, and the Saddler Gallery, DURHAM, amongst several Northumbrian galleries. A one-man exhibition of his work was held at the Tallantyre Gallery, MORPETH, in 2003. His home for many years has been at BELMONT, near DURHAM. Represented: Dryburn Hospital, Durham; Durham County Council; National Coal Mining Museum, Wakefield.

HINGE, David (b.1932)
Surrealist and theatrical painter in oil. Hinge was born at NEWCASTLE, the son of Tyneside cinema and theatre pioneer 'Teddie' Hinge, and after his education at the city's Jesmond Towers School, joined the family business, booking acts into local theatres. After a period of regular service with the Fleet Air Arm he joined the Patrick Dowling Repertory Company, returning three years later to NEWCASTLE to work first as a publicist for a major film company, later as a manager of one of the family cinemas. On the winding up of the family business in 1966 he joined the security industry and began to develop his keen boyhood interest in painting. This interest later led him to set up a number of art exhibiting venues in Northumbria at which he also showed his own work. These included the Armstrong Bridge open-air Sunday exhibitions, NEWCASTLE, started in 1969; the Nova Gallery, Jesmond Dene, NEWCASTLE, 1970; Gallery Seven, TYNEMOUTH, 1982, and the Pentangle Gallery & Theatre Museum, 1975. All of these venues, except Armstrong Bridge, lasted only a few years. Hinge rarely exhibited outside the venues which he had established, an exception being the DLI Museum & Art Gallery, DURHAM, at which examples of his work were shown at its *Theatre Memories* exhibition in 1976. Hinge continued to exhibit at his Pentangle Gallery until its closure in 1981, following which he only painted as a relaxation from his work in the security industry. On his retirement in 1997 he left Tyneside to live on the south coast of England. The Armstrong Bridge exhibitions which he started have remained a popular venue for Northumbrian artists setting out on their careers.

HINGLEY, Oswin F (1945–2004)
Landscape and coastal painter in oil. Hingley lived at CULLERCOATS, from which in 1906 he began exhibiting his work at the Artists of the Northern Counties exhibitions at the Laing Art Gallery, NEWCASTLE, showing *A Study of the Sea*. He remained an exhibitor at NEWCASTLE for several years, showing a wide variety of seascapes and coastal views.

HOBSON, Richard (1945–2004)
Industrial and landscape painter in oil, watercolour, and pastel; muralist; printmaker. He was born at Derby but moved with his family to NEWCASTLE as an infant. After taking his national design diploma at Newcastle College in 1965 he worked in London designing furniture and interiors, later following this with similar work for Swan Hunter's Shipyard on Tyneside. In 1971–1973 he successfully studied for a diploma in the conservation of easel paintings at Gateshead College, following which he combined work in the latter capacity at the Bowes Museum, BARNARD CASTLE, with that of a professional artist, living at BLAYDON, near GATESHEAD, and later nearby RYTON. He began exhibiting his work before turning professional, showing examples at the Royal Scottish Society of Water Colour Painters, Edinburgh, in 1971,

David Hinge,
The Gaiety Theatre,
Newcastle,
oil, 73 x 102cm.
Anderson & Garland.

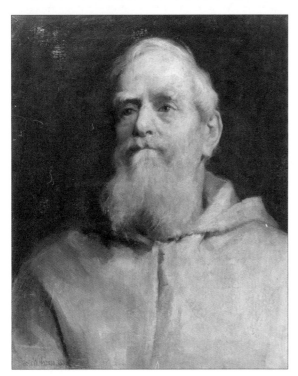

Victor William Hobson, *Portrait of an old man*, 1887,
oil, 51 x 39.5cm.
Borough of Darlington Art Collection.

and the Royal Academy in 1973. He also enjoyed his first one-man exhibition, at the Shipley Art Gallery, GATESHEAD, in 1972. He then continued to show his work in many other group exhibitions, and had further one-man exhibitions. The former included further Royal Academy, and Royal Scottish Society of Water Colour exhibitions, and other venues in London, Northumbria, Cumbria and Wales; his one-man exhibitions included the Gulbenkian Gallery, People's Theatre, NEWCASTLE, 1974; the Bondgate Gallery, ALNWICK, 1984; the Vicarage Cottage Gallery, NORTH SHIELDS, 1994; the Quaker Gallery, London, 1999, and the Customs House Gallery, SOUTH SHIELDS, 2000. The shipyards of Tyneside were a primary source of inspiration for much of his work over his years as a professional artist, but he also produced and exhibited a wide range of other watercolours and monotypes depicting Northumbrian scenery generally. Represented: Hartlepool Arts & Museum Service; Shipley A G, Gateshead. [See colour plate]

HOBSON, Victor William (1865–1889)

Portrait and landscape painter in oil. Hobson was born at DARLINGTON, and studied art at the town's Mechanics' Institute under Samuel Averill Elton (q.v.). following his general education. A Queen's Prizeman in examinations for the South Kensington School of Art, he won the Bronze Medal in 1883, and in the same year gained a place at the Royal Academy Schools, winning a silver medal for drawing in 1884. He exhibited one work in Manchester in 1888, while living at DARLINGTON. He died at Lugana, Tenerife. Represented: Bowes Museum, Barnard Castle; Darlington A G.

HODGE, Robert (c.1875- after 1926)
Marine, landscape and coastal painter in oil. This artist practised at SOUTH SHIELDS from 1895 until c.1926, in the town's Fowler Street. South Shields Museum & Art Gallery has several examples of his work. His marine work is particularly accomplished.

HODGES, Charles Clement (1852–1932)
Amateur architectural and antiquarian draughtsman; sculptor. Holmes was born at Wentworth, Yorkshire, the son of a curate and received his education at Oxford, and later Manchester. At the age of seventeen he joined the drawing office staff of the iron works at CONSETT, remaining there for seven years before moving to HEXHAM where he set up practice as an architect. He had been interested in architecture and archaeology from an early age, and had become particularly fond of HEXHAM on visits to the town from CONSETT. HEXHAM remained his home and business base for most of his life, and here he took a special interest in the Abbey, serving for many years as architect to the building, and writing and illustrating several works on its history, among which was his *The Abbey of St. Andrew, Hexham*, 1888, described by William Greenwell as 'the grandest and most exhaustive illustration of an ecclesiastical establishment which has been published in England'. The restoration of the Abbey is generally regarded as his most important work as an architect. Later in his life, however, he designed several memorial crosses, notable among which in Northumbria are those at DURHAM, ROKER, near SUNDERLAND, HEXHAM and ROTHBURY. He also sculpted the cross at ROKER, which is in memory of Bede. In his final years he was associated with William Henry Knowles (q.v.), in his architectural and antiquarian work. He died at GATESHEAD.

HODGES, Florence Mary (c.1865–after 1929)
Landscape painter in watercolour. She was born at DURHAM, the daughter of a bank manager, and later studied at the Royal Female School of Art; Calderon's School of Animal Painting, and under Frank Short, winning several prizes during her studies. She exhibited at the Royal Academy; Manchester Ladies Art Gallery; the Walker Art Gallery, Liverpool; Southport Art Gallery; Southampton; Winchester, and Brighton. One of her major works was her *Door in Henry VII's Chapel in Westminster Abbey*, shown at the Royal Academy in 1890. She began her artistic career in London, but later lived at Petersfield in Hampshire.

HODGKIN, Jonathan Edward, RBA (1875–1953)
Amateur landscape painter in watercolour. He was born at DARLINGTON, the son of Jonathan Backhouse Hodgkin, and received his education at Bootham School, York, and Leighton Park School, Reading. He later trained as an engineer, and on returning to DARLINGTON to take up business, became a keen spare-time painter, proving so successful that his work was widely accepted for exhibition. He exhibited at the Royal Institute of Painters in Water Colours; the Royal

Society of British Artists; the Paris Salon, and at various London and provincial galleries, including the Laing Art Gallery, NEWCASTLE, whose Artists of the Northern Counties exhibitions he contributed to for many years. Hodgkin was elected an associate of the Royal Society of British Artists in 1926, and became a full member two years later. He took an active interest in local artistic matters, in 1922 helping to found the Darlington Society of Arts, and serving as its chairman for thirty years. He was also a trustee of the Bowes Museum, BARNARD CASTLE, and was at one time a councillor at DARLINGTON, and president of the town's Rotary Club. In addition to his artistic, business and town council activities, Hodgkin was also deeply interested in local history and archaeology, and was author of *A little guide to the County of Durham*. Represented: Bowes Museum, Barnard Castle; Darlington A G.

HODGSON, Edward (fl. late 19th, early 20th cent.)
Landscape and coastal painter in watercolour. This artist practised at NEWCASTLE, GATESHEAD and TYNEMOUTH. He appears to have exhibited his work exclusively in Northumbria, and principally at the Bewick Club, NEWCASTLE, at whose inaugural exhibition in 1884, for instance, he showed two works: *Stella Coal Staiths* and *Scotswood Suspension Bridge*. Many of his later works were painted along the coast near his home at TYNEMOUTH, and exhibited at the early Artists of the Northern Counties exhibitions at the Laing Art Gallery, NEWCASTLE.

HODGSON, Louisa (1905–1980)
Figure, portrait and landscape painter in oil and egg tempera; muralist; art teacher. She was born at MONKSEATON, the daughter of London and North Eastern Railway official Edward Hodgson, and after education locally enrolled as an art student at Armstrong College (later King's College; now Newcastle University). In 1928 she won an Abbey Scholarship in mural decoration, spending three years at the Royal College of Art, where she specialised in this subject. In 1931 she returned to Northumbria to join the teaching staff at Armstrong College on a part-time basis, shortly afterwards being selected as one of several local artists to contribute a lunette to the Laing Art Gallery, NEWCASTLE. Her subject was the *Shipwrights' Guild at the Feast of Corpus Christi*. She later became a frequent exhibitor at the Royal Academy, and the Artists of the Northern Counties exhibitions at the Laing Art Gallery, NEWCASTLE, at the former showing imaginative subjects, and at the latter mainly portraits. While at Armstrong College she worked with scientists to reproduce colours used by the Italian Old Masters and became interested in the restoration of old paintings. She continued this interest when she later moved from TYNEMOUTH to live at ALNMOUTH, but she soon became a virtual recluse and little is known of her final years. She died at ALNMOUTH. Represented: Hatton Gallery, Newcastle; Laing A G, Newcastle; Levens A G, Hull; Manchester City A G.

Louisa Hodgson, *Portrait study*, 1950, pencil, 51 x 39.5cm. Private collection.

HODGSON, William (fl. late 18th cent.)

Portrait and landscape painter in watercolour; copyist. Hodgson's parents lived at GATESHEAD, and he was sent as a boy to study drawing under Boniface Muss (q.v.), at NEWCASTLE, where he is said to have become an 'exquisite painter in water colours'. On later moving to London he was patronised by Lewis Schiavonetti, the engraver, who gave him lessons both in drawing and Italian. He quickly established a reputation for accurate copying, and was commissioned to visit Castle Howard, in Yorkshire, to copy the *Three Marys*. He died there before completing his commission.

HOGARTH, John, ARCA ARSA (b.1935)

Landscape and figure painter in watercolour; draughtsman; illustrator. He was born at BEDLINGTON, and studied at the art school at SOUTH SHIELDS, and the Royal College of Art. At the latter he studied under John Minton and Ruskin Spear among others, and won the Bearica Mosca Award in 1956 to travel and study in Florence and Rome. In this year also he became an associate of the Royal Society of Arts. On completing his studies he worked in advertising, also teaching at various American air base schools in Europe, and exhibiting his work widely in Britain and occasionally in North America and Europe. His theatrical costume designs have been exhibited at the Wright Hepburn Gallery, London and New York, while his landscapes have been shown in Oslo, Lisbon, Melbourne, Oxford, Brighton, Edinburgh and

DURHAM. The Dean Gallery, NEWCASTLE, of which he was for some time a director, exhibited his work on a regular basis, and was responsible for publishing many examples as prints, including a series of Tyneside characters executed in pen and watercolour. Many private and commercial collections hold examples of his wide range of landscape and figurative work, while his costume designs have been employed by various ballet and theatrical companies in Britain and abroad. He lives at NEWCASTLE.

HOLE, Henry Fulke Plantagenet Woolcomb (c.1781–c.1830)

Wood engraver. He was the son of a captain in the Lancashire Militia, and served an apprenticeship with Thomas Bewick (q.v.), from 1795 until 1801. On completing his apprenticeship he left for Liverpool, taking with him a letter of introduction from Bewick to a picture merchant in the town, remarking: 'The bearer of this my late pupil – Mr Henry Hole – intends to begin business in Liverpool. I hope, from his sobriety and attention, that he will, when more settled, make a Figure in the line of his profession'. Hole, who had cut a few engravings for Bewick's *Birds* before his departure from NEWCASTLE, was moderately successful at Liverpool, where he was patronised by several leading local men, and even called on Bewick to help him complete one particularly large commission. He also became a member of the Liverpool Academy, and at its exhibition in 1814, contributed *An Attempt to restore the Old Method of Cross-lining on Wood*. He later inherited a large estate in Devon, his sudden good fortune leading him to give up wood engraving, and take to a life of drinking and self-indulgence. He cut illustrations for several works in his brief career as a professional wood engraver, among these Ackermann's *Religious Emblems*, 1809.

HOLLAND, Michael (1947–2002)

Painter of various subjects in oil; constructivist; art teacher. Born at SUNDERLAND, Holland studied at Sunderland Polytechnic, and subsequently the Royal College of Art before taking up a career as an art teacher. It is said that he went to the Royal College in 1972 as 'a painter of strange, surrealist landscapes, with fine detail and Bosch-like figures seen against areas of empty space', and that 'it may have been the painting of this kind that won him the Stowell's Trophy in 1973'. The picture was titled *Desert Landscape*, and was accepted for the John Moore's exhibition in 1974. Later work while at the Royal College saw him produce a mixture of cubism and pop art, working in several dimensions. He later said that this work while a student was very important to him and that his painting when later a fellow of Cheltenham College of Art and a Rome Scholar derived directly from it. During his career as an art teacher, during which he successively held the position of part-time lecturer in painting in UK and Australian Art Institutions; head of painting at Cheltenham & Gloucester College of Higher Education; head of painting at the University of Northumbria, NEWCASTLE; head of painting at the

John Hogarth, *Dr Gibb*, pen and wash, 20 x 10cm. Private collection.

Birmingham Institute of Art & Design, and finally, head of fine art at the latter institution, Holland showed his work widely in Britain and abroad displaying a variety of styles. His work was shown at the Royal Academy; the Galleria Rondanini, Rome; the South London Art Gallery; the Artists Market Gallery, London, and the Praxis Gallery, Bristol, among several major venues. A major exhibition of his work was held at the University of Northumbria in 2002, following his early death due to cancer. The exhibition was held in the University's Foyer Gallery, Squires Building, and consisted of paintings, drawings and prints reflecting his varied painting interests from his time as a student at SUNDERLAND, to his final days under the duress of illness.

HOLLOWAY, Edwin Francis ('Ted') (1926–1987)
Landscape, industrial and thematic painter in oil; draughtsman; art teacher. He was born at Upham, Hampshire, and on leaving school at fifteen became a forestry worker, spending much time drawing and painting. At eighteen he was called up as a Bevin Boy in the Durham Coalfield, this experience leaving a marked effect upon his life both artistically and emotionally. At twenty-eight he decided to devote himself to art more seriously. He attended art classes at Durham University Extramural Department, and in 1958 won a bursary to study full-time at Sunderland College of art. He then spent a year at London University to gain his art teacher's diploma, eventually returning to Northumbria to teach. He became head of art at Springfield Comprehensive School, JARROW, remaining there until 1981, when he decided to give up teaching to paint full-time. He moved to Gloucestershire, where he became fascinated by early Celtic art and mythology, producing over 300 paintings and drawings based on Celtic themes. This was stimulated by a visit to Southern Ireland in 1982 to paint, draw and study Celtic art. In 1983 Holloway began a large series of drawings based upon his life as a Bevin Boy in the Durham Coalfield as a record of the relatively primitive methods of mining in the 1940s, and the toughness of life underground. Some of these were exhibited in GATESHEAD and DURHAM in 1984, and he was still working on them when he died suddenly on a painting trip to Scotland in 1987. The series of drawings was featured in a touring exhibition in 1993/1995, originating in Stoke-on-Trent, and were accompanied by a book illustrating his mining-related paintings, drawings and woodcarvings, edited by his widow, the artist and art historian Gill Holloway (q.v.). Also containing an introduction to her husband's life and work, this was published as *A Bevin Boy Remembers* and represents the first major book on the some 20,000 young men who were conscripted to work down the mines during the later years of the Second World War. Apart from the touring exhibition of Holloway's work for which the book was published, and an exhibition in 1997 at the Hutchinson Gallery at the Town Hall, BISHOP AUCKLAND, examples were included in a number of group exhibitions. He was a close friend and painting companion of fellow miner Thomas Lamb (q.v.). Many of Holloway's mining

drawings are represented in the collections of Durham County Council; the National Coal Mining Museum, Wakefield, and the Hutchinson Gallery, Town Hall, BISHOP AUCKLAND.

HOLLOWAY, (HARMAN), Gill (b.1928)
Landscape painter in oil and watercolour; art teacher. She was born in London and studied art at King's College (now Newcastle University), before in 1950 becoming tutor in art at Durham University Extramural Department. She remained in this position until 1967, and during this period showed her work at several group and other exhibitions in Northumbria. In 1969 she was appointed head of art and art history at Cheltenham Ladies College, remaining there until her retirement in 1988. In 1981 she became the second wife of Edwin Francis Holloway (q.v.), who had also moved to Gloucestershire on leaving his teaching position in Northumbria. She continued to paint during and after her years at the College, showing examples in group and one-man exhibitions in London, DURHAM, MIDDLESBROUGH, and elsewhere in the provinces. Following the death of her husband in 1987 one of her main preoccupations apart from painting was the preparation of *A Bevin Boy Remembers* – a book of his paintings, drawings and woodcarvings based on his life as a miner in the Durham Coalfield during the Second World War. This was produced to accompany a touring exhibition of his work, starting at Stoke-on-Trent, in 1993. She now lives at Condicote, Gloucester, where she continues to paint, write and teach. In recent years she has travelled widely abroad to paint and a major one-man exhibition of her work was held at the Anderson Gallery, Broadway, Worcestershire, in 1998, containing examples painted in the Mediterranean and elsewhere. Her work is represented in many public and private collections.

HOLMES, Sheriton (1829–1900)
Amateur landscape painter in watercolour; antiquarian draughtsman. Holmes was born at SOUTH SHIELDS, and following his education at Wharfedale in Yorkshire, was articled to John Bourne, civil engineer and land agent of NEWCASTLE. While working with Bourne he surveyed several important sections of railway line in the North East of England. After serving his time he became connected with a number of other railway enterprises throughout the North of England, then went to work in London, where he continued his railway work. On his return to the North East he became responsible for several major projects, mainly associated with the construction of shipbuilding and repair facilities on Tyneside, and served as resident engineer to the Border Counties Railway Line. Throughout his professional career as a civil engineer Holmes maintained a strong interest in antiquarian matters, and contributed many articles and sketches to the publications of the Society of Antiquaries, NEWCASTLE, also serving as treasurer for some years. He also took an interest in artistic activities in the city, and was a founder-member of the Arts Association, NEWCASTLE, as well as an exhibitor in 1881 and 1882. He was responsible for writing and illustrating several publica-

tions associated with old buildings on Tyneside, amongst these *The Walls of Newcastle*, 1895, and with Heslop, *A Short Guide to the Castle and Black Gate*, 1899. Some of his drawings were issued as lithographs by Akermann of London. Newcastle University Library has a copy of Mackenzie's *History of Newcastle*, containing six watercolour, twenty sepia, and three black and white drawings, of NEWCASTLE, executed in the last twenty years of his life. Represented: Laing A G, Newcastle.

HOLMES, Walter (b.1936)

Landscape, marine and still life painter in oil, water-colour and pastel; illustrator. He was born at WALLSEND, near NEWCASTLE, and after education at his local grammar school went on to take a BSc in geology at King's College (now Newcastle University). A diploma in geophysics from Imperial College followed two years later, and it was while studying for this in London that a chance visit to the National Portrait Gallery reawakened a boyhood love for drawing and painting. This led to part-time study at Hammersmith and Chelsea Schools of Art, and on returning to Tyneside to work as a technical editor with a local manufacturing company he began attending Newcastle University, gaining a certificate in art. By 1971 he had made such progress in his studies that he was able to hold his first one-man exhibition, at the Gulbenkian Gallery, People's Theatre, NEWCASTLE. Other one-man exhibitions followed, and the acceptance of his work for exhibitions by the Royal Society of Marine Artists; the Northern Art Show, and the Shipley Art Gallery, GATESHEAD, in 1978, and the John Laing Competition Exhibition, at the Mall Galleries, London, in 1981, (for which he gained second prize). Against this back-ground of continuing success he decided to become a full-time artist, and has since vindicated his choice of profession by undertaking commissions for the premises of several major British companies, and exhibiting his work widely in Northumbria, including NEWCASTLE, HEXHAM, WHITLEY BAY, DURHAM, ALNWICK and DARLINGTON. In 1999 he won the Dover Prize in the annual exhibition of that name held at Darlington Art Gallery, organised by Darlington Borough Council, and supported by the Darlington Society of Arts. Major exhibitions of his work were held at the Tallantyre Gallery, MORPETH, in 2000, and Colliers Gallery, NEWCASTLE, in 2002, and he has since had his work reproduced in a number of art publications. Much of his work has also been reproduced in the form of limited-edition prints. He has lived and worked at PONTELAND, near NEWCASTLE, for many years.

HOPPER, Frederick William (b.1891)

Amateur marine painter in watercolour. Hopper was for thirty-eight years general manager and director of the Wm Pickersgill Shipyard, SUNDERLAND, and during that period designed every vessel built there. He is also said to have made a painting of each one in watercolour and presented it to the lady officiating at its launching. He was largely a self-taught artist, and exhibited his work at the Royal Society of Marine Artists. Following his retirement he lived at Cambridge.

Walter Holmes, *The Bridge at Morpeth, with St George's*, oil, 91.5 x 91.5cm. Private collection.

HORSLEY, Thomas John (1795–1844)

Miniature painter. Born at SUNDERLAND, Horsley practised as a painter of portrait miniatures in London from his early twenties. He exhibited five works at the Royal Academy between 1820 and 1833, the first of which was a self portrait; the last: *Portrait of a gentleman*. He also in this period exhibited one work at the New Water Colour Society (later the Royal Institute of Painters in Water Colours). It is believed that he died in London.

HORTON, George Edward (1859–1950)

Marine, coastal and landscape painter in oil and watercolour; illustrator; etcher. Horton was born at NORTH SHIELDS, the son of a butcher. When he left school he became a delivery boy for his father, but spent every spare moment drawing. One day his mother found him drawing an animal skull which he had borrowed, and disgustedly asked him to leave the family home. Then aged about seventeen, he moved in with a relative, and deciding to become a full-time professional artist, produced his first significant work in watercolour and pencil. He first exhibited his work in 1881, showing his watercolour. *Harrowed Fields*, at the Arts Association, NEWCASTLE. He again exhibited at the Association in the following year, then in 1884 exhibited his first work at the Bewick Club, NEWCAS-TLE; an oil entitled *Morning Light*. He continued to exhibit at the Bewick Club over the next eight years, and encouraged by older artists such as Robert F Watson (q.v.), and Henry Hetherington Emmerson (q.v.), made rapid progress as a painter. Towards the end of this period, however, he became increasingly interested in producing drawings for illustration, achieving his first success in this field with the publi-cation in 1892, of *South Shields: A Gossiping Guide*, written by his friend, local newspaper editor and art writer Aaron Watson (q.v). In that year also he was commissioned to supply his first illustrations for *The Banks O' Tyne: A Christmas Annual*, published by the

South Shields Daily Gazette, subsequently illustrating its 1893 and 1894 numbers entirely himself. About 1895 he decided to move to SOUTH SHIELDS, and from there in 1896 sent his first work for exhibition at the Royal Academy: *The Fish Quay, North Shields*. It would appear that he made his first sketching trip to Holland in the following year, later preparing an illustrated article on his experiences, which was published in *The Studio*, Volume II, 1897. In 1902, and having by then exhibited his work widely in England, Horton sent his first work to the Royal Scottish Academy. Three years later, and still living at SOUTH SHIELDS, he sent his first work to the Artists of the Northern Counties exhibitions at the Laing Art Gallery, NEWCASTLE, showing his *On the beach at Scheveningen*, and *Autumn*. In 1918, and with the encouragement of the Laing Art Gallery's curator, C Bernard Stevenson, Horton left SOUTH SHIELDS, and settled in London. Here he quickly established a demand for his work, helped by one-man exhibitions at the Greatorex Gallery in 1922, and the Fine Art Society in 1927. Throughout his early years in London he continued to make regular trips to Holland, and in 1921 made his only trip to Venice, where he made a large number of pencil sketches, and a few watercolours. Horton exhibited his work until late in his life, showing examples at the Royal Academy; the Royal Scottish Academy; the Royal Institute of Painters in Water Colours; the Paris Salon; the International Society of Aquarellists, and at many leading London and provincial galleries. He enjoyed several exhibitions of his work in Holland, and in 1934 shared a loan exhibition at the Laing Art Gallery, NEWCASTLE, with Francis Thomas Carter (q.v.), Thomas Bowman Garvie (q.v.), and John Falconar Slater (q.v.). While obviously infatuated with the scenery around Rotterdam and Dordrecht for much of his life, Horton never forgot his native Northumbria, and, indeed, every one of his Royal Academy exhibits 1930–38, portrayed subjects from the area. His Academy exhibit of 1930 was *Winter in Newcastle upon Tyne*; that of 1938, *The Fish Quay, North Shields*. He also retained many contacts among artist friends, particularly Joseph Henry Kirsop (q.v.), with whom he shared a deep interest in the art of etching, and with whom he corresponded for many years on this subject. Following his last showing of work at the Royal Academy in 1938, he exhibited almost exclusively at the Artists of the Northern Counties exhibitions, showing his last works in the year before his death. Following the bombing of his London studio in 1940, he spent five years at NEWCASTLE. At the end of the Second World War, however, he returned to the capital, dying there in 1950, at the age of ninety. Horton was one of the most individual Northumbrian watercolourists working in the 20th century, and exhibited his work for a longer period than any other artist from the area; a total of sixty-eight years. South Shields Public Libraries held major exhibitions of his work in the year following his death, and in the centenary year of his birth. Important exhibitions of his work were held at the Moss Galleries, HEXHAM, and the Laing Art Gallery, NEWCASTLE, in

1982, and at North Tyneside Public Library, NORTH SHIELDS, in 1986 to mark its acquisition of a large collection of his work from the son and daughter of fellow artist and friend, William Redpath (q.v.). This important collection of Horton's watercolours, sketches, etchings, letters, etc, has since been divided between the Laing Art Gallery and Tyne & Wear Archives, NEWCASTLE. Represented: British Museum; Laing A G, Newcastle; North Tyneside Public Libraries; Pen & Palette Club, Newcastle; Shipley A G, Gateshead; South Shields Museum & A G; Tyne & Wear Archives, Newcastle. [See colour plate]

HOWEY, John William (1873–1938)
Amateur landscape, coastal and genre painter in oil, watercolour and pastel. Howey was born at WEST HARTLEPOOL (now HARTLEPOOL), and trained for some time at the local School of Art. Lacking confidence in his ability to succeed as a professional artist, however, he joined the West Hartlepool Gas & Water Company, eventually rising to the position of head collector. He maintained a lifelong interest in painting, and was accepted as the equal of many professional artists. He built a studio at the top of his house, at which he painted alongside many now well-known artists, including Rowland Hill, and was particularly fond of painting along the Yorkshire coast in the company of Hill, Mark Senior and Florence Hess. Runswick Bay and Staithes were among his favourite subjects, but he also painted along the Scottish coast, and produced a large number of Northumbrian landscapes, genre works, and portraits. He is known to have exhibited his work outside Northumbria on only one occasion, this being at the Royal Institute of Oil Painters in 1923, but he was a regular exhibitor at the Artists of the Northern Counties exhibitions at the Laing Art Gallery, NEWCASTLE, from 1909 until his death, and also showed work at the Gray Art Gallery, WEST HARTLEPOOL, enjoying a special one-man show there in 1925. This exhibition contained some thirty works in oil, including his Royal Institute of Oil Painters' exhibit of 1923, and two works said to have been exhibited at the Royal Academy in 1924 and 1925, but of which no records exist. He died at HARTLEPOOL. His son, Robert Leslie Howey (q.v.) was a talented professional artist. Represented: Hartlepool Arts & Museum Service; Pannett A G, Whitby.

HOWEY, Robert Leslie (1900–1981)
Landscape, coastal and portrait painter in oil, watercolour and pastel; linocut artist. The son of John William Howey (q.v.), he was born at WEST HARTLEPOOL (now HARTLEPOOL), and studied at the local School of Art before practising as a professional artist in the town. In his youth he frequently accompanied his father on family holidays to Runswick Bay and Whitby, on the Yorkshire coast, and in this way became acquainted with several of the well-known artists then working in these areas. He exhibited his work at the Royal Scottish Academy, the Redfern Gallery, London, and at various provincial public and private galleries, including among the former, the Laing Art Gallery, NEWCASTLE, whose Artists of the

Robert Leslie Howey,
Readying the Nets,
watercolour, 46 x 71cm.
Private collection.

Northern Counties exhibitions he contributed to for many years. A one-man exhibition of his work was staged at the Gray Art Gallery, WEST HARTLEPOOL, in 1949, at which a large number of his watercolours, pastels, and linocuts were shown. Howey was one of the first British artists to produce significant work in the last named medium. He died at SEATON CAREW. Represented: Hartlepool Arts & Museum Service.

HUDSON, John (1829-c.1896)
Marine painter in oil and watercolour. Hudson was born at SUNDERLAND, the son of mariner James Hudson. At the age of fourteen he was apprenticed as a shipwright, but by the time he was sixteen he was already producing marine studies such as his *Launch of the 'Polka', 1841* (painted from memory), in the National Maritime Museum, albeit with little accomplishment. He remained a shipwright until after his marriage in 1851, painting ship portraits in his spare time, but in 1880, and now having moved from the MONKWEARMOUTH to the BISHOPWEARMOUTH district of the town, he was describing himself as a marine artist. Hudson painted ship portraits well into the 1890s, one of his latest dated works being his oil, *2nd Royal Yacht, Victoria & Albert, Spithead*, 1895. He died at SUNDERLAND. Represented: National Maritime Museum; Sunderland A G.

HUDSON, R M (1899- after 1956)
Amateur landscape and coastal painter in oil. Hudson was a builder at SUNDERLAND who painted in his spare time, and exhibited his work with the art club in the town. His *North Dock, Sunderland*, 1955, is in the collection of Sunderland Art Gallery.

HUDSON, Thomas ('Tom') (1922–1997)
Painter of various subjects in oil and watercolour; muralist; art teacher. He was born at HORDEN, near EASINGTON, and studied at Sunderland College of Art and King's College (now Newcastle University), before doing a postgraduate course at the Courtauld Institute. Inspired by the example of tutor at SUNDERLAND, Henry Thubron (q.v.), and later Herbert Read, he decided on a career in teaching and obtained a position at Lowestoft School of Art. Other appointments followed at Leeds; Leicester; Cardiff College of Art, and in Vancouver, Canada. He also held a number of consultative appointments in Britain and abroad, displaying a keen interest in education, and the history of art. In addition to his teaching and consultancy roles Hudson was an active painter who showed examples of his work at the Drian Galleries, the Grabowski Gallery and abroad. A one-man exhibition was also held at the last named gallery in 1973. He also exhibited with the 56 Group of which he was a member; at the Society of Education in Art; the Royal National Eisteddfod, and elsewhere. His work as a muralist included an example for the University Hospital Wales, in Cardiff. He died in Bristol.

HUGONIN, James (b.1950)
Abstract painter in various media; art teacher. He was born at BARNARD CASTLE, and studied at Winchester School of Art; West Surrey College of Art and Design, Farnham, and Chelsea School of Art, under Ian Stephenson (q.v.), before taking up a teaching post at the latter. He later taught at colleges in Northumbria, and since 1998 has been an associate research fellow at the University of Northumbria, NEWCASTLE, with a role

John Hudson, *2nd Yacht, 'Victoria & Albert', at Spithead*, 1895, oil, 61 x 91.5cm. Simon Carter Gallery.

in teaching its art students on an occasional basis. He has remained an active painter throughout his teaching career and has widely exhibited his work in both Britain and abroad. Among the group exhibitions in which he has participated have been those at the LYC Gallery, Banks, Cumbria, in 1978; the Sally East Gallery, London, in 1979; the Coracle Gallery, London, the Bede Gallery, JARROW, near SOUTH SHIELDS, and the Graeme Murray Gallery, Edinburgh, in 1985; the Galerie Hoffman, Friedburg, Germany, in 1987, 2001 and 2002; the Cairn Gallery, Nailsworth, Gloucestershire, and Abbot Hall Art Gallery, Kendal, Cumbria, in 1996; the Marlene Eleini Gallery, London, and the Tate Gallery, St Ives, in 1997; the Kunsthalle, Osnabrück, Germany in 1999; the Gorinchem Museum & Art Gallery, Holland, and the Södertälje Art Gallery, Södertälje, Sweden, in 2000. He has also had one-man exhibitions at the Serpentine Gallery, London, in 1991; the Fruitmarket Gallery, Edinburgh, in 1993; the Kettle's Yard Gallery, Cambridge, in 1996; the Marlene Eleini Gallery, London, in 1997, and the Ingleby Gallery, Edinburgh, in 2002. One of the most individual artists working in Northumbria at the beginning of the 21st century, sometimes taking more than a year to complete one of his grid-based, slowly built up compositions adding first one small segment of colour, and then another, Hugonin states that he wants 'to create images which are meticulous in their execution, almost hypnotic in their effect on the eye and mind'. After returning to Northumbria to teach he joined the Newcastle Group of Artists, and has received several recognitions for his work, including the Northern Electric/Northern Arts Visual Arts Award, in 1990, and a nomination for the Jerwood Painting Prize, in 1999. He has for several years lived at HIGH HUMBLETON, near WOOLER, with his wife SARAH HUGONIN, who is also an artist. The Ingleby Gallery published a lavishly illustrated booklet on Hugonin's work in 2002, to coincide with his exhibition at the Gallery in that year. Represented: Tate Gallery; Victoria and Albert Museum; Arts Council; Contemporary Art Society; Bodleian Library, Oxford; Laing A G, Newcastle; Sheffield A G; University of Northumbria, Newcastle. [See colour plate]

HUMBLE, Stephen (1793–1853)
Landscape, figure, portrait and flower painter in oil and watercolour; miniature painter; draughtsman; drawing master. He was born at NEWCASTLE, the son of Edward Humble, bookseller, stationer and circulating library owner, and the grandson of engraver Joseph Barber, Senior (q.v.). He began his career in art as an engraver in London, but by 1819 had returned to NEWCASTLE where he established a picture gallery and began describing himself as 'miniature painter and engraver.' His father died in 1820, and when the business was later sold off, he led a precarious existence, advertising himself variously as bookseller, hatter and picture dealer, and evidently painting theatrical portraits, for he showed four such works at the First Exhibition of the Northumberland Institution for the Promotion of the Fine Arts, NEWCASTLE, in 1822. He was still at NEWCAS-

TLE when he showed his copy of *The Death of Wolfe*, at the Institution in 1823, but when he next exhibited at the Institution in 1826 he was practising at ALNWICK as a drawing master, having left NEWCASTLE two years previously as a bankrupt. He exhibited at the Institution in 1827, while still showing his address as ALNWICK, but when he next exhibited at NEWCASTLE in 1831, showing his *Head of Walter Scott; Varieties of Dahlia; Varieties of Camellia Japonica; Group of Shells* and *View of Alnwick Castle*, at the Northern Academy, he was practising at Edinburgh. His movements over the next sixteen years are uncertain. By 1848, however, he was practising at DARLINGTON, evidently spending several years in the town, for close to his death he produced what is today his best known work: *St. Cuthbert's Church, Darlington*. This work was drawn on the stone by Thomas Picken, and published as a large lithograph in the year following Humble's death at Scarborough, North Yorkshire.

HUMBLE, Stephen (1812–1858)
Portrait painter in oil. He was born at NEWCASTLE, and did not become a professional artist until he had spent some years working as a bricklayer, like his father. Legend has it that while he was working on structural alterations to the property of John Balmbra, the town's music hall proprietor, Balmbra saw some of Humble's sketches and was so impressed that a commission to paint Balmbra's portrait resulted. Following this evidently successful venture, Humble received many other portrait commissions in the town, eventually including amongst his sitters some of its leading citizens. He exhibited his work sparingly, showing a *Portrait of a Gentleman* at the 1843 exhibition in NEWCASTLE of the North of England Society for the Promotion of the Fine Arts, and two further portraits at its 1850 exhibition. He lived and worked in the town's Brunswick Place for most of his professional life, and died there at the age of forty-six, when by all accounts he was at the height of his powers as a portrait painter. The Literary and Philosophical Society, NEWCASTLE, has his portrait of the Rev William Turner.

HUNTER, Abraham (d.1799)
Engraver. This engraver practised at NEWCASTLE in the late 18th century, following an apprenticeship with Ralph Beilby (q.v.), and Thomas Bewick (q.v.), *c.*1778–84. The brother of William Nicholson (q.v.), was taught engraving by Hunter, and while Robert Johnson (q.v.), was working at NEWCASTLE, after his apprenticeship to Bewick, he made a drawing of the bridge at SUNDERLAND, which he engraved with Hunter.

HUNTLEY, Albert Ernest (fl. late 19th cent.)
Landscape and marine painter in watercolour. This artist practised in NEWCASTLE in the late 19th century. He mainly painted local views, and exhibited his work at the city's Arts Association in 1878 and 1879; the Bewick Club in 1894 and 1895, and Carlisle Art Gallery, in 1896. Typical subjects were Jesmond Dene, NEWCASTLE, and the Tyne from city to the mouth of the river. Much of his work was on a small scale painted in the manner of Myles Birket Foster (q.v.).

HUNTLEY, Eric (1927–1992)
Landscape painter in oil and watercolour. He was born at GATESHEAD, and studied art at King's College (now Newcastle University), graduating with first-class honours. After national service, he was in 1956 appointed art master at the grammar school at BERWICK-UPON-TWEED. He settled at nearby Paxton, and remained at the school until taking early retirement at the age of fifty-three to concentrate on his career as a professional artist. His work quickly won acclaim, particularly in Scotland, and reputedly sold as soon as it left his easel. Apart from showing examples of his work at a student exhibition while he was at King's College, and at the 'Contemporary Artists of Durham County' exhibition held at the Shipley Art Gallery, GATESHEAD, in 1951, in connection with the Festival of Britain, he mainly exhibited in Scotland. A commemorative exhibition of his work was held at BERWICK-UPON-TWEED in 1994, at the town's Borough Museum Art Gallery. Represented: Berwick A G.

HUTCHINSON, George Musther (b.1934)
Landscape painter in watercolour; art teacher. Born at WHEATLEY HILL, near SUNDERLAND, Hutchinson displayed a talent for drawing from an early age. It was not until he took early retirement from the advertising industry in 1988, however, that he began to paint seriously. He had been a regular exhibitor at the Federation of Northern Art Societies' exhibitions at the Laing Art Gallery, NEWCASTLE, and the Shipley Art Gallery, GATESHEAD for several years, and immediately followed his retirement with a one-man exhibition at the Theatre Royal, NEWCASTLE, to celebrate its reopening. This marked the beginning of a career as a professional artist which has seen him produce hundreds of accomplished watercolours. These have been shown in exhibitions all over Northumbria, and found their way into collections around the world. He has also become a popular demonstrator of watercolour painting to art clubs, schools, etc, and has helped to establish several art groups and exhibition venues on Tyneside. His work has been widely reproduced on calendars, and in the form of limited-edition prints. He lives and works at WHICKHAM, near GATESHEAD. [See colour plate]

HUTCHINSON, John, OBE (1884–1972)
Botanical illustrator. Hutchinson was born at WARK, near HEXHAM, and after education at Rutherford College, NEWCASTLE, and privately, took up the first of a succession of positions at the Royal Botanic Gardens, Kew. These culminated in his role as Keeper of the Museum 1936–1948. During his work for the Botanic Gardens he undertook several tours abroad to study the botany of various regions, these including South Africa, in 1928; Rhodesia, in 1930, and the Cameroon Mountains, in 1937. He also received several awards for his studies, among these the Veitch Memorial Gold Medal, in 1946; the Darwin-Wallace Centenary Medal, in 1958, and the Linnean Gold Medal, in 1965. His abilities as a botanist were highly regarded, and led to the publication of many books, commencing with *The Families of Flowering Plants*,

Thomas Swift Hutton,

Cullercoats,

watercolour, 36 x 56cm.

Private collection.

1926 and 1934 (Vol II). He also wrote and in some cases illustrated several popular books for 'Penguin', including *Common Wild Flowers*; *More Common Wild Flowers*, and *Uncommon Wild Flowers*. One of his last publications before his death was his *The Genera of Flowering Plants*, in 1969. His home for many years was at Kew. He received an OBE for his work in the year of his death.

HUTCHINSON, William (1732–1814)

Topographical artist. Hutchinson was born at BARNARD CASTLE, and later practised as a solicitor in the town, taking a keen interest in antiquarian matters. This interest led him to write, and in some instances illustrate, a number of publications on the history and topography of the North, notable amongst which was his *History and Antiquities of the County Palatine of Durham*, 1785–94, to which he contributed a number of views. His younger brother ROBERT HUTCHINSON (d.1773) was also artistically talented, and helped to illustrate Hutchinson's first publication: *Excursions to the Lakes in Westmorland and Cumberland, with a Tour through part of the Northern Counties, in 1773–74*. Robert died midway through the excursion, leaving his elder brother to complete a number of the publication's illustrations. He died at BARNARD CASTLE and was interred in the town's graveyard with his wife, who had predeceased him by only a few days. There is a small portrait of Hutchinson on the title page of his *The Spirit of Masonry*, a treatise on the Brotherhood, of which he had long been a distinguished member.

HUTTON, Thomas Swift (1860–after 1935)

Landscape and coastal painter in watercolour. He was born at Edinburgh. Details of his artistic training are not known, but by the age of twenty-seven he was exhibiting at the Glasgow Institute of Fine Arts, showing a landscape. He was then living at Glasgow, but he later moved to NEWCASTLE from where he began exhibiting at the city's Bewick Club, and later the Royal Academy, showing his *A Peep at the River Derwent*, in 1895. He continued to exhibit at the Royal Academy when he subsequently moved to Merseyside, showing work in 1898, and 1899, and also in this period exhibited at the Royal Scottish Academy; the Dudley Gallery, London; the Walker Art Gallery, Liverpool, and Manchester City Art Gallery. On returning to Northumbria some time after 1906 he practised at various locations in the area, but does not appear to have continued exhibiting his work. He is believed to have finally settled at SEATON SLUICE, near BLYTH, dying there some time after 1935. Hutton's work is well known in Northumbria for its portrayal of a wide variety of local beauty spots, predominantly along the coastline, and up various river valleys. Many of his works were painted on small pieces of cardboard reputedly from shirt boxes, but several much larger works are known, notably of DURHAM; Eyemouth, near BERWICK-UPON-TWEED, and various Scottish scenes. Represented: Shipley A G, Gateshead; South Shields Museum & A G.

I

INGRAM, Anthony (c.1856–1936)
Landscape and architectural artist in cork. Ingram was a coal miner at SOUTH SHIELDS who created realistic images of famous old buildings in the town using cork as his medium, and a penknife as a tool. Many of his subjects were public houses at SOUTH SHIELDS and were bought by their owners to display on their premises, but he is also known to have produced images of Durham Cathedral, Norwich Cathedral and Windsor Castle. His work is highly regarded in his home town, where it hangs in many private homes and several public houses.

IONS (I'ONS), Algernon (c.1860- after 1910)
Landscape painter in oil and watercolour. He was born at NEWCASTLE, the son of Walter J Ions, organist at St Nicholas' Church, in the town. He first began exhibiting his work at the Bewick Club, NEWCASTLE, showing a number of Northumbrian and Irish landscapes between 1890 and 1900. He later moved to London, where he exhibited one work at the Royal Academy in 1910: *A fishing haven in Cornwall*.

IRELAND, Mrs Jennie Moulding (d.1945)
Amateur landscape and portrait painter in oil and watercolour. This artist painted at NORTH SHIELDS in the early years of last century, contributing one work to the Artists of the Northern Counties exhibition at the Laing Art Gallery, NEWCASTLE, in 1913. She later moved to SOUTH SHIELDS, from which in 1942, 1944 and 1945, she again sent work to the Artists of the Northern Counties exhibitions. These works included: *Self Portrait* (1942); *Lillian* (1944), and *Seascape* (1945). She may have been related to LESLIE G IRELAND, who lived at GATESHEAD, maintained a studio at NEWCASTLE, and exhibited at the Artists of the Northern Counties exhibitions at the city's Laing Art Gallery in 1923, showing a landscape in watercolour. Represented: South Shields Museum & A G.

IRVING, William (1866–1943)
Portrait, landscape and genre painter in oil and watercolour; illustrator. Born at Ainstable, Cumbria, the son of a farmer, Irving moved with his parents to Tyneside in his infancy, and later attended the School of Art, at NEWCASTLE, under William Cosens Way (q.v.). At the end of his tuition he was recommended by Way for a position with the *Newcastle Weekly Chronicle* as an illustrator, and he remained in this occupation for many years while building up a reputation as a portrait painter. He also in this period became a member of the Bewick Club, NEWCASTLE, showing at its exhibition in 1891 his first important landscape with figures: *The End of the Season*. Later he began exhibiting his work at the Royal Academy, showing his *Ducks and Darlings*, in 1898, and his *Happy Days*, in 1901. In 1903 he painted what is today regarded as one of the North East of England's most popular and famous paintings: *Blaydon Races – A Study from Life*. It is said of this painting that when it was exhibited in the window of an art dealer's shop at NEWCASTLE it attracted the attention of such a large crowd that the manager was asked by the police to draw the blinds. This picture was painted at OVINGHAM, where he lived

for several years at the turn of the century before returning to NEWCASTLE. Irving was frequently called upon to prepare portraits of local celebrities as pen and ink drawings for line reproduction in *The Newcastle Weekly Chronicle*. Many of these assignments subsequently led to portrait commissions in oil, from either the sitters, or other interested parties. He was also a regular contributor of highly finished cartoons and performed much the role of the present day press photographer in illustrating local incidents, and scenery. Shortly after painting his *Blaydon Races* he was commissioned to paint two portraits of MP for NEWCASTLE and newspaper proprietor, Joseph Cowen (one for the *Chronicle*, and one for Cowen's family). On receiving payment for this commission he decided that he would increasingly look to portraiture for his living and further to enhance his reputation in this field he would study in Paris. About 1905 he left NEWCASTLE and enrolled as a pupil in the Académie Julian, where he had amongst his tutors some of the leading French painters of the day. Returning to Tyneside by 1906, he resumed his profession with renewed vigour and, according to contemporary accounts, with a marked improvement in his skill. Irving painted portraits until close to his death, but with the growing competition of photography found it increasingly difficult to find sitters. In his final years he turned to picture restoration as a source of income, and was responsible for extensive work on the painting by Luca Giordano in St Andrew's Church, NEWCASTLE. He also produced advertising drawings for local traders. After last exhibiting at the Royal Academy in 1906 showing his *Expectation*, Irving mainly exhibited at the Artists of the Northern Counties exhibitions at the Laing Art Gallery, NEWCASTLE. His *Blaydon Races* painting became the subject of a public outcry when it was entered for sale by auction in London in 2002 by the Marriott Gosforth Park Hotel, NEWCASTLE (which had acquired it some years previously from its ninety-odd year owners, the city's County Hotel). However, Tyne & Wear Museums were successful in bidding for the painting at a world record for his work of £110,000, and it is now in the collection of the Shipley Art Gallery, GATESHEAD. His son, STANLEY ROWLINGS IRVING, (b.1894), was a keen amateur painter in oil and watercolour. Represented: Carlisle A G; Laing A G, Newcastle; Shipley A G, Gateshead. [See colour plate]

IRWIN, Annie L. (d.1894)
Flower, landscape and figure painter in oil and watercolour. This artist practised at SUNDERLAND in the late 19th century, and first began exhibiting publicly when she sent two works to the Arts Association exhibition, NEWCASTLE, in 1882, *Rose of Sharon*, and *Autumn Leaves*. She was a regular exhibitor at the Bewick Club, NEWCASTLE from 1884 until her death, also sending one work to the Royal Academy in 1890, *Chrysanthemums*, and showing her work on several occasions at the Royal Institute of Oil Painters; the Society of Women Artists, and various provincial exhibitions. Her Bewick Club exhibits included flower studies, British and Continental landscapes, and occasional genre works. She last exhibited with the Club in the year of her death at SUNDERLAND, when her contributions were *A Normandy Peasant* and *Pink Peonie Rose*.

J

JACK, Richard, RA RI RMS RP (1866–1952)

Portrait, figure and landscape painter in oil and watercolour. Born at SUNDERLAND, Jack was educated at York, and later studied at the city's School of Art, where he won a national scholarship to South Kensington. While at South Kensington he gained the Gold Medal travelling scholarship, afterwards studying at the Académie Julian, and at Calarossi's, Paris. He first began exhibiting his work publicly while still studying in Paris, showing his *Portrait of a Lady*, at the Royal Academy, in 1893. Two years later he settled in London, and resumed exhibiting at the Academy, showing more than 160 works there between 1895 and 1951. During this period he also exhibited at the Royal Scottish Academy; the Royal Institute of Painters in Water Colours; the Glasgow Institute of Fine Arts, and at many leading London and provincial galleries. While practising in London as a portrait painter, Jack handled a number of commissions in his native Northumbria, and was an occasional exhibitor in the area, showing examples of his work at the Artists of the Northern Counties exhibitions at the Laing Art Gallery, NEWCASTLE, and the North East Coast Exhibition, Palace of Arts, 1929. He also achieved considerable distinction in his profession, becoming a member of the Royal Miniature Society in 1896, a member of the Royal Society of Portrait Painters in 1900, an associate of the Royal Academy in 1914, a member of the Royal Institute of Painters in Water Colours in 1917, and a full Royal Academician in 1920. Several of his works were purchased for public collections, notably his *Rehearsal with Nikisch*, for the Tate Gallery, through the Chantrey Bequest, in 1912. In 1930 he visited Canada, where he painted several landscapes, among other subjects, and in 1932 he decided to move permanently to that country, remaining based at Montreal until his death in 1952. Among his last exhibits were two portraits shown at the Royal Academy in 1951, and his landscape in oil, *Anglesey*, which was included in the 'Contemporary Artists of Durham County' exhibition, staged at the Shipley Art Gallery, GATESHEAD, in that year, in connection with the Festival of Britain. Jack was one of Northumbria's most successful portrait painters of the last century, and included some of the most famous men of his day among his sitters. He received many medals for his work in portraiture, including several in his student days in Paris; the Silver Medal for portraiture at the Paris International Exhibition in 1900, and the Silver Medal at Pittsburgh, U.S.A., in 1914, for his *String Quartette*. Like many well-known portrait painters, however, Jack was also an able painter of other subjects, his landscape work, for instance, bearing favourable comparison with that of many professionals in this field. Represented: Tate Gallery; Hartlepool Arts & Museum Service; Laing A G, Newcastle; Sunderland A G.

JACKSON, John (1801–1848)

Wood engraver; draughtsman. He was born at OVINGHAM, and is said to have worked for George Armstrong (q.v.), and James Walker (q.v.), at NEWCASTLE, before joining Thomas Bewick (q.v.), as an apprentice at the age of twenty-three. He remained with Bewick only a year, however, leaving NEWCASTLE following a dispute with his master to work in London under former Bewick apprentice William Harvey (q.v.). Here he worked principally as a wood engraver, reproducing the work of others. His first work of note in this field was for *Northcote's Fables*, 1828, while from 1832 he worked for Charles Knight on the *Penny Magazine*. He later prepared wood engravings for Lane's *Arabian Night's*, 1849–51, but is now best remembered for *A Treatise on Wood Engraving*, 1839, which he prepared with W A Chatto. Some excellent examples of his work may be seen in this book, including a portrait of Bewick from memory. According to Robert Robinson in his *Thomas Bewick*

Richard Jack,
The Woodland,
oil, 58 x 89cm.
Dunelm Fine Art.

– *his life and times*, 1887, Jackson 'drew and painted domestic subjects with much originality of feeling, and he always had a strong desire to be a painter'. He died in London. His younger brother, Mason Jackson (q.v.), was also a wood engraver, in addition to painting landscapes, and working as an illustrator.

JACKSON, Mason (1819–1903)
Landscape painter in oil and watercolour; wood engraver; illustrator. He was born at OVINGHAM, and studied wood engraving under his brother, John Jackson (q.v.), in London, before taking up the profession in the capital. A man of miscellaneous talents, he also executed illustrations for books and periodicals, and between 1856 and 1879 exhibited two works at the Royal Academy, and some fourteen works at various London exhibitions. In 1860 he became art editor of the *Illustrated London News*, succeeding to the editorship of the paper in 1875. He is credited with being the first historian of illustrated journalism. Jackson's two Royal Academy exhibits were entitled: *Black Gang, Isle of Wight*, (1858), and *Warkworth Castle, Northumberland*, (1859). He illustrated *Walton's Compleat Angler*, and *Ministering Children*, and contributed illustrations to *Cassell's Illustrated Family Paper*, 1857, and the *Illustrated London News*, 1876–78. He died in London.

JACKSON, Robert Griffiths (1891–1961)
Amateur landscape painter in oil and watercolour. Born at DARLINGTON, Jackson worked in the family painting, decorating and sign writing business, executing landscapes and occasionally other subjects in his spare time. He was a largely self-taught artist and exhibited his work with the Barnard Castle Art Society, and at the Federation of Northern Art Societies, at the Shipley Art Gallery, GATESHEAD.

JACKSON, Robert Story (1868–1952)
Amateur landscape and portrait painter in oil and watercolour. Jackson was born at NEWCASTLE and took up a career in commerce in the city on leaving school. He was a keen painter in watercolour from his youth, and is believed to have received some tuition in the use of this medium from Thomas Swift Hutton (q.v.) before becoming a regular exhibitor of his work at the Bewick Club, NEWCASTLE, and later the Artists of the Northern Counties exhibitions at the city's Laing Art Gallery. Jackson rose to the position of manager of the company at NEWCASTLE at which he was employed, then moving to WHITLEY BAY in the mid–1920s, he became a timber merchant. He died at WHITLEY BAY. Although predominantly a painter in watercolour of landscapes and coastal views, Jackson also painted a number of portraits.

JAMES, Hon Walter John – *see* NORTHBOURNE, Lord Walter John

JAMESON, Thomas (fl.18th century)
Engraver. Jameson practised as an engraver at NEWCASTLE in the late 18th century, and was said by Thomas Bewick (q.v.), in his autobiographical *Memoir*, to have 'had the whole stroke of business in Newcastle', when, 'having been detected in committing a Forgery upon the old Bank . . . left the town'. Jameson's misfortune made way for Bewick's master, Ralph Beilby (q.v.), enabling him to 'get forward in his business unopposed by anyone in Newcastle'. Jameson's work included the engraving of several landscape and architectural views such as his *Tanfield Arch*, and a portrait of Dr Isaac Watts, which was prefixed to an edition of the *Psalms of David*, published by William Charnley of NEWCASTLE. In collaboration with Whitehead, of NEWCASTLE, he published in 1776 an 'Explanation of the Arms of the Incorporated Companies of Newcastle'.

JARVIS, John Wesley (1780–1840)
Portrait painter in oil; miniaturist; engraver. He was born at SOUTH SHIELDS, a nephew of John Wesley, the famous evangelist. At the age of five he emigrated to Philadelphia, USA joining there his father, who had left SOUTH SHIELDS some years earlier. He was apprenticed as a youth to an engraver, and moved with his master to New York in 1802 before setting up his own engraving establishment. While working in New York he learned of the success in the field of portraiture of another immigrant artist called Martin, and decided himself to become a professional portrait painter. He met with immediate success in his new profession, but contemporaries recorded him as 'extravagant, irascible, and unpredictable'. He made several trips to the south of the USA, with his pupil, Henry Inman, and is said on one occasion to have finished six portraits in a week. Following his final visit south he received a commission which made him famous as a painter on the eastern seaboard of the continent. He was asked by the City of New York authorities to paint a series of full-length portraits of American military and naval heroes. Meanwhile, he continued to live in New York, and to pursue his interests in engraving. His success in portrait painting and engraving was short lived, however, and he died in extreme poverty. Dunlap, in his *A History of the Rise and Progress of the Arts of Design in the United States*, 1834, described Jarvis as an artist of 'astonishing powers, but unfortunately of the most depraved habits'. He was also described as one of the best portrait painters of his day, and eccentric, witty and convivial. His work is well represented in galleries and museums in the USA.

JEFFERSON, Charles George (1831–1902)
Landscape and coastal painter in oil and watercolour. Jefferson was born at SOUTH SHIELDS, the son of an old and respected local family. A man of independent means, he was able to devote himself to drawing and painting from his youth without any of the difficulties normally attendant on a career in art, and quickly developed into an accomplished artist. It appears that he first exhibited his work while living at Glasgow in 1880, sending examples to the Glasgow Institute of Fine Arts, and the Royal Scottish Academy. He continued to exhibit in Scotland following his return to SOUTH SHIELDS, also sending work to the town's Art Club exhibitions of 1892, 1893 and 1894, and to

the Bewick Club, NEWCASTLE. He last exhibited in the year of his death. He died at SOUTH SHIELDS. Represented: South Shields Museum & A G.

Charles George Jefferson, *In Jesmond Dene*, 1892, oil, 34.5 x 29.5cm. Anderson & Garland.

JEFFERSON, John (fl. late 18th, early 19th cent.)
Portrait and landscape painter in oil. This artist practised in Northumbria in the early 19th century, and is first recorded practising at St Nicholas' Churchyard, NEWCASTLE, in 1811. He was practising at NORTH SHIELDS in 1818, when the *Northumberland & Newcastle Monthly Magazine* recorded the birth of his son on January 17th of that year, but by 1822, and exhibiting at the Northumberland Institution for the Promotion of the Fine Arts, NEWCASTLE, he had moved to SUNDERLAND. He exhibited at the Institution throughout its early life, showing a number of portraits of sitters from SUNDERLAND, and in 1824, a *Landscape Study*, but does not appear to have exhibited subsequently. Sunderland Art Gallery has his portrait of Robert Thompson, dated 1825.

JEFFREY, Edward (1898–1978)
Landscape painter in watercolour; illustrator. Jeffrey was born on Tyneside and studied art at Armstrong College (later King's College; now Newcastle University), before becoming a professional artist at NEWCASTLE. He first began exhibiting his work shortly after his graduation, showing examples at the Artists of the Northern Counties exhibitions at the Laing Art Gallery, NEWCASTLE. He later went on to exhibit at the Royal Institute of Painters in Water Colours; the Royal Scottish Academy; the Royal Society of British Artists; the National Society of Painters, Sculptors and Gravers, and widely in the provinces. Much of his

life was spent in illustration, initially with Philipson & Son, NEWCASTLE, where he was employed for eleven years, then in London and Huddersfield. In 1944 he was asked, with the writer Sheila Hodgetts, to create a new character for children, and the pig Toby Twist was created. This ran as a cartoon strip in a Yorkshire paper and appeared in annuals. Following this Jeffrey turned to designing inn-signs in the Lake District, settling at Ravenstonedale. He also executed many illustrations for the magazine *Cumbria*, and became a member of the Lake Artists' Society, and Kendal Art Society. He exhibited with both societies, and occasionally abroad. He lived for a number of years at Kirkby Stephen, Cumbria.

JENNINGS, Charles Henry (c.1875–c.1940)
Landscape, genre and portrait painter in oil and watercolour; lithographer. Jennings was born at NEWCASTLE, the son of a builder from Gloucester, and received his education at the city's Rutherford College. He appears to have become a largely self-taught artist before becoming a lithographer, painter, and producer of illuminated addresses at NEWCASTLE, and exhibiting his work at Rutherford College Art Club, and later the city's Laing Art Gallery, to whose Artists of the Northern Counties exhibitions he was a regular contributor, 1909–1936. He died at NEWCASTLE.

JEPSON, Sybil (1895–1975)
Landscape and marine painter in oil and watercolour; art teacher. She was born at DURHAM, the daughter of Dr Edward Jepson, mayor of the city in 1895, and 1896. After attending art schools at Worthing and Willesden she became an art mistress and began to exhibit her work. She showed one example at the Royal Academy in 1929, entitled *Houghton Bridge*, but mainly exhibited with the West Sussex Art Club, of which she was for some years secretary, and between 1954 and 1969, at the Royal Society of Marine Artists' exhibitions. Apart from service on the land in both World Wars Jepson lived mainly at Worthing, Sussex. A large exhibition of her work, including many Northumbrian views, was held at the Burlison Art Gallery, DURHAM, in 1954. Worthing Art Gallery has a substantial collection of her work.

JEVONS, Mrs Louisa E (fl. late 19th, early 20th cent.)
Miniature painter. She contributed two works to the Royal Academy, and one work to the Royal Miniature Society, in the period 1893–1901, while living at DURHAM. Her two Royal Academy exhibits were: *Mrs Fitzhugh Whitehouse*, and *Principal Jevons, M A*. It is believed that she was the wife of the latter, who was head of a college at DURHAM.

JOBLING, Isabella ('Isa') (née Thompson) (1851–1926)
Landscape and genre painter in oil and watercolour. She was born at NEWCASTLE, the daughter of Mark Thompson, a ship's chandler, and may have attended the town's Government School of Design, like her sister Margaret, before being sent by her father to

study art in Paris. She first began to exhibit her work publicly when she sent her *Study of a Head* to the 'Gateshead Fine Art & Industrial Exhibition', in 1883, where a fellow exhibitor was her future husband Robert Jobling (q.v.). In 1884, and now having moved to CULLERCOATS, she sent four works to the first exhibition of the Bewick Club, NEWCASTLE, these consisting of two oils and two watercolours. In 1885 she began exhibiting at the Suffolk Street Gallery, showing a watercolour, *Jack and His Mates*, and in 1892 sent to the Royal Academy from her studio in NEWCASTLE, a work entitled *Blossom*. She continued to exhibit at the Royal Academy until 1912, also showing work at the Royal Scottish Academy, and at various London and provincial exhibitions, including the Artists of the Northern Counties exhibitions at the Laing Art Gallery, NEWCASTLE, to which she contributed from their inception in 1905, until the year before her death. In 1893 she became the second wife of Robert Jobling, and thereafter signed her work using her married name. Husband and wife frequently accompanied each other on painting expeditions, one of their favourite haunts being the Yorkshire fishing village of Staithes. The couple began visiting the village from 1895, although Isa's Royal Academy exhibit of 1892, *Blossom*, picturing a local girl on the cliffs nearby, suggests that she had made its acquaintance earlier. Their work here was similar in subject-matter to that which they painted at CULLERCOATS, throughout their respective careers, but there is little doubt that the village close to their home at WHITLEY BAY quickly took second place to the attractions of Staithes. She continued to exhibit following her husband's death in 1923, her final exhibits at the Artists of the Northern Counties exhibitions at the Laing Art Gallery in 1925 containing a mixture of Staithes and Northumbrian subjects. She died at WHITLEY BAY the following year. A major exhibition of the work of Robert and Isa Jobling was held at the Laing Art Gallery, 1992/3, under the title *A Romance with The North East*, with an excellent account of their lives and work by then curator John Millard. Represented: Laing A G, Newcastle; Shipley A G, Gateshead. [See colour plate: Isabella Thompson]

JOBLING, Joseph (1869–1930)

Coastal, landscape and bird painter in oil and watercolour; draughtsman. One of the three sons of Robert Jobling (q.v.), by his first wife, Jobling was born at NEWCASTLE, and received some tuition from his father before becoming a professional artist. He first began exhibiting his work publicly at the Bewick Club, NEWCASTLE, following his family's move to WHITLEY BAY; here he exhibited on several occasions alongside his father choosing much the same subjects as Jobling, Senior, and often displaying equal competence as an artist. Later, however, he turned to photography as a career, and after taking a studio at NEWCASTLE in the early years of the century, he only painted in his spare time. He was an occasional exhibitor at the Artists of the Northern Counties exhibitions at the Laing Art of Gallery, NEWCASTLE, from 1908 until the death of his father, but thereafter exhibited little. In his later life he

worked mainly in the area around his home at WHITLEY BAY, handling technical photography, and producing a large number of drawings and paintings of bird life. He also painted several studies of the fish quay at NORTH SHIELDS for illustrative purposes. He died at WHITLEY BAY. His wife ELIZABETH JOBLING (née Ewen), was also talented artistically, and was an accomplished picture restorer. His stepmother was Isa Jobling (née Thompson) (q.v.).

JOBLING, Robert (1841–1923)

Marine, landscape and figure painter in oil and watercolour; illustrator; art teacher. Jobling was born at NEWCASTLE, the son of a glassmaker employed in the glassworks of Sir Matthew White Ridley & Co, on the banks of the Tyne. His first employment was alongside his father, where he remained until the age of sixteen. He next became a ship painter in the Tyne General Ferry Company's yard on the Tyne, attending the art classes of the Government School of Design, NEWCASTLE in his spare time. He rose to become foreman in the shipyard, but became increasingly disillusioned with his occupation, and decided to become a full-time professional artist. The date at which he made this decision is unknown, but by 1866 he was exhibiting a work, *Sea Piece*, at the 'Exhibition of Paintings and other Works of Art', at NEWCASTLE, following this with his *Shields by Moonlight*, at the 'Central Exchange News Room, Art Gallery, and Polytechnic Exhibition', in the town, in 1870. His work was included in several important local exhibitions over the next few years, including the exhibition of works by local painters, at the Central Exchange Art Gallery, and the first exhibition of the Arts Association, in 1878. By 1883 he had a studio in Shakespeare Street, NEWCASTLE, and in this year sent his first works to the Royal Academy, and the Suffolk Street Gallery; an oil, *Moonlight*, and a watercolour, *North Sea Fishers*. He remained at Shakespeare Street for more than eleven years, later moving to the old Academy of Arts' building at Blackett Street, where he stayed until about three years before his death. He then began to paint at his home for many years, at WHITLEY BAY. Jobling remained an exhibitor at the Royal Academy until 1911, also exhibiting his work at various London and provincial galleries, and for many years at the Bewick Club, NEWCASTLE, of which he was one of the founders, and later president. For the last eighteen years of his life he exhibited mainly at the Artists of the Northern Counties exhibitions at the Laing Art Gallery, NEWCASTLE, and as one of the founders and lifelong members of the city's Pen & Palette Club, his work inevitably appeared at various of its exhibitions. Two major exhibitions of his work were held in NEWCASTLE during his lifetime; one in 1899; the other just a few months before his death, at Armstrong College (later King's College; now Newcastle University), in honour of his great assistance in conducting its art classes. Jobling married twice, his second wife being the artist Isa Thompson (q.v.). Joseph Jobling (q.v.), a son by his first wife, was also artistically gifted. Most of Jobling's work was associated with the sea, and featured fishing

Robert Jobling, *The Tyne – A Souvenir of the Sixties*, c.1911, oil, 102 x 153cm. Private collection.

boats, fishermen and their activities, and figure studies, many of these works painted at CULLERCOATS, or at the North Yorkshire fishing village of Staithes. Like his wife Isa, Jobling benefited enormously from his association with the latter, both through his contact with other artists painting in the village, and in terms of the subject matter and light which he found there. His technique changed considerably and his palette became brighter. In addition to painting, Jobling was also an occasional illustrator, several of his drawings of the Tyne, and its shipping, appearing in books and periodicals. Examples of his work in illustration also appeared in *Wilson's Tales of the Borders*, and editions of Burns' poems. He died at WHITLEY BAY. A major exhibition of the work of Robert and Isa Jobling was held at the Laing Art Gallery, 1992/3, under the title *A Romance with the North East*, with an excellent account of their lives and work by then curator John Millard. Represented: Carlisle A G; Hatton Gallery, Newcastle; Laing A G, Newcastle; Natural History Society of Northumbria, Newcastle; Shipley A G, Gateshead; Pen & Palette Club, Newcastle. [See colour plate]

JOHNSON, Alfred (d.1944)
Landscape painter in watercolour. This artist practised at SOUTH SHIELDS in the first half of the last century. He exhibited his work at the Artists of the Northern Counties exhibitions at the Laing Art Gallery, NEWCASTLE, in the later years of his life. His last work, shown in 1944, was bequeathed to South Shields Museum. This work was his water colour: *Durham Cathedral*. He died at his home at SOUTH SHIELDS.

JOHNSON, Deryk Blythe ('Ben') (1943–2002)
Organic painter in mixed media; art teacher. Johnson was born at NEWCASTLE, and after training at the Newcastle College of Art & Industrial Design taught art all his working life in County Durham. He was, however, an artist throughout and after his teaching career, and while living at STAINDROP, near BARNARD CASTLE, participated in many group exhibitions, and enjoyed occasional one-man shows. Among the venues at which he exhibited his work were the Hatton Gallery, NEWCASTLE; the Arts Centre, DARLINGTON; Darlington Art Gallery; Grey College, DURHAM; The Town Hall, BISHOP AUCKLAND, and The Quaker Gallery, London. His early work was figurative but he increasingly turned to organic compositions, in his final years using as a studio an old keeper's cottage in Bath Wood in the heart of Lord Barnard's Raby Estate, near BARNARD CASTLE. Here his technique was to apply wet earth to his canvases from the nearby woodland, and from the basic marks of the earth which he brushed onto his canvases using bundles of leaves and grass, to build up his images organically with shapes, forms, etc, continuously adjusting and modifying until he felt the resulting images captured something of the multi-faceted and vibrant life force of which he felt we are all part. Many examples of this highly original work were shown in a major retrospective held at the McGuinness Gallery, The Town Hall, BISHOP AUCKLAND, in the year following his death, under the title *The Man and his Mark*. His work is represented in various public, university and private collections.

JOHNSON, James (1699–1777)
Sculptor; stonemason. Johnson was a member of a family of stonemasons at STAMFORDHAM, and from about 1750 was mainly engaged in cutting stone figures for the barbican of the castle at ALNWICK, for the 1st Duke of Northumberland. These figures are each one metre high and replaced earlier figures which had become decayed. They formed part of the wholesale refurbishment of the castle, and reportedly took Johnson 'upwards of twenty years' to complete.

JOHNSON, John (c.1769–1794)
Wood engraver; draughtsman. He was born at STANHOPE, and was apprenticed to Ralph Beilby (q.v.), and Thomas Bewick (q.v.), in their workshop at NEWCASTLE, in 1782. Bewick later wrote of Johnson, in his autobiographical *Memoir*: 'John Johnson . . . we put to do engraving on Wood, as well as other kinds of work – I think he would have shone out in the former branch – but he died of a fever, at about the Age of 22 when only beginning to give great promise of his future excellence'. ‡ While working for Beilby and Bewick he prepared a design for *The Hermit at his Morning Devotion*, for *Poems of Goldsmith and Parnell*. Bewick engraved this design for the publication, which appeared in the year following Johnson's death. Some of the engravings in Bewick's *Birds* have been credited to Johnson by John Jackson (q.v.), in his book with W A Chatto: *A Treatise on Wood Engraving*, 1839. He died at NEWCASTLE. He was the cousin of Robert Johnson (q.v.).

‡ See p. 195. *A Memoir of Thomas Bewick Written by Himself,* edited and with an introduction by Iain Bain. Oxford University Press, 1975.

JOHNSON, Nerys Ann (1942–2001)

Flower and landscape painter in watercolour; art teacher. She was born at Colwyn Bay, North Wales, and studied at King's College (now Newcastle University), where she was awarded her BA (Hons) in fine art, specialising in painting. She later took her diploma in education at the University, and taught evening classes in life drawing and painting while serving as keeper of fine art at the Laing Art Gallery, NEWCASTLE. Among the several important exhibitions which she helped to organise while there, was the centenary exhibition of John Wilson Carmichael (q.v.) in 1968, and the John Martin (q.v.) exhibition 1970. Following her position at the Laing Art Gallery she became keeper-in-charge at the DLI Museum and Arts Centre, DURHAM, remaining there for nineteen years, and initiating many exhibitions and supporting education programmes. She also became well known for her work in the museums service, leading to her presidency of the Northern Federation of Museums and Art Galleries, in 1984. During her career in the museums service she had participated in several group exhibitions and enjoyed several one-man exhibitions. It was not, however, until her retirement from the service in 1989 due to ill health, that she was able to devote herself fully to her love of drawing and painting. Despite prolonged periods in hospital she began to exhibit her work throughout Britain in many more group and one-man exhibitions, among the former, the Friends of the Hatton Gallery Summer Exhibition, NEWCASTLE, 1990, and 1995, and *A Splash of Colour*, Laing Art Gallery, NEWCASTLE, 1998. Her one-man exhibitions included *Mostly Flowers*, Trevelyan College, DURHAM, 1990; *View of Venice*, Cass di Risparmio, Campo S Luca, Venice, 1994; *Drawings & Paintings*, Customs House Gallery, SOUTH SHIELDS, 1996, and at the Broughton House Gallery, Cambridge, 1999. She also received many awards for her work, among these the Northern Arts Artists Award, 1993, and the Leverhulme Trust Award, 1996. Her work has been the subject of a number of video productions, including *Nerys Johnson, Views of Venice*, 1994, and *My Favourite Object*, Tyne Tees Television, 1996. Examples of her work have been employed by greetings card and calendar publishers. Most of her later life was spent at DURHAM, where she continued to draw and paint until close to her death, despite crippling disabilities. On her death a sale of work from her studio was held at her express wish to raise cash for a fund to support the purchase of work by living artists for public collections. A major exhibition of her work, entitled 'Nerys Johnson: the last year', was held at the DLI Museum & Art Gallery in 2003, also for the latter purpose. Represented: Abbot Hall A G, Kendal; the Arts Council; Laing A G, Newcastle. [See colour plate]

JOHNSON, Ralph (1896–1980)

Landscape painter in oil and watercolour. Johnson was born at ANNFIELD PLAIN, near CONSETT, and was a builder by trade, who painted in his spare time. Until 1930 he painted in both oil and watercolour, but following this date he increasingly concentrated on watercolour alone. He exhibited his work for many years at the Artists of the Northern Counties exhibitions at the Laing Art Gallery, NEWCASTLE, and regularly showed his work with the Durham & District Artists Society, of which he was for some time vice president. He painted mainly Northumbria, Lake District and Scottish scenes, many with outstanding accomplishment. He died at ANNFIELD PLAIN.

JOHNSON, Robert (1770–1796)

Landscape painter in watercolour; draughtsman; engraver. Born at SHOTLEY, near CONSETT, the son of a joiner and cabinet maker, Johnson is said to have shown such promise as an artist as a youth that his parents moved to GATESHEAD, where they thought his abilities could receive greater encouragement than in his native village. This story, like the one told of a lady at NEWCASTLE paying for his instruction in drawing at a local academy, must be treated with some reservations, however, if we are to believe the account of his training given in the autobiographical *Memoir* of Thomas Bewick (q.v.).‡ According to this account, Johnson through his mother's friendship with the Bewick family, was led to believe from his earliest years that he would one day become Bewick's appren-

‡ See pp. 196–9, *A Memoir of Thomas Bewick, Written by Himself*, edited and with an introduction by Iain Bain, Oxford University Press, 1975.

Ralph Johnson, *A Lane near Ebchester*, watercolour, 17 x 14cm. Private collection.

187

Robert Johnson, *North West View of Bamburgh Castle*, watercolour, 21 x 35cm. Tyne & Wear Museums, Laing Art Gallery.

tice. To equip himself for this day he therefore 'at every opportunity kept closely employed in drawing'. At thirteen, and although still too young to become an apprentice, he was taken into Bewick's home 'till the proper time arrived'. Curiously, this day did not arrive until some four years later, Johnson not becoming apprenticed to Bewick, and his partner Ralph Beilby (q.v.), until 23rd August, 1787. He then served his full seven years as an apprentice, during this period receiving special treatment from his masters because of his obvious aptitudes as an artist, and delicate health. 'He was mostly employed in drawing', says Bewick, '& was also at intervals practising himself in the use of the graver & in etching on copper – but being very delicate in his health, we were carefull not to confine him too closely at any thing.' Bewick next gives a detailed account of his training of Johnson, from copying his own designs, to colouring them, and concludes by stating that 'He soon coloured them in a style superior to my hasty productions of that kind – indeed, in this way he became super-excellent, & as I conceived he could hardly be equalled, in his water coloured drawings of views & landscapes, by any artist . . .' While still an apprentice, Johnson accumulated a portfolio of watercolours, some of which his masters thought fit to sell to the Earl of Bute, for £30. This sum the partners retained on the grounds that they were the work of an apprentice, and therefore part of the business. Johnson did not agree, however, a lawsuit ensued, and rather unjustly in the light of Bewick's help to him in developing his undoubted talents as a watercolourist, he was allowed to claim the £30, while the partners paid the costs. After leav-

ing Beilby and Bewick, Johnson took rooms in NEWCASTLE, and followed the business of copperplate engraver, but was seemingly unsuccessful. He executed several drawings of local architectural subjects, some of which he later engraved, notable among these being his famous *A North View of St. Nicholas' Church*, *c*.1795, for Joseph Whitfield's *Annual Ladies' Pocket Book*. In the summer of 1796 he was recommended by Messrs Morison & Son, publishers at Perth, Scotland, to make drawings of portraits by Jamesone, the 'Scottish Vandyke', at Taymouth Castle, Kenmore, the seat of Lord Breadalbane. These were intended for Pinkerton's *Scottish Portraits* of 1799. Of the some nineteen copies of portraits by Jamesone required, Johnson had completed fifteen when he was taken ill with a fever. His illness was taken to be a form of madness, and he was bound with ropes and beaten. A passing doctor fortunately recognised his symptoms and attempted to give him proper treatment, but he died shortly afterwards and was buried at Kenmore. Johnson's abilities as a watercolourist were second only to those of fellow Bewick apprentice Luke Clennell (q.v.), while in regard to his draughtsmanship Bewick once remarked to John Hancock (q.v.), that he could not draw out of perspective, so true was his eye. His work as an engraver though slight, was keenly appreciative of current techniques, and, indeed, he had very clear ideas as to how his copies of Jamesone's portraits should be handled. His contributions to Bewick's *Birds* is still a matter of debate, although much has been done by Iain Bain in recent years to clarify Johnson's likely involvement, notably in *The*

188

Rev George Liddell Johnston, *A Playing Child and various imaginary creatures*, pen and watercolour, 15 x 42cm. Private collection.

Watercolours & Drawings of Thomas Bewick and his Workshop Apprentices, 1981. A tablet to Johnson's memory is situated in the exterior wall of the south transept of the Parish Church at OVINGHAM. He was the cousin of John Johnson (q.v.). Represented: Scottish National Portrait Gallery; Laing A G, Newcastle; Natural History Society of Northumbria, Newcastle; Newcastle Central Library.

JOHNSON, Robert James, FSA (1832–1892)

Architectural draughtsman. Johnson was born near DARLINGTON, and after showing an interest in following a career as an architect, was apprenticed to John Middleton in the town. On completing his apprenticeship he moved to NEWCASTLE to complete his studies. He first followed his profession in London, but returning to Northumbria a few years later, he practised at NORTH SHIELDS, and later NEWCASTLE, remaining at the latter for many years, and taking over with Thomas Austin, the practice of John Dobson (q.v.). Most of his career as an architect was occupied in designing churches, banks and offices. He exhibited several of his designs for churches at the Royal Academy between 1862 and 1887, including among these *St Hilda's Church, Whitby*, and *All Saints' Church, Gosforth, Newcastle*. He also wrote on architectural matters, and in 1861 published *Specimens of French Architecture*. He was especially interested in antiquarian matters, and was a fellow of the Society of Antiquaries, London, and a member of the Society of Antiquaries, NEWCASTLE. He died at Tunbridge Wells, Kent. Hexham Abbey Museum has examples of his pen and ink drawings of the Abbey, prepared while he was architect to the building as a member of the practice headed by Charles Clement Hodges (q.v.).

JOHNSTON, Rev George Liddell (1817–1902)

Draughtsman. Born at SUNDERLAND, Johnston studied at University College, DURHAM, before becoming ordained as a minister in 1849. In 1850 he left DURHAM, and began his ecclesiastical career in the Exeter Diocese, remaining there until 1856, when he left Britain to take up an appointment to the British Embassy in Vienna, until 1885. In 1892 he spent a holiday at Merano in the Italian Tyrol, and there produced a sketch-book of drawings upon which his reputation as an artist almost entirely rests. This sketch-book was not given much attention until 1969, when it was discovered in Vienna, but subsequent study of its contents has revealed an artist of extraordinarily grotesque vision, whose drawings are far from the restrained exaltations of nature which one might have expected from a clergyman. The drawings were exhibited by the Stone Gallery, NEWCASTLE, in 1970, and superbly introduced by proprietor Ronald Marshall in his exhibition catalogue. To him more than anyone else are we indebted for a glimpse of surely some of the strangest drawings produced by a Northumbrian artist: skeletons, three-headed men, animals – legendary and otherwise – with the heads of men; kings, queens and courtiers of bizarre appearance, and a pear dressed as a ballet dancer. Johnston died in London without, it seems, leaving us any example of his work apart from his sketch-book. Represented: Shipley A G, Gateshead.

JOLIN, Mabel (born c.1895)

Landscape and figure painter in watercolour. Jolin was born at NEWCASTLE, and did not start painting until she was in her forties. She had meanwhile moved to CORBRIDGE, from which she exhibited her work at the Royal Scottish Academy; the Royal Society of British Artists, and the Artists of the Northern Counties exhibitions at the Laing Art Gallery, NEWCASTLE. She was also an exhibitor at the 'Contemporary Artists of Durham County' exhibition held at the Shipley Art Gallery, GATESHEAD, in 1951, in connection with the Festival of Britain. A member and for some time secretary of the North Tyne Sketch Club, she was also a regular exhibitor with that organisation.

JONES, Francis W Doyle, RBS (1873–1938)

Sculptor. He was born at HARTLEPOOL, the son of a monumental sculptor, and studied under his father before attending the local School of Art. He later studied at Armstrong College (later King's College; now Newcastle University), and at the Royal College

of Art, under Lanteri, before becoming a professional sculptor in London by the early years of the 20th century. Jones exhibited his work regularly at the Royal Academy throughout his professional career, showing some thirty works between 1903 and 1936. He also exhibited at the Royal Hibernian Academy, and at various London and provincial galleries, including among the latter the Laing Art Gallery, NEWCASTLE, whose Artists of the Northern Counties exhibitions he contributed to from their inception in 1905. His principal works were his war and other memorials for various parts of the British Empire, amongst these his South African War Memorial for the Ward Jackson Park at HARTLEPOOL, for which the town's Hartlepool Arts & Museum Service, has his original bronze statuette. This gallery also has his relief panels *Fame & Patriotism*, exhibited at the Royal Academy in 1903. Jones spent most of his professional life in London, travelling widely to carry out commissions for his memorial and portrait work. He was a member of the Royal Society of British Sculptors. Examples of his work may be seen in parks and other public places widely throughout the North East of England.

Francis W Doyle Jones, *South Africa, 1899-1902*, bronze, 49cm high. Hartlepool Arts & Museum Service.

JONES, John Rock, Senior (c.1798- c.1855)
Portrait painter in oil. This artist's place of birth is not known, but by the early years of the 19th century he was working in London as studio assistant to Henry Sass, and later James Ramsay (q.v.). He subsequently moved to the Isle of Man, where his son, John Rock Jones, Junior (q.v.), was born, then in 1840 settled on Tyneside, where he is said to have become friendly with Thomas Miles Richardson, Senior (q.v.), and Henry Perlee Parker (q.v.), among several leading local artists of the day. He does not appear to have continued painting after his arrival on Tyneside, but to have lived a life of independent means in a house of some substance at FOREST HALL, near NEWCASTLE, until his death about 1855. He is believed to have exhibited his work on only one occasion, this being when he sent his *Portrait of the Artist* to the Suffolk Street Gallery in 1826, while working with Ramsay.

JONES, John Rock, Junior (c.1836–c.1898)
Landscape painter in watercolour; art teacher. He was born on the Isle of Man, the son of John Rock Jones, Senior (q.v.), the portrait painter. His father some time later decided to move to Tyneside, where Jones Junior, was educated privately, and evidently showed an early inclination towards art by 'copying pictures by Richardson, Copley Fielding, David Cox, and others, that were lent out by Mr Kaye, artists' colourman and stationer, Blackett Street ...'. On completing his education he became an art teacher at NEWCASTLE, remaining in this profession until his death at FOREST HALL, near NEWCASTLE, about 1898. He was one of the first members of the Newcastle Life School, which later developed into the Bewick Club, NEWCASTLE, and served on the Club's art council for many years. He first began exhibiting his work publicly in 1866, when his *On the Wansbeck* was included in the 'Exhibition of Paintings and other Works of Art', at the Town Hall, NEWCASTLE. He next exhibited at the Arts Association, and at the exhibition of works by local painters, at the Central Exchange Art Gallery, NEWCASTLE, in 1878, later becoming a regular exhibitor at the city's Bewick Club. Jones was the author of *Groups for Still-Life Drawing and Painting*, and a series of papers called *Leisure-graphs, or Recollections of an Artist's Rambles*. He also delivered several lectures on popular art subjects, and in 1887 was elected a member of the Society of Science, Letters, and Art, London. He is believed to have exhibited outside Northumbria on only one occasion, this being when he sent two landscapes to Carlisle Art Gallery, in 1896.

JONES, Jonah (b.1919)
Sculptor; art teacher. Born at EAST BOLDON, near SOUTH SHIELDS, Jones attended part-time evening classes at King's College (now Newcastle University) before service in the Second World War. After the War he suffered from pulmonary tuberculosis, but was sufficiently recovered by 1949 to work in the workshop of Eric Peter Gill (who was a teacher at Liverpool School of Art, as well as a practising artist).

Some two years later he set up as an artist himself, in north-west Wales, using slate as his principal medium. He later served as director of the National College of Art and Design in Dublin, and lectured in sculpture at the British School in Rome. He has mainly been a working sculptor, however, and has exhibited his work at the Royal Cambrian Academy, with the Welsh Arts Council, and the North Wales Group. He has also enjoyed several one-man exhibitions, but his work is mainly known through his sculptures and inscriptions for public places. Among the former are his depictions of Mercy and Justice on the Law Courts in Mold, and sculpture on the theme of Peace for the Emrys ap Iwan School at Abergele; and the latter, his inscriptions to David Lloyd George and Dylan Thomas, in Westminster Abbey. He has also sculpted a number of portrait busts, including the architect Clough Williams-Ellis, and the writer John Cowper Powys. Jones has also displayed a talent for writing, and in addition to scripting several television films, published *A Tree May Fall*, in 1980, and *The Lakes of North Wales*, in 1983. He lived for many years in Gwynedd, Wales, and later Cardiff. His work is represented in the collection of the Contemporary Art Society of Wales.

JOPLING, Isaac, Senior (1752–1827)

Sculptor; marble mason. Born on Tyneside, Jopling became a successful marble mason who occasionally turned his hand to works of sculpture. He established a marble works at GATESHEAD in 1780, one of his later trade cards describing its activities as including the execution 'in the best foreign, Irish, and British Marbles, CHIMNEY PIECES, MONUMENTS, GRAVE-STONES, TOMBS, ETC.'. This trade card also bore replicas of both sides of the Gold Medal with which he was presented by the Society of Arts in 1810, for discovering in the Highlands of Scotland a variety of fine marbles. In his later years, and following the development in skill of his son and business partner, Isaac Jopling, Junior (q.v.), he took a lesser interest in the marble works, and sold books, and ran a circulating library from this establishment. A few days after his death, however, his son disposed of this side of the business. Jopling's work embraced a large number of monuments and tablets for churches throughout Northumbria. He was for some years in partnership with his brother, John Jopling (q.v.). He died at GATESHEAD.

JOPLING, Isaac, Junior (c.1790- after 1842)

Sculptor; marble mason. He was born at GATESHEAD, the son of Isaac Jopling, Senior (q.v.), and was apprenticed to his father before becoming a partner in the family mason's works in the town. In the latter capacity he worked frequently with his father in the production of monuments and tablets for churches throughout Northumbria. There is, however, reason to suppose that he was a more accomplished sculptor than his father, for in 1811 he was presented with the Silver Medal of the Society of Arts, for his plaster cast of *The Dying Gladiator*, and occasionally exhibited his work. One of his exhibits was the *Original Bust of*

a Child, which he showed at the Northumberland Institution for the Promotion of the Fine Arts, NEWCASTLE, in 1823.

JOPLING, John (died c.1810)

Sculptor; marble mason; miniature painter. He was born at GATESHEAD, and was for many years partner with his brother Isaac Jopling, Senior (q.v.), in the Jopling marble works in the town. In 1806 he decided to branch out on his own, moving to NEWCASTLE, where he possibly took on Richard George Davies (q.v.) as an apprentice or helper during his few years in business there. Eneas Mackenzie in his *History of Newcastle*, Volume II, page 589, says of him: 'The Late John Jopling, of Newcastle, and predecessor of Mr Davis (sic), marble mason, was a good sculptor, and had a fine taste for miniature painting.' It is believed that he died at NEWCASTLE, his widow carrying on his business for some years following his death.

JORDAN, Phyllis Tiel (ex. 1928–1935)

Landscape, flower and still life painter in watercolour. This artist lived at DARLINGTON, from which in 1928 she sent a watercolour entitled *Roses*, to the Royal Academy. She also exhibited two watercolours entitled *Rocks, Kennach Sands*, and *Portmellon Beach, St Ives*, at the St Ives Society of Artists Summer Exhibition in 1935.

JOWSEY, John Wilson (1884–1963)

Portrait and landscape painter in oil; muralist. He was born at ASHINGTON, the son of a shipwright and keen amateur sailor, and studied art at Edinburgh, Paris, and Newlyn, Cornwall, before practising as an artist in Northumbria, and later London. In the early part of his career he painted at ASHINGTON and NORTH SHIELDS, shortly after the First World War opening a studio at NEWCASTLE, where he painted portraits of leading Tyneside shipowners. Among these shipowners he found a patron in Lord Kirkley, chairman of the Tyne Improvement Commission, who, in addition to having his portrait painted by the artist, obtained a commission for him to paint a series of nine murals for the frieze of the Commission's one-time headquarters at NEWCASTLE. The murals were unveiled in November, 1927, and in the following year Jowsey moved to London, where he followed the profession of portrait painter until his death. Many notable personalities of his day were among his sitters, including Sir Winston Churchill, painted for an American patron while Churchill was serving as Prime Minister 1951–5. Jowsey first exhibited his work at the Artists of the Northern Counties exhibitions at the Laing Art Gallery, NEWCASTLE, later exhibiting at the Royal Society of British Artists; the Royal Cambrian Academy; the Royal Portrait Society and the Paris Salon. He died in London.

K

KEEDY, Elizabeth (c. 1870- after 1908)
Landscape and coastal painter in oil and watercolour; art teacher. Born at SOUTH SHIELDS, she served for some years as a teacher at the town's School of Art, painting in her spare time. South Shields Museum & Art Gallery has her *Bent's Cottage*, 1908, and an undated view of SEATON SLUICE, near BLYTH, presented by her father.

KEEN, Adam Douglas (1870-c.1940)
Landscape painter in oil and watercolour; stained glass designer. Keen was born at GATESHEAD and followed the profession of stained glass designer, painting in his spare time. He was a regular exhibitor at the Artists of the Northern Counties exhibitions at the Laing Art Gallery, NEWCASTLE, from 1909, and also showed work at the city's Bewick Club. During this period he lived at NEWCASTLE. His exhibits included a wide range of local views around Northumbria. Keen designed stained glass for several churches at NEWCASTLE, including Holy Trinity, JESMOND, and later moved to Exeter to work for church furnishers, Wimpole & Co. He died at Exeter during a flu epidemic at the outbreak of the Second World War.

KELL, Robert John (d.1934)
Amateur landscape painter in oil, watercolour and pastel. He was born at SOUTH SHIELDS, the son of an income tax collector for the Borough, and later became a teacher, painting in his spare time. He began teaching in 1887 at SOUTH SHIELDS, but later abandoned his profession in favour of accountancy work on income tax. He resumed teaching in 1926, but retired in 1932, due to ill health. Kell was honorary secretary of South Shields Art Club for many years, and one of its best known members. He exhibited his work regularly with the Club, and occasionally at the Bewick Club, NEWCASTLE, and at the Artists of the Northern Counties exhibitions at the city's Laing Art Gallery. One of his best known works was his oil, *The Bents, Ballast Hills*, painted in 1901. This work was reproduced by Hodgson in his *History of South Shields*. An exhibition entitled 'Water Colour Drawings, Sketches of Old Shields Beauty Spots, Oils and Pastels, by the late Robert John Kell of South Shields', was held in his home town in the year following his death.

KENT, Ann Sophie (fl. late 19th cent.)
Amateur still life and landscape painter in watercolour. Kent was a keen amateur watercolourist who exhibited her work at the Bewick Club, NEWCASTLE, while living in the city in the late 19th century. She also exhibited one work, at the Loan Exhibition, at the Central Exchange Art Gallery, NEWCASTLE, in 1889. The Shipley Art Gallery, GATESHEAD, has two of her studies of vases.

KIDD, John Andrews (d.1811)
Engraver. This engraver practised at NEWCASTLE in the late 18th, and early 19th centuries, engraving many plates for locally published prints and books. His

John Andrews Kidd, *Portrait of Thomas Bewick, after Miss Kirtley*, engraving, 9.5 x 7.5cm. Private collection.

best known work is his engraving of a portrait of Thomas Bewick (q.v.), after a Miss Kirkley, published in London and NEWCASTLE, in 1798. This engraving, of which early impressions are extremely rare, was inserted in the *Gentleman's Magazine*, for January, 1829, following Bewick's death. Kidd died at NEWCASTLE. He was the master of Thomas Fryer Ranson (q.v.).

KIDD, William A (fl. 1834–1851)
Portrait and landscape painter in oil; lithographer. This artist practised in Northumbria during the first half of the 19th century. He is first recorded at NORTH SHIELDS in 1834, from which address he sent two landscape works to the Newcastle upon Tyne Institution for the General Promotion of the Fine Arts. Both of these works were Scottish views. Later in the same year (September) he issued an announcement to the effect that William A Kidd 'portrait and landscape painter (late of London)', would be executing 'a large oil painting of the opening and shipment of coals from Stanhope & Tyne Railway', which painting would 'afterwards be published in Lithography at a modest price'. This view was taken on September 10th, 1834, and was duly 'drawn on the stone' by Kidd and published by Kelly of NORTH SHIELDS. He exhibited on three further occasions at NEWCASTLE; in 1838 showing four landscapes; in 1839, two landscapes, and in 1843, two landscapes. These works comprised Continental and local views, and were sent from NORTH SHIELDS, and SOUTH SHIELDS. It would appear that Kidd devoted most of his later life to running a

Joseph Dixon Clark, Sen.,
Hitching the Plough,
oil, 54.5 x 75cm.
Anderson & Garland.

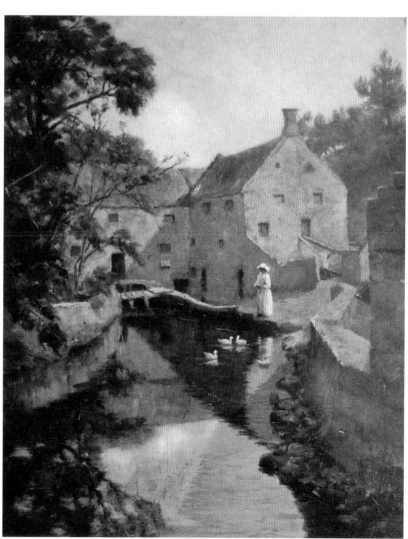

William Cole,
Dalehouse Mill,
oil, 48.5 x 39cm.
Private collection.

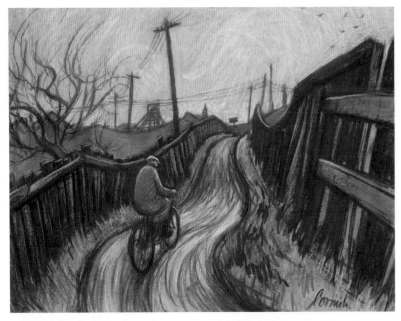

Norman Cornish,
Man on a Bicycle,
pastel, 58 x 71cm.
Anderson & Garland.

Stephen Crowther,
*Windswept Tree, Hawthorn Dene,
Seaham Harbour*, 1962,
oil, 61 x 91.5cm.
Anderson & Garland.

Denis Victor Curry,
Golden Eagle, 2002,
bronze, 120cm high.
Private collection.

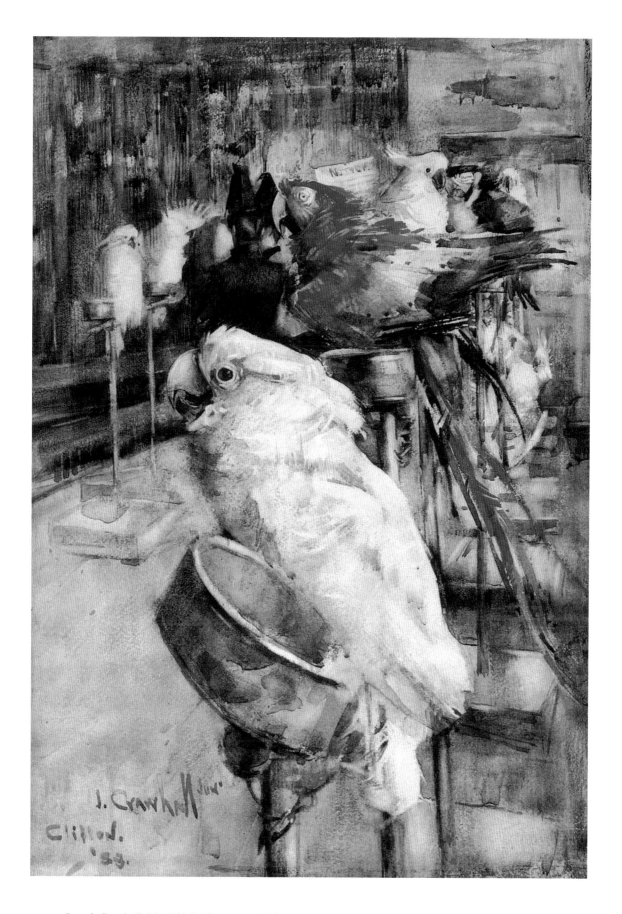

Joseph Crawhall, The Third, *The Aviary, Clifton*, 1888, watecolour, 51 x 35cm. The Burrell Collection.

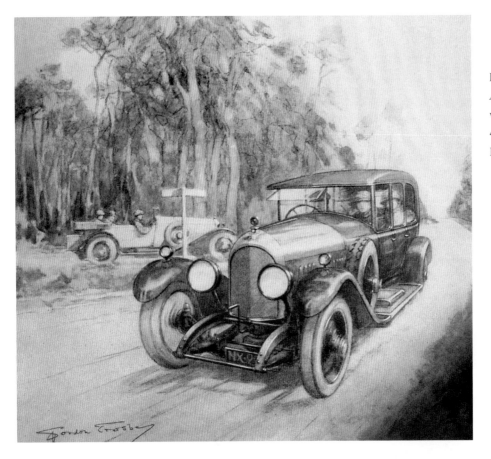

Frederick Gordon Crosby,
An Autumn Spin,
watercolour,
40 x 45cm.
Private collection.

Alfred Cuthbert,
Tynemouth Priory,
oil, 45 x 50cm.
Private collection.

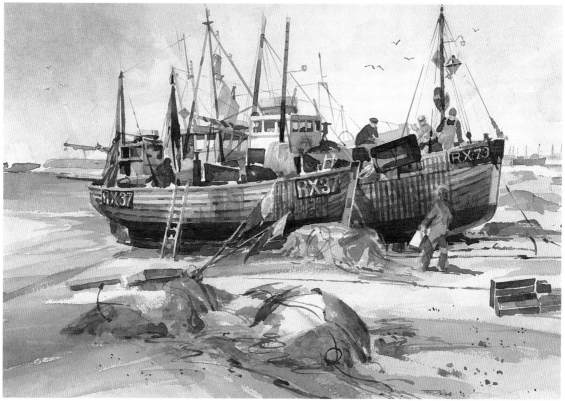

Thomas Gamble, *Hansa City*, watercolour, 38 x 54cm. Private collection.

Thomas Dack, *Boats on Beach at Hastings*, 2000, watercolour, 31 x 41cm. Private collection.

Charles John de Lacy, *Newcastle*, 1910, oil, 51 x 35.5cm. Private collection.

Raf Fulcher,
*The Swirle Pavilion,
Quayside, Newcastle*, 1998,
stone, concrete and metal,
10m diameter x 9.5m high.
Newcastle City Council.

Jeffrey Dellow,
KP2, 2000,
acrylic, 167 x 175cm.
Private collection.

Leonard Charles Evetts,
Creation Window, St Nicholas Church,
Bishopwearmouth, Sunderland.

Eric Dobson,
Still Life with Chair, 1956,
oil, 51.5 x 77cm.
Private collection.

Peter Michael Hicks,
Northern Landscape,
acrylic, 183 x 244cm.
Private collection

John Wilson Ewbank,
*Alexander's Entry into
Babylon*, 1825,
oil, 152.5 x 213.5cm.
Natural History Society of
Northumbria, Newcastle.

John Binney Gibbs,
High Row, Darlington,
oil, 74 x 102cm.
Borough of Darlington Art
Collection.

Leslie Donovan Gibson,
*Sheep Dipping, Bellingham,
Northumberland*, 1934,
oil, 46 x 61cm.
Private collection.

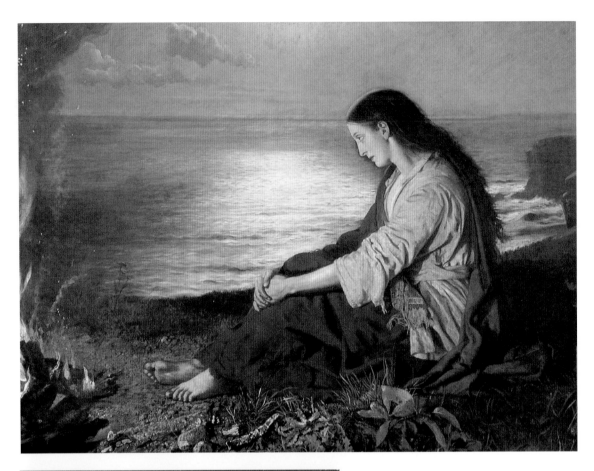

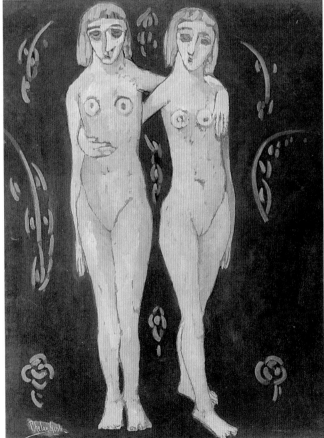

Henry Hetherington Emmerson,
Waits for the Bark that Never can Return,
oil, 74 x 101cm.
Hatton Gallery, University of Newcastle.

Henry William Gibb,
Two Nudes, 1908,
oil, 127 x 96.5cm.
Private collection.

Albert Edward Gilmour, *Drivers Relaxing*,
oil, 51 x 61cm.
Private collection.

Anne Gillie, *Harlequin*, 1965,
collage and oil, 122 x 91cm.
Hatton Gallery, University of Newcastle.

John Thomas Young Gilroy, *Guinness 1953 Coronation Poster*. Copyright Guinness 1953.

Richard Hobson,
After Closure – Tyne
Dock Engineering,
South Shields,
watercolour, 58 x 105cm.
Private collection.

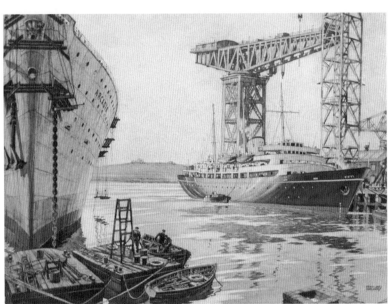

Fred Jay Girling,
The Royal Yacht
'Britannia' at John
Brown's Shipyard,
Glasgow for fitting out,
watercolour, 34 x 47cm.
Dean Gallery.

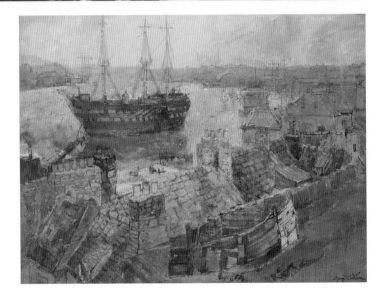

George Edward Horton,
The Wellesley,
North Shields,
watercolour, 45 x 59cm.
Anderson & Garland.

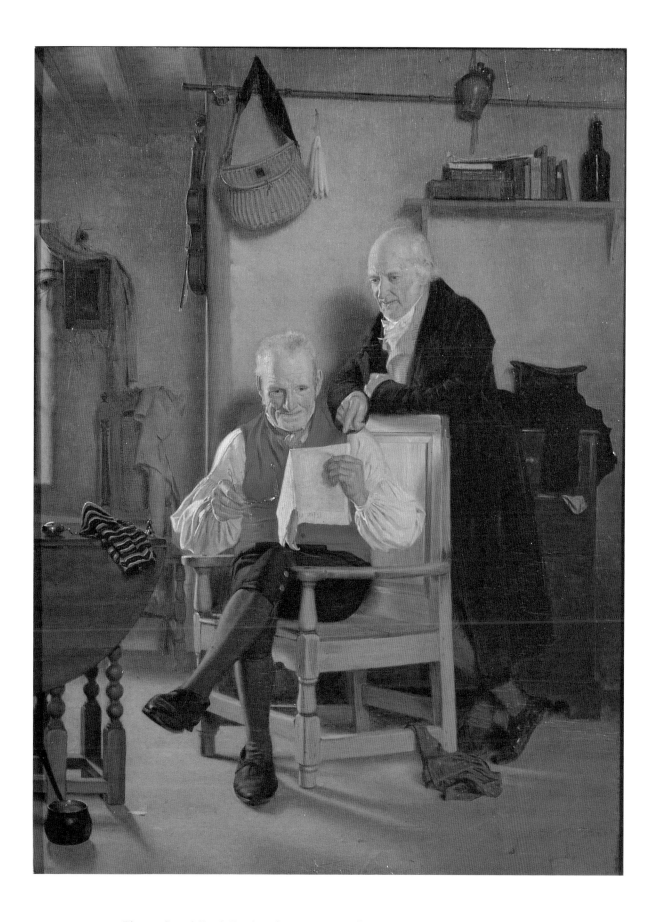

Thomas Sword Good, *Reading the News*, 1822, oil, 40 x 29.5cm. Anderson & Garland.

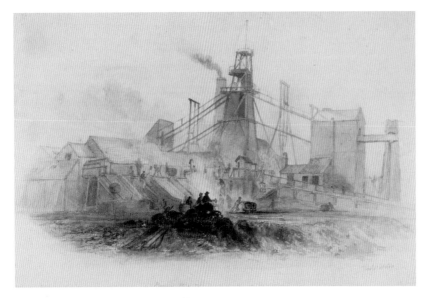

Thomas Harrison Hair,
Percy Pit, Percy M\ain Colliery,
watercolour, 21.5 x 31.5cm.
Hatton Gallery, University of
Newcastle.

.

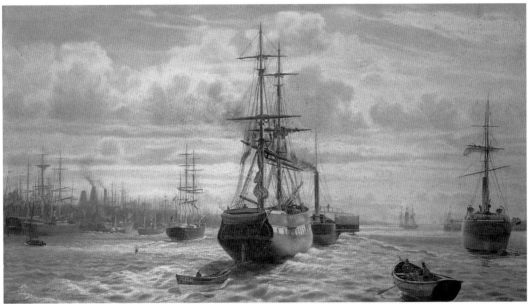

Thomas Marie Madawaska Hemy,
*The Collier Brig 'Lovely Nancy'
leaving Sunderland Harbour*, 1877,
oil, 60 x 106.5cm.
Anderson & Garland.

Charles Napier Hemy,
Life, 1913,
oil, 124 x 183cm.
Tryon & Swann Gallery.

Ralph Hedley,
His First Voyage, 1892,
oil, 111 x 129cm.
Anderson & Garland.

Reginald Watson Hepple,
Percy Point Point-to-Point,
Ratcheugh Crag, 1972,
oil, 51 x 76cm.
Private collection.

Ross Hickling, *Bugatti*, acrylic, 43 x53cm. Private collection.

James Hugonin,
Study for Untitled (VII), 1991,
oil and wax, 20.4 x 18.9cm.
Private collection.

Wilson Hepple, *Gallowgate Hoppings, Newcastle*, 1875, oil, 121 x 213.5cm. Newcastle Breweries plc.

Joseph Henry Kirsop, *Tyne Bridges*, etching, 25 x 32.5cm. Private collection.

bookselling, stationery and map-selling business at SOUTH SHIELDS, painting only in his spare time. His wife was sole proprietor of the business by 1855, suggesting that the artist was by then deceased. Represented: South Shields Library.

KILBOURN, Oliver (1904–1993)

Mining and landscape painter in oil; illustrator. He was born at ASHINGTON, the son of a pitman, and at the age of thirteen started work at the local colliery. He later moved to nearby Ellington Colliery, and while working there in 1934 joined a course on art appreciation launched by the Workers' Educational Association under the tutelage of Robert Lyon (q.v.), master of painting at King's College (now Newcastle University). This led to the foundation of what quickly became known as 'The Ashington Group of Painters', and Kilbourn's emergence as its most accomplished and best known member. The Group's first exhibition was at the Hatton Gallery, NEWCASTLE, in 1936, with Kilbourn as one of its several participants, and his work was represented in all of its subsequent exhibitions both in Britain and abroad. These included the Bensham Grove Settlement, GATESHEAD, in 1938; the Laing Art Gallery, NEWCASTLE, in 1941; the Lefevre

Gallery, London, and the National Gallery, Scotland, in 1942; Berlin and Nottingham in 1977; Rotterdam and London in 1978; Peking in 1980, and ASHINGTON in 1986. He was also a regular exhibitor independently at the Artists of the Northern Counties exhibitions at the Laing Art Gallery, NEWCASTLE, in the middle of the century, showing both mining scenes and landscapes. By the time of the last Group exhibition in 1986, organised by the WEA's Wansbeck branch to mark the first anniversary of the end of the Miners' Strike, the Group's meeting hut (erected 1943), had become little used and had been pulled down. In 1989, however, the local Council opened a new museum at the former Woodhorn Colliery (closed in 1980), and a specially designed gallery was created to display the Group's paintings. These included all of Kilbourn's works from his series *My Life as a Pitman* (covering his some fifty years down the pits), as well as other works by him, and fellow Group members, including George Blessed (d.1997); George Brown (d.1963); James Leslie Brownrigg (d.1974); William Crichton (d.1983); James Floyd (d.1974); Jack Harrison (b.1904); Fred Laidler (d.1988); George Jude McLean (q.v.); Tom McSloy (d.1953); John Leonard Robinson (d.1987); George Rowe (d.1991); Arthur Whinnom (d.1962);

Harry Wilson (1898–1972), and Henry Youngs (d.1950). An excellent account of the Group's history may be found in *Pitmen Painters: The Ashington Group 1934–1984*, by William Feaver, Chatto & Windus, London, 1988, while the work of its members within the context of the mining art of the North East region may be found in *Shafts of Light – Mining Art in the Great Northern Coalfield*, Robert McManners & Gillian Wales, Gemini Productions, Bishop Auckland, 2002. Represented: Laing A G, Newcastle; Woodhorn Colliery Museum, Ashington. [See colour plate]

KILVINGTON, George (1858–1913)
Landscape painter in oil. Kilvington was born at WEST HARTLEPOOL (now HARTLEPOOL), and was employed as clerk to the Hartlepool Guardians for many years. A keen spare-time painter, he exhibited his work at the Bewick Club, NEWCASTLE, and later at the Artists of the Northern Counties exhibitions at the city's Laing Art Gallery, showing a wide range of Northumbrian, North Yorkshire and Lake District landscapes, frequently with buildings. He died at HARTLEPOOL. Hartlepool Arts & Museum Service has his *Thatched Cottage, Runswick*.

KIM, John Alexander (b.1948)
Landscape painter in oil, pastel and watercolour; etcher; printmaker; art teacher. Born at WARKWORTH, Kim studied at Newcastle University, where he took his Bachelor of Art and Master of Fine Art degrees, under Kenneth Rowntree (q.v.), Derwent Wise (q.v.), and Andrew Maclaren. He then lived and painted briefly in Italy before, in 1975, taking up a position at Sandyford Adult Education Centre, NEWCASTLE. He then studied briefly at Leicester Polytechnic (now De Montfort University), before joining the high school at CRAMLINGTON, near ASHINGTON, as an art teacher, remaining there for seven years until 1989. During his teaching career at both NEWCASTLE, and later CRAMLINGTON, he was a member of the Charlotte Press (Printmakers) NEWCASTLE, demonstrating the broadening of his artistic interest into printmaking. He also showed his work in several one-man and group exhibitions, the former including the Bondgate Gallery, ALNWICK, 1975–1994, and 2002; the Gulbenkian Gallery, People's Theatre, NEWCASTLE, in 1976; the South London Art Gallery, 1978; the LYC Gallery, Banks, Cumbria, 1981, and the St Martin's Gallery, Leicester, 1982. His group exhibition participations include the Royal Academy, and the Royal Institute of Painters in Water Colours in 1984. Since leaving teaching he has combined work as a professional artist with the role as valuer with a leading Northumbrian bookshop, and continued to exhibit his work widely in Northumbria, including the annual exhibitions at NEWTON-ON-THE-MOOR, near ALNWICK, instigated by George Jude McLean (q.v.); *Life in the North*, Newcastle Arts Centre, 1996, and together with Sarah Sells, *Images of Nature*, Bondgate Gallery, 2002. His work has encompassed a wide range of subjects in a variety of media, and he has handled many private and institutional commissions, including etchings for the Northern Heritage Trust, and English Heritage. He has lived for many years at LONGHOUGHTON, near ALNWICK.

KINDBERG, Agnes Mary (b.1906)
Landscape and figure painter in oil; collagist; art teacher. She was born at WEST HARTLEPOOL (now HARTLEPOOL), and studied at the town's School of Art under Alfred Josiah Rushton (q.v.). She next studied in NEWCASTLE and London before gaining her art teacher's diploma. She was a keen painter throughout and after her teaching career and exhibited her work at the Royal Scottish Academy; the Society of Scottish Artists, and the Scottish Craft Centre. She also enjoyed a succession of one-man exhibitions at the Edinburgh International Festival from 1970, and was responsible for a number of works in restaurants, churches and other public places. Most of her later life was spent in Edinburgh.

KINGSLEY-WOOD, Eva (1890–1976)
Amateur landscape and flower painter in watercolour. This artist lived at SUNDERLAND for most of her life, and was believed to be the last descendant of the family of the famous Captain Cook. She was a member of Sunderland Art Club, and died in the town in 1976.

KIRKPATRICK, James (fl. late 19th cent.)
Portrait painter in oil. This artist initially practised at Carlisle, Cumbria, but after finding it increasingly difficult to find sitters in the area, decided to move to NEWCASTLE in 1845. Armed with a letter of introduction to John Wilson Carmichael (q.v.), written by his friend Sam Bough, Kirkpatrick took up residence in the town's Camden Street. Little is known of him thereafter.

KIRSOP, Joseph Henry (1886–1981)
Landscape and architectural painter in watercolour; draughtsman; etcher. Born at NEWCASTLE, Kirsop did not become a full-time professional artist until his retirement from the city's Tyne Improvement Commission in 1951. He had, however, maintained a lifelong interest in art, receiving his early training as an artist at evening classes at GATESHEAD, under William Fitzjames White (q.v.), and later Armstrong College (later King's College; now Newcastle University). Part of his training was in the art of etching, in which he subsequently established himself as a distinguished artist, winning a gold medal in 1933 from *The Artist* magazine for the best etching submitted for its judgement in that year, and receiving much acclaim for his Royal Academy exhibit of 1943: *Sandhill, Newcastle upon Tyne*. He was also an outstanding painter in oil and watercolour, exhibiting his first work in the former medium at the Artists of the Northern Counties exhibition at the Laing Art Gallery in 1912, *The Bridges, Newcastle upon Tyne*, and later becoming a regular exhibitor of works in a variety of media at the Laing Art Gallery, the city's Bewick Club, and the exhibitions of the Newcastle Society of Artists. Kirsop travelled widely to draw and paint until shortly after his retirement, visiting the USA, France, Spain, Belgium and Norway, as well as various parts of Britain, and often producing etchings based on this work. His home for many years before

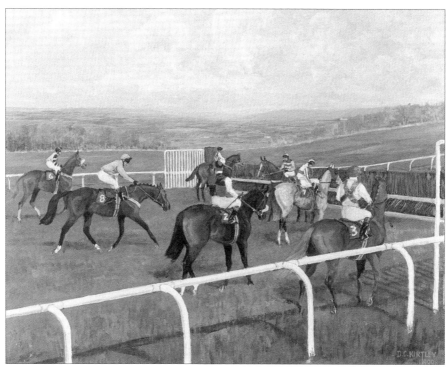

Dennis Campbell Kirtley,
Exploration,
acrylic, 46 x 51cm.
Private collection.

his retirement was at GATESHEAD. In the late 1950s he moved to NEWCASTLE to live and work, occupying studios successively in the Groat Market, and at Plummer Tower. He was an exhibitor at the 'Contemporary Artists of Durham County' exhibition at the Shipley Art Gallery, GATESHEAD, staged in 1951, in connection with the Festival of Britain, and thereafter exhibited his work mainly with the Federation of Northern Art Societies, at the Laing Art Gallery, and the Shipley Art Gallery, and with Gateshead Art Society. He was a lifelong member of the Newcastle Society of Artists and upon his death at WESTERHOPE, near, NEWCASTLE, bequeathed a legacy to the Society, and the North of England Art Club, which is used to provide an annual award in his memory. Represented: Laing A G, Newcastle; Pen & Palette Club, Newcastle; Shipley A G, Gateshead.

KIRTLEY, Dennis Campbell (b.1924)
Amateur equestrian artist in oil, acrylic, pastel and watercolour. Kirtley was born at SUNDERLAND, where, apart from spells at school at Hertfordshire and service in the Fleet Air Arm during the Second World War, he has lived ever since. Although fascinated by horses from his childhood it was not until many years later, and working in a jeweller's shop at SUNDERLAND that he first decided to put his talent of drawing them to commercial use. The shop sold hand painted table-mats and trays, and it suddenly occurred to him to sell some of his horse illustrations in this way. His first order came from the Aga Khan's stud manager. A present to the Aga Khan, they were seen by Prince Aly Khan, who also liked them and ordered a large number. From drawing horses he quickly graduated to painting them, and in 1967 he was invited to stage a

one-man exhibition at Sunderland Art Gallery. Until the exhibition he had had little to do with horses directly but at forty-five he visited Middleham, the well-known horse training centre in North Yorkshire, and became a regular rider of various racehorses over the next twenty-seven years. In 1974 his growing reputation as a painter of famous racehorses led to him having his work accepted first by the Ascot Gallery, and then by Austin Hayes, York. Since then his work has been shown at many galleries throughout Britain, and he has held several further one-man exhibitions. Venues for the latter have included the Hutchinson Gallery, Town Hall, BISHOP AUCKLAND, 1999, and Seaton Holme, EASINGTON, 2000. One of his most important commissions has been the painting of pictures for the Marriott Gosforth Park Hotel, NEWCASTLE. He has continued to live at SUNDERLAND since his retirement from the jewellery business, and now devotes most of his available time to painting horses, dogs, and other subjects.

KITE, William Frederick (b.1929)
Amateur landscape painter in oil and watercolour. Kite was born at HENDON, SUNDERLAND, and became a tailor's cutter by profession, painting in his spare time. Although self-taught he exhibited his work widely, showing examples on several occasions at the annual International Amateur Art Exhibition, London, in the early 1970s, and regularly over many years at the Federation of Northern Art Societies' exhibitions at the Shipley Art Gallery, GATESHEAD, and the Laing Art Gallery, NEWCASTLE. He also exhibited with the Sunderland Art Club, of which he was for some time secretary before leaving Wearside in 1978 due to redundancy in his employment. He then moved to

William Frederick Kite,
Old Sunderland,
oil, 51 x 76cm.
Private collection.

William Henry Knowles, *Old Houses, Dog Bank, Newcastle*, pen and ink, 36 x 28cm. Private collection.

Whitney, Oxfordshire, to work in various jobs until his retirement aged sixty-three. He continues to live at Whitney, where he is well known for his local street scenes. Represented: Sunderland A G.

KNOTHE, Alice Kewney (fl. late 19th cent.)
Amateur figure painter in oil and watercolour. She was the widowed daughter of a solicitor at NORTH SHIELDS, who married as her second husband Alexander Shannon Stevenson (1826–1900), the wealthy Tyneside chemical company director, and collector of Pre-Raphaelite paintings. She was a talented amateur figure painter who exhibited her work in Northumbria, and may have been the Alice Knothe who exhibited one work in Britain while living at Dresden, Germany, in 1873.

KNOWLES, William Henry, FSA (1857–1943)
Architectural and antiquarian draughtsman; illustrator. Knowles was born at NEWCASTLE, and practised as an architect, drawing in his spare time. He was particularly interested in the old buildings of Tyneside, and published in 1890, jointly with J R Boyle, FSA, *Vestiges of Old Newcastle and Gateshead*, for which he provided the illustrations. He also illustrated several other publications, and occasionally exhibited his work, notably at the Royal Academy; the Royal Scottish Academy, and the Artists of the Northern Counties exhibitions at the Laing Art Gallery, NEWCASTLE. He was a fellow of the Society of Antiquaries, London, a member of the Architectural Committee of the Victoria Histories for the Counties of England, and a member of the Society of Antiquaries, NEWCASTLE, in addition to being associated with several other bodies connected with the study and preservation of old buildings. Among the many local buildings for which

he was architect was the major portion of Armstrong College (later King's College; now Newcastle University), including the School of Art. He died at NEWCASTLE. Represented: Shipley A G, Gateshead.

KNOX, Peter Cecil (b.1942)
Marine painter in oil and watercolour. Knox was born at HARTLEPOOL, and studied at the local College of Art, and Leicester College of Art before taking up a teaching post at the College of the Sea (now the Marine Society). He later lectured in art at Keswick Hall College of Education, Norwich, before becoming a freelance artist in 1974. His seafaring experience with the College of the Sea as artist-tutor left him with an abiding interest in shipping and he has exhibited with the Royal Society of Marine Artists. He has also taken an interest in aircraft, and exhibited with the Guild of Aviation Artists, as well as being involved in a project with the RAF, BOULMER, near ALNWICK, dealing with search and rescue helicopter work. Throughout his career as a professional artist he has lived in the Scottish Borders and Northumberland, and in addition to the venues already named, exhibited his work at the Omell Gallery, London, and the Tallantyre Gallery, MORPETH. He lives at Coldingham, near Eyemouth, Berwickshire, and maintains a studio at BERWICK-UPON-TWEED. Represented: National Maritime Museum; Hartlepool Arts and Museum Service; Berwick A G. [See colour plate]

KOPEL, Harold, ROI (b.1915)
Painter of various subjects in oil, acrylic and pastel; art teacher. He was born at NEWCASTLE, and after education at the city's Rutherford Grammar School, went on to study at University College, London. He next studied at the Central School of Arts and Crafts, in the capital, then became a secondary school art master and senior lecturer in further education for the Inner London Education Authority. A keen painter throughout and after his teaching career Kopel exhibited his work at the Royal Academy; the Royal Society of Oil Painters; the Royal Society of British Artists; the New English Art Club; the Paris Salon; the Barcelona Biennial; the Royal Glasgow Institute of Fine Arts, and at the Contemporary Art International, Olympia, in 1989, as well as at many private galleries. He won a silver medal when exhibiting at the Royal Institute of Oil Painters' annual exhibition in 1990. He is a member of the latter body, and served as honorary treasurer from 1984–1994. He has had a number of one-man exhibitions and his work is represented in the collections of University College, London; the Nuffield Foundation, and the Inner London Education Authority. He lived in London.

L

LAING (OGILVIE-LANG), Gerald, FRBS (b.1936)

Sculptor; silkscreen artist; art teacher. Laing was born at NEWCASTLE, a descendant of the family of Alexander Laing, founder of the city's Laing Art Gallery, and following a short army career attended St Martin's School of Art. After leaving the School in 1964 he lived in New York for five years, also serving as artist-in-residence at Aspen Institute for Humanistic Studies, Colorado, in 1965. He was initially a pop artist, but by the late 1960s had become known as a sculptor of minimal forms. He gradually became disillusioned with this approach to his work, and in 1969 acquired a castle on the Black Isle, Scotland, which he restored, and some eight years later equipped with a bronze foundry to handle his work. He had by this time become wholly absorbed in figurative sculpture, but continually experimented within it. This brought him widespread recognition and the appointment to a number of teaching posts and arts appointments, including visiting professor at the University of New Mexico, Albuquerque; professor of sculpture at Columbia University, New York; the art committee of the Scottish Arts Council, and commissioner on the Royal Commission for Fine Art For Scotland. He also showed his work internationally, having one-man exhibitions of his paintings, at the Laing Art Gallery, NEWCASTLE, in 1963, and in 1964; the Institute of Contemporary Art, London, and the Richard Feigen Gallery, New York. The Cincinnati Center for Contemporary Art gave him a retrospective in 1971, others following at the Herbert Art Gallery, Coventry in 1983; the Fruitmarket Gallery, Edinburgh, in 1993, and Whitford Fine Art, in 1996. The Whitford Fine Art exhibition showed seventeen of his silkscreen prints made in 1968, while at exhibitions of his sculpture at the Fine Art Society, London in 1999, and the Kilmorach Gallery, Inverness-shire in 2002, examples of his work produced from the 1960s to date were shown. Laing has shown his work in many group exhibitions from 1967 and has handled many important public sculpture commissions in Britain and abroad, including *The Conan Doyle Memorial*, Edinburgh, 1991; *Ten Dragons* at Bank Underground Station, London, 1995; *Four Rugby Players* at Twickenham Stadium, Middlesex, 1995/6; the *Fire Icon at Bluewater*, Dartford, Kent, 1999, and a bas-relief commemorating the courage of his one-time regiment, the Northumberland Fusiliers, breaching the walls of the Spanish town of Badajoz in 1812, during the Peninsular War of 1809–14. This latter work was exhibited at the Fusilier Museum at ALNWICK, and at the Discovery Museum, NEWCASTLE, on its completion in 2000, before being erected near the battle site. He was at that time living in Inverness-shire. Although his preferred material for his sculptures is bronze, Laing has worked in many other materials and proved himself one of the most versatile and accomplished sculptors working in Britain at the turn of the century with a body of work that spans the pop movement of the sixties to his current commitment to representational bronze sculptures. He was elected a member of the Royal Society of British Sculptors in 1987, and a fellow in 1994. Laing is also known as 'Gerald Ogilvie-Lang'. Represented: National Gallery; Tate Gallery; National Portrait Gallery; Victoria and Albert Museum; The Scottish National Gallery of Modern Art; Glasgow Art Gallery; The Scottish Arts Council; Inverness Museum; The Museum of Modern Art, New York; The Whiting Museum, New York, and various other North American, European, African and Japanese public galleries. [See colour plate]

LAMB, John (née Potts) (1798–1875)

Landscape and figure painter in oil and watercolour. Lamb was born at NEWCASTLE, the son of Alexander Potts. When his father died he was adopted by his uncle by marriage, Friend Lamb, of RYTON, and from then on became known as John Lamb. The Lamb family moved to London by 1818 and here he began exhibiting his work by showing his *View of Glasswell, Derbyshire*, at the Royal Academy, in 1827. He exhibited at the Academy on three occasions subsequently, showing one further landscape, and two scenes from Shakespeare, but after his last exhibit in 1834 does not appear to have exhibited elsewhere. In the middle of the century he began work with his son, JOHN LAMB, JUNIOR (1839–1909) on a diorama, *From London to Hong Kong in Two Hours*, completing this by 1860. It was executed in watercolour and is now on permanent loan to the British Museum. The diorama was exhibited on two occasions late in the last century, at the Panoramania exhibition at the Barbican Art Gallery, 1988–1989, and the Sehsucht das Panorama, Bonn, in 1993. Lamb Senior's 1834 Academy contribution, *A Midsummer Night's Dream; Titania Awakening*, was included in the Victorian Fairy Painting exhibition at the Royal Academy in 1997. His daughter HELEN LAMB (1851–1887) was also artistically gifted, and, like her brother, exhibited her work.

LAMB, Thomas ('Tom') (b.1928)

Landscape and industrial painter in oil and watercolour. Lamb was born at BEAMISH, near STANLEY, and first became interested in drawing while convalescing from an illness as a child. On leaving school in 1942 he went to work at a nearby colliery and in the following year began to paint landscapes. Following his transfer to underground work at the age of eighteen, however, he became fascinated with sketching the scenes around him, and he thereafter painted both mining scenes and landscapes. After he left the mines in 1969, due to the closure of his work place, he joined the staff of the DLI Museum & Art Gallery, at DURHAM. Here, although employed as an attendant, he helped to arrange and hang exhibitions until his eventual retirement in 1993. While working underground as a miner Lamb made the acquaintance of fellow worker Edwin Francis Holloway (q.v.), who encouraged him to develop his skills as an artist. Lamb made rapid progress and exhibited two of his works at the National Coal Board's headquarters in London in 1975, in the company of Henry Moore, the famous sculptor, and Norman Cornish (q.v.). These two mining scenes from his under-

R Thompson Lambert,
On the Northumberland
Coast,
watercolour,
74.5 x 110cm.
Private collection.

ground sketchbook were purchased by the Industrial Editor of the *Sunday Times*. On his retirement from the DLI Museum & Art Gallery in 1993 a special exhibition of his work was held to mark the event. This comprised examples of his work from its own collection and some forty of his paintings ranging from mining scenes to rural landscapes. He has continued to paint since his retirement and has had many one-man exhibitions. These have included his *Fading Memories*, at the Hutchinson Gallery, Town Hall, BISHOP AUCKLAND, in 1999, and his *My Mining Days*, at the Mall Gallery, CROOK, in 2001, both consisting of mining paintings. Although best known for his mining scenes Lamb has painted a considerable number of North of England landscapes. These also have received recognition, one being purchased by Durham County Council in 1973 as a gift to the Czechoslovakian Ambassador, and a second chosen in 1994 by the Lord Mayor of Durham as the subject of his personal Christmas Card Appeal. He lives at DURHAM. Represented: DLI Museum & A G, Durham. [See colour plate]

LAMBART, Alfred J (b.1902)

Portrait painter in oil; illustrator; poster designer. Lambart was born at DARLINGTON, and studied art at the Allan-Fraser College, Arbroath, before practising as an artist in London. He exhibited four portraits at the Royal Academy between 1927 and 1932, and was also an exhibitor at the Artists of the Northern Counties exhibition at the Laing Art Gallery, NEWCASTLE, in 1923, while still living at DARLINGTON. His exhibit at the latter was entitled *The Sacrifice of Iphigenia*. Lambart was responsible for some fine poster design work for leading railway companies. Some examples of his work have been released as colour reproductions by the National Railway Museum, York.

LAMBERT, John (fl. late 18th cent.)

Artist and illuminator. Lambert was a law-stationer of DURHAM who in the last quarter of the 18th century wrote and illuminated a copy of the Cathedral statutes, 1777, and other manuscripts. He may have been the J Lambert responsible for the drawing of Sherburn Hospital, in volume two of the *History and Antiquities of the County Palatine of Durham*, 1787, by William Hutchinson (q.v.).

LAMBERT, Mark (1781–1855)

Engraver; lithographer: draughtsman. Lambert was born at NEWCASTLE, and began his career as an apprentice to Ralph Beilby (q.v.), and Thomas Bewick (q.v.), in their workshop in the town. In 1807 he commenced business on his own account, and soon established himself as the busiest copperplate engraver at NEWCASTLE, taking several apprentices who were later to make considerable reputations as engravers, notably Thomas Abiel Prior, of London. By the 1820s he is said to have been employing four or five men in engraving for reproduction, and on silver, etc, in addition to handling much engraving himself, sometimes in association with William Collard (q.v.). One of his best known series of engravings was that of a number of views of the Tyne executed by John Wilson Carmichael (q.v.), who produced so many drawings for Lambert that he was frequently described as the latter's 'chief draughtsman'. Lambert's main accomplishment, and the one to which he principally devoted himself after his son, MARK WILLIAM LAMBERT (1812–1893), joined him in 1840, was bookplate engraving, and an interesting account of his work in this field can be found in *Lambert (Newcastle upon Tyne) as an Engraver of Bookplates*, by John Vinycomb, MRIA, 1896. After his son joined the business they traded as 'M & M. W Lambert', and with the help of their new draughtsman George Finlay Robinson (q.v.), rapidly

expanded into lithography. Later, they bought out the largest letterpress printer at NEWCASTLE, the new business including the *Newcastle Chronicle*. Mark William's contribution to the success of the Lambert business lay mainly in the field of management, though it published many engravings bearing the joint initials of father and son. Lambert died at NEWCASTLE in 1855. His son ran the business until 1890, when it was sold to his father's one-time apprentice, Andrew Reid (q.v.). Both father and son were keen collectors of works of art; the latter's daughter, KATE LAMBERT, was a talented amateur artist who exhibited her work.

LAMBERT, R Thompson (fl. early 20th century)

Marine and coastal painter in oil and watercolour. Lambert was born at NORTH SHIELDS into a family of picture framers which had been in business from the early 1880s. He evidently took over the business in the early part of the 20th century and also became a fine art dealer in the town, displaying works by many local artists on his premises in the town's Linskill Street. Details of his artistic training are not know, but by the late 1920s he had become a regular exhibitor at the Artists of the Northern Counties exhibitions at the Laing Art Gallery, NEWCASTLE, and the North East Coast Art Club, WHITLEY BAY. He also contributed one work to the North East Coast Exhibition, Palace of Arts, 1929. This was entitled *Low Tide, Tynemouth*, and was typical of the several works he contributed to the other two exhibitions. Lambert's work was highly competent, and similar in style and execution to that of fellow North East Coast Art Club member John Falconar Slater (q.v.), particularly in his sea studies in watercolour. His last exhibits on Tyneside were in the mid–1930s, and it is believed he retired about that time from business. He may have been related to portrait painter JOHN SEDGWICK LAMBERT, who was also an innkeeper at NORTH SHIELDS in the late 19th century.

LANDELLS, Ebenezer (1808–1860)

Engraver; draughtsman; illustrator. Born at NEWCASTLE, Landells is popularly believed to have served an apprenticeship with Thomas Bewick (q.v.), before leaving for London in 1829. It is, however, more likely that he served all, or most of his apprenticeship, under former Bewick apprentice Isaac Nicholson (q.v.). Whatever his training as an engraver, Landells was evidently a largely self-taught artist, and competent enough to have his work exhibited while still an apprentice. He exhibited at the Northumberland Institution for the Promotion of the Fine Arts, NEWCASTLE, in 1826 and 1827, showing views of TYNEMOUTH, and Duns, near BERWICK-UPON-TWEED, in the first of these years, and *The Young Anglers*, and *Portrait of a Gentleman*, in the second; he also exhibited at the Northern Academy, NEWCASTLE, in 1828, showing *Vessels stranded on the coast at Durham*. On arriving in London in 1829, he looked up fellow Northumbrian engravers John Jackson (q.v.), and William Harvey (q.v.), and through their influence got a job superintending the fine art department of Branston & Vizetelly. Landells' work for a decade

after his arrival in London lay almost exclusively in the field of wood engraving, wherein he distinguished himself principally for his work for *Northcote's Fables*, 1833. Also in this period he exhibited his engravings, showing examples at the Suffolk Street Gallery in 1833 and 1837. He later became ambitious to become a publisher, however, and in 1841 started with Douglas Jerrold, the Brothers Mayhew, Mark Lemon, and others, the magazine *Punch*. This was the beginning of a long association with the publication of magazines on Landells' part, though in 1842 he left *Punch* to handle what was to prove his most important assignment as an illustrator; the coverage for the *Illustrated London News* of Queen Victoria's first tour of Scotland. The Queen was so impressed by his productions that she later bought them for her own collection. He later handled several other commissions for the *News*, but remained fascinated by publishing, and subsequently became one of the promoters of the *Illuminated Magazine*, 1843, and one of the proprietors of the *Lady's Illustrated Newspaper*, 1847. The latter publication was later incorporated into *The Queen*. Throughout his involvement in publishing Landells remained deeply involved in wood engraving, and at one time had as a pupil in his 'office', Myles Birket Foster (q.v.), among several artists who were later to make their names as wood engravers, illustrators, or artists in the round. But he was not successful in his publishing ventures, and the constant strain of having to tackle onerous wood engraving and illustrative commissions is said to have led to his death in London at the early age of fifty-one. His son ROBERT THOMAS LANDELLS (1833–1877), was a talented illustrator and War Artist.

LANGLANDS, George (fl. early 19th cent.)

Marine and coastal painter. This artist practised at GATESHEAD, and later NEWCASTLE, in the early 19th century, and first exhibited his work publicly when he sent a *View of the Tyne* to the Northern Academy, NEWCASTLE, in 1831. He remained an occasional exhibitor at NEWCASTLE for several years, mainly contributing marine views, such as the *Entrance to Shields Harbour; View of Tynemouth*, and *Dutch Fishermen*, which he showed at the 'Exhibition of Arts & Manufactures & Practical Science', in 1840. He was still practising at GATESHEAD when he sent three works to the North of England Society for the Promotion of the Fine Arts, in 1841, but by 1844 had moved to NEWCASTLE, where *Williams Directory* of that date shows him living in the east end of the town. He may have been the George Langlands who traded as a tin brazier at Bottle Bank, GATESHEAD, in the first few decades of the century, as this was the address given by the artist when sending works for exhibition in this period. It is possible that he was related to the famous Langlands family of silversmiths at NEWCASTLE.

LARMONT, Eric (b.1943)

Landscape painter in oil; printmaker; sculptor in metal; art teacher. He was born at SOUTH SHIELDS, and studied at Sunderland College of Art, and Goldsmiths' College School of Art. He next attended the National School of

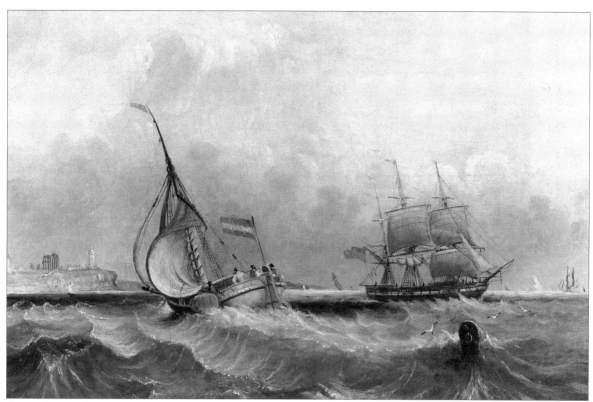

George Langlands, *Off Tynemouth*, oil, 36 x 44cm. Private collection.

Architecture and Visual Arts, Brussels, on a Belgian Government Scholarship, leaving there in 1969 to teach part-time at Sotheby's, and the Putney School of Art. Larmont began to exhibit his work before the conclusion of his art studies showing at a group exhibition at Sunderland Art Gallery in 1965. He later showed work at other group exhibitions, including the Ikon Gallery, Birmingham, in 1976; Liverpool Academy 1978, 1979 and 1980, and the Royal Academy in 1981 and 1982. His exhibits at the Academy were *Moving Landscape, Whitburn* (1981), and *Corner of a cornfield, Cambridgeshire*, and *Bournemouth Seashore* (1982). He also had his first one-man exhibition while still studying, this being held at the 273 Gallery in 1968. Later such exhibitions included the Galerie Blankenese, Hamburg, Germany, 1984. He had a two-man exhibition at the Jonathan Poole Gallery in 1985, since when he has worked in seclusion without exhibiting his work, although continuing to sell his prints privately in England, and commercially in Germany. He has lived in London for a number of years.

LASERKY (LASCHKE), Edwin Hugo (1861–1933)
Amateur marine painter in oil. He was born at SUNDER-LAND, the second son of a Polish Count from Warsaw, who moved to the town a short time before Laserky's birth. His father described himself as an artist on his son's birth certificate, and may have taught his son to paint while himself practising as an artist in the town. Laserky, however, did not take up art as a full-time career, but worked on the railways most of his life,

painting in his spare time. He was particularly fond of painting ships, and would often sketch them from a rowing boat, or while working at the Albert Edward Docks, near his home at NORTH SHIELDS. Several examples of his work are in public and private collections on the German Coast. He died at NORTH SHIELDS.

LAVENDER, Alfred J (1899–1966)
Landscape painter in oil and watercolour; etcher; art teacher. He was born at GOSFORTH, near NEWCASTLE, and studied at Gateshead Secondary School, and Bede College, DURHAM, before attending Armstrong College (later King's College; now Newcastle University). In 1927 he was appointed art master at Swansea Grammar School, remaining there until his retirement in 1964. Lavender exhibited his work at the Royal Cambrian Academy, and at various London and provincial galleries, including the Laing Art Gallery, NEWCASTLE, whose Artists of the Northern Counties exhibitions he contributed to for several years. Three of his etchings, *Durham; Warkworth*, and *Dunstanburgh*, were included in the 'Contemporary Artists of Durham County' exhibition at the Shipley Art Gallery, GATESHEAD, in 1951, in connection with the Festival of Britain. He served as a part-time lecturer at Swansea Art School, and secretary of Swansea Art Society and South Wales Group, and was organiser of the Festival exhibitions in Swansea in 1951. Lavender illustrated *A Guide to Gower*, by J M Williams, published in 1965. He lived in Swansea for many years but died in Cambridge.

LAWS, Geoffrey Frederick ('Geoff') (b.1947)
Caricaturist; illustrator; sculptor. Laws was born at
BLYTH, and after education locally attended the College
of Art & Industrial Design at NEWCASTLE, where he
took his degree in 1969. After a succession of jobs
locally and in London, he returned to NEWCASTLE in
1973, where a year later he was appointed editorial
artist to the *Newcastle Chronicle & Journal* in succes-
sion to Dudley Hallwood (q.v.), whose part-time
employment by the papers had ceased on retirement.
Laws appointment was on a much broader basis,
however, and encompassed illustration, graphics, logo,
cartoons and caricatures for the *Evening Chronicle*,
Journal, and the *Sunday Sun*. He stopped working for
the *Evening Chronicle* in 1998, but has continued on a
part-time basis for the *Journal*, producing daily carica-
tures for the TV review page; a political cartoon for the
Saturday edition, and occasional work for special
events like Budget Day and elections. In addition to
producing work as a caricaturist and illustrator for both
regional and national newspapers, Laws has also
carried out a variety of design and illustrative work for
books, posters and greetings cards, and in 2000 was
commissioned by Newcastle City Council to sculpt
caricature heads for giant figures of local celebrities
for the city's Millennium Parade. He has received
several national awards for his caricatures and
cartoons, including the Cartoonist Club of Great
Britain Awards, 1981, in which he was runner-up
feature cartoonist. He has also had several one-man
exhibitions of his work in Northumbria, notably at the
Calouste Gulbenkian Gallery, NEWCASTLE, in 1980;
Newcastle Polytechnic Gallery, in 1982; Newcastle
Central Library, in 1986; Newcastle Discovery
Museum, in 1996, and the DLI Museum & Art Gallery,
DURHAM in 2002. In 1982 he shared an exhibition at the
latter with Luck & Flaw, creators of 'Spitting Image',
and Reginald Smythe (q.v.). Generally acknowledged
as one of Northumbria's most outstanding latter-day
caricaturists, Laws remains based at NEWCASTLE, and
continues to produce a wide range of work employing
a variety of media.

LAWS, John (1765–1844)
Engraver; wood-carver. He was born at Breckney Hill,
near HEDDON-ON-THE-WALL, and later served an
apprenticeship with Ralph Beilby (q.v.), and Thomas
Bewick (q.v.), at NEWCASTLE. While with the partners
he mainly concentrated on the decorative engraving of
silver, establishing such a reputation for his work that
about a year after completing his apprenticeship in
1789 he left the workshop to set up on his own
account. Although continuously successful in his occu-
pation as silver engraver Laws is popularly believed to
have left his busy workshop some time between 1801
and 1802 to visit the USA. Some accounts state that
this was to improve his health, others to procure
'certain birds' eggs' in pursuit of his lifelong interest in
ornithology. Laws was certainly fascinated by the
subject and despite his commitments to his workshop,
and the family farm at Breckney Hill, was an accom-
plished taxidermist whose work is in the collection of
the Hancock Museum, NEWCASTLE. He remained

Geoffrey Frederick Laws, *Caricature of Des O'Connor*,
watercolour, 16 x 12cm. The artist.

active as an engraver until close to his death at
Breckney Hill, in 1844, and is also credited with work
as a carver of furniture. Bewick, in his autobiographi-
cal *Memoir*, wrote most flatteringly of Laws' abilities
as a silver engraver. See p.195, *A Memoir of Thomas
Bewick, Written by Himself*, edited and with an intro-
duction by Ian Bain, Oxford University Press, 1975.
An exhibition devoted to Laws' work was held at the
Thomas Bewick Birthplace Museum at CHERRYBURN,
near OVINGHAM IN 2000. The Laing Art Gallery,
NEWCASTLE, has an album of impressions of his work
in engraving.

LAWSON, Eva – see CARTER, Mrs Eva

LAWSON, Fenwick Justin John, ARCA (b.1932)
Sculptor; wood-carver; art teacher. He was born at
SOUTH MOOR, near STANLEY, and studied at Sunderland
College of Art, and the Royal College of Art, at the
former under Henry Thubron (q.v.) and others; at the
latter under John Skeaping. After the conclusion of his
studies at the Royal College in 1957, he was awarded
the Sir James Knott Travelling Scholarship and trav-
elled to France, Italy and Greece. In 1961 he was
appointed lecturer in sculpture at Newcastle
Polytechnic (now Northumbria University), setting up
its fine art course. He was later appointed head of sculp-
ture and remained at the Polytechnic for the next
twenty-five years. He first began exhibiting his work in

1964, when examples were included in group exhibitions at the Gulbenkian Gallery, People's Theatre, NEWCASTLE, and the city's Laing Art Gallery. In the same year he also enjoyed his first one-man exhibition at the latter gallery, later going on to show in many group and one-man exhibitions, among the former, the Laing Art Gallery, 1965 and 1972; the Northern Sculptors Exhibition, Shipley Art Gallery, GATESHEAD, 1967; the Royal Academy, 1980, and 1994 (on which latter occasion he was Invited Sculptor); the Royal Festival Hall and South Bank, London, 1985, and Oxford University 1986/7. Other one-man exhibitions have included those held at the Richard Demarco Gallery, Edinburgh, 1967–8, and York City Art Gallery, 1987, apart from showings of individual works at York Minster in 1984; Durham Cathedral, 1984–96, and various other locations in Northumbria to date. Following retirement from the Polytechnic he has held several positions as artist-in-residence, and during the period 1987–1989 was visiting lecturer at the Duncan of Jordanstone College of Art, Dundee, and the Royal Academy, London. Free of his major teaching commitments since 1986, however, he has concentrated mainly on his work as a sculptor and wood-carver, completing a variety of works mainly for ecclesiastical settings. He has said 'Around 1973 there had come a moment when I was beginning to be unhappy that my sculpture was wholly embraced by the parameters of what was then the fashionable mainstream… Witnessing external events in the real world… I came to the realisation that I needed to give voice to my feelings… I entered on the religious image as a subject because it gives me a voice to communicate the fundamental emotions of humanity.' Although he had by then already completed a number of religious theme works (while still a student at the Royal College he had submitted an entry of the Risen Christ for the porch of the new Coventry Cathedral), his early work had come much under the influence of Jacob Epstein and included a wide range of non-secular works in material ranging from ciment fondu to welded scrap metal. From the early 1970s, however, his themes were increasingly religious and very often carved in wood. Many were specifically commissioned for churches in Northumbria, or sited on a long-term loan basis at other places with ecclesiastical connections, including the cloisters, Durham Cathedral, and Brinkburn Priory, near ROTHBURY. One of his carvings for the former, his St Cuthbert, executed in 1983 from an elm which had fallen close to the Cathedral, became over the next twelve years until its deterioration due to dampness, one of the most eye-catching features of its location, but has now been cast in bronze. The casting of his wood-carvings in bronze to ensure the longevity of his compositions has now become an increasing practice of the artist, and this particular one was appropriately erected at Lindisfarne Priory, HOLY ISLAND, the saint's spiritual home. A more recent composition in wood for which casting in bronze has also been considered is his monumental *The Journey*, involving six full-size carved figures bearing the coffin of St Cuthbert. The most important wood-carver working in Northumbria in the late 20th century, examples of his work may not only be found in ecclesiastical settings throughout Britain, but also in the Pontificio Collegio Beda, Rome, where his *The Venerable Bede* was sited in 2001. It has also been the subject of a number of books and television programmes, including *Fenwick Lawson Sculptor*, published by York City Art Gallery, and a Tyne Tees Television documentary on the casting and location of his bronze St Cuthbert for HOLY ISLAND. He lives and works at DURHAM. Represented: Laing A G, Newcastle. [See colour plates]

LAWSON, Sonia, RA RWS ARCA (b.1934)
Landscape and figure painter in oil and watercolour; printmaker; art teacher. Lawson was born at DARLINGTON, the daughter of artists Muriel Metcalfe and Fred Lawson, and was brought up in the Yorkshire Dales. On completing her general education she studied at Doncaster College of Art and then the Royal College of Art. At the latter she studied under Carel Weight, gaining first-class honours, a postgraduate year and a travelling scholarship to France. She later lectured at the College, and the Royal Academy Schools, also showing her work at a variety of group exhibitions including the Royal Academy; Midland Group; Tolly Cobbold and John Moores Exhibition, Liverpool, 1991–2. She held her first one-man exhibition at the Zwemmer Gallery in 1960, other major exhibitions including a retrospective at the New City Gallery, Milton Keynes, and tour 1982–3; Manchester City Art Gallery, 1987; Wakefield and Bradford, 1988, and a thirty year retrospective at the Dean Clough Galleries, Halifax in 1996. In 1989, together with her parents, she showed her work in an exhibition entitled *A Family of Painters*, organised by Wakefield Art Gallery. She was elected a member of the Royal Society of Painters in Water Colours in 1988, and in 1991 a member of the Royal Academy. Lawson, who has lived at Leighton Buzzard, Bedfordshire, for many years, has remained a very singular painter throughout her career, never forming attachments with artists' groups or courting attention in the public eye. Her work is represented in the collections of the Arts Council; the Open University; the Imperial War Museum, and many provincial art galleries. [See colour plate]

LAWSON, Thomas (b.1922)
Landscape and still life painter in oil. He was born at NEWCASTLE, and after studying window display at the city's College of Art & Industrial Design spent much of his life working in this profession on Tyneside. After studying art at evening classes at King's College (now Newcastle University), where he won the John Christie Prize for Life Drawing, he became keenly interested in painting, and exhibited widely in Northumbria, including the Artists of the Northern Counties exhibitions at the Laing Art Gallery, NEWCASTLE. Typical exhibits at the latter were his oils *Still Life*, in 1960, and his *Water Taps*, in 1962. He was a member of the Newcastle Society of Artists, and Wallsend Art Club.

LAZARRI, Carl, ARCA (b.1934)
Landscape and portrait painter in oil and watercolour; art teacher. Lazarri was born at NEWCASTLE, and follow-

ing his training as an artist at the Royal College of Art became head of painting at Leicester Polytechnic (now De Montfort University). He then took the position as head of the department of Visual and Performing Arts at Newcastle Polytechnic (now University of Northumbria), giving this up in 1989 to become a full-time artist. His first work in this capacity was as visiting fellow and artist-in-residence in the music department of Newcastle University, this being immediately followed by a small exhibition of his work, based on his residence, at the Hatton Gallery, NEWCASTLE. A second exhibition at the gallery in 1993 of more than fifty works included further residency based paintings, portraits of friends and colleagues, large Northumbrian landscapes, and subjects from a second residency based on St Albans Primary School, WALKER, near NEWCASTLE. Lazarri's exhibiting activity by the end of his residencies at NEWCASTLE, in that year had also included many group and one-man exhibitions around Britain, among the former the Royal Academy; Young Contemporaries, London; the British Council in Hong Kong; the Royal Birmingham Society of Artists, Birmingham; an Arts Council Exhibition; the Vicarage Cottage Gallery, NORTH SHIELDS, and various public and private galleries. His one-man exhibitions before 1989, included the Elizabeth Gallery, Coventry; the Gulbenkian Gallery, People's Theatre, NEWCASTLE; Leicester Polytechnic, and Newcastle Polytechnic. On concluding his residency at Newcastle University in 1993 he held other residencies in Britain and regularly participated in the annual Laing Art Competitions as well as other group exhibitions. His residencies from that year have included those at Magdalen College, Oxford University; a period with its Aid to Bosnia, in Croatia, and Michigan State University, in the USA. He was also art director for Coventry and Brecon Cathedral Youth Theatres and continues to serve as adviser to various bodies in Britain and abroad, while still remaining an active painter and occasional exhibitor of his work. Represented: Magdalen College, Oxford; Merton College, Oxford; Royal College of Art; Larpool Hall, Yorkshire; University of Northumbria, Newcastle; Newcastle University.

LEAR, William Henry (1860–1932)

Amateur landscape and animal painter in watercolour. He was born at DARLINGTON, the son of an ironmonger with a long established and well-known business in the town. He was educated privately at DARLINGTON, and worked for an ironmonger in London for fifteen years before joining the family business. On the death of his father in 1914 he took control of the business, running it until his death at DARLINGTON in 1932. Lear was throughout his life a keen and talented spare-time painter in watercolour, much of whose work resembles in style and competence that of Wilson Hepple (q.v.). He mainly showed his work at the exhibitions of the Darlington Society of Arts. Darlington Art Gallery has his *Carting Sand*.

LEE, John (c.1869- after 1934)

Portrait, genre and landscape painter in oil and watercolour. Lee's place of birth is not known, but the fact that he studied at the School of Art, DARLINGTON, under Samuel Averill Elton (q.v.), may suggest that he was a native of Northumbria. By 1889 he was working as a professional artist in London, and exhibiting at the Royal Institute of Oil Painters, and in 1891 he sent a work to the Royal Society of British Artists: *Cynthia*. He returned north just before the turn of the century, and by 1900 had settled at MIDDLETON-IN-TEESDALE, near DARLINGTON, from which he sent his only contribution to the Royal Academy: *Meditations*. It is believed that he died at MIDDLETON-IN-TEESDALE. The Bowes Museum, BARNARD CASTLE, has several examples of his work, and Darlington Art Gallery has his portrait of Victor Hobson (q.v.).

LIDDELL, Captain Hedworth (b.1825)

Amateur landscape and sporting painter in oil. He was born at Ravensworth Castle, near GATESHEAD, the son of Sir Henry Thomas Liddell (q.v.), and after entering the Army, occasionally exhibited his work at NEWCASTLE. He was still in the Army when he married at Jersey, in 1856, having by then achieved the rank of captain. His mother, Lady Isabella-Horatia Liddell (q.v.), and uncle, Thomas Liddell (q.v.), were also talented amateur artists.

LIDDELL, Sir Henry Thomas, Third Baron, and First Earl of Ravensworth (1797–1878)

Amateur painter. He was born at Ravensworth Castle, near GATESHEAD, eldest son of the Second Lord Ravensworth, Sir Thomas Henry Liddell, and was educated at Eton, and St John's, Cambridge. After travelling Europe, and visiting Paris, Rome, Berlin and Vienna, he married, and settling at Ravensworth Castle, entered politics, serving as MP for DURHAM, and Liverpool, before entering the House of Lords on the death of his father. A deeply cultured man, Sir Walter Scott wrote of him in 1831: 'I like him and his brother Tom very much ... Henry is an accomplished artist, and certainly has a fine taste for poetry, though he may never cultivate it ...'. Sir Henry did, indeed, cultivate his 'fine taste for poetry', writing considerably in verse, and translating the Odes of Horace, but nothing is known of his productions as an artist, no examples of his work appearing at the Ravensworth Castle sale of 1920.* He died at Ravensworth Castle. His wife, Lady Isabella-Horatia Liddell (q.v.), his brother, Thomas Liddell (q.v.), and son Captain Hedworth Liddell (q.v.), were all talented amateur artists.

LIDDELL, Lady Isabella-Horatia (1801–1856)

Amateur landscape and figure painter in oil; copyist. She was the eldest daughter of Lord George Seymour, and in 1820 married Sir Henry Thomas Liddell (q.v.), of Ravensworth Castle, near GATESHEAD. She was a keen amateur painter from her girlhood, and following her marriage travelled extensively with her husband, visiting many famous collections of paintings in Europe, and

* It may be noted, however, that the *Illustrated London News*, showing additions to Ravensworth Castle completed in 1846, said that the principal front was designed by the 'Hon H T Liddell'.

studying the styles of the Old Masters. She was particularly influenced by the work of Poussin, and later painted many landscapes in the style of this artist. She also painted abroad, including Dutch street and canal scenes, and Italian landscapes among her work. She died in London. The Ravensworth Castle Sale in 1920 included more than thirty examples of her work, some of very large proportions. Her brother-in-law, Thomas Liddell (q.v.), and her son, Captain Hedworth Liddell (q.v.), were both talented amateur artists, as were also her grand-daughters, LADY LILLIAN LIDDELL (d.1962), and LADY MARY LIDDELL (d.1958). Both of these granddaughters were tutored in art by the wife of John Surtees (q.v.).

LIDDELL, John Davison (1859–1942)

Marine and landscape painter in oil and watercolour; illustrator; art teacher. Born at NORTH SHIELDS, Liddell first worked as a tinsmith, but gave up this occupation in his twenties to devote himself to art. In 1884 he began exhibiting at the Bewick Club, NEWCASTLE, showing an oil, *Sunset on the Tyne at North Shields*, and by 1895 he was describing himself as a full-time professional artist, living at Grey Street, NORTH SHIELDS. Grey Street remained his home and work place for the remainder of his life. During this period he visited the Continent on several occasions to paint, and on one occasion took an exhibition of his work to Spain on a ship captained by his brother. Most of his work consisted of studies of tugs and colliers in and around the mouth of the Tyne, but he painted many landscapes, frequently featuring cattle. Some of his coastal views were reproduced by chromolithography. He died at NORTH SHIELDS following a period in the town's Preston Hospital, and was buried in the nearby cemetery. His cousin Ralph Walter Liddell (q.v.), was also an artist. Represented: South Shields Museum & A G.

LIDDELL, Ralph Walter (1858–1932)

Architectural, landscape and coastal painter in oil and watercolour; art teacher. He was born at NORTH SHIELDS, and appears to have taken up art as a career after some years in another employment. He was an occasional exhibitor at the Bewick Club, NEWCASTLE, in the 1890s but otherwise appears to have confined his artistic activities to his occupation as art master of Tynemouth Secondary School, where he taught Victor Noble Rainbird (q.v.), among several well-known Northumbrian artists. He died at NEWCASTLE.

LIDDELL, Thomas (1800–1856)

Amateur marine and landscape painter in oil and watercolour. He was born at Ravensworth Castle, near GATESHEAD, second son of the Second Lord Ravensworth, Sir Thomas Henry Liddell. He was a keen amateur painter from his youth, and may have received some tuition from his elder brother, Sir Henry Thomas Liddell (q.v.), before exhibiting *A composition from the collection of H T Liddell*, at the Northumberland Institution for the Promotion of the Fine Arts, NEWCASTLE, in 1826. Three years later, and exhibiting at the Northern Academy, NEWCASTLE, his contributions were described by W A Mitchell, in the

Tyne Mercury, as 'two pretty pencil drawings and a beautiful piece of watercolour drawing by the Hon T Liddell'. He continued to exhibit at NEWCASTLE until the early 1840s, showing a large number of local marine, coastal and landscape views, occasional Continental landscapes, and one North American landscape. Following his marriage in 1843, however, he appears to have given up exhibiting his work. The Ravensworth Castle Sale in 1920 included his oil *The Painter's Paradise – Jesmond Dene*. His sister-in-law, Lady Isabella–Horatia Liddell (q.v.), and nephew, Captain Hedworth Liddell (q.v.), were also talented amateur artists. Liddell had considerable architectural skill, and in addition to superintending the rebuilding of Ravensworth Castle initiated by his father in 1808, also designed a Gothic gate-lodge at Ravensworth. His reputation as a Gothic expert was highly regarded and in 1835 he was one of the members of a committee appointed to select the design for the new Houses of Parliament.

LILEY, William, ARCA (1894–1958)

Landscape and portait painter in oil and watercolour; art teacher. Liley was born at SUNDERLAND, and after education at the Bede Collegiate School, attended the town's School of Art. Here he was an outstanding pupil, winning the National Silver and Bronze medals for wood engraving in 1913–14, and the King's Prize for Design, in 1922. He later attended the Royal College of Art, and the Central School of Arts and Crafts, London, before taking up an appointment as assistant master at the School of Art, SUNDERLAND. On leaving SUNDERLAND, he became headmaster at the Heginbottom School of Art, Ashton-under-Lyme, Lancashire, remaining there until his retirement twenty-four years later, and also serving as a national examiner for the Board of Education. He died at Bollington, Cheshire. Liley only occasionally exhibited his work, among his few known exhibits being the landscapes and portraits which he contributed to the Artists of the Northern Counties exhibitions at the Laing Art Gallery, NEWCASTLE, 1931–34. He was an associate of the Royal College of Art.

LISHMAN, Walter, SGA (1903–1985)

Landscape painter in watercolour; etcher; art teacher. He was born at WOLVISTON, near BILLINGHAM, and studied art at Armstrong College (later King's College; now Newcastle University) before going on to exhibit his work at the Royal Institute of Painters in Water Colours; the National Society of Painters, Engravers and Sculptors; the Society of Graphic Artists; the Artists of the Northern Counties exhibitions at the Laing Art Gallery, NEWCASTLE, and other provincial exhibitions, showing both watercolours and etchings. Two of the latter were included in the 'Contemporary Artists of Durham County' exhibition held at the Shipley Art Gallery, GATESHEAD, in 1951, in connection with the Festival of Britain: *Ebb Tide; Whitby*, and *Durham*. Lishman was a BSc, and a member of the Society of Graphic Artists. He was also a member of Sunderland Art Club for many years while living at nearby HOUGHTON LE SPRING.

John Davison Liddell,
Outward Bound from the Tyne,
oil, 30.5 x 46cm.
Private collection.

Walter Lishman,
On the Wear, Sunderland,
coloured etching.
Private collection.

LONGBOTTOM, Sheldon (fl. late 19th cent.)
Landscape painter in watercolour. This artist practised at BARNARD CASTLE in the late 19th century. He was an occasional exhibitor at the Bewick Club, NEWCASTLE, in 1890 showing his *Early Morning on the Tees*, and in 1891, *A bit of Egglestone Abbey near Rokeby*. He was also an exhibitor at Carlisle Art Gallery in 1896, showing a landscape. The Bowes Museum, BARNARD CASTLE, has his *Barnard Castle Church*.

LONGDEN, Major Alfred Appleby (1876–1954)
Landscape painter in watercolour. Born at SUNDERLAND, Longden was educated at Durham School, and studied at the School of Art in his native town, and at the Royal College of Art, before becoming a professional artist, and later a gallery director and art adviser. He first began exhibiting his work in 1901, while working in London, in the next seven years showing several landscapes at the Royal Academy; the Royal Institute of Painters in Water Colours, and the New Gallery. In this period he also served as British Government Representative for Fine and Applied Art, New Zealand International Exhibition, 1906–7. He was director of Aberdeen Corporation Art Gallery from 1909 until 1911, then resuming his career as a professional exhibition director and art adviser, he held a variety of posts associated with British and overseas exhibitions, until his appointment as director of the Wernher Collection, Luton Hoo, Bedfordshire, a few years before his death. Longden only occasionally exhibited his work after the early years of the century, notable examples being his participation in the 1948 Olympic Games, International Exhibition (which he helped organise), and the 'Contemporary Artists of Durham County' exhibition, staged at the Shipley Art Gallery, GATESHEAD, in 1951, in connection with the Festival of Britain. He was the author of *British Cartoon and Caricature*, 1944, and contributed many articles on fine and applied art to magazines and newspapers. He died at Luton Hoo. Several honours were conferred on him in recognition of his service to art, and for his bravery in the Second World War, including the Order of the British Empire, and the Distinguished Service Order. Represented: Wernher Collection, Luton Hoo.

LONGLEY, Albert Ross (1913–1987)
Amateur townscape painter in watercolour. Born at Manchester, Longley later worked as a translator for ICI on Teesside, painting local townscapes in his spare time. He died at DARLINGTON. Darlington Art Gallery has his *Union Street Demolition*, in watercolour.

LONGSTAFF, John Colin ('Cluff') (b.1949)
Cartoonist. Longstaff was born at DARLINGTON, and after education locally attended Teesside College of Art from 1969-1972. He later became a successful freelance cartoonist, having his first cartoon accepted by *Private Eye* in 1982. Since then his cartoons have appeared in *Punch*; *The Spectator*; *Literary Review*; *The Independent*; *Sunday Telegraph*; *The Cartoonist*; *Daily Mirror*, and on a regular basis from 1990, *The Northern Echo* DARLINGTON. The last-named publica-
tion in 2005 published Volume One of his cartoons, *A Year of Cluff*, looking back at highlights of 2004. He lives and works at DARLINGTON.

LONGSTAFFE, William Hylton Dyer, FSA (1826–1898)
Architectural and antiquarian draughtsman. He was born at Norton, in Yorkshire, the son of a surgeon. Following his education at grammar school he worked briefly at York and Thirsk as an attorney's clerk, before moving to DARLINGTON, in 1845, where he remained for five years, before becoming articled to a solicitor at GATESHEAD. In 1857 he became a partner in this practice, remaining a solicitor for the rest of his life. Longstaffe had early developed an interest in old churches, and made careful drawings and notes of interesting specimens from his boyhood. This interest led to the publication of his *Richmondshire, its Ancient Lords & Edifices*, 1852, and his better known *History and Antiquities of the Parish of Darlington*, 1854, in which latter may be found several excellent examples of his draughtsmanship. Longstaffe remained interested in architectural and antiquarian matters all his life, and was a member of several societies connected with their study, including the Society of Antiquaries, NEWCASTLE, and the Surtees Society. He was also a fellow of the Society of Antiquaries, London. He died at GATESHEAD.

LORD, Harry Bennett (1915–1966)
Amateur figure, landscape, still life and abstract painter in oil and watercolour. Lord was born at SEAHAM, but his family shortly after fled with him to North America to avoid the Depression, and he was educated in the USA and Canada. He returned to Britain to serve in the Second World War, and subsequently became a civil servant at NEWCASTLE, studying art at evening classes held at the Shipley Art Gallery, GATESHEAD, and painting in his spare time. He also began to write on art and became a founder and co-director of the Univision Gallery, NEWCASTLE, showing works by international painters such as Joan Miró, and also presenting his own first one-man exhibition. Throughout his some twenty years as a serious painter he exhibited his work widely in Britain, including such venues as the Royal Institute of Painters in Water Colours; the Royal Institute of Oil Painters; the Royal Society of British Artists, and the Artists of the Northern Counties exhibitions, at the Laing Art Gallery, NEWCASTLE, and elsewhere on Tyneside. The latter included the Newcastle Society of Artists; the Federation of Northern Art Societies' exhibitions at the Shipley Art Gallery, GATESHEAD; the Gateshead Art Society, and the West End Art Society, and the Park Road Group, NEWCASTLE. He died while still a civil servant at NEWCASTLE, having long been a member of the Ministry of National Health Insurance Art Society. A memorial exhibition of his work was held at the Laing Art Gallery, in 1967, in which his development from a largely figurative painter in the early fifties, through to his final abstract work of the sixties, was demonstrated by a substantial showing of

his work. His brother ALAN LORD also painted and was one of the co-founders of the Univision Gallery.

LOUGH, John Graham (1798–1876)

Sculptor; draughtsman. Lough was born at the hamlet of GREENHEAD, near CONSETT, the son of a farmer, and after a rudimentary education, began work on his father's small farm. Here he spent spare moments drawing and modelling in clay, his works one day coming to the attention of local squire George Silvertop, who helped crystallize Lough's desire to become a sculptor by showing him examples of sculpture at his home at Minsteracres. He afterwards became an apprentice to a local stonemason and builder, but disliked the work and later went to NEWCASTLE, where he found employment carving decorations for the new Literary and Philosophical Society's building then being built in the town to the design of John Green, Senior (q.v.). About 1825, and wishing to expand his talents yet further, he persuaded a collier captain to give him a free passage to London, little realising as he left the Tyne, that one of his monuments would one day dominate its mouth. Arrived at London, he took modest lodgings in Burleigh Street, studied the Elgin Marbles, and commenced work on his first sculpture of note, his bas-relief of *The Death of Turnus*. This work was accepted for showing at the Royal Academy in 1826, and in the same year he was admitted as a student to its Schools, on the recommendation, it is said, of J T Smith. There is little evidence that he took advantage of the lectures at the Schools, and, indeed, occupied as he was over the next few months with his giant *Milo*, it seems unlikely that he would have found the time. Commenting on this work, Benjamin Robert Haydon, the historical and genre painter friend of Lough, said in his autobiography: 1827 – May 18th. – 'From me Lord Egremont went to young Lough, the sculptor, who has just burst out, and has produced a great effect. His *Milo* is really the most extraordinary thing, considering all the circumstances, in modern sculpture: It is another proof of the efficacy of inherent genius.' Helped by Haydon, Lough subsequently held a very successful exhibition of his work, as a result of which no less a personage than the Duke of Wellington placed commissions. By the following spring he had completed other figures and in March opened a second exhibition, featuring *Milo, Sampson, Musidora*, and *Somnus and Iris*. Society again flocked to the show, but commissions came slowly. For the next four years Lough continued his practice of exhibiting privately, with moderate success, then decided to resume exhibiting at the Royal Academy by showing his *Duncan's Horses* (inspired by 'Macbeth'), also in this year marrying MaryNorth, the daugher of a clergyman. He commenced exhibiting at the British Institution in the following year, with his *Monk*, and *Group of Horses*, then in 1834, and taking his wife with him, he began four years studying great works of sculpture in Italy. He also in this period executed several commissions for several leading British aristocrats, including the Duke of Northumberland, and a number of wealthy commoners. Returning to England in 1838, he resumed exhibiting at the Royal Academy and the British Institution,

John Graham Lough, *Admiral Lord Collingwood Monument, Tynemouth*, 1845, Portland stone, figure 7m high. North Tyneside Council.

showing among his early exhibits several inspired by his Italian sojourn – *Boy giving Water to a Dolphin, A Roman Fruit Girl, A Bacchanalian Revel*, and similar groups. He remained a regular exhibitor at both establishments until 1863, showing a wide range of sculpture, including a large number of portrait statues and busts, and occasional compositions based on Shakespearian themes. Several of his exhibits aroused controversy. His model of a statue of Queen Victoria (designed as a companion to his statue of the Prince Consort, for the Royal Exchange, London), when exhibited at the Royal Academy in 1845, was described by the *Art Journal* as 'an obviously coarse production in which not one feature of the Queen is recognisable'. This sort of attack upon him from the press did little to damage his success, however, and, indeed, some of his most accomplished and lucrative work was executed for aristocrats such as the Duke of Sutherland, Earl Grey, and Sir Matthew White Ridley. His works for Sir Matthew's home, Blagdon Hall, near SEATON BURN, and for Carlton House, London, were perhaps more numerous than for any other of these patrons; for the former including figures, busts, groups, etc., and for the latter, a bas relief and ten statues representative of characters from Shakespeare. The Blagdon Hall works comprise some of his finest in sculpture, the best being his *Milo*, later placed by Sir Edwin Lutyens, the distinguished architect, in the ornamental water to the west of the building, when he remodelled Blagdon's gardens. In addition to his work for private patrons, Lough received several commis-

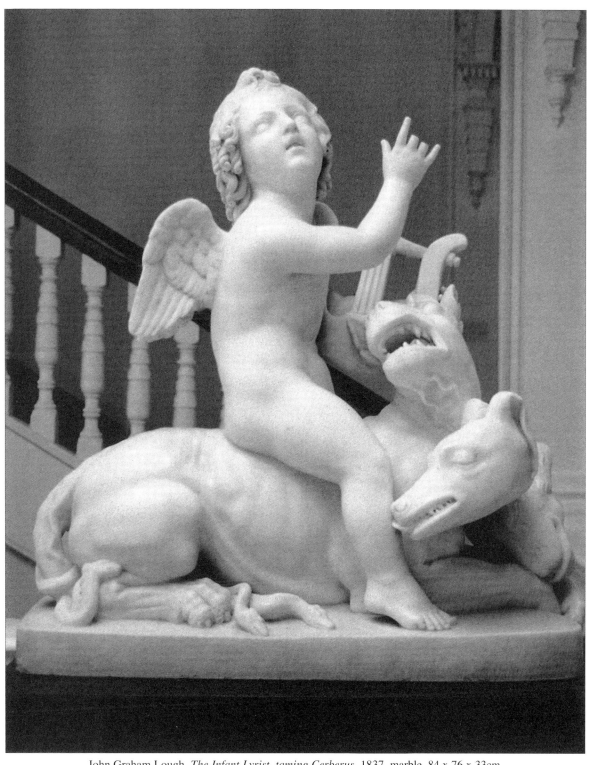

John Graham Lough, *The Infant Lyrist, taming Cerberus*, 1837, marble, 84 x 76 x 33cm.
Hatton Gallery, University of Newcastle.

sions as a result of public subscription; these include some of his best known work in Northumbria: the monument to Lord Collingwood, at TYNEMOUTH, 1847, and the Stephenson monument at NEWCASTLE, 1862. The architectural base of the former was designed by John Dobson (q.v.), the statue measuring 7m tall; the pedestal, 15m. Lough continued to work vigorously after he last exhibited in London in 1863, his latest dated work being the bust of Dr Campbell de Morgan, which he executed in 1875 for Middlesex Hospital. He died in London, the *Art Journal* making amends for its earlier, and sometimes virulent attacks on his work, by stating in a substantially flattering obituary: 'in private life no artist has been more largely esteemed and respected. His personal friends were numerous, including many of the most famous men and women of the age of science, art and letters.' Lough maintained close connections with his native Northumbria throughout his life, and, apart from executing commissions for the area, donated several examples of his work to establishments on Tyneside; in 1828 he sent a cast of his *Milo* to the Literary and Philosophical Society, NEWCASTLE, and in 1838, when exhibiting at the town's North of England Society for the Promotion of the Fine Arts, he presented two of his four exhibits to this society. Following his death his widow gave his models, etc., to the Corporation of NEWCASTLE, and these were exhibited for many years at Elswick Hall, in the west end of the city. Lough was Northumbria's most outstanding sculptor of the nineteenth century. A well-deserved study of his life and work by descendants of his family, J and E Lough, was published by Boydell Press in 1987, under the title *John Graham Lough, 1798–1876, A Northumbrian Sculptor*. Represented: National Portrait Gallery; Victoria and Albert Museum; Hatton Gallery, Newcastle; Laing A G, Newcastle; Literary and Philosophical Society, Newcastle; Walker Art Gallery, Liverpool.

LOVIBOND, Mrs Phillis Ellen – *see* **BICKNELL, Phillis Ellen**

LOWDON, George Edward (b.1935)
Landscape painter in watercolour; art teacher. Born at PRUDHOE, near OVINGHAM, Lowdon studied at King's College (now Newcastle University), and at the College of Art & Industrial Design, NEWCASTLE, and later embarked on a career as a graphic artist. On his retirement as joint manager of a Tyneside silkscreen printing company he became a full-time professional artist and art teacher and has exhibited his work widely in Northumbria. His group exhibitions have included several at the Bondgate Gallery, ALNWICK; the Coquetdale Gallery, ROTHBURY; the Studio House Gallery, Ambleside, Cumbria, and with the Knightsbridge Art Group which he helped to found at NEWCASTLE, in 1991. He has also had several one-man exhibitions at Gosforth Library, NEWCASTLE, and at Kirkley College, PONTELAND, near NEWCASTLE, at which he has for some years been a lecturer and teacher. He lives at NEWCASTLE, and has his work represented in several Northumbrian and Cumbrian collections. It has also been reproduced in the form of limited edition prints. [See colour plate]

LOWTHIN, Thomas (1825–1863)
Landscape painter. This artist's work was exhibited at the exhibition of works by local painters, at the Central Exchange Art Gallery, NEWCASTLE, in 1878. Three of his landscapes were shown, among them his *Vale of Tyne*. Nothing more is known of this artist, except that he maintained a studio for many years in the mid–19th century, and that the St Nicholas' Cathedral collection has his oil of the building with the vicarage in the foreground.

LUMSDEN, John (1785–1862)
Landscape, portrait and animal painter in oil. This artist practised at NEWCASTLE in the early 19th century, variously advertising himself as animal painter (1811), and landscape painter (1822–1838). He occasionally exhibited his work in the town from 1824, in which year he showed two landscape works at the Northumberland Institution for the Promotion of the Fine Arts. He again exhibited at the Institution in 1827, and at the First Exhibition of the Northern Academy, NEWCASTLE, in the following year, showed: *View on the Tyne, Evening, View from Dunston Hill*, and *Bank of the Tyne, near Benwell*. In the Academy's next exhibition, in 1829, his *Newcastle from Byker Hill*, earned from W A Mitchell, in the *Tyne Mercury*, the remark: '. . . this picture shows a considerable improvement in the artist'. Lumsden continued to exhibit at NEWCASTLE until 1838, also exhibiting at the Carlisle Academy, in 1828, showing his *View on the Tyne*, and *Scene on the bank of the Tyne*. His *View in Pandon Dene*, painted in 1821, was engraved by J Knox. He died at NEWCASTLE.

LUND, Neils Moeller, RBA ROI ARE (1863–1916)
Landscape and portrait painter in oil and watercolour; etcher; lithographer. Lund was born at Faaborg, Denmark, but moved with his parents to NEWCASTLE at the age of four. Here he studied at the town's School of Art under William Cosens Way (q.v.), before leaving for London, where he studied first at St John's Wood, later at the Royal Academy Schools. On leaving the Schools he enrolled as a pupil in the Académie Julian, in Paris, deciding at the end of his period there to become a professional artist in London. Much of his subsequent life was spent in the capital, though he spent long periods on Tyneside while painting local landscape and portrait commissions, and in addition to showing his work at the Royal Academy; the Royal Scottish Academy; the Royal Institute of Oil Painters, and various major London and provincial venues, from 1887, he was a regular exhibitor at NEWCASTLE. He was an exhibitor at the Bewick Club, NEWCASTLE, from his early twenties, and exhibited at the Artists of the Northern Counties exhibitions at the city's Laing Art Gallery, from 1908. Several of his Royal Academy exhibits featured Northumbrian subjects, notable amongst which was his *The City of Newcastle upon Tyne*, shown in 1898. So popular was this work that he painted two smaller versions, and reproduced it as a lithograph. Late in life he became interested in etching, and in 1912 joined the classes of Sir Frank Short. His work in oil, watercolour and etching was

well recognised in his lifetime, leading to his election as a member of the Royal Society of British Artists in 1896; member of the Royal Institute of Oil Painters, in 1897, and associate member of the Royal Society of Painter-Etchers and Engravers, in 1915. One of his exhibits at the Paris Salon – *The Land of the Leal* – was purchased by the French Government for the Luxembourg Galleries. He died in London. A major exhibition of his work, consisting of many of his Northumbrian and Scottish landscapes, portraits, and etchings, was staged at the Laing Art Gallery in the year of his death, along with works by Joseph Crawhall, The Third (q.v.). Represented: Hatton Gallery, Newcastle; Laing A G, Newcastle; Literary & Philosophical Society, Newcastle; Shipley A G, Gateshead, and various provincial and overseas galleries.

LYON, Robert, ROI ARCA (1894–1978)

Landscape, portrait and figure painter in oil and watercolour; muralist; art teacher. Lyon was born at Liverpool and studied art at the Royal College of Art, and the British School at Rome, before becoming a lecturer in fine art and master of painting at Armstrong College (later King's College; now Newcastle University), in 1932. In 1934 he was invited to run an extramural class in art appreciation for miners at ASHINGTON, backed by the Workers' Educational Association. Lyon accepted the invitation but rather than lecture his mainly miner pupils on art, he decided to have them paint set subjects. Their development as painters over the eight years he was in charge of their classes was phenomenal, leading to their speedy identification as 'The Ashington Group of Painters', and a string of exhibitions throughout Britain, and later abroad. Much of their early recognition was due to Lyon's lecturing and writing about the Group's achievements as 'pitmen painters', but he also acknowledged that what had started out as an 'experiment in art appreciation' had for him as an art educationalist succeeded beyond all expectation. Lyon's help in developing the artistic skills of the Group, and in particular that of Oliver Kilbourn (q.v.), was undoubtedly his greatest achievement as an art teacher, but he was also a considerable artist who widely exhibited his work both before and after his career at NEWCASTLE. He first began exhibiting his work in his native Liverpool while only in his early twenties and went on to show examples at the Royal Academy from 1931–1969, including designs for tapestries, historical subjects, landscapes, and portraits including that of Oliver Kilbourn. He also exhibited with the Royal Society of British Artists, and the Royal Society of Portrait Painters, London, and was a regular exhibitor at the Artists of the Northern Counties exhibitions at the Laing Art Gallery, NEWCASTLE, from the year following his appointment in the city, until more than a quarter of a century later. On leaving NEWCASTLE in 1942 Lyon was principal of Edinburgh College of Art for some eighteen years. Following his retirement he lived in Sussex. An excellent account of Lyon's role in the foundation and development of The Ashington Group may be found in *Pitmen Painters: The Ashington Group 1934–1984*, by William Feaver, Chatto & Windus, London, 1988.

M

McANDREW, Thomas (b.1916)

Landscape painter in oil and watercolour. Born at HARTLEPOOL, McAndrew attended a small private art school from the age of seven and has painted ever since. During the Second World War he served in the army, but was able to attend Nottingham College of Art. Also in his time there he exhibited at the College as a member of the Midland Regional Designers' Group, and shared a three-artist exhibition at Wisbech. Before his demobilisation he also attended a course at Welbeck Abbey to determine whether he should train as an art teacher, and was subsequently offered the opportunity to join a teacher-training course at Goldsmiths' College, London. Having already trained as a dental technician before the War, however, he decided to re-establish himself in this line and treat art only as a hobby. Returning to his birthplace after the War he joined the recently formed Hartlepools Art Club, and showed his first work in its second annual exhibition at the town's Gray Art Gallery, in 1948. (His work has featured in every annual exhibition of the Club since.) In the 1950s the Club was asked to paint scenery for Hartlepool Pageant and after being co-opted to help with this he did scenery painting in a semi-professional capacity for numerous Northumbrian theatres for the next twenty years. In 1961 he had his first work hung at the Royal Academy, *Tofts Farm, West Hartlepool*, and he has also since exhibited at the Artists of the Northern Counties exhibitions at the Laing Art Gallery, NEWCASTLE, and at public galleries in SUNDERLAND, BILLINGHAM, and DARLINGTON. He has also had several one-man exhibitions at the Gray Art Gallery, HARTLEPOOL, including ones in 1971, 1983 and 1994. In 1998 he was guest curator of an exhibition at Hartlepool Art Gallery, when he also had a major retrospective of his work. Examples have also been included in an exhibition at the Gallery in 2001–2002, entitled *Hartlepool's Treasures*. Represented: Hartlepool Arts & Museum Service.

McARDLE, Terence (b.1940)

Landscape painter in oil and watercolour; art teacher. Born at WALLSEND, near NEWCASTLE, McArdle studied commercial art and illustration at Sunderland College of Art, and painting at King's College (now Newcastle University), before practising as a commercial artist and later part-time art teacher. He has shown his work in a number of group exhibitions at Northumbrian private galleries, including his own gallery; Mawson Swan & Morgan, NEWCASTLE, and the Tallantyre Gallery, MORPETH, and also had his work reproduced as prints by the Medici Society, London. He lives at NORTH SHIELDS, and has his work represented in many local private collections.

MACCOBY, David (b.1925)

Landscape, portrait and figure painter in oil and pastel; draughtsman. Maccoby was born at SUNDERLAND, and studied at the town's College of Arts & Crafts before serving in the Royal Navy in Europe and the Far East. On his demobilisation he continued his studies by enrolling at Chelsea School of Art, where his teachers included Ceri Richards and Vivian Pitchforth. His initial work as an artist consisted of portraits, landscapes and figure studies, two of which were included in the 'Contemporary Artists of Durham County' exhibition at the Shipley Art Gallery, GATESHEAD, in 1951, in connection with the Festival of Britain. He spent a period of time later dabbling with abstract expressionism, with a hint of surrealism, but in the 1970s travelled widely to pursue his earlier occupation of

Terence McArdle,

A breezy day at Tynemouth,

oil, 61 x 91.5cm.

Private collection.

painting portraits in oil and pastel. Failing eyesight ultimately prevented him from following this occupation, however, and he virtually retired to his long-time home in London. Maccoby exhibited widely during his career, and he had many one-man exhibitions in Britain and the USA. Among the group exhibitions in which he showed work were those of the Royal Society of Portrait Painters; the Artists' International Association; the London Group; the National Society of Painters, Sculptors and Gravers/Printmakers, and the Drian and Alwin Galleries. His one-man exhibitions included those at the Ben Uri Art Society, 1975, and the Sternberg Centre for Judaism, 1992. His portraits featured several important people of the day such as Bertrand Russell and J B Priestley. The Ben Uri has his oil on paper: *Spring Equinox.*

McCHEYNE, John Robert Murray, RBS (1911–1982)

Sculptor; art teacher. McCheyne was born in Scotland and studied at Edinburgh College of Art, and later in Copenhagen, Athens and Florence, before becoming master of sculpture at King's College (now Newcastle University) in 1939. In addition to his role as teacher he regularly exhibited his work and undertook various public and ecclesiastical commissions in Northumbria. Among the venues at which he exhibited were the Royal Scottish Academy; the Society of Scottish Artists, and the Artists of the Northern Counties exhibitions at the Laing Art Gallery, NEWCASTLE, at which last a one-man exhibition of his work was held in 1970/71. His early work was in the style of Aristide Maillol and the Danish sculptor Gerhard Hemming. His later work, however, was influenced by that of Henry Moore. Among his commissions in Northumbria were his *Seahorse Heads* for the tower of the Civic Centre, NEWCASTLE, and his *Family Group* for the city's Shieldfield. The former were completed for the building's opening in 1968; the latter, completed in 1959, has since been lost, but the Laing Art Gallery has a small version of the work. McCheyne, who was for some time assisted by Derwent Wise (q.v.), was an influential teacher of sculpture during his long period in NEWCASTLE, and included among his pupils Charles Edward Sansbury (q.v.). He was a member of the Royal Society of British Sculptors.

McCOLVIN, John Andrew (c.1860–after 1930)

Landscape and figure painter in oil. McColvin practised as an artist at NEWCASTLE, in the late 19th and early 20th centuries, mainly painting local views and figure studies. He was an exhibitor at the 'Gateshead Fine Art & Industrial Exhibition' in 1883, and later went on to show regularly at the Bewick Club, NEWCASTLE. His son, Lionel Roy McColvin (1896–1977) became a fellow of the Libraries Association and author on art.

McDERMOTT, Brendan (1924–1989)

Landscape and figure painter in oil; etcher; art teacher. He was born at SPENNYMOOR, and studied at Sunderland College of Art before serving in the North

John Robert Murray McCheyne, *The Oracle*, plaster, 100 x 38 x 33cm. Private collection

African desert and Italy during the Second World War. After the War McDermott became an ex-service student at the Royal College of Art, studying illustration. Here he gained a John Knox Scholarship enabling him to paint in Brittany and Paris, at the latter developing an interest in etching, and exploring the city's printing studios. He then taught for some time at WEST HARTLEPOOL, (NOW HARTLEPOOL), going on to teach at Liverpool College of Art for most of his remaining career as an art teacher. Much of his painting was reminiscent of his childhood in Northumbria, but subject to depression he destroyed many examples of his work.

MACDONALD, James Edward Harvey (1873–1932)

Landscape painter in oil; illustrator; art teacher. MacDonald was born at DURHAM and at the age of fourteen emigrated to Canada with his family. Two years later he was apprenticed to a Toronto lithographic company, also attending Saturday classes at the Central Ontario School of Art and Design to develop his skills as an artist. Two early influences on his subsequent design work are said to have been

213

John Andrew McColvin, *At the village well*, oil, 30 x 45cm. Anderson & Garland.

James Edward Harvey
MacDonald,
The Tangled Garden, 1916,
oil, 122 x 152cm.
National Gallery of Canada.

Thomas MacDonald,
Seahouses,
watercolour,
36 x 66cm.
Private collection.

William Morris and English art nouveau, some of this gained through studying *The Studio* magazine, published in England from 1893. His first book designs reflected these influences and in order to study them more closely he returned to England in 1903, working here as a designer for Carlton Studios until 1907, and visiting several major exhibitions in London which later determined him to become a full-time painter rather than exclusively a book designer and illustrator. Further work in the latter capacity followed for *The Grip*, in Canada, but a year after visiting the remote Georgian Bay area of Northern Canada, and falling under the spell of its landscapes, he felt impelled to fulfil his ambitions as a painter, while handling book work only in a freelance capacity. His first work of note was his *Tracks and Traffic*, of 1912, an urban landscape showing railway yards and gas storage tanks in Toronto. In the following year he visited Buffalo, USA, to see an exhibition of Scandinavian art, and was particularly impressed by the way in which art nouveau designs had been adapted to depict the Scandinavian landscape. This resulted in *The Tangled Garden*, of 1916, painted in his Toronto back garden. In the early years after the First World War MacDonald made annual autumn visits to Algoma, Michigan, USA, where the brilliant colours of the foliage at that time of year, the light, and the rocks and hills of its landscapes provided him with much inspiration. He made dozens of sketches on these trips which, during the winter months, he worked into large paintings, such as his *Leaves in the Brook*, of 1919, and *Forest Wilderness*, of 1921. He made an important contribution to the development of Canadian landscape painting with his Algoma subjects, sharing this achievement with seven painters known as 'The Group of Seven', formed in 1920 in the hope of gaining recognition for their work. In 1921

he joined the teaching staff of the Ontario College of Art, but continued to travel widely throughout North America to paint, developing a highly personal vision of its landscapes until his death at Toronto in 1932. Represented: National Gallery of Canada.

MACDONALD, Thomas, ('Tom') (b.1934)
Landscape and marine painter in watercolour. Born at SUNDERLAND, MacDonald studied at the town's College of Art under Frank Wood (q.v.), Herbert Simpson (q.v.), and Henry Thubron (q.v.), among others, before spending a period of time in London in advertising. He later worked as a graphic designer in NEWCASTLE, eventually opening his own studio in the city, serving the promotional industry. In the late 1980s he began painting for pleasure but found a ready market for his work in the gallery which he had opened in 1976 as an extension to his graphics work, and later more widely in Northumbria. He has also exhibited his work at the Laing Art Gallery, the Hatton Gallery, and the University of Northumbria Gallery, NEWCASTLE. Most of his work consists of Northumbrian landscapes and urban scenes, many of which have been reproduced as part of his own *MacDonald Collection* of prints and cards. He lives and works at NEWCASTLE.

McEUNE, Robert Ernest (1876–1952)
Portrait, figure, landscape and still-life painter in oil, watercolour and pastel; art teacher. He was born at GATESHEAD, and studied figure drawing and painting at the town's School of Art, under William Fitzjames White (q.v.), before attending Armstrong College (later King's College; now Newcastle University). He later took up employment as an executive of a Tyneside coal company, but continued to take a keen interest in art in his spare time, producing many paintings and drawings, and preparing book illustrations.

Robert Ernest McEune, *Self Portrait*, charcoal, 51 x 26cm.
Tyne & Wear Museums, Shipley Art Gallery.

At the beginning of the Second World War he was
forced to retire due to ill health, and resigning his
coal company position he retired to Penrith, Cumbria.
Here he taught art as a member of the staff of the
Royal Grammar School, NEWCASTLE, while its pupils
were evacuated to the town. McEune first exhibited
his work at the Artists of the Northern Counties exhi-
bitions at the Laing Art Gallery, NEWCASTLE, later
showing examples at the Royal Institute of Painters in
Water Colours, and the London Pastel Society. He was
a contributor to the 'Contemporary Artists of Durham
County' exhibition staged at the Shipley Art Gallery,
GATESHEAD, in 1951, in connection with the Festival of
Britain, and a posthumous exhibition of his work was
held at this gallery in 1971, following its acquisition
of a large number of his oils, watercolours, charcoal
drawings and pencil sketches. Represented: Laing
A G, Newcastle; Shipley A G, Gateshead; Pen &
Palette Club, Newcastle.

McGUINNESS, Thomas, ('Tom') (b.1926)
Mining and industrial painter in oil and watercolour;
printmaker. He was born at WITTON PARK, near BISHOP
AUCKLAND, and on leaving school worked in the
timber industry until 1944, when he was conscripted to
the coal industry as a Bevin Boy. He had been inter-
ested in drawing from his school days but had no

formal training until his colliery training officer
recommended him to attend art college evening
classes at DARLINGTON, under Ralph Leslie Swinden
(q.v.). In 1947 he left the mines and at about this time
joined the Sketching Club at The Settlement, SPENNY-
MOOR, where a fellow member was Norman Cornish
(q.v.). By 1948 he had begun to paint seriously, and in
the following year showed his work for the first time
at the Artists of the Northern Counties exhibitions at
the Laing Art Gallery, NEWCASTLE, and the Federation
of Northern Arts Societies' exhibitions at the Shipley
Art Gallery, GATESHEAD. The latter gallery in 1949
purchased his drawing *Miner and Child*, but although
this led to a local demand for his work, and he was
offered a job as a commercial artist, he resumed work
down the mines, and continued as a pitman until made
redundant in 1983. During this period he remained a
regular exhibitor of his work in group exhibitions
throughout Northumbria and after turning to oil paint-
ing in 1951 showed many examples in this medium, as
well as watercolours and drawings. By the early 1960s
he was also enjoying one-man exhibitions in the North
of England, and in 1972 held his first such show, at
the Wibley Gallery, London, to widespread critical
acclaim. Other one-man shows immediately followed,
in London and elsewhere. His work was featured in
the BBC's *Omnibus* Series; in two new film produc-
tions of the National Coal Board's *Mining News*, and
a Channel Four Series *Everyone a Special Type of
Artist*. Following the broadcasting of the latter in
1983–1984, his career as an artist took a different
direction when he was appointed artist-in-residence at
Hartlepool Nuclear Power Station. This resulted in a
large body of work which was exhibited at the
Dovecote Arts Centre, STOCKTON-ON-TEES, in 1985.
Many other one-man exhibitions have since been held,
these including *Mines a McGuinness* at the Bowes
Museum, BARNARD CASTLE, in 1997, to mark the publi-
cation of an exhaustive account of his life and work,
Tom McGuinness – the art of an underground miner,
by Robert McManners (q.v.), and Gillian Wales; at the
Hutchinson Gallery, Town Hall, BISHOP AUCKLAND, in
1997 and 2001, to show a collection of his works
donated to Durham County Council in 1996, by Jack
Reading; *The Power and the Glory*, Hutchinson
Gallery, Town Hall, BISHOP AUCKLAND, 2000; *Mines a
McGuinness*, Civic Hall, STANLEY, and tour, 2001, and
The Shaft, Hutchinson Gallery, Town Hall, BISHOP
AUCKLAND, 2002, to coincide with the publication of
*Shafts of Light – Mining Art in the Great Northern
Coalfield*, by Robert McManners (q.v.), and Gillian
Wales. He features in Philip Vann's *Face to Face;
British Self-Portraits in the Twentieth Century*, 2004
(Sansom & Company). His work has encompassed a
wide variety of subjects and media but has mainly
underlined his reputation as a 'pitman painter'.
Originally a draughtsman in charcoal, conté and
pastels his work has diversified over the years to
include oil and watercolour, and printmaking by
means of etching and lithography. He has also
designed stained glass. He has lived at BISHOP
AUCKLAND for many years. A gallery at the Town Hall,
BISHOP AUCKLAND has been named in his honour.

Represented: Darlington A G; Durham County Council; Laing A G, Newcastle; Middlesbrough A G, and various local authority, college, school, and other collections.

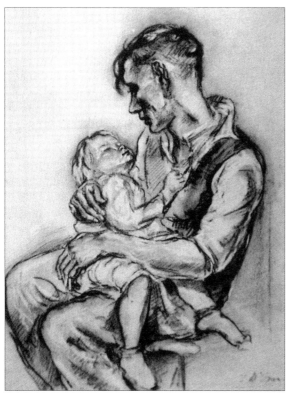

Thomas McGuinness, *Miner and Child*, 1949, conté, 48 x 35cm. Tyne & Wear Museums, Shipley Art Gallery.

McGURK, Cecil Dillon (b.1894)
Aviation and landscape painter in oil and watercolour; wood engraver. McGurk was born at BISHOP AUCKLAND, and after studying at Darlington Art School attended the Slade School of Fine Art. During the First World War he served as a second lieutenant in the Durham Light Infantry, and later as a lieutenant in the Royal Flying Corps. On his demobilisation he became a professional artist based at Redhill, Surrey, working as both painter and wood engraver. Three of his aviation paintings and two of his wood engravings were purchased by the Imperial War Museum, London, and his wood engraving work is also represented in the collections of the British Museum, and the Victoria and Albert Museum.

McINTYRE, Joseph Wrightson (c.1844–after 1894)
Landscape, coastal and genre painter in oil and watercolour. He was born at MORPETH, the son of itinerant Scottish born artist Joseph McIntyre, who had earlier practised at SOUTH SHIELDS. He received his early tuition in art from his father at Sheffield, later moving to London, where in 1866 he commenced exhibiting at the Suffolk Street Gallery, showing his *Clearing up after a storm*, and *Glen Tilt*. In 1871 he showed his first work at the Royal Academy, *A north-easterly*

gale on the Yorkshire Coast, three years later settling at Sheffield, from which he continued to exhibit at the Royal Academy and the Suffolk Street Gallery, mainly showing North East of England coastal scenes, and Scottish landscapes. He also exhibited at the Royal Hibernian Academy, and in the provinces, where he was an exhibitor at the Arts Association, NEWCASTLE, in 1879 and 1882. It appears that he remained at Sheffield from *c.*1875, until some time after last exhibiting his work, in 1894. Sheffield Art Gallery has his 1872 Royal Academy exhibit: *A Gleam of Hope*. His brothers, JAMES McINTYRE, and ROBERT FINLAY McINTYRE, were also professional artists, and exhibited their work.

MACKAY, Thomas (1851–after 1909)
Genre painter in oil and watercolour; architectural draughtsman. Mackay was born at MORPETH, later moving to NEWCASTLE, where he practised as an architect, painting in his spare time. He first exhibited his work publicly in 1878, showing *A bottle of Tom*, at the Arts Association, NEWCASTLE. In 1880 he showed his *In Trouble, Saved,* and *Birds of Prey*, at the Association, and later became an occasional exhibitor at the Bewick Club, NEWCASTLE. He last exhibited on Tyneside in 1909, showing his *Tidings of a reverse*, at the Artists of the Northern Counties exhibition in that year, at the Laing Art Gallery, NEWCASTLE. The Shipley Art Gallery, GATESHEAD, has his oil *Contentment*, 1880. *The Haunted Library* by J F Layson, published by Mawson Swan & Morgan, NEWCASTLE, in 1880, contains a number of his illustrations. His younger brother, WILLIAM OLIVER MACKAY (b.1853), also painted, and exhibited his work on Tyneside.

McKELVIE, Robert (1889–1979)
Amateur landscape and architectural painter in watercolour; architectural draughtsman. Born at GATESHEAD, McKelvie showed a talent for drawing from an early age, but decided on a clerical career instead of attempting to succeed as an artist. He became an office worker in a shipyard, meanwhile attending local evening classes in art, as well as other studies. From leaving the shipyard office, and throughout his subsequent career as buyer for a Tyneside paint firm he did little drawing and painting, but on his retirement at seventy, resumed his early hobby with considerable success. Within a short while his work was included in an exhibition at DURHAM, and in 1973 he was one of several Northumbrian artists whose work was included in an exhibition in the library of St. Nicholas' Cathedral, NEWCASTLE. He died at GATESHEAD.

McKENDRICK, James Cantley (c.1919–after 1964)
Amateur landscape painter in oil and watercolour. McKendrick was a bank manager on Tyneside for many years in the middle of the last century, who regularly exhibited his work at the Artists of the Northern Counties exhibitions at the Laing Art Gallery, NEWCASTLE. He painted widely throughout Britain and along the French coast, while on holiday, and occasionally handled illustrative commissions

217

such as his front cover for *Gosforth in Northumberland*, produced by Gosforth Urban District Council in 1953 to mark the year of the coronation of her Majesty Queen Elizabeth II.

McKENDRICK, Thomas (1862–1890)
Amateur landscape painter in watercolour. He was born at NEWCASTLE, the son of the chairman of the Newcastle Cooperative Society, and worked most of his life in a city bank, painting and sketching in his spare time. His first exhibit of note was his *Derwentwater, from near Friar's Crag*, shown at the 'Gateshead Fine Art & Industrial Exhibition', in 1883. He was a member, and towards the end of his life treasurer, of the Newcastle Sketching Club, and was a frequent exhibitor with this club, and the Bewick Club, NEWCASTLE, until his death.

MACKIE, Sheila Gertrude (b.1928)
Landscape, animal, portrait and flower painter in oil, acrylic and watercolour; muralist; illustrator; art teacher. She was born at CHESTER LE STREET, and studied art at King's College (now Newcastle University) before taking up a position as head of the art department of the grammar school at CONSETT, in 1950. Throughout her thirty-two year career in teaching on Derwentside she remained an enthusiastic and accomplished painter of a wide variety of subjects, and exhibited her work at the Royal Academy; the Royal Scottish Academy; the Royal Society of British Artists; the Artists of the Northern Counties exhibitions at the Laing Art Gallery, NEWCASTLE, and the Federation of Northern Art Societies' exhibitions at the latter, and the Shipley Art Gallery, GATESHEAD. Her work was also included in the Festival of Britain Touring Exhibition in 1951, and in the 'Contemporary Artists of Durham County' exhibition in that year at the Shipley Art Gallery. A one-man exhibition of her work was held at Foyles Gallery, London, and also during her teaching period she was for twelve years artistic adviser to Bertram Mills Circus, drawing, painting, and designing programmes. Since her retirement from teaching in 1982 she has continued to exhibit her work throughout Northumbria and has illustrated several publications. In 1994 and 2001 she enjoyed further one-man exhibitions at the DLI Museum & Art Gallery, and the publications she has illustrated have included *The Mouse Book* (with David Bellamy), 1982; *Lindisfarne – The Cradle Island* (with Magnus Magnusson), 1984; *Beowulf* (with Magnus Magnusson and Julian Glover), 1987, and *The Beasts of Sutton Hoo* (with Magnus Magnusson), 2002. Throughout the early 1990s she was also principal artist for J R S Laurenco & Co Ltd. The Civic Centre at CONSETT in 1996 named a council committee room after her following its purchase of five of her paintings, and examples are also held by the Royal Collection; H M Foreign Office, and the Shipley Art Gallery, GATESHEAD. Her work has been the subject of a number of limited-edition prints. She has lived and worked for many years at SHOTLEY BRIDGE, near CONSETT. [See colour plate]

MACKLIN, John Eyre (1834–1916)
Landscape painter in oil and watercolour. He was born at NEWCASTLE, of Irish parentage, and served in the Army as a lieutenant before becoming a toy and fancy goods dealer in the town, painting in his spare time. Following the birth of his son Thomas Eyre Macklin (q.v.), he began to take an increasing interest in painting for a living and in 1878 exhibited his *Rowlands Gill*, which was included in the exhibition of works by local painters, at the Central Exchange Art Gallery, NEWCASTLE. By 1881 he was describing himself as an artist in local trade directories, continuing this practice until the First World War years, even though he exhibited little of his work. It is believed that he died at NEWCASTLE, and that in addition to being an artist of some accomplishment, he also worked as a freelance journalist for Tyneside publications. The Laing Art Gallery, NEWCASTLE, has a portrait of him painted by his son.

MACKLIN, Thomas Eyre, RBA (1863–1943)
Landscape, portrait and figure painter in oil and watercolour; sculptor; illustrator. He was born at NEWCASTLE, the son of John Eyre Macklin (q.v.), and displayed such a talent for drawing as a child that he was placed as a pupil at the town's School of Art at the age of ten. Here he was an outstandingly successful pupil, on one occasion gaining the first four prizes of the year. He next spent two or three years studying the Antique at the British Museum, and at Calderon's School, London, later gaining

Thomas Eyre Macklin, *South African War Memorial, Haymarket, Newcastle*, 1908, bronze, with fibreglass restoration, figure 4m high. Newcastle City Council.

Thomas Eyre Macklin,
Whittle Mill, 1909,
oil, 123 x 191cm.
Tyne & Wear Museums.

admission to the Royal Academy Schools, and largely supporting himself by acting as special artist to the *Pall Mall Budget*, and painting in his vacations at CULLERCOATS, where he met, and was befriended by, the American artist Winslow Homer. In 1889 he sent his first work to the Royal Academy, *From the Sunny South*, shortly afterwards establishing himself as a successful portrait painter in the capital. He remained in London until the early part of 1893, when he returned to Northumbria and made sketches for two publications prepared by William Weaver Tomlinson: *Historical Notes on Cullercoats, Whitley and Monkseaton*, 1893, and *Denton Hall and its associations*, 1894, and commenced exhibiting at the Bewick Club, NEWCASTLE. In 1893–4, he also prepared illustrations for *The Works of Nathaniel Hawthorne*, 1894. He next spent a short period on the northern coast of France with his journalist and artist wife ALYS EYRE MACKLIN (née Philpott), after which he settled at NEWCASTLE. He continued to exhibit throughout his ten-year stay in his native city, showing work at the Royal Academy; the Royal Scottish Academy; the Royal Society of British Artists; the Paris Salon, and at several provincial exhibitions, including the Bewick Club, NEWCASTLE. Following his election as a member of the Royal Society of British Artists in 1902, he maintained studios at NEWCASTLE and London for some twenty years, but finally settled in the capital, where he continued his success as a portrait painter, and became a popular sculptor of war memorials, illustrator for books and periodicals, and poster designer. His work in portraiture included some of the best known men of his day; that in sculpture, the South African War Memorial, in the Haymarket, NEWCASTLE, unveiled in 1908, and war memorials for Auckland, New Zealand, and Bangor, Co Down. He exhibited little after settling in London, mainly showing his work at the Artists of the Northern Counties exhibitions at the Laing Art Gallery, NEWCASTLE. Several of his works shown at NEWCASTLE were Northumbrian landscapes, indicating that he was a frequent visitor to the area in his later life. He died in London. Represented: Laing A G, Newcastle; Pen & Palette Club, Newcastle; Shipley A G, Gateshead; South Shields Museum & A G, and various provincial and overseas art galleries.

MACKRETH, Harriet F S (1803- after 1851)
Miniature painter. She was born in London, the daughter of Robert Mackreth (q.v.). After education in the capital, and some tuition in miniature painting, she joined her family in their move to Tyneside in 1823, following her father's appointment as receiving inspector of stamps and taxes at NEWCASTLE. She first began exhibiting her work in 1828, showing portrait miniatures at the Royal Academy, and the Northern Academy, NEWCASTLE. She remained a regular exhibitor at the Royal Academy until 1842, also showing work at NEWCASTLE throughout this period, and at the Suffolk Street Gallery in 1829, and the Carlisle Academy in 1833. Most of her exhibits were portrait miniatures of well-known Northumbrian personalities, including John Dobson (q.v.), the Rev John Hodgson, and William Chapman, the civil engineer. Her portrait of Hodgson was engraved for his *History of Northumberland*. She did not marry, and was still living with her family at NEWCASTLE in 1851. One of her sisters, MISS J MACKRETH, was also talented artistically, and exhibited her work briefly at NEWCASTLE.

MACKRETH, Robert (1766- c.1860)
Amateur landscape, coastal and genre painter in oil; lithographer. He was born at Northfleet, Kent, and after working as a government official in London, took up an appointment as receiving inspector of stamps and taxes at NEWCASTLE, in 1823. He first began exhibiting his work at NEWCASTLE, showing four north

219

Thomas Hope McLachlan,
Evening Quiet,
1891, oil, 59 x 87cm.
Tate Gallery.

country landscapes at the First Exhibition of the Northumberland Institution for the Promotion of the Fine Arts, in the year before his appointment. In 1823, and now settled at NEWCASTLE, he again exhibited at the Institution, and sent his first work to the Carlisle Academy. In the following year he commenced exhibiting at the British Institution, showing his *The Entrance to Shields Harbour*, and from 1824 until 1833, was a regular exhibitor at NEWCASTLE, Carlisle and London, mainly showing Northumbrian landscape works. From 1826, however, he exhibited a number of Rhine Valley subjects, and occasional genre works, such as his *Fisher Girl* (British Institution, 1829), and *A Monk at his Devotions* (Carlisle Academy, 1833). After 1833, and his retirement from his official position, he exhibited exclusively at NEWCASTLE, and appears to have become a semi-professional artist, possibly working in the same studio as his artist daughter Harriet F S Mackreth (q.v.), and undertaking both oil painting and lithographic commissions, amongst the latter several for the Rev John Hodgson's *History of Northumberland*. He died at his home for many years, High Swinburne Place, NEWCASTLE.

McLACHLAN, Thomas Hope, RI ROI NEAC (1845–1897)

Landscape and genre painter in oil and watercolour; etcher. McLachlan was born at DARLINGTON, the son of a banker, and received his education at Merchiston Castle School, Edinburgh. He later studied law at Trinity College, Cambridge, then entering Lincoln's Inn Courts in 1865, was called to the Bar in 1868. Throughout his education, and later training for the law, McLachlan had taken a keen interest in painting and drawing, and after exhibiting at various London galleries from 1875, and the Royal Academy in 1877, he was encouraged by John Petrie and others to become a full-time professional artist. Aware of his lack of training, however, he first studied in Paris in the

studio of Carolus Duran, and here became much influenced by the work of Millet. On returning to Britain he resumed exhibiting at the Royal Academy, and in the next twenty years exhibited widely throughout the country, showing examples of his works at the Royal Institute of Oil Painters; the Royal Institute of Painters in Water Colours; the New English Art Club, and at various London and provincial venues, including among the latter, the Bewick Club, NEWCASTLE. Most of his exhibits were painted in Scotland, the Lake District, and Northumbria, and frequently featured stretches of water, woodland or marshland, with twilit skies. He achieved considerable success in his brief career as an artist, becoming elected a member of the New English Art Club in 1887, the Royal Institute of Oil Painters in 1890, and the Royal Institute of Painters in Water Colours in 1897. In the year prior to his death at Weybridge, Surrey, he attracted much interest when his work was exhibited alongside that of five other painters, in the 'Landscape Exhibition', at the Dudley Gallery, London. A typical example of his work is his *Evening Quiet*, in the Tate Gallery. McLachlan was later in his life deeply interested in etching, and dry point work, and provided illustrations for B Hall's *Fish Tails and some true ones*, 1897. He also exhibited his work in the former medium, at the Royal Society of Painter-Etchers and Engravers. Darlington Art Gallery has several examples of his later work in oil, watercolour and etching. His daughter, ELIZABETH HOPE McLACHLAN, was also a talented artist, and exhibited her work. Represented: Tate Gallery; Darlington A G.

McLEA, Duncan Fraser (1841–1916)

Marine, landscape and portrait painter in oil and watercolour; draughtsman. He was born in Scotland, the son of a drawing master. He went to sea in his youth, and after serving for some years as a ship's mate, decided to take up painting as a career, settling at SOUTH SHIELDS.

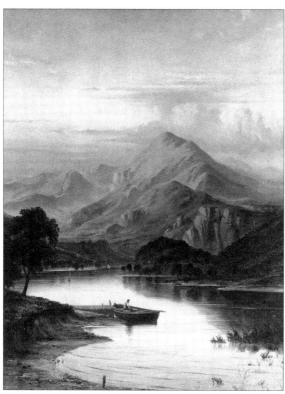

Duncan Fraser McLea, *Close of Day*, 1879, oil,
91.5 x 51cm. Private collection.

Here he became well known for his paintings of local
shipping and coastal scenes, and for his pen and ink
drawings of similar subjects for reproduction. He is
known to have exhibited outside Northumbria on only
two occasions, these being at the Royal Scottish
Academy in 1884 and 1886. He was, however, a regu-
lar exhibitor on Tyneside from 1878, when he showed
a total of eight works at the exhibitions of the Arts
Association, and the Central Exchange Art Gallery,
NEWCASTLE, in that year. He was an occasional
exhibitor at the Bewick Club, NEWCASTLE, and exhib-
ited his work at South Shields Art Club in 1892, 1893
and 1894, also serving as vice president and committee
member. He was an occasional portrait painter, two of
his subjects being himself, and Robert F Watson (q.v.);
both of these works, together with a substantial number
of his oils, watercolours and drawings, are in the collec-
tion of South Shields Museum & Art Gallery. McLea's
landscape work included a number of Scottish subjects,
one of these, *Close of day*, exhibited at the Arts
Association in 1879, being accounted his best work.
A comparable work, however, is his study of John
Thompson's shipbuilding yard, at SUNDERLAND, in the
collection of Sunderland Art Gallery. Much of his later
work is characterised by rather crude colouring, and
indifferent draughtsmanship, this being due, it is said,
to his failing eyesight. He died at SOUTH SHIELDS.
His daughter, MARGARET McLEA (d.1947), was also
a talented artist, and occasionally exhibited her work at
the Bewick Club. Represented: South Shields Museum
& A G; Sunderland A G.

McLEAN, George Jude (1920–1993)

Landscape painter in oil and watercolour. He was born
at ASHINGTON, and became a keen amateur painter
while working as a teacher in the town. In the early
1940s he became a member of the Ashington Group of
Painters, accompanying Oliver Kilbourn (q.v.) and
others on their trip to the National Gallery, and Tate
Gallery, London, in 1948. Following his move in 1951
to take up a teaching post at ALNWICK, however, his
contact with the Group was less frequent, and he
concentrated instead on founding the town's Bondgate
Gallery. He continued to run the Gallery with his wife
for almost thirty years, forming friendships with many
aspiring and established Northumbrian artists, and
encouraging them by showing their work. They also
staged a number of exhibitions including one related
to recent work by The Ashington Group, in 1965. This
work on behalf of the Gallery resulted in him receiv-
ing a Contribution to The Arts Award, presented by
the Princess of Wales in 1992, on behalf of Help the
Aged. Following his retirement from the Gallery in
1979 McLean was able to spend more time pursuing
his early love of painting, and instigated a series of
art exhibitions at his home village of many years,
NEWTON-ON-THE-MOOR, near ALNWICK, with participa-
tion by Malcolm Gleghorn (q.v.), Arthur Rousselange
Young (q.v.), Paul Speed (q.v.), and others, which
continued for several years. Apart from exhibiting
with the latter exhibitions, he showed his work at the
Artists of the Northern Counties exhibitions at the
Laing Art Gallery, NEWCASTLE, for several years from
1947, and a major retrospective was held at the
Bondgate Gallery following his death in 1993.
Represented: Woodhorn Colliery Museum, Ashington.

McMANNERS, Robert (b.1948)

Amateur portrait, figure and ornithological painter
in oil and watercolour; illustrator. He was born at
CROXDALE, near DURHAM, and after studying medicine
at Newcastle University and with the Northumbria
Vocational Training Scheme has since worked as a
general practitioner at BISHOP AUCKLAND. A painter for
pleasure and relaxation since his childhood he formed
a friendship with commercial artist and cartoonist
Geoff Gillespie while at university which led to him
developing his graphic art abilities considerably. He
has continued to paint on a regular basis throughout
his career as a medical practitioner and in addition to
showing his work in a number of group and one-man
exhibitions, has illustrated more than twenty books on
subjects ranging from aviation to Roman history, and
written considerably on the work of Northumbrian
artists associated with mining subjects. He first
enjoyed a one-man exhibition at the Dean Gallery,
NEWCASTLE, in 1969/70, since when he has held
similar events at DARLINGTON and BISHOP AUCKLAND,
as well as joining in a number of group exhibitions
at these, and other locations in Northumbria. His
published writing includes *Tom McGuinness – The
Art of an Underground Miner* (with Gillian Wales),
and articles on Norman Cornish (q.v.), Thomas Lamb
(q.v.), and other mining artists, for the publication
Bands and Banners. In addition to his paintings and

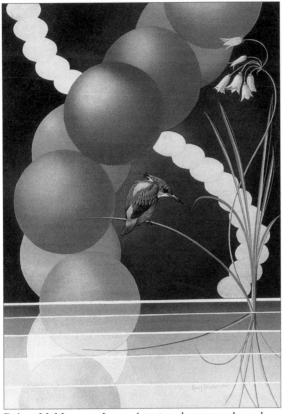

Robert McManners, *Image 4*, watercolour, gouache and ink, 67 x 42cm. Private collection.

book illustrations, McManners has produced many logos which have been used nationally by medical and non-medical organisations. His work is represented in many public and private collections in Northumbria. In 2002 he published a book entitled *Shafts of Light – Mining Art in the Great Northern Coalfield*, together with Gillian Wales. He lives at BISHOP AUCKLAND.

McPARTLAN, Maurice Patrick Anthony (1919–1998)

Landscape painter in oil, watercolour and pastel; muralist; sculptor; wood-carver; art teacher. He was born at MIDDLESBROUGH, and after attending St Cuthbert's Grammar School, NEWCASTLE, studied art at King's College (now Newcastle University). Immediately after completing his studies at the College he was called up for service in the army, spending six years in Malta and Europe in the Second World War. During his service in Malta in the 32nd Light Anti-Aircraft Regiment he was appointed official war artist to the Royal Artillery, but was not able to fulfil his intention of teaching art until his demobilisation at the end of the War. He first taught art at grammar schools and colleges in NEWCASTLE, one of the former being his old school St Cuthbert's, where leading British contemporary architect Terry Farrell was a pupil. In 1959, however, he decided to give up teaching and embarked on his professional career as an artist by travelling to Milan to paint a mural for the

Maurice Patrick Anthony McPartlan, *Mary and Infant, St James's Church, Hebburn*, woodcarving, 147 x 26 x 26cm.

Convent Chapel of the Collegio Arcivescoville, Sarronmo. This marked the beginning of a long career in producing ecclesiastical work, which eventually included many statues for churches in Northumbria, and various other religious pieces. After some years in this activity he returned to teaching in 1975, as head of art at the North Tyneside College of Further Education, WALLSEND, near NEWCASTLE, combining the handling of private commissions with his work there, until his retirement in 1984. These commissions not only included ecclesiastical work but a wide range of commercial activity including exhibition design. McPartlan first began to exhibit his work while still at King's College, showing examples at the Artists of

Maurice Patrick Anthony McPartlan,
The Amethyst leaving the Tyne,
watercolour, 23.5 x 33cm.
Private collection.

the Northern Counties exhibitions at the Laing Art Gallery, NEWCASTLE. After his service in the War he resumed showing at the latter, and went on to exhibit at the Royal Society of Painters in Water Colours; the Pastel Society, and at other group exhibitions in Britain. In 1979 he held an exhibition of Northumberland scenes in watercolour, at the Coquetdale Gallery, ROTHBURY, and in 1993, at Valetta, Malta, probably the most important one-man exhibition of his career as a professional artist. Entitled *A Tribute to Malta*, it consisted of landscapes of the island, and a number of images based on sketches he had made during his service at Malta. He donated most of the latter to the Malta War Museum at the conclusion of the exhibition, and other examples of his work as a painter are represented in public and private collections around the world. Notable among the many fine wood-carvings which he executed for Northumbrian churches is his *Risen Christ*, for St James's Church, HEBBURN, near GATESHEAD. He died at NORTH SHIELDS, his home for most of his professional life. An art prize donated by Terry Farrell is presented annually at St Cuthbert's in McPartlan's memory.

MACPHERSON, Hamish, RBS (b.1915)

Sculptor; industrial designer; art teacher. Macpherson was born at WEST HARTLEPOOL, (NOW HARTLEPOOL), but was educated in New Zealand. Here he attended the Elam School of Art, Auckland, before returning to Britain and studying at the Central School of Arts & Crafts, London, until the outbreak of the Second World War. He later taught at the Central School, and at the Sir John Cass School of Art. In addition to being an accomplished sculptor and art teacher he was also a gifted industrial designer, and completed work for the British Pavilion at the Paris Exhibition, in 1937, and for the Festival of Britain, in 1951. One of his

wood-carvings was shown at the 'Contemporary Artists of Durham County' exhibition, at the Shipley Art Gallery, GATESHEAD, held in connection with the latter event, and he also exhibited widely in Britain and abroad showing works of sculpture at various group exhibitions, including the London Group and the National Society of Sculptors, Painters and Gravers. He also enjoyed a number of one-man exhibitions and was elected a member of the Royal Society of British Sculptors in 1949. In the middle years of the last century he lived in London, but had moved to Bedfordshire by the time of his retirement from the Royal Society of British Sculptors in 1974.

McVAY, George Beattie (1902–1967)

Amateur landscape and marine painter in oil and watercolour; illustrator. McVay was born at SOUTH SHIELDS, the son of a local town hall official, and after receiving a box of paints at the age of eight became a keen amateur artist. While still in his teens he had a watercolour of the Market Place, SOUTH SHIELDS, acquired by the town's public libraries committee, and in 1923 began showing his work at the Artists of the Northern Counties exhibitions at the Laing Art Gallery, NEWCASTLE. In 1927 he joined the staff of the council at SOUTH SHIELDS, and over the following eighteen years mainly exhibited with South Shields Art Club. However, after receiving a commission from the *Shields Gazette* towards the end of the Second World War to supply a series of scraperboard illustrations of local views he resumed exhibiting at the Laing Art Gallery for several years. His exhibits there included *South Beach, South Shields* (1945); *Bamburgh Castle* (1947), and *The Buttercross and High Street, Winchester* (1952). During his career at the town hall McVay handled a number of commissions to paint portraits of locally built ships. Principal

George Beattie McVay, *Marsden Grotto*, illustration from *Shields Sketches*, c.1946.

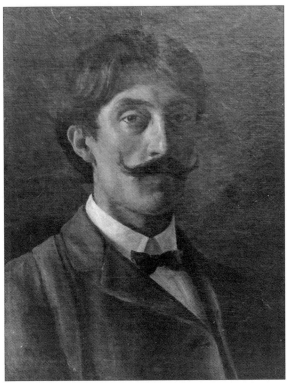

Frederick J Maher, *Self Portrait*, oil, 76 x 51cm. Private collection.

among these commissions were the *Empress of England; Empress of Canada*, and the *Northern Star*. He also completed a souvenir book consisting of watercolours of the town, for presentation to the Prince of Wales (later Edward VIII) on his visit to SOUTH SHIELDS in 1932, and produced dozens of greetings card illustrations for the National Association of Local Government Officers, of whose local branch he was an official, and for some time president. He died while still employed as senior rating and valuation assistant at the town hall, SOUTH SHIELDS. In 2002 illustrations from the *Shields Gazette,* later published in book form as *Shields Sketches*, were used by locally born poet James Kirkup to illustrate a similarly titled book of poems and autobiographical reminiscences featuring SOUTH SHIELDS. Represented: South Shields Museum & A G.

MADDISON, John (c.1875- c.1925)

Still life, landscape and portrait painter in oil and watercolour; art teacher. He was born at Great Ayton, North Yorkshire, and studied at South Kensington Art School, and the Royal College of Art, before practising as a professional artist and art teacher at MIDDLESBROUGH. He achieved considerable recognition for his work in painting and teaching in his day, and exhibited both in Britain and abroad. He exhibited his work at the Royal Academy 1896–1901, first showing a still life, *Brown Jar and Onions*, and later attracting much attention with his *Bachelor's Breakfast* (1898). He exhibited widely in the provinces, showing examples of his work at Bradford, York, Leeds and Manchester, and was specially invited to exhibit at the Copenhagen International Art Exhibition, in 1891. Represented: Middlesbrough A G; Walker A G, Liverpool.

224

MAHER, Frederick J (1871–1963)

Portrait and landscape painter in oil and watercolour. Maher was born at NEWCASTLE, and later became a teacher of art at the city's Rutherford Grammar School. He was a frequent exhibitor at the Bewick Club, NEWCASTLE, from his early twenties, and showed work at the Artists of the Northern Counties exhibitions at the city's Laing Art Gallery, for several years from 1910. Among his exhibits at the Bewick Club, was his *Wayside Inn, Lincolnshire* (1893), while typical of his Laing Art Gallery exhibits were his *Wicklow Hills, Showery Day*, and *On the River Teith* (1910); and *Summer Sunset, Loch Arklet* (1914). After leaving Rutherford College, Maher taught for many years at Armstrong College (later King's College; now Newcastle University). He was well known in Tyneside art circles, and was a member of several local art societies, and clubs, including the Benwell Art Club. He painted well into his late life, dying at NEWCASTLE at the age of ninety-two.

MAINDS, Allan Douglass, ARSA (1881–1945)

Portrait, landscape and figure painter in oil and watercolour; costume designer; commercial designer; art teacher. He was born at Helensburgh, Dumbartonshire, Scotland, the son of an artist. On completing his general education he studied at Glasgow School of Art, where he received the Haldane Travelling Scholarship, enabling him to study in Brussels under Jan Delville, then in Rome. He then returned to Glasgow, where, in 1909, he was appointed to the staff of the city's School of Art. In 1931 he left the

School to take up an appointment as professor of fine art, at King's College (now Newcastle University), remaining there until his death at GOSFORTH, near NEWCASTLE, in 1945. Mainds first exhibited his work publicly in the year in which he took up his teaching appointment at Glasgow, later showing work at the Royal Academy; the Royal Scottish Academy; the Glasgow Institute of Fine Arts, and the Royal Scottish Society of Painters in Water Colours. He was a member of the Glasgow Art Club for much of his teaching life in the city, and in 1929 was elected an associate of the Royal Scottish Academy. Following his move to Tyneside he exhibited almost exclusively at the Artists of the Northern Counties exhibitions at the Laing Art Gallery, NEWCASTLE, and the city's Pen & Palette Club, of which latter he was a member, and for some time Master of Pictures. He last exhibited at the Laing Art Gallery in the year of his death, showing *Spring Morning, Peasant*, and *Chess Players*. Represented: Laing A G, Newcastle; Pen & Palette Club, Newcastle.

MALKIN, Pamela (b.1944)
Landscape painter in oil and watercolour. She was born at Lytham St Anne's, Lancashire, and spent most of her working life in the cosmetics industry before she settled at MATFEN, near STAMFORDHAM, in 1985. She had long been interested in drawing and painting, and already with an Open University degree in art history behind her, decided to take a Certificate in Visual Studies at Newcastle College as a foundation course for an eventual BA(Hons) degree in fine art. This she took at Sunderland University under Virginia Bodman and Robert Soden, and after her graduation became a full-time professional artist. Her main preoccupation since beginning her career has been landscape, with a special emphasis on evoking the 'spirit' of her subjects. She has held several one-man exhibitions of her work in Northumbria, as well as participating in many group exhibitions. Her one-man exhibitions have included those held at the Queen's Hall, HEXHAM, in 1998 and 1999, and at the Tallantyre Gallery, MORPETH, in 2000. She is a member of the Tynedale Artists' Network, and the National Association of Artists.

MANGIN, Constance Wilhelmina (1850–1946)
Amateur landscape, animal and portrait painter in oil and watercolour. This artist lived at CHATHILL, near WOOLER, for a number of years and first exhibited her work in 1884, when she sent a landscape to the Royal Scottish Academy from an address in Selkirk, Scotland. She settled at CHATHILL after marrying her estate agent husband, and began to exhibit her work at the Bewick Club, NEWCASTLE, and later at the Artists of the Northern Counties exhibitions at the city's Laing Art Gallery. Following her husband's death she moved to WOOLER, from where she continued to show her work at the Laing Art Gallery until 1926. She became well known for her work in the area around WOOLER during her lifetime despite her amateur status, and many local homes own examples of her landscapes.

MANNING, C – see ROBSON, Featherstone

MANSON, Thomas (b.1940)
Landscape and figure painter in oil, acrylic and watercolour; illustrator. Manson was born at NORTH SHIELDS and after training as a commercial artist became a graphic designer working for leading advertising agencies on Tyneside. He later began to combine his work in the latter field with spare-time painting and occasional illustrative work, among this portraits of artists for the end papers of *The Artists of Northumbria*, 1973 and 1982 editions. He for some time maintained a gallery at TYNEMOUTH in which he showed his work, and later became a regular exhibitor at the Vicarage Cottage Gallery, NORTH SHIELDS, and other galleries in Northumbria. Much of his work portrays the fishing industry based at NORTH SHIELDS – both past and present – and several of his works have been reproduced in calendars and other media.

Thomas Manson, *Barrelling fish at North Shields*, oil, 23.5 x 27.5cm. Anderson & Garland.

MANVILLE, Mrs Ethel Kate (née Gibson) (1880–1942)
Portrait, flower and decorative painter in oil and watercolour. She was born at NEWCASTLE, the great-grand-daughter of William Dalziel (q.v.), and studied art at Armstrong College (later King's College; now Newcastle University), under Richard George Hatton (q.v.). She exhibited her work at the Artists of the Northern Counties exhibitions at the Laing Art Gallery, NEWCASTLE, from 1906 until her death, mainly showing portraits. Her *Head of a Young Girl*, exhibited in 1934, was singled out for comment and illustration in *Moderne Illustrée Des Arts et de la Vie* (Paris), 28th February, 1935, a correspondent writing: 'I know too little of the work of Mrs. Ethel K. Manville to pass any judgement on her. I have only the impression of good art applied with a sincere sensitivity and free from all influence.' She contributed one work to the 1929 North East Coast Exhibition, Palace of Arts. She died at NEWCASTLE, where she had spent all her life.

MARFITT-SMITH, Cecil, ARCA (c.1895–after 1968)

Landscape painter in oil and watercolour; art teacher. Marfitt-Smith was born in the south of England, and after education at the Royal College of Art, in 1932 became art master at the Royal Grammar School, NEWCASTLE. He retired from this position in 1956. During his period as a teacher he regularly exhibited his work at the Artists of the Northern Counties exhibitions at the Laing Art Gallery, NEWCASTLE, and was an occasional exhibitor at the Bondgate Gallery, ALNWICK, and elsewhere in Northumbria. He sometimes signed his work 'Marfitt'. Represented: Laing A G, Newcastle; Shipley A G, Gateshead.

MARKS (MARK), George (fl. early 19th cent.)

Landscape and portrait painter in oil: engraver. Marks is best remembered as the artist at DARLINGTON, who was one of the earliest teachers of William Bewick (q.v.). In a lengthy passage in *The Life and Letters of William Bewick (Artist)*, edited by Thomas Landseer, 1871, Bewick delightfully describes his acquaintanceship with this 'bookbinder, bird-stuffer, botanist, herbalist, geologist, mineralogist, geographer, astronomer, surveyor, engraver', and states: 'It was by him that I was initiated into the mysteries of 'oil'; it was by him I was told of the wonders of the palette, its mixtures and compound tints, those which were evanescent and those which stood the test of time . . .'. William Hylton Dyer Longstaffe (q.v.), also makes reference to Marks in his *History and Antiquities of the Parish of Darlington*, published in 1854.

MARR, Leslie (b.1922)

Landscape painter in oil and watercolour. Born at DURHAM, Marr initially trained as an engineer, and spent the Second World War in the RAF. He first started to paint while serving in Palestine, and on his demobilisation in 1947 enrolled at a private art school in London. Here he was introduced to David Bomberg by Dinora Mendelson, the artist's stepdaughter, whom he married in the following year. He joined Bomberg's classes at the Borough Polytechnic, and later joined the Borough Group centred on the artist, also briefly serving as its secretary. Marr took part in several Borough Group exhibitions, and later went on to enjoy several one-man exhibitions at the Everyman Gallery, from 1959; the Laing Art Gallery, NEWCASTLE, 1965; the Maddermarket Theatre Gallery, Norwich, from 1976; the Wells Centre, Norfolk, 1981, and the Catto Gallery, 1990. He also participated in the Bomberg-related exhibition *Spirit in the mass*, Fine Art Associates, 1989. Marr became increasingly interested in photography in his later career as a painter and in 1979 published a volume of photographs of Norfolk churches, entitled *From my Point of View*. The Laing Art Gallery has his oil *The Slipper Stones*, and he is also represented in the collections of Sheffield Art Gallery, and the University of Haifa. A self-portrait of his is held in the Ruth Borchard Collection, and he is featured in Philip Vann's *Face to Face: British Self-Portraits in the Twentieth Century*, published by Sansom & Company Ltd in 2004. He lived for some years on the Isle of Arran, Strathclyde, but later lived at Melton Constable, Norfolk.

MARSH, Arthur Hardwick, ARWS (1842–1909)

Portrait, genre, landscape and coastal painter in oil and watercolour; illustrator; stained glass designer. Marsh was born at Manchester, and received his education at Fairfield, Lancashire, at the Moravian School. As a concession to his love of drawing his parents allowed him when he left school to become articled to an architect, with whom he spent five years.

Cecil Marfitt-Smith,
The Old Barn,
watercolour, 26 x 39cm.
Private collection.

During this period he became an intimate friend of artist John Dawson Watson, and through Watson was encouraged to go to London, where he studied at the British Museum, the National Gallery, and at the life classes of the Artists' Society, Langham Place. Within a few weeks of arriving in the capital he had commenced exhibiting at the Old Water Colour Society (later the Royal Society of Painters in Water Colours), and in 1867 showed his first work at the Suffolk Street Gallery: *The Nosegay*. In 1868 he exhibited for the first time at the Royal Academy, showing his *Under the Willows*, following this in 1869, with *The Harpsicord*, which picture led to his election as an associate of the Old Water Colour Society, in 1870. In 1869, Marsh was invited to visit the north by merchant at TYNEMOUTH, Alexander Shannon Stevenson, who had met him at the home of Myles Birket Foster (q.v.), at Witley, Surrey. Marsh stayed with his host at TYNEMOUTH in the company of his friend Watson, Watson's brother Thomas, and William Quiller Orchardson, and visiting nearby CULLERCOATS, like them fell in love with the village. In the following year, and still at CULLERCOATS, Marsh exhibited his first of many works associated with the village, showing his *Baiting the lines*, at the Royal Academy. This was immediately followed by several other Academy exhibits inspired by the village and its fisherfolk, including *The Missing Boats* (1871); *The signal . . .* (1872); *The Salmon Fishers*, and *The Departure* (1873), and *Anxiety* (1874). He remained attached to CULLERCOATS for the remainder of his life, visiting the village regularly in the period 1875–1882, while based in London, and making his home there in 1882–3, while directing and acting as designer for the Gateshead Stained Glass Company, GATESHEAD, of John George Sowerby (q.v.). Following his marriage in 1884 to the eldest daughter of F W Hall of RIDING MILL, he decided to make his home permanently in Northumbria, living first at ALNMOUTH, later at CULLER-COATS, where he maintained a studio for many years. Although most of Marsh's early exhibits connected with the village were in oil, he remained deeply attached to painting in watercolour, and, indeed, became best known for his work in this medium. Two of his early CULLERCOATS' studies in watercolour, *A pilot on the look-out*, and *The Pedlar*, both painted in 1871, were reproduced in leading magazines of the day, and he exhibited more than a hundred works at the Old Water Colour Society, apart from the many watercolours which he exhibited at the Royal Academy, and at various London and provincial exhibitions, including among the latter those of the Arts Association, NEWCASTLE, and later the city's Bewick Club. At the turn of the century he moved to NEWCAS-TLE, and thereafter exhibited mainly at the Artists of the Northern Counties exhibitions at the city's Laing Art Gallery, where his last exhibits in 1908 were his watercolours *Meal Time in the Field*, and *A Hertfordshire Cottage*. In addition to exhibiting at the various venues already mentioned, Marsh showed his work at the International Exhibitions in Paris in 1876 and 1889, and was represented at the Royal Jubilee Exhibitions at Manchester and NEWCASTLE, in 1887.

Examples of his stained glass design work for Sowerby, consisting of two Shakesperian panels, *Lady Macbeth*, and *Ophelia*, and three of his cartoons, featuring figures symbolizing *Faith*, *Hope* and *Charity*, were exhibited at the Manchester Art & Industrial Exhibition, 1882, along with many other of the firm's products. He was also an occasional illustrator, and published *Scenery of London*, and *Cathedral Cities of France*. In addition to being an associate of the Royal Society of Painters in Water Colours, Marsh was elected a member of the Royal Society of British Artists, but resigned his membership. Represented: Laing A G, Newcastle; Pen & Palette Club, Newcastle. [See colour plate]

MARSHALL, Daniel Whitely (fl. late 19th cent.)
Portrait and landscape painter in oil. A chemist by profession, Marshall became well known at SUNDERLAND in his day for his portraits of local celebrities, and his landscape work. He was an occasional exhibitor at the Bewick Club, NEWCASTLE, making his debut at its 1884 exhibition with his oil: *Waiting for the master*. Sunderland Art Gallery has several examples of his work, including his portrait of John Green, author of *Tales and Ballads of Wearside*, and several local street scenes.

MARSHALL, Ralph (c.1855- c.1945)
Amateur marine and landscape painter in oil and watercolour. Marshall was born at WEST HARTLEPOOL (now HARTLEPOOL), and worked most of his life as a carpenter in a local shipyard, painting in his spare time. He was a prolific painter and the quality of his work varied considerably. His best work compares favourably with that of John Scott (q.v.). He frequently repeated compositions in his work, and sometimes painted in collaboration with his friend and pupil BERNARD KEENAN, whoever finished the painting adding his signature. He died at HARTLEPOOL. Represented: Hartlepool Arts & Museum Service; Middlesbrough A G.

MARSHALL, Richard W (b.1944)
Landscape painter in acrylic. He was born at SOUTH SHIELDS and studied first at Sunderland College of Art, and then at the Slade School of Fine Art, before practising as a landscape painter in Northumbria. He lived for some time at NORTON.

MARTIN, David (fl. late 18th cent.)
Wood engraver. Martin was an apprentice of Ralph Beilby (q.v.), at NEWCASTLE, when Thomas Bewick (q.v.), joined the Beilby workshop. Little is known of his work except that he contributed some cuts to the *Select Fables*, of 1784, along with Bewick, and John Bewick, The First (q.v.). This book was later the subject of some dispute between Bewick and Emerson Charnley, NEWCASTLE, who advertised it in *The Printer*, 1819, as 'with cuts designed and engraved upon wood by Thomas and John Bewick previous to the year 1784'. This occasioned Bewick to write to the publication, saying that the cuts were '. . . executed

partly by my late Brother, when he was an apprentice, and partly by 'David Martin', whom I respected as a Man, but who was obliged from inability to seek some other line of work . . .'.

MARTIN, John, KL HRSA (1789–1854)

Historical, biblical, portrait and landscape painter in oil and watercolour; illustrator; engraver; decorative artist. Martin was born at HAYDON BRIDGE, the son of a tanner, and received his education at the free grammar school in the village. He left school in 1803, and partly because of his desire to become an artist, his family moved to NEWCASTLE, where he was apprenticed as an heraldic painter to a coachbuilder. After only a year with his master, however, and despairing of advancing his skills as an artist while serving this type of apprenticeship, he left his employer, and with his father's encouragement, became a pupil in the studio of Boniface Muss (q.v.), at NEWCASTLE. Here he was taught perspective drawing and enamel painting in the company of fellow pupil John Dobson (q.v.), but his tuition came to an abrupt end when Muss decided to follow his son, Charles Muss (q.v.), to London, in 1805. Martin followed his teacher to the capital in September, 1806, and initially attempted to earn a living by selling drawings of Northumbrian views. Ackermann bought three of these, but the idea was not generally successful. About 1807, Charles Muss started up in business with a partner, and took Martin on at £2 a week for five years, on condition that he would return half his pay for tuition in glass and china painting. Muss later went bankrupt, and he and Martin obtained positions in the stained glass workshop of William Collins, in the Strand. At the age of nineteen, Martin married, and began to combine his somewhat irregular work for Collins, with painting and teaching, but without any marked improvement in his financial circumstances. In 1811, and following two rejections of his *Clytie* by the Royal Academy, he had a *Landscape Composition* accepted, and leaving Collins in 1812 as an established craftsman and instructor, he decided to become a full-time professional painter. 'Ambitious of fame', he later wrote, 'I determined on painting a large picture, 'Sadak', which was executed in a month.' Exhibited at the Royal Academy in the year in which he left Collins, this painting launched him on a career which within five years led to his appointment as 'Historical Landscape Painter to the Princess Charlotte and Prince Leopold', and ten years later earned for him from Sir Thomas Lawrence, President of the Royal Academy, the description: 'the most popular painter of the day, John Martin'. Lawrence's tribute to Martin followed the showing at the British Institution in 1821, of the latter's *Belshazzar's Feast*, a picture so stunning and dramatic that it had to be railed off from its crowds of jostling spectators. This painting, deliberately designed by Martin to 'make more noise than any picture did before', won him a prize of 200 guineas from the Institution, but was small compensation for his disappointment at being rejected as a candidate for the Royal Academy in the previous year. Indeed, despite the fact that in 1828 Martin was the only painter besides Sir Thomas Lawrence to be included in *Public Characters of the Present Age*, and by 1831, thanks to his mezzotint engravings of his work, his had become a household name, he was never to become a Royal Academician. In fact he once complained of the Academy '. . . as I progressed in art and reputation my places on its walls retrograded'. The Academy accepted a total of eight-three of his paintings between 1811 and 1852, but its members obviously felt that though his work was unquestionably imaginative, it was rarely masterful in technical terms. In fairness to their view it must be said that Martin experienced difficulty in disposing of his major works throughout his life, and it was largely from the sale of engravings of these works, and his illustrations for books such as the poems of Milton, that he derived his main income for many years. In addition to exhibiting his work at the Royal Academy; the British Institution; the Suffolk Street Gallery, and the New Water Colour Society (later the Royal Institute of Painters in Water Colours), Martin also exhibited at the Scottish Academy and abroad, this activity leading to his election as an honorary member of the Royal Scottish Academy, and member of the Belgian Academy, and St Luke's Academy, Rome. He was also an occasional exhibitor at NEWCASTLE, showing work at the Northumberland Institution for the Promotion of the Fine Arts, 1822, the Northern Academy, 1829, and at various exhibitions subsequently. Not all of Martin's work was of the sort which had earlier shocked the public: in 1837 he painted his highly successful group portrait, *The Coronation of Queen Victoria*, and from 1840 he painted a large number of pure landscapes, two such works, *Scene in a forest – twilight*, and *View in Richmond Park*, appearing at the Royal Academy with his *Sodom and Gomorrah*, when he last exhibited there in 1852. In the autumn of 1853, and having just completed his famous trio of 'Judgement Pictures' – *The Last Judgement*; *The Plains of Heaven*, and *The Great Day of His Wrath* – Martin left the London which he had once excited so much and went on a visit to the Isle of Man. Here he suffered a stroke in February, 1854, dying at the same time as his 'Judgement Pictures' were being shown in the Victoria Rooms, Grey Street, NEWCASTLE. His work from then on gradually fell in popularity, the once famous 'Judgement Pictures' only bringing £7 when they were auctioned in London some sixty-odd years later. At the present time, thanks to regular exposure of his work from its extensive collection, by the Laing Art Gallery, NEWCASTLE, since its outstanding exhibition in 1970; an excellent book by William Feaver, *The Art of John Martin*, 1975, and Tate Britain's opening exhibition of his works from the Tate's permanent collection, it is probably enjoying its greatest appreciation since his heyday. This was reflected in its singling out for illustration and comment in two editions of *Britain's Paintings*, the *Daily Telegraph* five-part series on *The Story of Art through Masterpieces in British Collections*, by Neil MacGregor (then director of the National Gallery, London), in 2002, and the record price of £1.6 million paid at auction in 2003 for his Royal Academy exhibit of 1841, *Pandemonium*,

John Martin, *Alexander and Diogenes*, oil, 22 x 33cm. Hatton Gallery, University of Newcastle.

based on a theme from Milton's *Paradise Lost*. Martin's son, CHARLES MARTIN (1820–1896) was also a professional artist, and another son ALFRED MARTIN (d.1872), did some mezzotint engraving. Represented: British Museum; Victoria and Albert Museum; Tate Gallery; Carlisle A G; Glasgow A G; Laing A G, Newcastle; Manchester City A G; Walker A G, Liverpool. [See colour plate]

MASON, Frank Henry Algernon, RBA RI RSMA (1875–1965)

Marine and coastal painter in oil and watercolour; illustrator and poster designer; etcher. Mason was born at SEATON CAREW, and after education at private schools went at the age of twelve to study on HMS Conway, a naval training vessel moored in the Mersey. After his two year course on the vessel he spent a year at sea, then became an engineering apprentice with a firm at Leeds. His work for the company later involved him in visits to various engineering and ship-building locations in the North East of England, including HARTLEPOOL, and Scarborough, but frustrated by remaining shore based he undertook a number of private voyages to sketch at sea. In the middle 1890s he decided to settle at Scarborough, and giving up his job c.1897/8, became a full-time professional artist. He soon enjoyed success in selling his work through local picture dealers, and through them also met fellow-painters in Scarborough, including Thomas Bush Hardy (whose work was to have an important influence), and members of the artists'

colony from Staithes, now known as the Staithes Group. By 1900 he had prepared his first major work for exhibition *The Power and Wealth of the Tyne*, shown at the Royal Academy in that year. This was purchased by shipping magnate Sir John Milburn, of NEWCASTLE, and later in the year loaned for showing to the Walker Art Gallery, Liverpool. Over the next eleven years he showed seven further works at the Royal Academy, and gradually widened his circle of exhibition venues to include the Royal Society of British Artists (of which he was elected a member in 1904); the Artists of the Northern Counties exhibitions at the Laing Art Gallery, NEWCASTLE, and exhibitions held at various London and provincial galleries. He also took on agent A E Johnson, and began work in poster design for major shipping and railway companies which was to continue throughout his career. Many of his early exhibits resulted from sketching trips at sea, and visits abroad to Holland, Spain, Portugal, the Mediterranean, and the African coast. He also in this period illustrated his first books, and taking up dry point etching produced a wide variety of British, Continental and Middle Eastern views, generally with maritime connections. At the outbreak of the First World War he was commissioned as a lieutenant in the RNVR, and served in the North Sea, the Mediterranean, and at shore bases in Scotland and NEWCASTLE, first as a launch commander, later on ship camouflage. He did much sketching during his service and some Admiralty-commissioned watercolours. On his demobilisation and return to Scarborough, in 1919,

he also obtained a commission from the Imperial War Museum to produce gouache studies based on his Suez sketches, and oils featuring various fleet activities during the War. From his Scarborough base he quickly established a wider demand for his work including marine paintings, poster design, book illustration, limited edition etchings, and even model ships, and by 1925 could buy his own home in the town. Within two years, however, he felt that his career would be much better pursued in London, and moving there in 1927 spent the remainder of his life in the capital. During his London period Mason was much employed as a commercial designer but continued to exhibit his work as a marine artist, mainly showing at the Royal Institute of Painters in Water Colours (of which he was elected a member in 1929); the Laing Art Gallery, and various provincial galleries. Following his election to membership in 1961 he also exhibited at the Royal Society of Marine Artists, his last known exhibits anywhere being his *The Gattere, Venice*, and *The Open Sea*, shown there two years before his death in London, in 1965. Two of the most important exhibitions of his work have been those at the Sporting Gallery, London, in 1939, and at Hartlepool Art Gallery and Scarborough Art Gallery, in 1996. The latter exhibitions were accompanied by the publication of *The Life and Career of Frank Henry Mason* by Edward Yardley, which corrected a number of previous misconceptions about the artist's life and work, and presented the first detailed account of his talents as one of the most prolific and accomplished marine artists working in 20th century Britain, not to mention superb illustrator and outstanding poster designer. Represented: Bradford A G; Dundee A G; Hartlepool Arts & Museum Service; Hull Museum & A G; Imperial War Museum; Laing A G, Newcastle; National Maritime Museum; Pannett A G, Whitby; Pen & Palette Club, Newcastle; Rotherham Museum & A G; Scarborough A G. [See colour plate]

MATHER, John Robert (1834–1879)
Marine, coastal and landscape painter in watercolour. Mather was born at NEWCASTLE, the son of an iron-monger, and according to historian the Rev John Hodgson, was a captain in a West Indies regiment before practising as an artist in his native town by 1862. In that year he began exhibiting at the Suffolk Street Gallery, showing *At anchor on the lee shore – Day after the storm*, and contributed other exhibits to this gallery until 1872. Towards the end of this period he had moved to WHITLEY BAY, from where he also sent work to the Central Exchange News Room, Art Gallery, and Polytechnic Exhibition, at NEWCASTLE, in 1870, showing three marine subjects. He last showed his work at NEWCASTLE in 1878, when he sent seven works to the exhibition of works by local painters, at the Central Exchange Art Gallery. According to William Weaver Tomlinson, in his *Historical Notes on Cullercoats, Whitley and Monkseaton*, 1893, Mather spent his final years at 49, Beverley Terrace, CULLERCOATS, dying there in 1879, aged forty-five. His death certificate, however, states he was aged only forty-four. The Shipley Art Gallery, GATESHEAD, has a large early watercolour *On the Coast of Norway: Twilight after Storm*, dated 1860.

MATHIESON, William (d.1900)
Landscape and coastal painter in oil and watercolour. This artist practised at NEWCASTLE, GATESHEAD, and SUNDERLAND, in the late 19th century. Amongst his earliest known exhibits are the four landscapes which he sent to the exhibition of the work of local painters at the Central Exchange Art Gallery, NEWCASTLE, in 1878. His pictures in this exhibition were described in the catalogue notes as: 'hard and crude, but there is great promise of future excellence'. He showed a coastal work at the 'Gateshead Fine Art & Industrial Exhibition', in 1883, and later became a regular exhibitor at the Bewick Club, NEWCASTLE, several of his exhibits attracting favourable comment from reviewers. He died at GATESHEAD.

MAUGHAN, James Humphrey Morland (1817–1853)
Amateur landscape painter in watercolour. Maughan lived in Northumbria until 1844, when he moved to Maidstone, Kent, to work as a schoolmaster. In 1847 he joined HM Customs & Excise in NEWCASTLE, and in 1853 he was transferred to the London office. Two examples of his work were illustrated in *Country Life*, May 22nd, 1969, in connection with a letter to the editor. These works appeared over the title *Watery wastes*, and portrayed a coastal castle in ruins, and a river scene with bridge, and distant cathedral. He died in London.

MAWSON, Elizabeth Cameron (1849–1939)
Amateur landscape, genre and portrait painter in oil and watercolour. She was born at GATESHEAD, the daughter of businessman and later Sheriff of NEWCASTLE, John Mawson, and was educated at Bedford College, London, before taking up art as a hobby. Within a few years of returning to Tyneside she had achieved remarkable proficiency as a painter of a wide range of subjects, and in 1878 had examples of her work shown at two major exhibitions at NEWCASTLE; the exhibition of works by local painters, at the Central Exchange Art Gallery, and the Arts Association. Three of these works shown in 1878 were landscapes with buildings; two were flower studies. In 1881 she commenced exhibiting outside Northumbria, between that date and 1893, showing examples at the Royal Academy; the Royal Scottish Academy; the Royal Institute of Painters in Water Colours; the Royal Institute of Oil Painters; the Royal Scottish Society of Painters in Water Colours, and in the provinces. She continued to exhibit at NEWCASTLE throughout her life, contributing to later exhibitions of the Arts Association, and sending occasional works to the Bewick Club. She died at GATESHEAD. Represented: Shipley A G, Gateshead.

MEEHAN, Myles (1904–1974)
Landscape and figure painter in oil and watercolour; sculptor. Meehan was born at GATESHEAD and only

began painting at the age of forty-two. To develop his artistic skills he studied at Croydon and Chelsea art colleges, making such progress that he helped found Croydon Arts Club in 1952, and later served as its chairman. Within a short time also he was exhibiting his work, showing examples at the Royal Society of British Artists; the New English Art Club, and at various group exhibitions at Chelsea, Croydon, GATESHEAD, DARLINGTON and HARTLEPOOL. He also undertook commissions for Leicester and Gateshead Corporations and had work purchased by London County Council. In 1959 he was elected a fellow of the Royal Society of Antiquaries, and in 1969 moved to DARLINGTON, where he was commissioned by cartoonist Reginald Smythe (q.v.), to make a bronze statue of Smythe's cartoon creation 'Andy Capp'. Following Meehan's death a gallery in his memory was created in the town, which is now located at its Arts Centre and maintains a vigorous programme of arts-related exhibitions. Represented: Bowes Museum, Barnard Castle; Darlington A G; Shipley A G, Gateshead.

MEGORAN, Arthur Winston Dale (1914–1971)
Marine painter in oil and watercolour; etcher; illustrator. Megoran was born at SUNDERLAND, the son of a local tax inspector, and by his early twenties had begun to exhibit his work at the Artists of the Northern Counties exhibitions at the Laing Art Gallery, NEWCASTLE, showing marine paintings and occasional etchings. In 1948 he also showed an aquatint at the Royal Academy, *Down with the ebb*. Some of his work consisted of commissions for yachtsmen, and he also produced cover illustrations for *Yachting Monthly*, and motor boating magazines. Some of his work also appeared in the *Illustrated London News* in the 1940s and 1950s. Sunderland Art Gallery has his watercolour *Brent Geese*. Much of his work was contributed to exhibitions as 'Winston Megoran'.

Arthur Winston Dale Megoran, *Yacht Race off Roker*, oil, 51 x 76cm. Private collection.

MENZIES, Beryl (fl. early 20th cent.)
Amateur portrait, landscape and flower painter in oil and watercolour. This artist was born on Tyneside, the daughter of a construction engineer, and regularly exhibited her work at the Artists of the Northern Counties exhibitions at the Laing Art Gallery, NEWCASTLE, from their inception in 1905, until 1912. In the period 1908–11, she also exhibited work at the Walker Art Gallery, Liverpool.

METCALFE, J (fl. late 19th, early 20th cent.)
Amateur landscape painter in oil. Metcalfe was born on Tyneside and worked as an engineer in a local factory, painting in his spare time. Most of his work featured scenes in suburban NEWCASTLE, and frequently included well-known local buildings. Several of his views of the one-time village of BENWELL (now part of NEWCASTLE) are known.

MEYNELL, Jack (1894–1970)
Portrait painter in oil and watercolour; draughtsman; caricaturist; illustrator. Born at SUNDERLAND, Meynell attended the town's School of Art before obtaining employment as a commercial artist with a fine art publisher on Wearside. After service in the First World War he went to London, where he eventually joined Odhams Press as a commercial artist in 1932. From Odhams he joined the *News Chronicle*, remaining there until 1947, when he joined the *Daily Express*. He worked for the *Express* until his retirement at the age of seventy, when he returned to SUNDERLAND. He died at SUNDERLAND. A large collection of portrait work in monochrome, including Sir Winston Churchill, John F Kennedy, Hugh Gaitskill, and other famous men and women of his day, was presented to Sunderland Art Gallery in 1971.

MIDGLEY, Charles James (c.1865–c.1895)
Coastal and landscape painter in watercolour. Midgely was born on Tyneside, and practised as an artist in Northumbria throughout the late 19th century. He occasionally exhibited his work at NEWCASTLE, from 1878, in which year he exhibited his *St Mary's Island*, at the Arts Association, and several pictures of CULLERCOATS, at the exhibition of works by local painters, at the Central Exchange Art Gallery. He was later an exhibitor at the Bewick Club, mainly showing coastal views. He may have been related to another Bewick Club exhibitor, JAMES TYNDALL MIDGLEY, of SUNDERLAND.

MILLER, James Jerome (c.1880- after 1932)
Amateur landscape and coastal painter in oil and watercolour. Miller was born at SOUTH SHIELDS, and became a painter and decorator in the town, painting in his spare time. He first commenced exhibiting his work at the Artists of the Northern Counties exhibitions at the Laing Art Gallery, NEWCASTLE, in 1910 showing his *On the beach*, and *Harvest Time*. He continued to exhibit at NEWCASTLE until the early 1930s, meanwhile exhibiting one work at the Royal Academy in 1914, *Stephenson's Birthplace*, and sending a number of works for exhibition at the Royal

Scottish Academy; the Glasgow Institute of Fine Arts, and the Walker Art Gallery, Liverpool, 1912–15. It is believed that he died at SOUTH SHIELDS. Represented: South Shields Museum & A G.

MILLER, Joseph (fl. early 19th cent.)
Landscape painter in oil. This artist practised at STAIN-DROP, near BARNARD CASTLE, in the early 19th century, and sent several works for exhibition at NEWCASTLE in this period. When he exhibited *A View of Wensleydale*, and *Landscape, near Darlington*, at the Northern Academy, in 1829, W A Mitchell of the *Tyne Mercury* commented of Miller's first work: 'The artist shows considerable skill in detail, and when he gets rid of his stiffness and village painter-like manner, he should soon rank amongst rapidly rising artists', while of the second he said: 'Mr Miller has overcome his hardness and stiffness of manner ... we may have the best hopes of him ...'. Miller again exhibited at NEWCAS-TLE in 1831, showing two works at the Northern Academy, but appears to have exhibited on only one occasion subsequently, this being when he loaned his *Cottage near Middleton in Teesdale*, and *Moonlight, Gipsies*, to the 'Exhibition of Arts, Manufactures & Practical Science', at NEWCASTLE, in 1840. Darlington Art Gallery has his oil: *High Force*. [See colour plate]

MILLER, Lynn (1882–1977)
Landscape and coastal painter in oil and watercolour. This artist practised at SOUTH SHIELDS in the early years of the last century, and regularly exhibited his work at the Artists of the Northern Counties exhibitions at the Laing Art Gallery, NEWCASTLE, from their inception in 1905, until 1936. From 1911 he lived at RYTON. His final exhibits at the Laing Art Gallery comprised two watercolour views of Whitby Harbour, North Yorkshire. His artist son WILLIAM LYNN MILLER (1911–1982) spent several years at RYTON, before moving to SUNDERLAND, and also exhibited his work at the Artists of the Northern Counties exhibitions. They may have been related to FREDERICK MILLER, who shared an address at SOUTH SHIELDS with Lynn Miller in the early years of the century, when also exhibiting at the Artists of the Northern Counties exhibitions.

MILLER, Robert Appleby (d.1918)
Stained glass designer; portrait painter in oil; sculptor; decorative designer. Miller practised on Tyneside in the late 19th and early 20th centuries, and occasionally exhibited his work at the Artists of the Northern Counties exhibitions at the Laing Art Gallery, NEWCAS-TLE, from their inception in 1905, and at the city's Pen & Palette Club, throughout his membership. His exhibits at the Laing Art Gallery included his *Northumbria*, and *Tritons* (both in plaster), 1905, and his *Head of a Girl* (oil), 1910. Following his death in March, 1918, an exhibition of his work was held at the Pen & Palette Club, together with that of one-time fellow member, RICHARD J LEESON (d.1914). Miller was responsible for designing many items of printed matter associated with the Club, and also designed the cover of the catalogue which was used

for the Artists of the Northern Counties exhibitions 1908–1925. His work in stained glass was regarded as particularly fine, and one of his designs in this field was accepted for showing at the Royal Academy in 1902.

MILNE, Peter (b.1912)
Amateur landscape painter in watercolour. Born at NORTH SHIELDS, Milne worked in local government for much of his life, painting in his spare time. A largely self-taught artist he exhibited his work at the Federation of Northern Art Societies' exhibitions at the Shipley Art Gallery, GATESHEAD, and at the Artists of the Northern Counties exhibitions at the Laing Art Gallery, NEWCASTLE. Two of his exhibits at the latter in 1952 were his watercolours *Summer Shower*, and *Northumberland Dock, Howdon*. He had a long association with Wallsend Art Club throughout his many years living at nearby NEWCASTLE.

MILNE, William (1873–1951)
Amateur landscape and coastal painter in oil and watercolour. Milne was born on Tyneside, and worked most of his life as an official of the Corporation of NEWCASTLE, painting in his spare time. He studied art as a young man under Robert Ventress (q.v.), and later became a regular exhibitor at NEWCASTLE, showing work at the city's Bewick Club, and later the Artists of the Northern Counties exhibitions at the Laing Art Gallery, and the Newcastle Society of Artists. A one-man exhibition of his work was held at the Hatton Gallery, NEWCASTLE. He died at NEWCASTLE. The Laing Art Gallery has his *River Scene at Gilsland*.

MILNER, Elizabeth Eleanor (1861–1953)
Engraver. She was born at STOCKTON-ON-TEES, the daughter of a clergyman, and before deciding on a career in art studied at Lambeth; St John's Wood; the Royal Academy Schools, and at Hubert von Herkomer's School at Bushey, Herts. Although initially a painter in oil she became increasingly interested in mezzotint colour engraving. She exhibited her work in both mediums at the Royal Academy; the Society of Women Artists; the Royal Institute of Oil Painters; the Walker Art Gallery, Liverpool, and elsewhere. Many of her mezzotint exhibits were after portraits by famous artists such as Sir Edwin Landseer, Sir Peter Lely, George Romney and John Hoppner. She lived for many years at Bushey.

MITCHELL, Charles William (1855–1903)
Figure and portrait painter in oil and pastel; mosaic artist. Mitchell was born at WALKER, near NEWCASTLE, the son of a shipbuilder. Following his general education and after early displaying a talent for drawing and painting, his father permitted him to study in Paris under Comte. On returning to Tyneside he was allowed to continue his interest in painting, and by the age of twenty-two had commenced exhibiting at the Royal Academy, showing *A Duet*. Two years later he again exhibited at the Academy, showing a portrait, *Lucy*, and in the same year was one of the many Northumbrian artists who sent work to the first exhi-

bition of the Arts Association, at NEWCASTLE. He had by now moved to London, where he continued to exhibit at the Academy until his mid-thirties, and also showed work at the Bewick Club, NEWCASTLE, but his first major artistic success came with the exhibition of his *Hypatia*, at the Grosvenor Gallery, London, in 1885. This work was later shown at the Royal Jubilee Exhibition at Manchester in 1887, the Guildhall, London, in 1900, and finally at the Royal Academy, London, in 1977, as part of an exhibition to mark the Silver Jubilee of Her Majesty The Queen. Four years after first showing *Hypatia*, Mitchell left London, and virtually gave up painting to concentrate on his father's business interests, satisfying himself instead by helping to promote the arts on Tyneside. He became chairman of the School of Art Committee at the Durham College of Physical Science, NEWCASTLE, and purchased the old Academy of Arts building in the city with the object of presenting it as a home for the arts on Tyneside. He spent a considerable sum of money on refitting the Academy for this purpose, later enabling several important exhibitions to be staged on its premises. He also became vice president of the Northumberland Handicrafts Guild, and was a founder-member of the Pen & Palette Club, NEWCASTLE, later serving as president. He died at NEWCASTLE at the early age of forty-eight. The Laing Art Gallery, NEWCASTLE, has his *Hypatia*, and other works, and his mosaic of the Apostles may be seen in the chancel of St George's Church, in the JESMOND area of the city. This church was built in 1888 to the design of Thomas Ralph Spence (q.v.). A handsome memorial tablet with bronze figures was placed in the inside south wall of the church following Mitchell's death, to match his father's memorial tablet in the north wall.

MITCHELL, J Edgar (1871–1922)
Portrait, figure and landscape painter in oil and watercolour; stained glass designer; art teacher. Mitchell's place of birth is not recorded, but is thought to have been Scotland, as it was in Dundee that he first began practising as a professional artist, by the age of twenty-two. He first exhibited his work in Scotland, where in 1893, he sent one work to the Royal Scottish Society of Painters in Water Colours. Two years later, and practising in Edinburgh, he commenced exhibiting at the Royal Scottish Academy, meanwhile sending two works to the Bewick Club, NEWCASTLE, in 1894. Just before the turn of the century he decided to make his home in Northumbria, settling eventually at NEWCASTLE, where he maintained studios in the Haymarket area of the city until his death. One of his early commissions was to paint a series of canvases based on nursery rhymes for the children's room on the *RMS Mauretania*, then being built on the Tyne. While practising in the city he sent four works to the Royal Academy, commencing with *The Village Tailor*, and after joining the Pen & Palette Club, NEWCASTLE, became a regular exhibitor with the Club, and at the Artists of the Northern Counties exhibitions at the Laing Art Gallery, nearby. He showed work at the latter exhibitions, and at the city's Bewick Club, until

his death, showing a large number of portraits of local celebrities, and North country landscapes. At the time of his death he was art master at the Queen Elizabeth Grammar School, HEXHAM, and an important exhibition of his work was being held in NEWCASTLE. A stained glass window by Mitchell for the Laing Art Gallery when first built was returned to its original location in the building's south facing elevation in 2004 after many years in storage, and represents his finest work in the medium. Represented: Laing A G, Newcastle; Pen & Palette Club, Newcastle; South Shields Museum & A G; Sunderland A G.

MITFORD, Bertram Osbaldeston (1777–1842)
Caricaturist in line and wash. He was the owner of Mitford Castle, near MORPETH, and amused himself in leisure moments by producing crude though amusing caricatures in the manner of George Moutard Woodward (1760–1809), and copying the work of Rowlandson. He served as High Sheriff of the County of Northumberland in 1835, and in that year adopted the name 'Osbaldeston'. Represented: British Museum.

MOLE, John Henry, VPRI (1814–1886)
Landscape and figure painter in oil and watercolour; miniature painter. Mole was born at ALNWICK, the son of a jobbing cabinet-maker, who some years later moved his business to NEWCASTLE. Here Mole first worked as a clerk in the solicitor's office of a brother of William Wailes (q.v.), who encouraged his employee to draw when work was slack. While working as a clerk he also joined an art society at NEWCASTLE, comprising John Brown (q.v.), Thomas Hall Tweedy (q.v.), and other artists then seeking to develop their talents. This society flourished about 1830–35, and held its first exhibition at T Bamford's Long Room at Amen Corner in the town. It later moved its meeting place and exhibition venue to the Old Tower, Pink Lane, where Mole began to assume a leading role in encouraging his fellow members in their progress. Later he began to take instruction in miniature painting from Thomas Heathfield Carrick, the Carlisle artist, watercolour painting his likenesses on white marble statuary tablets in the manner of his master. He soon tired of this practice, however, and turning to landscape and figure painting as a relaxation, commenced exhibiting his work at NEWCASTLE, showing two theatrical studies, and one genre work, at the North of England Society for the Promotion of the Fine Arts, 1836. Mole continued to exhibit at NEWCASTLE until the middle of the century, also in this period exhibiting at the Royal Academy in 1845 and 1856; the New Water Colour Society (later the Royal Institute of Painters in Water Colours), from 1845, and the Carlisle Academy in 1846 and 1850. His Royal Academy exhibits were all portraits, and, indeed, he continued to advertise himself as a portrait painter at NEWCASTLE until his election as an associate of the New Water Colour Society in 1847. Following his election as a full member of the Society in 1848, however, he gave up painting portrait miniatures in favour of landscapes with figures, exhibiting more than 600 such works at the Society by the time of his death. He was also an

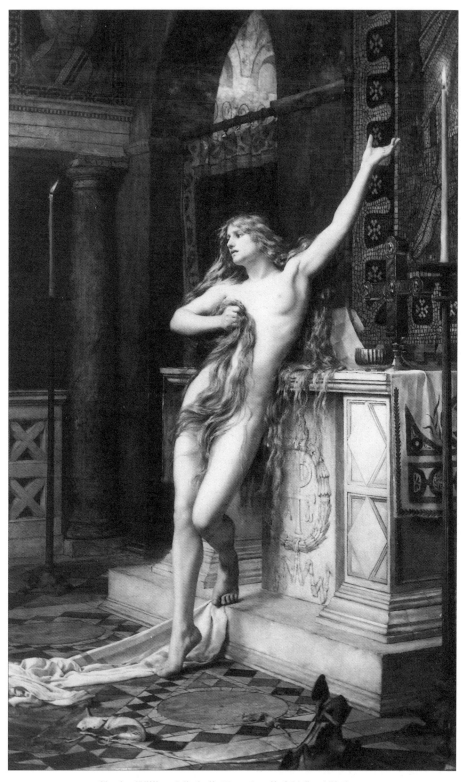

Charles William Mitchell, *Hypatia*, oil, 244.5 x 152.5cm.
Tyne & Wear Museums, Laing Art Gallery.

John Henry Mole, *The Young Corn Gatherers*, 1850, watercolour, 34 x 52cm. Anderson & Garland.

J Edgar Mitchell, stained glass window on main stairs, Laing Art Gallery, 1904. Tyne and Wear Museums.

occasional exhibitor of such works at the British Institution; the Suffolk Street Gallery; the Grosvenor and various other London galleries, and at NEWCASTLE, where his exhibits at the Bewick Club, in 1884, for instance, were *Old Mill in Jesmond Dene*, and *On the Derwent, Borrowdale, Cumberland*. Most of Mole's work was in watercolour (though he did exhibit an oil, *Carrying Peat*, at the Royal Academy in 1879), its quality, and the number of his exhibits at the New Water Colour Society, leading to his election as its vice president the year after it was authorised to style itself the Royal Institute of Painters in Water Colours. This honour came only two years short of his death at Russell Square, London, in 1886. Represented: Victoria and Albert Museum; Accrington A G; Cartwright Hall, Bradford; Hartlepool Arts & Museum Service; Laing A G, Newcastle; North Tyneside Public Libraries; Shipley A G, Gateshead; South Shields Museum & A G; Sunderland A G, and various provincial art galleries.

MONCK, Lady Mary Elizabeth (née Bennet) (d.1851)

Amateur landscape painter in watercolour. The daughter of the 4th Earl of Tankerville, of Chillingham Castle, CHILLINGHAM, she became in 1831 the second wife of Greek scholar and MP, Sir Charles Lambert Monck, of Belsay Castle, near CAMBO. A keen amateur artist from her childhood, she later received lessons from John Varley, and produced a considerable volume of watercolours and pencil sketches reflecting the influence of this artist. An illustrated memorandum containing twelve watercolours, and pencil sketches, and two other works, were included in 'The Picturesque Tour' exhibition staged at the Laing Art Gallery, NEWCASTLE, in 1982.

MOOD, Michael David (b.1946)

Thematic painter in various media; exhibition and film designer. He was born at NEWCASTLE and attended the city's College of Art & Industrial Design before going on to work at the Imperial War Museum in its research information department. He initially painted in a variety of media but from the mid–1970s began to experiment with monochrome compositions employing watercolour and ink. This interest has continued to the present time using a variety of monochromatic techniques and he has exhibited his work in several leading London galleries. His work for the Imperial War Museum has included the mounting of several important exhibitions, while among his private commissions has been the set design for the film *Overlord*, directed by Stewart Cooper. This film won a special award at the Berlin Film Festival in 1975, and won the Evening Standard Film Award in 1976. He lives in London.

MOODY, Eric (b.1946)

Urban subject artist in coloured relief; art teacher. Moody was born at SEDGEFIELD, and first became interested in art through his father's activities as a stone carver. After studying at Sunderland College of Art he spent formative periods in North America in the 1960s, and two separate years at London University studying aesthetics and the sociology and psychology of art. He then went on to teach with the arts policy and management department at City University. Moody has exhibited his work at the Air Gallery, London; the Whitechapel Gallery; the Royal College of Art, and the Curwen Gallery, among many galleries in the UK. He had a one-man exhibition at the Woodlands Art Gallery in 1986.

MOORE, Anthony John (1852–1915)

Amateur marine and coastal painter in oil and watercolour. Moore was born at MONKWEARMOUTH, near SUNDERLAND, the son of an India merchant, and became a violin maker, painting in his spare time. He spent most of his life on Wearside, and exhibited his work exclusively in Northumbria, one of his earliest known exhibits being the genre work *The Doll's Frock*, which he sent to the 'Gateshead Fine Art & Industrial Exhibition', in 1883. He was later an occasional exhibitor at the Bewick Club, NEWCASTLE, and at various venues in SUNDERLAND. He died at SUNDERLAND. He was possibly the brother of J White Moore (q.v.). Sunderland Art Gallery has a large collection of his work dated 1880–1912, and mainly consisting of shipping, river and street scenes in watercolour.

MOORE, J White (fl. late 19th cent.)

Landscape and coastal painter in watercolour. This artist practised at SUNDERLAND and HARTLEPOOL, in the late 19th century, from which he mainly sent work for exhibition to the Bewick Club, NEWCASTLE. In 1897 he sent one work for exhibition at the Glasgow Institute of Fine Arts, while practising at HARTLEPOOL. He may have been the brother of Anthony John Moore (q.v.). Sunderland Art Gallery has his views in watercolour: *Whitburn, near Sunderland*, and *River Wear, near Hylton*.

MOORE, Ronald Lambert, BWS (1927–1992)

Landscape, portrait and coastal painter in watercolour; illustrator. He was born at GATESHEAD, the son of a commercial artist, and after leaving school was apprenticed to an art studio in Manchester. He attended art classes at Manchester, and later King's College (now Newcastle University), before taking up an appointment at a leading department store at NEWCASTLE, as a staff artist. After twenty-two years at the store he left to become a full-time professional easel painter with his own gallery at TYNEMOUTH. He continued with the gallery until his death in 1992, meanwhile establishing a reputation as a popular painter of Northumbrian, Scottish, Lake District and North Yorkshire landscapes, and local seascapes. Moore first exhibited his work before leaving his employment with the department store, in 1970, showing an example at the Federation of British Painters exhibition at Pall Mall, London. He later exhibited at the Royal Institute of Painters in Water Colours; the Bondgate Gallery, ALNWICK; Ilkley Winter Gardens, and on a continuous basis in his own gallery. Many examples of his work hang in the boardrooms of local banks and other businesses, and have been purchased by prominent people for their homes. It has also been reproduced as prints, a practice which continues at his one-time gallery, now run by his son.

Ronald Lambert Moore,
Bamburgh Castle,
watercolour, 53 x 71cm.
Private collection.

A retrospective exhibition of his work was held at the gallery in 2002 to mark the tenth anniversary of his death. Moore was for many years a member of the British Water Colour Society.

MORGAN, Frederick W (b.1860)

Architectural and landscape draughtsman. Originally an architect's assistant, Morgan became a photographer, picture framer and art dealer with a business in DURHAM. He was also a prolific spare-time artist, who sketched extensively around the county and published some of his drawings. One of his sketchbooks in the possession of the Royal Institute of British Architects was included in the *Durham Cathedral Artists & Images* exhibition staged by Durham County Council in 1993 at Durham Art Gallery, DURHAM, to celebrate the 900th anniversary of Durham Cathedral. The Laing Art Gallery, NEWCASTLE, has a collection of his drawings of the city.

MORTON, Andrew (1802–1845)

Portrait, figure and landscape painter in oil and watercolour. He was born at NEWCASTLE, the son of ship owner Joseph Morton, and elder brother of Thomas Morton, the surgeon. He left NEWCASTLE for London at an early age to enter the Royal Academy Schools, where in 1821 he gained a silver medal, with the Discourses of Barry, Opie and Fuseli, for the best copy of Raphael's *A Madonna and Child*. From 1821 he exhibited at the Royal Academy; the British Institution and the Suffolk Street Gallery, mainly showing portraits. He also exhibited his work at NEWCASTLE, showing portraits, and occasional landscape and genre works, at the Northumberland Institution for the Promotion of the Fine Arts, and the Northern Academy. While working at NEWCASTLE in 1826, he also showed one work at the Carlisle Academy. Morton's work in portraiture has been likened to that of Sir Thomas Lawrence, the Royal Academician, and

Andrew Morton, *H.M. King William IV in the uniform of the Admiral of the Fleet*, 1832, oil, 279 x 179.8cm. Private collection.

one-time president of the Academy, and enabled him to build up a considerable demand for his work in London. Many distinguished men and women sat for him, including William IV, Sir James Cockburn, and Marianna, Lady Cockburn, Marianna Augusta, Lady Hamilton, and the Duke of Wellington. His portrait work also embraced several Northumbrian celebrities, among these Dr Charles Hutton, painted for the Literary and Philosophical Society, NEWCASTLE, and Thomas Bigge, Mayor of NEWCASTLE. He died in London. Represented: National Portrait Gallery; Scottish National Portrait Gallery; Tate Gallery; Laing A G, Newcastle; Literary and Philosophical Society, Newcastle; Newcastle Central Library.

MORTON, George (1851–1904)

Portrait and genre painter in oil and watercolour. Morton was born at HOUGHTON LE SPRING, and at the age of fifteen moved to NEWCASTLE to attend the Government School of Design, under William Cosens Way (q.v.). In 1873 he moved to London and entered the Royal College of Art, where he was very successful in his studies. He afterwards attended the Royal Academy Schools, where he is said to have been equally successful in pursuing his studies. In 1879 he began to exhibit his work at the New Water Colour Society (later the Royal Institute of Painters in Water Colours), and by 1884 had commenced exhibiting at the Royal Academy, and the Suffolk Street Gallery, at the former showing *A Gentle Breeze*, and at the latter, *Idleness*. He remained an exhibitor at the Royal Academy until his death, also exhibiting his work at the Royal Hibernian Academy; the Royal Institute of Oil Painters; the New English Art Club, and at various London and provincial exhibitions, including the Bewick Club, NEWCASTLE. During the last seven years of his life Morton held the position of deputy principal of the Royal College of Art. His *After the Bath* was purchased by Queen Victoria. He died at London. The Laing Art Gallery, NEWCASTLE, has his oil: *A portrait study*.

MOSSMAN, David (1825–1901)

Miniature painter; landscape and genre painter in watercolour. Mossman was born at NEWCASTLE, and first began practising as an artist in his native town, where among his earliest exhibits were the portrait miniatures which he showed at the North of England Society for the Promotion of the Fine Arts, 1852. In the following year, and still practising at NEWCASTLE, he sent his first work to the Royal Academy, exhibiting a portrait miniature of Sir John Fife. He continued to work on Tyneside for the next ten years, during which period he continued to exhibit his miniatures at the Academy, and in 1857 commenced exhibiting genre works at the Suffolk Street Gallery. By 1863 he had moved to London, remaining there until late in his life, and exhibiting his work at the Royal Academy; the Royal Hibernian Academy; the Royal Institute of Painters in Water Colours; the Royal Society of British Artists, and occasionally at NEWCASTLE, notably at the 'Exhibition of Paintings and other Works of Art', 1866, and the Royal Jubilee Exhibition, 1887. While

based in London he evidently paid several visits to his native Northumbria, one of his works produced on such an occasion being the *Turret at Blackcarts Farm*, 1875, which, together with a view of TYNEMOUTH, and a portrait of builder Richard Grainger, forms the collection of his watercolours in the Laing Art Gallery, NEWCASTLE. It is believed that he died in London.

MUIR, Charles (b.1898)

Botanical painter in watercolour. Muir practised as an artist at SUNDERLAND for much of the 20th century following a brief period in the USA assisting Walt Disney in the early development of his Mickey Mouse cartoon character. It is believed that he subsequently worked as a commercial artist on Wearside, but spent more than forty years seeking out and drawing wild plants and flowers around Britain as a hobby. By the age of seventy-seven he had amassed more than 1,000 drawings, of which a selection were shown in a one-man exhibition held at Sunderland Art Gallery, in 1976. His watercolours *Foxgloves*, and *Borage* are represented in the collection of this gallery.

MURIS, George (b.1914)

Landscape painter in oil. Muris was born at NEWCASTLE and worked as an errand boy, salesman, tailor's cutter and window-dresser before serving in the RAF during the Second World War. On leaving the RAF he settled briefly on Tyneside then decided to emigrate to South Africa, where he opened a business and at the age of thirty-two began to paint. In Durban he contacted C R D'Oyly John, the well-known South African palette knife artist, from whom he received tuition in what had formerly been his hobby. He quickly adopted John's technique, and on returning to NEWCASTLE after a few years, and opening a garage in the city, he began to develop his own distinctive style of palette knife painting. His work soon became popular and was regularly exhibited and sold by Tyneside art dealers Mawson Swan & Morgan over many years. Much of it featured scenes in the Channel Islands and the nearby French Coast, painted while living on his yacht there. Two of his typical sunlit landscapes were reproduced and sold as prints by the Medici Society. Muris attracted considerable publicity during his period of popularity as an artist at NEWCASTLE, some newspaper reports implying that he was born in the year quoted; some in 1916. The date at the head of this entry was calculated from an account of his life in the *Evening Chronicle*, NEWCASTLE, 9th August 1954. Among his few known exhibits in public galleries was his *Old Tree: South of France*, shown at the Artists of the Northern Counties exhibition at the Laing Art Gallery, NEWCASTLE, in 1955.

MURRAY, Andrew (1859–1943)

Amateur landscape painter in watercolour. Born at SUNDERLAND, Murray took up employment in a local sawmill as a boy, remaining there for some sixty years. During this period he painted widely in the North of England, and Scotland, and exhibited his work on several occasions at the Artists of the

Northern Counties exhibitions at the Laing Art Gallery, NEWCASTLE, and with the Stanfield Art Club, SUNDERLAND. He served for many years as secretary, and later chairman of the Club, and remained actively interested in artistic matters until his death at SUNDERLAND in 1943.

MURRAY, Edward (1924–2002)
Amateur portrait, still life and landscape painter in oil, watercolour, pastel and acrylic. Murray was born at Oldham and at the age of fourteen was apprenticed as a sheet metal worker. When he was thirty he decided to fulfil a long held ambition to paint, and enrolled at Oldham Art School. Three years later he decided to move to SUNDERLAND to take employment with a local crane manufacturer, and once settled there joined Sunderland Art Club. He also began attending evening classes at Sunderland Art College, and studied at weekend schools. Within three years he had begun exhibiting his work at international amateur art exhibitions in London, and in 1974 he was given a one-man exhibition at Sunderland Art Gallery. He subsequently showed his work at various exhibitions in London, and widely in Northumbria until his death at NEWCASTLE in 2002. Among his London exhibits were those shown at the Pastel Society in 1980 and 1982, while those in Northumbria included the Laing Art Gallery, NEWCASTLE, in 1986 and 1996; the University Gallery, University of Northumbria, NEWCASTLE, in 1998, and Middlesbrough Art Gallery in 2000. He also showed his work at various exhibitions of Sunderland Art Club, and the Federation of Northern Art Societies throughout his life at SUNDERLAND, and received several awards and prizes for his work. Although initially an amateur artist Murray increasingly relied on his income as a professional following redundancy from his work, and received a number of portrait commissions.

MUSS, Boniface (c.1758–after 1805)
Landscape and portrait painter in oil and watercolour; drawing master. Muss was born in Piedmont, Italy, and following some success as a painter in his native country decided to emigrate to England. Arriving in London some time before 1779, he remained in the capital until 1790, when he sent a work to the Society of Artists exhibition of that year *Landscape and ruins; Drawing*. In the latter year, if we are to believe Eneas Mackenzie, in his *History of Newcastle* (Volume II, page 579) Muss moved to NEWCASTLE 'with very respectable recommendations', and was here 'well patronised as a painter and drawing master'. It would appear that his main claim to fame was in the latter activity, for he was teacher of drawing not only to his son, Charles Muss (q.v.), later well known as an enamel painter, but to William Nicholson (q.v.), John Dobson (q.v.), and John Martin (q.v.), as well as the lesser known William Hodgson (q.v.). Muss's studio was in the attic of his lodgings at Newgate Street, NEWCASTLE, and here he also taught fencing and Italian. 'Though extremely indolent, he was a skilful artist', says Mackenzie, 'and a generous, liberal minded man, and was particularly anxious to foster rising genius'. His living in NEWCASTLE (and for some time at GATESHEAD, at which he lived and practised in 1801), was too precarious, however, and when his son Charles took a job as a china painter in London in 1805, he decided to join him there. His second period in London is as poorly documented as his first, and it is not known when, and where, he died. His daughter is said to have been artistic, and according to Mackenzie: 'painted and etched several local views', while living at NEWCASTLE. Her view of Fenham Hall may be seen in Hodgson's *History of Northumberland*.

MUSS, Charles (1779–1824)
Enamel and miniature painter; etcher; stained glass designer. Muss was probably born in London, some time after the emigration to England of his father Boniface Muss (q.v.), from Piedmont, Italy. At the age of eleven he moved with his family to NEWCASTLE, where he received tuition in drawing and enamel painting from his father. Towards the end of his ten-year stay in the town he began to practise as a miniature painter, experimenting in enamel painting in his spare time. In the early part of 1800 he moved to London, hoping to succeed as a professional artist in the capital. Later in the same year he sent his first work to the Royal Academy, *Dunkeld Cathedral*, following this in 1802 by exhibiting two miniatures: *Portrait of an Artist*, and *Portrait of a Lady*. He exhibited a further work at the Royal Academy in 1803, *Psyche*, but finding it increasingly difficult to succeed as a miniature painter and occasional enameller, he two years later took a job as a china painter in London, eventually intending to set up on his own. About 1807 he started a business with a partner, later taking on as a pupil John Martin (q.v.). An exhibition which he put on in Bond Street failed, however, and he was obliged to enter the stained glass workshop of William Collins, in the Strand. His work for Collins was highly regarded, specimens being used at St Bride's in London's Fleet Street, and at Brancepeth Castle, near DURHAM. Muss retained his interest in enamel painting throughout his early years in London, and produced several examples for George III. Following his success in exhibiting work at the Academy from 1817, he was appointed enamel painter to George IV, while Regent. Most of his Academy exhibits from 1817, until he last exhibited in the year before his death, consisted of enamel copies of works by leading Continental and English artists. Several of his enamels were of large proportions, his *Holy Family*, after Parmigianino being described as the 'largest enamel ever painted'. This work was purchased by George IV for 1,600 guineas. He left several enamels unfinished on his death in London in 1824, which were later finished by John Martin. The National Portrait Gallery, London, has his enamel after Sir Thomas Lawrence, the Royal Academician, of Sir Francis Baring Bt, measuring 30.5 × 23cm. Thirty-three original designs for Gay's *Fables*, drawn and etched by Muss, were published in the year following his death. His sister was also a painter and etcher of some ability.

N

NEIL, Shirley (1949–1998)

Still life, landscape and figure painter in oil, water-colour and gouache; printmaker; etcher; art teacher. She was born at WALLSEND, near NEWCASTLE, and on leaving high school attended Hornsey College of Art, London. She followed this by studying for a bachelor of education degree in Art and English at the Northern Counties College, and a BA (Hons) in Fine Art at the University of Northumbria, NEWCASTLE. On leaving the University she became a part-time lecturer at Sunderland College of Art, and various other local colleges, combining this initially with work as a graphic artist with a Tyneside company. In 1983 she decided to become a self-employed artist, lecturer and picture framer. Neil first began exhibiting her work in 1978, showing at group exhibitions both in Northern Ireland, and at various Northumbrian venues, including the Vicarage Cottage Gallery, NORTH SHIELDS; the Queen's Hall, HEXHAM; the Clayton Gallery, NEWCASTLE, and Design Works, GATESHEAD. She later participated in many other group exhibitions and had a number of one-man exhibitions, including among the former, Crane Arts, London, 1979–82; Northern Young Contemporaries, Manchester, 1980; the Watercolour Gallery, Berkeley, California, USA, 1982–1984; Castlegate House Gallery, Cockermouth, Cumbria, 1991; the Silver Longboat Art Competition, DARLINGTON, 1994; the Laing Collection, Mall Galleries, London, 1992–1994; the Middlesbrough Open, Middlesbrough Art Gallery, 1995–1996; the Royal Scottish Society of Painters in Watercolour, Edinburgh, 1996, and 'Two Obsessions', Bede's World, JARROW, near SOUTH SHIELDS, 1996–1997. Her first one-man exhibition was at the Bondgate Gallery, ALNWICK, in 1979, others following at various galleries in Northumbria and Scotland, including the Calouste Gulbenkian Gallery, People's Theatre, NEWCASTLE, 1982; the Shore Gallery, Leith, Edinburgh, 1983;

Browns Gallery, NEWCASTLE, 1991; Hanover Fine Arts, Edinburgh, 1994, and the Laing Art Gallery, NEWCASTLE, 1998. Entitled *All the Fear of the Fair*, the latter exhibition was staged close to her death at her long-time home at STAMFORDHAM, and in a departure from her still life and landscape painting included many imaginative compositions embodying fairground motifs and figures. During her brief career as an artist she won a number of awards for her work, including two for her watercolour *Memories of Spring*, at the Alnwick Visual Arts 'Arts of North' open exhibition in 1995. A founder-member of the Tynedale Artists' Network and keen participant in all its exhibitions and tutorial activities, the group helped finance a booklet on her life and work in 2001, and a major retrospective at the Queen's Hall, HEXHAM, in 2002. She once said: 'My paintings celebrate the special aura I perceive in simple objects I live with and handle every day,' this leading her to become one of the most productive and accomplished painters of still life practising in Northumbria in the late 20th century.

NESBIT, Charlton (1775–1838)

Wood engraver; illustrator, Nesbit was born at SWALWELL, near GATESHEAD, the son of a keelman, and was apprenticed to Ralph Beilby (q.v.), and Thomas Bewick (q.v.), at NEWCASTLE, in 1790, at the age of fourteen. While working for the partners he contributed a number of cuts to Bewick's *Birds*, 1797, the *Poems of Goldsmith and Parnell*, 1795, and *Le Grand's Fabliaux*, 1796 and 1800. His most notable work in engraving, however, was executed shortly after leaving Beilby and Bewick, and consisted of what was then described as one of the largest wood engravings ever attempted. His subject was *A North View of St Nicholas' Church*, painted by his late friend Robert Johnson (q.v.), and was engraved for the benefit of Johnson's aged parents, while Nesbit was still resident and working at NEWCASTLE. The cut was published in London in 1798, and earned Nesbit

Shirley Neil,
The White Candle,
watercolour,
23 x 30.5cm.
Private collection.

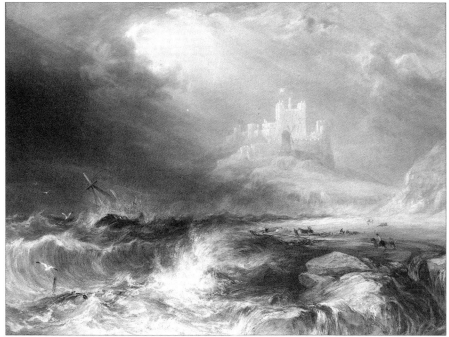

William Andrews Nesfield, *Bamburgh Castle, Northumberland*, watercolour, 53 x 70cm. Victoria and Albert Museum.

the lesser silver palette of the Society of Arts, and later its silver medal. Shortly after its publication Nesbit moved to London, where he is said to have 'found the art of engraving in a miserably low state'. Here, thanks to an early association with John Thurston, who allowed Nesbit to cut his designs, he quickly established a reputation as a fine reproductive engraver, and remaining in the capital until 1815, executed much fine work, notably for Ackermann's *Religious Emblems*, 1809. Following his return to SWALWELL, he continued engraving, though technically retired, thanks to an inheritance, and contributed cuts to Puckle's *The Club*, 1817; Emerson Charnley's edition of the *Select Fables*, 1820 (a portrait of Bewick drawn on the wood by William Nicholson (q.v.), and engraved by Nesbit as the frontispiece), and Northcote's *Fables*, 1828 and 1833. In 1830 he decided to return to the capital, and settling at Brompton, died there in 1838. Although his main success stemmed from his ability to interpret as wood engravings the designs on wood executed by leading artists of his day, Nesbit was evidently inventive in his work, and is credited with the introduction of cross-hatching, which it was imagined could not be done on wood. There is some suggestion also that he might himself have been capable of designing illustrations. Represented: Newcastle Central Library.

NESFIELD, William Andrews, OWS (1794–1881)
Landscape painter in watercolour. He was born at CHESTERLESTREET, the son of a local rector, and was educated at Winchester, Trinity College, Cambridge, and Woolwich. He entered the army in 1809, and served in the Peninsular War under Wellington, and in Canada as aide-de-camp to Sir George Drummond. He retired from the army in 1816 on half-pay as a lieutenant, and taking up watercolour painting became so successful in his handling of the medium that he was elected an associate of the Old Water Colour Society (later the Royal Society of Painters in Water Colours) in the February of 1823, and in the June of the same year became a member. He exhibited with the Society from the year of his election as member, until 1851, showing some ninety-one works. The subjects of these works suggest that he made visits in this period to the Alps, Scotland, Wales. Yorkshire and Ireland, as well as to his native Northumbria. Nesfield was also a member of a party of artists who stayed at the Bolton Arms, near Bolton Abbey, Yorkshire, in 1844, in the company of David Cox. Apart from his occasional visits to Northumbria to paint. Nesfield was also an occasional exhibitor in the area; he was, for instance, among the many well-known local artists such as Thomas Miles Richardson, Junior (q.v.), John Wilson Carmichael (q.v.) and Luke Clennell, who exhibited at the First Water Colour Exhibition of the Newcastle Society of Artists, in 1836. On his retirement from the Old Water Colour Society in 1852, Nesfield took up the profession of landscape gardening, and is said to have been responsible for helping to lay-out public parks in London, the Botanical Gardens at Kew, and the gardens of Alnwick and Arundel castles. He won high esteem for his pictures of waterfalls, Ruskin in his *Modern Painters*, 1843, referring to him as: 'Nesfield of the radiant cataract'. Nesfield's date of birth has long been given as 1793, but research by Shirley Evans for her *Country Life* article on Nesfield's landscape work, 12th May, 1994, and the exhibition at Durham Library, DURHAM, later in that year to celebrate the bicentenary of his birth, indicates that he was born in 1794. He died at London. His son, WILLIAM EDEN NESFIELD, became a well-known architect, and author on architectural subjects. Represented: British Museum; Victoria and Albert Museum; National Gallery of Ireland; Laing Art Gallery, Newcastle, and various provincial art galleries.

NEUPER, Christian (b.1876)

Sculptor. He was born at Weissenstadt, in Bavaria, Germany, and studied at the Academies of Nuremberg and Carrare, before practising as a sculptor in NEWCASTLE. He first exhibited his work shortly after setting up his studio in the city's Eldon Square, showing examples at the Artists of the Northern Counties exhibitions at the Laing Art Gallery, NEWCASTLE, from their inception in 1905. Over the following decade he exhibited a number of portrait busts at the Gallery, these including several well-known Northumbrian personalities of the day, such as Alderman H W Newton JP (1905); Richard Welford (1910); Lord Joicey (1911), and Sir H W Newton MP (1913). He also exhibited figure, bird and animal studies in plaster. One of his most important commissions was a bust of Alexander Laing (1828–1905), founder of the Laing Art Gallery. This was completed and presented to the Gallery in 1906 by 'his fellow citizens to commemorate the generosity of the donor in presenting the Laing Art Gallery to his adopted city'. Neuper was interned during the First World War and at its conclusion returned to his native Germany. His second studio, close to that of Ralph Hedley (q.v.), in the Haymarket, NEWCASTLE, was continued in the hands of JOHN EDWARD MARSHALL (b.1874), until the latter's death in 1946/7. The Laing Art Gallery has other examples of Neuper's work apart from the bust of Laing referred to earlier.

Christian Neuper, *Alexander Laing*, 1906, marble, 73.1 x 63 x 40cm.Tyne & Wear Museums, Laing Art Gallery.

NEVILLE, Herbert W (born *c*.1875)

Landscape painter in oil and watercolour; illustrator; art teacher. He was the brother, or son, of Hastings Mackelcan Neville, sometime rector of FORD, and author of several books associated with the village. His place of birth is not recorded, but by the closing years of the 19th century he was practising at NEWCASTLE, following which, and living successively at CORNHILL, Skipton, Yorkshire, Lymington, Hants, and Birlingham, Worcs., he exhibited his work at the Royal Academy; the Royal Institute of Painters in Water Colours; the Royal Institute of Oil Painters; the Royal Society of British Artists, and at various provincial exhibitions. Among his provincial exhibits were those shown at the Bewick Club, NEWCASTLE, and later the Artists of the Northern Counties exhibitions at the city's Laing Art Gallery. Some of his work is reproduced in Hastings Mackelcan Neville's *A Corner in the North; yesterday and today with Border folk*, 1903. This work was reprinted by Frank Graham in 1980.

NEWTON, George Henry (1825–1900)

Landscape and genre painter in oil and watercolour; art teacher. He was born at DURHAM, and after displaying a talent for drawing at an early age was placed as a student at the Royal Academy Schools, where he studied under F S Carey. He later studied at the Schools of the Department of Science & Art, in London, then returning to DURHAM he secured an appointment as master at the city's School of Art. He remained at the School from 1853 until his retirement, and became a regular exhibitor in London and the provinces. He exhibited at the Royal Academy and the Suffolk Street Gallery from 1858, at the former showing *The Village Lane*, (1858), and *The Fall of the Tees at Wynch Bridge*, (1859), and at the latter, a wide variety of Durham, North Yorkshire and Welsh views in watercolour. His provincial exhibits included his *Confidence and Timidity* genre work, and two Welsh Views, shown at the 'Exhibition of Paintings and other Works of Art', at the Town Hall, NEWCASTLE, in 1866. He died in London.

NICHOLSON, Alice M (1854–after 1890)

Fruit, flower and still-life painter in oil and watercolour. She was born at GATESHEAD, the daughter of a clerk, but later moved with her family to NEWCASTLE, where she pursued her education until she was eighteen. She had shown a remarkable talent for drawing from her childhood, and when she left school she studied for a time at the School of Art, at NEWCASTLE, under William Cosens Way (q.v.). When she left the School she decided to become a full-time professional artist, and with the blessing of her father, set up a studio in the Haymarket area of the town. She first began exhibiting her work in 1878, showing one work at the Arts Association, NEWCASTLE. She again exhibited at the Association in the following year, and by 1880 had commenced exhibiting outside Northumbria, showing works at the Royal Academy; the Royal Scottish Academy; the Royal Hibernian Academy; the Royal Society of British Artists; the Royal Society of Painters in Water Colours, and the Society of Women

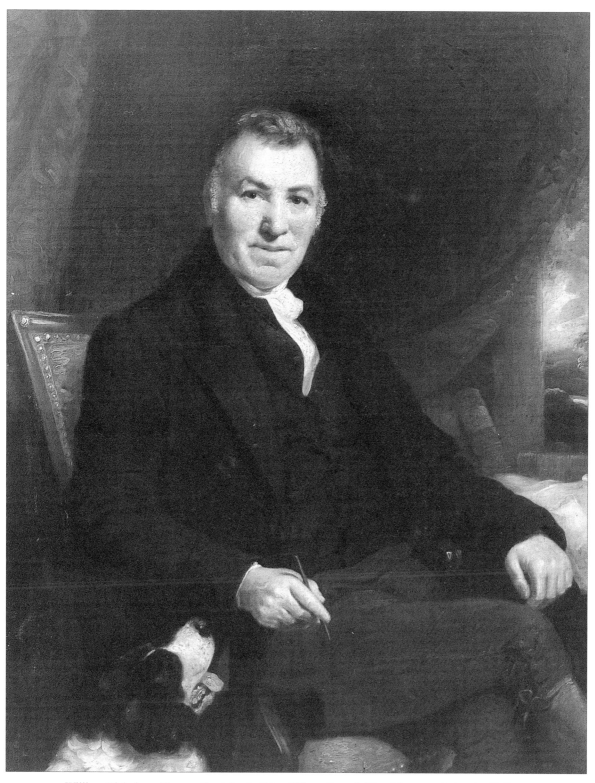

William Nicholson, *Thomas Bewick*, oil, 126 x 100cm. Tyne & Wear Museums, Laing Art Gallery.

Artists. She was also an exhibitor at later exhibitions of the Arts Association, and showed work at the 'Gateshead Fine Art & Industrial Exhibition', in 1883, and later the exhibitions of the Bewick Club, NEWCASTLE. Her Royal Academy contributions were *Herrings* (1884), and *Brambles* (1888). It is believed that she died at NEWCASTLE.

NICHOLSON, Charles Herbert (1900–1960)

Amateur marine, coastal and landscape painter in oil and watercolour. Nicholson was born at BLYTH, and became a master mariner and later a marine superintendent, painting in his spare time. He was largely a self-taught artist, but achieved considerable competence in his work, exhibiting examples at the Royal Academy; the Royal Scottish Academy; the Royal Society of Marine Artists, and the Artists of the Northern Counties exhibitions at the Laing Art Gallery, NEWCASTLE. He was also an exhibitor at the 'Contemporary Artists of Durham County' exhibition at the Shipley Art Gallery, GATESHEAD, staged in 1951 in connection with the Festival of Britain; his exhibits were *Thames Barges*; *Beauty Passes*, and *The River*. He was a member of the Newcastle Society of Artists, although his home was for many years at NORTH SHIELDS. He died at NORTH SHIELDS. His wife DOROTHY TARRANT NICHOLSON was also artistically gifted, and exhibited her work. Represented: North Tyneside Public Libraries, North Shields.

NICHOLSON, Isaac (1789–1848)

Wood engraver. Born at Melmerby, Cumbria, Nicholson moved at the age of fifteen to NEWCASTLE, to become a pupil of Thomas Bewick (q.v.). He remained with Bewick until 1811, subsequently practising at NEWCASTLE, and closely following the style of his former master without ever equalling Bewick's ability in wood engraving. Bewick had to take Nicholson to task for copying his work, but despite this circumstance was generous enough in his autobiographical *Memoir*,‡ to describe his former apprentice as '. . . a good Apprentice & a good Artist – his engravings on Wood are clearly or honestly cut, as well as being accurately done from his patterns . . .'. Much similarity between his work and that of Bewick is to be seen in the tailpieces which he engraved for Charnley's *Select Fables*, 1820, many of which later appeared in this publisher's *Fisher's Garlands* for various years. Indeed, because so many of these portrayed riverside scenes they are commonly but inaccurately attributed to Bewick. His best known work consists of his wood engravings for Sharp's *History of the Rebellion*. He also did work for Flower's *Heraldic Visitation of the County of Durham*; Watt's *Hymns*, and Defoe's *Robinson Crusoe*. Ebenezer Landells (q.v.), and Thomas Kerr Fairless (q.v.), both studied wood engraving under Nicholson.

‡ See p. 200, *A Memoir of Thomas Bewick, Written by Himself*, 1862; edited and with an introduction by Iain Bain. Oxford University Press, 1975.

NICHOLSON, John George (1895–1985)

Amateur landscape painter in oil and watercolour. He was born at NEWCASTLE and worked in the treasurer's department of the city council most of his life, only painting in his spare time. He is believed to have taken art lessons at evening classes held at Armstrong College (later King's College; now Newcastle University) but is not known to have exhibited his work. However, a substantial sale of his oils at auctioneers Anderson & Garland, NEWCASTLE, in 1994, revealed a considerable talent for landscape painting in the style of Alfred de Breanski, Senior, and with a similar choice of subject matter. He died at his home for many years, at HEATON, in the east end of NEWCASTLE.

NICHOLSON, Peter (1765–1844)

Architectural draughtsman. He was born at Prestonkirk, East Lothian, Scotland, and after training as an architect had moved to MORPETH by 1829. Following the death of his wife in 1832 he moved to NEWCASTLE to practise in his profession and began to take a keen interest in the artistic affairs of the town. This resulted in his presidency of the Newcastle Society for the Promotion of the Fine Arts in 1835, and later his teaching in its classes of architectural drawing, geometry and perspective 'to young and intelligent builders and engineers'. Nicholson occasionally exhibited his work while at NEWCASTLE, both with the Newcastle Society for the Promotion of the Fine Arts, and at the first Newcastle Society of Artists Water Colour Exhibition in 1836. After leaving NEWCASTLE he moved to Carlisle, where he died in 1844.

NICHOLSON, William, RSA (1781–1844)

Portrait, genre and landscape painter in oil and watercolour; miniature painter; etcher. Nicholson was born at OVINGHAM, the son of a schoolmaster, but shortly afterwards moved with his family to NEWCASTLE, where he was educated at the town's Grammar School. On leaving school he went to work for a stationer in the town, but showing a marked talent for drawing was allowed by his father to become a pupil in the studio of Boniface Muss (q.v.), at NEWCASTLE. Here he made rapid progress in learning perspective drawing and enamel painting from Muss, and perhaps encouraged by the example of his master's son, Charles Muss (q.v.), began painting miniatures. Within a short time he had attracted several commissions in this line, but feeling that his prospects as a miniature painter might prove better at Hull, he moved there with his engraver brother, and was soon at work painting miniatures of local army officers. Later, however, he began to work on a larger scale, and returning to Tyneside, he set up as a portrait painter in oil, sending his first contribution in this medium to the Royal Academy from NEWCASTLE in 1808: *A group of portraits, etc.; servants of C. J. Brandling, Esq., M. P., Gosforth House, Northumberland*. Six years later, and having exhibited a further two portrait works at the Academy, he decided to leave NEWCASTLE, and seek his fortune in Edinburgh. Here his first task, as he communicated in

John George Nicholson,
A Shepherd and his flock
by a Highland Loch,
oil, 23 x 34cm.
Private collection.

a letter to the Rev John Hodgson, sent from Edinburgh July 3rd, 1814, was to accumulate portraits of 'public characters' for the first exhibition of the Edinburgh Exhibition Society. 'It takes a long time to get known and connected here', he confided in Hodgson. 'They have elected me a member of the Society of Artists, which will enable me to get my pictures better placed in the Exhibition. My election I consider fortunate as the number to which the Society is limited is now full. If I once get connected here, which I flatter myself I shall be able to do, there is a much greater field here than in Newcastle.' Nicholson's faith in his ability to make good his position as a painter in Edinburgh was to prove fully justified. Within a few years of settling there he had painted many of Scotland's leading men and women, and later became a founding member of the Scottish Academy, as well as serving as its first secretary from 1826–30. Throughout his career in the Scottish capital, however, he never lost touch with his native Tyneside, and, indeed, executed many portrait commissions in the area. Two such portraits, painted before he left NEWCASTLE, in fact helped pave the way for his acceptance as a portrait painter in Scotland when they were shown at the Edinburgh Exhibition Society in 1814; those of Thomas Bewick (q.v.), and the Rev John Hodgson, both of which he later wrote to Hodgson, 'have been much noticed'. In 1816 he exhibited this same portrait of Bewick at the Royal Academy, and in 1829 sent for exhibition to the Northern Academy, NEWCASTLE, his portrait of George Gray (q.v.). Other well-known Northumbrians included amongst his sitters were John Trotter Brockett, and Robert Doubleday. He exhibited at NEWCASTLE throughout his stay at Edinburgh, and though famous on Tyneside for his oil portraits of local celebrities, and the engravings made of these, it was for his portraits in pencil and watercolour, and his etched likenesses in *Portraits of Distinguished Living*

Characters of Scotland, 1818, that he became best known in Edinburgh. His reputation as a portraitist has, however, tended to obscure the fact that he was an able landscape painter. Some of his earliest work was in this field (an example is his *The Demolition of Houses on the Site of Collingwood Street, Newcastle upon Tyne c.*1808, in the collection of the Laing Art Gallery, NEWCASTLE); while at the Royal Scottish Academy from its establishment in 1839, until his death at Edinburgh in 1844, he mainly showed landscapes. Represented: Victoria and Albert Museum; National Gallery of Scotland; Scottish National Portrait Gallery; Laing A G, Newcastle; Newcastle Central Library; Natural History Society of Northumbria, Newcastle.

NIXON, G Clement (1898–1975)
Amateur landscape and coastal painter in oil and watercolour. Nixon lived at WHITLEY BAY, and later nearby MONKSEATON, all his life, and was a keen amateur painter of local landscape and coastal subjects. He also exhibited his work, showing examples at the Artists of the Northern Counties exhibitions at the Laing Art Gallery, NEWCASTLE, from 1916 until late in his life. His exhibits at NEWCASTLE in 1916 were *Morning*, and *Rough Weather – North-East Coast*. He was friendly with many well-known Northumbrian professional artists, including John Atkinson (q.v.), John Falconar Slater (q.v.), and George Edward Horton (q.v.), and was a member of the North East Coast Art Club, WHITLEY BAY, and the Newcastle Society of Artists. He died at MONKSEATON.

NOBLE, Michael (1919–1993)
Sculptor; painter in oil and tempera; draughtsman; potter. Noble was born at SOUTH MOOR, near STANLEY, and although gifted as a sculptor from an early age chose journalism as his first employment. At the age

of sixteen he joined the staff of the *Evening Chronicle*, NEWCASTLE, as a junior reporter at its office at DURHAM, then two years later went to the *Manchester Evening News* as a reporter and music critic. He then set his sights on Fleet Street and hitchhiked to London. Failing to get work as a journalist in the capital, however, he decided to employ his skill in painting and drawing by producing portraits in city cafes. He pursued this successfully until the outbreak of the Second World War, when he joined the army as a private. He became a major by the age of twenty-three and was seconded to the Foreign Office, and made head of its Psychological Warfare Branch with the special brief of restoring the press of Northern Italy, devastated by the war. His work in this respect proved outstandingly successful and in Florence he provided the first independent newspaper, and raised funds to revive the city's symphony concerts. Its corporation fêted him for this work and presented him with an illuminated parchment: 'To Major Noble of the Buffs'. While in Florence he also returned to art, holding his first exhibition of drawings there in 1947. One of his exhibits was a drawing lent by Bernard Berenson, the famous art historian, who had long lived in Florence and befriended Noble. When Noble, now an ex-colonel, was offered a job in Fleet Street in 1949, Sir Robin Darwin, head of the Royal College of Art, persuaded him to accept a four-year scholarship to the College. Here he studied under professor of sculpture Frank Dobson, but insisted on leaving the College after a year so as to work on his own. In 1951 he impulsively returned to Italy and was soon exhibiting his work as a sculptor, showing examples in Milan, Venice, Turin, Florence and Rome to considerable critical acclaim. An exhibition at the gallery of Cordier and Ekstrom, New York, in 1967, introduced his small, semi-abstract sculptures in Connemara marble to the American art world and were hailed by the *New York Times* as those of a sculptor 'in the top rank'. Noble continued to live and work in Europe for the remainder of his career, with homes in Italy and France. He never lost his early love of the Connemara marble with which he had made his debut in the USA, and used it almost exclusively for his later work. Some of these later works were sold in various European countries, and he also exhibited extensively. One of the more important exhibitions of his later life opened in Marseilles, France, in 1977, and visited major towns in that country. A later and even more important exhibition was that held at the Rotunda, the gallery of modern art, Milan, in 1987, when he was living and working at Grasse, in the south of France. He subsequently maintained homes and studios at both Grasse, and a mountainside location near Lucca in Italy, dying of cancer at the former, in 1993. Noble's reputation as a sculptor has not yet been fully established. It was recognised by his election to the Academy Tiberina, Rome, in 1968 (he was the first Briton to be elected and one of only seven non-Italians since its foundation in 1813), but it had languished sufficiently by 1989 for Robert Pincus-Witten to describe him in an article published in the March of that year in *Arts Magazine*

as a 'Neglected Sculptor'. Indeed he referred to Noble as 'the least known sculptor of his generation', notwithstanding the Milan exhibition of 1987, which was accompanied by a lavishly illustrated catalogue. Little has been done since to establish his entitlement to be regarded as one of the most original British sculptors working in Europe in the second half of the last century, even although his work occupies a number of outdoor sites in Italy and France, including among the latter his *Bird Bath* on the banks of the Seine, in Paris. Examples are also held by several European museums and galleries. His work as a potter is even less widely known than his sculpture, despite his having been twice winner of the Palladium Prize at the International Salon for Ceramics, Vincenza, Italy.

Michael Noble, *Le Trou*, 1973, Connemara marble, 80 x 45 x 22cm. Private collection.

NOBLE, John Rushton (b.1927)

Landscape painter in watercolour; illustrator; art teacher. Born at GATESHEAD, Noble studied art at King's College (now Newcastle University) before teaching for some time at the Technical College in his native town. On leaving the College in 1953 he appears to have practised as a painter, commercial designer and illustrator for the remainder of his career, exhibiting his paintings at the Royal Society of British Artists; the Royal Institute of Oil Painters; the Artists of the Northern Counties exhibitions at the Laing Art Gallery, NEWCASTLE, and in Europe and the Americas. He also handled a substantial amount of illustrative work for Northumbrian magazines. His home was for many years at NEWFIELD, near BISHOP AUCKLAND.

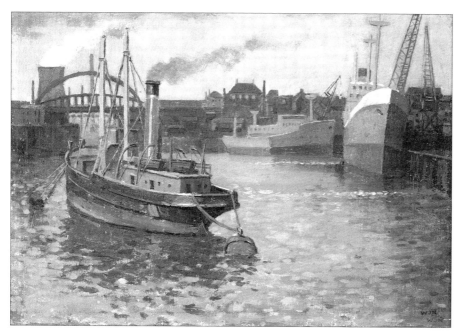

Walter John Norman,
Shipping at Sunderland,
oil, 31 x 46cm.
Dean Gallery.

NORMAN, Walter John, ARCA (1912–1994)

Landscape and marine painter in oil and watercolour; art teacher. Norman was born at Gosport, Hampshire and studied at the Winchester School of Art; the Royal College of Art, and Goldsmiths' College School of Art before becoming appointed principal of the Ryland Memorial School, an art school at West Bromwich. In 1949 he took over as principal of Sunderland Art College, from Richard Archibald Ray (q.v.), and later took up a similar post at Liverpool Regional College of Art. While serving as principal at SUNDERLAND he exhibited his work at the Artists of the Northern Counties exhibitions at the Laing Art Gallery, NEWCASTLE, and showed two works at the 'Contemporary Artists of Durham County' exhibition staged at the Shipley Art Gallery, GATESHEAD, in 1951, in connection with the Festival of Britain. He also showed his work with the London Group; the New English Art Club, and the Royal Birmingham Society of Artists. During his time at SUNDERLAND his tall, commanding figure earned him the nickname 'The Captain'. The city's art gallery has his oils *Wear Tugs* (1952), and *River Wear* (1955), and watercolour *Porchester Castle*, and his work was included in an exhibition there in 1995. Represented: Sunderland A G; Gosport Museum & A G.

NORTH, Arthur and Frederick (fl. late 19th cent.)

Illustrators. Arthur North, together with his brothers Frederick and Herbert, published *The Northumbrian*, an 'Illustrated Society Paper', in NEWCASTLE, in the 1880s. Both Arthur and Frederick contributed illustrations to its pages, the former using the pseudonym 'ANT'. Much of their work featured cartoon subjects or social activities, but both artists also produced portraiture. 'ANT' sometimes collaborated with Ralph Hedley (q.v.), under Hedley's pseudonym 'Pendennis'. Other Northumbria artists who contributed illustrations to the paper during its short life included William James Hepper (q.v.), Charles Spicer (q.v.), and John Storey (q.v.). The paper was sold at a penny, and advertised its content as 'Humorous, Satirical, Critical'. Its circulation claimed to cover the Northern Counties but appears to have failed within a few years despite having obtained 'the valuable service of many leading artists in the North of England'.

NORTHBOURNE, Lord Walter John, RE (1869–1932)

Landscape painter in oil and watercolour; etcher. He was born in London, the son of Walter Henry, 2nd Lord Northbourne, and was educated at Harrow and Magdalen College, Oxford, before studying art under A D Cope in London, and the Royal College of Art School of Engraving. He spent most of his time between Eastry, Kent, and his home at OTTERBURN, and exhibited his work at the Royal Academy; the Royal Society of Painter-Etchers and Engravers; the New Gallery, and at various provincial exhibitions including those of the Artists of the Northern Counties at the Laing Art Gallery, NEWCASTLE. He also enjoyed a number of one-man exhibitions in London. His most distinguished work was in the field of etching, and he was elected a member of the Royal Society of Painter-Etchers and Engravers in 1912. He was also for some time president of the Newcastle Society of Artists, and the East Kent Art Society. Most of his work was submitted for exhibition as that of 'W. J. James', even after his succession to the title in 1923, and included many scenes around his home at OTTERBURN. Typical of these were his Royal Academy exhibits of 1905: *The River Rede*, and *Northumberland Moors*. The Laing Art Gallery, NEWCASTLE, has his watercolours *Cheviot*, and *Souvenir of Loch Ericht*.

O

O'BRIEN, Alfred Ainslie (1912–1988)

Townscape and landscape painter in oil and water-colour. O'Brien was born in SUNDERLAND, and later followed the occupation of painter and decorator, drawing and painting in his spare time. He soon developed a high level of competence in his work but only began exhibiting it outside his native town when he sent his oil *The Brew* to the Artists of the Northern Counties exhibition at the Laing Art Gallery, NEWCASTLE, in 1949. He continued to show his work at the Laing for several years and in 1962 shared an exhibition at the People's Theatre, Green Room, NEWCASTLE, with friend and fellow artist Alfred Cuthbert (q.v.). In 1968 he opened a gallery in his home at SUNDERLAND from which to sell his work, and in 1969 shared an exhibition at the Central Library, SOUTH SHIELDS, with Ronald William Thornton (q.v.). O'Brien's work was by now attracting considerable attention locally and in 1976 became the subject of a film by Miranda Films, NEWCASTLE. This coincided with a major exhibition of his paintings at the Bede Gallery, JARROW, near SOUTH SHIELDS, and was followed by a showing of his work at the Margaret Fisher Gallery, London, in 1977. The latter exhibition attracted national interest, the *Sunday Times* commenting: 'There can be few places on earth more bleakly banal than the back streets of an industrial town, and the back lane is surely the ultimate in visual nullity, or so we may have thought until Alf O'Brien taught us otherwise.' O'Brien's other work remained continuously on display at the Bede Gallery until his death at nearby SOUTH SHIELDS in 1988. The Gallery held a major exhibition of his work in the year following his death, as 'a tribute to his life and dedication to art'. Represented: South Shields Museum & A G. [See colour plate]

OGDEN, Rev J W (fl. late 19th, early 20th cent.)

Amateur landscape painter. Ogden settled at GOSFORTH, near NEWCASTLE, c.1900, apparently after his retirement as a clergyman, and contributed several works to the Artists of the Northern Counties exhibitions at the city's Laing Art Gallery, from 1906. His daughter, FANNY OGDEN, also painted, and exhibited her work at the Laing Art Gallery.

OGILVIE, Frank Stanley (c.1859–after 1935)

Portrait, genre and landscape painter in oil and watercolour. He was born at NORTH SHIELDS, the son, or nephew, of local salt manufacturer and whiting merchant, Joseph Ogilvie, and studied art in London, and at Bushey, Herts., at the school of Sir Hubert Von Herkomer, before practising as a professional artist. He first began to exhibit his work in 1885, showing examples in London, and at the Bewick Club, NEWCASTLE. His first exhibits of note, however, were shown at the Royal Academy and the Suffolk Street Gallery, in 1888, while he was at Herkomer's. His Academy exhibit was *The old, old story at Capri*, while at the Suffolk Street Gallery he showed another Continental subject, *A picturesque washing place*. Back at NORTH SHIELDS in the year in which these works were shown, he also exhibited at the Bewick Club, and remaining at his birthplace for the next three years, earned a considerable reputation as a portrait painter on Tyneside. Encouraged by this success he decided to practise in London, spending several years there, and at Letchworth, Herts., before returning to Northumbria, and settling first at TYNEMOUTH, later at NEWCASTLE. In this period he continued to exhibit at the Royal Academy, and also sent work to the Royal Scottish Academy; the Royal Society of British Artists; the Glasgow Institute of Fine Arts, and to various London and provincial exhibitions. He was a contributor to the Artists of the Northern Counties exhibitions at the Laing Art Gallery, NEWCASTLE, from their inception in 1905, until close to his death, showing among his several portraits, those of John Smales Calvert (q.v.), and Charles Napier Hemy (q.v.). He was the brother of Frederick Dove Ogilvie (q.v.). Represented: Dundee A G; Laing A G, Newcastle; Middlesbrough A G; Pen & Palette Club, Newcastle; South Shields Museum & A G.

OGILVIE, Frederick Dove (1850–1921)

Landscape and coastal painter in watercolour. He was born at NORTH SHIELDS, the son of local salt manufacturer and whiting merchant, Joseph Ogilvie, and worked in a solicitor's office before deciding to become a professional artist. He first began to exhibit his work in 1875, sending a coastal view, *Coldingham by the Sea, Berwickshire*, to the Suffolk Street Gallery. Two years later he exhibited at both the Royal Academy, and the Suffolk Street Gallery, at the former showing his *Winter*, and at the latter, *Tarbut – Loch Fyne*. He again exhibited at the Academy in 1878, shortly afterwards leaving NORTH SHIELDS for Scotland, where he practised successively at Edinburgh, Bonhill, Glasgow and Helensburgh, until the turn of the century, and exhibited his work at the Royal Academy; the Royal Scottish Academy; the Royal Hibernian Academy; the Royal Scottish Society of Painters in Water Colours, and at various London and provincial galleries. He also exhibited at the Bewick Club, NEWCASTLE, sending his first work in 1885, while working in Edinburgh: *The Wansbeck at Morpeth*. By 1901 he had settled at Harrogate, Yorkshire, from which he continued to exhibit at the Bewick Club, and for many years from their inception in 1905, the Artists of the Northern Counties exhibitions at the Laing Art Gallery, NEWCASTLE. About 1913 he left Harrogate and joined his brother Frank Stanley Ogilvie (q.v.), in London. He last exhibited his work in 1918 while practising in the capital, showing twelve works at the Laing Art Gallery in that year. He died at Bosham, Sussex. Two of his daughters, or nieces, CONSTANCE OGILVIE, and MAY OGILVIE, were also artists, the former exhibiting her work at the Royal Academy, in 1911 and 1950, and at the Royal Institute of Painters in Water Colours. Both women exhibited at the Artists of the Northern Counties exhibitions at the Laing Art Gallery, NEWCASTLE.

Frank Stanley Ogilvie,
Cottage interior,
oil, 93 x 72.5cm.
Tyne & Wear Museums,
Laing Art Gallery.

OGILVIE, John C (fl. mid–19th cent.)

Marine painter in oil and watercolour. This artist practised at NEWCASTLE, and later WILLINGTON QUAY, near NORTH SHIELDS, in the middle of the 19th century, and may have been related to the artist brothers Frank Stanley Ogilvie (q.v.), and Frederick Dove Ogilvie (q.v.). Little is known of his work except that one of his patrons was the pioneer iron shipbuilder John H S Coutts, of Tyneside. Writing to a London friend in 1856, Coutts said: 'I have at present, OGILVY (sic), the artist, who has recently returned from Paris where he has been working for the Emperor... he is to paint some of my vessels.' Ogilvie is shown in a local directory of 1855 as practising at WILLINGTON QUAY while Coutts was living at Willington Lodge.

OGILVIE–LANG, Gerald – see LAING, Gerald

OGLE, Charles Frederick (c.1878–after 1930)

Landscape painter in oil and watercolour. He was born at GATESHEAD, the son of a draughtsman, and practised as an artist in his native town for several years in the late 19th century, before taking a studio at NEWCASTLE. He practised at NEWCASTLE from the early 1900s, contributing many landscapes to the Artists of the Northern Counties exhibitions at the city's Laing Art Gallery, from their inception in 1905, when his exhibits were: *Breakers*, and *Ravensworth*.

OGLE, Richard Bertram (1889-c.1985)

Portrait painter in oil; illustrator. He was born at EGLINGHAM, near ALNWICK, and later moved to London where he became a successful portrait painter, illustrator, and writer of children's books. He exhibited his portrait work at the Royal Academy; the New Gallery, and the Dudley Gallery, between 1920–1929, and is said to have illustrated the first book published by Enid Blyton in 1923. Other books and publications which he illustrated included *Hereward the Wake*, by Charles Kingsley (1948); *He sailed with Dampier*, by Philip Rush (1947); *The Boy's Own Paper; The Graphic* and the *Printer's Pie*. He also illustrated his own books published between 1936 and 1962.

OLIPHANT, Francis Wilson (1818–1859)

Religious, figure and portrait painter in oil; stained glass designer. He was the son of Thomas Oliphant of Edinburgh, but was born at NEWCASTLE while his parents were visiting the town. He was trained as an artist at the Edinburgh Academy of Art, and became fascinated in his youth by the revival of the Gothic style. This led to a deep study of ecclesiastical art,

and eventually an invitation from William Wailes (q.v.), to join his stained glass manufactory at NEWCASTLE. Here Oliphant soon established himself as an important member of a trio of designers which included fellow Scotsmen James Sticks (q.v.), and John Thompson Campbell (q.v.). This trio, at the instigation of Wailes, visited cathedrals and other buildings on the Continent to study the best examples of stained glass, and it was very much on the basis of their subsequent efforts that their employer's business quickly established itself as one of the busiest of its kind in Britain. While living at NEWCASTLE, Oliphant continued to take an interest in drawing and painting, and in 1840 sent a sketch to the 'Exhibition of Arts, Manufactures & Practical Science', at NEWCASTLE. In the following year he sent a portrait in chalk, and a genre work, *The Mother's Knee*, to the North of England Society for the Promotion of the Fine Arts, NEWCASTLE, afterwards moving to London to work with the famous architect Pugin, on the painted windows of the New Houses of Parliament. In the period 1849–55 he exhibited at the Royal Academy, and submitted a cartoon to the competition for the decoration of Westminster Hall. His first Academy exhibit was *The Holy Family*, and was also shown at NEWCASTLE, in 1850. Outstanding among his later Academy exhibits were his large Shakespearian study of the interview of Richard II, and John of Gaunt, shown in 1852, and *Coming home – the prodigal son*, shown in 1853. In 1852 he married his writer cousin Margaret Oliphant Wilson. His later years were spent trying to improve the art of stained glass in Britain by involving himself in its actual production, as well as design, this resulting in much fine work for various educational and ecclesiastical establishments. Perhaps his most famous work of this period was the choristers' window at Ely, which he executed jointly with William Dyce, Oliphant being responsible for the original design. His work was, however, interrupted by ill health, and he was forced to seek a warmer climate. He moved to Rome, dying there, it is said, mainly from the results

of overwork. Towards the end of his life he published a short treatise, *A Plea for Painted Glass*. A relative, JOHN OLIPHANT, was also an artist and practised briefly in NEWCASTLE as a portrait painter; the Shipley Art Gallery, GATESHEAD, has this artist's portrait of William Wailes.

OLIVER, Edith, RMS (c.1885–after 1940)

Miniature painter. She was born at NEWCASTLE, and studied at the Praga School, Kensington, London, before practising at CULLERCOATS, by 1906. She first began to exhibit her work publicly at the Artists of the Northern Counties exhibitions at the Laing Art Gallery, NEWCASTLE, in 1906, later exhibiting at the Royal Academy; the Royal Miniature Society, and at various provincial exhibitions including the Walker Art Gallery, Liverpool. She appears to have lived briefly in the south of England in her later life, but had returned to CULLERCOATS when she last exhibited at the Artists of the Northern Counties exhibitions, in 1940. Oliver established a considerable reputation for her work as a portrait miniaturist and was a member of the Royal Miniature Society. She painted several members of the Royal Family, including HM Queen Mary.

OLIVER, Thomas (fl. 1766)

Architectural and topographical draughtsman. This artist practised at HEXHAM, and is known only via his drawing of nearby Dilston Hall, published as an engraving in 1766, with the note: 'Drawn on the spot by Thos. Oliver of Hexham in Northumberland & pub^d according to A of P July 17, 1766.' Oliver's original drawing survived for many years, and was sometimes exhibited at NEWCASTLE in a frame made from wood from the Old Tyne Bridge. A half-scale version of the engraving published is reproduced opposite page 100, in *The Old Halls, Houses and Inns of Northumberland*, written and published by Frank Graham, 1977. He may have been related to Thomas Oliver 1791–1857 (q.v.).

Thomas Oliver, *Newcastle upon Tyne from the South, Drawn on the Spot*, engraving after the artist, 12 x 40cm.

Robert Olley, *Toil*, 1993, 92 x 122cm. Private collection.

OLIVER, Thomas (1791–1857)

Architectural and topographical draughtsman. He was born at Jedburgh, Roxburghshire, the son of a weaver, and received his education in his native town. In 1814 he married the daughter of a stonemason at nearby Kelso, by whom he may have been employed for some time, then settling at NEWCASTLE, he was possibly employed by John Dobson (q.v.), before setting himself up as a land surveyor and architect in the town in 1821. In addition to practising as a land surveyor and architect, Oliver offered lessons in architectural and perspective drawing, and in 1829 exhibited at the Northern Academy, NEWCASTLE, one of his own works in this field which earned from W A Mitchell, in the *Tyne Mercury*, the comment: 'A carefree, neatly finished piece of architectural drawing'. Oliver is best remembered for his series of excellent maps of NEWCASTLE, rather than his architectural work, which, apart from his superb Leazes Terrace, consisted of undistinguished houses, and some commercial property. His maps were published in 1830, 1844, 1849, 1851, and in the year of his death, and provide an invaluable guide to the topography and growth of the town throughout one of its greatest phases of development. His abilities as an architectural and topographical draughtsman, however, are seen to their best advantage in his *A New Picture of Newcastle*

upon Tyne, 1831, in the form of a pull-out view of NEWCASTLE from GATESHEAD, described as 'Drawn on the Spot by Thomas Oliver'. He died at NEWCASTLE. His son by his first marriage, THOMAS OLIVER, JUNIOR (1824–1902), was a distinguished architect.

OLLEY, Robert ('Bob') (b.1940)

Figure, landscape and mining painter in oil; caricaturist; muralist; sculptor. Born at SOUTH SHIELDS into a mining family, Olley first developed an interest in drawing and painting through his art teacher, Harry Buckland, at his local secondary modern school. On leaving school at fifteen he worked as a painter and decorator until he was old enough to become a pitman, then taking up work at nearby Whitburn Colliery, stayed in the mining industry until 1968. A spell of five years with a telecommunications company followed, by which time his growing preoccupation with painting led him to decide on becoming a full-time professional artist. He had already participated in his first group exhibition by 1970, showing at the Bede Gallery, JARROW, near SOUTH SHIELDS, and held his first one-man exhibition at South Shields Art Gallery & Museum, in 1973, but has admitted to having been surprised by the success he has enjoyed since becoming a professional artist in 1974. One of his exhibits in his first one-man show contributed

Robert Olley, *Stan Laurel, North Shields*, 1992, fibreglass, figure 2.6m high. North Tyneside Council.

considerably to this success; his painting of the inside of a gentleman's toilet at SOUTH SHIELDS entitled *The Westoe Netty* created such controversy that his name immediately became known throughout the North of England. His next one-man exhibition at the Metal Precinct Gallery, SOUTH SHIELDS, entitled *The Heart & Humour of the North East*, consolidated his success and in 1984 enabled him to buy the gallery. He renamed it 'The Gambling Man Gallery', and it has provided a base for his continued success as both painter and sculptor ever since. Several other one-man exhibitions and many commissions have followed. His most recent examples of the former have been held at the Customs House Gallery, SOUTH SHIELDS, 1995, 1996 and 2000, and the DLI Museum & Art Gallery, in 1998. Much of his work at these exhibitions has shown a humorous attitude to his varied subjects, and this has also been reflected in his several mural commissions. His public sculptures have treated their subjects in a more serious vein, however, and include his *Durham Miners*, for the National Union of Mineworkers, DURHAM, 1989; his *Man with the Donkey* (John Simpson Kirkpatrick), public subscription, 1988, and *Merchant Navy Memorial*, public subscription, 1990, both at SOUTH SHIELDS. His *Stan Laurel*, NORTH SHIELDS, 1992, (Stan spent his formative years at NORTH SHIELDS), more directly relates to his painting style, and was commissioned by a firm of developers, with support from the Tyne & Wear Development Corporation. His works in sculpture for Northumbria are comprehensively detailed and illustrated in *Public Sculpture of North-East England*, Paul Usherwood, Jeremy Beach and Catherine Morris, Liverpool University Press, 2000. Olley has never forgotten his period in mining and in 2002 held an exhibition of his

paintings at the Hutchinson Gallery, BISHOP AUCKLAND, entitled *Sweat, Water & Dirt*, reflecting his experiences in the 1950s and 1960s. However, his 'Olley on Aesop' exhibition at the Customs House Gallery in 2003/4, consisting of forty gouache interpretations of the famous fables, could not represent a greater contrast to the latter in content and execution and show him to be an artist of great versatility. He continues to live and work at SOUTH SHIELDS.

ORANGE, Elizabeth ('Libby') (b.1944)
Botanical, still life, landscape and figure painter in oil; mosaicist. She was born at TYNEMOUTH and developed an interest in art at an early age. It was not, however, until she had spent much of her life on farms in Northumberland that, in 1989, she decided to seek formal training as a painter. She enrolled as a mature student on a foundation course in art design at Sunderland College of Art, following this with a three-year degree course at the University of Northumbria, NEWCASTLE, from which she graduated in 1993. During her first year she was awarded the Aeneas Award Travelling Scholarship, by the Royal Academy, enabling her to study for two months at the British School at Rome. On completing her studies she applied herself to painting the human figure, but later turned to painting wild and domestic plants. Her first one-man exhibition at the Centennial Gallery, The Barracks, BERWICK-UPON-TWEED, combined both of these interests. Entitled *Fauves et Flores*, it showed her large paintings of human figures alongside flowers and still lifes. Following the success of this exhibition she continued her preoccupation with vegetation, this resulting in a further important exhibition at the Barkes & Barkes Gallery, London, in 1998, entitled *Rude Plants and other projects*. One of her exhibits was her triptych *The Tweed Valley Hogweed*, which she counts one of her most important works to date. Although mainly a painter of vegetation and flower subjects Orange has also painted a number of portraits, showing a selection in 1998 as part of the ISIS Arts exhibition *Hand*, which toured Northumbria in that year. Her work has also been influenced in recent years by exposure to the Australian landscape from direct observation and the study of Australian artists from colonial times. This came about as the result of her marriage to Anglo-Australian art dealer John Ness Barkes, who also introduced her to the work of Russian artists trained in the traditional Soviet Academy of Art. A skilled mosaicist, she has carried out a number of local authority commissions in this field, notably for the Millennium Green Project, MORPETH, and Tweedsmouth Middle School, BERWICK-UPON-TWEED. She has lived at BERWICK-UPON-TWEED for a number of years. A one-man exhibition of her work was held at the Tallantyre Gallery, MORPETH, in 2001. Her work is represented in many Northumbrian and overseas collections. [See colour plate]

ORD, Brian (b.1946)
Sculptor; art teacher. He was born at NEWCASTLE, and studied at Chelsea School of Art before eventually

becoming lecturer in sculpture for the foundation course at Newcastle College. He has exhibited throughout his teaching career, enjoying several one-man exhibitions and participating in a wide range of group exhibitions. His one-man exhibitions have included the Bede Gallery, JARROW, near SOUTH SHIELDS, 1979; the Waterloo Gallery, London, 1980; Lancashire Polytechnic, 1983; the Northern Centre for Contemporary Art, SUNDERLAND, 1983, and Washington Arts Centre, WASHINGTON, 1990. Among his many group exhibitions have been *Ten Sculptors*, Laing Art Gallery, NEWCASTLE, 1980; Smiths Gallery, Covent Garden, London, 1987; the Richard Demarco Gallery, Edinburgh, 1988, and the Newcastle Group's, 'Northern Lights', DLI Museum & Art Gallery, and tour, 1990. His work is largely abstract and recycled from debris. 'Regeneration, transformation, and recycling have always figured in my work,' he said in the catalogue to the last named exhibition. A number of public collections hold his work, and he has received several awards, including a travel award to New York and Chicago, and a Northern Arts Major Travel Award (1989). He lives and works in NEWCASTLE.

ORD, William (1781–1855)
Amateur draughtsman. He lived at Whitfield Hall, near HALTWHISTLE, and was a patron and pupil of John Varley. He painted several compositions in the Varley manner on his Continental tours between 1814–1816.

OWENS, James Edward ('Ned') (1918–1990)
Figure, landscape and industrial painter in oil and watercolour; cartographer; art teacher. Owens was born at NEWCASTLE, and after attending King's College (now Newcastle University), taught part time at Manchester School of Art for some fifteen years. He also painted as a freelance and together with his first wife Margo Ingham set up the Mid-Day Studios in Manchester to show the work of the area's more advanced artists. On leaving teaching by 1959 he joined the staff of the *Manchester Guardian*, as cartographer for the paper, remaining there until 1975. His work as a painter is said to have been influenced by that of Sickert, Daumier and Rembrandt, and to have shown a preference for 'the female nude, figures in landscape, industrial scenes, single figures, the poor and deprived materially and emotionally'. His work also included well-known actors and civic dignitaries. He exhibited at Manchester City Art Gallery, and elsewhere in the North of England. He died at Milnthorpe, Cumbria. Represented: Salford A G, and various other provincial art galleries.

OYSTON, George (c.1860–after 1897)
Landscape painter in oil and watercolour. Born at NORTH SHIELDS, the son of an engineering superintendent, Oyston practised as a professional artist in his native town throughout the 1880s, sending many works for exhibition at the Bewick Club, NEWCASTLE, in that period. He later moved to the south of England, practising in the Thames Valley, first at Walton, later at Shepperton, He continued to exhibit at the Bewick Club while working outside Northumbria, and also sent one work to the Royal Institute of Painters in Water Colours, and one work to the Royal Society of British Artists. Typical of his Bewick Club exhibits were those shown in 1885: *Harvest Time, Near the Oxford, Tynemouth; In Hollywell Dene* and *At Dinsdale, near Darlington*.

P

PAE, William (b.1841)

Landscape and marine painter in oil and watercolour. He was born at NEWCASTLE, the son of a dyer from BERWICK-UPON-TWEED, who used the names 'Pae', and 'Pea'. Nothing is known of his early artistic training, but by his early twenties he was advertising himself as a professional artist at his birthplace. He later moved to GATESHEAD, where his work enjoyed a measure of popularity in his lifetime, although he rarely sent it for exhibition. He specialised in small watercolour studies of local landscape subjects, usually featuring buildings, and occasionally painted marine subjects. He died at GATESHEAD in the late 19th century. The Shipley Art Gallery, GATESHEAD, has twenty of his local views. Represented: Shipley A G, Gateshead; Sunderland A G.

PAGE, Alan Smith (b.1946)

Landscape, figure and still life painter in acrylic and watercolour. He was born at NEWCASTLE, and after attending the city's College of Art & Industrial Design became a junior interior designer for a local company. He later worked as a graphic designer for a number of design studios and organisations in Northumbria, then in 1977 took up a position as lecturer in this subject at Newcastle College. Over the following twelve years he became head of the graphic design and advertising division. He then joined its marketing department, remaining there until 1993, when he became a freelance publicity consultant. In 1989 he had an exhibition of his watercolours at Grey's Gallery, GOSFORTH, near NEWCASTLE, and in 2001 he held a substantial one-man exhibition at the Shire Pottery Gallery & Studio, ALNWICK, under the title *Familiar Territories*.

PALMER, Gerald (born c.1887)

Landscape painter in watercolour. This artist lived at CORBRIDGE in the first quarter of the last century. In 1907 he enjoyed a one-man exhibition of some thirty-seven of his watercolours of Venice, at the gallery of Mawson Swan & Morgan, NEWCASTLE, later going on to exhibit at the Royal Academy; the Royal Society of British Artists; Walker's Gallery, London, and the London Salon. He also exhibited in the provinces, notably at the Artists of the Northern Counties exhibitions at the Laing Art Gallery, NEWCASTLE. In 1927 he was living in London.

PARBURY, Kathleen, FRBS (1901–1986)

Sculptor. Born at Boreham Wood, Hertfordshire, Parbury studied at the Slade School of Fine Art under Henry Tonks and Havard Thomas before becoming a professional sculptor. In addition to producing portrait sculptures of such famous people as Eisenhower, and Dame Sybil Thorndyke, she worked extensively in churches throughout the world, and examples may be found in London, Salisbury, Southampton, Sutton Coldfield, Ireland, Canada, Nigeria, and Northumbria. While she was a student she became interested in Anglo-Saxon sculpture and visited HOLY ISLAND. In 1966 she decided to live on the island, later giving up sculpture to write *The Saints of Lindisfarne*, published by Frank Graham in 1970. Probably her best known work in Northumbria is her statue to St Aidan, erected in the churchyard of St Mary's, HOLY ISLAND, in 1958, before she settled on the island. She later lived at nearby BEADNELL. Parbury was made a fellow of the Royal Society of British Sculptors in 1966. Apart from her church and public sculptures she is represented in museums in New Zealand, and Ohio, USA. She signed her work 'KOTP', her full name being Kathleen Ophir Theodora Parbury. [See colour plate]

Alan Smith Page,
White flowers in dappled light,
2001,
acrylic, 34 x 46cm.
Private collection.

PARK, John, ARE (d.1919)

Landscape and coastal painter in watercolour; etcher. This artist practised at SOUTH SHIELDS in the late 19th century. He mainly exhibited his work at the Bewick Club, NEWCASTLE, but in 1885 sent one work to the Royal Academy: *Gillingham Church*, after William Müller. He was elected an associate of the Royal Society of Painter-Etchers and Engravers in 1898. He may have been related to amateur artist GEORGE H PARK, who painted in the area around SOUTH SHIELDS, in the late 19th and early 20th centuries.

PARK, Septimus (fl. early 20th cent.)

Amateur landscape painter in watercolour. Park practised as a photographer at NORTH SHIELDS and was a keen spare-time painter of local street scenes and buildings, much in the manner of George Edward Horton (q.v.). His photographic premises were in the town's Railway Street.

PARKER, Henry Perlee, HRSA (1795–1873)

Portrait, figure, genre, landscape and marine painter in oil and watercolour; drawing master. Parker was born at Devonport, Devon, the son of Robert Parker (1748–1830), a woodcarver and gilder who had taken up the profession of artist and art teacher. His first work in art followed a brief period as tailor and coachmaker, and consisted of portrait painting, and making drawings for his father's pupils to copy. About 1813 he was employed by C T Gilbert to produce illustrations for the latter's 'Historical Survey of the County of Cornwall' (published in 1815). This commission

required him to tour Cornwall with Gilbert, and brought him into contact with paintings in the private collections of noblemen. In 1814 he married, and settled down at Plymouth as a professional portrait painter. His work was much admired, but discouraged by his meagre income he decided to stay with relatives at SUNDERLAND for a while, to see what opportunities for a portrait painter might exist in Northumbria. He made his living at SUNDERLAND for some months painting portraits on tin, giving drawing lessons, and painting window blinds, but after visiting NEWCASTLE on several occasions he found he liked the town, and settled here for just over a quarter of a century. Parker's years at NEWCASTLE 1815–1841 saw him become one of Northumbria's best known artists, and an active participant in the artistic life of the town. One of his first portraits was that of George Gray (q.v.), and soon he was attracting so many commissions that he and his wife were able to move to 'respectable apartments in the most public street in the town' – Pilgrim Street. He then commenced painting 'fancy pictures', in addition to his portraits, took on pupils, and soon made several important friendships with local artists, including Thomas Bewick (q.v.), and Thomas Miles Richardson, Senior (q.v.), later collaborating with these two, and others, in the foundation of the Northumberland Institution for the Promotion of the Fine Arts, NEWCASTLE. In 1817 Parker exhibited his first of twenty-three works at the Royal Academy, *Dead Game*, and after selling his popular *Principal Eccentric Characters of Newcastle* to Charles John Brandling MP, of Gosforth House NEWCASTLE began to be patronised by some of the most important men on

Henry Perlee Parker,

Cleaning Fish on the Old Quay, Hoe, Plymouth, 1860,

oil, 63 x 76cm.

Private collection.

255

Tyneside. In 1822 he was appointed to the committee of the newly founded Northumberland Institution for the Promotion of the Fine Arts, NEWCASTLE, and showed thirteen works at its first exhibition; he also in this year showed his first works at the British Institution: *Fishermen selling Fish to a Cottage Girl, Coast of Devon*, and *Celebration of the Coronation of His Most Gracious Majesty George IV, on the Sand-Hill, Newcastle upon Tyne, July 19, 1821*, which latter work was purchased by the Mayor and Corporation of NEWCASTLE for one hundred guineas, and placed in the Mansion House. In the following year he again exhibited at the Royal Academy, sent a further work to the British Institution, and exhibited at the Institution for the Encouragement of the Fine Arts in Scotland, Edinburgh, the Carlisle Academy, and at NEWCASTLE. From this point forward he continued to exhibit his work widely, showing his last work at the Royal Academy in 1859; the British Institution in 1863; Edinburgh in 1839; Carlisle in 1833, and NEWCASTLE in 1866 (loan). The smuggling subjects for which he later became famous, and which led to his becoming nicknamed 'Smuggler Parker', were first exhibited in 1826, and continued to appear until 1850. But these were by no means his only preoccupation as an artist, his work, indeed, recording everything from the grand to the ordinary in Northumbria for quarter of a century, and with titles ranging from *The Fancy Dress Ball at the Mansion House to celebrate the Coronation of William IV*, 1831, to *Pitmen at Play near Newcastle: Painted from Nature*, 1836. Drama also featured in his work, as with his *William and Grace Darling going to the Rescue of the Forfarshire Survivors*, painted jointly with John Wilson Carmichael (q.v.), in 1839. Perhaps his most outstanding contribution to the artistic activity of the area lay not in his paintings, however, but in his joint promotion with Thomas Miles Richardson, Senior (q.v.), of the Northern Academy of Arts, NEWCASTLE, in 1828. Parker was throughout his life keenly aware of critical reaction to his work, and to celebrate the twentieth anniversary of his arrival at NEWCASTLE, he published in 1835 his 'Critiques of Paintings by H P Parker . . . with etchings showing the compositions'. He was also ambitious, and though he had been elected an honorary member of the Scottish Academy in 1829, yearned for yet greater recognition. In 1839 he painted a picture which accidentally opened the door to this recognition; the *Wesleyan Centenary Picture*, in anticipation of the John Wesley Centenary Conference, held at NEWCASTLE in 1840. As a result of the success of this work he was in 1841 offered the post of Drawing Master at Wesley College, Sheffield. He accepted the post, and taking his wife, two daughters, and son Raphael Hyde Parker (q.v.), with him, moved to Sheffield, never to return to NEWCASTLE again. Once settled at Sheffield, and despite his commitments at the College, he immediately began painting subjects associated with the town: *The Sheffield Milk Boys*, and *The Burial of Sir Francis Chantrey*, to name only two. Between 1842 and 1844, and now supple-

menting his income by giving private drawing lessons, and taking classes at Chesterfield, as well as painting local subjects, he joined in efforts to establish a School of Design at Sheffield. This School was in due course set up in 1845, but Parker was not offered a post there, and some two years later he left the College for London, leaving Raphael Hyde to succeed him as Drawing Master. What little is known of Parker's remaining years suggests that while he continued to exhibit his work, his stay in London until his death in 1873 was not profitable, and he died penniless. A major exhibition of his work, consisting of many oils, watercolours and drawings, was held at the Laing Art Gallery, NEWCASTLE, in 1969–70. Represented: Victoria and Albert Museum; Grace Darling Museum, Bamburgh; Laing A G, Newcastle: Natural History Society of Northumbria, Newcastle; Newcastle Central Library; Sheffield A G; Shipley A G, Gateshead; Sunderland A G.

PARKER, Raphael Hyde (1829–1886)

Genre, portrait, landscape and marine painter in oil and watercolour; drawing master. He was born at NEWCASTLE, the son of Henry Perlee Parker (q.v.), and lived with his family in the town until his father's appointment as Drawing Master at Wesley College, Sheffield, in 1841. He learnt drawing and painting from his father, and when the latter left Sheffield for London c.1847, succeeded him as Drawing Master at the College. He first exhibited his work in 1848, showing his *The Itinerant Pan-Maker*, and *View of the Entrance of the Port of Tyne, Northumberland*, at the Suffolk Street Gallery. He again exhibited at this Gallery in 1849, showing *An Italian Boy displaying his white mice*, and in 1858 sent his only work to the Royal Academy, *The Sail in Sight*. He died at Sheffield, where directories up to 1884 record him as a 'drawing master'. Several examples of his work in watercolour were included in the 'Henry Perlee Parker Exhibition', at the Laing Art Gallery, NEWCASTLE, in 1969–70, including a portrait of his father, three genre works and one landscape. An elder sister was also a talented artist, and exhibited her work at NEWCASTLE while her father practised in the town. The National Portrait Gallery, London, has his half-length portrait of his father in oil.

PARKER, Robert (1748–1830)

Marine and coastal painter in oil. This artist practised at SUNDERLAND in the early 19th century, and exhibited his work at the Northumberland Institution for the Promotion of the Fine Arts, at NEWCASTLE, from its foundation in 1822, until 1826. His early exhibits all featured coastal views in Lincolnshire, Northumbria and Scotland, but in 1826 he exhibited *a View of Tobago, West Indies*, suggesting a visit abroad. He may have been related to Henry Perlee Parker (q.v.), who is known to have had relatives at SUNDERLAND. Indeed, it is possible that this was Parker's father, who painted marine subjects, and may have accompanied his son to SUNDERLAND, spending some years there before returning to Devonport, where he died in 1830, aged eighty-two.

256

PARKER, Walter F (b.1914)
Landscape painter in watercolour; printmaker; art teacher. Parker was born at Carlisle, Cumbria, and studied at the local School of Art. He then attended the Royal College of Art under Ernest Tristram and Stanley Spencer, specialising in illustration and textile design. Following a period working as a freelance designer he attended London University and the Courtauld Institute, and after gaining his art teacher's diploma became art master at Rutherford College, NEWCASTLE. After serving in the RAF during the Second World War he taught at Preston College of Art, and Hastings School of Art, then joined Hartlepool College of Art, where he was principal from 1954–78. He was elected a member of the Society of Industrial Art & Design in 1947, and was a member of the Lake Artists' Society from 1964, and its president in 1989. Parker showed his work widely in the North of England while living at SEATON CAREW, including Carlisle, Manchester, and HARTLEPOOL. Hartlepool Arts & Museum Service has an example of his work in watercolour entitled *Seaton Carew*.

PARSONS, Dorothy (1905–1967)
Landscape and street scene painter in oil and watercolour; illustrator. She was born in Sussex, and after training at Brighton Art College practised as a book illustrator and painter. Following her marriage, however, she painted only in an amateur capacity, showing her work at Brighton Art Gallery as a member of Brighton Art Club; at the Sussex Members' Art Club, and in 1942 only, at the Royal Academy. On moving to RYTON, near GATESHEAD, after the Second World War, she exhibited at the Artists of the Northern Counties exhibitions at the Laing Art Gallery, NEWCASTLE, on a number of occasions showing mainly local landscape and street scenes. A large collection of her work was sold at auction by Anderson & Garland, NEWCASTLE, in 1995, following the death of her husband at RYTON. This included her 1962 exhibit at the Artists of the Northern Counties exhibition, *Industrial Landscape, Blaydon Haughs*, and many other local landscape studies.

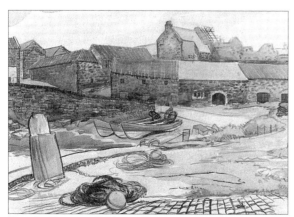

Dorothy Parsons, *Cobles at Craster*, watercolour, 36 x 54.5cm. Anderson & Garland.

Thomas William Pattison, *The Side, Newcastle upon Tyne*, watercolour, 43 x 30cm. Tyne & Wear Museums, Laing Art Gallery.

PATTISON, Thomas William (1894–1983)
Portrait, landscape and animal painter in oil and watercolour. He was born at Cardiff and is said to have shown marked artistic ability from an early age. On completing his general education he became a pupil at Armstrong College (later King's College; now Newcastle University) under Richard George Hatton (q.v.), but at the outbreak of the First World War volunteered for the Army. He served in the Royal Field Artillery from 1915–18, constantly carrying painting materials with him throughout his service. A frieze later designed by him was based on sketches, made during his service, of French peasants working in the fields at dawn. On leaving the Army he returned to Armstrong College, gaining the School Medal with distinction, in recognition of the high quality of his work. On completing his artistic training he travelled widely on the Continent. In France he was greatly influenced by the work of Puvis de Chavannes – an influence of which there is evidence in his lunette for the Laing Art Gallery, NEWCASTLE, *The Building of the Castle (Newcastle upon Tyne) c.1177, A.D.* This was the first lunette completed for the gallery. Pattison served on the teaching staff of the School of Art at King's College for a number of years, combining his academic duties with the painting of a number of portrait commissions, landscapes, street scenes, and industrial scenes. He later taught at HEXHAM, and on leaving teaching practised as a full-time professional artist, including among his later work a wide variety of commissions, such as his

John Peace,
New Scotswood Bridge,
Newcastle, under
construction, 1989,
oil, 36 x 44.5cm.
Private collection.

portrait of Alderman Sanderson, of MORPETH, and his mural for the County Hall, DURHAM: *The Building of Durham*. He showed his work at the Royal Academy, and was an exhibitor for many years at the Laing Art Gallery, NEWCASTLE, notably at its Artists of the Northern Counties exhibitions. This gallery staged a major one-man exhibition of his work in 1942. He died at NEWCASTLE, his home throughout his professional career. Represented: Laing A G, Newcastle.

PAULSON, E (fl. early 19th cent)
Marine painter in oil. This artist practised at SUNDER-LAND, and may have been employed in a local shipyard before embarking on his career as a ship portrait painter in the early 19th century. The National Maritime Museum has his oil *The City of Carlisle*, dated 1853. At this time it was the largest vessel built by Robert Thompson's shipyard at SUNDERLAND, and is pictured on her maiden voyage.

PEACE, John (b.1933)
Landscape, portrait and still life painter in oil and watercolour; art teacher. Peace was born at LEMINGTON, near NEWCASTLE, and after education at his local primary school, and later St Cuthbert's Grammar School, NEWCASTLE, attended the School of Art at SOUTH SHIELDS. After leaving the School he studied at the College of Art, Leeds, where he won entrance to the Slade School of Fine Art, London, and completed his artistic education. Following his national service in the King's Own Yorkshire Light Infantry, mainly in Cyprus, he returned to LEMINGTON, and began a career in teaching art with a position at the John Marley School, WESTERHOPE, near NEWCASTLE. He later took a similar position at Sunderland Polytechnic (now

Sunderland University), remaining there until his retirement, as senior lecturer in painting. Peace had painted and exhibited his work throughout his artistic education and his later career in teaching, and on his retirement decided to become a full-time professional painter. He had first exhibited his work in his twenties, showing examples at the Royal Academy; the Royal Drawing Society; the Society of West Riding Artists; the Arts Council, and the Stone Gallery, NEWCASTLE. In 1959 he shared an exhibition at the Stone Gallery, NEWCASTLE, with Frank Avray Wilson (b.1914), and in 1961 with John Minton (1917–1957). This gallery also gave him his first one-man exhibition in 1962, since when he has continued to show his work extensively in Northumbria in one-man, joint and group exhibitions, including among the latter the seasonal exhibitions at the Dean Gallery, NEWCASTLE. His main preoccupation throughout his work has been landscapes and coastal views, characterised by simplified compositions and subtle colours. Many of these have been painted in Northumbria, but he has also painted extensively in Europe. He has additionally painted a variety of other subjects, including portraits and still lifes, and has had his work reproduced as limited edition prints. He lives and works at LEMINGTON. Represented: Sunderland A G, and various public and private collections.

PEARSON, John (fl. early 19th cent.)
Landscape painter in watercolour. This artist practised at DURHAM in the early 19th century, where he made the acquaintance of Clement Burlison (q.v.) when the latter also lived in the city. Burlison describes him in his autobiographical *The Early Life of Clement Burlison, Artist* (published posthumously in 1914) as 'one of the old school of water-colour painters who

258

drew very carefully and then put the light and shade etc, in neutral tints. His pictures were very like nature, but a little hard and mechanical in appearance.' Burlison became friendly with Pearson's son John Loughborough Pearson, who, after working for local architect Ignatius Bonomi through the influence of Burlison's brother George, went on to become an architect himself, and a member of the Royal Academy.

PEASE, Claude Edward, (1874–1952)
Amateur landscape painter in watercolour. He was the youngest son of Arthur Pease, MP for DARLINGTON, and was for many years associated with Pease and Partners Ltd., and Barclay's Bank, in the town, also serving as a director of Horden Collieries. He was a keen spare-time painter and frequently exhibited his work at the Darlington Society of Arts. He also took a strong interest in local sporting activities, and was president of the Darlington Horse and Dog Show in 1936. His home was at Selaby Hall, GAINFORD, near DARLINGTON. He was the brother of Evelyn Ada Pease (q.v.). Darlington Art Gallery has his watercolour: *The view from Keodale Hotel, Durness (at midnight)*.

PEASE, Evelyn Ada (1876–1950)
Amateur landscape painter in watercolour. The youngest daughter of MP, for DARLINGTON, Arthur Pease, she painted widely in Scotland, Yorkshire and Northumbria, and exhibited her work at the Alpine Club, London, and frequently at the Darlington Society of Arts exhibitions. She served on the committee of the latter organisation, and was for some time vice president. Her home was for several years at Skeeby, near Richmond, Yorkshire. She was the sister of Claude Edward Pease (q.v.). Darlington Art Gallery has two of her Scottish landscapes in watercolour.

PEEL, James, RBA (1811–1906)
Landscape, portrait and figure painter in oil and watercolour. Peel was born at NEWCASTLE, the son of a wine

and woollen merchant in the town. Following his education at Dr Bruce's School, he entered an attorney's office, but soon gave up his employment to place himself as a pupil of Alexander Dalziel (q.v.), at NEWCASTLE. At the age of twenty-three he began exhibiting his work at NEWCASTLE, showing a portrait of a Rev Syme, at the Newcastle upon Tyne Institution for the General Promotion of the Fine Arts. He again exhibited at NEWCASTLE, in 1836, showing *Portrait of an artist*; a genre work; a double portrait; a figure study and four landscapes, and continued to exhibit in the town until the end of the decade, when he moved to London. Here he became one of the early organizers of the 'independent' exhibitions, such as the Dudley and Portland Galleries, in association with the two Landseers, Ford Madox Brown, William Bell Scott (q.v.), and others. This was followed by the opening of a large gallery at Hyde Park Corner, as a free exhibition. In 1842 Peel sent the first of his some 248 works to the Suffolk Street Gallery: in 1843 he began exhibiting at the Royal Academy, and in 1844, at the British Institution. Several of the works which he sent to these exhibitions in his early career were based on historical incidents, but he quickly settled down to become a landscape painter, and most of his subsequent Royal Academy; British Institution; Suffolk Street Gallery and other London gallery contributions, were landscapes, many of which were painted in Northumbria, Wales, the Lake District and south east England. About 1848 Peel left London, and marrying at DARLINGTON, remained in the town for about eight years. By 1860 he had returned to London, and here he remained based for the rest of his professional career, finally ceasing to exhibit in the capital in 1901, by which time he had moved to his home for his final years, Reading, Berkshire. Peel was an occasional exhibitor at NEWCASTLE in the late nineteenth century, notably at the Bewick Club, of which he was an honorary member. He was elected a member of the Royal Society of British Artists in 1871, and at the time of his death at Reading was its oldest member. He was also a Burgess of Newcastle

James Peel,
Landscape with cows,
oil, 70 x 95.5cm.
Darlington Borough Council
Art Collection.

259

upon Tyne, and a member of the Worshipful Company of Plumbers and Pewterers. In 1907 the Laing Art Gallery, NEWCASTLE, staged a major loan exhibition of his work. His daughter, AMY PEEL, was a talented landscape painter. Represented: Victoria and Albert Museum; Darlington A G: Laing A G, Newcastle; Leeds A G; Shipley A G, Gateshead; Sunderland A G.

PELEGRIN, Mariano (d.1920)

Amateur marine and landscape painter in watercolour. He was born at NEWCASTLE, the son of Manuel Jose Pelegrin, merchant and Argentinian Consul in the town. He later joined his father's business, painting in his spare time a large number of watercolours of sailing ships, fishing boats and other craft, off the Northumbrian and North Spanish coasts. He exhibited his work at the Bewick Club, NEWCASTLE, from the early 1890s, and later at the Royal Society of British Artists; the Royal Institute of Painters in Water Colours; the Walker Art Gallery, Liverpool, and the Artists of the Northern Counties exhibitions at the Laing Art Gallery, NEWCASTLE, from their inception in 1905, until close to his death. He died at NEWCASTLE. Pelegrin's father was apparently of Spanish descent, and collected works by artists of his native country. On his death in 1905 he bequeathed two 'Spanish School' paintings to the Laing Art Gallery. Represented: Shipley A G, Gateshead.

PENDENNIS – see HEDLEY, Ralph

PITTUCK, Douglas Frederick (1911–1993)

Landscape painter in oil and watercolour; art teacher. Pittuck was born in London, and worked as a clerk at New College, Oxford, before discovering his talent for drawing. Encouraged by the College authorities he became a part-time student at the Ruskin School of Drawing. In 1941 he was called up for military service and spent the next five and a half years with the Oxford and Buckinghamshire Light Infantry, before returning to the School as a full-time student. In 1948 he gained the University Diploma in Fine Art, and, on leaving Oxford was appointed art master at Barnard Castle School, BARNARD CASTLE. Pittuck was particularly fond of painting local scenery, but also painted widely abroad, including Austria and Australia. He exhibited his work at the Royal Society of British Artists; the Cooling Gallery, London, and on a number of occasions at the Artists of the Northern Counties exhibitions at the Laing Art Gallery, NEWCASTLE, and the Darlington Society of Arts exhibitions, DARLINGTON. He also had one-man exhibitions at the Laing Art Gallery in 1963, and the Bowes Museum, BARNARD CASTLE, in 1975. His major work was a mural for the Parish Hall at Newgate, BARNARD CASTLE, painted in 1959. His son, JOHN PITTUCK, has also painted and exhibited his work. Represented: Ashmolean Museum, Oxford; Bowes Museum, Barnard Castle; Laing A G, Newcastle. [See colour plate]

PLACE, Francis (1647–1728)

Portrait, bird, fish, flower and still-life painter in oil, watercolour and crayon; topographical draughtsman and painter in watercolour; etcher; engraver; potter. Place was born at DINSDALE, near DARLINGTON, and spent his early life articled to an attorney at Gray's Inn, London. In London he became a friend of Wenceslaus Hollar, one of the earliest engravers working in England, and generally regarded as the most important illustrator and topographer working in this country in the seventeenth century. Hollar encouraged Place in his efforts to master etching and topographical drawing, influencing his style considerably in the process. Their association was, however, interrupted for a period by the Great Plague of London, during which Place returned to DINSDALE, not returning to the capital until 1667. On resuming their friendship Place and Hollar worked on a variety of illustrative works in the form of etchings, but in 1668 the latter left London on an expedition to Tangiers, and Place later set off on the first of what was to become a series of far-ranging topographical tours encompassing much of Britain, and parts of the Continent. From London he went to Rochester in Kent, and from DINSDALE he went north to TYNEMOUTH, producing at the latter one of his earliest known topographical works, *Tinmouth Castle and Lighthouse,* c.1670, in pen, grey wash, and some watercolour. DINSDALE appears to have been his base during these early tours, but after drawing a series of views of York about 1675, he formed an increasing attachment for this city, eventually settling there in 1692, and spending the remainder of his life there. In the period 1675–1700, and thanks to an inheritance on the death of his father, Place was able to widen his artistic activities to include portraiture in oil, crayon and mezzotint, and to embark on several further topographical sketching tours. His mezzotint portraiture became particularly accomplished in these years, and must be reckoned amongst his finest artistic achievements in any medium, while his topographical drawing gradually loosened and began to show greater assurance. But while his work in portraiture – ranging from a self-portrait in oil, to portraits in mezzotint of his friends – was completed by 1700, his landscape work continued until close to his death. In 1677 he travelled in the Isle of Wight and France; in 1678 in north east and south west England, and Wales; in 1681 he was in France; in 1683 he was in London; in 1698–9 he toured Ireland, and from 1700 wandered widely throughout Yorkshire, and Northumberland, and paid a visit to Scotland. His later travels were principally confined to Yorkshire, his last recorded trip being to Hull in 1722, when he was seventy-five years old. His fascination with landscape was extraordinary in his time, and, indeed, it has been observed that he was 'the first English artist whose main preoccupation was landscape'. Some of his work was executed for etching, but by far the greater proportion of his landscape drawings were clearly done for his own satisfaction, and were a radical departure from the popular imaginary landscape of his time. In addition to his interests in portraiture and topographical drawing, Place was an inventive potter, and like many members of the York Virtuosi, a man of varied interests. An exhibition of his work including his self-portrait in oil, drawings, prints, books to which he contributed illustrative work, and examples of his

Francis Place, *Gateway to Bamburgh Castle*, watercolour, 13.5 x 40.5cm. Tyne & Wear Museums, Laing Art Gallery.

pottery, was staged at the City Art Gallery, York, in 1971, accompanied by a catalogue compiled by Richard Tyler which probably represents the most comprehensive study of Place's work to date. Represented: British Museum; Victoria and Albert Museum; National Gallery of Scotland; National Gallery of Ireland; Laing A G, Newcastle; Leeds A G: York A G.

POLLARD, Maria Ethel (1876–1963)
Animal painter in oil. She was born at HARTLEPOOL, but after living for some years in Yorkshire she moved to Tyneside. She later lived at Seaton Delaval Hall, near BLYTH, for many years, and there produced a number of accomplished animal paintings. Her *Cancel and Casket*, featuring two life-size portraits of foxhounds, was sold at auctioneers Anderson & Garland, NEWCASTLE, for £4,000 in 2002, and oils of a cat and a horse are also known. She spent her final years in Yorkshire.

Maria Ethel Pollard, *Cancel and Casket*, oil, 96.5 x 122cm. Anderson & Garland.

POLLARD, Robert (1755–1838)
Landscape and marine painter in oil; engraver; etcher. Pollard was born at NEWCASTLE, and as an apprentice to John Kirkup, silversmith in the town, became acquainted with Thomas Bewick (q.v.), then also an apprentice. While on visits to Bewick's workplace with work from Kirkup he became interested in engraving, and was later allowed by his father to learn the art from Isaac Taylor of London. Bewick, on his first visit to London in 1776, met up with Pollard, and through him got work from Taylor, the two Tyneside men remaining friends and correspondents until Bewick's death in 1828. After leaving Taylor, Pollard is said to have become a pupil of Richard Wilson, following which he began to paint landscapes and seascapes, and exhibited two of the former at the Free Society of Artists in 1773. Engraving eventually reclaimed his interest, however, and he was subsequently successful in executing a variety of work after leading artists of the day, as well as producing many plates from his own designs, among these *The Blind Beggar of Bethnal Green*, and *Lieutenant Moody Rescues Himself from the Americans*. He practised as an engraver at Spa Fields, Croydon, also selling prints and taking an active interest in the Incorporated Society of Artists, becoming its director in 1789. One of his pupils was John Scott (q.v.). Pollard's final years were spent in poverty. Shortly before his death he handed over to the Royal Academy the records of the Incorporated Society of Artists, of which he was then the only surviving member. He died at Chelsea, London. His son, JAMES POLLARD (1792–1867), became one of the most popular painters of the coaching era in Britain. The National Portrait Gallery, London, has a portrait of Robert Pollard, by R Samuel, dated 1784.

POOLE, Anthony R (fl. 20th cent.)
Amateur landscape painter in watercolour. Poole was a businessman at DARLINGTON who was a member, and regular contributor to the exhibitions of Darlington Society of Arts. Darlington Art Gallery has his watercolour *Eggleston Bridge*.

POPHAM, William John (1907–c.1992)
Marine and landscape painter in oil and watercolour. Popham was born at SOUTH SHIELDS, and did not become a full-time professional artist until his retirement from the garage business in 1972. He had meanwhile moved to MONKSEATON, from which he first began exhibiting his work by showing his watercolour

William John Popham,
The Helen Pembroke at sea,
oil, 58 x 90cm.
J C Featonby.

Black Bull Inn, Etal, at the Artists of the Northern Counties exhibition at the Laing Art Gallery, NEWCASTLE, in 1937. He continued to exhibit landscapes at NEWCASTLE for a number of years but on his retirement decided to specialise in marine painting in oil, modelling his style on that of Montague Dawson. His work became popular in the southwest of England through its promotion by a Bristol gallery, and he continued to produce work of high competence until well into his eighties. He died at WESTERHOPE, near NEWCASTLE, where he had lived and practised as an artist for many years following his retirement from business.

PORRITT, Frank S (b.1902)
Amateur landscape painter in oil and watercolour. He was born at DARLINGTON, and was apprenticed as an engineering draughtsman. On completing his apprenticeship in 1922 he worked as an architectural assistant, then returning to engineering he became chief draughtsman at Darlington Forge Ltd, in 1947. On his retirement in 1967 he began to paint under the influence of local artists, including Jonathan Edward Hodgkin (q.v.), John Brown Harrison (q.v.), and Thomas Bell Young (q.v.), and went on to successfully exhibit his work. Darlington Art Gallery exhibited his work in 1975, and has his oil *Pease's House, Darlington*.

PORTER, Sir Robert Ker (1777–1842)
Military, religious, portrait and landscape painter in oil and watercolour; etcher; illustrator. He was born at DURHAM, the son of a retired army officer. His father shortly afterwards died, and together with his mother and sisters, Porter moved to Edinburgh. Here he received his earliest education, and making the acquaintance of Flora Macdonald, was so taken by a 'battle-piece' in her possession that he decided to become a painter of such pictures. When he was thirteen his mother again decided to move, and

settling her family in London she took him to meet Benjamin West, President of the Royal Academy. West was so struck by the promise of Robert's sketches that he immediately obtained a place for the boy at the Royal Academy Schools. His progress as an artist from this point forward was spectacular. Two years after enrolling in the Schools he exhibited his first work at the Royal Academy: *The Death of Sir Philip Sidney*. In 1793 he was commissioned to paint an altar-piece for Shoreditch Church. In the following year he painted a picture of *Christ allaying the Storm*, which he presented to the Roman Catholic Chapel at Portsea, and in 1798, *St. John Preaching*, for St John's College at Cambridge. Throughout this period he also continued to exhibit at the Academy, showing portraits, battle-scenes, and military subjects, painted scenery for the Lyceum Theatre, and became acquainted with several rising young artists of the day, including Turner and Girtin. With Girtin, and others, Porter founded at his London rooms in 1799 what fellow member Louis Francia described on the reverse of a drawing made on the memorable day, as 'the Brothers ... a school of Historic Landscape', but which is now recognised as the forerunner of all the world's watercolour exhibiting societies. In 1800 Porter completed in eight weeks a picture so large and spectacular that he became a celebrity overnight. Titled *The Storming and Capture of Seringapatam*, it measured 35m long, and contained 700 figures – seventy of which were recognisable. Other battle scenes followed, among these the *Battle of Agincourt*, for the city of London; the *Battle of Alexandria*, and *The Death of Sir Ralph Abercrombie*. All of these works were painted while he continued to produce other military pictures, portraits, etc., for exhibition at the Royal Academy, and mastered the technique of etching. In 1804 he visited Russia, and was appointed historical painter to Tsar Alexander I. He then travelled in Finland and Sweden, in which latter

262

country King Gustavus IV, knighted him. In 1808 he went with Sir John Moore to Spain to help expel the French from the Peninsula, and was at hand at the general's tragic death at the moment of victory at Corunna, 16th January, 1809. Following this he paid a second visit to Russia where he married the Princess Mary, daughter of Prince Theodore de Scherbatoff. On his return to England he published his best-selling 'Narrative of the Campaign in Russia' 1812, and in 1813 was re-knighted by the Prince Regent. Between 1817 and 1820 he travelled in the East, producing many sketches which are in the British Museum. After this he published an account of his travels in Georgia, Persia (where he was decorated by the Shah), Armenia, Ancient Babylon, and other places, containing numerous portraits, and studies of costumes and antiquities. In 1826 Porter was appointed British Consul at Venezuela, and for sixteen years while based at Caracas, with Bolivar and others made history as one of the founders of the Republic. While at Caracas he also continued to paint, executing three religious works, *Christ instituting the Eucharist*, *Christ Blessing a little Child*, and *Ecce Homo*. He also painted a portrait of Bolivar, and produced a number of sketches. In 1841 he paid his last visit to Russia, dying of apoplexy at St Petersburgh in 1842 as he was preparing to return to England. Porter's connections with his native Northumbria were slight after he left DURHAM for Edinburgh (though it has been claimed that he and his family returned to DURHAM for some time before settling in London); he exhibited a view of Durham Cathedral at the Royal Academy in 1797, and sent a single work, *Fitz-James*, to the Northern Academy, NEWCASTLE, in 1830. There is a monument to Porter and his author sisters, Jane and Anna Maria, in Bristol Cathedral. Represented: British Museum; Victoria and Albert Museum; Paul Mellon Collection of British Art, Washington.

POTTS, John Joseph (1844–1933)
Amateur landscape painter in watercolour. Potts was born at NEWCASTLE, and became an accountant by profession, painting in his spare time. He first exhibited his work on Tyneside, showing one example at the 'Gateshead Fine Art & Industrial Exhibition', in 1883. In the following year he commenced exhibiting at the Bewick Club, NEWCASTLE, and between 1887–89 showed two works at the Walker Art Gallery, Liverpool. Potts continued to exhibit at the Bewick Club throughout his life, also for some time serving as its honorary treasurer. He was a regular exhibitor at the Artists of the Northern Counties exhibitions at the Laing Art Gallery, NEWCASTLE, from their inception in 1905, until 1931. He died at NEWCASTLE. The Laing Art Gallery has his watercolours, *Victory Tea, Pilgrim Street, Newcastle upon Tyne*, 1919, and two Welsh landscapes.

PRIESTMAN, Francis (d.1897)
Sculptor. He was born at DARLINGTON, the youngest son of John Priestman (q.v.), and received his early tuition as a sculptor under his father. He continued working with his father after his training, later establishing a considerable reputation for the quality of his work. He predeceased his father by some two years, his obituary stating: 'Mr. Priestman's skill as a sculptor secured for him the execution of numerous artistic and life-like busts of prominent local people as well as sculpture for Roman Catholic places of workship'. One of his best known portrait busts is that of Edward Pease, sculpted by Priestman in 1885, and erected by public subscription in the public library at DARLINGTON, built with money bequeathed by Pease. The bust now stands in the adjacent Darlington Art Gallery.

PRIESTMAN, John (1811–1899)
Sculptor; draughtsman. Priestman was born at HIGH CONISCLIFFE, near DARLINGTON. At an early age he moved into DARLINGTON, where he is said to have learnt to sculpture under a local marble mason. On completing his training he established a studio on the site of the town's Mechanics' Institute, and in 1832 paid his first visit to London, sailing from STOCKTON-ON-TEES. On returning to DARLINGTON he practised as a sculptor, mainly working on memorial tablets. In 1848 he was asked by local solicitor, and chief-bailiff of the town, Francis Mewburn, to complete a copy of the Temple of Vespasian, Rome, in Sienna Marble. This model remained in Mewburn's possession throughout his life, but was bought back by the artist following the solicitor's death in 1867. In 1851 Priestman paid another visit to London, with a brief from Mewburn to look at the Great Exhibition, at Crystal Palace. Here he met the famous sculptor R Monti, who was later commissioned to sculpture a bust of Mewburn at DARLINGTON, using Priestman as assistant. The bust was an outstanding success, and copies of it in plaster were widely purchased for placing in public and other buildings. Priestman was a capable draughtsman, one of his most accomplished works in drawing being his pen and ink study of Durham Cathedral. This work he framed in gypsum for which he specially travelled to Carlisle. He lived at Blackwellgate, DARLINGTON, for some thirty-eight years, with a studio next to his home, and during this period became one of the best known sculptors in the area. He died at DARLINGTON. His son Francis Priestman (q.v.), was also a talented sculptor.

PRINGLE, Agnes (d.1934)
Portrait and figure painter in oil. She was born at GATESHEAD, and is said to have attended classes at the School of Art at NEWCASTLE, under William Cosens Way (q.v.), from the age of twelve. A brief period of tuition under Robinson Elliot (q.v.) followed, then in 1882 she entered the Royal Academy Schools. By the end of her first year at the Schools she had won a gold medal for the best drawing from the Antique, and a premium for the best drawing of a statue, and in 1883 secured the premium for the best model of a statue. In 1884 she commenced exhibiting at the Royal Academy and the Suffolk Street Gallery, later showing her work at the Royal Institute of Painters in Water Colours; the Royal Society of British Artists; the London Salon, and widely in the provinces. Among her provincial exhibits were several sent to the Artists of the Northern Counties exhibitions at the Laing Art Gallery, NEWCASTLE. She appears to have spent all her

life as a professional artist based in London. She may have been related to David Pringle (q.v.), who practised at GATESHEAD. Although primarily a figure painter she occasionally produced landscapes in watercolour. A typical example of her figure work is her *Flight of Anthony and Cleopatra*, in the collection of the Laing Art Gallery, NEWCASTLE.

PRINGLE, David (fl. late 19th cent.)

Landscape painter in oil and watercolour. This artist practised at GATESHEAD in the late 19th century. He regularly exhibited his work at the Bewick Club, NEWCASTLE, from 1884, his first exhibits being described as *Roslin Castle*, and *Warkworth Castle*. The Shipley Art Gallery, GATESHEAD, has examples of his local views dating from 1851 to 1900. These include: *Carr Hill – old houses* (1885–1900), and *Johnson's Quay* (1900). He may have been related to Agnes Pringle (q.v.).

PROCTER, Anthony (1913–1993)

Amateur landscape painter in oil; draughtsman. He was born at Cheadle Hulme, Cheshire, and was educated at Bootham School in York, spending much time as a schoolboy sketching various parts of the city. After studying electrical engineering at Manchester University he worked for two major manufacturing companies in Northumbria until his retirement in 1976. Although enjoying no formal art training while working in industry, apart from two evening classes a week for over a decade at Newcastle University (where he was awarded a certificate in fine art), Procter developed considerable skill as an artist. He travelled widely in Europe, the USA, Mexico, India, Australia and Japan in the course of his career, and often using the influences of these countries exhibited his work at the Royal Academy; the Royal Scottish Academy; the Royal Institute of Oil Painters; the New English Art Club; the United Society of Artists; the Royal Society of British Artists, and the Glasgow Institute of Fine Arts. At the Paris Salon he gained an honourable mention in 1967 and a silver medal in 1978. He had a one-man exhibition at the Laing Art Gallery, NEWCASTLE, in 1971, and a memorial exhibition of his work was held at the Vicarage Cottage Gallery, NORTH SHIELDS, in 1994. His work mainly consisted of North of England and Scottish landscapes and cities and is represented in a number of major corporate collections. He lived for a number of years at PONTELAND, near NEWCASTLE.

PROCTER, Ernest, ARA NEAC IS (1886–1935)

Landscape, figure and religious painter in oil and watercolour; decorative painter; sculptor; art teacher. Born at TYNEMOUTH, Procter studied at Newlyn, Cornwall, under Stanhope Forbes, and at Calarossi's, Paris, before practising as a professional artist. While still at Newlyn in 1906 he commenced exhibiting his work at various London and provincial galleries. On his return from Paris he settled at Leeds, Yorkshire, and in 1909 sent his first of some forty-nine works for exhibition at the Royal Academy: *Out in the cold*. Throughout his several-year stay at Leeds Procter

exhibited widely, typical titles being his *A Lake District Cottage*, shown at the New English Art Club in 1909, and his *A Brittany Antique Shop*, and *Dust*, shown as his first of many exhibits at the Artists of the Northern Counties exhibitions at the Laing Art Gallery, NEWCASTLE, in 1912. He first came to notice, however, after returning to Britain following a year spent in Rangoon in 1920, decorating the Royal Palace with his artist wife DORIS ('DOD') M PROCTER (née Shaw) (1891–1972). From Burma he brought home a number of paintings which he exhibited in London, and gained for him an immediate reputation. On his return he settled once again at Newlyn, and began to paint local landscapes, treated in a decorative manner, both in colour and composition, later accepting commissions to paint the interiors of, and execute decorative stone carvings for, several local churches, including St Hilary, Marazion, near St Michael's Mount, Cornwall. In addition to showing his work widely throughout Britain Procter enjoyed joint exhibitions with his wife at the Leicester Galleries, London, in 1925, 1927, 1929, and in the year of his death. Examples of his work were acquired for Japan, Luxembourg, Australia, and for several British collections, including that of the Tate Gallery, for which his picture *The Zodiac* was purchased through the Chantrey Bequest. He was a member of the International Society of Painters, Sculptors and Engravers for several years, and became a member of the New English Art Club in 1929, and an associate of the Royal Academy in 1932. He died at NORTH SHIELDS on his way to Glasgow to take up his duties as director of Studies in Design and Craft at the city's School of Art, a post which he had held for the last year of his life. A memorial exhibition of his work was held at the Laing Art Gallery in 1936, and five of his works were shown at the Royal Academy exhibition in that year. His wife became an associate of the Royal Academy in 1934, and a full member in 1942. A large joint exhibition of their work was held at the Laing Art Gallery in 1990, accompanied by a catalogue with a section devoted to the two artists' mutual influence. Represented: Imperial War Museum; Tate Gallery; Bradford A G; Dundee A G; Laing A G, Newcastle; Leeds A G.

PRY, Paul – see HEATH, William

PURVES, Alexander (b.1938)

Landscape painter in oil and watercolour; art teacher. He was born at BERWICK-UPON-TWEED and after graduating with a Bachelor of Arts degree at Newcastle University in 1962 went on to teach at the Secondary School at ASHINGTON. He first commenced exhibiting his work by showing examples at the Artists of the Northern Counties exhibitions at the Laing Art Gallery, NEWCASTLE, later going on to participate in a number of group, and two-man exhibitions in various parts of Northumbria. He held his first one-man exhibition at the Calouste Gulbenkian Gallery, NEWCASTLE, in 1964. A retrospective exhibition covering the period 1961–1965 was held at the Laing Art Gallery in 1966, consisting of some twenty-

Ernest Procter, *The Zodiac*, 1925, oil, 153 x 168cm. Tate Gallery.

three paintings and drawings. On leaving his teaching post at ASHINGTON he went on to teach at Leeds College of Art. The Shipley Art Gallery, GATESHEAD, has two of his landscapes in watercolour.

PUTT, Hilda (fl. late 19th, early 20th cent.)

Genre, landscape and flower painter in oil and watercolour. This artist first practised at SOUTH SHIELDS, from which she commenced exhibiting her work at the Bewick Club, NEWCASTLE, soon after its foundation in 1884. By the middle 1890s she had moved to NEWCASTLE, from which she sent one work to the Royal Academy in 1898. She later exhibited her work at the Artists of the Northern Counties exhibitions at the Laing Art Gallery, NEWCASTLE, for several years.

PYLE, Madge (b.1913)

Painter and collagist in various media; art teacher. She was born at Carlisle, Cumbria, and first lived in Northumbria when she moved at the age of eleven to County Durham. After obtaining her Bachelor of Arts Diploma of Education (Hons), at Durham University she taught in Cumbria for some two and a half years, relinquishing her position when she married in 1937. She subsequently lived at various locations in Northumbria, finally settling at STOCKSFIELD in 1957. Here, in 1962, she helped found the Stocksfield Art Club, and shortly after began participating in various group exhibitions, including, in 1966, *Northern Painters*, Laing Art Gallery, NEWCASTLE, and from 1969 the Artists of the Northern Counties exhibitions, at the Laing Art Gallery, NEWCASTLE, and the Free Painters and Sculptors Exhibition, London. She has also shown her work in a wide range of other group exhibitions, notably the Federation of British Artists' Open Salon, London, 1970; the Northern Open, Laing Art Gallery, 1982; the Royal Institute of Oil Painters, Mall Gallery, London, 1984, and the Manchester Academy of Fine Art Open Exhibition, 1996. Her first one-man exhibition was held at the Moot Hall, HEXHAM, in 1967, since when others have included the Loggia Gallery, London, 1974; Washington Arts Centre, 1985; the Trevelyan College, Durham University, 1991, and the Customs House Gallery, SOUTH SHIELDS, 1998. In 1970 she was elected a member of the Free Painters and Sculptors, London; in 1971, a member of the Society of Women Artists, and in 1988, a member of the British Society of Painters, Yorkshire. She continues to paint, and exhibits her work annually with the Stocksfield Art Club, at the Moot Hall, HEXHAM. Her work is included in various public collections, including the Arts Council; Northern Arts Council; Leeds Art Gallery, Education Department; Ealing Education Authority; Durham University, and the Laing Art Gallery.

Madge Pyle, *The Return*, collage overpainted with oil, 82.5 x 49cm. Anderson & Garland.

266

R

RAILTON, James Coates (b.1920)

Landscape painter in watercolour. He was born at Carlisle, Cumbria, and after studying at Carlisle School of Art became a studio apprentice at the town's Metal Box Company of Hudson Scott & Sons. His apprenticeship was interrupted by service in the Second World War, and on his return to the company he became a colour retoucher, correcting the colour balance of photographic negatives. In 1960 he decided to develop his talents further and moving to Liverpool worked in the colour section of News International. Here he also resumed studying art by attending classes at the Liverpool Institute, and Liverpool School of Art, and exhibited his work with the Liverpool and North Western Artists, at the Walker Art Gallery, Liverpool, and other venues. Following his retirement at Liverpool in 1986, and having earlier lost his wife, he decided to move to LANCHESTER, near DURHAM, where he has lived ever since. Throughout his period living in Northumbria he has been a member of Lanchester Art Group, and has shown his work at many local exhibitions, notably at the Laing Art Gallery, NEWCASTLE. He has worked almost exclusively in watercolour, choosing a wide variety of European and British landscape subjects, prominent amongst which have been his studies of Northumbrian and North Yorkshire villages.

RAINBIRD, Victor Noble (1888–1936)

Landscape, street scene, coastal and figure painter in oil and watercolour; muralist; illustrator; stained glass designer. Rainbird was born at NORTH SHIELDS, and first studied art at local evening classes under Ralph Walter Liddell (q.v.). Later he attended Armstrong College (later King's College; now Newcastle University), where he studied for four years under Richard George Hatton (q.v.), and others. During his time at the College he was awarded the Silver Medal for the highest placed student in all subjects; he was King's Prizeman in design, with honours, and won a national silver token for figure compositions, his drawings being subsequently included in the Government exhibition of work which was staged in New Zealand, Canada and Australia. Also while at the College he commenced exhibiting his work on Tyneside, showing his oil, *Nocturne*, and watercolour, *Gathering Storm*, at the first Artists of the Northern Counties exhibition, at the Laing Art Gallery, NEWCAS-TLE, in 1905. He next studied at the Royal College of Art, taking a special course under Professors Lanteri, Lethaby and Moira. Following this he became a student at the Royal Academy Schools, where he won the Silver Medal and £40 for life studies; the Silver Medal and £15 for figure composition, and the Landseer Studentship and £40, tenable for two years. At the outbreak of the First World War Rainbird enlisted as a private in the Northumberland Fusiliers, and after serving as a musketry instructor at York, was sent to serve in France. A variety of postings followed, including intelligence work, anti-aircraft service, field observation, and shock troop training. He was

recommended and sent back to England for a commission, and was with the Officer's Training Corps at Ripon and Catterick, Yorkshire, when the War ended. Following his demobilisation he returned to NORTH SHIELDS to practise as a professional artist, and resumed exhibiting his work at the Artists of the Northern Counties exhibitions. He also exhibited at the North East Coast Exhibition, Palace of Arts, 1929; the Walker Art Gallery, Liverpool, 1930, and the Royal Academy in 1926 and 1930. His first Academy exhibit was *Sir Galahad*; his second, *St. Jan ter Biezon*. He also did a considerable amount of stained glass work in the years following the war, some of which was erected at NEWCASTLE, SUNDERLAND, ALLENDALE, and other parts of the British Isles. He also turned his hand to illustration, an example being his seven drawings for *The North Shields Lighthouses* by Madeleine Hope Dodds, 1928. Rainbird practised at various places in the North during his brief life as a professional artist, spending periods at NORTH SHIELDS, Richmond, Yorkshire, NEWCASTLE, and finally SUNDERLAND. He also made several trips to France and Belgium to paint street scenes, and, indeed these are amongst his best known and most accomplished works. Two years before his death, and then practising at NORTH SHIELDS, Rainbird completed his largest single work – a mural decoration covering more then 1,000 square feet of wall space in the Ship Hotel, WHITLEY BAY. His last public commission while working at his birthplace was his personal impression of Earl Haig, standing at the salute, for the Mayor of TYNEMOUTH. From NORTH SHIELDS he moved to SUNDERLAND, dying there after an illness of some months, at the early age of forty-seven. His brother STEWART RAINBIRD, pupils TELFORD ROBSON and PERCIVAL FENNEMORE were also artistically gifted. Represented: Laing A G, Newcastle; South Shields Museum & A G.

RAMSAY, James (1786–1854)

Portrait, historical, religious, genre and landscape painter in oil; etcher. He was the son of Robert Ramsay (1754–1828), carver and gilder at Sheffield, and one-time master of Francis, later Sir Francis Chantrey, the famous sculptor. At the time of Ramsay's birth at Sheffield, his father's business was very much confined to carving and gilding, but it was soon extended to dealing in prints and plaster models, and eventually became 'a repository of works of art not equalled in the town'. Thus Ramsay was brought up in an atmosphere of artistic activity, this being further intensified when Chantrey, then a precociously talented youth of sixteen, became an apprentice in the businesss in 1797. In the following year Ramsay Senior published two mezzotint portraits of well-known Sheffield men, painted by Chesterfield artist E Needham. The mezzotints were produced by John Raphael Smith, and possibly influenced by his contact with Needham and Smith, Ramsay, Junior himself became attracted to a career in art. His earliest known work is his drawing of Samuel Peech, of the Angel Inn, Sheffield, and at the age of fifteen his father took him into the family business, announcing in the *Iris*,

James Coates Railton,
Staindrop Village, County Durham,
watercolour, 28 x 41cm.
Private collection.

Victor Noble Rainbird,
Driven Ashore,
watercolour, 41 x 61cm.
Anderson & Garland.

12th February, 1801, that in addition to always having in stock 'prints, transparencies, medallions and caricatures by eminent artists', the services of Ramsay, Junior, were available 'As a Portrait and Miniature Painter'. In 1803 he left Sheffield, taking with him a self portrait, and after showing it to an old friend of his father in London, Robert Pollard (q.v.), exhibited it at the Royal Academy. He was then only seventeen, and uncertain of his future in the capital, returned several times to Sheffield in the next four years. After commencing to exhibit at the British Institution in 1807, Ramsay evidently felt confident enough of his success in London, and the capital remained his base for the next forty years. He first appears to have established connections with Northumbria with his painting in 1816 of his first portrait of Thomas Bewick (q.v.). This work may have been painted at the request of Pollard, who wrote to Bewick 9th February, 1816, stating 'I should like to have a good likeness of you, either Painting or Print'. In this letter he also mentioned his early acquaintance with Ramsay, and provided valuable confirmation of the artist's Sheffield origins. Ramsay's portrait of Bewick was exhibited at the Royal Academy in 1816,

James Ramsay, *The Lost Child*, 1823, oil, 91.5 x 71cm. Newcastle Central Library.

and engraved by John Burnet in 1817. This engraving was the one most approved by the Bewick family of the many based on portraits of Bewick, and a close intimacy between the Bewicks and Ramsay followed. He began to include Northumbria more frequently in his professional visits, and on one of the earliest of these in 1819, painted two local views, *The Ruins of Tynemouth Castle and lighthouse*, and *View of the Harbour of North and South Shields*, as well as several portraits. Two years later, and again visiting the area, he was invited to join the committee of the Northumberland Institution for the Promotion of the Fine Arts, NEWCASTLE, showing at its first exhibition in 1822, portraits of fellow committee member Bewick, and president of the Institution, Edward Swinburne (q.v.). In the following year he again exhibited at the Institution, on this occasion showing yet another portrait of Bewick, and a figure of the artist (together with those of Ramsay and his wife), in *The Lost Child*. In this same year Ramsay became anxious to advance his career, writing to a Mr Reid, bookseller at Leith, near Edinburgh, asking the Scotsman's opinion as to whether he might hope to succeed the recently deceased Sir Henry Raeburn – 'His Majesty's First Limner and Painter in Scotland'. Reid's reply is not recorded, but Ramsay's continued residence mainly in London for the next twenty-four years suggests that it was not encouraging. Between exhibiting at NEWCASTLE in 1823, and settling in the town permanently in 1848, Ramsay exhibited sporadically in the north, showing work at the Carlisle Academy in 1824, 1826 and 1828; at various exhibitions at NEWCASTLE in 1833, 1834 and 1838, and at Carlisle Athenaeum in 1846. Throughout this period, however, he paid several professional visits to northern towns, showing many portraits of local worthies in London, principally at the Royal Academy; the British Institution, and from 1824, the Suffolk Street Gallery. After moving to NEWCASTLE, and taking a house at Blackett Street, he continued to exhibit both in London and the north, showing work at the Royal Academy and the Suffolk Street Gallery, until his death seven years later; at Carlisle until 1850, and NEWCASTLE, until 1852. He died at NEWCASTLE in 1854, aged sixty-eight. Although principally regarded as a portrait painter, Ramsay produced a number of historical, religious, genre and landscape works. Many of his portraits were engraved for sale, among these Thomas Bewick; G G Mounsey, the first reform mayor of Carlisle, and the Rev James Birkett of OVINGHAM, which last he etched himself. The Laing Art Gallery, NEWCASTLE, has his self portrait, painted in 1848. Represented: National Portrait Gallery; Carlisle A G; Carlisle Old Town Hall; Hull A G; Laing A G, Newcastle; Literary and Philosophical Society, Newcastle; Natural History Society of Northumbria, Newcastle; Newcastle Central Library.

RANSON, Thomas Fryer (1784–1828)
Engraver; draughtsman. Ranson was born at SUNDERLAND, the son of a tailor. His parents shortly afterwards moved to NEWCASTLE, where at the age of fourteen he was apprenticed as an engraver to John Andrews Kidd (q.v.). After completing his apprenticeship he remained at NEWCASTLE for some years, and executed 'several pieces with great taste and delicacy'. He was still practising at Newgate Street in the town in 1811, but a year or two later moved to London, where he soon became well known for his work, and in 1814 received a silver medal from the Society of Arts for his engraving of a portrait of Sir Thomas Gresham. In 1816 he published his engraving of a portrait of Thomas Bewick (q.v.), by William Nicholson (q.v.), this work being immediately acclaimed the best portrait of Bewick executed up to that date. Two years later he became heatedly involved in a controversy respecting the forgery of bank notes, which resulted in the bank authorities taking proceedings against him. He was confined in Coldbath Fields Prison, where he engraved one of his best known works: *An interior view of Cold-Bath-Fields Prison, in which Thomas Ranson was unlawfully confined by the Bank of England for holding an alleged One Pound Note (that he paid Forty Shillings for), which was proved to be genuine in a Court of Justice. Dedicated without Permission, to the Govr. and the Company of the Thread Needle Street Paper Establishment*. He contended that the Bank had no right to impound notes which were the property of others, and that inspectors could not always distinguish between a forged and a genuine note. The resulting action was decided in his favour and he received much praise for his stand against the authority of the Bank. Ranson remained successful as an engraver for several years further, in 1821 receiving the Gold Isis Medal from the Society of Arts for his portrait of the Duke of Northumberland, and in the following year, the same medal for his engraving of Sir David Wilkie's *Duncan Gray*. He later accomplished little, however, and died in London in 1828 a man of very slender means. His brother, CUTHBERT RANSON, was a talented sculptor, and practised in London.

RARA AVIS – see BIRD, James Lindsay

RASMUSSEN, Osborne (1896–after 1967)
Landscape and sporting painter in oil and watercolour; illustrator. Rasmussen was of Danish descent and practised as an artist at NEWCASTLE for many years following tuition at King's College (now Newcastle University), where he was awarded the John Christie Scholarship and Certificate in Fine Art. He later exhibited his work widely, including the Royal Scottish Academy; the Royal National Eisteddfod, Wales, and for many years from 1920, at the Artists of the Northern Counties exhibitions at the Laing Art Gallery, NEWCASTLE. His *Yachting off the Jutland Coast* was also included in the North East Coast Exhibition, Palace of Arts, 1929. Most of his work consisted of illustrations for Northumbrian magazines and newspapers, notably *Newcastle Life*, for whom he both wrote and illustrated articles on sporting subjects for many years. He was a keen student of the work and life of Thomas Bewick (q.v.) and contributed an illustration embodying images from the latter's wood engravings to *A Beilby Odyssey*, by James Rush, 1987.

His *Big Top & Caravans* forms part of the Fenwick Collection of Circus & Fairground Material held by the Laing Art Gallery, NEWCASTLE, and was included in its exhibition of this material in 1970.

RATHBONE, William (b.1884)
Portrait and figure painter in oil; miniaturist in bronze; art teacher. Rathbone was born at SUNDERLAND, and studied at the town's School of Art before obtaining a post as second master at the School of Art, at DARLINGTON, in 1905. He remained at DARLINGTON until 1914, when he was appointed headmaster of the Preston School of Art. He exhibited his work at the Royal Academy; the Royal Miniature Society, and at the Walker Art Gallery, Liverpool. He was an associate of the Royal Miniature Society.

RAWSON, Philip (1924–1995)
Figurative and abstract artist in two and three dimensions; art teacher. Rawson was born at MIDDLESBROUGH, the son of a local industrialist, and after education at Winchester College, entered the Fleet Air Arm. After being invalided out of the service and taking a short wartime course at Oxford University, he taught himself Sanskrit to enter London University's School of Oriental and African Studies. Here he became a distinguished scholar in these studies, and following an assistant curatorship at the Ashmolean Museum, Oxford, he became founder-curator of the Gulbenkian Museum of Oriental Art, Durham University, DURHAM. He remained for some fifteen years, and established it as a museum of international importance. On leaving the Museum in 1975 he shortly after joined the Royal College of Art as a full-time senior tutor, meanwhile completing his book *The Art of Tantra*, based on research for an exhibition on this subject which he had arranged at the Hayward Gallery several years earlier. After teaching painting, sculpture and ceramics at the Royal College for three years he became dean of the faculty of arts at Goldsmiths' College School of Art, remaining there until his retirement in 1984. He then moved to Dorset to live, and concentrate on his little known work as a figurative and abstract artist in two and three dimensions.

RAY, Richard Archibald, ARCA (1884–1968)
Landscape and figure painter in oil and watercolour; sculptor; memorial and badge of office designer; art teacher. Ray was born at London, and studied at Brighton School of Art, and the Royal College of Art, before taking up his appointment as principal of the College of Arts & Crafts at SUNDERLAND. While serving at the College, Ray remained deeply interested in painting, and also became involved in designing war and other memorials, and badges of office. He rarely exhibited his work outside SUNDERLAND, three examples being his oil, *Fraglioni Rock, Isle of Capri*, and watercolours, *Durham*, and *A New Forest Ride*, shown at the 'Contemporary Artists of Durham County' exhibition, staged at the Shipley Art Gallery, GATESHEAD, in 1951, in connection with the Festival of Britain. Two examples of his memorial work are the War Memorial at Mowbray

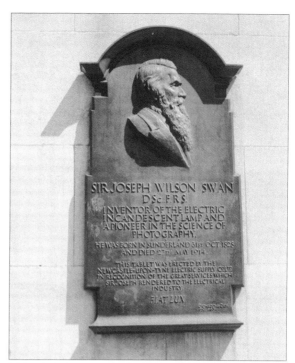

Richard Archibald Ray, *Monument to Sir Joseph Swan, Carliol House, Newcastle*, 1931, bronze, 150 x 80 x 6cm.

Park, SUNDERLAND, and his monument to Swan on the exterior of Carliol House, NEWCASTLE. Ray continued to live at SUNDERLAND following his retirement, dying there in 1968. He was an associate of the Royal College of Art, and during his thirty years on Wearside was for some time president of the Stanfield Art Society, SUNDERLAND, and a member of the town's art club. Represented: Sunderland A G.

REA, Vincent (b.1936)
Landscape painter in oil and acrylic; printmaker; sculptor; gallery director. Rea was born at SOUTH SHIELDS, and after education at nearby JARROW, won a scholarship to study art at Strawberry Hill College, London. In 1952 he had work reproduced in colour as a frontispiece to *The Teaching of Art to Children*, by L D C Boucher, but notwithstanding this early success in art decided to join the merchant navy. His career in the latter was interrupted by two years' national service in the army in North Africa, and in 1961 he left the sea to marry Wilhelmina Nee (b.1933), and became a sales executive with a Tyneside company. In 1962 he resumed his early interest in painting and began arranging exhibitions of regional artists' work including that of Thomas Bewick (q.v.), at the Civic Hall, JARROW. He also in that year had his first one-man exhibition, staged at Morden Tower Book Room, NEWCASTLE, and showed his work in group exhibitions at the Laing Art Gallery, NEWCASTLE, and the Shipley Art Gallery, GATESHEAD. In 1966 he gave up his job as a sales executive to devote himself entirely to art, and in 1967 began converting a disused air-raid shelter in Springwell Park, JARROW, into what was later to become one of the most active

Vincent Rea, *Jarrow March*, 1984, silver painted steel plate, 2.1m x 2.5m x 3cm. Tyne & Wear Passenger Transport Executive (Nexus).

Frederick William Reaveley, *Wallflowers*, oil, 35 x 29cm. Private collection.

and innovative art galleries in Northumbria. This was opened in 1970 as the Bede Gallery, Rea meanwhile obtaining experience of gallery operation by serving as deputy director of the Shipley Art Gallery from 1968–1970. Over the next twenty-seven years Rea, together with his wife 'Willa', and partner Alfred Corlett (q.v.), progressively developed the gallery to enable it to stage major exhibitions. These included the work of major names in British and international art, as well as that of Northumbrian artists such as Basil Beattie (q.v.), Tisa von Schulenburg (q.v.), and Alfred Ainslie O'Brien (q.v.). During this period he also developed a keen interest in sculpture and photography, the former resulting in a commission to produce a work entitled *Jarrow March*, unveiled at the Metro station, JARROW, in 1984, by the then Leader of the Labour Party, Neil Kinnock, to mark the 50th anniversary of the March; the latter, in 2001, the publication of a book of 200 photographs of JARROW taken by him in 1978, under the title *The Jarrovians*. In 1997 Rea and his wife set up a studio complex with small gallery in the shopping centre at JARROW in which they continued to hold small exhibitions until in 2000 a major gallery was opened to cope with larger events, similar to those of the Bede. Now known as the Viking Gallery it has continued its policy of showing works by locally and nationally well-known artists and photographers, under the auspices of the Vince & Willa Rea Bede Gallery Trust.

REAVELEY, Frederick William (1870–1950)
Amateur landscape, coastal and flower painter in oil and watercolour. Reaveley was born at TYNEMOUTH, and followed the profession of tailor all of his life, painting in his spare time. He exhibited his work mainly at the Artists of the Northern Counties exhibitions at the Laing Art Gallery, NEWCASTLE, showing examples for some forty years from 1908. He was a founder-member of the North East Coast Art Club, at WHITLEY BAY, and also showed work with the Club for a number of years. Reaveley maintained a studio at CULLERCOATS and was a close friend of John Falconar Slater (q.v.). He died at WHITLEY BAY.

REAVELL, George (1865–1947)
Architectural draughtsman; sculpture designer. Reavell was born at Ramsey, Hunts, but later moved with his parents to ALNWICK. After education at Alnwick Grammar School he practised as an architect, mainly designing and restoring public and private buildings in north Northumberland and the Borders. One of his commissions was the United Free Church, Coldstream, near BERWICK-UPON-TWEED, of which he exhibited a view from the south-west at the Royal Academy in 1907. He also designed several sculptures erected in Northumbria, including the Ravensworth Fountain, at WHITTINGHAM, near ALNWICK, for which the work was executed by the sculptor BROWNLEE, in 1905, and the Robertson Memorial Fountain, at BRANXTON, near FORD, installed in 1910, and executed by several local tradesmen. Illustrations and descriptions of both works are contained in *Public Sculpture of North-East England*, Paul Usherwood, Jeremy Beach and Catherine Morris, Liverpool University Press, 2000.

272

REAY, John (1817–1902)
Portrait and landscape painter in oil; copyist. This artist practised at NORTH SHIELDS in the middle years of the 19th century, later moving to SUNDERLAND, where he appears to have spent the remainder of his life. He first began to exhibit his work while at NORTH SHIELDS, sending examples to the North of England Society for the Promotion of the Fine Arts, NEWCASTLE, in 1838. In 1840 he sent two of his copies of the Old Masters, to the 'Exhibition of Arts, Manufactures and Practical Science', at NEWCASTLE, following this by sending his portraits of W S B Woolhouse, the well-known mathematician of NORTH SHIELDS, Italian astronomer Galileo, and others, to a similarly titled exhibition at NEWCASTLE in 1848. When he moved to SUNDERLAND, Reay became friendly with William Crosby (q.v.), accompanying him on a visit to Antwerp to copy Old Masters, and subsequently sharing with his friend available portrait commissions in the town. It is believed that he died at SUNDERLAND. Represented: Sunderland A G.

REAY, William (c.1837–c.1920)
Portrait and landscape painter in oil. He was born at GATESHEAD, and later worked in the local coal mines, painting in his spare time. His work at this point was varied in subject matter, and included local views and portraits, but when he and his brothers subsequently emigrated to Australia, he is said to have become a successful portrait painter there. Regrettably, his work is now little known in Australia, in which country he died in the first quarter of the last century. His miner brothers were also successful in Australia, one becoming a mine owner, the other a hotel proprietor in New South Wales.

REDPATH, William (1893–1985)
Amateur landscape painter in watercolour; art critic. Redpath was born at MIDDLESBROUGH, while his father William James Graham Redpath (q.v.) worked in journalism on Teesside. He was trained as an artist and designer but instead took up journalism, starting in Cornwall in 1920. In the following year he joined the *Evening Chronicle*, NEWCASTLE, as a junior sub-editor, and after service in the Royal Navy during the First World War, was appointed editor of its associated paper, the *Illustrated Chronicle*. He was then the youngest morning paper editor in the country, subsequently rising to occupy the positions of editor-in-chief of his newspaper group, and later director. Soon after taking up his editorship of the *Chronicle*, Redpath's father introduced him to George Edward Horton (q.v.), and the two became lifelong friends and correspondents. This led to Redpath's accumulation of a large collection of Horton's work, which his son David, and daughter Marjorie, inherited from their father, and was shown at North Tyneside Libraries & Art Department, NORTH SHIELDS, in 1986, prior to its deposition with the town's Local Studies Centre. Redpath, like his father a freeman of Alnwick, occasionally exhibited his work at the Artists of the Northern Counties exhibitions at the Laing Art Gallery, NEWCASTLE, and wrote art critiques for his papers. He was also a prominent figure in the Pen & Palette Club, NEWCASTLE, and friendly with many artists on Tyneside, including Byron Eric Dawson (q.v.), whose career as a newspaper illustrator he launched by commissioning him to begin a series of local drawings for his newspaper. Redpath left NEWCASTLE for Fleet Street in 1939, working there until his retirement in 1958.

REDPATH, William James Graham (1866–1956)
Amateur landscape painter in watercolour; etcher; art critic. He was born at ALNWICK, and was a journalist from his early teens until the age of seventy-two, painting and etching in his spare time. He began his journalistic career on Tyneside, and during his work on the *South Shields Daily Gazette* is believed to have penned the first critical appreciation of the work of George Edward Horton (q.v.). The two became friends, and it was Redpath who first introduced Horton to the scenic attractions of Holland by suggesting that the latter honeymoon there following his marriage in 1894. After leaving the *South Shields Daily Gazette* Redpath worked as a journalist on Teesside and elsewhere in the provinces before returning to the North East of England. Here he spent the last twenty-five years of his career on the staff of the *Newcastle Chronicle*, also acting as art critic for the *Manchester Courier*, and the *Birmingham Post*, as well as his own newspaper. For part of this period he worked under the editorship of his son William Redpath (q.v.). Redpath was a freeman of ALNWICK.

REED, Elizabeth (fl. late 19th cent.)
Amateur landscape and coastal painter in watercolour. This artist lived at SOUTH SHIELDS in the late 19th century, and regularly sent her work for exhibition to the Bewick Club, NEWCASTLE, from the early 1890s. She mainly painted local landscape and coastal views, several of which are now in the collections of the Shipley Art Gallery, GATESHEAD, and South Shields Museum & Art Gallery. She may have been related to the ELEANOR REED who painted at SUNDERLAND in the same period, and sent ten works to Manchester City Art Gallery 1890–94.

REED, John (1811–after 1861)
Religious, landscape and figure painter in oil; copyist. Reed was born at NEWCASTLE, the son of Alderman Archibald Reed, six times mayor of the town, and friend of Thomas Bewick (q.v.). He showed a talent for drawing and painting from an early age, and by the age of seventeen had commenced showing his work at the Northern Academy, NEWCASTLE. In 1829 his exhibit at the Academy *The Head of Jupiter* (a drawing for which he had received the Large Silver Medal of the Society of Arts), was highly praised by W A Mitchell, in the *Tyne Mercury*, and he continued to exhibit exclusively in his native town until 1835, when he showed his *The Assumption of the Virgin*, after Murillo, at Liverpool. In 1839 he began exhibiting in London, at the British Institution showing *The Falconer* – a work which he had already shown at the First Exhibition of the North of England Society for

Kenneth Reed,
Swilkin Bridge, St Andrews,
watercolour, 71 x 49.5cm.
Private collection.

the Promotion of the Fine Arts, NEWCASTLE, in 1838, along with fifteen copies of works by various European masters. He showed his first work at the Royal Academy in 1849, *The Wounded Brigand*, having by then made his home in the capital. He continued to live in London until his marriage in 1858, when he moved to Douglas, Isle of Man. In 1861 he sent his last exhibit to the Royal Academy while living on the island: *Fête Champetre – autumn; mountains of Cadore in the distance*. It is believed that he died shortly after exhibiting this work. His brother, ARTHUR REED (d.1883), was a talented amateur artist, and an occasional exhibitor at NEWCASTLE.

REED, Kenneth, FRSA (b.1941)
Golfing and landscape painter in watercolour. Reed was born at HEXHAM and studied at the College of Art & Industrial Design, NEWCASTLE, before taking up a position with the north-east branch of an international packaging company. He next ran his own graphic design firm before, in 1969, becoming a lecturer at Cleveland College of Art & Design, HARTLEPOOL. In 1996 he gave up this position to concentrate on his long-standing interest in painting golfing scenes in watercolour. Since then he has established a considerable reputation for his work on both sides of the Atlantic. He undertakes annual assignments for the Royal & Ancient Golf Club of St Andrews, and the United States Golf Association, to create posters for their respective Open Championships, and both the Wall Street Journal and ABC Television have commissioned exclusive paintings to enhance their championship coverage. Other special commissions have come from Greg Norman, Gary Player and Bob Charles, for whom he has created scenes from the courses where they won their championships. Among the courses which he has painted on both sides of the Atlantic are those at Sunningdale, Gleneagles,

Muirfield, St Andrews, and the Ailsa Course at Turnberry, in Britain, and Pebble Beach, Cyress Point, Spyglass Hill, Del Monte, Augusta National and the Olympic Club, San Francisco, in the USA. Several of his watercolours have been reproduced as limited edition prints, among these his *4th Hole, Ganton Golf Club, North Yorkshire*. In a departure from his normal golfscapes he has also painted the No 5 court at Wimbledon during the All-England Championships. He has been a fellow of the Royal Society of Arts since 1962, and has lived at PONTELAND, near NEWCASTLE, for many years. His son ALAN REED (b.1961), is also a successful professional artist.

REID, Andrew (1823–1896)
Engraver; lithographer; draughtsman. Born at NEWCASTLE, the son of David Reid, partner in a well-known local jewellers, Reid was apprenticed at fourteen to Mark Lambert (q.v.), in the Lambert engraving workshop in the town. After completing his apprenticeship he gained experience in lithography and general printing, with Day & Son, London, principally working on railway plans. Returning to NEWCASTLE in 1845 he commenced business as an engraver, but later became increasingly interested in printing, and was responsible for many publications associated with the area, some of which he illustrated himself, and engraved the plates. Notable amongst his local interest works was his *Handbook to Newcastle*, first published in 1864, but revised and reprinted in 1886. For this work by Dr John Collingwood Bruce, he provided a large number of drawings which he indicated as having been drawn by himself, and in many instances provided the wood or other engravings. Reid took a great interest in art outside his engraving and printing activities, and was associated with the foundation and running of the Arts Association NEWCASTLE, with Joseph Crawhall The Second (q.v.), as well as serving on the committee of

the School of Art in the town for several years. Reid's company became the largest of its kind at NEWCASTLE, his sons Philip and Sidney joining him in 1889, and their newly styled business 'Andrew Reid, Sons & Co' soon after buying out his old master's company, M & M W Lambert. He died at NEWCASTLE.

REID, James Eadie (fl. late 19th, early 20th cent.)
Portrait, figure and landscape painter in oil and watercolour; stained glass designer. Reid practised as a professional artist in Northumbria in the late 19th, and early 20th centuries, and while living at WHITLEY BAY, exhibited at the Artists of the Northern Counties exhibitions at the Laing Art Gallery, NEWCASTLE, for several years. He later moved to London, where he exhibited at the London Salon from 1908–1917. In 1910 he published a book on artist John Everett Millais, in *The Makers of British Art* series. The Shipley Art Gallery, GATESHEAD, has his portrait of Canon W Moore Ede, MA, DD, Rector of GATESHEAD 1881–1907. The town's Christ Church has his stained glass windows depicting *Victory and Love*, and a war memorial, dated 1921, designed while he was employed by the Gateshead Stained Glass Company founded by John George Sowerby (q.v.).

REID, John W M, ARCA (c.1890–1968)
Sculptor; landscape painter in oil and watercolour; draughtsman. Reid studied at the Royal College of Art, and later took up the appointment of master of sculpture at Armstrong College (later King's College; now Newcastle University). After service in the First World War he returned to the College, remaining there until the late 1920s, and executing as his major work on Tyneside, a figure of St George, in bronze, for the grounds of St Thomas's Church, Haymarket, NEWCASTLE. This memorial to officers and men of the 6th Battalion of the Northumberland Fusiliers, stands just to the right of the church entrance, and was unveiled in 1924. The enamel plaque on the central stone pedestal was executed by RENE BOWMAN, of NEWCASTLE, while the carved stone decorations for the whole pedestal were carried out by WILLIAM CURRIE of BIRTLEY, near GATESHEAD. Reid was also responsible for the memorial of Ashington Colliery Disaster, ASHINGTON, 1923, and together with Alex Proudfoot, the North Shields First World War Memorial, NORTH SHIELDS, 1923. Reid exhibited both landscapes and works of sculpture at the Artists of the Northern Counties exhibitions at the Laing Art Gallery, NEWCASTLE, for several years from 1922. In 1927 he became master of design at the School of Art, West Ham, London. He subsequently lived at ickmansworth, Hertfordshire, and Benenden, Kent, and was an exhibitor at the Royal Academy from 1945–1968, showing a variety of woodcarvings. His last exhibit when shown at the Academy, from an address in Hastings, described him as 'The late'. He was an associate of the Royal College of Art.

RENTON, Joan, SSA SSWA RSW (b.1935)
Landscape painter in watercolour; art teacher. She was born at SUNDERLAND, and after education at Dumfries Academy and Hawick High School, in Scotland,

John W M Reid, *6th Battalion, Northumberland Fusiliers, War Memorial, Haymarket, Newcastle*, 1924, bronze, figure 1.8m high. Newcastle City Council.

studied at Edinburgh College of Art. Among her teachers there were William Gillies, John Maxwell and William MacTaggart, and after her post-diploma scholarship, in 1959 she was awarded a travelling scholarship with which she went to Spain. In the following year she took her teaching diploma at Moray House, Edinburgh, then until 1980 taught art at schools in Edinburgh. While studying for her teacher's diploma in 1960 she was elected a member of the Scottish Society of Artists. In 1972 she was elected a member of the Scottish Society of Women Artists, and in 1977, a member of the Royal Scottish Water Colour Society. She first exhibited her work by showing examples in various group exhibitions, including the Contemporary Art from Scotland, Arts Council tour, 1965. This was followed by her showings at the Knightsbridge Gallery, Wichita, USA, in 1979; the Ancrum Gallery, Ancrum, Scotland, in 1984, and the National Trust for Scotland, in 1985. She has also enjoyed a number of one-man exhibitions, among these ones held at Douglas & Foulis, Edinburgh, in 1965; the Macaulay Gallery, Stenton, East Lothian, Scotland, in 1985/6, and Sally Hunter Fine Art, in 1987. In 1985 she was honoured by a special award by the Scottish Society of Women Artists. One of the best known watercolourists presently working in southern Scotland, examples of her work are held in the collections of HRH The Duke of Edinburgh; Yorkshire Education Department; the

Arthur Richardson,
*Eltringham Ferry on the
Tyne, near Ovingham*, 1906,
watercolour, 26 x 41.5cm.
Anderson & Garland.

Charles Richardson,
Borrowdale, watercolour,
65 x 98cm.
Tyne & Wear Museums,
Laing Art Gallery.

Edinburgh Schools Collection; the Royal College of Physicians, and the Jean Watson Trust. She has lived for many years in East Lothian, Scotland.

RICHARDS, Albert F (1859–1944)

Landscape and coastal painter in watercolour. Richards was born at Bridport, Dorset, but later moved to Northumbria, where he first settled at JARROW, near SOUTH SHIELDS, later at ROKER, near SUNDERLAND. He first began exhibiting his work while living at JARROW, showing his *Coquet Island from Warkworth Beach*, and *Coquet Island from Amble*, at the Artists of the Northern Counties exhibition at the Laing Art Gallery, NEWCASTLE, in 1908. He continued to exhibit at NEWCASTLE throughout his life, showing his last work at the Artists of the Northern Counties exhibition in the year of his death, at ROKER. Sunderland Art Gallery has several examples of his work, including *Sea at South Shields*, and *Summer Haze*.

RICHARDSON, Arthur, RBA (1865–1928)

Landscape and seascape painter in oil and watercolour; art teacher. He was born at NEWCASTLE, the son of leather tanner David Richardson, and appears to have studied in London before practising as a professional artist in the capital at the age of twenty-two. He first began exhibiting his work in the provinces, while living at NEWCASTLE, showing examples at the city's Bewick Club, in 1885. Later, he moved to London, from which he commenced exhibiting at Liverpool and Manchester. In 1889 he sent his first work to the Royal Academy: *A Groyne at Leigh, Essex*. The following year he returned to NEWCASTLE, and from there sent his second work to the Academy, *Ryton Church*, and further works to the city's Bewick Club. By the mid-1890s he had settled in Gloucestershire, from which he continued to exhibit at the Bewick Club, and in 1897 sent one further work to the Academy. By the turn of the

century, however, and then working as an art teacher at Cheltenham, he was exhibiting his work almost exclusively at the Royal Society of British Artists, and in 1904 was elected a member of that Society. He occasionally exhibited at the Bewick Club, and at the Artists of the Northern Counties exhibitions at the Laing Art Gallery, NEWCASTLE, in the early years of the century, and last exhibited at the Royal Society of British Artists, in 1919. It is believed that he died at Dawlish, Devon. His sister, Edith Richardson (q.v.), was also a talented artist. He was the father of the distinguished stage and film actor, Sir Ralph Richardson. Represented: Cheltenham A G; Laing A G, Newcastle.

RICHARDSON, Charles (1829–1908)

Landscape and seascape painter in oil and watercolour; drawing master. He was born at NEWCASTLE, a son of Thomas Miles Richardson, Senior (q.v.), by his second marriage, and practised as a professional artist and drawing master in the town after some tuition from his father, and possibly his elder brother, Henry Burdon Richardson (q.v.). He first began to exhibit his work at NEWCASTLE, showing two examples at the exhibition of pictures by living artists at the North of England Society for the Promotion of the Fine Arts, in 1852. Three years later he sent his first work to the Royal Academy, *Old Flour Mill near Newcastle upon Tyne*, and in the following year (1856), began exhibiting at the Suffolk Street Gallery, showing a watercolour: *Scene in Borrowdale looking towards Rosthwaite*. By 1873 he had moved to London, leaving there just before the turn of the century to live at Petersfield, Hants. He remained a regular exhibitor at the Royal Academy until 1901, having by then shown some twenty-eight works, and also exhibited in this period at various London and provincial galleries. Most of his works were landscapes, in which he frequently included groups of people, horses or cattle. Richardson sometimes collaborated with his brothers in the production of watercolours, an example being the seascape with shipping, in the Laing Art Gallery, NEWCASTLE, which he painted together with Thomas Miles Richardson, Junior (q.v.). He also worked with his brother, Henry Burdon, as a drawing master, and in 1848 jointly illustrated with him by means of watercolour, Dr John Collingwood Bruce's lectures on the Roman Wall, his brother producing the greater number of works. Some of these were later reproduced in Dr Bruce's *Handbook to the Roman Wall*. A later work which he illustrated independently was Sir William Lawson's *The Conquest of Camborne*, 1903. He is said to have died at Petersfield, but notices of a sale of his collection of oils and watercolours at NEWCASTLE in 1913, state his place of death as Peterborough, Huntingdonshire. These notices may have been correct, as his younger brother John Isaac Richardson (q.v.), was living there in 1908. Richardson's wife was also a talented watercolourist, and exhibited a work at the Royal Academy in 1846. Represented: National Gallery of Ireland; Laing A G, Newcastle; Shipley A G, Gateshead.

RICHARDSON, Rev Charles Edward (c.1849–c.1937)

Genre and still-life painter in oil. He was the son of Thomas Richardson of CASTLE EDEN. He was educated at Trinity College, Cambridge, receiving his Bachelor of Arts degree in 1875. He was ordained into the priesthood in 1877, and spent the next thirteen years in London. About 1890, he moved back to Northumbria to become rector of RED MARSHALL, near STOCKTON-ON-TEES, remaining there until 1895. Following the death of his father he moved to Kirklevington Hall, near YARM, and in 1897 commenced exhibiting at the Royal Academy, showing a still life. He exhibited at the Academy until 1907, showing a total of eleven works, with titles such as *Memories; A flaw in the title*, and *True Blue*. He died at Kirklevington Hall about 1937.

RICHARDSON, Charles W (c.1865–after 1913)

Amateur landscape and genre painter in oil and watercolour. Richardson was born on Tyneside, and later took up a business career, painting and sketching in his spare time. He first worked at NEWCASTLE, where he exhibited at the city's Bewick Club from 1885. He later took up a managerial post at MIDDLESBROUGH, where he became one of the founder-members of the Cleveland Sketching Club, with John Smales Calvert (q.v.). He became a regular exhibitor with the Club, later showing work at the Artists of the Northern Counties exhibitions at the Laing Art Gallery, NEWCASTLE. He regularly showed his work at NEWCASTLE from 1905 until the outbreak of the First World War, showing a wide range of landscape and genre works, some with Continental themes. His first exhibits in 1905 were: *Carr's Glen, Co. Antrim*, and *The Tyne at Wylam*. Represented: Middlesbrough A G.

RICHARDSON, Christopher (1709–1781)

Sculptor; stonemason, Richardson's place of birth is not known, but is thought to have been Northumbria. His best known work in the area is the statue of British Liberty on top of the column in Gibside Park, ROWLANDS GILL, near GATESHEAD, which was erected over a seven-year period as part of the landscaping of the park begun by George Bowes in 1729. The column is 44.5 m in height, and Richardson's 3.96 m statue on top was worked in situ. He worked on a solid block of stone which was hoisted to the top of the column, protecting himself from the elements meanwhile, within a wooden shed erected for this purpose. His payment for his mammoth task, which took about four months, was £40. The figure of *Liberty* holds what appears to be a staff in her hand with a cup on top, both being made of copper. The cup has long been a target for local marksmen believing that it is made of gold, or that it contains coins of this precious metal. Richardson's later work in Northumbria included carvings in stone for Alnwick Castle, and for the coat of arms on the Town Hall, BERWICK-UPON-TWEED. Most of his subsequent work was executed in other parts of Britain. He died at Doncaster, Yorkshire, and was buried there.

Edward Richardson, *Tynemouth Priory and Lighthouse*, 1872, watercolour, 30.5 x 60cm.
Tyne & Wear Museums, Laing Art Gallery.

RICHARDSON, Edith (1867–after 1929)

Landscape and genre painter in oil and watercolour; decorative artist; illustrator. She was born at NEWCASTLE, the daughter of leather tanner David Richardson, and studied at Armstrong College (later King's College; now Newcastle University), and in Paris, before becoming a professional artist on Tyneside. By her early twenties she had become a regular exhibitor at the Bewick Club, NEWCASTLE, and in 1899 sent her first works to the Royal Academy: *The Path*, and *The Boy and the Winds*. In 1900, and still living at the family home in the ELSWICK area of NEWCASTLE, she again exhibited at the Academy, showing *White Butterflies*. Later in this same year she moved to Hertfordshire, where she apparently spent the remainder of her life. She exhibited only one further work at the Academy following her move, but throughout the early years of the century she was a regular exhibitor at various London and provincial establishments, including the Royal Institute of Painters in Water Colours; the London Salon; the Walker Art Gallery, Liverpool, and the Laing Art Gallery, NEWCASTLE, whose Artists of the Northern Counties exhibitions she contributed to from their inception in 1905. She was the author of several books, some of which she illustrated herself. She was still living in Hertfordshire in 1929. Her brother Arthur Richardson (q.v.), was also a talented artist.

RICHARDSON, Edward, ANWS (1810–1874)

Landscape painter in oil and watercolour. He was born at NEWCASTLE, the second son of Thomas Miles Richardson, Senior (q.v.), and practised as a professional artist from an early age, following some tuition from his father. Unlike his elder brother George Richardson (q.v.), and younger brother Thomas Miles Richardson, Junior (q.v.), however, he did not exhibit his work until relatively late in life, and then first in London. Here he moved in his early thirties, and commenced exhibiting in 1856, sending his *Watermill, Castleton of Braemar, Aberdeenshire*, to the Royal Academy, and a number of works to the New Water Colour Society (later the Royal Institute of Painters in Water Colours). He exhibited at the Academy on only one further occasion, this being in 1858, when he showed a view of *Boppart on the Rhine*, but continued to exhibit at the New Water Colour Society until his death, showing a total of 187 works, and becoming elected an associate member in 1859. He painted several Continental views in addition to his many Northumbrian and Scottish works, but it is not clear whether he actually travelled abroad. He appears to have spent most of his later life based at London, but paid occasional visits to his native Tyneside. He died in the same year as his younger half-brother, Henry Burdon Richardson (q.v.). A sale of his watercolours was held at Christie's in 1864; the remainder at the same establishment in

1875. Represented: Victoria and Albert Museum; City A G, Manchester; Laing A G, Newcastle; Newport A G; South Shields Museum & A G; Williamson A G, Birkenhead.

RICHARDSON, George (1808–1840)

Landscape, genre, architectural and seascape painter in watercolour. He was born at NEWCASTLE, the first son of Thomas Miles Richardson, Senior (q.v.), and by the age of fourteen was advertising his services as 'historical and landscape painter' in a local directory. By the age of eighteen he was also offering 'Drawing Classes for Figure, Landscape and Animal Painting'. He first worked as a painter and drawing master at Brunswick Place, NEWCASTLE, later opening an Academy at Blackett Street with his younger brother, Thomas Miles Richardson, Junior (q.v.). He also gave private lessons, and offered evening tuition to those who could not attend his day classes. He first exhibited his work at the age of fifteen, sending a *Study of a Plaster Cast* to the 1823 exhibition of the Northumberland Institution for the Promotion of the Fine Arts, NEWCASTLE. He continued to exhibit at the Northumberland Institution throughout its short life, also sending one work to the Carlisle Academy in 1825: *Boy Dressing after Bathing*. In 1828 he began exhibiting at the British Institution, and the Northern Academy, NEWCASTLE, and in this year also sent one further work to the Carlisle Academy. He continued to exhibit at the British Institution; the Northern Academy, and the Carlisle Academy, for the next five years, also showing two works at the New Water Colour Society (later the Royal Institute of Painters in

George Richardson, *Doune Castle, near Stirling*, watercolour, 37 x 32cm. Victoria and Albert Museum.

Water Colours). He exhibited at the Newcastle upon Tyne Institution for the General Promotion of the Fine Arts from its foundation in 1832, and was also an exhibitor at the first Exhibition of Paintings and Sculpture of the Newcastle Society of Artists, in 1835, and its First Water Colour Exhibition, in 1836, while practising at DARLINGTON. He exhibited at NEWCASTLE until close to his death from consumption in 1840, his last recorded exhibits being the eight watercolours which he sent to the North of England Society for the Promotion of the Fine Arts, in 1839; these comprised several views taken in North Yorkshire; a view near ALNWICK; a view of Carlisle Cathedral and Castle, and one Continental view. He occasionally exhibited other Continental views but is not known to have travelled abroad. He died at NEWCASTLE, a lottery of his works being held subsequently for the benefit of his widow. Represented: Victoria and Albert Museum; Laing A G, Newcastle.

RICHARDSON, George Bouchier, FSA (1822–1877)

Wood engraver; landscape and architectural painter in watercolour; art teacher. The son of Moses Aaron Richardson (q.v.), and nephew of Thomas Miles Richardson Senior (q.v.), he was born at NEWCASTLE, and received tuition in drawing and painting from his uncle before becoming a wood engraver in the town. He practised as a wood engraver at NEWCASTLE, until 1850, meanwhile taking a keen interest in antiquarian matters, and producing many pictures of 'decaying streets and buildings in his native town'. He became a member of the Society of Antiquaries, NEWCASTLE, in 1848, and later became a fellow of the Society of Antiquaries, London. He produced wood engravings for a variety of locally published works, notably the *Reprints of Rare Tracts*, published by his father, but following the latter's departure for Australia in 1850, until he himself went there four years later, he mainly concerned himself with printing. Arriving in Melbourne some time in 1854, he obtained a position as a proof-reader, then via a succession of sub-editorial posts became editor of the *Wallaroo Times*. In 1874 he left Wallaroo and settled in Adelaide, where he taught music, drawing and watercolour painting until his death in 1877. The Society of Antiquaries, NEWCASTLE, has two portfolio volumes of his sketches of local old buildings, and the city's Central Library, a single volume of sketches of buildings and landscapes in Northumberland and on Tyneside. He was the elder brother of John Thomas Richardson (q.v.).

RICHARDSON, Henry Burdon (1826–1874)

Landscape, antiquarian and marine painter in watercolour; drawing master. He was born at NEWCASTLE a son of Thomas Miles Richardson, Senior (q.v.), by his second marriage. After some tuition from his father, and possibly his elder half-brothers. George Richardson (q.v.), Edward Richardson (q.v.), and Thomas Miles Richardson, Junior (q.v.), he practised as a professional artist and drawing master in the town,

279

joined for a period by his younger brother Charles Richardson (q.v.). In 1848 he was given his first important commission: the production of a series of watercolour drawings of the Roman Wall to illustrate the lectures on this subject of Dr John Collingwood Bruce. Most of these watercolours were first executed on the spot in sepia and washed with colour subsequently, and collectively comprise a work of major topographical accomplishment. Several were later reproduced in Dr Bruce's *Handbook to the Roman Wall*. In 1850 he issued an announcement that he would give 'lessons in Landscape and Marine Painting' either at his own home, or the homes of pupils. With him at this time lived his younger brother Charles, who also gave classes in drawing. In this year he also exhibited in London for the first time, showing a *Scene in Borrowdale*, at the Suffolk Street Gallery. He again exhibited at the Suffolk Street Gallery in 1851, showing a *Seapiece*, and in 1853 sent his first work to the Royal Academy: *Deck of the Hotspur, East Indiaman*. Richardson exhibited little in his later life, showing one further work at the Royal Academy in 1861, *Near Dunkeld, Perthsire*, and one work at the Suffolk Street Gallery, in 1862: *View in Borrowdale*. He exhibited infrequently at NEWCASTLE, among his few known exhibits being the three works which he sent to the exhibition of pictures by living artists at the North of England Society for the Promotion of the Fine Arts, in 1852. Some confusion has existed regarding Richardson's exhibiting dates, but it is clear from his date of birth as confirmed in the Census Return referred to below, that he could not have been the 'Henry Burdon Richardson' said to have exhibited Continental views at the Royal Academy, and the Suffolk Street Gallery 1828–1834. He died at NEWCASTLE at the early age of forty-eight. Represented: Laing A G, Newcastle; Shipley A G, Gateshead.

RICHARDSON, Henry ('Harry') (*c.*1867–*c.*1928)

Landscape painter in oil and watercolour; art teacher. Richardson was born at DURHAM and appears to have become a largely self-taught artist before practising professionally in the city by the early 1880s. He first began exhibiting his work publicly in 1879, showing his *Sketch in Durham Cathedral*, at the Arts Association, NEWCASTLE. He later became a regular exhibitor at the city's Bewick Club, at which his first exhibit in 1884 was *Durham Cathedral from the Prebends Bridge*. He continued to exhibit at the Club until the 1890s, and subsequently exhibited several works at the Artists of the Northern Counties exhibitions at the Laing Art Gallery, NEWCASTLE. He died at DURHAM.

RICHARDSON, John Isaac, RI ROI (1836–1913)

Landscape and subject painter in oil and watercolour. He was born at NEWCASTLE, a son of Thomas Miles Richardson, Senior (q.v.), by his second marriage, and according to Algernon Graves in his *Dictionary of Artists*, etc. (see Bibliography), exhibited at the Royal Academy from the age of ten. The work first shown was *Laon attempting the Rescue of Cythna . . .*, an ambitious work for a child of his tender years, and one can only assume he must have been helped more than considerably in its execution by one of his artist relatives, or that Graves was incorrect in attributing this, and the several other works which followed it from an address at Islington, to this particular Richardson. He was certainly still living at NEWCASTLE at the age of fourteen,‡ when Graves gives his address as Islington, and was, indeed, still living in the town as late as the middle 1850s according to local trade directories. Significantly, from the time that he was definitely in London, his exhibits at the Royal Academy, the British Institution and the Suffolk Street Gallery were

‡ His mother's Census Return for 1851 shows him living with the family at 20, Ridley Place, NEWCASTLE, and still at school.

Henry Burdon Richardson,
Cullercoats,
watercolour, 36 x 46cm.
Dean Gallery.

John Isaac Richardson,
A wayside stop,
watercolour, 23 x 40cm.
Anderson & Garland.

different in character to those earlier attributed to him; landscape works featuring people, cattle and agricultural activities, and painted in Northumbria, Cumbria and Scotland. Once settled in the capital he soon began to take an interest in its artistic affairs. By the middle 1860s he had joined a committee which led in 1865 to the foundation of the Dudley Gallery, and he was later elected a member of the Royal Institute of Painters in Water Colours, and the Royal Institute of Oil Painters. He mainly exhibited his work with the first of these two institutes, showing, some sixty-nine works, and was an occasional exhibitor at the latter during his short period of membership. He also exhibited considerably in London at various exhibitions, and in the provinces. According to his obituaries he died at Peterborough, Huntingdonshire, his home for several years, and not his native Northumbria, as is frequently claimed. He was the youngest and last surviving son of Thomas Miles Richardson, Senior. A large collection of his work was sold at auction in 2000 by Anderson & Garland, NEWCASTLE, revealing an artist of great versatility and accomplishment. Represented: Laing A G, Newcastle.

RICHARDSON, John Thomas (1835–1898)
Landscape and animal painter in oil and watercolour; engraver. He was born at NEWCASTLE, the eighth child of Moses Aaron Richardson (q.v.), and younger brother of George Bouchier Richardson (q.v.), and received his first tuition in art from his father, and uncle Thomas Miles Richardson, Senior (q.v.). He is said to have been a remarkably gifted artist as a child, his uncle sending for him one day when he was twelve, to sketch into a large picture in oil a team of horses drawing a huge tree trunk from a forest. The boy's sketch was then faithfully followed by Richardson when completing this work. John Thomas joined his father in the family's move to Australia in 1850, later practising as an artist and engraver until his death at Richmond, near Melbourne, in 1898.

RICHARDSON, Moses Aaron (1793–1871)
Etcher. He was born at NEWCASTLE, the younger brother of Thomas Miles Richardson, Senior (q.v.), and later became a well-known printer and publisher in the town, also dabbling in bookselling, bookbinding, picture cleaning, and selling artists' colours. His shop, 'Richardson's Repository of Arts', specialised in pictures and engravings, but he is best known for his local history publications and directories, among the former, his eight-volume *Local Historian's Table Book*, 1838–46, and *Reprints of Rare Tracts*, which latter were illustrated by his eldest son, George Bouchier Richardson (q.v.). In 1834 he started to publish in parts by subscription *The Castles of the . . . Border, A Series of Views*, drawn and engraved in mezzotint by his elder brother, but the project was abandoned after the publication of two parts. His work in etching was mainly confined to reproducing by this process drawings executed for publication by his brother, these including several views of old buildings in and around NEWCASTLE. In 1850 he emigrated to Australia, leaving his son to run his printing business, and took a job as a rate collector in Prahran, a suburb of Melbourne. He died at Melbourne in 1871. His eighth child, John Thomas Richardson (q.v.), was also a talented artist.

RICHARDSON, Thomas Miles, Senior, HRSA (1784–1848)
Landscape, marine and figure painter in oil and watercolour; illustrator; engraver; lithographer; etcher; art teacher. Richardson was born at NEWCASTLE, the son of a school master. As a child he showed a passionate love of drawing, and while staying with relatives at ALNWICK, made his first studies 'from nature' in watercolour, at the age of eleven. Impressed by his talents as an artist, his parents later placed him as an apprentice of Tyneside engraver Abraham Hunter (q.v.), but Hunter died shortly afterwards, and by his own choice Richardson became apprenticed to a firm of cabinet-

Thomas Miles Richardson, Senior, *Newcastle from Gateshead Fell*, oil, 142 x 234cm. Tyne & Wear Museums, Laing Art Gallery.

makers at NEWCASTLE. He soon found that he did not like the work, however, and consoling himself by pursuing his artistic studies in his spare time, he spent a miserable seven years in his chosen trade, only escaping it with the death of his father in 1806, and his appointment in the latter's place as master of St Andrew's Charity School, NEWCASTLE. But his long hours of working in damp conditions as a cabinet-maker had left him with symptoms of consumption, and acting on medical advice he absented himself from his school duties and went on a sea trip to London. Here he was walking along the Strand one day when he saw in a window a watercolour of Conway Castle by David Cox, which so impressed him that he returned to NEWCASTLE with a renewed enthusiasm for painting. During a second visit to London some time later he saw his first Royal Academy exhibition, and when he returned to NEWCASTLE, he was prevailed upon by surgeon William Fife to become a drawing master, accepting as his first two pupils Fife's sons William and John. Other pupils soon followed, and for the next six years he was both master at St Andrew's, and a drawing master. By 1813 Richardson felt that he might be able to support himself and his growing family by his work as a drawing master alone, and leaving St Andrew's he at first devoted himself entirely to this profession. Within a few months, however, he was leaving his classes to go on painting expeditions, and with the acceptance of his *A View of the Old Fish Market, Newcastle*, by the Royal Academy in 1814, he began increasingly to rely on painting for a living. His work at first attracted little attention, and in an effort to supplement his income from painting and teaching drawing, he made his first of several forays into the field of illustration, in 1816 producing with William Dixon (q.v.), a series of aquatint views of places of interest at NEWCASTLE. This work was not successful, and for the next six years he struggled on as a painter, becoming increasingly frustrated by the absence at NEWCASTLE of a suitable place at which he and fellow artists might

show their work. He decided to remedy this situation, and together with Thomas Bewick (q.v.), Henry Perlee Parker (q.v.), John Dobson (q.v.), and others, founded the Northumberland Institution for the Promotion of the Fine Arts, holding its first exhibition at his home in Brunswick Place, NEWCASTLE, in 1822. He remained one of the most prominent exhibitors at this Institution throughout its six-year life, also from 1822 showing further works at the Royal Academy, and in 1824 commencing to exhibit at the British Institution. But by the Northumberland Institution's exhibition of 1827 he had become completely disillusioned with its success as a means of promoting the sale of his paintings, and in that year he began to exhibit his work even more widely outside Northumbria, sending his first examples to the Royal Scottish Academy, and the Suffolk Street Gallery, and also making appearances at the exhibitions of the Old Water Colour Society (later the Royal Watercolour Society), and the New Water Colour Society (later the Royal Institute of Painters in Water Colours). Late in 1827 those principally involved in the running of the Northumberland Institution decided to found an academy in the town to take over its role as an exhibition venue for the area. Its construction was financed jointly by Richardson and Parker, with a grant from Newcastle Corporation, and was designed by John Dobson. Named 'The Northern Academy of Arts', and built on the town's Blackett Street, the Academy staged its first exhibition in June, 1828. Some of the biggest names in contemporary British art sent work to this, and subsequent exhibitions of the Academy, but by 1832 it found itself in considerable financial difficulties and had to be wound up, with Richardson and Parker obliged to pay off a large mortgage. During his four years of helping to run the Academy Richardson embarked on a number of other ventures, notably in 1830, when he painted, and exhibited with 'dioramic effects' at NEWCASTLE, four large pictures, and was responsible with others for the foundation of the Northern Society of Painters in Water Colours. Undaunted by the failure

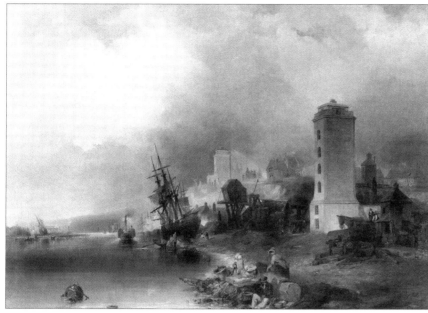

Thomas Miles Richardson,
Senior,
The High and Low Lights,
North Shields,
oil, 60 x 90cm.
Private collection.

of the Academy, and the Northumberland Institution before it, he next helped to found the Newcastle upon Tyne Institution for the General Promotion of the Fine Arts, and in 1836 took a leading part in the formation of the Newcastle Society of Artists. But none of these later art promoting ventures absorbed his time as fully as those in which he had been involved in the 1820s, and concentrating on his painting, he was successful in 1833 in selling to the Corporation what is widely regarded as his finest landscape: *View of Newcastle from Gateshead Fell*, for which he received 50 guineas. A second success came with the purchase by the Corporation in 1835 of his *View of the Side, Newcastle, the Procession of the High Sheriff of Northumberland going to meet the Judges*, and with his work now widely recognised, he was able to live his remaining years at NEWCASTLE in moderate prosperity. Richardson last exhibited at the Royal Academy and the Royal Scottish Academy, in 1845, and in the following year sent his final exhibit to the British Institution. Always a keen supporter of north country art exhibitions, he continued to exhibit at NEWCASTLE until just short of his death, and exhibited at Carlisle from 1824 until 1846, showing his earlier works at the Carlisle Academy, and his last work in the town, at Carlisle Athenaeum. His last known exhibits were those shown at an exhibition of works mainly by members of his family, staged at his home at Blackett Street, in September 1847. He died at NEWCASTLE six months later, following a painful illness lasting seven weeks. Richardson's interest in illustration continued throughout his life, his aquatint work with William Dixon, referred to earlier, being followed by *The Castles of the English Borders*, 1833, for which he mezzotint engraved the plates of his drawings himself; a series of etchings of the *Antiquities of Newcastle*, and the several plates which he drew and lithographed for the *Sketches of Shotley Bridge Spar on the River Derwent*, published by his

son, Thomas Miles Richardson, Junior (q.v.), in 1839. He is best known, however, for his superb work in oil and watercolour, most of it portraying Northumbrian, Scottish and Lake District scenery. Few honours came the way of this remarkable artist and man who did so much to encourage and promote the work of fellow Northumbrian artists; he was elected an honorary member of the Scottish Academy in 1829, and was an associate of the New Water Colour Society (later the Royal Institute of Painters in Water Colours) briefly from 1840. His work as a watercolourist has tended to be somewhat overshadowed by the acclaim of his important oils, but he was a superb practitioner of the medium in the old English watercolour tradition and an excellent teacher of watercolour drawing. Richardson married twice, having by his first wife: George Richardson (q.v.), Edward Richardson (q.v.), and Thomas Miles Richardson, Junior (q.v.), and by his second wife: Henry Burdon Richardson (q.v.), Charles Richardson (q.v.), and John Isaac Richardson (q.v.). He was the elder brother of Moses Aaron Richardson (q.v.), and the uncle of George Bouchier Richardson (q.v.), and John Thomas Richardson (q.v.). A major loan exhibition celebrating the artistic achievements of his immediate family was held at the Laing Art Gallery, NEWCASTLE, in 1906. Represented: British Museum; Victoria and Albert Museum; National Gallery of Ireland; Cartwright Hall, Bradford; Derby City A G; Grosvenor Museum, Chester; Laing A G, Newcastle; Leeds City A G; Manchester City A G; Portsmouth City Museum; Reading A G; Shipley A G, Gateshead; Sunderland A G; Walker A G, Liverpool.

RICHARDSON, Thomas Miles, Junior, RWS (1813–1890)
Landscape and figure painter in oil and watercolour; lithographer. He was born at NEWCASTLE, the third son of Thomas Miles Richardson, Senior (q.v.), and first

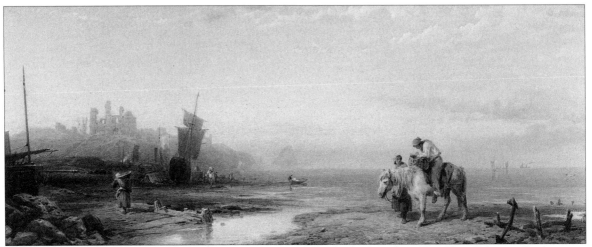

Thomas Miles Richardson, Junior, *Dunstanburgh Castle, Northumberland*, watercolour, 22 x 56cm. Private collection.

exhibited his work at the age of fourteen, when he sent a *Sketch in Pencil after Cooper R.A.*, to the town's Northumberland Institution for the Promotion of the Fine Arts, in 1827. From this point forwards, and evidently coached closely by his father, he was a regular exhibitor of work at NEWCASTLE, showing examples at the First Exhibition of the Northern Academy in 1828, and all its succeeding exhibitions, and later at the various exhibitions of the institutions for the promotion of the fine arts which flourished in his native town. He first exhibited outside Northumbria in 1830, when he sent two works to the Carlisle Academy. In 1832 he commenced exhibiting in London, showing *Feeding the Shelty*, at the British Institution. In 1834 he showed at the Suffolk Street Gallery a scene from Sir Walter Scott's *Tale of the Betrothed*, and in 1837 exhibited for the first time at the Royal Academy, choosing a Northumbrian scene: *Prudhoe Castle, with the River Tyne – sunset*. In 1837 Richardson made his first of many trips abroad, visiting France, Switzerland, Italy, Germany and Holland, and later produced an imperial folio work of lithographs entitled: *Sketches on the Continent . . .* Eleven of the lithographs for this work were produced by himself, this leading to his involvement in another illustrative work employing this process, *Sketches of Shotley Bridge Spa on the Derwent*, published jointly with his father in 1839. He remained based at NEWCASTLE until after his election as an associate of the Old Water Colour Society in 1843, when he moved to London. He was elected a member of the Old Water Colour Society (later the Royal Watercolour Society), in 1851, and from then on exhibited almost exclusively with the Society, eventually showing some 702 works. Thomas Miles Richardson, Junior, is generally regarded as second only to his father in his skill as a watercolourist, his relatively few oils, which he produced mainly between 1832–1848 during his early period of exhibiting at London, being altogether too few to provide a fair basis for comparison. Much of his watercolour work differed widely in subject matter from that of his father, however, with an emphasis on highly coloured Continental views which enjoyed a popularity far beyond anything achieved by his father's more restrained British views. His *Como*, for instance, reached £315 in a sale room in 1876, and his *Sorrento*, £310, in 1878 – while he was still living. On his death at London in 1890 his unsold works were disposed of at Christie's. Represented: British Museum; Victoria and Albert Museum; Blackburn A G; Darlington A G; Derby A G; Hartlepool Arts & Museum Service; Laing A G, Newcastle; Shipley A G, Gateshead; Sunderland A G; Pen & Palette Club, Newcastle and various provincial art galleries. [See colour plate]

RICHARDSON, William Dudley (1862–1929)
Landscape and architectural painter in watercolour. He was born at DARLINGTON, and educated at Scarborough, North Yorkshire and later in Switzerland. He spent much of his time on the Continent painting buildings, and showed his work at the Royal Academy; the Walker Art Gallery, Liverpool, and the Paris Salon. Darlington Art Gallery has several of his Continental watercolours, painted shortly before his death in 1929. He is believed to have spent his final years living at DARLINGTON, from which in 1928, and 1929, he sent works to the Artists of the Northern Counties exhibitions at the Laing Art Gallery, NEWCASTLE.

RIDLEY, Matthew White (1837–1888)
Landscape, portrait and genre painter in oil and watercolour; illustrator; etcher. He was born at NEWCASTLE, the son of a draughtsman, and is said to have worked in an architect's office before entering the Royal Academy Schools as a probationer at the age of nineteen. On completing his studies at the Schools under Smirke and Dobson he spent some years in Paris, where he became the first pupil of Whistler, and formed friendships with several important artists of the day, including Fantin-Latour, who painted Ridley's portrait. He then returned to London, where he founded his own art school. While

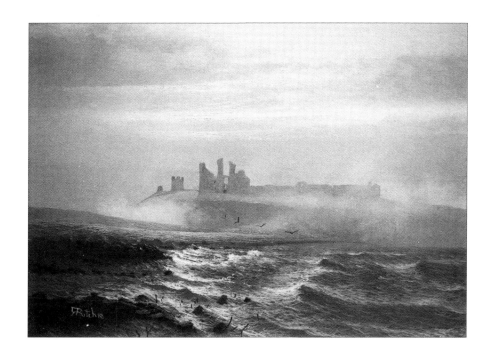

Robert Ritchie, *Mist, Dunstanburgh Castle*, oil, 26 x 36cm. Private collection.

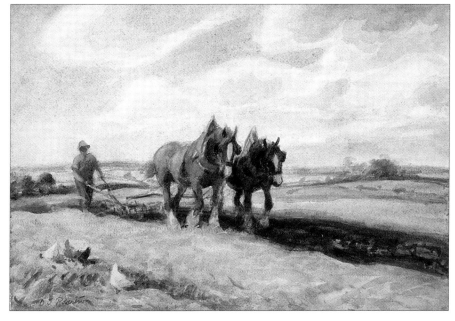

David Thomas Robertson, *The Plough Team*, watercolour, 33 x 48.5cm. Private collection.

running the school he began painting and exhibiting river, dock, harbour, genre scenes and portraits, and later became a regular illustrator for several leading publications, including Cassell's *Family Magazine*, and *The Graphic*. He first began exhibiting his work publicly at the Suffolk Street Gallery in 1857, showing *The Neapolitan Piper*; in 1860 he sent his first work to the British Institution, *The Boquet*, and in 1862 he exhibited for the first time at the Royal Academy, showing among his four works: *Seaham Harbour*, and *High Level Bridge, Newcastle upon Tyne*. He continued to exhibit at the Royal Academy until the year of his death, and also sent work to a number of other London and provincial exhibitions, including among the latter those of the Arts Association, NEWCASTLE, from 1878. In the year following his death in London in 1888, his students and admirers founded in his memory The Ridley Art Society. This Society still flourishes today, and has mounted several important exhibitions of his work. Ridley's work in illustration has been applauded for its social realism, and is said to have been admired by Vincent Van Gogh. Represented: Tate Gallery, and various provincial art galleries. [See colour plate]

'RILETTE'– see Sykes, Charles

RITCHIE, Robert (b.1934)
Landscape and coastal painter in oil. He was born at NEDDERTON, near BEDLINGTON, and developed an interest in art at an early age. He attended classes held at the Ashington Group's hut at ASHINGTON, but it was not until he had worked in a local factory for many years that he decided to become a professional artist. At the age of forty he gave up his job and immediately began showing his work at the Sunday exhibitions on Armstrong Bridge, NEWCASTLE, initiated by David Hinge (q.v.), proving so successful that he continued for several years. He also formed associations with leading galleries in Northumbria and the Lake District and quickly established a demand for his closely finished landscape and coastal studies of North of England and Scottish subjects. He has had several one-man exhibitions on Tyneside and Wearside. His home and studio for many years has been at ASHINGTON.

ROACH, John ('Jack') Joseph (1911–1989)
Amateur landscape and figure painter in oil and water-colour. Roach was born at TRIMDON VILLAGE, near SEDGEFIELD, and while working as a blacksmith at collieries around the village became attracted to the Sketching Club at The Spennymoor Settlement. He later exhibited his work at The Settlement; the Artists of the Northern Counties exhibitions at the Laing Art Gallery, NEWCASTLE, and the Federation of Northern Arts Societies' exhibitions at the Shipley Art Gallery, GATESHEAD. The Sketching Club was affiliated to the latter organisation, and Roach was one of its exhibitors when Norman Cornish (q.v.), Herbert Bewick Dees (q.v.), and Thomas McGuinness (q.v.), showed at the gallery in 1949, under its auspices.

ROBERTSON, Annie Theodora (b.1896)
Landscape painter in oil and watercolour. She was born at Bradford, and studied at Sunderland College of Art, and Manchester, before making her home at GATESHEAD. She exhibited her work at the Federation of Northern Art Societies' exhibitions at the Laing Art Gallery, NEWCASTLE, and the Shipley Art Gallery, GATESHEAD. Two examples of her work were included in the latter gallery's 'Contemporary Artists of Durham County' exhibition, staged in 1951, in connection with the Festival of Britain, and an exhibition of some thirty of her oils was held there in 1954. She was also one of the several Northumbrian artists whose work was included in the exhibition of 'Paintings and Drawings of Living Northern Artists selected from the Fine Northern Art Galleries', held at the Shipley Art Gallery in 1956. She was a member of the Newcastle Society of Artists. Represented: Shipley A G, Gateshead.

ROBERTSON, David Thomas (1879–1952)
Landscape, animal and portrait painter in oil and watercolour; etcher Robertson was born at DARLINGTON, of Scottish parents, but moved to SUNDERLAND as a child. Here he became a largely self-taught artist, and practised in the town until his death in 1952. Robertson was a close friend, and possibly a pupil of John Atkinson (q.v.), and shared the latter's marked preference for painting horses and cattle. He exhibited his work exclusively in Northumbria, where he was a regular exhibitor at the Artists of the Northern Counties exhibitions at the Laing Art Gallery, NEWCASTLE, and enjoyed special showings of his work at SUNDERLAND in 1922, and NEWCASTLE in 1924. Represented: Laing A G; Newcastle; Shipley A G, Gateshead; South Shields Museum & A G; Sunderland A G.

ROBERTSON, Thomas (1823–1866)
This artist was born at ALNWICK, and later practised in the town before moving to Glasgow, where he died in 1866. Nothing is known of his work.

ROBINSON, Francis (1830–1886)
Landscape painter in oil. Born at DURHAM, Robinson received his education at the Blue Coat School, and was subsequently apprenticed to a tailor at his birthplace. He was strongly interested in drawing, however, and while still an apprentice studied under Forster Brown (q.v.), at evening classes at the Mechanics' Institute. Here he won several prizes for his work, and after working some time as a tailor, he decided to change his profession to that of artist. He soon became well known throughout the county for his landscapes, finding many clients among the aristocracy and wealthy businessmen, and receiving a number of offers to advance his career elsewhere. But Robinson remained attached to his native Northumbria all his life, only ceasing to paint its river valleys, hills and villages when towards the end of his life he suffered several paralytic strokes, with a consequent effect upon his artistic output. He died at DURHAM, and was buried in St Margaret's churchyard.

ROBINSON, George Finlay (1816–1902)
Landscape and coastal painter in watercolour; engraver; lithographer. Robinson was born at WHICK-HAM, near GATESHEAD, and at fourteen was apprenticed to William Collard (q.v.), at NEWCASTLE. While with Collard he learnt the art of engraving, and became skilled at drawing, contributing several examples of his work to his master's publications. He also in his early years developed a keen interest in painting in water-colour, and became a member of an art society at NEWCASTLE, comprising John Henry Mole (q.v.), Thomas Hall Tweedy (q.v.), John Brown (q.v.), and other artists then seeking to develop their talents. This society flourished about 1830–35, and held its first exhibition at T Bamford's Long Room at Amen Corner in the town. It later moved its meeting place and exhibition venue to the Old Tower, Pink Lane, where Mole began to assume a leading role in encouraging his fellow members in their progress. In 1839, and mean-while having married a girl from Skelton, Cumbria, Robinson began to exhibit his work, showing his *View of the Tyne from Bensham*, and *Dunston on Tyne*, at the North of England Society for the Promotion of the Fine Arts, NEWCASTLE. Two years later he joined the staff of Mark Lambert (q.v.), taking over from John Wilson Carmichael (q.v.), the latter's role as 'chief draughts-

George Finlay Robinson,
Bywell Castle,
watercolour, 40.5 x 61cm.
Dean Gallery.

man' to the Lambert engraving company. Shortly after joining the company he began experimenting with lithography on behalf of his employers, and for the next half century combined the duties of draughtsman, engraver and lithographer for Lambert, and later his son, Mark William Lambert. Although Robinson exhibited his work from his early twenties, it was in the last twenty-five years of his life that he engaged most frequently in this activity. In 1878 he showed at the Arts Association, NEWCASTLE, two studies of Coniston Water painted while visiting relatives of his wife, and at the first exhibition of the city's Bewick Club, in 1884, three further Lake District views: *The Old Mill, Borrowdale; Sweden Bridge, Ambleside*, and *Slate Bridge, Patterdale*. Most of his life was spent at NEWCASTLE, but following his retirement in the early 1890s, he moved to nearby GOSFORTH, from which he continued to exhibit at the Bewick Club until his death in 1902. Robinson was one of the many Northumbrian artists who found themselves attracted to CULLERCOATS for their subject matter, and made many sketches of the village from 1842. One of these sketches is reproduced opposite page seventy-one of William Weaver Tomlinson's *Historical Notes on Cullercoats, Whitley and Monkseaton*, 1893, and an engraving of the village by Robinson was published by his employers, M & M W. Lambert, about 1844. It is said that Henry Hetherington Emmerson (q.v.), served a brief apprenticeship as an engraver under Robinson, and that John Surtees (q.v.), made his 'first sketch from nature' in Robinson's company. He remains today probably one of Northumbria's least known watercolourists, and as yet unrepresented in any local public collection.

ROBINSON, Gerrard (1834–1891)

Wood-carver; landscape, figure and decorative painter; illustrator. Northumbria's outstanding wood-carver of the nineteenth century, Robinson was born at NEWCASTLE, the son of a blacksmith, and displayed a talent for drawing from an early age. His elder brother John Ewbanks Robinson (q.v.), gave him his first lessons in art, but following the discovery of his talents by the chairman of the town's Government School of Design, he was admitted as a pupil to the School, under William Bell Scott (q.v.). In 1848 he left the School and became apprenticed to Thomas Hall Tweedy (q.v.), the wood-carver and gilder at NEWCASTLE, and in 1855 became foreman of the latter's workshop. In the next seven years he accomplished some of his finest work, including his famous Shakespeare Sideboard, completed within the Tweedy workshops, and exhibited under its proprietor's name, and the even more famous Chevy Chase Sideboard, which is said to have been largely completed at his home in his spare time. The latter work was first exhibited at NEWCASTLE, in 1863, the year after Robinson left Tweedy, and was hailed as a triumph of workmanship by the *Newcastle Daily Chronicle*; '. . . surely so wondrous a piece of furniture never passed from the hands of an artist', commented this newspaper. Shortly after the work was shown, Robinson left NEWCASTLE, and set up as wood carver in London. Here he quickly built up a fashionable clientele for his wood carvings, and was a successful teacher of his skills. In 1866, however, he gave up this successful business, and returned to NEWCASTLE, hoping to take over his former employer's business. But Tweedy gave up the business without first giving Robinson an opportunity to purchase it and he was obliged to start from scratch. The demand for wood-carving began to wane in the late 1860s, and although he had secured much work to begin with, notably from William Wailes (q.v.), who employed him extensively on work for Saltwell Tower, GATESHEAD, Robinson's diffidence as a businessman led to the eventual collapse of his business.

Gerrard Robinson, *Shakespeare Sideboard*, c.1862, oak, 2.74m x 2.13m x 97cm. Tyne & Wear Museums, Shipley Art Gallery.

He was helped by friends such as his former pupil, Seymour Lucas, the Royal Academician, and managed to supplement his income from these friends by teaching carving at NEWCASTLE, and illustrating children's books, but he died so impoverished at NEWCASTLE in 1891, that he was buried in a public grave. His son, Henry Thomas Robinson (q.v.), with whom he spent his final years, was also a gifted woodcarver and painter. On Robinson's death he was described by the *Newcastle Daily Chronicle* as having been 'foremost amongst the wood-carvers of the Kingdom'. A major exhibition of his work entitled *Gerrard Robinson – Newcastle Woodcarver* was held at the Laing Art Gallery, NEWCASTLE, and the Shipley Art Gallery, GATESHEAD, in 1991, to mark the centenary of his death. Tyne & Wear Museums have a large collection of his work, including his Shakespeare Sideboard (permanently on display at the Shipley Art Gallery), and some 200 of his drawings. The Victoria and Albert Museum has a smaller version of the Shakespeare Sideboard.

ROBINSON, Henry Thomas (1872–1952)
Woodcarver; landscape painter in oil and watercolour. He was born at NEWCASTLE, the son of Gerrard Robinson (q.v.), and served his apprenticeship as a carver under his father. On his father's death in 1891, he carried on in business at Pine Street, NEWCASTLE, where he is said to have specialised in 'carving for

hearses, coffins, and circus things'. His business failed about 1900 and he went to work as a carver at the Cooperative Wholesale Society furniture works at PELAW, near GATESHEAD, remaining there until his retirement about 1938. Robinson retained a strong interest in painting and drawing throughout his career as a woodcarver, exhibiting examples of his work in this field at the Bewick Club, NEWCASTLE, from an early age, and later showing at the Artists of the Northern Counties exhibitions at the city's Laing Art Gallery. He did little carving to his own design while employed at PELAW, but did occasionally exhibit works carved in his spare time, a notable example being the work for which he was awarded Second Prize in the Artisan's Section of the North East Coast Exhibition, Palace of Arts, 1929, losing First Prize to William Robinson (q.v.). He died at PELAW. Represented: Shipley A G, Gateshead.

ROBINSON, John Ewbanks (c.1830–after 1860)
Engraver; landscape painter in watercolour; draughtsman. He was born at NEWCASTLE, and later served an apprenticeship as an engraver with Mark Lambert (q.v.), before following this profession in the town. He was an accomplished draughtsman and watercolourist from his youth, and while serving his apprenticeship gave lessons to his younger brother, Gerrard Robinson (q.v.). He is believed to have worked for Lambert for several years before following his profession

William Irving, *Blaydon Races – a Study from Life*, 1903, 96.5 x 142cm. Tyne & Wear Museums, Shipley Art Gallery.

George Musther
Hutchinson,
*A Cold Morning near
Lanchester,
County Durham*,
watercolour, 51 x 76cm.
Private collection.

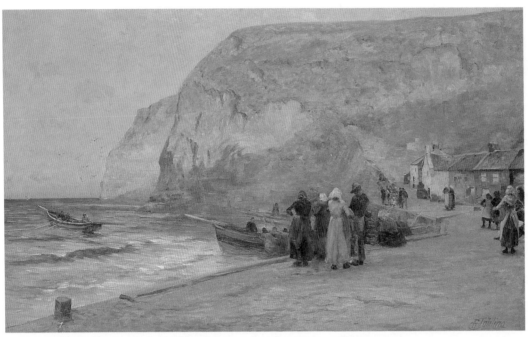

Robert Jobling,
*Fisherfolk on the
Quay at Staithes
Harbour,*
oil, 73 x 119cm.
Anderson &
Garland.

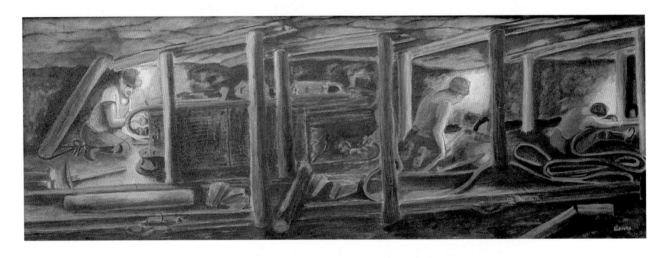

Oliver Kilbourn,
*Coal-cutting on Longwall
Face in the 1930s,*
oil, 41 x 121cm.
Private collection.

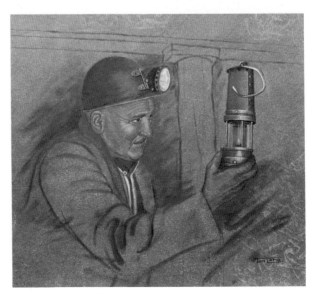

Thomas Lamb,
Testing for Gas, 1950,
oil, 35.5 x 38.1cm.
Private collection.

Kenneth Glover, *Still Life with Flowers*, oil, 41 x 50cm. Anderson & Garland.

Nerys Ann Johnson, *Sunflower and Artichoke*, 2000, gouache, 15 x 28.5cm. Private collection.

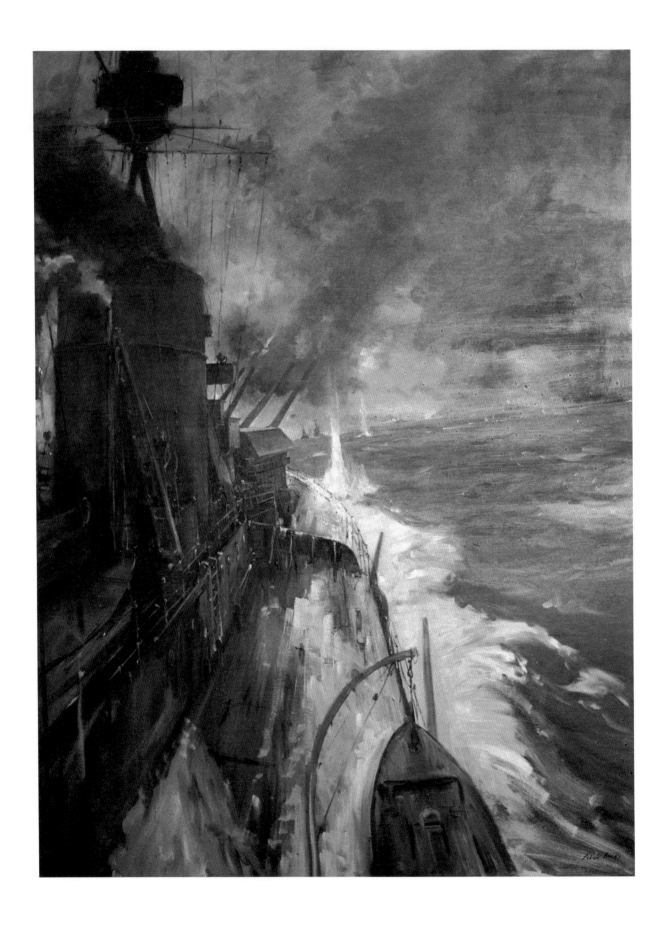

Peter Cecil Knox, *Battle of Jutland*, 1914, oil, 122 x 91.5cm. Tallantyre Gallery.

Gerald Laing,
Galina, 1977,
bronze, 33 x 23 x 33cm.
The Fine Art Society.

Sonia Lawson, *The Deserted Village*, oil, 67 x 61.5cm. Bonhams.

Sheila Gertrude Mackie, *Winter Circus*, oil, 89 x 120cm. Anderson & Garland.

Fenwick Lawson, *The Venerable Bede*, 2001, chestnut, 155 cm tall. The Bede College, Rome.

Fenwick Lawson, *The Journey*, 2002, elm, 244 x 122 x 183 cm. The artist.

George Edward Lowdon, *Tyne Bridge, Newcastle*, watercolour, 40 x 21 cm. Private collection.

Arthur Hardwick Marsh, *The Workers-out, Marden Farm, Whitley Bay*, watercolour, 60 x 92cm. Anderson & Garland.

John Martin, *The Destruction of Sodom and Gomorrah*, oil, 133.5 x 209.5cm. Tyne & Wear Museums, Laing Art Gallery.

Joseph Miller, *Raby Castle*, oil, 57 x 82.5cm. Borough of Darlington Art Collection.

Frank Henry Mason, *Naval Manoeuvres off the Needles*, oil, 46 x 66cm. N R Omell Gallery.

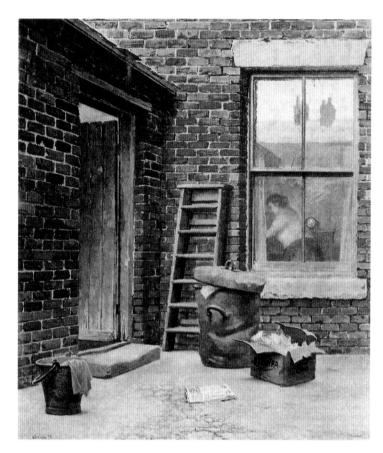

Alfred Ainslie O'Brien,
Back Yard,
oil, 76 x 68cm.
Private collection.

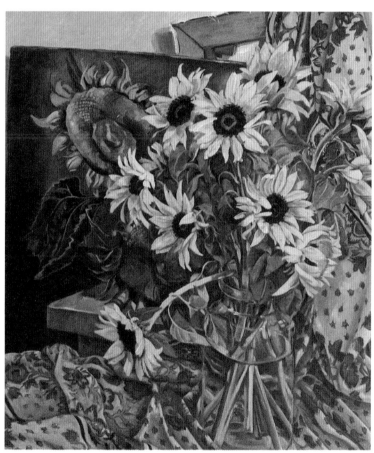

Elizabeth Orange,
Sunflowers in the Studio, 1998,
oil, 127 x 76cm.
Private collection.

Kathleen Parbury,
St Aidan, St Mary's Churchyard,
Holy Island, 1998,
red concrete, figure 3.4m high.
Photo: M Scott Weightman.

Colin Rose,
Window, Bensham Bank, Gateshead
(detail).
Gateshead Metropolitan Borough
Council. Photo: Mark Pinder.

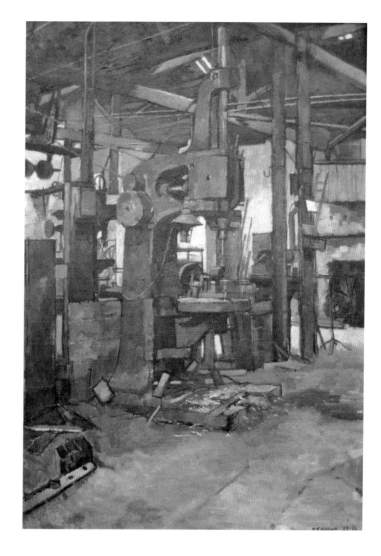

Douglas Frederick Pittuck,
Drilling Machine,
oil, 100 x 71cm.
Private collection.

Charles Edward Sansbury,
Untitled Abstract,
mild steel, 23 x 23 x 20cm.
Private collection.

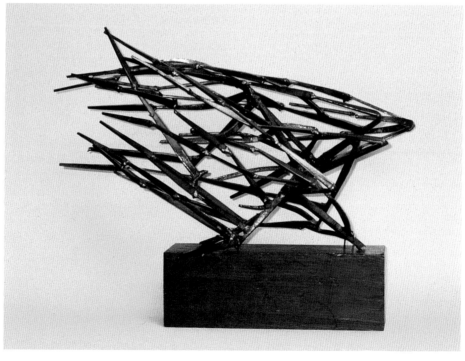

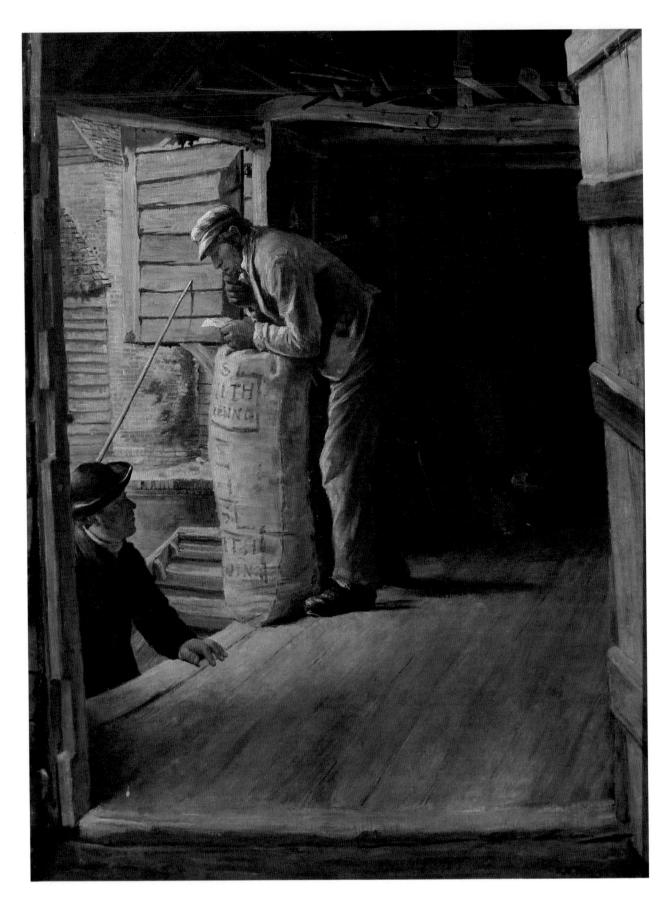

Matthew White Ridley, *A Peep inside the Old Mill*, oil, 109 x 84cm. Anderson & Garland.

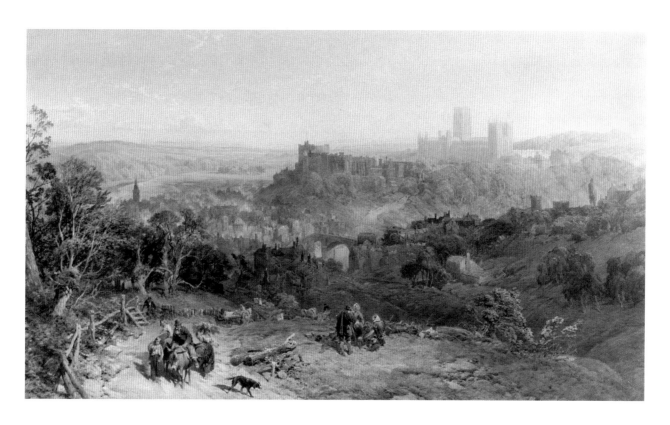

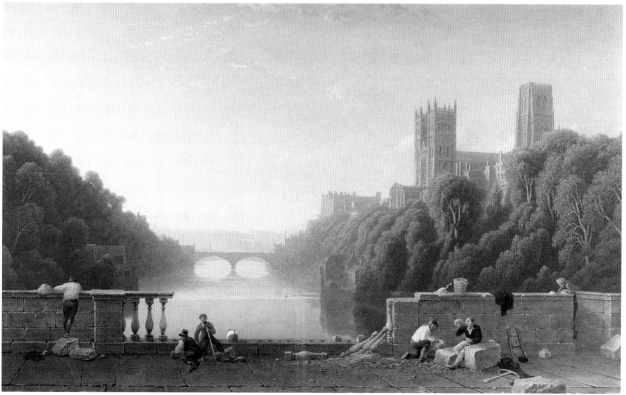

Thomas Miles Richardson, Jun., *City of Durham*, 1860, watercolour, 76 x 129cm. Anderson & Garland.

George Fennel Robson, *Durham Cathedral from Prebends Bridge*, watercolour, 49 x 77cm. Bowes Museum, Barnard Castle.

Brian Roxby, *Salmon Nets*, oil, 76 x 102cm. Private collection.

Kenneth Rowntree, *Findochty*, 1978, acrylic, 25.5 x 38cm. Private collection

William R Robinson,
Boy by the Edge of the Sea,
1827, oil, 33 x 26cm. Sotheby's.

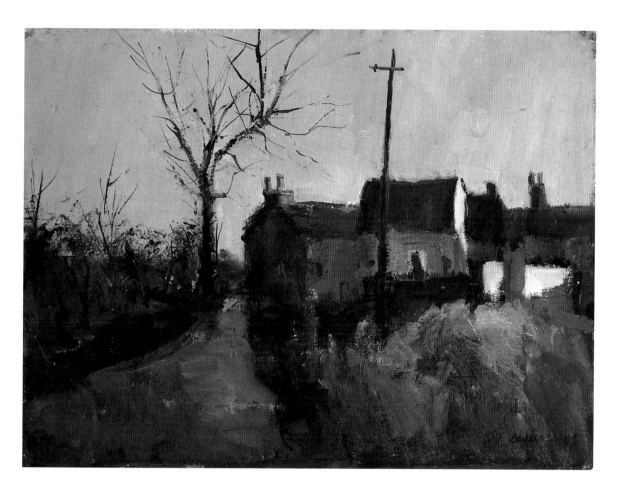

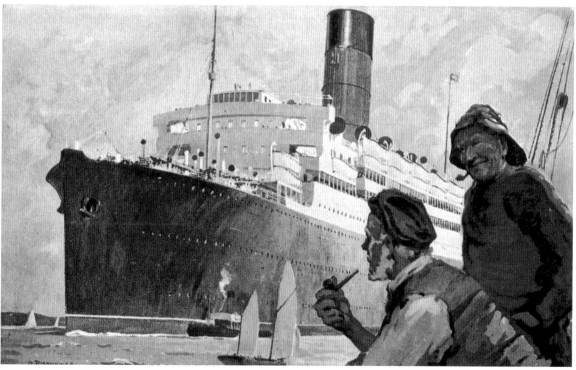

Ronald Ronaldson, *The Red House*, 1992, oil, 46 x 61cm. Chappel Galleries.

Odin Rosenvinge, *RMS Laconia*. Cunard Line postcard illustration.

Ralph Rumney, *The Change*, 1957, oil, house paint and metal leaf, 152.4 x 198.5cm. Tate Gallery.

independently, and his later work as an artist outside engraving is little known. He died on Tyneside.

ROBINSON, William (1867–1945)

Wood-carver; genre, portrait, and landscape painter in oil and watercolour. Robinson was born at GATESHEAD, and following study at Rutherford College, and the College of Physical Science, NEWCASTLE, took up employment as a woodcarver with the woodcarving firm in the city owned by Ralph Hedley (q.v.). Here he was responsible for much of the ecclesiastical carving of the firm for some thirty-eight years, while maintaining a keen interest in painting and drawing genre and landscape subjects, possibly encouraged by his employer. The first work which he exhibited was, indeed, in the latter field, and he soon became a well-known exhibitor at the Bewick Club, NEWCASTLE, and later the Rutherford College Art Club, and other art clubs on Tyneside. In 1907 he exhibited at the Northumberland Handicrafts Guild, NEWCASTLE, one of his earliest known wood-carvings – a carved panel of floral design – and from this point forward he exhibited both woodcarvings and paintings, showing his work at the Artists of the Northern Counties exhibitions at the Laing Art Gallery, NEWCASTLE, and the city's Benwell Art Club. His most outstanding exhibition success came in 1929, when his *The Bird's Nest* woodcarving, exhibited in the Artisan's Section of the North East Coast Exhibition, Palace of Arts, was awarded First Prize, the Second Prize going to Henry Thomas Robinson (q.v.), son of Gerrard Robinson (q.v.). Robinson lived at NEWCASTLE for many years, but retired to GATESHEAD, where he died in 1945. The Shipley Art Gallery, GATESHEAD, has his *The Bird's Nest*, and his other exhibit at the North East Coast Exhibition, *Natural Foliage Panel*, as well as a collection of his paintings and drawings. Examples of his work for Hedley may be seen at St Nicholas Cathedral, NEWCASTLE, the Parish Church of St Chad, GATESHEAD, and Seaton Hirst Parish Church, SEATON DELAVAL.

ROBINSON, W R (fl. 1810–1875)

Portrait, genre and landscape painter in oil and watercolour; lithographer. This artist first practised at Richmond, Yorkshire, from which in 1831 he sent a number of landscape works to the Northern Academy, NEWCASTLE. He was still practising at Richmond in 1838, when he sent eight works to the first exhibition of the North of England Society for the Promotion of the Fine Arts, NEWCASTLE, but by 1844 he had moved to SUNDERLAND. In the middle 1840s he was practising at DURHAM, from which in 1846 he sent three genre works to Carlisle Athenaeum, but he appears to have spent his later life at SUNDERLAND. His *View of Durham Cathedral from Crossgate Peth*, 1844, was included in the 'Historic Durham' exhibition at the DLI Museum & Arts Centre, DURHAM, in 1980, and the *Durham Cathedral Artists & Images* exhibition at Durham Art Gallery, DURHAM, in 1993. Robinson occasionally painted figure studies much in the style of Thomas Sword Good (q.v.), an example being his *A boy by the edge of the sea*, 1827, sold by

Sotheby's in 2001. Represented: British Museum; Sunderland A G. [See colour plate]

ROBSON, Edward (fl. late 18th, early 19th cent.)

Landscape painter in oil and watercolour; etcher. William Hylton Dyer Longstaffe (q.v.), in his *History and Antiquities of the Parish of Darlington*, published in 1854, says of Robson that he was an 'amiable and accomplished botanist' who 'was fond of landscape painting in both oil and watercolours, and used to rise at four o'clock to gratify his taste, which was ... much repressed at the time, as a useless acquisition to the business of life'. In 1817, Robson 'to delight his nephews', wrote a small volume, *Hartlepool and Seaton*, which contains small etchings of views associated with the towns. These etchings are believed to have been executed by Robson.

ROBSON, Featherstone (1880–1936)

Landscape and portrait painter in oil and watercolour; commercial artist. Robson was born at HEXHAM, but had moved with his family to SOUTH SHIELDS by the age of three. After attending school locally he began an apprenticeship with a harness, leather and rubber manufacturer at SOUTH SHIELDS, also taking lessons to develop his early skill at drawing, from George Edward Horton (q.v.). On the basis of his progress as an artist he went to London in 1897 to find work with printing and engraving firms, returning to SOUTH SHIELDS in the following year to resume his art lessons at the town's Art School under John Heys (q.v.). Here his improvement was so rapid that he was offered a post as an assistant teacher at the School. Robson first began exhibiting his work by showing two works at the Artists of the Northern Counties exhibition at the Laing Art Gallery in 1905, shortly afterwards leaving for London to become a pupil of Frank Brangwyn at the artist's school there. Following his father's death in 1909 he briefly returned to SOUTH SHIELDS, but in the following year he went to Vancouver, Canada, with his fiancée, marrying there in 1911. He then spent some time in the USA, at Seattle, Chicago and New York, returning to SOUTH SHIELDS in 1913 for the birth of his daughter. Later in that year he returned to

Featherstone Robson, *Frenchman's Bay, South Shields*, watercolour, 32 x 44.5cm. Private collection.

Chicago, where he became involved in colour gravure and painting. He also worked as a commercial artist and exhibited at both Chicago and New York. In 1915 he returned to England and after working for various engraving and printing firms was commissioned to work for John Swaine & Son, London. He also did freelance work illustrating jewellery for the Liberty store, London. In 1918 he exhibited two works at the Royal Institute of Oil Painters, showing *In Old Kendal*, and *The Fish Market*. On leaving Swaine's he worked for the Carl Hentschel commercial art studio in London, then Haigh & Sons, where he began to paint subjects for the firm's popular series of prints featuring cathedral towns, old coaching inns, etc. These were sold by large department stores, Portings of Kensington selling 151,000 prints of York Minster in 1926. In 1923 Robson showed his only work at the Royal Academy: *The River Colne, Watford*. He had by then settled at Barnet in a house which he named 'Brangwyn' as a tribute to his one-time teacher, but in 1930 he again set off for Canada, and found work with the *Toronto Star*. By 1935, he had decided to return to England, where he obtained a position with Odhams Press to start in 1936. While finalising arrangements to leave Canada, however, he fell ill in Toronto, and died in a hospital there. Robson was one of Britain's most prolific producers of landscape subjects for reproduction as colour prints, or etchings, with hundreds of subjects recorded. He usually signed his work 'F. Robson' or 'Featherstone Robson', but also used the name 'R. Featherstone', and sometimes 'C. Manning'. A major exhibition of his work including his original watercolours, oils, prints, etc, was staged at the Queen's Hall, HEXHAM, in 2000, accompanied by an excellent publication on his life and work, by its organiser Leonard Franchetti.

ROBSON, George Fennel, POWS (1788–1833)

Landscape painter in watercolour; etcher. Robson was born at DURHAM, the eldest son of a wine merchant, and began to show an interest in art at the age of four. At this early point in his life he began to make careful outlines of the wood-engraved illustrations by Thomas Bewick (q.v.), in the *History of Quadrupeds*, later loitering in the company of visiting artists, and finally taking drawing lessons from George Harle (q.v.). He quickly found that he could draw more ably than his master, however, and with five pounds in his pocket was allowed by his father to seek his fortune in London. Arriving in the capital at the age of about seventeen he quickly became friendly with several other rising young artists of the day, and in 1807 exhibited his first works at the Royal Academy: *High Force Cataract: a fall of the River Tees; View on Ettersgill Beck, Teesdale, Durham*, and *Distant View of Durham Cathedral from Shincliffe*. A year later he published *A View of Durham* which proved so successful that he was able to repay the borrowed five pounds, and embark on a prolonged visit to Scotland, where he fell in love with the wild and rugged scenery of the Highlands. Scottish subjects thereafter predominated amongst Robson's exhibits, and it was probably the successful exhibition of the first of these at the

Royal Academy early after his return from Scotland, which led to his election as a member of the Old Water Colour Society (later the Royal Watercolour Society), in 1813. In the year after his election he published a volume of soft ground etchings depicting his Scottish tour, and from 1813 to 1820, he was a prolific exhibitor with his society, mainly showing scenes in the Grampian and Perthshire Highlands. In many of these scenes the cattle depicted were added by animal painter Robert Hills, and the two artists worked together in many other instances, adding passages to each other's compositions, and exhibiting their work jointly. Seven years after becoming a member of the Old Water Colour Society, Robson was elected to its presidency. He was then the youngest artist ever to hold this appointment, and had clearly established a reputation as one of Britain's leading watercolourists, though not by John Ruskin's estimation in the 'front rank'. He exhibited almost exclusively with the Society until his death, showing a total of 651 works, many of which he 'previewed' at his home, and frequently sold before sending them for exhibition. Robson visited many parts of Britain apart from the Highlands of Scotland for his subject matter, touring the Lake District and Ireland in 1827, various parts of England for his 'Picturesque Views of English Cities', published in 1828, and in the year of his death, Jersey with Robert Hills. He was on his way to paint in his native Northumbria in 1833, when he took ill on a fishing smack, and though attended by a doctor at STOCKTON-ON-TEES, died at his home in London a few days later. He was buried at DURHAM, a subject second only to his beloved Highlands of Scotland, in his affections as a painter, and of which he produced some of his most accomplished works. An example was sold by auction at Sotheby's in 2002 for £21,850. Represented: British Museum; Victoria and Albert Museum; Blackburn A G; Bowes Museum, Barnard Castle; Cartwright Hall, Bradford; Laing A G, Newcastle; City A G, Manchester; National Gallery of Scotland; Newport A G; Portsmouth City Museum; Ulster Museum, Belfast; Warrington A G; Williamson A G, Birkenhead. [See colour plate]

ROBSON, Thomas (fl. 1808–1861)

Engraver; lithographer. Robson practised at SUNDERLAND from 1808–1861, initially as an engraver, later expanding his business to embrace letterpress and lithographic printing. In 1830 he wrote the text and engraved the plates for the *British Herald*, and the *History of Heralds*, but he later concentrated mainly on printing.

ROCK, David Annison (b.1929)

Amateur landscape and architectural painter in watercolour; draughtsman. He was born at SUNDERLAND and studied architecture at King's College (later Newcastle University). It is believed that he later practised as an architect in his native town, only painting in his spare time. He was a member of Sunderland Art Club, and exhibited both there and at the Artists of the Northern Counties exhibitions at the Laing Art Gallery, NEWCASTLE. Two of his works, *An Austrian*

Tapestry, and *Bishopwearmouth Church, Sunderland*, were included in the 'Contemporary Artists of Durham County' exhibition, staged in 1951, at the Shipley Art Gallery, GATESHEAD, in connection with the Festival of Britain.

ROGERS, Charles Herbert (b.1930)
Landscape painter in oil and watercolour; draughtsman. Rogers was born at GATESHEAD and became a clerical worker on Tyneside before his national service. Following his national service he returned briefly to clerical work, then took up a variety of occupations both on Tyneside and in the south of England before settling permanently at GATESHEAD. From his early thirties until his early forties he was employed by Durham County Council helping to maintain local playing fields, and during this period saw a poster advertising art classes at Gateshead Technical College under Wilfred Taylor (q.v.). He was then thirty-four, and although he had previously done little sketching or painting he made such rapid progress that in 1965 he was invited to join in a three-man exhibition at the Univision Gallery, NEWCASTLE. Participation in other local exhibitions followed, and in 1967 he was successful in having the first of four works shown at the Royal Academy: *October Morning, Cotfield Street, Gateshead*. In 1968 he also exhibited at the Royal Scottish Academy and quickly followed this by showing at various London and provincial exhibitions. In 1974 he became redundant from his position with the Council and has since practised as a full-time professional artist specialising in local urban views, many of these portraying parts of GATESHEAD about to be demolished. In addition to the venues already mentioned, he has shown his work at various exhibitions staged at the Shipley Art Gallery, and the Central Library, GATESHEAD, and the Laing Art Gallery, and University of Northumbria, NEWCASTLE. His work has also been shown in exhibitions at many private galleries on Tyneside and been the subject of a number of limited edition prints. He lives and works at GATESHEAD. Represented: Shipley A G, Gateshead.

ROGERS, J (c.1880-c.1950)
Sculptor. Rogers was employed in the workshop of Robert Beall (q.v.), and later his son, ROBERT E BEALL, for some fifty-five years, and is best known for his stone carvings of the twenty-two heads of Worswick House and Chambers, at the junction of Worswick and Pilgrim streets, NEWCASTLE. These heads were long thought to have been of various celebrated people, but a one-time acquaintance of the sculptor, writing in a local newspaper in 1961, said he once told her that they were based on selections from a family photographic album. The building which they adorn was erected in 1900, and was at one period occupied by the Bewick Club, NEWCASTLE.

ROGERS, John George (1886–1967)
Amateur landscape and still life painter in oil and watercolour. Born at BISHOP AUCKLAND, Rogers was for fifty-five years a painter and decorator at DARLINGTON, painting local landscapes, and occasional still life works in his spare time. He is said to have received tuition in art privately before exhibiting his work, which he commenced in his early twenties by showing examples at the Darlington Society of Arts. In 1926 he began exhibiting his work at NEWCASTLE, showing his oil, *Still life*, at the Artists of the Northern Counties exhibition at the city's Laing Art Gallery. He remained a regular exhibitor at NEWCASTLE, and DARLINGTON for much of his life, also showing examples of his work in other provincial towns and cities. He is said to have exhibited several works at the Royal Academy in his later life, and one of his oils, *Flower Piece*, was included in the 'Contemporary Artists of Durham County' exhibition, staged at the Shipley Art Gallery, in 1951, in connection with the Festival of Britain. His work is represented in several overseas collections.

RONALDSON, Ronald (b.1919)
Landscape and still life painter in oil. Born at NEWCASTLE, Ronaldson first showed signs of artistic talent at elementary school. At the age of eleven he won a scholarship to a junior technical school where he was taught technical drawing, but at the age of fifteen left to work for a builder's merchant. After a short period in this employment he joined the Royal Navy, remaining in the service for twelve years and buying his first oil paints when his ship called at Cape Town. Following the Second World War he worked as a medical laboratory scientific officer until his retirement, only painting in his spare time. He first began exhibiting his work by showing examples at the Artists of the Northern Counties exhibitions at the Laing Art Gallery, NEWCASTLE, in 1947, where his exhibit was his *Cingalese Head*. He then went on to exhibit with Bury St Edmunds Art Society; at Bury St Edmunds Art Gallery; the Phoenix Gallery, Lavernham, and Gainsborough's House, Sudbury. The artist Rowland Suddaby, who lived at Sudbury, encouraged him to have a one-man exhibition of his still lifes, but he never took up the offer, and when he submitted his work to the Royal Academy in the 1960s it was accepted but not hung. He is a member of the Suffolk Art Society and in addition to participating in its exhibitions has also shown his work at the St John's Street Gallery, Bury St Edmunds, and since 1988 at the Chappel Galleries, Chappel, near Colchester. He was a participant in the Laing Competition in 1991 and 1992. The Chappel Galleries held one-man exhibitions of his work in 1993 and 1997, the *East Anglian Times* art critic writing of the latter 'Ronald Ronaldson is a painter of quiet strength and conviction. His landscapes glow with light, celebrations of the beauty of our countryside, and have a glorious freshness about them which quite lifts the soul.' [See colour plate]

ROOKE, Caroline Mary (b.1848)
Landscape painter in watercolour. She was born at EMBLETON, the daughter of Canon George Rooke, and became a largely self-taught artist before exhibiting her work at the Dudley Gallery, London; the Society of Women Artists, and at the Artists of the Northern

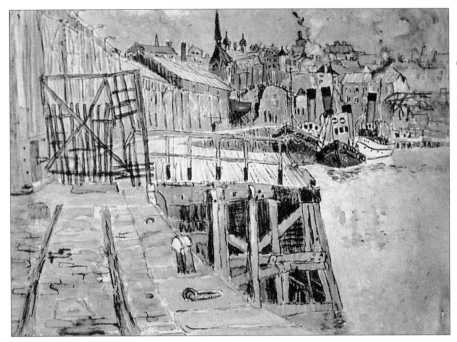

Charles Herbert Rogers, *Quayside, Byker, Newcastle*, mixed media, 36 x 46cm. Private collection.

Counties exhibitions at the Laing Art Gallery, NEWCASTLE. She also exhibited her work at other provincial galleries, including those at Birmingham and Bath. Much of her later life was spent at Bath.

ROSE, Colin (b.1950)
Sculptor; printmaker; art teacher. Rose was born at NEWCASTLE and studied at Newcastle Polytechnic (now University of Northumbria), and Newcastle University, before commencing his career as a sculptor at twenty-five. Among the first of many group exhibitions to which he contributed work were the Northern Young Contemporaries, Whitworth Art Gallery, Manchester, 1975; the 'Cleveland International Drawing Biennial', MIDDLESBROUGH, 1977, and 'Northern Art', Shipley Art Gallery, GATESHEAD, 1978. His first one-man exhibitions were held at the Gulbenkian Gallery, People's Theatre, NEWCASTLE, in 1978 and the city's Hatton Gallery, 1979. His work quickly achieved recognition, resulting in awards from the Arts Council of Great Britain, a Northern Arts Travel Award and the Northern Arts Major Bursary (1985/6). He was also appointed resident sculptor at Woodhorn Colliery Museum, ASHINGTON, in 1986, and artist-in-residence at Ashington Community Initiatives Centre, in 1987. In the latter year he became an active member of the Newcastle Group, and went on to participate in further group exhibitions, both in Britain and abroad. These have included the Newcastle Group, Laing Art Gallery, NEWCASTLE, 1987; Kunstverein, Bremen, West Germany, 1988; the RIBA Sculpture Court, London, 1989; the Newcastle Group's 'Northern Lights', DLI Museum & Art Gallery, DURHAM, 1990, and tour; Yorkshire Sculpture Park, 1992, and Sculpture at Goodwood, 1996. A one-man exhibition of his work was held at the Hatton Gallery, in 1992. Rose has been responsible for several works of public sculpture in Northumbria throughout his career, these including his *Window*, GATESHEAD, 1986; *Rolling Moon*, GATESHEAD, 1990, and *Whirling Bean*, Leaplish Waterside Park, KIELDER, 1996. He has also carried out commissions for other parts of Britain, and examples of his work are held by the Arts Council of Great Britain, and Sculpture at Goodwood. He is a visiting lecturer at Sunderland and Newcastle universities, and in 2000 won a £20,000 prize in a national competition to design a barrier to reduce the impact of noise on people living near motorways. Rose describes his work as minimal, and reflects his early background in engineering with its emphasis on clean lines, and extensive use of metal. In recent years he has also involved himself in printmaking. He lives near ALNWICK. Detailed descriptions and illustrations of his public works in Northumbria are contained in *Public Sculpture of North-East England*, Paul Usherwood, Jeremy Beach and Catherine Morris, Liverpool University Press, 2000. [See colour plate]

ROSE, Jeannie Morrison (c.1868–after 1928)
Landscape, portrait and genre painter in oil and watercolour. This artist practised at NEWCASTLE in the late 19th and early 20th centuries, and regularly exhibited her work from 1890, showing examples at the Royal Society of British Artists; the Royal Miniature Society; the Royal Birmingham Society of Artists, Birmingham; the Glasgow Institute of Fine Arts; the Walker Art Gallery, Liverpool, and elsewhere in the provinces, including the Bewick Club. NEWCASTLE. After 1903, she exhibited mainly at the last named venue, and at the Artists of the Northern Counties exhibitions at the Laing Art Gallery, NEWCASTLE, showing as her first exhibits in 1905: *The Smithy*, in oil, and *La Gagnante*, in watercolour. She remained a regular exhibitor at NEWCASTLE until 1928.

ROSE, Robert Traill, SSA (1863–1942)
Landscape and figure painter in oil and watercolour; engraver; lithographer; illustrator. Rose was born at NEWCASTLE, but left his birthplace at an early age to study at Edinburgh School of Art. Following his artistic education he remained in Edinburgh for many years, later moving to Tweedsmuir, Peeblesshire. He was a frequent exhibitor at the Royal Scottish Academy throughout his professional career, and also showed his work at the Royal Scottish Society of Painters in Water Colours, the Society of Graphic Arts, and at various London and provincial galleries. Influenced by William Morris and Walter Crane, Rose worked mainly as a book illustrator. Among his works were *The Book of Job; Omar Khayyàm; Edinburgh Vignettes*, and *Children's Dante*. The National Gallery of Scotland has several of his drawings for illustrations, including work prepared in the form of pen drawings for *The Book of Job*, which was published in Edinburgh in a limited edition in 1902. He was a member of the Scottish Society of Artists. He died at Edinburgh.

ROSENVINGE, Hjalmar (1890–1962)
Landscape and coastal painter in watercolour. He was born at NEWCASTLE, the son of a Tyneside ship's chandler of Danish descent, and appears to have become a largely self-taught artist, although he may have received some tuition from his elder brother Odin Rosenvinge (q.v.). It is possible that he was for some time associated with his family's business, but he later became moderately successful as a painter of local coastal scenes and apparently eked out a living selling these to businessmen and private householders in TYNEMOUTH, NORTH SHIELDS and WHITLEY BAY. It is also believed that he did some commercial design and is popularly credited with the logo for the North East Coast Exhibition, in 1929. Much of his work was executed in watercolour, and on a small scale, using bright colours. He died at CULLERCOATS.

ROSENVINGE, Odin (1880–1959)
Marine and landscape painter in oil and watercolour; poster designer; illustrator. He was born at NEWCASTLE, the son of a Tyneside ship's chandler of Danish descent. He showed an early aptitude for art but on leaving school became a reporter covering local law courts. He enlivened his reports with quick sketches, however, and with these as evidence of his abilities was later able to obtain a position as artist with a leading printing firm at Leeds. From Leeds he moved to Merseyside, where he obtained a similar position with Liverpool printers Turner & Dunnett, eventually rising to the post of senior artist. The firm had many of the big-name shipping lines among its clients and Rosenvinge increasingly specialised in designing posters and other publicity material for Cunard, Canadian Pacific and others. During the First World War he served in the RASS in the Middle East, but was reinstated as senior artist with Turner & Dunnett on his return to civilian life. On the firm's liquidation in the early 1930s he was obliged to turn freelance, and continued in this practice until late in his life. Private commissions formed the greater part of his later output, but it was also sold via various

Liverpool galleries. Although he regularly exhibited his landscape, marine and architectural works at the Walker Art Gallery, Liverpool, between 1913 and 1933 Rosenvinge is today best remembered for his poster work. His work in the field compares favourably with that of Frank Henry Mason (q.v.), and pictures some of the most famous passenger and cargo vessels of the day. On first settling on Merseyside Rosenvinge lived at Formby but by 1913 had crossed the river to live at Rock Ferry, Cheshire, where he died in 1953. His younger brother Hjalmar Rosenvinge (q.v.), and son OLAF ROSENVINGE (b.1913), also practised as artists. Represented: National Museums & Galleries on Merseyside. [See colour plate]

ROSS, Christina Paterson, RSW (1843–1906)
Landscape and genre painter in watercolour. She was born at BERWICK-UPON-TWEED, the daughter of Royal Scottish Academician, ROBERT THORBURN ROSS (1816–1876), during her father's short period as a professional artist in the town. After receiving tuition from her father, she also became a professional artist, practising mainly at Edinburgh, and exhibiting her work widely throughout Britain. She exhibited at the Royal Academy; the Royal Scottish Academy; the Royal Hibernian Academy; the Royal Institute of Painters in Water Colours; the Royal Scottish Society of Painters in Water Colours, and at several provincial exhibitions, including those held at NEWCASTLE, in the late 19th century. Among her exhibits at NEWCASTLE, were her watercolours *Staithes, Yorkshire*; *The Young Fisherman*, and *Durham Cathedral*, shown at the city's Bewick Club, in 1884. She was elected a member of the Royal Scottish Society of Painters in Water Colours in 1900, and died at Edinburgh six years later. She was the sister of Joseph Thorburn Ross (q.v.).

ROSS, Joseph Thorburn, ARSA (1849–1903)
Landscape and portrait painter in oil and watercolour. He was born at BERWICK-UPON-TWEED, the son of Royal Scottish Academician, ROBERT THORBURN ROSS (1816–1876), during his father's short period as a professional artist in the town. After receiving tuition from his father, he also became a professional artist, and practised at Edinburgh until his death in 1903. He exhibited his work at the Royal Academy; the Royal Scottish Academy; the Royal Institute of Painters in Water Colours, and at several provincial exhibitions, including those held at NEWCASTLE about 1880, showing both British and Continental subjects. He was an associate of the Royal Scottish Academy. His sister, Christina Paterson Ross (q.v.), was also a talented artist. Represented: National Gallery of Scotland; Darlington A G.

ROWDEN, Kenneth (1935–1999)
Sculptor in metal; landscape and figure painter in oil; art teacher. Born at HORDEN, near EASINGTON, Rowden spent most of his life as an industrial welder. In 1971, however, he began to sculpt in his spare time using an oxy-acetylene torch in his home workshop to produce full-standing and wall-mounted sculptures in scrap metal. These he exhibited widely throughout

Northumbria, showing examples at the DLI Museum & Art Gallery, DURHAM; the Gray Art Gallery, HARTLEPOOL; Sunderland Art Gallery; Jarrow Hall, JARROW, near SOUTH SHIELDS, and elsewhere. He also carried out a number of commissions, including a phoenix for the outside of the People's Theatre, NEWCASTLE. By 1985 his work had become in such demand that he decided to become a full-time professional artist. His figures in metal, some from literature, some from memory or imagination, soon became popular among national and local celebrities, as well as the general public, and were shown at exhibitions throughout Britain, in France and the USA. In addition to his sculpture Rowden was an able painter of a wide range of subjects and had agreed to an exhibition of the whole range of his work at EASINGTON, when he died of a heart attack aged only sixty-three. The exhibition was later held as a retrospective at Seaton Holme, EASINGTON, in 2000, drawing upon sculptures and paintings loaned by collectors.

Kenneth Rowden, *The Miners*, chromed mild steel, 61 x 61 x 31cm. Private collection.

ROWE, Thomas William (c.1835-after 1878)
Sculptor; draughtsman. Rowe was born at SOUTH SHIELDS, and later practised as a sculptor in the town. While at SOUTH SHIELDS he commenced exhibiting his work at the Royal Academy, showing two portrait busts: *The Hon, Mrs, Geo. Denham*, and *Miss Wood*. His most notable exhibit, however, was his bust of Thomas Salmon, the first Clerk of SOUTH SHIELDS, which he showed at the Royal Academy in 1868, and subsequently presented to the Town Hall. After leaving SOUTH SHIELDS he practised in London, and continued to exhibit at the Royal Academy until 1878.

ROWNTREE, Kenneth, SMP ARWS (1915–1997)
Landscape, townscape and figure painter in oil and watercolour; muralist; collagist; draughtsman; illustrator; art teacher. A Quaker, born at Scarborough, Rowntree studied at the Ruskin School of Drawing, Oxford, under Albert Rutherston, and the Slade School of Fine Art, with Randolph Schwabe. In 1940

during the Second World War, whilst living near Great Bardfield in Essex, he was one of a select group of artists chosen by Sir Kenneth Clark to work for the Recording Britain scheme, funded by the Pilgrim Trust. These paintings were later published by the Oxford University Press in a book of the same name. In 1943 he was also elected a member of the Society of Mural Painters, this interest leading to his appointment in 1948 as tutor in mural painting at the Royal College of Art. In 1949 he moved his family to Putney, London. After leaving the Royal College of Art in 1958 (his students had included David Hockney, Peter Blake and John Bratby) he received a Ford Foundation Grant to paint in the USA and, the following year, was appointed professor of fine art at King's College (now Newcastle University). By this time he had completed his series of oil paintings of the Oxford College barges, exhibited at the Ashmolean Museum, in 1959. He remained professor of fine art at Newcastle until retirement in 1980. Rowntree had his first one-man exhibition at the Leicester Gallery, London, in 1946 – a show that first illustrated his great love of France and, subsequently, Italy. Others followed at the Zwemmer Gallery; the Bear Lane Gallery, Oxford; the New Art Centre; the Laing Art Gallery, NEWCASTLE, and the Fry Gallery, Saffron Walden, Essex. Retrospectives were also held at the Hatton Gallery, NEWCASTLE, in 1980, and in 1992 at the Davie Memorial Gallery, Newtown, Wales, which later toured to Cardiff; the Royal Festival Hall, London; the DLI Museum & Art Gallery, DURHAM, and the Abbot Hall Gallery, Kendal, Cumbria. Both before and after teaching at the Royal College of Art he completed several mural commissions, these including Barclay School, Stevenage, in 1946; the RMS *Orsova, Iberia*, and *Orcades* (1953–4), and the British Pavilion at the Brussels International Exhibition of 1958. In 1948 he had completed a celebrated commission for King Penguin, entitled *A Prospect of Wales*, a book today greatly sought-after by collectors. In addition to one-man exhibitions, Rowntree was represented in a number of group exhibitions, including those of the New English Art Club; the Royal Watercolour Society (of which he was elected an associate in 1946); the Artists, International Association, and the Artists of the Northern Counties exhibitions at the Laing Art Gallery, NEWCASTLE. Throughout his career at NEWCASTLE, he lived mainly in the Tyne Valley; initially at ACOMB, near HEXHAM, and finally at CORBRIDGE. A lavishly illustrated book on his work, by professor of art history John Milner, was published in 2002. An exhibition of his work was held at the Hatton Gallery, NEWCASTLE, in September-November 2003. Represented: Tate Gallery; National Library of Wales; Imperial War Museum; Victoria and Albert Museum. [See colour plate]

ROXBY, Brian, ROI (b.1934)
Landscape, still life and portrait painter in oil, acrylic, and watercolour; art teacher. Roxby was born at SEAHAM and first developed his interest in art while a pupil at St Cuthbert's Grammar School, NEWCASTLE, under Maurice McPartlan (q.v.). He then enrolled at Sunderland College of Art, under Henry Thubron

(q.v.), and left with a national diploma in design and a scholarship to the Royal College of Art. After leaving the College he exhibited in the 'Some Contemporary British Painters' show at Wildensteins, London, in 1958, and at the Piccadilly Gallery, London. Despite this early success as a painter, however, he opted to teach art rather than become a full-time professional, and taught at various schools in London and elsewhere. He was eventually offered a position as art teacher at his old school, St Cuthbert's, where he remained until his retirement twenty-five years later, in 1985. He has since exhibited regularly in London, including the Mall Galleries; the New English Art Club; the Royal Society of Marine Painters; the Royal Institute of Painters in Water Colours; the Royal Society of British Artists, and the Royal Institute of Oil Painters, of which latter he was elected a member in 1993. He has also exhibited at several provincial galleries, and enjoyed one-man exhibitions at HEXHAM, in 1988; DURHAM, in 1989, and at Thirsk, North Yorkshire, in 1999. He moved from his long-time home at HETTON-LE-HOLE, in 1997, to live in Lincolnshire, and has since enjoyed a further one-man exhibition at The Gallery, Lincoln, in 2001. He has also continued to teach in a part-time capacity. His work is represented in the National Museums and Galleries of Wales, and the Government Art Collection. [See colour plate]

RUMNEY, Ralph (1934–2002)
Abstract painter in oil; art teacher. Rumney was born at NEWCASTLE, the son of a clergyman, and after education at boarding school went to Halifax School of Art. He soon dropped out of the school, however, and when he was later called up for National Service fled to the Continent. Here he settled in Paris and soon began to achieve notoriety as an original artistic talent, painting in the tachiste and abstract modes. After founding an arts weekly named *Other Voices* he went to Trieste and here held his first one-man exhibition. This was followed by another two such events, in Milan, and London. Following his participation in an international exhibition in Tokyo in 1957, he next showed in the key Metavisual, Tachiste and Abstract exhibition at the Redfern Gallery, London. A visitor to the exhibition was leading modern art collector Peggy Guggenheim (1898–1979). She subsequently decided to buy his exhibit *The Change*, which had been illustrated on the catalogue cover, but Rumney refused her offer and gave it to her painter daughter Pegeen. He and Pegeen married in the following year, and for almost the next ten years divided their time between London, Paris and Venice. Rumney continued to paint during the first years of their marriage, and having become a founder-member of the Internationale Situationniste Movement in 1957, collaborated in the setting up of the environmental project *Place*, at the International Centre for Contemporary Art, London. He also exhibited his work at the Paris Biennale, and was involved in 'Situation', at the Royal Society of British Artists, but he gradually became disillusioned with the gallery system's tendency to hinder innovation, and in the early 1960s abandoned painting to become a writer and broadcaster for the next sixteen years. After working for French broadcasting for much of this time he next taught art history and theory, and involved himself in film making at Canterbury College of Art. In 1983 he resumed making artworks, and in 1985 enjoyed a further one-man exhibition, at the Transmission Gallery, Glasgow. This was followed by a major retrospective at England & Co, London, in 1989, and in this year also *The Change* was acquired for the permanent collection of the Tate Gallery. He subsequently enjoyed a revived interest in his work, but spent much of his later life working on his autobiography *Le Consul*. Published in 1999, it took as its title the name of the alcoholic Englishman in Malcolm Lowry's *Under the Volcano*, and which was given to Rumney as a nickname in his early days in Paris. He spent his final years in Provence living alone. His first wife, Pegeen, had died in 1967, and his second wife, Michelle Bernstein, whom he had married in 1974, had long been separated from him. Michelle was the ex-wife of Guy Debord, together with whom he had founded the Internationale Situationniste Movement – a movement said in Rumney's obituary in the *Daily Telegraph*, March 9th 2002, to have 'helped to inspire the Paris Riots of May 1968, the Sex Pistols, the K Foundation, the décor of the Hacienda Club in Manchester, and Damien Hirst'. [See colour plate]

RUNCIMAN, Thomas (1841–1909)
Amateur landscape and coastal painter in watercolour. He was born at SPITTAL, near BERWICK-UPON-TWEED, a member of the well-known Runciman family of shipowners. Three of his works were shown at the Artists of the Northern Counties exhibition at the Laing Art Gallery, NEWCASTLE, in 1908, but he is not known to have exhibited elsewhere in his lifetime, except at the 'Gateshead Fine Art & Industrial Exhibition' in 1883. A large exhibition of his work, loaned by his family, was held at the Academy of Arts, Blackett Street, NEWCASTLE, in 1911. The more than 200 watercolours on show included Northumbrian, Lake District and Continental scenes, and were accompanied by an illustrated catalogue. Runciman was a published poet, and a perceptive writer on art. He died in London.

RUSHTON, Alfred Josiah, ARCA (b.1864)
Portrait, figure and landscape painter in oil; art teacher. Rushton was born at Worcester, and studied at Birmingham School of Art, and at the Royal College of Art before becoming a professional artist. Just after the turn of the century he was appointed second master of the Leeds School of Art, leaving this appointment in 1905 to become principal of the School of Art at WEST HARTLEPOOL (NOW HARTLEPOOL) in succession to Edwin Ely Denyer (q.v.). He first began exhibiting his work publicly when he sent a genre work, *I do like my butter*, to the Suffolk Street Gallery, in 1875/6. In 1880 he sent his first of three works to the Royal Academy: *Fanny; a portrait*. He exhibited little in Northumbria while living at HARTLEPOOL, preferring to exhibit his work in London and Birmingham. He last exhibited at the Royal Academy in 1908, showing *In the Garden*.

Charles Rutherford,
A view towards Old Hartley,
oil, 39 x 65cm.
Anderson & Garland.

He retired from his post as principal of the School of Art at HARTLEPOOL in 1930. He was an associate of the Royal College of Art. Represented: Hartlepool Arts & Museum Service.

RUSHTON, George Robert, RI RBA RBSA (1869–1948)

Landscape painter in oil and watercolour; muralist; stained glass designer. Rushton was born at Birmingham, and later studied art in his native town, and in London. About 1895 he moved to Tyneside, where he married the sister of Sydney Ash (q.v.). He later settled at NEWCASTLE, where he did stained glass designs, and mural work, and in 1897 sent his first work for exhibition to the Royal Academy: *The Widow*. In 1900 he received his art master's teaching certificate, later gaining a teaching post at Armstrong College (later King's College; now Newcastle University), under Richard George Hatton (q.v.), and remaining at the College until 1906. He later practised as a landscape painter, working mainly in watercolour, and painting extensively in Berkshire, East Anglia, Sussex, Northumbria, and on the Continent. On leaving NEWCASTLE he first settled at Ipswich, in Suffolk, and from there commenced exhibiting his work widely, showing examples at the Royal Academy; the Royal Society of British Artists; the Royal Institute of Painters in Water Colours, and several London and provincial exhibitions, including among the latter, the Artists of the Northern Counties exhibitions at the Laing Art Gallery, NEWCASTLE. He was a regular exhibitor at NEWCASTLE from the 1920s until his death at Ipswich in 1948. Rushton was a member of the Royal Society of British Artists; the Royal Institute of Painters in Water Colours, and the Royal Birmingham Society of Artists. His daughter WINIFRED RUSHTON (b.1901), was a talented designer and craftswoman. Represented: Laing A G, Newcastle, and several provincial and overseas galleries.

RUSSELL, Lady Ena, ROI (1906–1997)

Landscape, portrait, figure and flower painter in oil and watercolour; illustrator. She was born near MIDDLESBROUGH, the daughter of local architect, A Forrester FRIBA. Her father won a competition to redesign MIDDLESBROUGH after the First World War, but when this was prevented by the recession the family suffered some deprivations. To assist with her upkeep, however, she was prompted to take up writing and illustrating fashion articles as 'EVA GLEN'. After marrying she was able to develop her early interest in painting by studying art at St Alban's; Chelsea, and the Sir John Cass Colleges of Art. On concluding her studies she widely exhibited her work, showing examples at the Royal Academy; the Royal Society of Portrait Painters; the Royal Society of British Artists; the Royal Institute of Oil Painters; the Royal Welsh Academy; the Paris Salon; the New English Art Club, and at various galleries in and around London. She also had one-man exhibitions at St John's Wood and the House of Commons, in 1974; Qatar, in 1980, and in a touring exhibition entitled *Contemporary Art*, at Kyoto and Osaka, Japan, in 1988. In 1968 she organised and participated in a Wives of Westminster exhibition to show support for her favourite charity, the Artists' General Benevolent Institution. She continued to write and illustrate articles on travel, and arts and crafts subjects into her old age, and also painted at her studios in Provence, France, and London, despite increasingly poor eyesight. She was elected a member of the Royal Society of Oil Painters in 1972, and remained in membership until her death in London in 1997. She was the wife of Sir Ronald Russell, MP and author.

RUTHERFORD, Charles (fl. late 19th, early 20th cent.)

Coastal and landscape painter in oil and watercolour. This artist practised at NORTH SHIELDS, and NEWCASTLE in the late 19th and early 20th centuries, and was a regular exhibitor at the Bewick Club, NEWCASTLE, and

later the Artists of the Northern Counties exhibitions at the city's Laing Art Gallery. Most of his works were in oil, and featured views along the Northumbrian coastline, and occasional inland views. He had a gallery at The Side, NEWCASTLE, for many years, at which he occasionally allowed brother artists to stage exhibitions, as with the exhibition staged there by Harry James Sticks (q.v.), in 1895. Rutherford commonly signed his work with an interlocked 'C' and 'R'.

RUTHERFORD, Isabella – see DOBSON, Mrs Isabella

RUTLEDGE (ROUTLEDGE), William (c.1865–after 1918)
Portrait, landscape and coastal painter in oil and watercolour. Born at SUNDERLAND, Rutledge practised as a professional artist in the town from his early twenties, and commenced exhibiting his work in 1881, by showing his *Girls Hoeing*, at the Arts Association, NEWCASTLE. He exhibited exclusively at NEWCASTLE for the next few years, showing work at the city's Bewick Club from 1884, but after moving to London by 1892, he began to exhibit his work at the Royal Institute of Oil Painters, and the Royal Society of British Artists, as well as in the provinces. In 1897 he sent his only work to the Royal Academy, *The wind and the waves*, some four or five years later returning to SUNDERLAND, where he practised until his death, and exhibited his work only at NEWCASTLE. Here he was an exhibitor at the Artists of the Northern Counties exhibitions at the city's Laing Art Gallery, from their inception in 1905, for thirteen years. Sunderland Art Gallery has his oils *Walt Whitman*, and *Portrait of a Young Girl*; and watercolour, *Whitburn Foreshore*.

RUTTER, Andrew Craig (1912–2000)
Amateur marine painter in oil and watercolour. Rutter was born at SEAHOUSES and worked as a fisherman and later as a National Trust warden on the nearby Farne Islands, painting in his spare time. Although entirely self-taught he was a prolific and competent artist whose work was sold at London department store Harrods, and in his native Northumbria, for substantial sums. He also enjoyed a one-man exhibition at Bamburgh Castle, BAMBURGH, and in 1998 published *A Seahouses Saga*, containing reproductions of his work. He died at SEAHOUSES, where apart from war service in the navy, on minesweepers, he had spent all his life. His work is in many private collections around the world, although he is not known to have exhibited it elsewhere than the Methodist Church, SEAHOUSES.

RUTTER, Robert Walker ARCA (1909–1955)
Portrait, figure and interior painter in oil and tempera; art teacher. Born at SUNDERLAND, Rutter studied at Hammersmith School of Art, under William Washington, and at the Royal College of Art, under Percy Hague Jowett. After completing his studies at the latter in 1940 Rutter himself became an art teacher, returning to Hammersmith School of Art as painting master. He exhibited at the Royal Academy between 1946 and 1949, showing a variety of portraits, figure studies and interiors, among these *The Rocking Chair* (1947); *Woman Sewing* (1948), and *Through an Open Door* (1949). He also exhibited in the provinces and in the USA. The Contemporary Art Society for Wales holds examples of his work.

RYOTT, James Russell (d.1851)
Animal, sporting, landscape and portrait painter in oil and watercolour. Ryott practised in NEWCASTLE during the first half of the 19th century, living and working for much of this period in the town's Northumberland Street. He was an acquaintance of Thomas Miles Richardson, Senior (q.v.), Henry Perlee Parker (q.v.), and John Wilson Carmichael (q.v.), and regularly exhibited his work alongside these three artists at exhibitions held at NEWCASTLE from the early 1820s. He first exhibited his work publicly when he showed horse portraits at the 1824 exhibition of the Northumberland Institution for the Promotion of the Fine Arts, NEWCASTLE. He again showed a horse portrait at the 1826 exhibition of the Institution, and went on from showing at the Institution to become a regular exhibitor at the Northern Academy, NEWCASTLE, from its foundation in 1828, and at the exhibitions of the various institutions for the promotion of the arts which flourished in the town subsequently. Most of these works were of animal or sporting subjects, but he occasionally showed genre works, and landscapes. One of his best known works was a painting of Newcastle Races, depicting the Grandstand filled to capacity during a close race. The Laing Art Gallery, NEWCASTLE, has two of his landscape works in oil: *The Keep, Newcastle upon Tyne*, and *Newgate, Newcastle upon Tyne*. He was the father of William Ryott (q.v.).

RYOTT, William (1817–1883)
Landscape painter in oil. The son of James Russell Ryott (q.v.), he was born at NEWCASTLE, and worked most of his life as a foreman painter with the London & North Eastern Railway Company, painting landscapes in his spare time. From 1866 he occasionally sent his work for exhibition at NEWCASTLE, two works shown at the exhibition of works by local painters, at the town's Central Exchange Art Gallery, in 1878, earning in the catalogue notes, the comment: '. . . both good specimens of his work indicating careful study, fidelity in colour, and much minuteness of detail . . .'. He died at GATESHEAD, where for some time previously he had lived in the town's Hutt Street, and advertised himself as a professional artist. Three of his works were included posthumously in the 'Gateshead Fine Art & Industrial Exhibition', 1883, and a similar number of his works were included in the inaugural exhibition of the Bewick Club, NEWCASTLE, in the following year; these latter comprised his oils: *Ashness Bridge, near Keswick*; *Near Bardon Mill*, and *On the Derwent*. Represented: Shipley A G, Gateshead.

S

SANGLIER, Lewis Herbert (b.1885)
Amateur landscape painter in watercolour. Sanglier practised as a dentist or dental mechanic at NORTH SHIELDS for many years in the first half of the 20th century and was a keen painter of watercolours in his spare time. He is said to have painted with Victor Noble Rainbird (q.v.), and John Falconar Slater (q.v.), and developed a high degree of competence as a painter of mainly local views, much in the manner of the former. He showed examples of his work at the Artists of the Northern Counties exhibitions at the Laing Art Gallery, NEWCASTLE, in 1910 and 1911, but after marrying in 1912, does not appear to have exhibited again. His son PETER BARLOW SANGLIER (1922–1997), was also artistically talented, and like his father, painted as a relaxation from his profession as a dentist at NORTH SHIELDS.

SANSBURY, Charles Edward (1916–1989)
Sculptor in metal; metalwork designer; art teacher. Born at Watford, Sansbury took an interest in painting from his teens, and in 1943 trained as an art and craft teacher at Shoreditch Training School. For the next fourteen years he taught at schools in the south of England, then in 1957, while teaching at the grammar school at BEDLINGTON, enrolled at King's College (now Newcastle University) to read for a BA in fine art. Here he came under the influence of Murray McCheyne (q.v.), and began to concentrate on sculpture, with a special interest in metal. He learnt to weld at Swinney's engineering works at MORPETH while making an armature for a large clay figure, and while working there became fascinated by scrap metal bins and their possibility of being assembled into new and evocative forms. In 1960 he became a lecturer at Lincoln Training College, and the gates for the main entrance of the College were his first large scale commission. In 1963 he was asked to make 480 motifs for the lift doors of the new Civic Centre at NEWCASTLE, and in the following year moved to teach at the Northumberland College of Education at nearby PONTELAND. While there, he was one of several artists awarded contracts for the Civic Centre, his including the 52m long portcullis screens, and other external features. During his time working on this commission he decided to become a full-time sculptor, and leaving the College settled at ALLENDALE. Based there from 1964, he became one of the most sought after 'freelances' in his field, and over the next quarter century completed a variety of commissions, among these another of gigantic proportions in his approximately 12m x 9m x 2m cut steel relief for an overpass at KILLINGWORTH, near NEWCASTLE, symbolising the town's association with railway pioneer George Stephenson (installed 1971; removed 1986, and now in storage). Other commissions included constructions and sculptures for a wide variety of ecclesiastical, university and public locations, as well as dozens for private clients throughout Britain. Sansbury first showed his work at the Royal Society of British Artists Open Exhibition in 1954; a one-man show was held at the Theatre Royal, Lincoln, in 1962, and examples were shown in various exhibitions at NEWCASTLE, HEXHAM, and MIDDLESBROUGH until his death at ALLENDALE in 1989. Major retrospectives were held at the Queen's Hall, HEXHAM, before his death in 1989, and at Allendale Library, in 1999, to mark the tenth anniversary of his death. A plaque has been placed on the building at ALLENDALE in which he lived and worked throughout his professional career as a sculptor. His nephew, GEOFFREY SANSBURY (b.1941), has also practised as a sculptor and exhibited his work. [See colour plate]

SAWKINS, Harold (1888–1957)
Landscape painter in watercolour. Sawkins was born at STOCKTON-ON-TEES, and educated at BARNARD CASTLE. After some twenty years in advertising in the south of England he became a publisher of art journals, including *The Artist*, and the *Paris Salon Illustrated*, only painting in his spare time. While living at Harrow, Middlesex, in 1936, he exhibited two works at the Royal Institute of Painters in Water Colours, and is believed to have exhibited elsewhere in subsequent years. He later lived in London, and in Bournemouth, Hampshire.

SCHMALZ, Herbert Gustave – see CARMICHAEL, Herbert

SCHULENBURG, (HESS 'Tisa'), Countess Elisabeth von der (1903–2001)
Industrial, landscape and figure painter in oil and watercolour; sculptor; draughtsman; lithographer. She was born at Tressow, Germany, the daughter of Count Friedrich von der Schulenburg, but spent her infancy in London, where her father was the Kaiser's military attaché from 1902–1906. After the family returned to Germany she decided at seventeen that she wished to be an artist. She later attempted to gain entry to the Berlin Academy as a student, but failing to impress the authorities with her drawing, instead attended the sculpture classes of Fritz Klimsch. In 1927 she travelled to Paris where she met the French sculptor Despiaux, further confirming her interest in sculpture, and a year later married wealthy Jewish businessman and art collector Fritz Hess. The couple lived an affluent lifestyle in Berlin, but embarrassed by their wealth 'Tisa', as she had long been nicknamed by her family, began to develop what was to remain a lifelong interest: picturing the poor, oppressed, or disadvantaged in her drawings, paintings and sculpture. In 1934 she and her husband moved to London in the face of growing anti-semitism in Germany, and shortly after built a weekend cottage at Walberswick, Suffolk. Here she met sculptor Henry Moore, who advised her to concentrate on drawing rather than sculpture, and coincidentally a visitor from Northumbria who was to provide an immediate inspiration for this development. This visitor from Northumbria invited her to the County Durham coalfield to give lectures in art and wood-carving classes at the recently established Spennymoor Settlement, SPENNYMOOR. She arrived there in 1936 and became art supervisor for the whole district for the next three years. During this period she went down coalmines several times to draw miners

Tisa von Schulenburg, *Durham Miners*, pencil study,
10 x 15cm. Viking Gallery.

at work and formed a lifelong attachment to the
local mining community. This was later to result in a
similar attachment to the mines of the Ruhr, in
Germany, and exhibitions of her work featuring both
at the Bede Gallery, JARROW, near SOUTH SHIELDS, in
1975, and at its successor, the town's Viking Gallery,
in 2000. A further exhibition was held at the
Hutchinson Gallery, Town Hall, BISHOP AUCKLAND, in
2001, as part of the celebrations to mark the 70th
anniversary of The Spennymoor Settlement. After
divorcing her husband, she returned to Germany
where she later married for a second time. Throughout
the Second World War years she, like her brother
Fritz, was an opponent of the Nazis (he paid for his
life by being involved in the Hitler assassination plot
in 1944), and was so appalled by the eventual revela-
tions of the Holocaust that she became one of the first
artists to portray its horrors. In 1950 she entered a
Catholic Order at Dorsten, in the Ruhr, adopting
the name Sister Paula, and continuing to sculpt, draw
and paint until close to her death, died there in 2001.
She was one of Northumbria's most extraordinary
visitor artists and left a large body of her work in the
region. Some of this is signed simply 'Tisa', some
'Tisa Hess'. Represented: The Holocaust Museum,
Auschwitz, Germany; The Viking Gallery, Jarrow.

SCOTT, Eric (b.1945)

'Super-humanist' portrait and figure painter in oil and
acrylic. Scott was born at SUNDERLAND, and after
completing a year-long foundation course in art at
Sunderland College of Art in 1965 left to become a
full-time painter. In the following year he won the
Northern Art Competition, sponsored by Pernod, and
in 1967 enjoyed the first substantial showing of his
work at the Bede Gallery, JARROW, near SOUTH
SHIELDS. A further such showing was held at the DLI
Museum & Art Gallery, DURHAM, in 1969, following
which he left Northumbria for London to pursue his
career. After struggling to encourage gallery owners to
show his work he was signed to the capital's
Treadwell Gallery, starting an almost twenty-year
relationship which saw his 'super-humanist' style win
many admirers, and the purchase of his work by a

number of well-known people, including actor
Anthony Quinn; film director and one-time fellow art
student Tony Scott; former British Prime Minister
Harold Wilson; singers Paul McCartney and Sting,
and model Jerry Hall. His one-time flat-mate Dave
Stewart of the Eurythmics bought many of his works,
and in 1985 commissioned him to paint the cover of
the group's album *Revenge*. He also created the
animation for the award-winning single *Shame*. After
splitting with the Treadwell in 1987 Scott left his twin
bases of London and Cornwall for Los Angeles, and
following a successful one-man exhibition of his work
at the city's Caz Gallery, based on his travels around
the world over the previous ten years, decided to
return to Europe. In 1991 an exhibition of his work
was held in Epinay, near Paris, as part of an exchange
scheme funded by South Tyneside Council. In the
following year he decided to live in France and now
lives at Esterel, near Cannes, with his own gallery.
One of his commissions since settling in France has
been the painting of an epic work entitled *The Last
Supper*, including seventeen life-size portraits. Scott
has exhibited his work in more than forty galleries in
the USA, France and Britain and his work is held by a
number of corporate collections, including Saatchi
and Saatchi Advertising. A major exhibition of his
work entitled 'Close-Up' was held at the Air Gallery,
London, in 2001. Sunderland Art Gallery has two of
his early works in watercolour: *Old Man wearing a
scarf*, and *Sidcup*, both dated 1967.

SCOTT, John (1774–1827)

Engraver; draughtsman. Scott was born at NEWCASTLE,
and served an apprenticeship as a tallow chandler,
meanwhile amusing himself by drawing in pencil, and
pen and ink. A local carver and gilder who had seen
his drawings encouraged him to try his hand at
engraving, and when he was finsihed his apprentice-
ship he was engaged by Abraham Hunter (q.v.), to
engrave profiles of the king, queen, and dauphin of
France, for Angus' *History of the French Revolution*,
published in 1796. Hunter refused to pay for this
work, claiming that artists were never paid for their
first piece, but confident of his abilities as an engraver,
Scott went to London, and seeking out Robert Pollard
(q.v.), was engaged by his fellow townsman for a year.
His initial attempts to succeed as an engraver were not
encouraging but from the turn of the century, and for
the next twenty years, he was one of the most popular
engravers of sporting works of his day, providing
plates for the *Sportman's Cabinet*; Daniel's *Rural
Rides*, and *A Series of Horses and Dogs*, among publi-
cations of this kind, and also engraving illustrations
for Britton's *Cathedral of Antiquities*, and Westall's
Illustrations of the Book of Common Prayer. He is
best remembered, however, for his two large engrav-
ings, *Breaking Cover*, and *The Death of the Fox*, after
Gilpin and Reinagle, for which he was presented with
a gold medal by the Society of Arts, in 1811, and his
many engraved illustrations of dogs, mainly in the
Sportsman's Cabinet, which was first published in
1803, and reprinted in 1820. Scott suffered a paralytic
stroke in 1821 and on the advice of his medical atten-

dants returned to NEWCASTLE for a few months. On his return to London he was faced with financial ruin, but the president and members of the Royal Academy raised a subscription to enable him to resume work. In 1823 he published an engraved portrait of his mother, Mary Scott, but this appears to have been his last work of any significance before his death at Chelsea, London, in 1827. A portrait of Scott was painted by Jackson, and engraved by Fry.

SCOTT, John (1802–1885)

Marine and landscape painter in oil. Scott was born at MORPETH, and not at SOUTH SHIELDS, as has long been popularly believed. Shortly after his birth, however, his bakery owning parents moved from MORPETH, settling first at SUNDERLAND, and later SOUTH SHIELDS. Already a seaman by then, SOUTH SHIELDS became Scott's adopted town too. He married a local girl in 1825, and around 1834 decided to come ashore to become a grocer in the town, painting in his spare time. Soon he was taking lessons from John Wilson Carmichael (q.v.), and like his master painting predominantly marine subjects. These included colliers, keelboats, tugs and wrecks, and occasional more ambitious works like his *Opening of Tyne Dock*, of 1859. One of his notable works in ship portraiture was his painting of Garibaldi's vessel the *Commonwealth*, which work was sent to Italy as a present to the Italian patriot. His work in ship portraiture is, indeed, regarded as important; 'an excellent and productive specialist in portraits of merchantmen off points of land as far apart as Dover and Cape Town', says C H Ward-Jackson, in his *Ship Portrait Painters*, published by the National Maritime Museum, 1978, doubtless basing his view on the several fine works by Scott in the Museum's collec-

tion, dated 1851–70. Scott was also skilled in making models of ships, yachts and other vessels, and in 1851 won a medal at the Great Exhibition in London in a competition organised by the Duke of Northumberland. He exhibited sparingly, among his few exhibits being his *The Castle Fort from Shields Bar*, shown at the 1843 exhibition of the North of England Society for the Promotion of the Fine Arts, NEWCASTLE, early in his career as a professional artist. However, his marines achieve high prices when sold at auction, based on his competence as an artist alone. He painted until quite late in life, dying at the age of eighty-three at the home of his daughter at SOUTH SHIELDS, just as the great days of the sailing ship were drawing to a close. A substantial exhibition of his work from the Tyne and Wear Museums' collection was held at South Shields Museum & Art Gallery, and the Shipley Art Gallery, GATESHEAD, in 1993. Represented: National Maritime Museum; Laing A G, Newcastle; Shipley A G, Gateshead; South Shields Museum & A G. [See colour plate]

SCOTT, Robert Sadler (c.1790–1856)

Wood and stone carver; coastal and landscape painter. Scott was born at SUNDERLAND, and after serving an apprenticeship at NEWCASTLE, set up as a wood-carver in the town. He was also an occasional coastal and landscape painter and exhibited his work on a number of occasions at NEWCASTLE between 1825–1835. Scott is credited with a carving in wood of the River God Tyne face mask for printer and bookseller Moses Aaron Richardson (q.v.), of NEWCASTLE. He based it on the original by Agostino Carlini RA, at Somerset House, and it was used by Richardson to adorn the outside of his shop, and as a printer's colophon. When Richardson emigrated to Australia in 1850 it was later

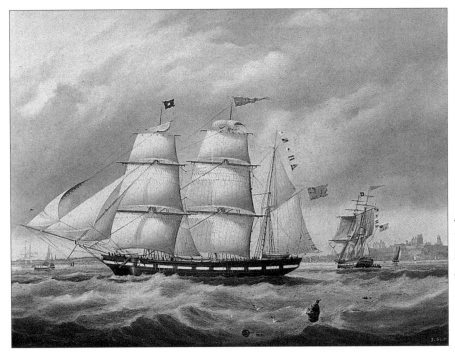

John Scott,
The Old England leaving the Tyne,
oil, 67 x 90cm.
Anderson & Garland.

300

Robert Sadler Scott, *River God Tyne*, wood, 108 x 60 x 34cm. Elanders Hindson Ltd.

used by his son George Bouchier Richardson (q.v.) for the same purpose until he, too, emigrated to Australia in 1854. Some time between the latter date and 1863, the carving was purchased by Andrew Reid (q.v.) for his company's arched entrance on Akenside Hill, NEWCASTLE. It remained there until the company moved to new premises in 1926, whereafter it hung in their reception area until their closure for redevelopment in 1997. The mask is now owned by the firm's successors, Elanders Hindson Ltd, of NORTH SHIELDS. Scott carried out stone carving for a number of buildings in NEWCASTLE, and according to his son Alfred, in a newspaper letter of 1912, also had a hand in carving the name letters, etc, in wood for the exterior of Stewart's shop in Grainger Street, along with Bentham Hall (q.v.). The work, he claimed, was carried out in the workshop of Thomas Hall Tweedy (q.v.), also on Grainger Street. In 1968 London sculptor David Wynne completed a new version of the River God Tyne which now forms part of the frontage of the Civic Centre, NEWCASTLE.

SCOTT, Septimus Edwin, ARBA ROI RWS (1879–1966)

Landscape, portrait and genre painter in oil and watercolour; poster designer; illustrator. Born at SUNDERLAND, Scott studied at the town's School of Art, and the Royal College of Art before practising as a professional artist at his birthplace by 1900. In 1902 he moved to London, and practising there for the next thirty-seven years, exhibited his work at the Royal Academy; the Royal Society of British Artists; the Royal Institute of Painters in Water Colours; the Royal Institute of Oil Painters, and at various London and provincial galleries. About 1939 he moved to Brighton, Sussex, from which he continued to exhibit his work at the Royal Academy until 1952. He was elected an associate of the Royal Society of British Artists in 1919, a member of the Royal Institute of Oil Painters in 1920, and a member of the Royal Institute of Painters in Water Colours in 1927, resigning his membership of the last named body in 1932. Scott contributed illustrative work to *The Graphic*, and *The Bystander*, and prints of his work were also issued. His less usual work included a number of football scenes, and he is represented in The Harry Langton Collection of Football Art. It is believed that he died at Brighton. Scott was a one-time fellow pupil of Stanley Thompson (q.v.), at Sunderland School of Art, and shared a studio with him at Chelsea during their early careers as artists.

SCOTT, Thomas McCree (1881–1926)

Landscape and figure painter in oil and watercolour. Scott was born at SUNDERLAND, and after leaving school attended the town's School of Art. By the beginning of the 20th century he was practising as a professional artist on Wearside mainly painting local views. He exhibited several of these at the Artists of the Northern Counties exhibitions, at the Laing Art Gallery, NEWCASTLE, in 1911, 1913, and 1914, then in 1915 showed his only work at the Royal Academy, *The Bridges, Sunderland*. Following this he enlisted in the army to fight in the First World War, and during his two-year period as a lance-corporal in France drew many scenes recording his experiences. On his demobilisation he resumed his work as an artist, despite having lost the use of his right arm, and by 1919 had resumed exhibiting at the Artists of the Northern Counties exhibitions, showing local landscapes, and occasional figure studies. He also worked as a public house manager at SUNDERLAND, and gave performances on the ukulele both publicly and on BBC Radio. Scott was a member of the town's Stanfield Art Society, and regular exhibitor with the Society, but he did not exhibit elsewhere in the final few years of his life, before dying of meningitis at SUNDERLAND in 1926. The DLI Museum, DURHAM, has several of his wartime sketchbooks, and Sunderland Museum & Art Gallery has a number of his oils and watercolours. His practice of sketching during his army service is said to have earned him the nickname 'The soldier with the pencil'.

SCOTT, William Bell, HRSA (1811–1890)

Historical, landscape, portrait and figure painter in oil and watercolour; illustrator; engraver; etcher. The son of a famous Scottish engraver, and the younger brother of artist David Scott (1806–1849), he was born at Edinburgh, and received his early tuition in art in his father's studio, and at the Trustees' Academy in the city. In 1831 he spent some time in London, drawing the marbles in the British Museum, then returning to Edinburgh he once more worked for his father, and in 1833 commenced exhibiting his engravings at the Scottish Academy. In 1837, and by then having shown both engravings and works in oil at the Academy, he decided to seek his fortune as a painter in London. His first success came with his exhibition at the Suffolk Street Gallery in 1840, of his *The Jester; The Wild Huntsman*, and *King Alfred disguised as a Harper*. . . . A year later he sent his first work to the British Institution, *Bell ringers and Cavaliers celebrating the entrance of Charles II into London, on his Restoration*, and in 1842 he commenced exhibiting at the Royal Academy, showing his *Chaucer with his friend and patron, John of Gaunt*. . . . Shortly after exhibiting this work at the Royal Academy, and in the same year showing his British Institution exhibit at the Scottish Academy, Scott entered a competition sponsored by the Government to encourage design in historical painting, and though he did not feature among its prize-winners, his contribution was recognised to be of sufficient merit to lead to his appointment as director of the Government School of Design, NEWCASTLE. Scott's tuition at NEWCASTLE, 1843–1863, was one of the major influences on the development of artistic talent in Northumbria in this period. Many young artists later to become well known both locally and nationally received tuition at his hands: Charles Napier Hemy (q.v.), Henry Hetherington Emmerson (q.v.), and George Blackie Sticks (q.v.), to name only three. Indeed, such was the attraction of the School to these young men that Thomas Miles Richardson, Senior (q.v.), was once provoked to complain that it was taking pupils who would normally have gone to

Thomas McCree Scott,
Old Manor House, Hylton,
Sunderland,
watercolour, 24 x 37cm.
Anderson & Garland.

him. Scott also produced some of his best work while in Northumbria: atmospheric seashore scenes painted at TYNEMOUTH while visiting Alice Boyd (q.v.), and her brother Spencer; bustling street scene drawings such as his *The Bigg Market*, in the Laing Art Gallery, NEWCASTLE; several of his best known imaginative works, and most important of all, perhaps, his series of eight large canvases depicting scenes from Northumbrian history, for the inner hall of Wallington Hall, near CAMBO. These canvases were commissioned from him through the influence of Lady Pauline Trevelyan (q.v.), who had first become acquainted with his work through her reviews for the Scottish newspapers. Scott was offered the commission in March, 1856, and accepting it gladly he at once resolved the subject matter, and began making preliminary sketches of each scene. Every character depicted should be based on a real person, he decided, this leading to the portrayal of Lady Pauline as a terrified Briton watching the approach of the Danish galleys in one work, while in another he used the figure of his new friend and pupil, Alice Boyd (q.v.), as Grace Darling. He was only paid £100 for each of these pictures, but his association with Lady Pauline, and her husband Sir Walter Calverley, furnished an introduction to his idol John Ruskin, and gave added status to his image in the eyes of local men of influence, such as industrialist and art collector James Leathart, who began increasingly to look to Scott for advice on pictures for his Pre-Raphaelite collection. In 1861 Gambart exhibited the eight completed Wallington canvases at the French Gallery in London, but their reception was not entirely flattering to the artist and his patrons, and it was not until two years later that he was able to get a definite commission to paint canvases for the spandrels of the upper part of the inner hall, having already painted those of the lower part with portraits of famous Northumbrians. In 1863 an opportunity arose to resign his position at NEWCASTLE, and move back to London with a small pension. Here he was at work on

his eighteen canvases for the spandrels – each portraying a scene from the famous Border ballad of Chevy Chase – when Lady Pauline died in Switzerland, and though much distressed by the news he was able to complete them in time for them to be shown at the International Exhibition in Paris in 1867. They were finally erected in the following year, but Sir Walter's marriage meanwhile to Laura Capel Lofft (who was a stern critic of Scott's work), had alienated him from the home which he had helped to decorate so beautifully. Scott had continued to exhibit at the Royal Academy; the British Institution, and the Royal Scottish Academy throughout his stay at NEWCASTLE, and also contributed to several major exhibitions in the town, notably those staged in 1850 and 1852, jointly by the North of England Society for the Promotion of the Fine Arts, and the Government School of Design. After settling in London late in 1864, he remained an exhibitor at the Royal Academy until 1869, and the Royal Scottish Academy until 1870, thereafter exhibiting his work only on Tyneside, where examples were shown at the Arts Association in 1878; the 'Gateshead Fine Art & Industrial Exhibition', in 1883, and the Bewick Club, in 1884. Shortly after they had settled in the capital, Scott and his wife began to spend their summers at the castle home of his friend Alice Boyd, at Penkill, Ayrshire, while she spent her winters with them. This practice continued for some twenty years, whereafter Scott spent an increasing amount of time at the castle without his wife, much of this occupied writing his *Autobiographical Notes etc.* (published in 1892). He died at Penkill after a long illness, and was buried there. In addition to being a gifted painter, Scott was a talented poet, and, indeed, it was through his poetry that he first became acquainted with Pre-Raphaelite Dante Gabriel Rossetti, and subsequently began painting in the manner of the Brotherhood. (Indeed, his *The Nineteenth Century: Iron and Coal*, from his Wallington series of canvases is now regarded as the most outstanding Pre-Raphaelite influenced painting

produced by a Northumbrian based artist in the 19th century). He also wrote and illustrated many books, and in later years frequently returned to engraving and etching. In 1887 he was elected an honorary member of the Royal Scottish Academy. In 2003 his Wallington canvases were removed from the Hall while it was being refurbished, and shown at the Laing Art Gallery, NEWCASTLE, and later Sunderland Art Gallery, in a special exhibition under the title *William Bell Scott – A Northern Pre-Raphaelite*. Represented: British Museum, Hatton Gallery, Newcastle; Victoria and Albert Museum; National Gallery of Scotland; Tate Gallery, Laing A G, Newcastle; Literary and Philosophical Society, Newcastle; Natural History Society of Northumbria, Newcastle; Penkill Castle, Girvan, Ayrshire; Wallington Hall, Cambo. [See colour plate]

SELBY, Prideaux John, HRSA MA (1788–1867)

Amateur ornithological and botanical painter in oil and watercolour: illustrator; engraver. Selby was born at ALNWICK, and was educated at Durham Grammar School, and University College, Oxford. After spending some time at university he left without taking his degree, and took up residence at the family home at TWIZELL, near WARENFORD. He was attracted to the study of ornithology from an early age, and by the time that he was twelve or thirteen he had already composed copious notes on the commoner British birds, illustrated with his own coloured drawings. In 1821 the first part of his nineteen-part *Illustrations of British Ornithology* appeared, at once establishing him as a highly gifted artist, and ornithologist. In 1827 he began to exhibit his bird studies, showing a work entitled *Dead Game*, at the Northumberland Institution for the Promotion of the Fine Arts, NEWCASTLE. He then became a regular exhibitor at the Scottish Academy (which had made him an honorary member in 1827), and the Northern Academy, NEWCASTLE. He continued to exhibit at Edinburgh and NEWCASTLE, for several years, meanwhile working on his *Illustrations of British Ornithology*, the whole of which was completed by 1834. Twenty-six of the some 228 plates for this work were contributed by his brother-in-law, and former pupil of Thomas Bewick (q.v.), ADMIRAL ROBERT MITFORD (1780–1870), the rest being drawn by Selby, for some time with Edward Lear as his assistant. He also engraved a considerable number of his drawings for this work, after experiencing difficulty in getting others to do this satisfactorily. The completed work was the first attempt to produce life-sized illustrations of British birds, and simultaneously with its production he assisted Sir William Jardine in bringing out yet another book on birds: *Illustrations of Ornithology* (four volumes, 1825–1843). Selby remained absorbed in ornithological study, writing and illustrating, for the rest of his life, adding to these interests following visits to Sutherlandshire, Scotland, those of fauna and flora, and in 1837 helping to found the *Magazine of Zoology, Botany and Geology*. He was elected a fellow of the Royal

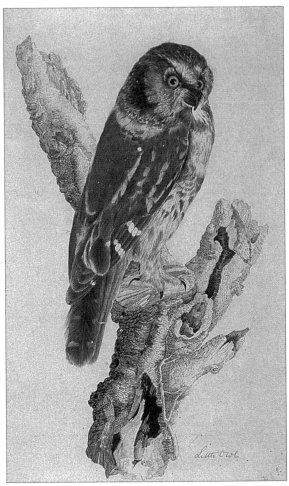

Prideaux John Selby, *Little Owl*, watercolour, gouache and ink, 32.7 x 20cm. Private collection.

Society of Edinburgh, of the Linnean, and other scientific societies, and in 1839 had the Master of Arts degree conferred upon him by Durham University. In 1842 he published *British Forest Trees*, based on a broad experience gained in the plantations which he began at TWIZELL early in his life. In addition to his ornithological and other studies, his writing and illustrating, Selby took an active part in the social and political life of Northumberland, holding several offices within the county. He was an acquaintance of Thomas Bewick (q.v.), and as a member of what is today the Natural History Society of Northumbria, NEWCASTLE, was one of the several men responsible for the naming after the artist, of the Bewick's Swan. Another of his acquaintances was the famous American naturalist and ornithological illustrator, John James Audubon. Selby died at TWIZELL. An interesting account of his life, liberally illustrated with examples of his work, may be found in *Prideaux John Selby – A Gentleman Naturalist*, by Christine Jackson, Spredden Press, 1992.

SETON,* Ernest Thompson (1860–1946)

Landscape and animal painter in oil and watercolour; wildlife illustrator. Born at SOUTH SHIELDS, Seton emigrated with his family to Canada in 1866, and later studied at several public schools in Toronto, Ontario, before attending Ontario College of Art. He subsequently studied art in London 1879–1881, and Paris 1891–1896. In London he attended the Royal Academy Schools, gaining entry by his submission of a drawing of Michaelangelo's *Satyr*. In Paris he attended the studios of Gêrome; Bouguereau, and Ferrier. While studying in Paris he showed his first major painting in oil, at the Chicago World Fair, 1893. This work, entitled *Awaited in vain*, portrayed a wolf pack in the act of devouring a dead man. On returning to North America, Seton became one of Canada's most distinguished artist-naturalists. He was appointed naturalist to the government of Manitoba, and published more than forty books about wild animals, illustrating most of them himself. Among his many major works were his *Birds of Manitoba*, 1891; *Life Histories of Northern Animals*, 1910, *Woodland Tales*, 1921, and *Lives of Game Animals*, 1925. His drawings are regarded as being notable not only for their accuracy, but for their strong decorative sense in the context of book design. He died at Seton Village, Santa Fé, New Mexico, where he had founded the College of Indian Wisdom following his lifelong interest in the American Indian. Seton was head of the Boy Scout movement in the USA until 1915.

SHAND, Christine R (fl. late 19th, early 20th cent.)

Landscape, portrait and flower painter in oil and watercolour. This artist practised at NEWCASTLE in the late 19th and early 20th centuries, and first appears to have exhibited her work at the 'Gateshead Fine Art & Industrial Exhibition', 1883, showing a charcoal drawing: *Landscape – Arran*. In the following year she commenced exhibiting her work at the Bewick Club, NEWCASTLE, showing two landscapes and two portraits, between that year (1884), and 1903, continuing to exhibit at the Club, and sending three works to the Royal Academy; three works to the Society of Women Artists' exhibitions and various works to provincial exhibitions. She later exhibited her work exclusively at the Bewick Club, and from their inception in 1905, the Artists of the Northern Counties exhibitions at the Laing Art Gallery, NEWCASTLE. She was a regular exhibitor at the latter until 1909.

SHEARER, Jacob (fl. late 19th, early 20th cent.)

Landscape and coastal painter in oil and watercolour. Shearer is believed to have been born at SUNDERLAND, of a seafaring family, and practised as an artist in his native town in the late 19th and early 20th centuries. Sunderland Art Gallery has his oil: *Training Hulk on River Wear*, 1900.

Ernest Thompson Seton, *The Lynx at Bay*, illustration from *Life Histories of Northern Animals*, 1910.

SHEPHERD, Vincent (1750–1812)

Sculptor. Shepherd worked as architect to the Duke of Northumberland, at ALNWICK, and also executed a large amount of stone carving for his patron. In the choir of St. Michael's Church, ALNWICK, he executed some work in the latter line, which was described in the *Gentleman's Magazine*, 1812, page 601, as 'a piece of Gothic trellis work, which for elegance of fancy and superiority of workmanship has seldom been equalled and perhaps never excelled'. He died at ALNWICK.

SHERATON, Thomas (1751–1806)

Furniture and interior painter in watercolour; draughtsman; drawing master. Sheraton was born at STOCKTON-ON-TEES, and served an apprenticeship as a cabinet maker while teaching himself mathematics and drawing. He subsequently became a journeyman in his trade, remaining in the area of his birth until he was nearly forty. In 1789 or 1790, he decided to work in London, taking with him much of the manuscript of his first technical book, *The Cabinet Makers' and Upholsterers' Drawing Book*, and a large number of sketches and drawings which were eventually published as *Designs of Furniture*. This book was issued in 1790 as a collection of eighty-four folio plates made from Sheraton's drawings. This was followed by a month-by-month publication of the

Cabinet Makers' and Upholsterers' Drawing Book, the series of which was completed in 1794. A second and enlarged edition of this part-work was started before the completion of the first, and was followed by a third edition in 1802. The first two editions were almost identical in form, but as the section on *Drawing and Perspective* proved to be less popular than he had anticipated, he cut it down drastically in the third edition. Sheraton's income from his book publishing brought him little money and he was obliged to support his family by giving drawing lessons. Not dismayed by this lack of reward from publishing, however, he was ready with his next work, *The Cabinet Dictionary*, within two years of the publication of the third edition of *The Cabinet Makers' and Upholsterers' Drawing Book*. It contained an explanation of terms used in the cabinet and upholstery trades, eighty-eight copper plate engravings, and a supplement on drawing and painting. In another two years he was ready with his *Cabinet Makers' and Upholsterers' and General Artists' Encyclopaedia*, intended for publication in 125 monthly parts. He died after only a few numbers had been issued. Sheraton's fame as a furniture designer is legendary. His skill as a draughtsman is not as well known. It enabled him to express his design vision much more accurately than most of his competitors. He had a thorough knowledge of linear perspective, and because he was able to draw his furniture designs in room interiors using pen and ink, and watercolour, his draughtsmanship went far beyond the requirements of a pure designer. Unfortunately none of his original drawings appear to have survived, our only knowledge of their capability being derived from a study of them in their engraved form. An exhibition exploring his life and work entitled *Design Classic – Thomas Sheraton*, was held at Preston Hall Museum, STOCKTON-ON-TEES, in 2001.

SHIELD, George (1804–1880)

Bird and landscape painter in oil and watercolour. Shield was born at TWEEDMOUTH, near BERWICK-UPON-TWEED, the son of a tailor. After working briefly in London as a tailor and draper he settled at WOOLER to follow the same occupations, remaining there until his death. Although heavily involved in running his business at WOOLER Shield found time to become an accomplished naturalist and artist, travelling widely throughout Northumberland to collect bird specimens and draw from life, without any formal tuition. Large books of bird illustrations were then being published by fellow-Northumbrian artist Prideaux John Selby (q.v.), and inspired by his example Shield set about producing plates to illustrate his own ornithological work, *Ornithologia Britannica*. However, after Selby had completed his *Illustrations of British Ornithology*, publishers were unwilling to speculate on another work of such a large and expensive scale and Shield is believed to have had only six of his works engraved. These were engraved on copper and printed by Alexander Turnbull Aikman of Edinburgh, c.1841, and evidently in some number as several sets and individual examples have been sold by auction houses and antiquarian book dealers over the past century. The last

complete set was sold at auction by Sotheby's, London, in 2002. The set realised £35,000, and is one of only five complete sets now known to exist; the others comprise one purchased in 1922 for the British Museum's Department of Prints; one owned by the City & University Library of Berne, Switzerland, where it forms part of the Holzer collection of antiquarian books; one in McGill University, Montreal, and one in an unlocated collection in the USA. The subjects of Shield's six, usually hand-coloured plates, are: *Cormorant*; *Black Birds and Spotted Flycatchers*; *Peregrine Falcon*; *Moorhens*; *Great Tits, Blue Tits and Robin*; *Rough Legged Buzzard*, and show him to have been one of the most talented bird illustrators working in Britain in the mid–19th century. An excellent account of Shield's life and work, accompanied by illustrations of his complete set of plates, was published in the *Northumbrian*, Spring, 1990, by Peter Holt. [See colour plate]

SHIELDS, Frederic James, ARWS (1833–1911)

Landscape, genre and religious painter in oil and watercolour; illustrator; muralist; stained glass designer. Born at HARTLEPOOL, Shields left the town with his family at the age of three, and settling with them in London, received his education at St Clement Danes Charity School. He left school at fourteen and spent one year at the capital's School of Design, meanwhile making studies of the sculptures in the British Museum in the evenings. This was followed by a year-long period with a lithographic firm in London, after which he was sent to join his father at Newton-le-Willows, near Manchester, whence his father had moved in 1848. Over the next few years he worked for several lithographic firms, painting portraits of fellow-workers for a few shillings to increase his income. He also became a designer for Bradshaw and Blacklock's, Manchester (the railway-guide printing firm), at 10 shillings per week, and from this point forward became increasingly involved in illustrative work, tackling as one of his earliest assignments *The Greyt Eggshibishun* (Manchester, 1851). On visiting the Manchester Art Treasures Exhibition in 1857, he fell under the spell of the Pre-Raphaelite works shown there, and began increasingly to work in the style of the Brotherhood, in his illustrative work, his watercolours, and later his murals and stained glass designs. The bulk of his illustrative work was executed 1860–70, and included Defoe's *History of the Plague of London*, 1862, and Bunyan's *Pilgrim's Progress*, 1864, as well as contributions to *Touches of Nature by Eminent Artists*, 1866; *Once a Week*, 1867, and *Punch*, 1867–70. In 1865 he was elected an associate of the Old Water Colour Society (later the Royal Society of Painters in Water Colours), and in addition to contributing some 106 works to its exhibitions by 1893, showed work at various London and provincial galleries. Among his exhibits at the latter was his *After the Storming* for which he was awarded the Heywood Prize, in 1871, at the Manchester Institution. Shields' early reputation as a painter was established in the Merseyside area

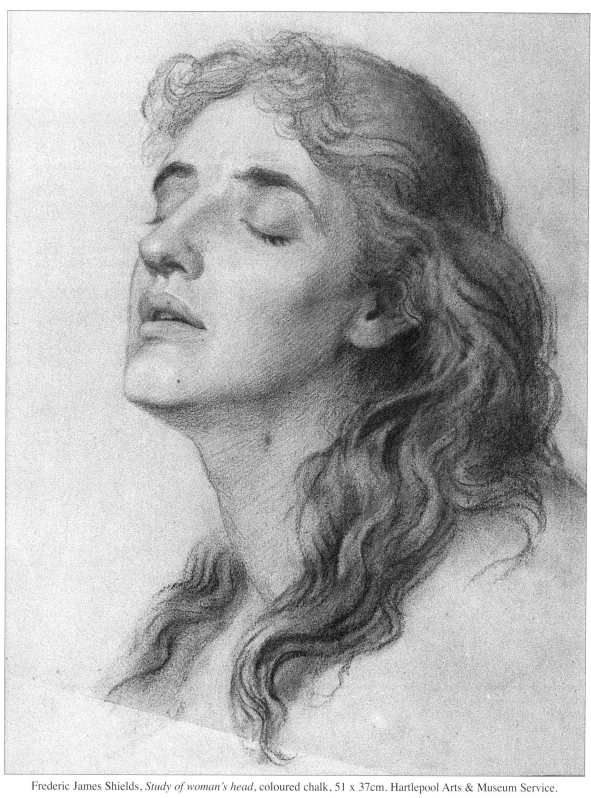

Frederic James Shields, *Study of woman's head*, coloured chalk, 51 x 37cm. Hartlepool Arts & Museum Service.

and was partly built on his portraits of children, for which he found a ready sale. In 1874 he married one of his child models, Matilda Booth, and by the following year had settled in London. Here his friends arranged an exhibition in recognition of his being a 'well known Manchester artist'. In 1876 he visited Italy with one of these friends, looking at churches and galleries there, and on his return received his first of several stained glass commissions, for Eaton Hall Chapel. During its two-year completion his style underwent considerable change through contact with Ford Madox Brown, and Dante Gabriel Rossetti. Through Rossetti he also received what was later to prove his major work as a muralist, for the Chapel of the Ascension, Bayswater Road, London. Indeed, he deemed it so important a commission that he again visited Italy in 1889 to study its churches, and spent the next almost twenty years completing it. Tragically, the entire chapel was destroyed by a German bomb in the Second World War, but his stained glass and mosaics for the Duke of Westminster's chapel at Eaton Hall survive, as do his superb windows for St Ann's, Manchester. In 1893 his friend Ford Madox Brown died, and Shields did a deathbed drawing of him as he had done when Rossetti died in 1882. After Madox Brown's death he was asked to repair the murals done by the artist for Manchester Town Hall. In 1897 Shields was obliged to move house to Merton, where he built a studio in which to complete his murals for the Chapel of the Ascension. Never in good health, his condition deteriorated in the year following and he made a trip to Italy in the hope of improving it. His condition did not improve, however, and in considerable discomfort he continued work on the chapel murals. Sadly he died at Merton within five months of completing them, claiming that his occupation 'was now gone'. Shields' work attracted considerable interest in his lifetime. He enjoyed a one-man exhibition in Manchester in 1908 which earned him many glowing tributes, and a memorial exhibition was held following his death in 1911. *The Life and Letters of Frederic James Shields*, was published in 1912 by his former pupil Ernestine Mills, but apart from an exhibition at the Gray Art Gallery, HARTLEPOOL, in 1983, to celebrate the 150th anniversary of his birth in the town, little has been done to restore the reputation of this remarkable Northumbrian artist, who, as its catalogue remarked is 'unknown to all but the most knowledgeable of students of the Pre-Raphaelites and their followers', despite his association with two of their most important members. Represented: British Museum; Dudley A G; Fitzwilliam Museum, Cambridge; Hartlepool Arts & Museum Service; Laing A G, Newcastle; Manchester A G; Victoria and Albert Museum; Whitworth Gallery, Manchester.

SHORTT, Mrs Georgina Hastings (c.1872–after 1952)

Amateur miniature painter; religious painter in oil and watercolour; sculptor. The wife of the Rev Joseph Rushton Shortt, she first exhibited her work while her husband was a classical lecturer at DURHAM, showing a landscape: *Durham*, at the Bewick Club,

NEWCASTLE, in 1895. In 1898 her husband became rector of SOUTHWICK, near SUNDERLAND, and from here in 1908 she began exhibiting her work more widely, showing examples at the Royal Academy; the Royal Scottish Academy; the Royal Cambrian Academy; the London Salon, and at several provincial venues, including the Royal Birmingham Society of Artists, Birmingham; the Walker Art Gallery, Liverpool, and the Artists of the Northern Counties exhibitions at the Laing Art Gallery, NEWCASTLE. She last exhibited her work outside Northumbria in 1924, but remained a regular exhibitor at NEWCASTLE until 1952, in which year she was living at EAST BOLDON, near SOUTH SHIELDS – her home since her husband's death in 1919. Her daughter, MURIEL SHORTT, was also a talented amateur artist, and exhibited her work at NEWCASTLE.

SHOTTON, James (1824–1896)

Portrait, landscape and coastal painter in oil; copyist; art teacher. Shotton was born at NORTH SHIELDS, and after displaying a talent for drawing at an early age was entered by his parents as a student at the Royal Academy Schools. Here he became a close friend of Holman Hunt, and made excellent progress with his studies until the death of his father obliged him to return to NORTH SHIELDS. Back at NORTH SHIELDS he first found employment designing a Turkish Bath in the town for George Crawshaw. This is said to have been the first such bath in England, and was followed by another in NORTH SHIELDS, and a third in NEWCASTLE, all to Shotton's designs. While at NEWCASTLE, he resumed his studies in painting under Robinson Elliot (q.v.), later practising as a portrait painter, copyist and drawing master at NORTH SHIELDS. His earliest exhibits of note in the first capacity were the portraits of a Mr J Hudson, and an unknown gentleman, which he exhibited at the exhibition at NEWCASTLE, in 1850, of the North of England Society for the Promotion of the Fine Arts, and the Government School of Design, and two other portraits which he showed at their joint exhibition in 1852. He later exhibited little in Northumbria, and on only one occasion outside the area, this being when he showed a portrait of W S B. Woolhouse, the well-known mathematician of NORTH SHIELDS, at the Royal Academy in 1863. Shotton enjoyed considerable success as a portrait painter, including the Italian patriot Garibaldi, and several local dignitaries among his sitters. He was also an able copyist, and was particularly fond of copying Turner, Raphael, Rubens, Veronese and Titian. His ability as a drawing master was also valued, securing him a position as first drawing master at the School of Art, NORTH SHIELDS. He died at NORTH SHIELDS. North Tyneside Public Libraries has a large collection of his work, including portraits, Northumbrian landscape and coastal views, and copies after Turner, etc. The Garibaldi Museum, Caprera, Sardinia, Italy, has his portrait of Garibaldi. Interestingly, the two men remained friendly for many years after it was painted, and corresponded regularly with each other.

SIMPSON, Alfred J (1895-after 1983)
Amateur landscape painter in oil and watercolour. Simpson was born at NEWCASTLE and became a clerical worker in the city, who painted in his spare time. He first exhibited his work at the Artists of the Northern Counties exhibition at the Laing Art Gallery, NEWCASTLE, and the city's Benwell Art Club. He later moved to HEBBURN, near GATESHEAD, where he continued to exhibit at both venues for many years, showing Northumbrian, North Yorkshire, Scottish and Cornish subjects. He finally moved to PETERLEE, where he died some time after 1983.

SIMPSON, Frederick (d.1909)
Landscape painter in watercolour; commercial designer. He was born at GATESHEAD, and at the age of fifteen joined the art staff of the printing company owned by Andrew Reid (q.v.), at NEWCASTLE, eventually rising to the position of departmental chief. While working for Reid he was responsible for designing many posters for railway and shipping companies. Several of his posters for the former portrayed scenes along the Tyne Valley, for which he painted the originals in watercolour at such places as OVINGHAM, BYWELL, etc. He died at GATESHEAD.

SIMPSON, Herbert Walter, ARCA (1907–1972)
Landscape painter in oil and watercolour; engraver; printmaker; art teacher. Simpson was born at Hud Hey, Haslingden, Lancashire. He won a scholarship to Accrington Grammar School, attended the local art school, and was its first student to win a scholarship to the Royal Academy of Art. Here he initially studied painting, but later transferred to the engraving school under Robert Austin, proving so outstanding that he became a junior tutor, and was soon exhibiting his work at the Royal Academy. After leaving the Royal Academy Schools he took up an appointment at Leicester College of Art, some three years later taking up a similar appointment at Sunderland College of Art, where he remained until his retirement in 1967. During his some thirty-three years at the College 'Herbie', as he was popularly known, proved an outstanding teacher, yet claimed that he would rather have been a naval architect. This fondness for ships led him to paint many subjects along the River Wear at SUNDERLAND, although he was almost equally fond of painting disappearing older parts of the town, including industrial scenes. Although Simpson had become a regular exhibitor at SUNDERLAND, and had also sent work to the Royal Society of British Artists; the Royal Institute of Oil Painters; the Glasgow Institute of Fine Arts, and the Walker Art Gallery, Liverpool, from taking up his post at the College in 1934, he mainly exhibited at the Artists of the Northern Counties exhibitions at the Laing Art Gallery, NEWCASTLE, and at SUNDERLAND. He died at SUNDERLAND in 1972. Sunderland Art Gallery has a substantial collection of his watercolours of mainly local shipyard and river scenes, and held an exhibition of his work in 1995. His son IAN SIMPSON (b.1933), became an artist, art teacher, presenter on TV and author on art-related subjects.

SINCLAIR, James (fl. early 19th cent.)
Portrait and landscape painter in oil; drawing master; wood engraver. Sinclair was a house and sign painter at BERWICK-UPON-TWEED in the first half of the 19th century, who occasionally turned his hand to portrait, landscape and seascape painting. One of his portraits, in the collection of Berwick Museum & Art Gallery, is of John McKay Wilson (1804–1835), author of the *Border Tales*. Wilson was an admirer of Sinclair's work and in the *Berwick Advertiser* of 6th April 1833, described his *View of Berwick* of that year as 'by far the most complete view of Berwick we have seen'. In 1836 Sinclair executed a number of woodcuts to illustrate *The History of Coldingham*, by Dr Alexander Carr, and drew its frontispiece illustration. He also published with J Gellatly an engraving of *Hutton Mill Bridge*. Sinclair rarely exhibited his work, the only known occasion being when he sent two works to the Scottish Academy in 1830. One of his later works was his painting of the rescue of the crew of the *Forfarshire* on 7th September 1838, by Grace Darling and her father. He did this at the request of a crew-member's relative and is interesting in that it shows how the survivors actually got off the rocks on which their vessel was wrecked, and into the Darling's boat. Represented: Grace Darling Museum, Bamburgh.

SINNED SSARRAB – see BARRASS, Dennis

SKEE, George (b.1884)
Sculptor; modeller. Skee was born at BLYTH, and after studying art at Armstrong College (later King's College; now Newcastle University), was sent by his patron, Lord Ridley, to learn the pottery trade at Barnstaple. In 1918 he was appointed manager of the Newsham Art Pottery, BLYTH, remaining there until the First World War, when he enlisted in the army. At the conclusion of the War he emigrated to California, where he obtained work as a model maker and helped to produce 'monsters' for *The Lost World*, and *The Hunchback of Notre Dame* film productions. One of his sculptures, which he produced just after leaving Armstrong College, was his bust of Matthew White Ridley for the south entrance of Ridley Park, near BLYTH. It was presented to the Park by the 2nd Viscount Ridley, in memory of his father's generosity in providing the land on which it was located. Skee exhibited his work at the Artists of the Northern Counties exhibitions, at the Laing Art Gallery, NEWCASTLE, both before, and after his service in the First World War. His first exhibit in 1908 was a bust of Ralph Young, Secretary of the Northumberland Miners' Union; his last, in 1918, a number of head studies in ivory. He is not known to have exhibited elsewhere.

SKELTON, Joseph (1860–1901)
Landscape painter in oil and watercolour. This artist practised at NEWCASTLE in the late 19th century, also working as a master sign-writer for a local company. He painted widely throughout Northumbria, but was particularly fond of architectural subjects. One of his best known works is a bird's-eye view of NEWCASTLE

Joseph Skelton, *Corner of Pilgrim Street and Blackett Street, Newcastle*, watercolour, 62 x 89cm. Private collection.

from the north east in the city's Laing Art Gallery collection, but he also produced a variety of street scenes and studies of Tyneside buildings. He was an occasional exhibitor at the Bewick Club, NEWCASTLE. On his death in 1901 the work in his studio on the city's Mosley Street was claimed by the sign-writing company's proprietor and sold at auction. The works included English, Scottish and Continental scenes dated from 1884–1894. Represented: Laing A G, Newcastle; Natural History Society of Northumbria, Newcastle.

SKELTON, Joseph Ratcliffe, RWA (d.1927)
Figure painter in oil and watercolour; illustrator. He was born at NEWCASTLE, but by 1891 had moved to Hinckley, Leicestershire, from where he showed one work at the Royal Academy, *A forgotten author*. He later moved to Bristol, where he lived for several years and became one of the founder-members of the city's Savage Club. By 1908 he had decided to quit Bristol as he had not achieved the success as a painter he had expected, and moved to Sevenoaks, Kent, from which he again exhibited at the Royal Academy, following this with five exhibits at the Savage Club's exhibition in 1912. Some time after this he moved to London, where, according to the Club's records, he died 'in very straitened circumstances', in 1927. In addition to exhibiting at the Royal Academy, and with the Savage Club, Skelton also showed examples of his work at the Royal West of England Academy; the

Royal Institute of Oil Painters; the Royal Society of Portrait Painters, and Manchester Art Gallery. He also illustrated books for J W Arrowsmith Ltd. He was a member of the Royal West of England Academy. His work is sometimes confused with that of Joseph Skelton (q.v.), but is distinguishable as his by his signature 'J. R. Skelton', in block capitals.

SKRIMSHIRE, Eleanor May (1886–1978)
Landscape and figure painter in watercolour; art teacher. She was born at MORPETH and studied under the watercolourist Henry Barkas Dawson at Reading School of Art, and in London, before taking up a career in art teaching. She taught for many years in the Reading area, notably at the Blue-Coat School, and exhibited her work with the Reading Guild of Artists, and in Reading Art Gallery.

SLATER, John Falconar (1857–1937)
Landscape, marine, coastal, portrait, animal, flower and street scene painter in oil and watercolour; etcher; lithographer. Born at NEWCASTLE, the son of a corn miller, Slater worked as a book-keeper in his father's mill, and spent some time running a store in the diamond fields of South Africa, before deciding in his mid-twenties to become a professional artist. Back on Tyneside by then, and encouraged by his mother, he once more took up his boyhood practice of painting and drawing, and with little or no tuition was soon

310

exhibiting his work. His first exhibit of note was shown at the 'Gateshead Fine Art & Industrial Exhibition', in 1883, and consisted of an ambitious group portrait: *Members of the Dicky Bird Society*. In the following year he showed his first of dozens of works at the Bewick Club, NEWCASTLE, and in 1885, while practising at Ashton under Lyne, Lancashire, exhibited at the Walker Art Gallery, Liverpool, and at Manchester. Four years later he showed his first work at the Royal Academy, *The Boat Landing*, and from this point forward until his death, he was one of the most regular exhibitors of work of any Northumbrian artist of his period, showing examples at the Royal Academy until 1935; the Bewick Club until the early 1920s, and at the Artists of the Northern Counties exhibitions at the Laing Art Gallery, NEWCASTLE, from their inception in 1905, until the year of his death. For the first few years of his professional life he painted at the family home at FOREST HALL, near NEWCASTLE. Just before the close of the century, however, he established a studio in the city, painting there until 1910, when he spent some months at NORTH SHIELDS. In 1912 Slater made his home at WHITLEY BAY, remaining here until 1925, and becoming one of the best known artists painting along the Northumbrian coastline, and a leading member and president of the North East Coast Art Club, whose headquarters were in the village. CULLER-COATS became his next and final home, and here he spent the remaining twelve years of his life, living at St Oswin's Terrace, just off the harbour. In addition to exhibiting in London, Scotland, and the provinces, at annual and special exhibitions, Slater shared an exhibition at the Laing Art Gallery in 1934, with Francis Thomas Carter (q.v.). Thomas Bowman Garvie (q.v.), and George Edward Horton (q.v.). He also wrote considerably about art, contributing articles to the local press, and in 1914 publishing his *Odds and Ends from an Artist's Note Book*, containing much interesting information about his attitudes and experiences as an artist. Slater was one of the most versatile and prolific artists Northumbria has ever produced, tackling virtually every type of subject, and working in a great variety of media. Much of his work was painted in oil, even when working under difficult seashore conditions, but he was equally accomplished as a water-colourist, and experimented with etching, and later lithography. His work was widely reproduced in newspapers and magazines of his day, and was the subject of several chromolithographic reproductions, notable amongst which was his panoramic painting of CULLER-COATS, 1905. Slater is increasingly becoming recognised as one of the earliest British artists to adopt the Impressionist technique of painting. Examples of his work as early as the late 1890s were already being given this description, although he himself preferred the term 'expressionist'. It is popularly believed that he visited Monet to study the technique but there is no evidence to support this belief. Indeed, evidence suggests that his work was already progressing towards the technique by the time that it was becoming discussed in art magazines of the day. Many of his paintings of the sea compare with the best produced in Britain in his period, his practice of completing them on the spot, and often in extreme climatic conditions, earning him the nickname 'The Weatherproof Artist'. He died at CULLERCOATS, and was buried at WHITLEY BAY. His sister EDITH MAUD SLATER, was a talented amateur artist. Represented: National Maritime Museum; Laing A G, Newcastle; Shipley A G, Gateshead; South Shields Musuem & A G; Sunderland A G. (See colour plate)

SMALE, Miss Phyllis M, SWA (b.1897)
Landscape painter in oil; art teacher. She was born at DARLINGTON, and studied at the town's School of Art, and later at the Regent Street Polytechnic School of Art, before practising as a professional artist at her birthplace in her early twenties. She first exhibited her work in 1922, while at DARLINGTON, showing a number of landscape and other works at the Artists of the Northern Counties exhibition in that year, at the Laing Art Gallery, NEWCASTLE. About 1924 she moved to London to take up a position as teacher at the Regent Street Polytechnic School of Art, and in the following year commenced exhibiting her work in the capital, showing examples at the Royal Academy; the Royal Institute of Oil Painters; the New English Art Club and the Society of Women Artists, until 1940. She last exhibited her work at the 'Contemporary Artists of Durham County' exhibition at the Shipley Art Gallery, GATESHEAD, staged in 1951, in connection with the Festival of Britain. She was then living at Esher, Surrey, and her exhibits were *The Fex Valley, Engadine*; *Lakeside Corner, Buttermere*, and *A Cumberland September*. She was elected an associate of the Society of Women Artists, in 1940, and became a full member a few years later. Sunderland Art Gallery has her oil: *Wastwater*.

SMALL, Thomas Oswald (1814–1887)
Miniaturist; engraver; illustrator. Small was born at NEWCASTLE, the son of an auctioneer, and after private education at Brampton, Cumbria, worked in the Tyneside office of John Dobson (q.v.), before becoming a professional artist. By the age of twenty he was already exhibiting at NEWCASTLE at the Newcastle upon Tyne Institution for the General Promotion of the Fine Arts, showing a landscape. His first employment as an artist, however, was as portrait miniaturist, although he is known to have worked for some time as an engraver in the workshop in NEWCASTLE of Mark Lambert (q.v.). Small does not appear to have exhibited his work in his later life but some of his work included drawings for local publications. According to his obituary in the *Newcastle Daily Chronicle*, 6th May 1887, Small was a friend of Thomas Miles Richardson, Senior (q.v.), and John Wilson Carmichael (q.v.), and like them took an active interest in the promotion of local art. He died at GATESHEAD, and was buried in Jesmond Old Cemetery, NEWCASTLE.

SMART, Edmund Hodgson (1873–1942)
Portrait, genre and allegorical painter in oil and watercolour. Smart was born at ALNWICK, and studied at the Antwerp Academy, the Académie Julian, Paris, and

at Bushey, Herts, at the School of Sir Hubert Von Herkomer, before practising as a professional artist. He first exhibited his work at the Bewick Club, NEWCASTLE, in 1884, while living temporarily at GATESHEAD, when his exhibits were *An Old Cabinet Maker, Gateshead*, and *Portrait of Miss Florence A Smart*. In the next few years, and giving his address as ALNWICK, he showed further works at the Club, later moving to London, where he quickly established himself as a successful portrait painter, and commenced exhibiting his work at the Royal Academy; the Royal Society of Portrait Painters; the London Salon, and at various provincial and overseas exhibitions, including the Paris Salon, and the Walker Art Gallery, Liverpool. His principal exhibits included *Portrait of the Lady in Black*, shown at the Royal Academy in 1906, and the Paris Salon in 1908; *My Mother*, exhibited at the Royal Academy in 1906, and the Paris Salon in 1909; *F. W. Ancott*, exhibited at the Paris Salon in 1910, and *Dr Annie Besant*, exhibited at the Royal Academy in 1934. Smart practised in London, North America, Bermuda, and his native town, and painted portraits of some of the most famous military and political figures of his day. Much of his later life was spent in Bermuda, and at ALNWICK. Represented: National Gallery, Washington, USA; Cleveland Museum of Art, Ohio, USA, and various North American collections.

SMITH, Bernard (b.1928)

Townscape painter in watercolour; ceramic sculptor. Smith was born at STOCKTON-ON-TEES, but moved to HARTLEPOOL in 1941 when his father went to work at the town's zinc works. He, too, became an employee at the zinc works, and during this time took his HNC in engineering. A variety of occupations followed,

Bernard Smith, *Jackson Marine Landing, Hartlepool*, watercolour, 51 x 51cm. Private collection.

including engineer and draughtsman in HARTLEPOOL and MIDDLESBROUGH, acting with repertory theatres, then, after taking a degree in philosophy at Lancaster University, teaching for some twenty years. On his retirement from teaching in 1991 he began working in his own studio specialising in ceramics. In 1994 he decided to improve his skill in this field by enrolling as a student at Central St Martins College of Art and Design, London, graduating with a degree in ceramic design three years later. During this degree course he was introduced to painting and encouraged to apply his images to the surfaces of his porcelain sculptures. After graduation he looked to HARTLEPOOL for his new work, this resulting in a major exhibition of his paintings and ceramics at the Hartlepool Art Gallery, in 2000, entitled *In and Around Hartlepool*. It included many street and industrial scenes around the town, and led to an invitation to hold a similar exhibition at Billingham Art Gallery, BILLINGHAM, in 2002. He lives and works in London. Represented: Hartlepool Arts & Museum Service.

SMITH, Charles A (b.1876)

Amateur landscape and coastal painter in watercolour; etcher. Smith was born at NORTH SHIELDS and by the age of twenty had become a keen amateur artist and member of local art clubs, both in his home town and at NEWCASTLE. He is described as a 'relieving officer' in some early 20th century trade directories but may later have become a professional artist. He was a regular exhibitor at the Bewick Club, and the Artists of the Northern Counties exhibitions at the Laing Art Gallery, NEWCASTLE, from the early years of the century, continuing at the latter until several years after the Second World War. His exhibited work consisted mainly of watercolours and etchings of views around NORTH SHIELDS, which apparently remained his home until his death some time after 1950. He was for several years president of the North East Coast Art Club, based at WHITLEY BAY.

SMITH, James Burrell (1824–1897)

Landscape painter in watercolour; illustrator; drawing master. Smith was born at Middlesex City, the son of an excise officer from FRAMLINGTON, near MORPETH. His family moved back to Northumbria when Smith was still a boy and at an early age he was placed as a pupil under Thomas Miles Richardson, Senior (q.v.), at NEWCASTLE. At sixteen he was apprenticed to a painter and glazier named Bowman, at MORPETH, but served only two years of his apprenticeship before moving to ALNWICK to practise as a landscape painter. Here he remained some eleven years, marrying a girl from nearby ABBERWICK, and building up a considerable clientele for his watercolour work, which included a wide variety of Northumbrian and Lake District views. His patrons while at ALNWICK, included the Duke of Northumberland, for whom he prepared studies of Hulne Park, and William Davison, the local printer, who issued many engravings based on his work. He does not appear to have exhibited his work before 1850, in which year he sent three works to the Suffolk Street Gallery, and eight works to Carlisle

Charles A Smith,
A corner of Preston Village,
North Shields,
watercolour, 24 x 37cm.
Private collection.

Athenaeum. He was an exhibitor at NEWCASTLE, in 1850, and 1852, at the exhibitions staged jointly by the North of England Society for the Promotion of the Fine Arts, and the Government School of Design, but from 1854 until 1881 he exhibited almost exclusively at the Suffolk Street Gallery, showing some fifty works. Most of these works featured Northumbrian, Lake District, Scottish and Welsh scenes, but included some Continental views. In 1854 Smith left ALNWICK, and entered the art establishment of Dickenson of New Bond Street, London, as an artist and teacher of drawing and painting. After leaving Dickenson's he devoted himself to watercolour painting, and is said to have secured an 'extensive connection with the families of the nobility and gentry', whose children became his pupils. He also prepared illustrations for Dean Alfred and others for their contributions to periodicals. Smith spent the final years of his life in London, where he died at West Kensington. A daughter, SARAH BURRELL SMITH, was also a talented painter in watercolour, and exhibited in London. Smith's work is sometimes confused with that of John Brandon Smith, but unlike the latter he rarely painted in oil. Represented: Victoria and Albert Museum; Fitzwilliam Museum, Cambridge; National Museum of Wales; County Record Office of Gloucestershire; Laing A G, Newcastle.

SMITH, John (James) (1841–1917)
Landscape, marine and coastal painter in oil and watercolour. Born at SUNDERLAND, Smith practised as an artist in his native town, and at nearby ROKER, until the turn of the century, following which he practised at both the latter and SOUTH SHIELDS. His first exhibits of note were his *Doe Park on the Balder*, and *Percy Beck, Lower Fall, Barnard Castle*, shown at the 'Gateshead Fine Art & Industrial Exhibition', in 1883. In the following year he commenced exhibiting at the Bewick Club, NEWCASTLE, showing three Tees Valley landscapes and a flower piece. He later showed his

work at the Artists of the Northern Counties exhibitions at the Laing Art Gallery, NEWCASTLE, where typical exhibits were his *Old Mill, Cleadon, South Shields* (1908); *On the Wear* (1910), and *Wreck on the Long Sands, South Shields* (1914). He was popularly known throughout his later life, as 'John Smith of Roker'. Sunderland Art Gallery has several of his oils and watercolours painted in the late 19th century.

SMITH, William ('Bill') (b.1930)
Abstract painter in oil; collagist; sculptor. He was born at BLACKHILL, near CONSETT, and practised as an artist on Tyneside in the middle of the 20th century. He showed his work in several group exhibitions during this period, notably the Artists of the Northern Counties exhibitions at the Laing Art Gallery, NEWCASTLE, and the city's Univision Gallery, of which he was one of the founders, with Ross Hickling (q.v.), and Harold Lord (q.v.). He also exhibited a work of sculpture at the Newcastle Festival, in 1965. Several of his later exhibits had Scandinavian themes, and it is believed he eventually moved to Norway to pursue his career. [See colour plate]

SMYTHE, Albert (b.1904)
Amateur landscape painter in oil and watercolour. Smythe is believed to have been born at NORTH SHIELDS, and practised as a sign-writer most of his life, painting in his spare time. He exhibited his work at the Artists of the Northern Counties exhibitions at the Laing Art Gallery, NEWCASTLE, and with the Federation of Northern Arts Societies' exhibitions at the Shipley Art Gallery, GATESHEAD, as well as with various local art clubs. In 1972 he had two of his paintings included in the 15th International Amateur Art Exhibition, in London. These were entitled *Dryburgh Abbey*, and *Seaton Delaval Church*. Smythe was also a keen writer of fiction, and a long-time member of Newcastle Writers' Club. He lived at NORTH SHIELDS.

James Burrell Smith, *Durham Cathedral with the Prebends Bridge*, watercolour, 62 x 92cm. Private collection.

SMYTHE, Reginald ('Reg') (1917–1998)

Cartoonist. Smythe was born at HARTLEPOOL, the son of a boat builder. He left school at fourteen, worked as a butcher's delivery boy, and in 1936 joined the Northumberland Fusiliers. While serving in Egypt during the Second World War he submitted cartoons to a Cairo magazine, but it was only after demobilisation, and a spell as a Post Office telephone clerk that he started freelancing as a cartoonist. In 1954 he joined the *Daily Mirror*, and influenced by his cartoonist mentor Leslie Harding ('Styx'), produced the regular feature, *Laughter at Work*. His most famous creation, 'Andy Capp', was commissioned by the *Mirror*, in 1957, with the instruction to produce a cartoon series which would appeal to people in the North. In the event it was syndicated to 1,700 newspapers in fifty-one countries, read by 250 million people, and was translated into fourteen languages. Andy Capp, a pun on 'handicap', became a national institution, who was always unemployed, played football, rugby and snooker, but gave up smoking in 1983. Smythe continued to live in the London area until 1976, when he decided to move back to HARTLEPOOL, and continued his series by travelling to the capital two or three times a week. He died in 1998, a year after an exhibition launched at the Jack Dash Gallery, London, had set off on a two-year national tour to celebrate the 40th anniversary of his cartoon creation.

Reginald Smythe, *Andy Capp cartoon strip from the Daily Mirror*

314

John Wray Snow,
The Meet at Blagdon, 1836,
oil, 125 x 226cm.
Private collection.

This exhibition visited Hartlepool Art Gallery in 1997, under the auspices of The Centre for the Study of Cartoons and Caricature established by the University of Kent at Canterbury in 1973, and which later acquired a large collection of Smythe's work as part of its aim to 'collect, conserve and make accessible 20th century British cartoons to assist the study and use of cartoons'. A 'life-size' bronze statue of Andy Capp has been discussed for HARTLEPOOL in memory of Smythe and his creation (the second such representation in bronze, a smaller scale version having been completed for Smythe by Myles Meehan (q.v.) c.1970, at the cartoonist's request). Hartlepool Arts & Museum Service has a small collection of Smythe's original cartoon strips, which still appear in the *Daily Mirror* every day.

SNOW, John Wray (1801–1854)
Animal and sporting painter in oil and watercolour; illustrator. Snow's place of birth is not known, but records show him to have been working in NEWCASTLE throughout the 1830s, following stays in London, and Yorkshire. Robert John Charleton (q.v.), in his *Newcastle Town*, 1885, recognises Snow as a Northumbrian artist, stating: 'In Snow we had a painter of animals whose works, of great excellence, are to be seen in many houses in the neighbourhood.' Certainly he had a studio in NEWCASTLE, and was a founder-member of the Newcastle Society of Artists, showing large numbers of oils and watercolours at its annual exhibitions from its foundation in 1835. One of his contributions to the inaugural exhibition of the Society earned the comment in the *Newcastle Journal*, July 11th, 1835: '. . . we consider this artist's knowledge of the horse, particularly when in full action, to be inferior to few animal painters of the day . . .'. Another of his contributions to this exhibition was purchased by Sir Matthew White Ridley, of Blagdon Hall, near SEATON BURN, who became one of Snow's principal patrons in the area. He also showed work at the exhibitions of the North of England Society for the Promotion of the Fine Arts, NEWCASTLE. Much of

Snow's work was reproduced in the form of engravings, amongst these his *Castle Howard Ox*, which was mezzotint engraved by J Egan in 1833; *Harkaway, with Pedigree*, of which C Hunt produced an aquatint in 1839; and perhaps his best known work, *The Meet at Blagdon*, painted in 1836, and mezzotint engraved by Thomas Lupton in 1840 with a dedication to Sir Matthew White Ridley. Some of his work was also reproduced in *Tattersalls British Race Horses*, 1838, and the *Illustrated London News*, in 1848. He exhibited infrequently outside NEWCASTLE, showing two examples of his work at the Suffolk Street Gallery in 1832, *Portrait of a Dog*, and *The Parting*. Represented: British Museum.

SNOWBALL, Joseph (1860–1946)
Portrait, landscape and marine painter in oil. He was born at SUNDERLAND, the son of one of the manufacturers of the well-known 'Sunderland Ware'. His first employment was in his father's potteries, but finding the artistic requirements of his work there too limiting, he became a professional artist. By 1909 he had established a successful portrait studio in London, and was sending his work to the London Salon. In 1919 a portrait work shown at the Allied Artists' exhibition at the city's Grafton Gallery earned special comment from the *Hippodrome Magazine* (British Artists Series, November, 1919), and was accompanied by an article portraying the artist, and a landscape work featuring Durham Cathedral. The article described various of the works seen by its writer at Snowball's studio, several of which were marine works, including *The Needles in a Storm*, and *The Wreck of the Arethusa*. Little more is known of this artist.

SOORD, Alfred Usher (1868–1915)
Landscape, portrait, biblical and flower painter in oil and watercolour. Soord was born at SUNDERLAND, but was brought up at York. He studied part time for several years at York Art School under John Windass, and afterwards at Bushey, Herts, at the school of Sir

Hubert von Herkomer. After leaving the school he practised as a professional artist at Bushey throughout his career, sending many of his works for exhibition throughout Britain. He exhibited at the Royal Academy from 1893 until his death, showing a mixture of flower studies, landscapes and portraits, and also showed his work at the Royal Institute of Oil Painters; the Royal Institute of Painters in Water Colours, and at various London, Scottish and provincial galleries. In addition to his Royal Academy portraits of writer Rider Haggard and Dr Edward Wilson, of Captain Scott's Antarctic Expedition, both shown in 1910, Soord painted portraits of several leading contemporary personalities at York, and had several of his biblical theme works reproduced by lithography. He was also noted for his reredos at Oxford House, Bethnal Green, London. He died at Bushey. His wife was the painter EVELYN W SOLLY. York City Art Gallery has several of his portraits, and a landscape, dating from his early career as an artist.

SOPWITH, Thomas, MA (1803–1879)

Topographical and architectural draughtsman; etcher. Born at NEWCASTLE. Sopwith was apprenticed as a joiner and cabinet maker in the town at the age of fourteen. He did not like the trade, however, and by studying in his spare time such subjects as architecture, cartography, etc., at the end of his apprenticeship obtained a position as a trainee land and mining surveyor at Alston, Cumbria. His employer found him so useful that he was taken into partnership, and over the next four years made plans of all the lead mines at Alston Moor belonging to the estate of Greenwich Hospital. He had taken a keen interest in drawing from his youth, and when he later returned to NEWCASTLE to set up in practice as a civil and mining engineer, he began to develop this interest further, and produced a number of pen and ink sketches of local buildings, several of which he exhibited at the Newcastle upon Tyne Institution for the General Promotion of the Fine Arts, in 1833, and later etched for Hodgson's *History of Northumberland*. Sopwith remained at NEWCASTLE for some thirteen years, and during this period became acquainted through his profession with some of the most eminent railway and mining engineers of his day. He also wrote and published many learned treatises on subjects associated with his profession, one of the most successful of which was his *Treatise on Isometrical Drawing*, 1834, which went through several editions. About 1843 he was appointed agent of the W B Lead Mines of Northumberland and Durham, and thereafter lived mostly at ALLENHEADS. He later moved to London, resigning his position from the Lead Mines in 1871, and remaining in the capital until his death in 1879. Sopwith kept a journal from the age of eighteen, until within a fortnight of his death 'containing descriptions of places and people, and numerous and amusing pen and ink sketches, which would do credit to a professional artist'. This journal ran to 168 large, and three small volumes, and was edited and published as *The Life and Diary of T Sopwith*, in 1891, by his old friend B W Richardson.

Sopwith was a member of several learned societies, and in 1857 received an honorary Master of Arts degree from Durham University, for his writings on various subjects.

SORRELL, Elizabeth, RWS (1916–1991)

Landscape, figure and still life painter in oil and watercolour; designer; art teacher. She was born as Elizabeth Tanner, at NORTH SKELTON, near REDCAR, and studied at Eastbourne School of Art, and in the design department of the Royal College of Art, before becoming an art teacher and designer. She taught at several art colleges; worked as a designer of wallpapers and fabrics; did design for the British Industries Fair, and Ideal Homes exhibitions, and practised actively as a painter, showing her work at the New English Art Club from 1947, and the Royal Academy from 1948. Her Royal Academy exhibits, which ran into dozens over succeeding decades, included landscapes, figure and doll studies, still lifes, and paintings of wild plants and flowers. One of her paintings in the latter category, *Ferns in the Conservatory*, was purchased for the Tate Gallery, under the terms of the Chantrey Bequest, following its showing at the Academy in 1949. She also exhibited at the Royal Water Colour Society for many years, and was elected a member of that body in 1966. She was the wife of artist ALAN SORRELL (1904–1974). Their son, RICHARD SORRELL (b.1948), and daughter JULIA SORRELL (b.1955), also became professional artists. She died at Thundersley, Essex, her home throughout her professional career.

SOWERBY, John George (1850–1914)

Landscape and flower painter in oil and watercolour; illustrator. He was born at GATESHEAD, the son of glassmaker and art patron John Sowerby, and succeeded to his father's position in the family business after several years' responsibility in the company for the development of new products. These included stained glass, for which he established a special department in association with Thomas Ralph Spence (q.v.) in 1879. This department later employed as its chief designer Arthur Hardwick Marsh (q.v.). One of its major commissions was for the design of the windows of St George's Church, JESMOND, NEWCASTLE, for Charles William Mitchell (q.v.), and executed by Spence and John W Brown (q.v.). The department was also responsible for several innovations in the production of stained glass, which have since been acknowledged as testifying 'to the achievement of the highest standard of stained glass artistry of the 19th century'. Sowerby was a keen amateur painter from his youth, and first exhibited his work locally when he sent five works to the first exhibition of the Arts Association, NEWCASTLE, in 1878 – an exhibition for which, together with W De Brailsford, he produced a volume of notes. He also contributed illustrations to these notes, along with Joseph Crawhall, The Third (q.v.), Henry Hetherington Emmerson (q.v.), and Robert Jobling (q.v.). In 1879 he again showed work with the Arts Association, his exhibit, *Too Late*, provoking from Aaron Watson (q.v.) in his notes on exhibitors, the remark: 'Of all the local artists who exhibit, Mr John George Sowerby has made

the most decided advance…'. Also in this year Sowerby began to exhibit at the Royal Academy, showing a work entitled *Twilight*. Altogether he showed some twenty works at the Academy, also exhibiting his work at the Royal Scottish Academy; the Royal Institute of Painters in Water Colours, and at various London and provincial galleries. He was also interested in book illustration, following his first venture in 1878 with a work jointly illustrated with Henry Hetherington Emmerson: *Afternoon Tea* (1880). He then went on to illustrate with Ellen Houghton *At Home* (1880); *Abroad* (1882), and *At Home Again* (1888). Other books for which he provided illustrations either with others, or independently, were *Jimmy: scenes from the life of a black doll* (1888); and *Young Maids and Old China* (1889). His final illustrative work was *Rooks and their Neighbours* (1895), which he both wrote and illustrated himself. Sowerby moved from GATESHEAD to Benwell Towers, NEWCASTLE, following his father's death in 1879, but moved to CHOLLERTON, near HEXHAM, when he retired from the family business due to ill health about 1896. From Tyneside he moved to Essex, then to Surrey and Berkshire before finally settling near Ross-on-Wye, from which he sent his last work for exhibition shortly before his death in 1914. His daughter, Millicent Sowerby (q.v.), was a talented landscape painter in watercolour, and illustrator. An excellent account of his contribution to the development of the family glassware company and work as an artist is contained in *Sowerby – Gateshead Glass*, by Simon Cottle. This lavishly illustrated book was produced in association with a major exhibition of the firm's products mounted by Tyne & Wear Museums Service, in 1986. [See colour plate]

SOWERBY, Millicent (1878–1967)
Landscape and figure painter in watercolour; illustrator. The second eldest daughter of John George Sowerby (q.v.), she was born at GATESHEAD, and showed a talent for painting and drawing from an early age. Encouraged by her father she began to paint landscapes in watercolour many of which she exhibited at the Bruton Gallery, London, and the Royal Institute of Painters in Water Colours, in the years immediately following her family's move to the south of England at the turn of the century. Also in this period she began to collaborate with her elder sister Katherine Githa Sowerby (1877–1970), in the production of children's books, Millicent providing the illustrations, Katherine Githa, the texts. These included *The Bumbletoes*, and *Childhood* (1907); *Little Plays for Little People* (1910); *Poems of Childhood* (1912), and *The Pretty Book* (1915). In 1908 she illustrated *A Child's Garden Book of Verses*, by Robert Louis Stevenson. Later publications for which she provided illustrations included *The Glad Book* (1921); *The Dating Book* (1922), and *The Joyous Book* (1923) – all written by Natalie Joan. She also served as the first illustrator of *Alice in Wonderland* after the copyright on Tenniel's pictures expired and became a prolific illustrator of postcards for C W Faulkner. Publishers such as J M Dent; Grant Richards, and Oxford University Press employed her, as well as *The Tatler*, and *Illustrated London News*. Katherine

Githa, for whom she illustrated a final book, *Cinderella's Playbook*, in 1927, became famous overnight in 1912 following the production of her first play *Rutherford & Son*. The sisters spent most of their life in London.

SPEDDING, Sidney (b.1916)
Sculptor; art teacher. Spedding was born at ASHINGTON, and studied art at Armstrong College (later King's College; now Newcastle University), then at Edinburgh College of Art. He later held a number of teaching posts, including a spell in Pakistan, and lectured for a period in sculpture at Manchester School of Art. He exhibited one work at the Royal Scottish Academy in his final year at Edinburgh College of Art, in 1939, and later in the provinces. He lived for many years at Stockport, Cheshire.

SPEED, Paul Edward (1933–1999)
Landscape painter in oil and watercolour; art teacher. Speed was born at NEWCASTLE, and after studying at King's College (now Newcastle University) taught art at various schools in Northumberland from 1958–1990. He was a keen spare-time painter of landscape subjects from the late 1960s, and believed that he worked in the same tradition as the 19th century northern topographical artists. Speed exhibited his work sparingly in his lifetime, and principally at the exhibitions held at NEWTON-ON-THE-MOOR, near ALNWICK, by Malcolm Gleghorn (q.v.), and others. His home was for many years at STANNINGTON, near MORPETH.

SPEED, Sydney Alan (b.1911)
Landscape and still life painter in oil and watercolour. He was born at SOUTH SHIELDS and studied art at King's College (now Newcastle University). He later exhibited his work widely in Northumbria, including the Artists of the Northern Counties exhibitions at the Laing Art Gallery, NEWCASTLE, and the Federation of Northern Art Societies' exhibitions both at the latter, and the Shipley Art Gallery, GATESHEAD. He spent his later life at NEWCASTLE, and was a member and for sometime honorary secretary of the Newcastle Society of Artists. Two of his oils were included in the 'Contemporary Artists of Durham County' exhibition staged at the Shipley Art Gallery, in 1951, in connection with the Festival of Britain: *Still Life*, and *Low Tide nr Pagham, Sussex*. This gallery has a flower study in oil by him. He usually signed his work 'Speed'.

SPENCE, Charles James (1848–1905)
Landscape and coastal painter in watercolour; etcher. He was born at NORTH SHIELDS, the son of banker Robert Spence, and later became a partner in his father's firm. Much of his time was taken up, however, with public responsibilities associated with his birthplace, including the post of Borough Treasurer of TYNEMOUTH. Spence was keenly interested in antiquarian matters, and in addition to his public commitments served as one of the curators of the Society of Antiquaries, NEWCASTLE, and honorary treasurer of the town's Literary and Philosophical Society. He was also chairman of the School of Art, Armstrong College

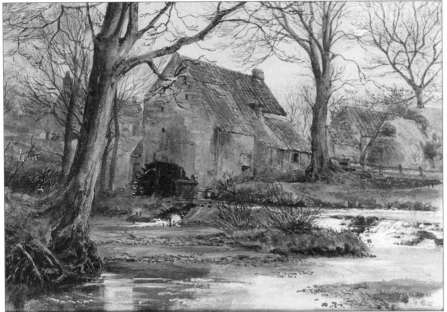

Charles James Spence,
Morwick Mill on the Coquet,
watercolour, 24 x 43cm.
Tyne & Wear Museums,
Laing Art Gallery.

(later King's College; now Newcastle University). Although in consequence of these various commitments he was able to spend only limited time on his hobby of watercolour painting and etching, Spence established a considerable reputation locally for his work. He was a regular exhibitor at the Arts Association, and later, the Bewick Club, NEWCASTLE, and contributed a series of etched illustrations to Dr John Collingwood Bruce's *Handbook to the Roman Wall*. He died at Edinburgh. An exhibition of watercolours and etchings selected from his work was held at The Academy of Arts, NEWCASTLE, in the year following his death, and later at his birthplace. The Laing Art Gallery, NEWCASTLE, has a substantial collection of his watercolours, including several Northumbrian coastal and river views. His sons Robert Spence (q.v.), and Philip Spence (q.v.), were also gifted artists.

SPENCE, Mary Emma (1857–1957)
Wood-carver; decorative artist. She was born at NORTH SHIELDS, a member of the well-known Spence family.* After her mother's death in 1885, she kept house for her father, and during his three years of office as Mayor of TYNEMOUTH acted as Mayoress. She continued to live on Tyneside for some years following his death, but spent much time receiving tuition in woodcarving from Arthur W Simpson of Kendal, Cumbria. She eventually moved to Hartsop, near Patterdale in Cumbria, where she pursued a variety of handicraft activities, including rug-making, embroidery and the decoration of hand painted china, until her death in a Kendal nursing home in 1957. Spence is best known for carving 'Wooden Dolly' number four, in the series of wooden figures of that name which have long been associated with NORTH SHIELDS. This figure, unveiled in 1902, was initially the

* See also: Charles James Spence (q.v.), Robert Spence (q.v.), and Philip Spence (q.v.).

318

subject of some controversy because of its departure from the traditional 'Dolly' design but soon became popular. It was replaced by 'Dolly' number five some fifty-odd years later, this being carved by the well-known firm of Robert Thompson of Kilburn, and placed in the town's Northumberland Square.

SPENCE, Philip (1873–1945)
Landscape painter in watercolour. He was born at TYNEMOUTH, the son of Charles James Spence (q.v.), and younger brother of Robert Spence (q.v.). Details of his early artistic training are not available, but by 1902, and having joined his brother in London, he had commenced exhibiting at the Royal Academy, showing two Continental landscapes: *Valley of the Domleschy, Switzerland*, and *The bed of the Nolla, Thusis*. He continued to exhibit at the Royal Academy for several years, eventually showing some seven works, but following his return to Tyneside about 1905, he exhibited mainly in the provinces. He exhibited at Liverpool, but sent most of his works for exhibition to the Artists of the Northern Counties exhibitions at the Laing Art Gallery, NEWCASTLE, showing Northumbrian landscapes, frequently with buildings. He lived at GATESHEAD for most of his later life, and is believed to have died there. In 1939 he was responsible for the publication of a book on the Spence family, based on notes compiled by Robert Spence, and Mary Emma Spence (q.v.).

SPENCE, Robert, RE (1871–1964)
Landscape and subject painter in oil; etcher; illustrator. He was born at TYNEMOUTH, the son of Charles James Spence (q.v.) and elder brother of Philip Spence (q.v.), and first studied art at NEWCASTLE. He later studied at the Slade School of Fine Art (1892–1895), and in Paris under Julian and Cormon, before becoming a professional artist in London about 1896, in

which year he first began to exhibit his work in the capital and in the provinces, and obtained commissions to illustrate *The Quarto*. In 1897 he was elected an associate member of the Royal Society of Painter-Etchers and Engravers, and in 1902 became a full member. He commenced exhibiting at the Royal Academy in 1902, eventually showing some twenty-four works, but sent the bulk of his work to the exhibitions of the Royal Society of Painter-Etchers and Engravers. He is, indeed, best remembered for his work in etching, and has been described as an 'important and original figure' in this field 'because of his use of the etched plate for both illustrations and text in the book'. His most notable achievement in etching is said to have been his illustrations for *George Fox and His Journal*. He also etched scenes from Wagner, and illustrated for several magazines. He continued to exhibit his work until 1940, in the early years of the century sending several works to the Artists of the Northern Counties exhibitions at the Laing Art Gallery, NEWCASTLE. He died in London. Represented: North Tyneside Public Libraries; Durham Cathedral Library.

SPENCE, Thomas Ralph (1848–1918)
Subject and landscape painter in oil; architectural, decorative and stained glass designer; woodcarver. Spence was born at Gilling, near Richmond, North Yorkshire, and practised as an architect before turning to easel painting, and a wide range of decorative arts. His father was a carpenter and joiner by trade, but also carved wood and stone as special assignments, and in spare moments painted in watercolour, and Spence may have received some instruction from his father in these activities before being placed as an architectural pupil, possibly at DURHAM. By the time that he had reached his early twenties he had worked for a number of architects, and had established himself as an architect in his own right at NEWCASTLE, following to the town Ralph Hedley (q.v.), who also was born at Gilling. Here he began painting in earnest, sending his first work to the Royal Academy from NEWCASTLE in 1876: *A breezy morning*. He again exhibited at the Academy in 1878, and in the same year showed three works at the first exhibition of the Arts Association, NEWCASTLE. In 1879, in partnership with John George Sowerby (q.v.), Spence established a stained glass department at the latter's Ellison Works, GATESHEAD, which by the following year had been incorporated as the Gateshead Stained Glass Company. Spence initially directed the company but was later succeeded by Arthur Hardwick Marsh (q.v.). He continued to exhibit at the Arts Association throughout its short life, and again exhibited at the Royal Academy in 1883, meanwhile making the acquaintance of Dr Charles Mitchell, father of Charles William Mitchell (q.v.), through whose influence he was appointed architect to the firm of Mitchell & Co, at WALKER and ELSWICK, near NEWCASTLE. Spence's association with Mitchell lasted until the latter's death in 1895, and led to his commission to design St George's Church, in the JESMOND area of NEWCASTLE. He also designed, and in some cases executed, deco-

rative features for the church including the North and South Windows (the exceptions were the East and West Windows by John W Brown (q.v.), the wood-carving by the firm of Ralph Hedley (q.v.), and the figures of the Apostles in the chancel in mosaic by Charles William Mitchell). St George's was to prove Spence's only major architectural work (he also handled work for Mitchell at his home Jesmond Towers), but it gave him a taste for architectural decoration which eventually led him to regard himself a 'decorator', rather then an easel painter, even although he continued to exhibit his paintings throughout his life. He exhibited on several occasions at the Royal Academy after the completion of the church in 1888, and also showed work at the Fine Art Society, London, and other establishments in the capital. He also exhibited widely in the provinces, including the Bewick Club, NEWCASTLE, and later the Artists of the Northern Counties exhibitions at the city's Laing Art Gallery. His diverse work in decoration included his contributions to St George's; Mitchell's home, and a wide range of structural and applied detail for churches and private homes in many parts of Britain and abroad. His work in painting included a number of subjects, but he was especially fascinated by historical themes, in particular those from Homer's Odyssey. He painted in Italy, Greece and Spain, the Fine Art Society showing a special exhibition of his topographical sketches made in these countries, in 1910. His wife was also artistically gifted, and exhibited on at least one occasion. [See colour plate]

SPENCE, William Geddes (1860–1946)
Coastal and landscape painter in watercolour. This artist was born on Tyneside, and painted mainly as a relaxation from his work in engineering and shipbuilding at SUNDERLAND, and NEWCASTLE. While living and working at SUNDERLAND he sent several works to the Bewick Club, NEWCASTLE, commencing in 1893 by showing *Cullen Bay, Banffshire: Clear Afternoon*, and *Cullen Harbour, Banffshire: Cloudy Morning*. He later showed several Scottish and Northumbrian landscapes at the Club, but following his appointment to a senior management post in shipbuilding in 1897, he appears to have exhibited on only one occasion, this being at the Artists of the Northern Counties exhibition at the Laing Art Gallery, NEWCASTLE, in 1905. He retired in 1931, and moving to Barton-on-Sea, died there fifteen years later.

SPICER, Charles (1868–1934)
Landscape, sporting and genre artist in oil and watercolour; illustrator. He was born at NEWCASTLE, the son of a master tailor, and after showing talent as an artist at an early age was placed as a pupil under Ralph Hedley (q.v.). His development from this point forward was so rapid that at the age of fifteen he had a picture, *A Winter's Afternoon*, accepted for the 'Gateshead Fine Art & Industrial Exhibition', and at the age of seventeen showed a genre work, *The Unstopped Drain*, at the Royal Academy. He was a

regular exhibitor at the Bewick Club, NEWCASTLE, from its inception, his occasional sporting pictures earning him special praise, as with his exhibit in 1892, of which the local press commented: 'It is called 'The Rogue', and describes an incident not infrequent at the start of a race, when one of the runners shows a little temper. There are few abler artists in this direction than Mr. Spicer; his horses are always accurately drawn, and full of movement; and the surroundings are always carefully studied and artistically depicted ...'. Despite this critical acclaim, however, Spicer later turned to journalism as a career, and while he continued to exhibit at the Bewick Club, and later showed work at other exhibitions at NEWCASTLE, he remained a journalist for the rest of his life, mainly working for newspapers based on Tyneside. He died at TYNEMOUTH in 1934, while still employed as a sub-editor for *The Journal*, NEWCASTLE.

STANFIELD, Clarkson, RA HRSA (1793–1867)

Marine, landscape and figure painter in oil and watercolour; scenic painter; illustrator; draughtsman. He was born at SUNDERLAND, the son of actor and author James Stanfield, who was at that time trading as a spirit merchant in the town. He showed a talent for drawing and painting from an early age, and in 1806 he was apprenticed to a local heraldic coach painter. Two years later, however, he left his master and went to sea on a Tyne collier, remaining with the ship until 1812, when he was pressed into the Navy to serve on HMS *Namur*, the Sheerness guardship. While with the *Namur* he is said to have painted scenery for amateur theatricals, and after serving on the Indianman *Warley* 1815–16, and visiting China, he obtained his first position as a professional in this field at the East London Theatre, Stepney (the 'Royalty'). He later moved on to the Coburg (the 'Old Vic'), then to Astley's Amphitheatre. Working for Astley's in Edinburgh in 1820–21, his father introduced him to his future professional colleague, friend, and eventual rival, David Roberts (1796–1864), and the two men worked together at the Coburg until 1822, before joining the Theatre Royal, Drury Lane. Here Stanfield soon established a reputation as 'the most brilliant theatrical painter of his age', achieving particular fame for his great moving dioramas for Christmas pantomimes, several of which were based on sketches taken on his foreign tours, undertaken in the early 1820s. Meanwhile, and having already exhibited his work at the Royal Academy and the British Institution from 1820, and the Suffolk Street Gallery from 1824, he had been developing his skills as an easel artist, this development encouraged by his work in scenic painting, both in style and content. Several of Stanfield's earliest successes as an easel artist were at the British Institution, with such titles as *Market Boat on the Scheldte* (1826), and *Wreckers off Fort Rouge, Calais in the Distance* (1828), for which latter he won the Institution's premium of £50. His first major success, however, came with his showing of a stormy seapiece at the Royal Academy in 1830, and entitled: *St. Michael's Mount, Cornwall*. This work attracted the attention of William IV, who commissioned him to paint *Portsmouth Harbour*, 1831, and *Opening of New London Bridge*, 1832. These works paved the way to his election as an associate member of the Royal Academy in November 1832, and from this point forward his work as an easel artist, scenic painter and illustrator was in increasing demand. But the second of these activities became progressively more difficult to accommodate within his available time, and at Christmas 1834, after a row with the manager of the Theatre Royal, Drury Lane, he resigned from the Theatre, and with his respectability as an artist enhanced, he was elected a full member of the Royal Academy in the February of the following year. Based at London for the remainder of his life, Stanfield continued to make the occasional trips abroad which he had commenced earlier in his career (the Alps, 1824; Venice, 1830, and France, 1832), first travelling to Belgium in 1836; later touring Italy, 1838–9; Holland, 1843, and southern France and northern Spain, 1851. He also made several British tours, many of the sketches and watercolours which he produced on these, and his foreign tours, being worked up later into highly finished pieces for exhibition at the Royal Academy and the British Institution, or copied by engravers for use in books and periodicals, such as his *Coast Scenery*, 1836, and *Sketches on the Moselle, the Rhine and the Meuse*, 1838. Most of his work was shown at the Royal Academy, at which he exhibited every year except one (1839) between 1830, and his death. Although not employed professionally in the Theatre after 1834, Stanfield continued to produce scenic work for friends, especially the actor Macready, and the author Charles Dickens. His undoubted love, however, was his work in oil and watercolour of dramatic coastal pieces, in which his superb abilities as a painter of the sea and ships, his skills as a topographical artist, and his flair for scenic painting, were combined in the production of some of the best work of its kind after Turner. Indeed, after Turner's death in 1851, Stanfield was recognised as the undisputed master of British marine painting, maintaining this status until his own death at Hampstead in 1867, at the age of seventy-three. In addition to enjoying the title of Royal Academician, Stanfield was from 1830 an honorary member of the Royal Scottish Academy (though all his exhibits at this Academy were sent there by collectors), and he was a founder-member of the Society of British Artists in 1823, and president in 1829. He married twice, having by his second wife a son, GEORGE CLARKSON STANFIELD (1828–1878), who also practised as an artist. Stanfield's younger half-brother, WILLIAM JAMES STANFIELD (1804–1827), was also a scenic painter of some ability. A major exhibition of Stanfield's work entitled: 'The Spectacular Career of Clarkson Stanfield,' was presented at Sunderland Art Gallery in 1979, by Tyne & Wear Museums, accompanied by a superbly written and illustrated catalogue prepared by Pieter van der Merwe, of the National Maritime Museum. Represented: British Museum; Victoria and Albert Museum; National Maritime Museum; Aberdeen A G; Blackburn A G; Cartwright Hall, Bradford;

Gloucester City A G; Haworth A G; Hove Library; Laing A G, Newcastle; Leeds City A G; Manchester City A G; Newport A G; Portsmouth City Museum; Shipley A G. Gateshead; Stalybridge A G; Sunderland A G; Ulster Museum, Belfast; and various overseas art galleries. [See colour plate]

STANILAND, Dr Bernard Gareth (1900–1968)

Amateur landscape, portrait, figure and abstract painter in oil and watercolour; sculptor; potter. Born at Canterbury, Kent. Staniland practised as a doctor at NEWCASTLE from his early manhood, and only became seriously interested in art after the Second World War. He had been a keen spare-time painter and sculptor for many years prior to the War, and exhibited his work on a number of occasions at the Artists of the Northern Counties exhibitions at the Laing Art Gallery, NEWCASTLE, almost from its outbreak, but in the late 1940s he enrolled in evening classes at King's College (now Newcastle University), and thereafter spent an increasing amount of time at his easel. He also became deeply involved in the activities of various local art societies, joining the Newcastle Society of Artists; the West End Art Club, and the Saville Art Group, and after founding the Federation of Northern Art Societies, serving as secretary, and later chairman. He showed his work at the Federation's exhibitions at the Laing Art Gallery throughout his life, and three examples of his work were included in the 'Contemporary Artists of Durham County' exhibition, staged at the Shipley Art Gallery, GATESHEAD, in 1951, in connection with the Festival of Britain. Staniland became art critic for *The Journal*, NEWCASTLE, in 1960 and contributed articles to its pages until his death at his home in the West End of the city, in 1968. Newcastle Central Library has several volumes of his cuttings and catalogues relating to Northumbrian art exhibitions and art topics, 1950–1968.

STEAVENSON, Charles Herbert (c.1870–after 1930)

Amateur landscape painter in oil and watercolour; etcher; illustrator. Steavenson's place of birth is not known, but is thought to have been North Yorkshire, as it was from this area that he sent his first work for exhibition to the Dudley Gallery, London, in 1893. Also, he first worked at his profession as mining engineer in that area, before settling at GATESHEAD, where he founded a mining accessories business about 1905, and later managed several local collieries, in addition to serving on the local council. As soon as he settled at GATESHEAD he commenced exhibiting at the Artists of the Northern Counties exhibitions at the Laing Art Gallery, NEWCASTLE, showing a wide range of Scottish, North Yorkshire, Surrey, Lancashire, and Durham landscape paintings and etchings. In this period he also published a book of his illustrations: *Colliery Workmen Sketched at Work*, 1912. He was serving on the local council when he became a member of the committee of the Shipley Art Gallery upon its opening in 1917, and in 1930 presented the Gallery with an example of his work: *Winter at Guisborough*, dated 1919. He died at GATESHEAD.

Charles Herbert Steavenson, *The Overman*, illustration from *Colliery Workmen Sketched at Work*, 1912.

STEAVENSON, Mrs Elizabeth Lucy Pease (née Robinson) (1882–1975)

Amateur landscape painter in watercolour. She was born at DARLINGTON, the daughter of well-known local engineer and surveyor, Robert Robinson. In 1911 she married Dr Charles Stanley Steavenson, and moved to MIDDLETON ST. GEORGE, near DARLINGTON, where her husband served on the County Council and as chairman of the Parish Council. A keen amateur artist and poet from her youth, she occasionally exhibited her work at DARLINGTON, and contributed verse to the *Darlington & Stockton Times* and the *Northern Echo*, both published in the town. Darlington Art Gallery has her *Coniston Lake, Afternoon*, 1929.

STEELE, Edward John (b.1949)

Animal, bird and landscape painter in acrylic and watercolour; draughtsman; illustrator. He was born at TYNEMOUTH and although interested in painting and drawing from an early age trained as a building surveyor. After some twelve years in the profession he became a ranger for the Northumberland National Park, later becoming senior ranger, and from 2000, species and habitats officer. His early interest in painting and drawing became focused on animal and bird

subjects by the mid–1980s, and he began exhibiting his work by showing examples at the Queen's Hall, HEXHAM, in 1985, along with colleagues from the National Park. In 1988 he was commended for an illustration shown at the Mall Galleries, London, as the result of a Bird Illustration of the Year Competition organised by *British Birds Magazine*, since when he has continued to show his work in many other group exhibitions, including the North East Bird Watchers Festival, 1988 and 1989; from 1990 at the regular exhibitions of the Coquetdale Gallery, ROTHBURY; the Art of Northumberland Open Exhibition, ALNWICK, 1997, and at the Stenton Gallery, East Lothian, Scotland, 1998. In 2003 he shared an exhibition at the Wildlife and Wetlands Trust, WASHINGTON, near SUNDERLAND, with Michael Oxley, including seascapes, rockscapes and wildlife subjects. Much of his spare time from the mid–1980s has also been spent in illustrative work, this including the front covers of the Birds of Northumbria Annual Reports of the Northumberland and Tyneside Bird Club, and for other of its publications; from 1988, for many of his articles on natural history for the *Northumbrian* magazine, and later its sister publication *Durham Town & Country*, and the *Northumbrian Nature Diary*, Sandhill Press, 1993. Although mainly self-taught apart from brief lessons in drawing from Scottish bird artist John Busby, Steele has won several awards and commendations for his work, and it has been extensively reproduced in the form of prints. He lives at ROTHBURY, where he is an active member of the local Coquetdale Art Group.

STEPHENSON, Ian, RA (1934–2000)

Abstract painter in oil; art teacher. Stephenson was born at BROWNEY, near DURHAM, but spent most of his childhood at BLYTH. He first became interested in art when he saw a print of *The Plains of Heaven*, after John Martin (q.v.), while evacuated to County Durham during the Second World War, and went on to study the subject at King's College (now Newcastle University), under Lawrence Gowing. Here he won a succession of prizes while studying for his degree, and shared a flat with Richard Hamilton – later to become famous as the father of British Pop Art. In 1959 Stephenson left Tyneside to teach at Chelsea School of Art, and shortly after became famous for his contribution to the 1960s landmark film *Blow-Up*. This came about as a result of director Michelangelo Antonioni using his Chelsea studio after hearing of Stephenson through a prestigious Italian art prize he had won. Stephenson had earlier received a John Moores junior prize and been awarded a Boise Travelling Scholarship to Italy. He had his first one-man show at the New Vision Centre in 1958, then went on to exhibit in several important group exhibitions in Britain and abroad. Following his period of teaching at Chelsea School of Art 1959–1966, he became director of foundation studies in fine art at Newcastle University. His return to his native Northumbria was marked by a one-man exhibition at the People's Theatre, NEWCASTLE, and his departure in 1970, with a major retrospective at the city's Laing Art Gallery. Stephenson returned to Chelsea School of Art in the latter year as principal lecturer in painting. His international reputation was consolidated in the 1970s, and in 1977 he had a retrospective at the Hayward Gallery which later toured. Following this he mainly exhibited at the Royal Academy, of which he was elected an associate in 1975, and a full member in 1986. He died of leukaemia in London at the early age of sixty-six. His wife Kate is also an artist. Represented: Arts Council; Hatton Gallery, Newcastle; Laing A G, Newcastle; Sunderland A G; Tate Gallery.

STEPHENSON, John Atlantic (1829–1913)

Landscape painter in oil and watercolour. Stephenson was born in mid-Atlantic, and later moved with his parents to Tyneside. He left the area for some twelve years to live in India, and shortly after his return went to work at the glassworks at GATESHEAD of John Sowerby, father of John George Sowerby (q.v.). He later joined the firm of John Rogerson & Co, as a representative, painting in his spare time, and taking an active interest in the affairs of the Bewick Club, NEWCASTLE, from its foundation. Stephenson exhibited his work at the Arts Association, NEWCASTLE, from 1878, and showed one work, *Black Gate, Newcastle*, at the 'Gateshead Fine Art & Industrial Exhibition', 1883; following the latter date he exhibited almost exclusively with the Bewick Club. Most of his life on Tyneside was spent at GATESHEAD, where he lived until 1908. Following this he lived at Manchester. Stephenson acquired a considerable reputation in his lifetime for his recitations in the local dialect, amongst the most popular of which was his composition, *Hawk's Men*. Several of his watercolours were exhibited at the Bewick Club in the year of his death. Represented: Laing A G, Newcastle; Shipley A G, Gateshead.

STEPHENSON, John Cecil (1889–1965)

Constructivist and abstract artist in various media; art teacher. Stephenson was born at BISHOP AUCKLAND, and attended the Technical College at DARLINGTON before going on to study at Leeds College of Art; the Royal College of Art, and the Slade School of Fine Art. On concluding his studies he took over the one-time studio of Walter Sickert at Hamsptead, London, where he lived from 1919, until he died. In 1922 he took up an appointment as head of art at the capital's Northern Polytechnic, teaching architectural students. He remained there until his retirement in 1955, meanwhile developing from the representational painter of his early years, into a constructivist and abstract artist whose grandest moment probably occurred in 1937, when he was included in the *Circle* book and exhibition. This was subtitled *International Survey of Constructive Art*, and included essays and paintings by Le Corbusier, Naum Garbo, Piet Mondrian, Herbert Read and Ben Nicholson. His first abstract paintings dated from 1933. He exhibited with the 7 & 5 Society in 1934 and spent the remainder of the decade using much of his spare time away from teaching in producing both abstract and constructivist works which he

showed mainly in London. During the Second World War years he produced a number of Blitz theme works which were purchased by the Imperial War Museum, and the Northern Polytechnic, and he later worked on thirty pictures for the Festival of Britain, staged in 1951. Within a few years of their showing he had become fascinated with the possibilities of Plyglass in his work, and after completing a commission including this material for the Engineering Faculty Building, Queen Mary College, London, in 1957, in the following year produced a mural for the Brussels International Exhibition. He received a silver medal for this Plyglass mural, which exemplified the vivid geometrical abstractions that are his strongest work, but did little in his final years to equal its importance. In 1963 the Tate Gallery bought one of his 1937 works, and a memorial exhibition was held at the Drian Gallery in the year following his death. Retrospectives were held at the Camden Arts Centre, London, in 1975, which later toured, and at Fischer Fine Art, in 1976. A well-researched and illustrated book by Simon Guthrie, was published by Cartmel Press, under the title *The Life & Art of John Cecil Stephenson*. Represented: British Museum; Imperial War Museum; Tate Gallery; Victoria and Albert Museum.

STEPHENSON, Margery Annette (b.1929)

Ornithological, wildlife and landscape painter in oil and watercolour; art teacher. She was born at MONKSEATON, the daughter of talented amateur artist FREDERICK BROWNE, and first decided on a career in teaching art after seeing a copy of Franz Hal's *Laughing Cavalier* at school while living with her father in Penrith, Cumbria, during the Second World War. After returning to WHITLEY BAY at the conclusion of the War she became a student at King's College (now Newcastle University), graduating in 1950. She returned to the College as a lecturer in art, after teaching in Liverpool and NEWCASTLE. She then worked as a freelance artist in Glasgow and Leeds over the next nine years. In 1966 she was appointed art mistress at Leeds Girls' High School, rising to the position as head of art before leaving in 1981 to live in Northumbria, at WOOLER. While working as a freelance artist earlier in her career she began illustrating printed matter for the Medici Society Ltd, and since 1960 has had more than 300 of her designs published by this internationally famous company. Recognition for her work during this period also included her winning in 1958, the national competition for the Northumberland National Park sign, and in 1961, the national competition for the Chest and Heart Association design. She has participated in many group exhibitions throughout her career both as art teacher and artist and has enjoyed ten one-man exhibitions of her work throughout the North of England, and Scotland. These have been held at Leeds University, in 1975; the Dunkeld Gallery, Dunkeld, Scotland, in 1983; the Macaulay Gallery, Stenton, East Lothian, Scotland, in 1987, 1989, 1990, 1994, and 1996; the Duncalfe Gallery, Harrogate, in 1988 and 1989, and the Stenton Gallery, Stenton, in 1998.

She continues to paint at her home at WOOLER, and teaches art and art appreciation at classes held locally by the University of the Third Age organisation. In 2001 she won the national competition for a Christmas card design for the U3A. She has said that the greatest influence on her work as a designer has been that of Leonard Charles Evetts (q.v.). Her work is represented in private collections throughout the world.

STEVENSON, Bernard Trevor Whiteworth (1899–1985)

Landscape painter in oil and watercolour. He was born at Nottingham, but moved to NEWCASTLE in his infancy, on the appointment of his father, Arthur Charles Bernard Stevenson, as first curator of the city's Laing Art Gallery. After education at the Royal Grammar School, NEWCASTLE, he studied art at Armstrong College (later King's College; now Newcastle University), under Richard George Hatton (q.v.). On completing his studies at the College, however, he decided on a career in librarianship, and worked successively at NEWCASTLE, Sheffield, and Southport. On his retirement as Borough Librarian at Southport, he returned to Northumbria, where he lived at HALTWHISTLE. He first began exhibiting his work publicly at the Artists of the Northern Counties exhibitions at the Laing Art Gallery, NEWCASTLE, in 1919, and has later exhibited widely in Britain. He also wrote art criticisms for newspapers and periodicals, and produced work as a potter. Represented: Laing A G, Newcastle.

STEWART, Ian – *see* CLARK, John Stewart.

STEWART, William (1884–1965)

Landscape painter in watercolour. Stewart was born at BELLS CLOSE, near NEWCASTLE, and later studied at the city's Rutherford College, and at Armstrong College (later King's College; now Newcastle University). Although he studied architecture he did not follow the profession, and appears to have taken up another occupation, painting in his spare time. He was a member of the city's Benwell Art Club, and regularly showed his work at the Artists of the Northern Counties exhibitions at the Laing Art Gallery, NEWCASTLE. Most of his work consisted of watercolour studies of scenes in the Tyne, Derwent and Wear valleys, and along the Northumbrian coastline. A large selection of his work was shown at various public libraries in NEWCASTLE, following his death. He died at LEMINGTON, near NEWCASTLE, where he had lived most of his life.

STHYR, Erik (b.1909)

Landscape, still life and figure painter in oil; art teacher. He was born at MONKSEATON, the son of Danish parents but moved to London at the age of twelve. Here he studied part-time at Clapham School of Art while still working in his father's business in the capital, later going on to study at Westminster and Chelsea Schools of Art before becoming a full-time student at the Slade School of Fine Art in 1928. During his three years at the Slade his teachers

George Blackie Sticks,
Loch Fynne, Scotland,
oil, 36 x 46cm.
Private collection.

included Henry Tonks, Philip Wilson Steer, Randolph Schwabe and Graham Sutherland, and he became a prize-winner in drawing and sculpture. He began his teaching career at St Paul's School of Art, continuing this at Winchester School of Art after service in the Second World War. His early work is said to have shown the influence of Walter Sickert. He has painted extensively in England, Denmark and France, and has exhibited his work at the Royal Society of British Artists; with the London Group, and at the Artists International War Exhibition. He has also shown his work in group exhibitions at the New Grafton Gallery, and the Alresford Gallery, and in 1994 shared an exhibition at Winchester Guildhall with sculptor John Souter. Sthyr lives at Winchester. He has sometimes used the Christian name 'Eric' when exhibiting.

STICKS, Andrew James (b.1855)

Stained glass designer; landscape painter in oil and watercolour. One of the five artist sons of James Sticks (q.v.), he was born at NEWCASTLE and was later apprenticed in the stained glass manufactory of William Wailes (q.v.), in the city, following his brothers William Sticks, Senior (q.v.), George Blackie Sticks (q.v.), and Henry Sticks (q.v.). He is believed to have remained with Wailes all his working life, although his name appears in local trade directories towards the end of the century as an artist, without reference to stained glass. He was a regular exhibitor at the Bewick Club, NEWCASTLE, from 1884, his first contributions being *Borrowdale; Snowing*, and *Bamburgh*. While working for Wailes he was joined by his younger brother Richard D Sticks (q.v.).

STICKS, George Blackie (1843–1900)

Landscape painter in oil and watercolour. The most distinguished member of the Sticks' family of artists,

he was born at NEWCASTLE, the son of James Sticks (q.v.), the stained glass designer and draughtsman. His early artistic training was as a designer in the stained glass manufactory of William Wailes (q.v.), at NEWCASTLE, which already employed his father, and his brother, William Sticks, Senior (q.v.). One of Wailes' requirements of his young designers was that they should excel in drawing. Sticks was placed under the tuition of William Bell Scott (q.v.), at the Government School of Design at NEWCASTLE, where he is said to have 'delighted in his studies ... but cared little for stained glass work'. He remained with Wailes until his indentures expired, but encouraged by his master he then embarked on a career as a full-time professional artist. Even before the expiry of his apprenticeship there had been a demand for his work, and within a short time of establishing a studio in the city he was able to claim a respectable living from his artistry. Sticks' first painting to attract attention was his *Morning after a Storm*, shown at the 'Exhibition of Paintings and other Works of Art', at the Town Hall, NEWCASTLE, in 1866. Such a picture, it was said, had not been exhibited for many a day; 'Train and Swift were dead, and Sticks alone occupied the field.' The painting was bought by Tyneside glassmaker John Sowerby – father of John George Sowerby (q.v.), who later became one of the major buyers of Sticks' work. Other commissions came in, and in order to satisfy his patrons he made extensive sketching tours in the Trossachs, Caithness, Skye, Arran, and the areas around Loch Lomond, Loch Katrine and Glen Tilt, in Scotland. The English Lake District also claimed his attention, but his principal subjects were taken from the wilder parts of Scotland. Heartened by the success of his early exhibiting efforts at NEWCASTLE, he sent work to the 'Central Exchange News Room, Art Gallery & Polytechnic

Exhibition' in the town in 1870, following this by showing regularly at the Arts Association exhibitions at NEWCASTLE, from their inception in 1878. In 1885, however, he became ambitious of wider acclaim and sent a work, *Storm on the Whitley Coast, Northumberland*, to the Royal Academy, having already exhibited his work at the Royal Scottish Academy from 1882. But he remained a regular exhibitor in his native city, sending works to the exhibitions of the Bewick Club until failing health caused him to virtually give up painting. According to family records, he died in 1900. Represented: Laing A G, Newcastle; Shipley A G, Gateshead.

STICKS, George Edward (1864–1904)

Landscape and genre painter in oil and watercolour. The eldest son of George Blackie Sticks (q.v.), and grandson of James Sticks (q.v.), he was born at NEWCASTLE, and received his early tuition in art from his father. By the time that he had reached his teens he was sharing his father's studio in the city's Westgate Road, and accompanying him on his sketching and painting expeditions. In 1888 he sent a work in oil, *The little stranger*, to the Bewick Club exhibition, following this with several exhibits over the next few years, including his *Near Ryton*, and *On the Cumberland Fell*, contributed in 1891. He painted in much the same style as his father, however an early commentator on his work stated: '. . . his pictures are by no means vain imitations, and time alone will develop his talent'. He remained a professional artist in NEWCASTLE for a number of years, dying in the city in 1904.

STICKS, Henry ('Harry') James (1867–1938)

Landscape painter in oil and watercolour. The son of Henry Sticks (q.v.), and nephew of George Blackie Sticks (q.v.), he was born at NEWCASTLE, and following some tuition from his father and uncle, practised as an artist in Northumbria throughout his life. He first began exhibiting his work publicly in his native NEWCASTLE, where he was a regular exhibitor at the Bewick Club from his early twenties. In 1894 he began to exhibit his work outside Northumbria, and a year later staged his first one-man show at the gallery at The Side, NEWCASTLE, of artist friend Charles Rutherford (q.v.); of this show the *Newcastle Weekly*

Henry James Sticks, *The Wear Below Frosterley*, oil, 30.5 x 60cm. Anderson & Garland.

Chronicle, 30th November, 1895, remarked: 'All the works exhibited are direct studies from nature and are distinguished by poetic feeling, reverence for nature, and delicacy of manipulation . . . he has depicted with rare fidelity scenes at Blaydon, Winlaton, Wylam and thereabouts . . . Mr. Sticks has made great progress within the last few years . . .'. Sticks remained a devoted recorder of Northumbrian scenery all his life, but also made annual trips to the Lake District to paint. He made only one notable tour abroad, this being in 1897, when he visited Jamaica, Barbados, Tampico, the Azores, Gibraltar, Malta, Salonica, Catalonia, Smyrna, Antwerp and Rotterdam, working on a commission for a Tyneside shipping company. Sticks exhibited at the Royal Scottish Academy; the Royal Institute of Painters in Water Colours, and the Royal Birmingham Society of Artists, Birmingham, until 1911, and from 1905 until his death, at the Artists of the Northern Counties exhibitions at the Laing Art Gallery, NEWCASTLE. He lived at GATESHEAD for most of his later life, while maintaining a studio at NEWCASTLE. He died at GATESHEAD. Represented: Laing A G, Newcastle; Shipley A G, Gateshead.

STICKS, Henry (1845–1878)

Stained glass designer; coastal and landscape painter in watercolour. One of the five artist sons of James Sticks (q.v.), and father of Henry James Sticks (q.v.), he was born at NEWCASTLE, and was apprenticed to William Wailes (q.v.) in the Wailes' stained glass manufactory in the town, under his father. Like his brothers, and fellow apprentices, George Blackie Sticks (q.v.), and William Sticks, Senior (q.v.), he was sent by Wailes to study under William Bell Scott (q.v.) at the town's Government School of Design. He remained with Wailes all his working life, producing watercolour views of local scenery in his spare time. He exhibited these views infrequently, amongst his few known exhibits being *Cullercoats Pier*, which he sent to the 'Exhibition of Paintings and other Works of Art', at the Town Hall, NEWCASTLE, in 1866, and the 'four brightly coloured sketches' which he exhibited at the Central Exchange Art Gallery exhibition of the work of local painters, at NEWCASTLE, in the year of his death.

STICKS, James (b.1813)

Stained glass designer; draughtsman. The father of William Sticks, Senior (q.v.), George Blackie Sticks (q.v.), Henry Sticks (q.v.). Andrew James Sticks (q.v.), and Richard D Sticks (q.v.), he is believed to have been born at Edinburgh, and to have joined the stained glass manufactory of William Wailes (q.v.), at NEWCASTLE, some time before the birth of his first son William, in 1841. He eventually rose to become one of Wailes' top designers, joining fellow Scotsmen Francis Wilson Oliphant (q.v.), and John Thompson Campbell (q.v.), on visits to cathedrals and other buildings on the Continent to study the best examples of stained glass, and later collaborating with the famous architect Pugin, in designing the stained glass windows for St Mary's Cathedral, NEWCASTLE.

STICKS, Richard D (b.1857)
Stained glass designer. One of the five artist sons of James Sticks (q.v.), he was born at NEWCASTLE, and was apprenticed to William Wailes (q.v.), in the Wailes' stained glass manufactory in the town, following his brothers William Sticks, Senior (q.v.), George Blackie Sticks (q.v.), Henry Sticks (q.v.), and Andrew James Sticks (q.v.). He is not known to have produced any artistic work outside of stained glass designs.

STICKS, William, Senior (b.1841)
Stained glass designer; draughtsman. One of the five artist sons of James Sticks (q.v.), he was born at NEWCASTLE, and was apprenticed to William Wailes (q.v.) in the Wailes' stained glass manufactory in the town. It is possible that, like his brother George Blackie Sticks (q.v.), he was sent by Wailes to study for a period under William Bell Scott (q.v.), at the town's Government School of Design. He appears to have remained with Wailes all his working life, without leaving any clearly identifiable examples of his artistry outside stained glass.

STICKS, William, Junior (1864–1937)
Stained glass designer; draughtsman; seascape and landscape painter in oil and watercolour. The son of William Sticks Senior (q.v.), and grandson of James Sticks (q.v.), he was born at NEWCASTLE, and appears to have served an apprenticeship with William Wailes (q.v.) in the Wailes' stained glass manufactory in the town, before leaving to live in Edinburgh, just before the turn of the century. Here he worked for another well-known stained glass company, Ballantyne & Son, retiring in 1934, some three years before his death. Sticks was a capable spare-time painter of seascapes and landscapes, one of which, *Entrance to Dunbar Harbour*, he sent to the Bewick Club, NEWCASTLE, in 1895, from Edinburgh. He died at Edinburgh.

STOBART, Adela (c.1855–1950)
Landscape and figure painter in watercolour. She was born at ETHERLEY, near BISHOP AUCKLAND and began painting at an early age. After her general education she studied under Walter Sickert and Lucy Kemp-Welch before herself becoming a professional artist, practising in the south of England. She exhibited her work at the Royal Institute of Painters in Water Colours; the Royal Cambrian Academy; the Society of Women Artists, and at several London and provincial galleries. Her work was also shown at the Paris Salon, and in a one-man exhibition at the Arlington Gallery, London. Some of her exhibits at these various venues, shown between 1921–1929, were watercolours of subjects painted while travelling in France, Switzerland and Italy. She was obliged to give up painting after damaging her eyesight in a wood-chopping incident. She lived in Sussex for many years.

STOKELD, James (1827–1877)
Genre, landscape and marine painter in oil. He was born at SUNDERLAND, at the Queen's Head, Queen Street, where his father was landlord. His father later moved to SEAHAM to become landlord of the Ship Inn, and at fourteen Stokeld was apprenticed to a painter and glazier at SUNDERLAND. After seven years as an apprentice he went to London to study at Leigh's Academy, remaining there for five years, and supporting himself by painting and photographic work. Lack of commissions, however, eventually forced him to return to Northumbria, where he lived first at HARTLEPOOL, later at NEWCASTLE. At NEWCASTLE he was helped by former fellow apprentice William Crosby (q.v.), who invited Stokeld to return to SUNDERLAND to assist in the execution of commissions from the wife of Edward Backhouse (q.v.). He took a studio at Fowler Terrace, in the HENDON district of the town, and soon established a reputation for painting 'fancy pictures'. In 1862 Stokeld sent his first work for public exhibition, to the Suffolk Street Gallery: *A Frosty Morning – Couldn't help it!* He followed this in 1863 by exhibiting at both the Suffolk Street Gallery, and the Royal Academy, his exhibit at the latter being *Whisperings of sweet nothings*. He remained an exhibitor at the Suffolk Street Gallery for the next two years, but did not again exhibit at the Academy. After 1865 he did not exhibit outside Northumbria, where amongst his few contributions to local exhibitions was the landscape which he sent to the 'Central Exchange News Room, Art Gallery & Polytechnic Exhibition', NEWCASTLE, in 1870. His final years were spent in precarious financial circumstances at SUNDERLAND, where he died in 1877, by drinking a bottle of carbolic acid following an argument with his wife. His sale of sketches in the week following his death realised £87. He regarded as his best work his large oil *Last Man Ashore*. This work was acquired by Tyne & Wear Museums to add to Sunderland Art Gallery's substantial collection of the artist's work, in 1980. An excellent account of Stokeld's life and work may be found in William Brockie's *Sunderland Notables*, 1894. Represented: Sunderland A G.

STOREY, John (1828–1888)
Topographical and architectural painter in watercolour; lithographer; illustrator. Born at NEWCASTLE, the son of a schoolmaster, Storey received his education from his father, and after tuition from Thomas Miles Richardson, Senior (q.v.), practised as a professional artist at his birthplace until a few weeks short of his death. His work lay mainly in the field of topographical and architectural drawing, and was in considerable demand from local authorities and public undertakings in connection with their various development projects. Indeed, two of his most important works fell into the category of topographical studies; an imaginative piece, *Newcastle in the Reign of Elizabeth*, and an on the spot drawing, *Newcastle in the Reign of Victoria*. Apart from three works shown at the Suffolk Street Gallery 1849–51, he appears to have exhibited exclusively on Tyneside, participating in several important exhibitions from 1850 until his death, including the exhibition of the North of England Society for the Promotion of the Fine Arts, and the Government School of Design, 1850; the

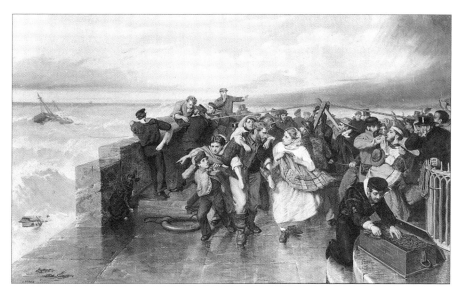

James Stokeld,
Last Man Ashore,
oil, 71 x 119.5cm.
Tyne & Wear Museums,
Sunderland Art Gallery.

'Gateshead Fine Art & Industrial Exhibition', 1883, and the Royal Jubilee Exhibition, 1887. Storey fell ill in the early part of 1888 and went to Harrogate, Yorkshire, to recuperate, but he died there only a few weeks later. His Elizabethan and Victorian views of NEWCASTLE, were both issued as large coloured lithographs, and are now popular collectors' pieces. The original watercolour for the former is in the Port of Tyne Authority's headquarters at SOUTH SHIELDS, while that of the latter is in the meeting room of the city's Literary and Philosophical Society. Storey did several other lithographic works based on his drawings, and illustrated for the local newspapers and periodicals. Represented: Laing A G, Newcastle; Shipley A G, Gateshead; South Shields Museum & A G; Sunderland A G. [See colour plate]

STOREY, Terence Lionel, PPRSMA FRSA (b.1923)

Marine and landscape painter in oil and watercolour. Storey was born at SUNDERLAND, and attended the town's School of Art, and Derby College of Art before practising as a professional artist. Although best known for his paintings of shipping he has also painted a number of landscapes, industrial scenes, aircraft and wildlife studies. His early interest in marine painting led him to exhibit at the Royal Society of Marine Artists, where his first exhibit in 1970 was his *Harbour View, Sunderland*, but he has also exhibited at the Royal Society of British Artists; the Royal Institute of Oil Painters; the New English Art Club; the National Society of Painters, Sculptors and Gravers/Printmakers, and the Society of Wildlife Artists. He has also received many commissions for his work from private individuals and clubs. These have included the Sultan of Oman; the Royal Eagles Club, and the Royal Burnham Yacht Club. His work has been widely illustrated, notably in the publications of Winsor and Newton, Rolls-Royce, and numerous shipping lines, and examples are held by several important collections including those of HRH the Prince of Wales; the Royal Society of Marine Artists

Diploma Collection, and the Picture Collection of the Port of London Authority. Storey has always played an active part in the Royal Society of Marine Artists, to which he was elected a member in 1972. He served as a council member from 1979–83; vice president in 1983, and president in 1988, retiring from the post in 1993. He is also a fellow of the Royal Society of Arts. He lives at Derby, where a substantial exhibition of his work was held at the city's Museum & Art Gallery in 1996. [See colour plate]

STOREY, Warren, RWA (b.1924)

Figure and portrait painter in oil; muralist; art teacher. He was born at SOUTH SHIELDS, and studied at the town's School of Art under Eric Gill, and Regent Polytechnic School under William Matthews and Norman Blamey before taking up a career in teaching art. He became head of Weston-super-Mare School of Art, and an extramural art history lecturer at Bristol University, meanwhile practising as a painter, general and ecclesiastical designer and mural artist with considerable recognition for his work. This was reflected in his election to the Royal West of England Academy in 1976, and his later service as its vice president. In addition to his regular appearance at its exhibitions he has also shown his work at the Royal Academy; the Royal Society of British Artists; Young Contemporaries, and in a number of one-man exhibitions in the West Country. Storey has painted a number of portraits for private clients, has carried out a variety of commissions for Harvey's Bristol Sherry, various churches and schools, and been a contributor to *Leisure Painter* since 1987. His work is represented in the collections of the Royal West of England Academy; Weston-super-Mare Museum, and various provincial and overseas art galleries and museums. He lives at Weston-super-Mare.

STOTT, Fred (b.1910)

Landscape painter in watercolour. Born at BERWICK-UPON-TWEED, Stott showed talent as an artist from his

Edwin Straker,
Untitled water study,
oil, 92 x 122cm.
Private collection.

schooldays. His first job, however, was working in his father's piano and music shop in the town, and apart from his service in the RAF, during the Second World War, he remained in the family business until his retirement aged fifty-five. With time on his hands, he then returned to his early love of painting, and without any professional tuition soon began to produce saleable work. Over the years since his retirement he has enjoyed a number of one-man exhibitions, notably at Berwick Art Gallery, and also participated in a number of group exhibitions. The main influence on his work, he confesses, is that of Frank Watson Wood, Senior (q.v.), both in style and choice of subject matter. Berwick Museum & Art Gallery has his *Bridge End in snow*, and *Marygate in snow*, both dated 1993. [See colour plate]

STRAKER, Edwin (b.1921)

Portrait, figure and landscape painter in oil and watercolour; commercial designer; art teacher. Born in London, Straker studied at the Camberwell School of Art under William Johnstone, Norman Dawson, Vivian Pitchforth and others before serving in the merchant navy during the Second World War. In 1945 he resumed his studies at the School, where his pre-war work as a student, and war-time work in drawing seamen, dock-workers, seas and foam patterns led Johnstone, as his principal, to offer him a post to teach drawing. He was also asked to teach basic design by A E Halliwell, undertaking private commissions to design posters and execute murals. He remained at the School for the next two years, leaving in 1947 when he was appointed lecturer in design at King's College (now Newcastle University). This was the first such position in any British university, and led to the first BA degrees in commercial art. Again retaining a private interest in

commercial design while teaching, he next progressed to an appointment in 1953 as head of the design school and helped to establish the Newcastle College of Art & Industrial Design. He also while serving in these capacities oversaw the establishment of a printing house design studio, spending a year as its full-time director before embracing an independent career in illustration, and print, exhibition, furniture and product design. Over the next twenty-five years he continued in this career, occasionally handling commissions for painting portraits and other subjects, but gradually abandoned his commercial work between the late 1970s and mid–1980s to concentrate entirely on painting. Although a precocious draughtsman whose talent as a boy of fifteen won him his studentship at Camberwell, and later a talented painter in oil and watercolour, Straker exhibited his work sparingly both during and after his periods of teaching; his later commercial work, and subsequent practice as a full-time professional painter. He was invited by Rowland Hilder to be guest exhibitor at the inaugural exhibition of the British Water Colour Society, and later showed his work at the Stone Gallery, NEWCASTLE; the Elizabeth Gallery, Southwell; the Mary Bucknall Gallery, Solihull, and at Browns Gallery, NEWCASTLE. His work, however, has remained in constant demand throughout these periods in his career, resulting in dozens of portraits and other commissions, and a considerable output of watercolour landscapes and seascapes with a particular emphasis on the movement and translucency of water. He has also handled a number of commissions for later reproduction as limited edition prints, notable among which was that in 1979 to paint *HMS Kelly*. This print was signed by all the surviving members of Lord Mountbatten's famous crew. His work is held by many corporate and private collections, including those of the

North East Press; Rolls-Royce; NEI; National Westminster Bank; Chatsworth House, and Blenheim Palace. He lives at Carlisle, Cumbria.

STRAKER, Henry ('Harry') (1860–1943)
Amateur landscape painter in oil and watercolour. He was born at Benwell Old House, NEWCASTLE, the son of wealthy parents, and subsequently followed the life of a gentleman, painting as a relaxation. In the early years of the century he maintained a studio in London, and exhibited his work at the Royal Academy on seven occasions. He also exhibited his work widely in the provinces while at London, but on returning to Tyneside in 1927, exhibited only at the Artists of the Northern Counties exhibitions at the Laing Art Gallery, NEWCASTLE. He died at RIDING MILL.

STROTHER-STEWART, Mrs Ida Lillie (née Taylor) (c.1890–after 1954)
Amateur portrait, figure and landscape painter in oil and watercolour; illustrator. She was born at NEWCASTLE, the daughter of a city businessman, and was a talented artist from her childhood. She first began to exhibit her work while still unmarried, showing a theme taken from Omar Khayyam, and a portrait, at the Artists of the Northern Counties exhibition at the Laing Art Gallery, NEWCASTLE, in 1908. She continued to exhibit at NEWCASTLE for many years following her marriage to local solicitor Robert Strother-Stewart, in 1913, also contributing one work to the Royal Institute of Painters in Water Colours, and two works to the Society of Women Artists, 1919–25. Among her exhibits at NEWCASTLE were portraits of her husband and herself, and several other members of her family, illustrations of American Indian activities, and various British, Continental, Middle Eastern and African landscapes and street scenes, painted while she was on holiday, or living with her husband abroad while he served in various judicial capacities. She was living at NEWCASTLE when her husband died in 1954. [See colour plate]

STUBBS, J Woodhouse (c.1860–c.1909)
Landscape, flower and still life painter in oil and watercolour; art teacher. Stubbs practised as an artist at NEWCASTLE and SUNDERLAND in the late 19th and early 20th centuries, and first exhibited his work when he sent his *Warkworth* to the Arts Association exhibition at the former, in 1882. In 1884, he again exhibited at NEWCASTLE, showing two flower studies at the city's Bewick Club, following which he appears to have exhibited little until moving to SUNDERLAND, from which in 1893 he sent his first work to the Royal Academy: *Pansies*. In the following year he took a teaching post at the Government School of Art in the town, and from there sent a second work to the Academy, and began exhibiting at the Royal Birmingham Society of Artists, Birmingham, and the Walker Art Gallery, Liverpool. He appears to have remained at the School until just before the turn of the century, when he returned to NEWCASTLE for a brief period, then moved to Norwich, Norfolk. He contin-

ued to exhibit his work at the Royal Academy, and in the provinces, while at Norwich, exhibiting for the last time in 1908. Sunderland Art Gallery has his watercolour, *Summer*, 1903.

SUMMERS, John (1896–1969)
Amateur landscape and marine painter in watercolour; etcher; illustrator. Summers was born on Wearside and after serving in the Royal Navy during the First World War worked for many years as a timekeeper in the borough engineer's department of the Council at SUNDERLAND. He was a keen spare-time painter and etcher throughout his life and first began exhibiting his work in the early 1920s, showing examples at the Artists of the Northern Counties exhibitions at the Laing Art Gallery, NEWCASTLE, and later at the Stanfield Art Society, SUNDERLAND. After the Second World War, during which he served in the Civil Defence at SUNDERLAND along with several other of the town's artists, he mainly exhibited with Sunderland Art Club. In his later life he became well known for his work in etching, and for his illustrations in newspapers and magazines. He was a friend of Sunderland Art School teacher Frank Wood (q.v.), and accompanied Wood on sketching holidays. Wood painted a portrait of Summers, which he exhibited at the Royal Society of Portrait Painters in 1937. Represented: Sunderland A G.

SUMMERS, Robert (c.1866-c.1930)
Amateur genre and landscape painter in oil and watercolour; copyist. Summers was born at DARLINGTON, and later followed the occupation of engine fitter in the town's locomotive works, painting in his spare time. His earliest known work is his *Death of Tyler* painted in watercolour, but he later began copying the work of John Martin (q.v.), in oil, and chose this medium when later painting his most celebrated picture: *The Doings of Drink*, or *The Publican versus The People*. This large work featured more than one hundred 'figures' whose lives in various ways had been affected by 'drink'. Inspired by its success he announced that he planned to paint two other large moral pictures, *Gambling*, and *Capital and Labour*, but it is not known whether these were ever completed. He died at DARLINGTON. Darlington Public Library has several of his watercolours, and the chromolithograph version of *The Doings of Drink* is in the collection of Beamish Museum, BEAMISH, near STANLEY. Although the latter work earned him the title of 'The Darlington Hogarth' he might more appropriately have been called 'The Darlington Cruikshank', since it has much in common with this artist's *The Worship of Bacchus*, painted in 1860–62, and demonstrating the evils of drink even more colourfully and variously.

SURTEES, John (1819–1915)
Landscape, portrait and figure painter in oil and watercolour. Born at EBCHESTER, Surtees' earliest ambition in art was to become an engraver. A career in engineering was offered to him, however, and accepting it he moved to NEWCASTLE, where he was apprenticed to R Stephenson & Co. On settling in the town he enrolled in the evening classes of the

John Surtees, *The Maid of the Mountains*, watercolour, 92 x 24cm (oval). Private collection.

Northumberland Institution for the Promotion of the Fine Arts. His work for Stephenson's involved him in superintending the making of a set of locomotives for the USA. He was rewarded on their arrival by a gift of two sovereigns, and with these bought his first box of colours, later taking them on a holiday to the Lake District along a route planned for himself and three artist companions, by Thomas Miles Richardson, Junior (q.v.). At the age of twenty-six he decided to become a full-time professional artist, and left Stephenson's to set up a studio at NEWCASTLE. In the following year (1846), he showed his first work in London; *A coastal scene with figures*, at the British Institution. By 1849, and now having moved to the capital, he had also exhibited at the Royal Academy, and the Suffolk Street Gallery. Over the next forty years Surtees exhibited regularly at the Royal Academy, and occasionally sent work to the British Institution; the Suffolk Street Gallery, and to the exhibitions of the Arts Association, NEWCASTLE, and the city's Bewick Club. He returned to NEWCASTLE in the early 1850s and appears to have spent most of his time subsequently working here, at CULLERCOATS, or in London, making extensive painting tours in between. He became particularly fond in his later life of Welsh scenery, painting it so successfully that two examples were purchased by David Roberts, the Royal Academician, at a Royal Academy preview. He died at Ashover, Derbyshire. His wife, ELIZABETH SURTEES (née ROYAL), was also a talented artist, and exhibited her work. Represented: Laing A G, Newcastle; Shipley A G, Gateshead; South Shields Museum & A G; Sunderland A G, and various provincial art galleries.

SWAINSTON, Laura G (b.1861)

Genre, portrait and landscape painter in oil; etcher. She was born at SUNDERLAND, the daughter of shipowner George Swainston, and appears to have become a largely self-taught artist before practising in the town. She first began to exhibit her work publicly when she sent four oils, *The Divining Peel*; *Judith*; *The Touch of Infinite Calm*, and *In the Cloisters*, to the Bewick Club, NEWCASTLE, in 1886. In the following year she exhibited her first work in London, at the Grosvenor Gallery, and in 1890 sent the first of three works to the Royal Academy: *A toiler of the fields*. She continued to exhibit at the Royal Academy until 1894, also in this period sending three works to the Royal Scottish Academy. Nothing is known of her subsequent career.

SWIFT, John Warkup (or Worcup) (1815–1869)

Marine and landscape painter in oil; scenic painter. Swift was born at Hull, Yorkshire, and after some years at sea took up painting scenery for an amateur dramatic society. He later settled at NEWCASTLE, where he practised as an artist until his death, achieving considerable local popularity. Six years before his death, the *Daily Chronicle*, NEWCASTLE, said: 'There are few more meritorious artists in the North of England than Mr J W Swift, and few studies betray evidence of more interest than his ... Mr. Swift is pre-eminently a self taught painter. Brought up at Hull amid ships and sailors, the bias of his mind soon manifested itself, his experience as a sailor became of immense advantage to him in after life, for if his marine pieces are examined they will be found to be not only admirable in the artistic sense, but to possess the additional merit of being technically correct ...'. Swift appears to have exhibited his work only at NEWCASTLE, where among his few known exhibits is an oil, *Crossing the Bar*, which he showed at the 'Exhibition of Paintings and other Works of Art', at the Town Hall, in 1866. His work has, however, been included in several exhibitions since his death, both at Hull, and NEWCASTLE. Some of his work was reproduced by means of chromolithography. Among his chief works are *The Channel Fleet running into Sunderland*, and *Shields Harbour*. He died at NEWCASTLE. Represented: Darlington A G; Ferens A G, Hull; Laing A G, Newcastle; Shipley A G, Gateshead.

SWINBURNE, Edward (1765–1847)

Amateur landscape painter in watercolour; etcher. He was born at CAPHEATON, near CAMBO, the younger brother of Sir John Swinburne, Bart., and uncle of Algernon Swinburne, the poet. He was a keen amateur painter from his youth, and travelled extensively throughout his life, sketching, making watercolour drawings, and visiting art collections. Two of his important visits abroad to paint were to Italy in 1792–3, and 1797, on the second of these painting with the artist William Artaud (1763–1823), who later described him as 'a most able designer of landscape'. In the early years of the 19th century he formed close friendships with Thomas Miles Richardson, Senior (q.v.), and other leading artists then practising at

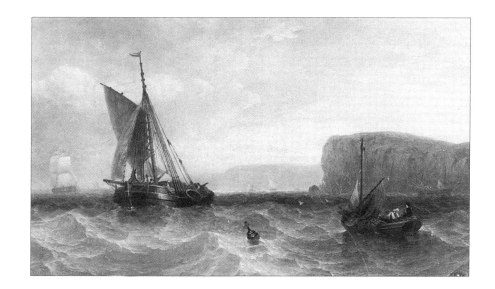

John Warkup Swift,
Off Flamborough,
oil, 21.5 x 38cm.
Borough of Darlington
Art Collection.

Edward Swinburne,
Shag Rock, Torbay,
watercolour 26.5 x 38.5cm.
Victoria and Albert Museum.

NEWCASTLE, and in 1822 became a founder-member of the town's Northumberland Institution for the Promotion of the Fine Arts. He did not, it seems, show work at its first exhibition in that year, but in the following year sent his *View of La Cervara, in the Apennines*. He subsequently exhibited at the Institution on several occasions, mainly showing Continental views, and remained its president until it was succeeded by the Northern Academy. He later served as president of the Northern Society of Painters in Water Colours (1831), and vice president of the Newcastle Institution (1832). At the first exhibition of the Northern Academy in 1828, he showed two Continental views, and in the following year his *Majuri, from a Cavern in Salerno* (a subject turned by Thomas Miles Richardson, Senior (q.v.), and Henry Perlee Parker (q.v.), into a giant diorama, also shown

at the Academy). After showing his *View of La Cervara*, at the Northern Society of Painters in Water Colours, in 1831, however, he appears to have lost interest in exhibiting, and though still an active water-colourist became increasingly absorbed in etching. Several of his works in this medium were used in Surtees' *History of Durham*, and Hodgson's *History of Northumberland*. He spent his later years mainly in London, dying there in 1847. Swinburne is believed to have studied under Turner, and was the leading amateur of the region of his period. His work has in recent years been included in several important exhibitions, including 'A Noble Art, Amateur Artists and Drawing Masters c.1600–1800', British Museum, 2000, for which his *Tasso's House, Sorrento*, 1797, was used for the catalogue cover illustration. His uncle, HENRY SWINBURNE (1743–1803), and his

Julia Swinburne,
Figures by a country house,
watercolour, 18 x 25cm.
Anderson & Garland.

niece Julia Swinburne (q.v.), were also talented amateurs, the former illustrating his book on Sicily; the latter producing many highly competent watercolours. Represented: British Museum; Victoria and Albert Museum; Laing A G, Newcastle.

SWINBURNE, Julia (1795–1893)
Amateur landscape and architectural painter in watercolour. She was the daughter of Sir John Edward Swinburne of CAPHEATON, near CAMBO (1762–1860), and niece of Edward Swinburne (q.v.), the leading amateur artist in Northumbria of his period. Like her uncle she is believed to have been a pupil of Turner, and developed considerable skill as a watercolourist. Represented: Laing A G, Newcastle.

SWINBURNE-CARR, Hugh (1895-c.1965)
Amateur landscape and historical painter in oil and watercolour; scenic painter; wood-carver. He was born at CHOPPINGTON, near MORPETH, and worked as a theatre scenic artist and managed cinemas, illustrating books and producing wood-carvings for churches in his spare time. Following his retirement as manager of the Playhouse Cinema, MORPETH, he moved to a caravan at CAUSEY PARK north of the town. Here he busied himself writing short stories and other works, until his death some time after 1963.

SWINDEN, Ralph Leslie (1888–1967)
Mural, portrait and decorative painter in oil; art teacher. Swinden was born at Meriden, Connecticut, USA, the son of a Sheffield cut glass manufacturer, and trained as a silver modeller and specialised in sculpture while attending Sheffield College of Art. He won a royal exhibition scholarship to the Royal College of Art and also studied at the Slade School of Fine Art, before teaching at Torquay School of Art and Portsmouth College of Art. In 1928 he moved to DARLINGTON, where he served as principal art master at the town's School of Art for a quarter of a century. During this period he taught many young Northumbrian artists either at college day or evening classes, including among the latter Thomas McGuinness (q.v.). He also painted several panels for Darlington Children's Library; the organ screen for the town's St Luke's Church, and several portraits, and exhibited his work at the Royal Academy; the Victoria and Albert Museum, and extensively in the provinces. He was for some time chairman of Teesside Art Association. His wife SYBIL DE BERNIERE SWINDEN was a gifted amateur watercolourist and art teacher. The work of both husband and wife is represented in the collection of Darlington Art Gallery.

SWINNEY, Denis Percy (1913–2002)
Amateur landscape painter in oil and watercolour. Born at MORPETH Swinney studied engineering at King's College (now Newcastle University) before joining the family engineering business at his birthplace. A keen painter in watercolour from his schooldays he first began to take the medium seriously as an officer in the 50th Division Engineers during the Second World War. While a prisoner of war in Germany he became one of a small group of artistically gifted officers who formed an art club with their own studio, his work later featuring along with theirs in a privately published book on the club, *Art in the bag*. On his demobilisation he rejoined the family firm at MORPETH and began to exhibit his work widely at the Coquet Galley, ROTHBURY; the Central Library, NEWCASTLE; the Artists of the Northern Counties exhibitions at the Laing Art Gallery, NEWCASTLE; the West End Art Group, NEWCASTLE, and the Morpeth Art Group, of which latter he was for some time chairman. He also enjoyed a number of one-man exhibitions of his work, notably at the Moot Hall, HEXHAM. Much of his work featured the coastline, hills, churches and castles of Northumberland, but he was also an avid

holiday painter mainly of South of France scenery. His family firm taught Charles Edward Sansbury (q.v.) to weld and Swinney acted as adviser to the sculptor on various projects involving metalwork. Represented: World War II Experience Centre, Leeds.

SYKES, Charles ('Rilette') ARBS (1875–1950)

Sculptor; figure, landscape and interior painter in oil and watercolour; commercial designer. He was born near REDCAR, the son of amateur marine painter Samuel Sykes (q.v.), but moved as an infant to NEWCASTLE with his family. While attending the city's Rutherford College he won a scholarship to the Royal College of Art, where he is said to have taken the opportunity to study every branch of the arts and crafts. On leaving the College he began his career in London by painting a triptych for the church of the Cistercian Abbey of which Lord Montagu of Beaulieu was the lay abbot. Lord Montagu was a pioneer of the motoring world, and as publisher of *The Car* commissioned Sykes to produce a succession of colour covers for the periodical at Christmastime. By then his interests as an artist had turned to sculpture, and following the showing of his bronze statuette *A Bacchante*, at the Royal Academy in 1908, he was in 1911 commissioned to design the famous Rolls-Royce mascot now known as the *Spirit of Ecstasy*. He continued to exhibit his sculptures at the Royal Academy until 1924, then in 1926 began to design a succession of gold and silver cups for Royal Ascot, and a miscellany of imperial sceptres, crosiers, fountains, trophies, medals, and memorial portraits for various royal, ecclesiastical and commercial clients. During the First World War, and having been pronounced unfit for active service, Sykes became famous as the artist of the De Reszke cigarette advertisements, using the pseudonym 'Rilette'. Under the same name he also did fashion drawings for the *Sunday Despatch; Woman* magazine, and posters for the London North Eastern Railway, and a wide range of other commercial clients. During his period as a commercial artist he continued to sculpt and paint, and showed his work at a wide range of exhibitions, including those of the Royal Society of British Sculptors (of which he was an associate); the Society of Graphic Artists, and the Royal Institute of Painters in Water Colours. At the outbreak of the Second World War he left London and finished his days in the country, devoting his time to painting oils and watercolours of figures, interiors and landscapes. He died at Drayton, Berkshire. A memorial exhibition was held at the Fine Art Society, London, in 1951, following his death, a second memorial exhibition following in 1963 at the home of his sculptor daughter JOSEPHINE SYKES (1908–1993), and later at Palace House, Beaulieu. Sykes' work as a watercolourist has attracted increasing interest over recent years, (an example entitled *Arrival at the Opera*, dated 1909, sold for £18,700 at auction in the 1990s) but it is still his *Spirit of Ecstasy* creation for which he is best known. It is today the most famous car mascot in the world, and still remains in use on the vehicle for which it was created. Represented: Victoria and Albert Museum.

Charles Sykes, *The Spirit of Ecstasy* (replica of original sculpture), bronze, 58.5cm high. Anderson & Garland.

SYKES, Charles Xavier (fl. late 19th cent).

Amateur landscape painter in watercolour. Sykes practised as a journalist at NEWCASTLE in the late 19th century and was a keen amateur painter of local scenery. He occasionally exhibited his work at the Bewick Club, NEWCASTLE, one of his exhibits at its 1892 exhibition attracting a newspaper comment that 'Charles X. Sykes exhibits an attractive picture of one of the most charming spots in all Yorkshire – Richmond Castle. It is well drawn, brilliant in colouring, and its effect is extremely pleasing.'

SYKES, Samuel (1850–1920)

Amateur marine and landscape painter in oil. Sykes was born at Middleham, North Yorkshire, where he was later apprenticed as a house painter. After finishing his apprenticeship he moved to live near REDCAR, where his son Charles Sykes (q.v.) was born. In the late 1870s or early 1880s, he moved to NEWCASTLE, where he set up in business as a house painter, and later began to exhibit his marine paintings at the Bewick Club, and subsequently the Artists of the Northern Counties exhibitions at the city's Laing Art Gallery. The Shipley Art Gallery has his *The Tyne with High Level Bridge*, painted in the year of his death at NEWCASTLE.

T

TABNER, Leonard ('Len') (b.1946)
Landscape painter in oil and watercolour; draughtsman; printmaker. Tabner was born at SOUTH BANK, near MIDDLESBROUGH, where his father was a worker on the river. On leaving school he did a foundation course at Middlesbrough School of Art, then in 1965 transferred to the Bath Academy of Art, Corsham, where he met his future wife, the sculptor Helen de Paravicini. Following this he did a postgraduate course at Reading University under Claude Rogers and Terry Frost. In 1970 he settled in a cottage at BOULBY, Teesside, the highest cliff in England, where he bought 250 acres of land and coastline to preserve it for posterity. Here he began to paint what has remained his main choice of subject matter ever since: wild atmospheric effects over land and sea. This has involved him in work on North Sea oil platforms and on trips with the Royal Navy to the Falklands, South Georgia and the South Atlantic. Agnew's, London, have held several exhibitions of his work, among which a major retrospective including many works from the latter trip, for which a book *A Voyage to the South* was produced. This exhibition was also held at the Laing Art Gallery, NEWCASTLE, in 1992–3, and similarly at Brian Sinfield's Compton Cassey Galleries, Gloucestershire, in 1995. Represented: Laing A G, Newcastle; Middlesbrough A G. [See colour plate]

TALBOT, Neil (b.1943)
Sculptor; art teacher. He was born at DURHAM and studied art at Newcastle University. After a period as visiting artist at the School of Art, Institute of Chicago, USA, in the early 1980s he went on to become resident artist at the British School at Rome, in 1986. He then went on to teach at the TCU University, Texas, USA, before taking up a position as head of sculpture at Northumbria University, NEWCASTLE. On leaving the University in 1993 he became a full-time professional sculptor. Talbot has regularly exhibited his work throughout his career as teacher, and later professional sculptor, and received a number of important public commissions in Northumbria. His group exhibitions since 1980 have included the West Hubbard Gallery, Chicago, USA; the Newcastle Group, Laing Art Gallery, NEWCASTLE, and Dovecote Arts Centre, STOCKTON-ON-TEES, 1987; Newcastle Group, Richard Demarco Gallery, Edinburgh, 1989; Centrum Beeldende Kunst, Groningen, Holland, 1988, and the Newcastle Group's 'Northern Lights' exhibition, at the DLI Museum & Art Gallery, DURHAM, and tour, 1990. His one-man exhibitions have included the Serpentine Gallery, 1980; Wolfsen College, Oxford, 1987; University of Texas, 1989 (as visiting artist); the Lest Gallery, Lest, Aberdeenshire, 2000, and the Queen's Hall, HEXHAM, 2001. Public commissions for which he has been responsible are his *Victorian Baker's Shop*, GATESHEAD, of 1986, and the *Keelrow*, NEWCASTLE, 1996. The first of these two was one of the earliest works in Gateshead's public art scheme. Other exam-

ples are at NEWCASTLE and HARTLEPOOL. His awards include a major prize in the Tyne Tees Northern Open in 1985, and his work is represented in the collections of Northern Arts and Eastern Arts Associations, as well as various public and private collections in the USA, Switzerland and the Virgin Islands. He lives and works at RIDING MILL.

TANKERVILLE, 7th Earl, George Montagu (1852–1949)
Miniature painter. He was a talented painter of portrait miniatures who contributed four works to the Royal Academy in 1900, while living at the family home of Chillingham Castle, CHILLINGHAM, at the end of the 19th century. These included a portrait of the COUNTESS OF TANKERVILLE, who was also a talented artist and sent two of her works for exhibition at the Society of Women Artists' exhibition, in 1896.

TATE, Christopher (1812–1841)
Sculptor. Tate was born at NEWCASTLE, and served an apprenticeship under Richard George Davies (q.v.), before becoming assistant to sculptor David Dunbar, Senior (q.v.), who was then working in the town. After a few years in Dunbar's studio he branched out on his

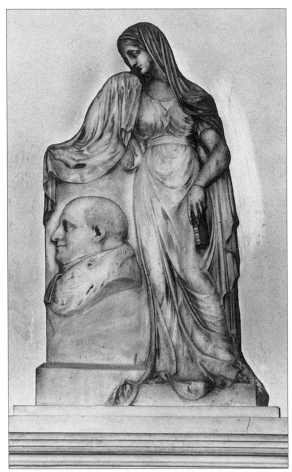

Christopher Tate, *Monument to Rev Robert Wasney, St Thomas's Church, Newcastle*, marble.

own account, first turning to bust portraits, and exhibiting two of these at the Newcastle upon Tyne Institution for the General Promotion of the Fine Arts, in 1833. He continued to exhibit at NEWCASTLE throughout his short career, mainly showing busts, but in 1836 exhibited his *Judgement of Paris*, and in 1838, his *Musidora*. He executed a number of monuments for local churches, one of the most impressive of these being one to the Rev Robert Wasney (d.1836), for the chancel of St Thomas's Church, Haymarket, NEWCASTLE. He was also responsible for carving the Royal Coat of Arms for the pediment of the Theatre Royal. NEWCASTLE, designed by Benjamin Green (q.v.). He exhibited this work at the Newcastle Society of Artists exhibition in the town in 1836, together with several other pieces for the theatre, and one of his best known works, *Blind Willie*. Consumption eventually forced Tate to seek a warmer climate, and he went to Malta. Soon realising that his health was not improving there, however, he sailed home, and died shortly after his ship reached London. Just prior to his death he was working on a statue of the Duke of Northumberland, to be erected in front of the Master Mariners' Asylum at TYNEMOUTH, but this work had to be completed by his former master, Davies. Of his portrait busts, the *Gentleman's Magazine*, in its obituary of him wrote: 'for execution, precision and arrangement' they could 'scarcely be surpassed': and of his *Judgement of Paris*, and *Musidora*: 'they would have done credit to

an artist of greater experience'. Tate is popularly credited with having exhibited at the Royal Academy between 1828 and 1833, although he would only have been sixteen when his first exhibit was shown.

TATE, Dingwall Burn (d.1936)
Landscape and portrait painter in oil and watercolour. This artist practised at SUNDERLAND for many years in the late 19th and early 20th centuries, mainly painting local scenes. He was also a photographer and is believed to have based many of his compositions on his photographs. On a visit to London he is said to have waved his walking stick to hail a taxi, and was struck by a passing bus. He returned home and died shortly afterwards. Tate exhibited his work principally at the Bewick Club, NEWCASTLE. Sunderland Art Gallery has a substantial collection of his work, including his best known oil, *Dicky Chiltern's House*.

TAYLERSON, John Edward (b.1854)
Sculptor; designer of medals. Taylerson was born at NORTON, and studied at Faversham, Kensington, and Westminster Schools of Art, before setting up as a sculptor in London. He later took a position as teacher of modelling and woodcarving at Battersea Polytechnic and became a regular exhibitor at the Royal Academy, showing some thirty-seven works between 1884 and 1926. His first exhibit was *Achilles defying Agamemnon*; his later exhibits included other

Neil Talbot,
Victorian Baker's Shop,
Gateshead, 1986,
fired ceramic tiles,
3.6m x 4.6m wide.
Gateshead Metropolitan
Borough Council.

classical subjects, portraits, and designs for medals. He also exhibited his work at Liverpool on a number of occasions. He died in London.

TAYLOR, Ida Lillie – see STROTHER-STEWART, Mrs Ida Lillie

TAYLOR, John (1840–1891)
Amateur painter, draughtsman and wood engraver. He was born at DUNSTON, near GATESHEAD, and worked as a railway clerk, and later as a brewery traveller, dabbling in songwriting, painting and engraving in his spare time. Several of his songs were published in *Allan's Tyneside Songs*, together with his wood engravings. These included *Blind Willy*; *Billy Purvis*, and *Geordy Black*. He also wrote songs for Chater's and Ward's Almanacs. He is believed to have attended classes at the Government School of Design, at NEWCASTLE, under William Bell Scott (q.v.), and to have had some talent as a painter. He died at DUNSTON. He was the younger brother of Thomas Taylor (q.v.).

TAYLOR, John (1875–1940)
Landscape, figure, portrait and religious painter in oil and watercolour; illustrator. He was born at DUNSTON, near GATESHEAD, the son of blacksmith Thomas Taylor

John Taylor, *Billy Purvis as a Clown*, wood engraving, 17 x 11cm, from *Allan's Tyneside Songs*.

336

(q.v.), and worked at Dunston Engine Works from his teens until its closure in the late 1920s, painting in his spare time. He was, however, determined to improve his skills as an artist from his earliest working years, and enrolled as a pupil at Gateshead School of Art under William Fitzjames White (q.v.), later going on to receive tuition at the life classes of the Newcastle Sketching Club and joining the city's Bewick Club. He made the acquaintance of several well-known local artists who gave him encouragement, and began exhibiting at the Bewick Club in 1896, showing *A Little Alien*, painted at its life classes. In 1899 he began contributing cartoons to the *Newcastle Weekly Chronicle*, and the *Northern Group*, then the *Judy*, London, and about this time painted a large lunette entitled *Christ Blessing the Little Children* for the New Lecture Hall, DUNSTON (now demolished). In 1910 he commenced exhibiting at the Artists of the Northern Counties exhibitions at the Laing Art Gallery, NEWCASTLE, showing oils and watercolours of a wide range of subjects until 1926, when the bankruptcy of the Dunston Engine Works precipitated the family's move to London. Here Taylor took up a position as secretary to Wheeler Dryden, half-brother of Charlie Chaplin, whom he had tutored in elocution when Wheeler's music-hall singer father Leo Dryden had lodged at DUNSTON in the early 1900s. Wheeler had by now also joined the film industry, like his half-brother, and was making films at Elstree Studios. Both during and after his employment as a secretary Taylor continued to paint actively, and also produced illustrations for books, Christmas cards and postcards. This led to a position as an artist in a commercial studio, until in 1938 he decided to move with his family to Luton, Bedfordshire, where he died two years later. Taylor's best known work is his Laing Art Gallery watercolour exhibit of 1926, picturing Grey Street, and the Theatre Royal, NEWCASTLE. The painting was long owned by the Theatre, and used as its programme cover illustration over a number of years.

TAYLOR, Robert (b.1836)
Marine painter in oil. Taylor was born at ALNMOUTH and followed the occupation of fisherman for most of his life, turning his hand to ship portraiture in his spare time. Most of his subjects were the sailing ships which used the port of ALNMOUTH, or that of nearby AMBLE, but he also painted other ships of the day, including the clipper ship *Thermopylae*, built at Hood's Yard, Aberdeen in 1868. From around 1890 until his death after 1920, Taylor appears to have turned increasingly to painting to supplement his livelihood as a fisherman. He is not known to have exhibited anywhere else than at the Hindmarsh Hall, ALNMOUTH, a one-time granary at the port. His painting of the *Ariel*, winner of the Ocean Race, 1893, was sold at Bonhams in 1986, and several examples of his work have since been sold at Anderson & Garland, the auctioneers, NEWCASTLE. An account of Taylor's life and work may be found in the *Northumbrian*, August/September, 1999, by Marshall Hall. [See colour plate]

John Scott,
The Snow-rigged Brig
'Welcome', off Tynemouth,
oil, 52 x 75cm.
Anderson & Garland.

Robert Taylor,
The Thermopylae, c.1905,
oil, 51 x 66cm.
Private collection.

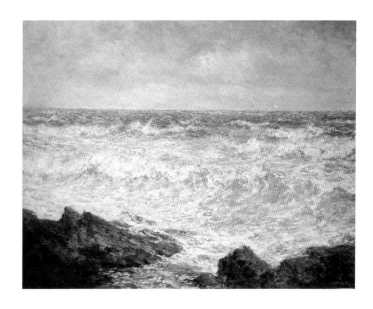

John Falconar Slater,
A Northerly at Whitley Bay,
76 x 107cm.
Private collection.

William Bell Scott, *The Nineteenth Century: Iron and Coal*, 1861 [detail]. Oil, 188 x 188cm. National Trust, Wallington Hall.

George Shield,
Rough-legged Buzzard,
illustration from
Ornithologia Britannica, c.1841.

John George Sowerby,
Forbidden Fruit,
illustration from
Afternoon Tea, 1880.

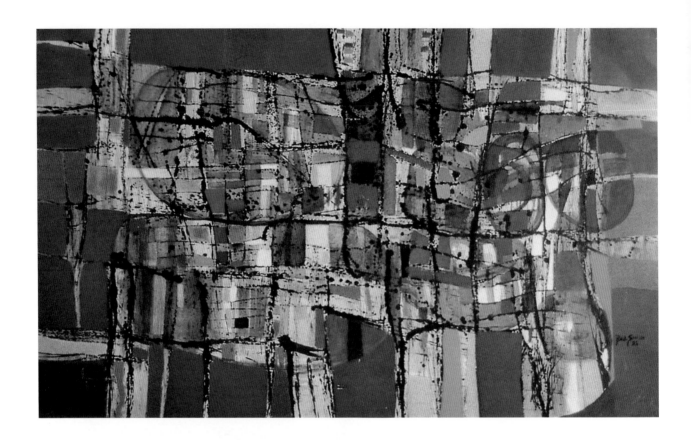

William Smith,
Olaf Tanger's Flowers, 1975,
oil, 120 x 195cm.
Private collection.

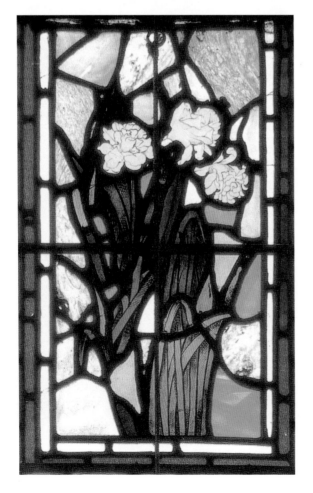

Thomas Ralph Spence,
Stained Glass Window, Jesmond Tower,
Newcastle

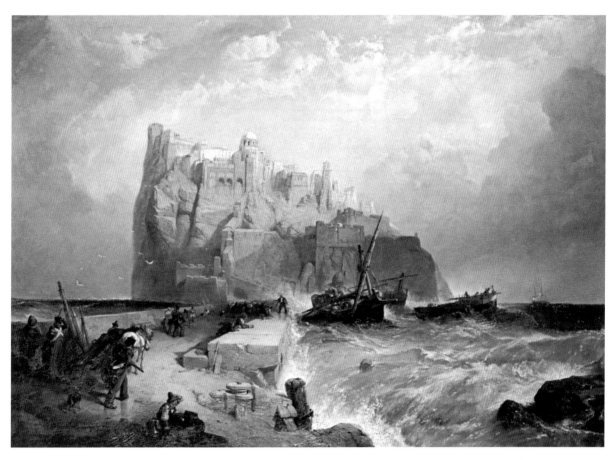

Clarkson Stanfield, *The Castle of Ischia*, 1841, oil, 143 x 231cm. Tyne & Wear Museums, Sunderland Art Gallery & Museum.

John Storey, *Tynemouth Priory*, watercolour, 68.5 x 48.5cm. Private collection.

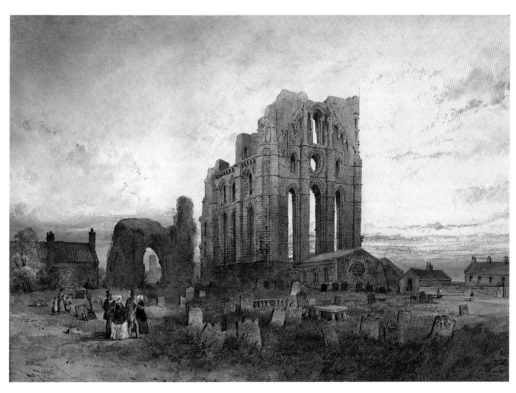

Terence Lionel Storey,
The Silver Jubilee River Festival, 1953,
oil, 76 x 122cm.
Private collection.

Fred Stott,
Bridge End, Berwick upon Tweed, 1960,
watercolour, 51 x 36cm.
Private collection.

Leonard Tabner, *Lindisfarne Castle from the Links Ridge*, 1989, watercolour, 67.5 x 102cm. Private collection.

Henry Thubron, *Beach X*, 1987, collage, 54.7 x 92.3cm. Hartlepool Arts & Museum Service.

Ida Taylor, *Isabella and Lorenzo*, oil, 46 x 51cm. Anderson & Garland.

Louisa Anne, Marchioness of Waterford, *Joseph sent to his Brethen*, watercolour, 2m x 2.2m. Trustees of Lady Waterford Hall.

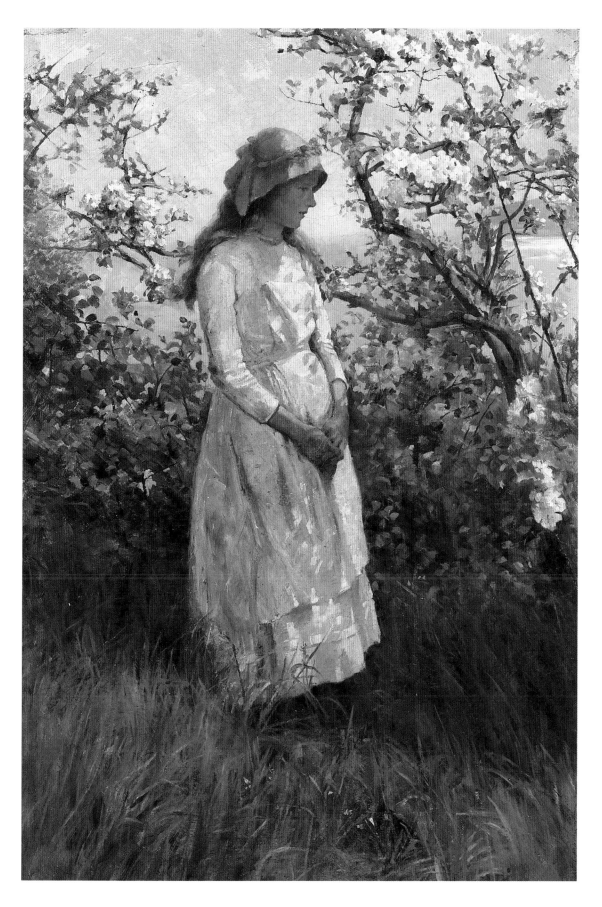

Isabella Thompson, *Blossom*, 1892, oil, 66 x 51cm. Private collection.

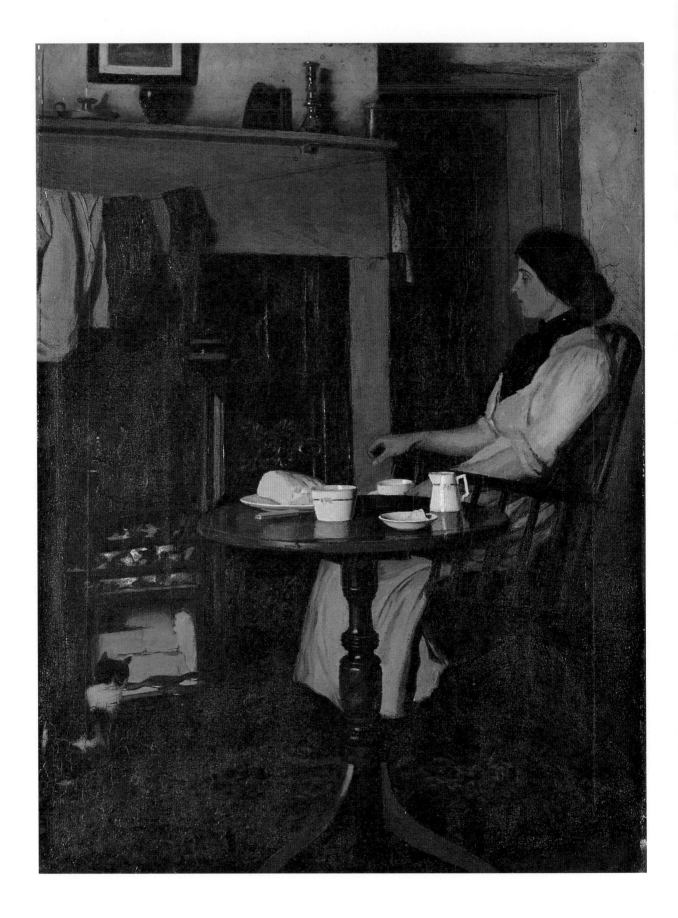

Stanley Thompson, *My Aine Fireside*, 1911, 60 x 44cm. Private collection.

William Tillyer, *Two Standing Forms on a Red Ground*, 1990, acrylic, 152.4 x 122cm. Bernard Jacobson Gallery.

Edward Train,
A Highland Morning,
oil, 24 x 21cm.
Anderson & Garland.

David Welsh,
Pres de Valensole, Provence,
watercolour, 55 x 75cm.
Private collection.

James Wallace, Jun., *Woman and Child on Old Berwick Bridge*, oil, 76 x 46cm. Berwick Borough Museum Collection.

Sylvia Ismay Venus,
jacket illustration for *More About
Amelia Jane!*, by Enid Blyton, 1954.

Richard Ward,
The History of Gateshead,
Queen Elizabeth Hospital, Gateshead
(detail of mural), 30m long.
Gateshead Metropolitan Council.
Photo: Mike Golding.

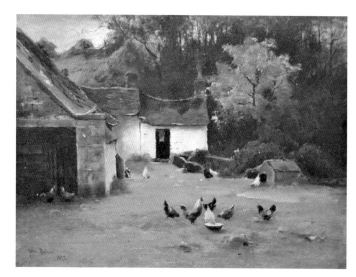

John Wallace,
Whittle Mill,
Northumberland, 1895,
oil, 45 x 59.5cm.
Anderson & Garland.

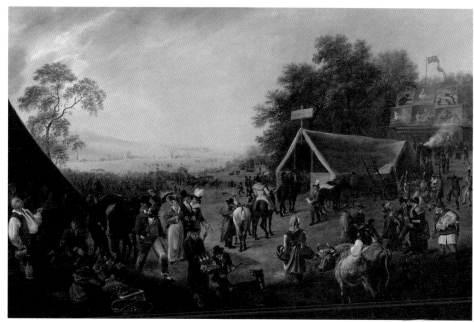

Thomas Fairbairn Wilson,
A Country Fair,
oil, 76 x 118cm.
Sothebys.

Kenneth Watts,
Home Bakery, Jarrow,
1996, oil, 63.5 x 76cm.
Private collection.

Adam Stanley Wood,
Boys with Football,
watercolour, 44.5 x 34.5cm.
Private collection.

Abraham Bruiningh van Worrell,
Fishermen and Women of Cullercoats,
Northumberland, 1846,
oil, 46 x 53.5cm.
Private collection.

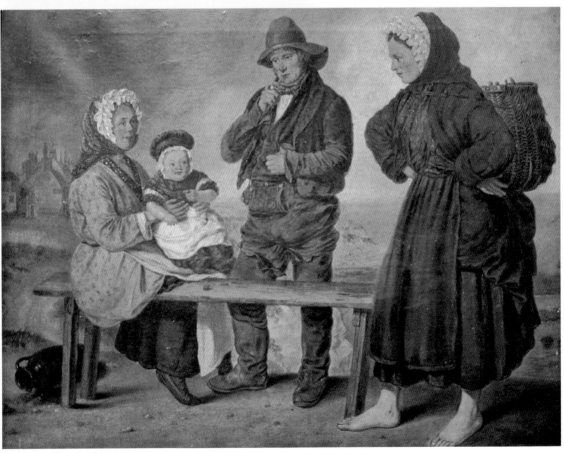

TAYLOR, Thomas (1830–1913)
Amateur natural history draughtsman. Taylor was born at DUNSTON, near GATESHEAD, and worked in the village as a blacksmith, writing for the *Newcastle Weekly Chronicle* in his spare time. He contributed to the publication under the nom de plume 'Village Blacksmith' for some forty years mainly writing on natural and local history subjects. His obituary in the *Weekly Chronicle* claimed that 'Mr Taylor's talents were versatile. Like his brother the late John Taylor, the well-known songwriter, he could turn his pencil to the production of beautiful drawings, mostly of birds, that won the admiration of William Bell Scott when he was in charge of the Newcastle School of Art over 60 years ago.' He died at DUNSTON. He was the father of John Taylor (q.v.).

TAYLOR, Wilfred (b.1915)
Landscape and still life painter in oil and watercolour; art teacher. Taylor was born at GATESHEAD and studied art at Armstrong College (later King's College; now Newcastle University). He later taught art at the Gateshead Education Committee evening classes held at the Shipley Art Gallery, GATESHEAD, and exhibited his work at Gateshead Art Society, and the Federation of Northern Art Societies' exhibitions on Tyneside. He was for some years assistant curator at the Shipley Art Gallery, and showed two oils at its 'Contemporary Artists of Durham County' exhibition, staged there in 1951, in connection with the Festival of Britain. His contributions were entitled *Herring*, and *Study of Flowers*, both painted in oil.

TEASDALE, John (1848–1926)
Architectural and landscape painter in oil and watercolour; art teacher. Born at NEWCASTLE, the son of a shoemaker, Teasdale studied at the town's Government School of Design under William Bell Scott (q.v.), from an early age. He later won a scholarship to the South Kensington School of Art, following which he held teaching positions at Belfast, Sherborne and Doncaster. On leaving the teaching profession he returned to NEWCASTLE, where for a period of some twenty-three years he maintained the art collection of local solicitor J A D. Shipley, at Saltwell Park House, GATESHEAD. He also wrote for the *Newcastle Weekly Chronicle*, under the pen name 'Briton', and occasionally exhibited his work, notably at the Bewick Club, NEWCASTLE. Much of his work was painted on a small scale, using body colour, and portrayed such city subjects as Plummer Tower: the Old Mill, Jesmond, and St. John's Church. Some of his line work was reproduced in local publications. Represented: Laing A G, Newcastle; Shipley A G, Gateshead: Sunderland A G.

TEMPERLEY, J A ('Doug') (b.1924)
Abstract painter in oil, enamels and other media. He was born on Tyneside, and studied at Sunderland College of Art, where he obtained a diploma in design in 1956. He later went on to become well known locally for his abstract paintings in a variety of media, and exhibited his work at a number of galleries

John Teasdale, *St Nicholas Cathedral, Newcastle*, oil, 38 x 28cm. Private collection.

in Northumbria, including the Artists of the Northern Counties exhibitions at the Laing Art Gallery, NEWCASTLE; the city's Westgate and Univision galleries; the Marsh Diapalo's Restaurant at DARLINGTON, and the Gray Art Gallery, HARTLEPOOL. One-man exhibitions were held at the People's Theatre, Green Room, NEWCASTLE, and the Marsh Diapalo's Restaurant, in 1962. In 1963 he and Thomas W Bartlett (q.v.), shared an exhibition at the Shipley Art Gallery, GATESHEAD. A large selection of his work was shown at the Gulbenkian Gallery, People's Theatre, NEWCASTLE, in 1966.

TEMPLE, William (c.1798–after 1844)
Wood engraver. Temple served an apprenticeship with Thomas Bewick (q.v.), at NEWCASTLE, 1812–1819, and in this period worked with fellow apprentices Robert Elliot Bewick (q.v.), and William Harvey (q.v.), engraving designs drawn on the wood by Bewick for his *Fables of Aesop*, 1818. He later gave up wood engraving and was for many years a linen draper at NEWCASTLE.

THOMAS – *see* **BARTLETT, Thomas W**

THOMPSON, Frank (c.1852–1926)
Landscape and genre painter in watercolour; art teacher. Thompson began his career as a professional artist in London, where in 1875/6 he showed his

Old Mill near Darlington, at the Suffolk Street Gallery. About two years later he moved to DURHAM to take up a teaching appointment at the School of Art there, and for the next ten years exhibited only in Northumbria, showing as his first exhibits *Barnard Castle on the Tees*; *A Westmorland Cottage*, and *Nothing Like Leather*, at the Arts Association. NEWCASTLE. In 1890 he began to exhibit his work more widely, showing examples at the Royal Academy; the Royal Society of British Artists; the Glasgow Institute of Fine Arts, and at various provincial exhibitions, including those of the Bewick Club, NEWCASTLE. From 1905 until his death, however, he exhibited almost exclusively at the Artists of the Northern Counties exhibitions at the Laing Art Gallery, NEWCASTLE, showing as his last works in 1925, *Camber Castle*; *Rye*, and *Piercebridge*. He died at DURHAM. Thompson taught many young artists his skills while teaching art at DURHAM, one of his pupils being Cecil Ross Wheatley (q.v.). Represented: Darlington A G; Bowes Museum, Barnard Castle; Sunderland A G; Pen & Palette Club, Newcastle.

THOMPSON, 'Isa' – *see* JOBLING, Mrs Isabella

THOMPSON, Mark (1812–1875)
Landscape, genre and coastal painter in oil. Born on Wearside, Thompson worked as a general agent before becoming a professional artist in his late forties. While working in the former capacity at SUNDERLAND, however, he was a keen amateur painter and is believed to have taken instruction from several artists then practising in the town. After becoming a professional artist he continued to live at SUNDERLAND for some years, and in 1865 and 1866, sent work for exhibition at the British Institution, in the first year showing his *The Tees, above Middleton*, and in the second, his *Sheep Walk, Cronkley Craggs, Teesdale*. In his later years he practised at BISHOPWEARMOUTH, near SUNDERLAND, dying there in 1875. Although best known as an accomplished painter of landscapes, frequently featuring country houses, Thompson first made his name as a painter of local harbour and dock scenes, outstanding amongst which is his *The Opening of Sunderland South Docks, 1850*. Represented: South Shields Museum & A G; Sunderland A G.

THOMPSON, Richard ('Rich') (1931–1999)
Cartoonist; illustrator. Thompson was born at NEWCASTLE and trained as a commercial artist before turning his hand to cartoon drawing in his thirties. His most popular cartoon creation was *Fred the Fan*, who featured in the *Evening Chronicle*, (NEWCASTLE) sports paper, *The Pink*, through the 1960s and 1970s and became a favourite among supporters of Newcastle United, at St James's Park. He also produced illustrations for the various books on Northumbria published by Frank Graham, NEWCASTLE, the latter also publishing a collection of 'Fred' cartoons in 1970. Thompson later moved to London to pursue his career as cartoonist and commercial artist, dying there of cancer in 1999.

Richard Thompson ('Rich'), *Fred the Fan* cartoon from *Evening Chronicle, Newcastle*.

THOMPSON, Stanley (1876–1926)
Figure and landscape painter in oil and watercolour. He was born at SUNDERLAND, the son of a shipowner, and studied at the town's School of Art, and later the Royal College of Art, under Walter Crane, before practising as a professional artist. While still living in London he shared a studio in Chelsea with fellow townsman and Sunderland School of Art pupil Septimus Edwin Scott (q.v.), and began exhibiting at the Royal Academy. He was then only twenty-three, and showed a Northumbrian landscape, *A Grey Day on the Wear*. Following this he returned briefly to SUNDERLAND, then moved to MIDDLETON-IN-TEESDALE, from which he resumed exhibiting at the Royal Academy in 1914 by showing the first of a succession of interiors with figures which attracted considerable publicity when they were hung. Notable amongst these was his 1924 exhibit *My Lady Nicotine*, painted following his service with the Artillery in France during the First World War. A large oil depicting a girl dressed in scarlet velvet puffing a cigarette while she admires herself in a mirror, it was widely commented upon in the press because of the novelty of its subject. Thompson last exhibited at the Academy in the year of his death, showing yet another interior with figure, *Patience*. Although his reputation as an artist mainly rests on his Academy exhibits (his *Chintz Curtains*, of 1914, was sold as a print by the Autotype Fine Art Co), he never lost his early love of landscape painting and showed many examples in watercolour at the Artists of the Northern Counties exhibitions at the Laing Art Gallery, NEWCASTLE, from their inception

Frank Thompson,
Street in York,
watercolour, 30 x 40cm.
Private collection.

Mark Thompson,
The Lynn Burn, near to
Witton-le-Wear, Durham,
oil, 66 x 76cm.
Borough of Darlington
Art Collection.

in 1905, until 1921. Thompson is popularly believed to have worked at some time in his career for the architect Frank Hall, at SUNDERLAND, and later for other architects. He died at his home at MIDDLETON-IN-TEESDALE, and was buried in the local churchyard. Throughout his career he signed his work simply 'S.T.'. The Bowes Museum, BARNARD CASTLE, has his *Chintz Curtains*. A large collection of his work was sold at auction by Anderson & Garland, NEWCASTLE, in 1997, including several of his interiors and landscapes. [See colour plate]

THOMSON, James (1789–1850)
Engraver. Born at MITFORD, near MORPETH, the son of a clergyman, Thomson showed an aptitude for drawing from an early age and his father allowed him to become apprenticed to an engraver called Mackenzie, in London. He embarked for the capital on a collier at NORTH SHIELDS, and when his ship was not heard of for nine weeks was presumed dead. On arriving safely in London he soon discovered that he disliked his master, and the style of his art, and after working closely with him for the last two years of his

apprenticeship, he set up on his own. His work was almost exclusively portraiture, in which he employed the stipple technique of engraving. His best known works are *The Three Nieces of the Duke of Wellington*, after Sir Thomas Lawrence, RA; an equestrain portrait of Queen Victoria, attended by Lord Melbourne, after Sir Francis Grant; *Prince Albert*, after Sir William Ross, and *The Bishop of London*, after George Richmond. He also engraved many plates for Lodge's *Portraits of Illustrious Personages; The Townley Marbles*, and other works. He died in London.

THORNTON, Ronald William (b.1936)

Landscape and seascape painter in oil, acrylic, pastel and watercolour; draughtsman; art teacher. He was born at SOUTH SHIELDS, and although an accomplished self-taught artist did not become a full-time professional until his retirement as a teacher in 1990. During his thirty years of teaching in which he rose to the position of headmaster of a middle school at NEWCASTLE, he occasionally exhibited his work in various joint and group exhibitions. An early example of the former was his exhibition with Alfred Ainslie O'Brien (q.v.), at the Central Library, SOUTH SHIELDS, in 1969. Since turning professional, however, his work has been exhibited throughout Northumbria, he has become one of the area's most successful teachers of art, and has produced a number of videos and books on painting in watercolour employing highly original teaching techniques. He has also founded a number of art groups on Tyneside, the first of which was at his home village of RIDING MILL, a few years before his retirement. His videos have included his four-part *The Art of Successful Water Colour*, covering Skies, Trees, Water and Buildings, and his two-part *Winning with*

Watercolours, while his books include *Winning with Watercolour*, and *Watercolour Workbook*. Two of his major artistic preoccupations since turning professional have been painting the sailing vessels which have visited NEWCASTLE as part of Tall Ships races in 1986 and 1993, and more than seventy watercolours picturing the Tyne from its source to the sea, incorporating pencil vignettes of local historical and other landmarks. The former work, and many other examples related to local landscapes and townscapes, have been extensively reproduced as prints, calendar illustrations and greetings cards, while the latter were reproduced in a publication in 2002, under the title *River Tyne from sea to source*. The watercolours and drawings reproduced comprise a unique survey of one of Britain's major rivers at the close of the 20th century, and were shown at a special exhibition at Bede's World, JARROW, near SOUTH SHIELDS, to launch the publication.

THORPE, Thomas (c.1812-after 1855)

Landscape painter in oil and watercolour; lithographer. Thorpe was born on Tyneside and studied painting and drawing under John Wilson Carmichael (q.v.), before becoming a professional artist at NEWCASTLE in his early twenties. He first exhibited his work by sending three landscapes to the Carlisle Academy in 1833. In the following year he commenced exhibiting at NEWCASTLE, showing several works at the Newcastle upon Tyne Institution for the General Promotion of the Fine Arts, and in 1836 at the First Watercolour Exhibition of the Newcastle Society of Artists some nineteen of his works were included, among these Scottish and Northumbrian landscapes and coastal scenes. He

Ronald William Thornton, *Bywell Cross and Church*, 1991, watercolour, 38 x 61cm. Private collection.

340

remained a regular exhibitor in the town for the next twenty years, also showing work at Carlisle Athenaeum in 1850. Thorpe practised at NEWCASTLE until the late 1840s, then about 1849 moved to DARLINGTON, where he remained some four years, and became quite well known for his work. While at DARLINGTON he made several visits to Northumbrian coastal towns to take views, and later lithographed these for Jordison of MIDDLESBROUGH, among several printers in the area. Some of his views were of HARTLEPOOL and nearby SEATON CAREW, and it was at the latter that he was last recorded working as an artist in 1855. Thorpe was one of Carmichael's most gifted pupils, the draughtsmanship evident in his series of lithographs of coastal towns being the equal of much that was produced by his master.

THUBRON, Henry ('Harry'), ARCA (1915–1985)

Figurative and abstract artist in various media; art teacher. Thubron was born at BISHOP AUCKLAND, and studied at Sunderland School of Art and then the Royal College of Art, before becoming an influential teacher at various art teaching establishments in Britain and abroad. His first teaching position was as head of fine art at Sunderland School of Art. After five years at the School he next taught at Leeds College of Art, and Leicester College of Art. During his period at the latter he was briefly visiting professor at the University of Illinois, USA. After leaving Leeds College of Art in 1968 he taught part time at Goldsmiths' College School of Art until his virtual retirement from teaching in the mid–1970s. He first began exhibiting his work while still a student at Sunderland College of Art, showing a self-portrait at the Artists of the Northern Counties exhibition at the Laing Art Gallery, NEWCASTLE, in 1937, while living at HARTLEPOOL. He continued to exhibit at NEWCASTLE until the late 1960s, enjoying the first of the several one-man exhibitions of his career, at the Gulbenkian Gallery, People's Theatre, NEWCASTLE, in 1965. Later one-man exhibitions included the Peterloo Gallery, Manchester, in 1976, and retrospectives held at St Paul's Gallery, Leeds, in 1985; Goldsmiths' College School of Art, in 1986, and the Gray Art Gallery, HARTLEPOOL, in 1987. Initially a figurative artist, Thubron turned increasingly from the mid–1960s into an abstract artist working in a wide variety of materials including resins, wood and metal. He also experimented with collages, often created from found material. He paid several visits abroad during his career, including the USA, Mexico and Spain, these leading to important influences on his work and teaching. He lived for several years in London with his artist wife ELMA THUBRON. Represented: Arts Council; British Council; Hartlepool Arts & Museum Service; Laing A G, Newcastle. [See colour plate]

TIBBS, Edward (b.1942)

Figurative painter in acrylic. Born at WEST SLEEK-BURN, near ASHINGTON, Tibbs studied at the Newcastle College of Art & Industrial Design under Norman Aspinall, John Crisp (q.v.), and Thomas Bromly (q.v.), before embarking on a career as a graphic designer on Tyneside. Although he exhibited

Edward Tibbs, *Running the Race*, 2002, oil, 81.5 x 56cm. Private collection.

his work as a painter in 1962 at the Artists of the Northern Counties exhibition at the Laing Art Gallery, NEWCASTLE, and the Northern Miners Exhibition, and was recognised for his work in a Tyne Tees Television programme in that year, he did not resume painting until his retirement as creative director of a design company. His work since then has met with considerable success. He was a prize winner in the People's Show at the University Gallery, Northumbria University, NEWCASTLE, in 2002, with his submission *Running the Race*, picturing a jockey at the racecourse at HEXHAM, and an important exhibition of his ballet studies was held in the Theatre Foyer, Queen's Hall, HEXHAM, in 2003. He lives and works at CORBRIDGE, and describes himself as a 'figurative artist attempting to capture the essence of a human experience', whose major influences are Edgar Degas and Lucian Freud.

TIERNEY, James (b.1945)

Printmaker; art teacher. Born at NEWCASTLE, Tierney studied at Sunderland College of Art, then did a post-diploma course in printmaking with Jennifer Dickson, at Brighton College of Art, before embarking on his career as printmaker and art teacher. He teaches printmaking at Surrey Institute of Art and Design, Farnham, and has exhibited his work in Northumbria, and the south of England. He lived in Basingstoke, Hampshire.

TILLYER, William (b.1938)
Abstract landscape painter in acrylic and watercolour; printmaker; illustrator; ceramicist; art teacher. He was born at MIDDLESBROUGH, and studied at the local College of Art, and the Slade School of Fine Art, painting with William Coldstream and etching with Anthony Gross. In 1962 he was awarded a French Government scholarship to study gravure with William Hayter, at Atelier17, Paris, and on returning to London in the following year worked in the Birgit Skiöld etching studio, and took up part-time teaching at Chelsea School of Art. From 1964 until 1973 he was visiting lecturer at various art schools and academies in London and elsewhere, following which he ceased regular teaching to concentrate on his career as an artist. In 1974 he paid his first visit to New York for his one-man exhibition at the city's Ariadne Gallery, after which he worked on lithographs in Los Angeles, 'Florist' paintings in London, and watercolours in Verona. In 1975 he travelled to Utrecht for his retrospective at the Museum of Modern Art, and over the next five years served as visiting professor at Brown University, USA; travelled through the eastern states from Niagra to Florida; spent time in Sweden and Wiltshire working on paintings and printmaking; took photographs for *The Furnished Landscape Book*, and began his *The Mesh Paintings*. A period as artist-in-residence followed at Melbourne University, Australia, after which he travelled widely in 1983 through France, Switzerland and Italy working on his 'Grand Tour' series of watercolours; in 1984 to south-western America, making drawings and watercolours, and in 1985–86, around Britain, making watercolours and producing *The Esk Bridge* print portfolio. After completing the latter he set himself up in a studio in North Yorkshire to work on *The Westwood Paintings*, and afterwards worked at the Fulham Pottery on a ceramic project. In 1990 he was invited to work with Mixographia in Los Angeles, and after travelling through California and Arizona produced his *Living in Arcadia* paintings. After returning to Britain in 1991 he was commissioned for the Broadgate development to produce his *The Mechanic Institute II* painting, and has since divided his time between visits abroad and work in his North Yorkshire studio. His later work has included a series of drawings to commemorate the centenary of the birth of Yates, based on a visit to the Lake Isle of Innisfree, Ireland; a series of watercolours based on Frank Lloyd Wright's house, Fallingwater, while visiting Pennsylvania, and a *Paris Interiors* series produced in Paris. From 1999 he started to add a more three-dimensional element to his work, introducing a variety of new surfaces from Formica, stone and glass. As well as having enjoyed more than fifty one-man exhibitions around the world, Tillyer has participated in dozens of group exhibitions. Many of his appearances in both categories of exhibition have in recent years been at the Bernard Jacobson Gallery, London, which in 2000, through 21 Publishing, published *Against the Grain* by Nobert Lynton, as an account of his life and work. One exhibition at the Bernard Jacobson Gallery in 2002 was of Tillyer's new work from a series titled *Hardware - Variations on a Theme of Encounter*, while another in association with the Broadbent Gallery, Chepstow, featured his watercolours. Represented: Arts Council; Museum of Modern Art, New York; Tate Gallery; Victoria and Albert Museum. [See colour plate]

TODD, Herbert William (1889–1974)
Amateur landscape painter in watercolour. Todd was in business for many years at DARLINGTON as a clothier and draper, but was a keen spare-time painter in watercolour. He was a founder-member of the Darlington Society of Arts, and in addition to showing work at its exhibitions, regularly exhibited at the Artists of the Northern Counties exhibitions at the Laing Art Gallery, NEWCASTLE, and was an occasional exhibitor at the Royal Institute of Painters in Water Colours. A one-man exhibition of his work was held at Darlington Art Gallery in 1968. This gallery has his *River Tees near Blackwell*, and *The Joiner's Shop, Lartington*. He died at DARLINGTON after living for many years at the Blackwell Hall Hotel.

TODD, John ('Jack') (1911–1989)
Amateur landscape and portrait painter in oil and watercolour. Todd was born at BLAYDON, near GATESHEAD, and after attending the local grammar school took an MSc in physics at King's College (now Newcastle University). A keen artist from an early age, he first began to exhibit his work publicly when he showed a view of the Quayside, NEWCASTLE, at the Artists of the Northern Counties exhibition at the city's Laing Art Gallery, in 1934. He continued to exhibit while living at BLAYDON, and later EASINGTON, when he took up a position as a teacher in a local school in 1936. Exhibitions of his sketches and watercolours were held at Seaton Holme, EASINGTON, in 1999 and 2001, including studies of buildings, bridges, ships and locomotives, as well as subjects from his service in the RAF in North Africa during the Second World War. Todd remained a teacher until his retirement as deputy head of his school. His son, JOHN TODD (b.1946) has, since retirement from the art department of a County Durham school, practised as a professional artist.

TOFT, Peter Petersen (1825–1901)
Architectural and landscape painter in oil and watercolour. Born at Kolding, Denmark, Toft practised as an artist mainly in London, and from the early 1870s showed work at various exhibitions, including the Royal Academy; the Suffolk Street Gallery and the New Water Colour Society (later the Royal Institute of Painters in Water Colours). Many of his exhibits at these, and other venues, were painted in Northumbria, and the Laing Art Gallery, NEWCASTLE, has a substantial number of local architectural and landscape views painted by him about 1880. He died in London. Represented: British Museum; Laing A G, Newcastle.

TOULMIN, John (1911–1967)
Amateur landscape painter in gouache and watercolour. Toulmin's place of birth is not known, but after study at Armstrong College (later King's College;

now Newcastle University), he joined a Tyneside company and eventually became one of its directors. He had no formal training as an artist but was a keen spare-time painter who showed his work at the Artists of the Northern Counties exhibitions at the Laing Art Gallery, NEWCASTLE; the Federation of Northern Art Societies' exhibitions, at the Shipley Art Gallery, GATESHEAD; at various exhibitions at Sunderland Art Gallery, and with the Tynedale Art Club. He lived at CORBRIDGE for many years and was from 1936 until his death a fellow of the Royal Geographical Society.

TRAIN, Edward (1801–1866)
Landscape, portrait and figure painter in oil; engraver. Train was born at GATESHEAD, and left Tyneside at an early age to take up an apprenticeship under London engraver Edward Scriven (1775–1841), a specialist in the stipple technique. On completing his apprenticeship he returned to NEWCASTLE, where he quickly formed friendships with several of its leading gentry, including George Clayton Atkinson (q.v.), and his two brothers, whom he accompanied on their expedition to the Hebrides and the Shetlands in 1831. This expedition, perhaps, gave Train his taste for Scottish Highland scenery, for from this date forward it became his main preoccupation as a painter. By the early 1830s he was exhibiting his Highland scenes at NEWCASTLE, giving both NEWCASTLE and Edinburgh as his address, and had obviously established a market for his work in the Scottish capital. In 1841, however, and again exhibiting at NEWCASTLE he listed the town alone as his address. Train exhibited sparingly outside NEWCASTLE throughout his life, showing one work at Carlisle Athenaeum in 1850, and a few works in Edinburgh. The bulk of his work lay in the field of Scottish landscape, which he occasionally combined with theatrical or historical matter, as with his *Macbeth and the three Weird Sisters*. He was also an able portrait painter, however, including several well-known Northumbrians among his sitters, and drawing a portrait of Thomas Bewick (q.v.), from Bailey's bust, for reproduction as an engraving in the *Sketch of the Life and Work of the late Thomas Bewick*, published by George Clayton Atkinson, in 1831. He died at his home at NEWCASTLE. Represented: Darlington A G; Laing A G, Newcastle; Natural History Society of Northumbria, Newcastle; Shipley A G, Gateshead. [See colour plate]

TREVELYAN, Lady Caroline (née Phillips) (1849–1928)
Amateur landscape painter in watercolour. She was the daughter of Robert Needham Phillips, a wealthy cotton merchant from Manchester and Liberal MP for Bury. In 1869 she married Sir George Otto Trevelyan (1838–1928), of Wallington Hall, near CAMBO, and thereafter spent much time at the Hall, particularly after her husband's retirement from public life in 1897. She was a keen watercolourist, who, in addition to painting several views around Wallington Hall and widely on the Continent, also produced a study of the Central Hall of the property. The study now hangs in the Writing Room of Wallington Hall and was painted in 1906. This, and three other of her locally painted watercolours are illustrated in the guide to the property, now administered by the National Trust. Her grandson, JULIAN TREVELYAN (1910–1988), was a distinguished painter, printmaker, art teacher and writer who was made an honorary senior Royal Academician in 1986.

TREVELYAN, Lady Pauline (née Jermyn) (1816–1866)
Amateur flower and insect painter in oil, tempera and watercolour. The eldest daughter of a Suffolk parson, she became in 1835 the first wife of Sir Walter Calverley Trevelyan, of Wallington Hall, near CAMBO. After settling at Wallington she began to contribute reviews of books and exhibitions to the *Edinburgh Review*, and the *Scotsman*, also continuing her girlhood practice of sketching and painting. Through her reviews she made the acquaintance of John Ruskin, and later William Bell Scott (q.v.), subsequently securing for the latter the commission to decorate the central hall at Wallington, and introducing him to the great art critic. Scott's commission mainly involved the production of large canvases to fill spaces in some of the arches of the new hall, and wishing to make every character depicted in them based on real persons, he included Pauline as a terrified Briton watching the approach of the Danish galleys. The pilasters between the arches also required decoration, and Pauline, together with LAURA CAPEL LOFFT (who later became the second Lady Trevelyan), Mrs Mark Pattison, later Lady Dilke, and even Ruskin, painted various flowers on them in tempera. She later went on a tour of the Continent with her husband and Ruskin, dying at Neuchâtel, Switzerland, in 1866. Scott's portrait of her hangs in Lady Trevelyan's Parlour at the Hall, which is open to the public courtesy of the National Trust. Several other members of the Trevelyan family were artistically gifted, including SIR JOHN TREVELYAN (1734–1828), two of whose watercolours hang at the Hall; Lady Pauline's husband SIR WALTER CALVERLEY TREVELYAN (1797–1879), who contributed illustrations to Hodgson's *History of Northumberland*; EMMA TREVELYAN (d.1857), several of whose sketches of Wallington appeared in Hodgson's work, and Lady Caroline Trevelyan (q.v.). Represented: British Museum.

TROUGHTON, Mrs Emily Wade (née Patterson) (c.1874–1924)
Amateur marine, coastal and figure painter in oil. She was born on Tyneside, and first began painting seriously after settling at WHITLEY BAY, following her marriage to a local postman. Here she became a familiar sight around the village (then named WHITLEY), often painting local views while carriages passed her on each side. She later moved to EAST BOLDON, near SOUTH SHIELDS, where she continued to paint until arthritis in her hands made this no longer possible. She died at SOUTH SHIELDS. An example of her work hung for many years in the Fishermen's Watch House, CULLERCOATS, showing figures gathered at a cliff face in a storm. Represented: North Tyneside Public Libraries.

Edward Train,

On the Esk, 1849,

oil, 43 x 56cm.

Borough of Darlington

Art Collection.

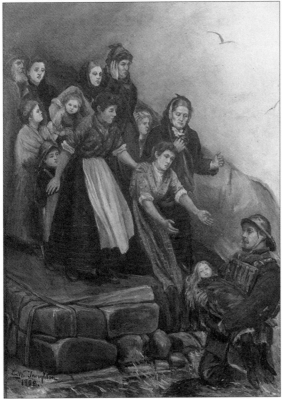

Emily Wade Troughton,

Saved at Last, 1908,

oil, 61 x 45.5cm. Anderson & Garland.

TROWELL, Jonathan
Ernest Laverick, FRSA NEAC (b.1938)

Landscape and figure painter in oil, pastel and water-colour. He was born at EASINGTON, and studied at Sunderland College of Art and the Royal Academy Schools, gaining his diploma from the latter in 1962. During his studies he was awarded the Landseer Silver Medal for Painting, and gained the St James Knott Travelling Scholarship from the Royal College of Art, enabling him to paint in Spain and North Africa. In 1964 he showed his first work at the Royal Academy, later going on to show examples in group exhibitions at the New Bauhaus, Cologne; Young Contemporaries, John Moores; Lee Nordnes, New York; Bilan Contemoporain, Paris; the Royal Society of British Artists, and the New English Art Club. He has also had one-man exhibitions at the Brod Gallery, London; the Century Gallery, Culham College, Oxford; Richard Hope-Reeves, New York; the Osborne Gallery, London, and the Stern Galleries, Australia. He was elected a fellow of the Royal Society of Arts, in 1983, and a member of the New English Art Club in 1986. He lives at Litcham, Norfolk. Represented: Culham College, Oxford; Imperial College of Science; Royal College of Art, and various corporate and private collections.

TUCKER, James Walker, ARCA ARWA
(1898–1972)

Landscape and subject painter in oil, tempera and watercolour. Tucker was born at WALLSEND, near NEWCASTLE, and received his early training in art at Armstrong College (later King's College; now Newcastle University) under Richard George Hatton (q.v.), gaining two silver medals, and a scholarship to

travel France in 1922. Later in that year he entered the Royal College of Art to study under Sir William Rothenstein, and in 1927 was awarded a travelling scholarship to Italy. In 1926 Tucker acted as studio assistant to Sir William while he was working on his mural for St Stephen's Hall, Westminster, this experience being later put to use when, on returning from Italy, the young artist was commissioned by Newcastle Corporation to paint one of the several lunettes for the Laing Art Gallery, NEWCASTLE, first shown in 1931. Tucker's subject was *The entry of Charles I into Newcastle upon Tyne*. In 1927 he sent his first work to the Royal Academy, and in 1931 was appointed head of Gloucester College of Art, a post which he held until his retirement in 1963. Tucker exhibited at the Royal Academy for many years, his exhibit in 1941, *The Champion*, being acclaimed picture of the year. This work sold for £200 at the private view, and was subsequently reproduced in colour. He also exhibited his work at the Royal West of England Academy; the Royal Society of Marine Painters; the New English Art Club, and at various London and provincial galleries, including among the latter the Laing Art Gallery, NEWCASTLE, whose Artists of the Northern Counties exhibitions he contributed to for several years. Tucker was an associate of the Royal College of Art, and an associate of the Royal West of England Academy. He died at Gloucester. A major memorial exhibition of his work was held at Cheltenham Art Gallery in 1974, this consisting of some ninety of his works in oil, tempera and water-colour. Represented: Cheltenham A G; Laing A G, Newcastle; Shipley A G, Gateshead.

TUKE, Lilian Kate (fl. late 19th, early 20th cent.)

Landscape, genre and portrait painter in oil and watercolour. This artist first practised at DURHAM, from which in 1893 she showed as one of her earliest exhibits at the Bewick Club, NEWCASTLE, *A Reformatory Boy*. She continued to exhibit at the Club until the early years of the century, then began to exhibit her work more widely, showing examples at the Royal Academy; the Royal Institute of Painters in Water Colours; the Royal Society of Portrait Painters, and at the Walker Art Gallery, Liverpool. In 1906 she commenced exhibiting at the Artists of the Northern Counties exhibitions at the Laing Art Gallery, NEWCASTLE, showing her landscapes, *The Castle, Durham*, and *Dordrecht*, but after moving to London about 1914 she appears to have exhibited little on Tyneside.

TULLY, Joyce Mary (b.1933)

Landscape and still life painter in oil and watercolour; calligrapher; art teacher. She was born at WOOLER, and after education at Duchess Grammar School, ALNWICK, attended the Teachers' Training College at SUNDERLAND. She then studied part-time at Hammersmith College of Art, before later studying privately under Harold Workman (1897–1975), the

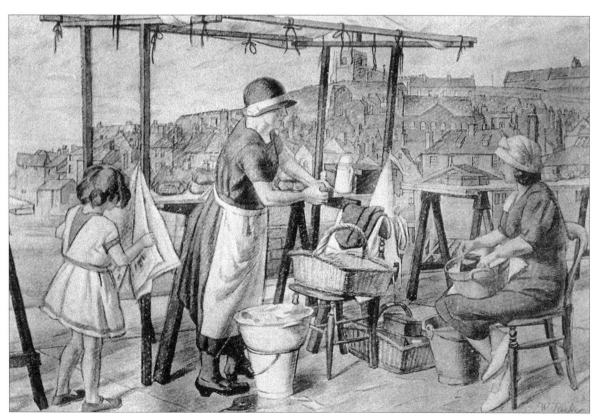

James Walker Tucker, *Crab Stall, Whitby*, watercolour, 38 x 92cm. Private collection.

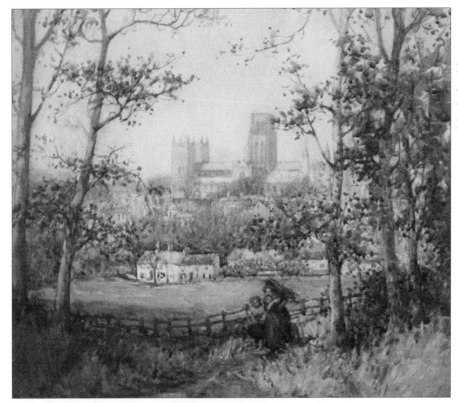

Lilian Kate Tuke,
Durham Cathedral,
watercolour, 33.5 x 38.5cm.
Private collection.

Joyce Mary Tully, *Still Life*, 2002, oil, 25 x 30.5cm.
Private collection.

landscape, townscape and interior painter, at Chelsea. Before returning to WOOLER in 1979, she began exhibiting her work with the United Artists Society, London, and the National Society of Painters, Sculptors, Gravers and Printmakers, becoming a member of the former in 1978, and then associate of the latter, in 1974. She has since exhibited her work in many other group exhibitions, including those of the Royal Society of British Artists; the Royal Institute of Oil Painters; the Royal Society of Marine Artists; Chelsea Artists; the Ridley Society; at the Paris Salon, and in Australia. In recent years she has mainly exhib-

ited her work with the United Society of Artists, and in Northumbria, where examples have been shown at the Bondgate Gallery, ALNWICK; the Three Feathers Gallery, and the Maltings, BERWICK-UPON-TWEED, and the Cheviot Centre, WOOLER. She has also been a speaker on art-related topics to various local societies, and has taught calligraphy. She still paints actively with a particular preference for local landscape subjects, and occasional still lifes. Examples of her work form part of the collection of Coupland Castle, near WOOLER, and are represented in many private collections in England, Europe and the USA.

TURNBULL, William (d.1935)
Landscape, coastal and flower painter in oil and watercolour. This artist practised at CULLERCOATS, and later LOWICK, near BERWICK-UPON-TWEED, in the late 19th and early 20th centuries, and regularly exhibited his work at NEWCASTLE throughout his career. He was an exhibitor at the Bewick Club, NEWCASTLE, from the mid-1890s, and showed work at the Artists of the Northern Counties exhibitions at the city's Laing Art Gallery, for thirty years from their inception in 1905. Many of his exhibits featured Northumberland landscapes, sometimes with sheep or cattle, but he was particularly fond of painting wallflowers, and showed many studies of these at the exhibitions. Two of his works were included in the Artists of the Northern Counties exhibition following his death early in 1935. These were *North Northumberland*, and *Old Shields*. It is believed that he died at LOWICK.

TURNER, Richard Sidon (b.1930)
Landscape and seascape painter in watercolour; art teacher. He was born at NORTH SHIELDS, but at the age of five went with his parents to live in Edinburgh. Here he attended the Edinburgh College of Art, under William McTaggart and Leonard Rosoman before his national service in the RAF. On leaving the RAF he returned to NORTH SHIELDS, and afterwards worked at NEWCASTLE as an industrial designer for Philipson's Studios, and the North Eastern Cooperative Society art department. He also for some time worked as an adult education teacher, and on his retirement at sixty-six became a full-time professional artist. He has participated in a number of group exhibitions and had several one-man exhibitions, among the former, North Shields Library, and the latter, the Coquetdale Gallery, ROTHBURY. He is a retired member of the Society of Industrial Artists and Designers, and lives at THROPTON, near ROTHBURY.

TURNER, William E (fl. late 19th cent.)
Landscape, coastal and genre painter in oil and water-colour. This artist practised at SOUTH SHIELDS in the late 19th century, and sent several works for exhibition at the Bewick Club, NEWCASTLE, in this period. Typical titles of works shown at the Club, were *Flowing Tide* (1891); *Waiting for a Bite* (1893), and *Clean your Step, Mum* (1894). It is possible that he was the 'William Eddowes Turner', who practised at Nottingham in the late 1850s and early 1860s, and exhibited work at the British Institution, and the Suffolk Street Gallery in these periods.

TWEEDY, Thomas Hall (1816–1892)
Wood-carver. Tweedy practised as a wood-carver at NEWCASTLE for many years in the middle of the 19th century, at one time being accounted the most influential figure in his field in Northumbria. At various times he had as his apprentices some of the finest wood-carvers the area has produced, among these Gerrard Robinson (q.v.), Ralph Hedley (q.v.), and Elijah Copland (q.v.). Tweedy was himself a proficient wood-carver, but like William Wailes (q.v.), in regard to stained glass designing, preferred to recruit the best available talent, and take the credit for his workshop. His shop on the town's Grainger Street was well known for its window displays of the workshop's productions, and through the several major exhibitions of crafts which were staged in Britain and abroad in the 1850s and 1860s, his name became identified in London and Paris with some of the finest carved furniture exhibited in these cities. The golden era of his workshop was during the vogue for such furniture c.1840-c.1860, and helped by men like Robinson, 'Tweedy' pieces became in demand from the local aristocracy. One of his most generous patrons was Algernon, Fourth Duke of Northumberland, who, notwithstanding his employment of his own wood-carvers, commissioned much work from Tweedy. In the late 1860s, and having earlier lost his star wood-carver, Robinson, to London, Tweedy decided to give up wood-carving, and about 1870 went into partner-ship with T P Barkas in running the Central Exchange News Room & Art Gallery in the town. Under their management, and later that of Charles Edward Barkas (q.v.), the establishment staged several successful art exhibitions, notably the exhibition of works by local painters, in 1878. Tweedy spent much of his later life at RYTON, and died at his home there in 1892. His work as a wood-carver is extremely difficult to distinguish from that of his pupils, several pieces once thought to have been by his hand now being attributed to one or other of his workshop apprentices.

Thomas Hall Tweedy, wood-carvings of Macbeth witch and Blind Willie, 27cm high. Private collection.

U

UNSWORTH, Peter (b.1937)

Landscape, figure, sporting and interior painter in oil, acrylic and pastel. Born at DARLINGTON, Unsworth studied at Middlesbrough and St Martin's schools of art before practising as a professional artist in London. By 1963 he was enjoying his first of several one-man exhibitions at the capital's Piccadilly Gallery, and in 1967 took part in his first group exhibition, at the Salon de la Jeune Peinture, Paris. Later one-man exhibitions included many Continental as well as British and Irish venues, among these the Galleria Carbonesi, Bologna, 1968; the Galerie Wittiepoppentoren, Hasselt, Belgium, 1977; Middlesbrough Art Gallery, 1980; the Galeria el Mensajero, Ibiza, Spain, 1982; the Galeria Munsterberg, Basle, Switzerland, 1986; the Solomon Gallery, Dublin, 1994, and the East West Gallery, London, 1998, 1999, and 2001. The group exhibitions in which he has participated have included many on the Continent, Britain, Africa, the Far East, and the USA, notable among which have been *Painters of the North*, Stone Gallery, NEWCASTLE, 1966; *Critics Choice*, Arthur Tooth & Son, 1970; Basle International Art Fair, 1975–1993; the Waddington Galleries, Montreal, Canada, 1978; The International Contemporary Art Fair, London, 1985–1990; The British Council Touring Exhibition *Picturing People*, 1989/90 at the National Art Gallery, Kuala Lumpur, Hong Kong Museum of Art, and the National Gallery of Zimbabwe, Harare. His work has also been regularly included in the exhibitions of the East West Gallery, London, 1997–2002. During the period in which his work has been shown at these various exhibitions he has lived in both Norfolk and Ibiza. Of his one-man exhibition at the East West Gallery in 1998 a commentator in the press observed: 'Unsworth's paintings seem to deal with an event about to happen; something just outside the picture frame. Sinister mise-en-scenes, they are painted in a disquietingly simple, pleasant style. This is the secret of their success.' In addition to his work as a painter he has also designed the sets and costumes of three ballets for The Royal Ballet Company. Represented: Abbot Hall A G, Kendal; Arts Council; Kettering A G; Middlesbrough A G; Towner A G; Eastbourne A G, and various overseas public and private collections.

URWIN, Jean Foster (c.1897-after 1936)

Amateur landscape, coastal and flower painter in watercolour. This artist lived at WARKWORTH in the first half of the 20th century, and contributed examples of her work to the Royal Academy in 1922, and the Artists of the Northern Counties exhibitions at the Laing Art Gallery, NEWCASTLE, 1921–1936.

URWIN, John (1939–1993)

Landscape painter in watercolour; art teacher. Urwin was born at DARLINGTON, and after education locally studied art at King's College (now Newcastle University). He later studied at Durham University Institute of Education, where he was awarded a diploma in advanced studies in education. In 1974 he was appointed head of year at Bishop Barrington Comprehensive School, BISHOP AUCKLAND, where he taught art and design for a number of years, as well as teaching at a number of adult education classes in the area. Darlington Art Gallery has his watercolour *Beadnell Bay, Northumberland*. He lived at HIGH ETHERLEY, near BISHOP AUCKLAND.

Peter Unsworth, *Starry Night*, 2001, acrylic and oil, 51 x 51cm. Private collection.

V

VALENTINE, John (1867–1947)

Landscape, animal and portrait painter in oil and water-colour; illustrator. Valentine was born at Aberdeen and lived there until his appointment to the press department of a York newspaper in his late teens. In 1904 he moved to Tyneside to work for the *Newcastle Chronicle* as an illustrator in the press department, remaining there for thirty-three years, until his retirement as manager in 1937. While living on Tyneside he commenced exhibiting his work by showing a landscape and two portraits at the Artists of the Northern Counties exhibition at the Laing Art Gallery, NEWCASTLE, in 1910. He remained a regular exhibitor both at the Laing Art Gallery, and the Bewick Club, NEWCASTLE, for the next ten years, then ceased exhibiting until the Second World War. Meanwhile he had purchased a house at NORHAM,near BERWICK-UPON-TWEED, moving there on his retirement. He resumed exhibiting at the Artists of the Northern Counties exhibitions at the Laing Art Gallery in 1944, continuing until the year of his death. His last exhibits were two oils: *The Ford*, and *The Tweed at Norham*. A large collection of his work was sold by auction at BERWICK-UPON-TWEED in 1989 following its discovery in the attic of his daughter's home at NORHAM. It included many examples of his later work as a landscape and horse painter, as well as early portrait studies. Most of the works were in watercolour. Represented: Cragside, Rothbury, Northumberland.

VAUGHAN, William Steains (fl. late 19th cent.)

Amateur landscape and coastal painter in watercolour. Vaughan lived at NEWCASTLE in the late 19th century, and was a keen painter of local landscape and coastal subjects in his spare time. He also exhibited his work, showing examples in 1878, at the exhibition of works by local painters, at the Central Exchange Art Gallery, NEWCASTLE, and the town's Arts Association exhibition. His three exhibits at the former exhibition were described in the catalogue notes as 'very creditable performances'. He later exhibited at the Bewick Club, NEWCASTLE, for several years.

VENTRESS, Robert (c.1846–c.1925)

Landscape and coastal painter in oil and watercolour. Ventress was born on Tyneside, and practised at NEWCASTLE as an artist, picture framer and gilder all his life, occasionally sending his paintings of local landscape and coastal views to exhibitions in Northumbria. He first exhibited his work in 1866, when he showed a *Burn Scene*, and a *Coast Scene*, at the 'Exhibition of Paintings and other Works of Art', at the Town Hall, NEWCASTLE. He was an exhibitor at the 'Gateshead Fine Art & Industrial Exhibition', in 1883, and was later a regular exhibitor at the Bewick Club, NEWCASTLE, and the Artists of the Northern Counties exhibitions at the city's Laing Art Gallery. He was a member of the Bewick Club, and the Benwell Art Club, NEWCASTLE. He died at NEWCASTLE.

Robert Ventress, *Ovington, Northumberland*, oil, 61 x 40.5cm. Private collection.

VENUS, Sylvia Ismay (1896–2000)

Illustrator; figure painter in watercolour. She was born at GATESHEAD, the daughter of the chief engineer of an American steamship company, and later studied art at Armstrong College (later King's College; now Newcastle University). At the outbreak of the First World War, however, the college buildings were commandeered as a hospital, and she became a volunteer nurse. She later worked for the local Food Office, and it was not until she was in her early twenties that she was able to pursue her ambition to become an artist. After first exhibiting her work by showing two examples at the Artists of the Northern Counties exhibition at the Laing Art Gallery, NEWCASTLE, in 1919, she moved to London. Here she eventually settled at Kew, where she soon obtained work as a children's illustrator for Raphael Tuck, and later for Newnes, the publishers. Through Newnes she began to illustrate work for Enid Blyton, continuing for some thirty years. She also illustrated the children's columns of various newspapers and periodicals, including the *Daily Sketch*; *Woman's Friend*, and *Toby Magazine*, and occasionally exhibited her work at NEWCASTLE, mainly showing watercolours or drawings of children at play. Midway during her work for Newnes she moved briefly to Caterham, Surrey, subsequently renting a cottage at Cloughton, near Scarborough, to care for an aunt who had been her guardian since her mother had died when she was eleven. Here she continued to work for

John Valentine,
The Spring Ride,
watercolour, 18.5 x 30.5cm.
Private collection.

London publishers until her retirement in 1954. Following her retirement she lived briefly in Surrey, then returned to Cloughton. She was admitted to a Scarborough nursing home in 1992 after long care by relatives, and died there in 2000 at the advanced age of 103. [See colour plate]

Sylvia Ismay Venus, frontispiece illustration for
More About Amelia Jane!, by Enid Blyton, 1954.

W

WAILES, William (1808–1881)

Stained glass designer; landscape painter in water-colour; draughtsman. Wailes was born at NEWCASTLE, the descendant of an old Northumbrian family, and endeavoured to succeed as a landscape painter before becoming first a grocer, later a manufacturer of stained glass. Accordingly, he placed himself as a pupil under Thomas Miles Richardson, Senior (q.v.), and by 1826 was exhibiting alongside his master at the Northumberland Institution for the Promotion of the Fine Arts, NEWCASTLE, albeit only showing a copy of Richardson's *View of Durham*. He again exhibited at NEWCASTLE, in 1828 showing his *The Vale of Tyne*, at the Northern Academy, but despairing of critical acclaim he decided to become a tradesman. Again his efforts met with failure, and it was almost as a last resort that he turned to the activity by which he was later to become famous: manufacturing stained glass windows. His earlier involvement with artists stood him in good stead, however, when selecting men to help him in his new venture. His judgement in selecting artists such as Francis Wilson Oliphant (q.v.), James Sticks (q.v.), and John Thompson Campbell (q.v.), was impeccable, and remained throughout a career which was to take his name around the world as the manufacturer, and in most cases mistakenly, the designer, of the finest stained glass windows. For although we have it from Wailes' grandson, William Wailes Strang, who ultimately succeeded his grandfather in owning the business, that he 'excelled in delicate Indian ink, sepia, water colour and pen and ink drawing', and that his chief hobbies were 'furniture designing, house building, and landscape gardening', there is no direct evidence that he actively involved himself in the designing of his windows.* Perhaps the best assessment of Wailes comes from the pen of William Bell Scott (q.v.), in his *Autobiographical Notes etc*. 1892, who observed: 'William Wailes was the last man one would have expected to organise and succeed in this new species of art. . . . He had been in trade and was unsuccessful, his reading was the *London Journal*, and his general knowledge of art nil. Yet he had the greatest delight in grand churches, and had visited many in France. This was his inspiration; he got hold of Oliphant, built a kiln in his back shop, introduced himself to Pugin, and in a few years had a hundred men busily at work with commissions more than he could handle. . . . Had Wailes been himself a Raphael or a Titian, what might he not have accomplished. . . .' As it was, Wailes accomplished much, supervising the production of some 360 windows annually for several years, and undoubtedly dictating their style and finish to no small degree. He spent his final years living at Saltwell Tower, GATESHEAD (which he is said to have designed and built himself), a short while before his death disposing of the house and adjacent land to Gateshead

Corporation, on condition that he could stay in the Tower as long as he lived. He died at GATESHEAD, and was buried in the graveyard of St Peter's, BYWELL, which church contains several windows erected in memory of his family. The Shipley Art Gallery, GATESHEAD, has a portrait of Wailes painted by JOHN OLIPHANT, relative of Francis Wilson Oliphant.

WALKER, James (fl. 19th cent.)

Engraver. He practised at NEWCASTLE in the early 19th century, for some years in association with George Armstrong (q.v.).

WALKER, M Kingston (born c.1895)

Portrait, animal, landscape and flower painter in oil and watercolour. She was born on Tyneside, and received her first tuition in art at Armstrong College (later King's College; now Newcastle University), where she won a three year scholarship. During the First World War she served as a voluntary ambulance driver, and did not resume her studies in art until 1920, when she became a pupil at the Byam Shaw and Vicat Cole Schools of Art. She returned to NEWCASTLE in the early 1920s, and there commenced exhibiting at the Artists of the Northern Counties exhibitions at the city's Laing Art Gallery, receiving much favourable comment for her work. In 1936 an exhibition of her work was held at the Walker Galleries, London. The Laing Art, Gallery, NEWCASTLE, has her *Thunderstorm: L'aig De Varan, Haute Savoie*.

WALKER, Seymour, NEAC (1859–1927)

Amateur landscape painter in oil. Walker was born at WEST HARTLEPOOL (now HARTLEPOOL), and following his general education entered his family's timber firm in the town. His involvement in the day-to-day running of the firm appears to have been limited, however, enabling him to indulge his early love of painting and drawing, often in the company of successful professional artists of his day, such as Whistler, Ludovici, Lee Hankey, and fellow Northumbrian artist, Ralph Hedley (q.v.). He was also able to paint widely on the Continent, where he became profoundly influenced by the work of Jean-Baptiste Corot. Walker first began exhibiting his work publicly when he sent three works to the Suffolk Street Gallery in 1887/8, from his home at SEATON CAREW. These works were *A Troopship*; *Off Hartlepool*, and *Waves*. He later exhibited at the Royal Institute of Oil Painters; the New English Art Club (of which he became member in 1889), and various provincial galleries, including the Laing Art Gallery, NEWCASTLE, whose Artists of the Northern Counties exhibitions he contributed to for several years. A major one-man exhibition of his work in oil was held at the Gray Art Gallery, HARTLEPOOL, in the year before his death, this including British and Continental scenes, copies after Corot, and a portrait of the artist by Emmeline Deane. He died at SEATON CAREW. A son, or nephew, J WYLAM WALKER, of SEATON CAREW, was also a talented artist, and exhibited his work.

* An exception may be the designs for the Chevy Chase window exhibited in his name at the First Water Colour Exhibition of the Newcastle Society of Artists, 1836.

WALL, George (1930–1974)

Landscape and abstract painter in oil and acrylic; art teacher. Born in County Durham, Wall studied art at King's College (now Newcastle University) and the Slade School of Fine Art, before becoming an art teacher. He participated in several exhibitions, initially the Artists of the Northern Counties exhibitions at the Laing Art Gallery, later the Arts Council of Great Britain Young Contemporaries, and various other shows in Europe and the USA. He spent his final years teaching at Coventry College of Art. His work was initially landscape, but he later turned increasingly to abstract compositions.

WALLACE, Aidan (b.1903)

Landscape painter in oil and watercolour; sculptor. Wallace was born at ELSDON, near OTTERBURN, and studied at the Technical College at DARLINGTON before becoming a member, and regular exhibitor with Darlington Society of Arts. He also exhibited at the Artists of the Northern Counties exhibitions at the Laing Art Gallery, NEWCASTLE, showing a wide variety of Northumbrian landscapes and occasional works of sculpture, while living in the city. Typical of his landscape exhibits at the gallery was his *The Castle, Holy Island*, shown in 1955. Represented: Darlington A G.

WALLACE, James, Senior (1841–1911)

Landscape and figure painter in oil and watercolour; art teacher. He was born at BERWICK-UPON-TWEED and began his working life as a schoolmaster, initially at BLYTH, later in his home town. He had shown himself a talented artist from his youth, and in 1873 was successful in obtaining the appointment as headmaster of the newly opened Berwick Art School. He held this position for some thirty-eight years, teaching art not only at the Art School, but at other establishments in the locality. Among his hundreds of pupils were his son James Wallace, Junior (q.v.), and Frank Watson Wood, Senior (q.v.), both of whom attended the Art School, and went on to become successful professional artists. Wallace, Senior, was a founder and, during the whole of its existence, president of Berwick Arts Club. He showed several examples of his work at its exhibitions but is not known to have exhibited elsewhere. His long tenure as headmaster of the Art School was cut short by his sudden illness in 1909. His post was temporarily taken over by Wallace, Junior, until his son, too, fell ill; the task was then taken over by his daughter Helen, home on leave from her own teaching post in South Africa. He died in 1911, and the Art School was shortly afterwards closed. The work of Wallace, Senior, has frequently been confused with that of his son because of their choice of similar subject matter. Represented: Berwick Museum & A G.

WALLACE, James, Junior, ARCA (1872–1911)

Landscape and figure painter in oil and watercolour; art teacher. He was born at BLYTH while his father, James Wallace Senior (q.v.), was headmaster at Blyth National School. Shortly after James was born the family returned to BERWICK-UPON-TWEED, where his father had been brought up. Here he later attended Berwick Art School, under his father, and in 1896 won a scholarship to the Royal College of Art to continue his studies. His final year at the College proved very successful when he won the First Prize in Painting from Life, and a prestigious Government Travelling Scholarship, which he used to travel to Italy, Germany and Belgium. On completing his college training in 1902 he became a professional artist, and taking a studio in London with fellow-pupil Septimus Edwin Scott (q.v.), remained there for the next seven years. His work during this period included teaching at evening classes and some commercial work, but his main interest remained that of succeeding as a professional artist. Wallace had begun exhibiting at the Royal Academy in 1899, while still a student, and he continued in this practice until the year of his death. He also exhibited at the Royal Scottish Academy; the Glasgow Institute of Fine Arts, and widely in the provinces. Although he remained a regular visitor to BERWICK-UPON-TWEED throughout his life, he also took regular holidays abroad, visiting France in 1905, and Holland in 1906, and 1907. He sketched and painted on all of his vacations, both at BERWICK-UPON-TWEED, and abroad, and from 1904, also sketched around Grimsby, Yorkshire, following his engagement to a local girl whom he had met at his doctor brother's wedding there. In 1909 his father was taken ill and Wallace returned to BERWICK-UPON-TWEED to take over the Art School for a time. On the death of his mother in the following year he felt obliged to make his return permanent and closed his London studio. By the autumn he had fallen ill, and after a period of care under his brother at Grimsby, and in a London hospital, died in 1911 at the early age of thirty-nine. He was buried at Goxhill, near Grimsby. An exhibition of his work was held at Berwick Museum & Art Gallery in 1995 in association with a display of journals to which he had contributed sketches. The exhibition was accompanied by a booklet on his life and times, lavishly illustrated with examples of his work from the journals, and the Gallery's extensive collection. Written and researched by Liz Doley, it reveals an artist of great versatility and ability, who had he lived longer might well have become one of the outstanding figures of early 20th century Northumbrian art.[See colour plate]

WALLACE, John (1841–1905)

Landscape and genre painter in oil and watercolour. He was born at RYTON, and on leaving the village school, joined his father's business as cartwright and joiner. At the end of his apprenticeship he continued with his father as journeyman joiner, later deciding to become a builder in the village. About 1868 he entered into several large building speculations in RYTON, eventually completing several projects which were later said to have 'added much to the attractions of the old place'; notable among these was Wallace Terrace, which still stands today. In the late 1870s, however, the property market became increasingly depressed, and he gave up the building trade to devote himself to his

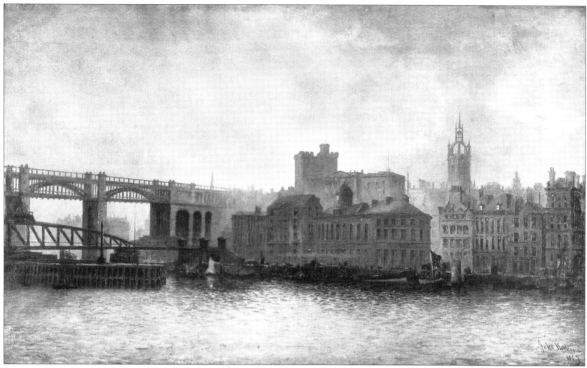

John Wallace, *Quayside, Newcastle*, 1887, oil, 74 x 127cm. Tyne & Wear Museums, Shipley Art Gallery.

lifelong love of painting. He studied for a short time under another local artist, then in 1880 moved to NEWCASTLE to practise as a full-time professional himself. He first began exhibiting his work publicly at the Arts Association exhibitions at NEWCASTLE, showing examples in 1880 and 1881. He subsequently became a member of the Bewick Club in the city, remaining an exhibitor with the Club until his death. One of his Club exhibits of 1885 was purchased by industrialist, art patron and father of Charles William Mitchell (q.v.), Dr Charles Mitchell; Lady Armstrong purchased one of his 1886 Club exhibits, and, indeed, all of his exhibits in that year found purchasers. In 1890 he sent his only work to the Royal Scottish Academy, following this in 1892, by sending his first work to the Royal Academy, *Butter Washing*. He exhibited at the Royal Academy on two further occasions, in 1896 showing *A Northumberland Dairy*, and in the year prior to his death, *Derwent Vale*. Wallace's later years at NEWCASTLE were increasingly taken up with producing black and white drawings for reproduction in local publications. He died at NEWCASTLE, several of his works appearing in the year of his death, at the first Artists of the Northern Counties exhibition at the city's Laing Art Gallery, including his *Jesmond Falls*, dated 1901. Represented: Laing A G, Newcastle; Shipley A G, Gateshead. [See colour plate]

WALLIS, Richard (fl. late 18th cent.)
Amateur etcher. Wallis was rector of SEAHAM, but was an occasional etcher of local views, including his own church in the town, dated 1784. His best known work is his etching of Wearmouth Bridge, SUNDERLAND, during the building of the structure, dated September 28th, 1795.

WALTON, George (1855–1891)
Portrait painter in oil. Born at BLENKINSOP, near HALTWHISTLE, Walton studied at the School of Art, NEWCASTLE, the Royal Academy Schools, and in Paris, before practising as a portrait painter on Tyneside by his early twenties. He first exhibited his work while still at NEWCASTLE, showing a portrait at the Royal Scottish Academy in 1881. In the following year he moved to London, remaining there for some six years, and exhibiting his work at the Royal Academy from 1882; the Suffolk Street Gallery in 1882/3, and the Bewick Club, NEWCASTLE from 1884. On his return to NEWCASTLE in 1888 he sent his last work to the Royal Academy, *Mrs. Chatt*, later moving to Appleby, Cumbria, where he died in 1891. He is believed to have practised briefly in Australia during his short career as a portrait painter.

WARD, Florence (1912–1984)
Amateur landscape and figure painter in oil and water-colour; collagist; sculptor. She was born at DUNSTON, near GATESHEAD, and although said to have displayed a talent for drawing from an early age did not take up art seriously until after the Second World War. Beginning in 1948 she took a two-year course at evening classes held at King's College (now Newcastle University), following which she became a regular exhibitor at the Artists of the Northern Counties exhibitions at the Laing Art Gallery, NEWCASTLE, and the Federation of Northern Art

Societies, at the Shipley Art Gallery, GATESHEAD. She also exhibited at the Royal Scottish Academy; the Westgate and Gulbenkian galleries, NEWCASTLE; Sunderland Art Gallery; the Bondgate Gallery, ALNWICK, and overseas at Pittsburgh, USA, and Nancy, France. She also became actively involved with the West End Art Club, and the '63 Society, at NEWCASTLE, helping to found the latter and for some time serving as chairwoman. One-man exhibitions of her work were held at the Calouste Gulbenkian Gallery, NEWCASTLE, in 1965, and the Laing Art Gallery, in 1967; a retrospective was held at the former in 1985, following her death. Apart from her Civil Service work during the Second World War she remained a housewife throughout her career as an artist, living at NEWCASTLE. Rock structures, growing forms and landscapes provided much of the subject matter for her work, which she continued until close to her death in 1984. Represented: Laing A G, Newcastle.

WARD, Gilbert (b.1935)

Sculptor in stone; art teacher. He was born in Yorkshire, and after studying art at King's College (now Newcastle University), held a number of teaching positions before joining Newcastle Polytechnic (now University of Northumbria) to teach sculpture. As well as holding the position of head of sculpture at the Polytechnic until taking early retirement in 1992, he was also involved in several residencies in Northumbria and has been visiting lecturer at a number of art colleges. Ward has exhibited his work widely during his career, and executed commissions for locations throughout Britain. He has had a one-man exhibition at York University, and has participated in many group exhibitions, including the Young Contemporaries, Federation of British Artists' Gallery, London; Peter Stuyvesant Northern Artists, Sunderland Art Gallery and Museum; the Royal Academy; 10 Sculptors, Laing Art Gallery, NEWCASTLE, in 1980; the Tyne Tees Northern Open, in 1983; the 3rd International Contemporary Art Fair, Olympia, in 1986; the Newcastle Group, Laing Art Gallery and Dovecote Arts Centre, STOCKTON-ON-TEES, in 1987; Landscape & Environment, Gray Art Gallery, HARTLEPOOL, in 1988; the Newcastle Group's 'Northern Lights' exhibition, DLI Museum & Art Gallery, DURHAM, and tour, 1990, and Hall of Artists, Moscow, in 1996. His public commissions in Britain have included many in Northumbria and Cumbria. Among these are his *Derwent Valley Sculptures*, 1989, for Medomsley Road Industrial Estate, CONSETT; *Fossilised Insect*, 1994, for a path and road junction in BEAMISH HIGH MOOR, County Durham; *Endless Column*, 1997, for a road junction in SUNDERLAND; *Sleeping Deer* and *Newt*, 1998, for Stephenson Way/Great Aycliffe Way, NEWTON AYCLIFFE, near DARLINGTON, and *Source of the River Tyne*, 2002, near Garrigill, Cumbria. He was also responsible for restoration work on the bronze panels of the South African War Memorial, NEWCASTLE, by Thomas Eyre Macklin (q.v.). A sculptor of work ranging from abstract to organic forms he has said: 'I am most

Gilbert Ward, *Derwent Valley Sculpture (one of three)*, *Consett*, 1989, 2.15m high x 1m x 70cm.
Derwent Valley Foods.

interested in making sculpture for places. It seems to me important that the work is considered for the place it is to occupy.' Several of his works for Northumbria are documented and illustrated in *Public Sculpture of North-East England*, Paul Usherwood, Jeremy Beach and Catherine Morris, Liverpool University Press, 2000. He lives and has his studio near HEXHAM.

WARD, Norman Yendell (1905–1959)

Cartoonist. Ward was born at PAGE BANK, near SPENNYMOOR, and first found employment as a telegraph boy with the Post Office. He later worked as a telegraph pole linesman, but frustrated by his efforts to advance in his work emigrated to Australia at the age of nineteen. The 'Big Brother' scheme under which he had emigrated involved farming under strict discipline, and after a short while he went absent to roam the country for the next eight years. On his return to Britain in 1932 he found it impossible to find work, and decided to try drawing cartoons. He took a correspondence course in commercial art and was soon selling his work to *Tit-Bits* and other popular weekly publications of that kind. He was thirty-one when he got his first comic strip published and within a short time he had carved himself a unique and profitable career as the mainstay of *Film Fun*, after the

death of G W Wakefield. He took over Wakefield's *Laurel and Hardy* strip – a task which he was able to continue even although called up to serve in the Royal Artillery in 1942. He also did strips on George Formby and other currently popular film personalities, and managed to continue in this way for the next fourteen years until just before his death in 1959. Ward's success with *Laurel and Hardy* somewhat overshadowed that in creating several 'characters' of his own invention, including *Stonehenge Kit, the Ancient Brit*, and his work for other publications than *Film Fun*, such as *The Knockout*. His son, Richard Ward (q.v.), is a successful artist and art teacher, and was born in London just at the start of his father's success as a cartoonist in the capital.

WARD, Penny (1914–2005)

Flower and garden painter in oil and watercolour; art teacher. She was born at NEWCASTLE, and at eighteen was accepted as an art student at King's College (now Newcastle University). Financial difficulties made it impossible to take up the offer, and she contented herself working in interior design in a London store. During the Second World War she drove ambulances during the Blitz, this leading to promotion through the ranks to become a Company Commander in the Army Camp, at Catterick, North Yorkshire. During the 1960s she was finally able to resume her interest in art by qualifying as a teacher at Newcastle College of Education, and taking up a position as an art teacher. In 1970 she became head of art, Parkside Comprehensive School, CRAMLINGTON, remaining there until her retirement in 1975. She then took up painting as a relaxation; initially in oil, but later in watercolour, when rheumatoid arthritis made it difficult to work in the former medium. Her flower and garden paintings quickly became popular throughout Northumbria, and have been shown at exhibitions throughout the region, including the Laing Art Gallery, NEWCASTLE, and the city's Hatton, Brown, and MacDonald galleries; the Federation of Northern Art Societies' exhibitions at the Shipley Art Gallery, GATESHEAD, and for many years in association with fellow artists Walter Holmes (q.v.), Joyce Gray (q.v.), Thomas MacDonald (q.v.), and Isabella Horton Havery (q.v.), at their annual exhibition at the Moot Hall, HEXHAM.

WARD, Richard ('Dick') (b.1937)

Mural and decorative painter in various media; printmaker; art teacher. He was born in London, the son of comic illustrator Norman Yendell Ward (q.v.), but moved with his family to GATESHEAD at the age of four. He later became a merchant seaman and served his national service in the Durham Light Infantry before deciding on a career in art by attending the Chelsea School of Art. After teaching part-time at various institutions he in 1977 became senior lecturer in painting at Sunderland Polytechnic (now Sunderland University), living at TYNEMOUTH. He has exhibited throughout his teaching career and completed a number of major mural projects for hospitals and other public buildings in Northumbria.

His one-man exhibitions have included the Serpentine Gallery, London; the Bede Gallery, JARROW, near SOUTH SHIELDS, 1973, and 1986; the Shipley Art Gallery, GATESHEAD, 1973; Sunderland Arts Centre, 1982; Gateshead Library, 1988: the Gallery Bastejs, Riga, Latvia, 2001 and the Central Library, GATESHEAD, 2003. His group exhibitions have included many London, provincial and overseas venues, including John Moores Liverpool Exhibition, 1976; Engelsk Grafikk, Galleri 15, Norway, 1982; Cleveland International Drawing Biennale, MIDDLESBROUGH, 1985; the Newcastle Group's 'Northern Lights' exhibition, DLI Museum & Art Gallery, DURHAM, and tour, 1990, and 'Apmaina', Vardy Gallery, SUNDERLAND, 2002, and tour. Among his mural commissions have been his 30m long *The History of Gateshead*, for the Queen Elizabeth Hospital, GATESHEAD, and another historical mural for the library at PRUDHOE, near OVINGHAM. More recent work has included murals for the Wansbeck Hospital, ASHINGTON, and the Royal Victoria Infirmary, NEWCASTLE. Apart from his teaching and mural work he has developed considerable skill as a printmaker and helped to organise a number of exhibitions in Russia and elsewhere. He lives at TYNEMOUTH, and maintains a studio at CULLERCOATS. [See colour plate]

WARD, William Wightman (1860–1936)

Landscape painter in oil and watercolour; etcher. He was born at NORTH SHIELDS, and left school at the age of twelve to support his family following the death of his father. While later working as a painter and decorator he attended art classes locally, and at the age of seventeen won the Queen Victoria Prize for Flower

William Wightman Ward, *Pandy Mill, Betws-y-Coed*, watercolour, 52.2 x 43.5cm. Anderson & Garland.

Painting. He subsequently became a master painter and decorator with premises in the town, above which he maintained a studio at which various local artists, including John Falconar Slater (q.v.), were regular visitors. He first exhibited his work at the Bewick Club, NEWCASTLE, where typical titles were his *Suffolk Landscape*, and *Marshes near Aldborough, Suffolk*, shown in 1893. He later became an occasional exhibitor at the Artists of the Northern Counties exhibitions at the Laing Art Gallery, NEWCASTLE, sending as his last works, two etchings: *Old Houses, Whitby*, and *Farmstead near Preston*. These were sent from his home at TYNEMOUTH, in 1928.

WASSERMAN, John Conrad (1846–c.1884)

Amateur landscape, coastal and flower painter in oil and watercolour. He was born at SUNDERLAND, the son of a commission agent, and after training under his father, joined Shield, Fenwick & Co, merchants, at NEWCASTLE. While living at NEWCASTLE, he became keenly interested in painting, and after his marriage, settled at CULLERCOATS, from which he sent work for exhibition in the period 1880–82, to the Royal Academy; the Royal Scottish Academy; the Glasgow Institute of Fine Arts; the Dudley Gallery, London, and the Arts Association, NEWCASTLE. His Royal Academy exhibits were *Autumn Beauties* (1880); *Dunstanborough Castle*, and *Summer Sunrise* (1882). It is believed that he died in the early 1880s. He was the husband of writer Lillias Wasserman (b.1848), who contributed articles to the *Art Journal*, and the *Northern Weekly Leader*. One of her articles in the latter, in her series *Where the North Wind Blows*, 1887, was *A Cullercoats Artist*, but does not appear to have referred specifically to her husband.

WATERFORD, Louisa Anne, Marchioness of (Hon. Miss Stuart), HSWA (1818–1891)

Amateur religious, figure, portrait and landscape painter in oil and watercolour. She was born in Paris, the daughter of British Ambassador, Charles, Lord Stuart de Rothesay, and spent her youth in the French capital. At the age of twenty-three she married the 3rd Marquess of Waterford, and spent the next eighteen years at his family home at Curraghmore in Ireland, in the later part of this period occasionally visiting Ford Castle, FORD, which he had inherited from his mother. In 1859 her husband died following a hunting accident, and she retired to Ford Castle, and Highcliffe, on the Hampshire Coast – the latter being an old Stuart family place left her by her mother. Most of her time was spent at FORD, however, where she became deeply interested in painting and began effecting changes to her castle home, and to the neighbouring hamlet. She built a model village just to the east of the castle grounds, a new village school, a blacksmith's forge, and an ornamental cottage, designing the last two buildings herself. Her main artistic activity while at FORD was the decoration of the school, which occupied her from the year after its opening in 1861, until some twenty-one years later. This consisted of what look like murals, but which are actually large watercolours on paper stretched to fit the wall spaces. The themes of

Louisa Anne, Marchioness of Waterford, *The Demon Drink*, watercolour, 18 x 25cm. Private collection.

these works were largely biblical, and the models for many of the figures portrayed were village children and adults who would come and sit for her in her castle studio on Saturdays. Her one-time master John Ruskin was not particularly impressed by his pupil's work, saying 'I expected you would have done something better', but over the years of their completion many distinguished people called to see them including Queen Mary, Mr Gladstone, and Sir Edwin Landseer. After working on decorations for the school for some sixteen years, Lady Waterford began to exhibit her work, from 1877 until her death showing examples at the Royal Hibernian Academy; the Society of Women Artists (which elected her an honorary member in 1877); the Grosvenor and Dudley galleries, London; Manchester City Art Gallery, and the Arts Association, NEWCASTLE. Although an extremely talented artist, she was very modest about her work, once writing: 'I see myself as just an amateur and no more – not altogether bad, but not good.' However, FORD evidently exercised a potent influence over Lady Waterford's dormant talents as an artist, not only encouraging her to paint, but to seek tuition and approval from men like Ruskin, Dante Gabriel Rossetti, and Joseph Arthur Palliser Severn. This resulted in the production of dozens of accomplished watercolours in addition to her impressive work for the school, and many have since been acquired for major public collections. In the year following her death a well-received memorial loan exhibition of her work was held in London, and in 1893 several examples were included in the Royal Academy exhibition of 'Works by the Old Masters'. Further loan exhibitions were held in London, in 1910, and FORD, in 1983. The latter exhibition was held at the Lady Waterford Hall to celebrate the 100th anniversary of the completion of her paintings for the building when it was the village school. Interesting and lavishly illustrated accounts of her life and work may be found in *Under a Border Tower*, by Hastings Mackelcan Neville, 1896, and *Louisa Anne, Marchioness of Waterford*, published in 1991 by

Michael Joicey to mark the centenary of her death. When Lady Waterford died at FORD she was buried in the graveyard of St Michael's Church, in the castle grounds. Her grave is marked by a great recumbent cross designed by George Frederick Watts, who painted her portrait in 1838, and remained friendly with her throughout her life. The Church contains a traceried stone reredos, which was erected in her memory by subscription from the 'rich and poor'. Her greatest memorial, however, is her series of magnificent and still little-known paintings for the village school. Represented: British Museum; Laing A G, Newcastle; National Gallery of Scotland; Tate Gallery; Victoria and Albert Museum. [See colour plate]

WATERS, Brian (b.1930)

Landscape painter in gouache and watercolour; illustrator; art teacher. Waters was born at Leeds, and studied at Leeds College of Art before taking up a teaching position at his birthplace in 1955. He later taught at Ripon, then took up a position as lecturer at Northumberland College of Education, remaining there until 1980. Since leaving the College he has practised as a freelance graphic designer and exhibited his work widely in Northumbria, mainly showing landscapes, with a particular interest in architecture. He is a founder-member of the Tynedale Artists' Network, has participated in its annual open studios 'Art Tour' for several years, and has also edited its network newsletter. His drawings have been reproduced in various Northumberland National Park publications, and he was one of the several artists, together with Birtley Aris (q.v.), whose work was included in the 'Church Outing' exhibition which toured Northumbria in 2001–2002, featuring rural churches, chapels and other places of worship. His wife, MARGOT WATERS, also participated in this exhibition, showing examples of her work in fabric collage, and material embroidery. He lives at HEXHAM.

WATERS, Ralph, Senior (1720–1798)

Landscape and architectural painter in oil and watercolour; draughtsman; scenic painter. Waters was born at NORTH SHIELDS, the son of a gardener, and practised as a professional artist in his native town for several years before moving to NEWCASTLE. In 1782 we find him being described in the *Newcastle Chronicle* for February 23rd of that year, as having been responsible for all the scenes painted for a presentation at the New Theatre, of the pantomime 'Robinson Crusoe, or the Harlequin Friday', in a 'most masterly fashion', while *Whitehead's Directory* of 1787 for the town, describes Waters and his son, Ralph Waters, Junior (q.v.), as 'Painters in General, Bigg Market'. Waters Senior exhibited his work on only one occasion, this being when he sent *A View of the Remains of Tynemouth Monastery taken in the year 1742*, to the Royal Academy in 1785. Several of his paintings were, however, engraved for Brand's *History of Newcastle*, these including *Tynemouth Priory*; *View of the Port of Tyne with Clifford's Fort*; *St Nicholas' Steeple*, and *View of the Remains of the Tyne Bridge*. The work by

Brian Waters, *Thockrington Church, Northumberland*, gouache, 10.5 x 15cm. Private collection.

which he is best remembered is his view of the Sandhill, NEWCASTLE, showing the Guildhall in the early morning, with the figures of several well known local people. Waters Senior, and Junior, were close acquaintances of Thomas Bewick (q.v.) and there is evidence in the latter's account books of work undertaken on each other's behalf. Another of Waters' sons, HENRY WATERS (c.1759–1833), was artistically gifted, and though mainly occupied as a picture and print dealer, occasionally executed drawings, as with his drawing of St Nicholas' Steeple, after his father, for Brand. Waters Senior died at NEWCASTLE, and is buried under the porch of the city's St Andrew's Church.

WATERS, Ralph, Junior (1750–1817)

Landscape and architectural painter in watercolour; draughtsman; drawing master. The eldest son of Ralph Waters, Senior (q.v.), he was probably born at NEWCASTLE following his father's move to the town from NORTH SHIELDS. He evidently worked closely with his father from his adolescence, sharing a studio with Waters Senior, in the town's Bigg Market, where *Whitehead's Directory* for 1787 not only describes them as 'Painters in General', but shows Waters Junior, as 'Teacher of Drawing, Pilgrim Street'. Waters Junior was, indeed, a prolific draughtsman, and began exhibiting his work at the Royal Academy a year before his father, in 1784, showing *The new bridge*

357

Ralph Waters, Senior,
St Nicholas, Newcastle, from
the South East,
oil, 79 x 88cm.
Tyne & Wear Museums,
Laing Art Gallery.

from the south, with a view of Newcastle upon Tyne, and three other topographical works. He again exhibited at the Academy in 1785, showing two topographical, and two architectural, drawings, but following this it would appear that much of his time was taken up with teaching drawing at the school for young ladies kept by his Edinburgh-born wife, at Pilgrim Street, or preparing drawings for reproduction, thereby leaving him little time to concern himself with exhibiting. He died at NEWCASTLE, and is buried in the interior of the city's St Andrew's Church, where a tablet still stands in his memory. His younger brother HENRY WATERS (*c*.1759–1833), was also artistically gifted.

WATERSONE, James S (fl. early 20th cent.)
Landscape and coastal painter in oil and watercolour. Watersone practised as an artist at NEWCASTLE in the early 20th century, and regularly exhibited his work at the Artists of the Northern Counties exhibitions at the city's Laing Art Gallery, from their inception in 1905, until 1922. In the period 1904–10 he also showed one work at the Royal Scottish Academy, and one work at the Walker Art Gallery, Liverpool.

WATERSTON, George Anthony (c.1855–c.1918)
Landscape, coastal and marine painter in oil and watercolour. He was born at NEWCASTLE, and later practised as a professional artist on Tyneside. He exhibited his work at the Arts Association, NEWCASTLE, from 1878, the city's Bewick Club from 1884, and the Artists of the Northern Counties exhibitions at the Laing Art

Gallery, NEWCASTLE, from their inception in 1905, until 1911. About 1909 he moved to Wreay, near Carlisle, where he is believed to have spent the remainder of his life. His exhibits included: *Sunrise* (Arts Association, 1879); *Entering the Harbour* (Bewick Club, 1893), and *Winter, Cumberland* (Artists of the Northern Counties exhibition, 1908).

WATKINS, Mrs Kate (fl. late 19th cent.)
Amateur landscape and genre painter in oil. She exhibited three works at the Royal Academy; two works at the Glasgow Institute of Fine Arts, and two works at the Grosvenor Gallery, London, while living at DURHAM, in the second half of the 19th century. Her works were shown 1850–1888.

WATSON, Aaron (1850–1926)
Amateur landscape painter in watercolour. Watson was born at Fritchley, Derbyshire, and after taking up journalism at an early age spent some twenty-eight years on Tyneside following the profession in the late 19th century. During this time he became sole editor and proprietor of the *Newcastle Critic*, and in this capacity received a grateful letter from John Ruskin when he published an appreciation of the now famous art critic's work when Ruskin was still unknown and greatly misunderstood. While on Tyneside he was also connected with the *Daily Chronicle*, edited the *Shields Gazette*, and finally the *Newcastle Daily Leader*. Throughout his stay he took a keen interest in art, and formed friendships with several local artists. Among these were George Edward Horton (q.v.), and Robert

George Anthony Waterston, *Shipping at the Mouth of the Tyne*, oil, 49 x 75cm. Dean Gallery.

Jobling (q.v.), for both of whom he was also instrumental in obtaining work. While he was editor of the *Shields Gazette* he commissioned Horton to illustrate his publication, *South Shields: A Gossiping Guide*, of 1892, and for Jobling he obtained several illustrative commissions both before and after he left Tyneside. He also took a keen interest in promoting the arts, serving as the first president of the South Shields Art Club, on its foundation in 1891, and first president of the Pen & Palette Club, NEWCASTLE, in 1900. His work as an amateur watercolourist is little known; the Pen & Palette Club has long owned his *Cornstooks in landscape*, and he was a contributor to an album of watercolour views of NORTH SHIELDS, and TYNEMOUTH, presented to Joseph Spence JP, Liberal candidate to TYNEMOUTH at the general election of 1885, which album was sold by auction at Anderson & Garland, NEWCASTLE, in 1991. Other contributors to the album included professional artists Jobling, and Henry Hetherington Emmerson (q.v.). Watson is best remembered for the earliest biography of John Wilson Carmichael (q.v.), printed in Richard Welford's 1881 edition of the artist's *Pictures of Tyneside*. On moving to London c.1902, he worked on the *Pall Mall Gazette*, and the radical newspaper the *London Echo*. He also wrote articles for the *Magazine of Art*, among these *The Coaly Tyne*, illustrated by Jobling. He was a member of the London Sketch Club, and retained an interest in drawing and painting until his death in 1926. The Pen & Palette Club has his portrait in oil by one-time fellow club member, Arthur Hardwick Marsh (q.v.).

WATSON, Frederick ('Fred') (b.1937)

Sculptor in stone and wood; draughtsman; art teacher. Born at DUNSTON, near GATESHEAD, Watson studied art at King's College (now Newcastle University), where his awards included a Christie Memorial Prize and a Hatton Scholarship. In 1965 he was appointed to teach sculpture at Newcastle Polytechnic (now University of Northumbria), remaining there until 1989 when he took early retirement to concentrate on the increasing demand for his work as a sculptor. He first began exhibiting his work at the outset of his teaching career, showing examples with the Newcastle Group from 1965–1967, and at the Northern Sculptors exhibition, Shipley Art Gallery, GATESHEAD, in 1967. He has since participated in many other group exhibitions and enjoyed several one-man exhibitions. The former have included 'Wood', at the Yorkshire Sculpture Park, and 'The Craft of Art', Walker Art Gallery, Liverpool, in 1979; 'Wood' at the Sunderland Art Centre, and tour, 1981; 'Alternative Tate', at the Paton Gallery, London, 1982; 'Still Life', at the Harris Art Gallery, Preston, in 1985; the Newcastle Group's 'Northern Lights' exhibition, DLI Museum & Art Gallery, DURHAM, in 1990, and tour; the Air Gallery, London, in 1998, and at Eastnor Castle, Herefordshire in 2001. His first one-man exhibitions were held in 1980, at the Nevill Gallery, Llanelli Festival; Sunderland Arts Centre, and the Moira Kelly Gallery, London, others following at Gainsborough's House, Sudbury, in 1985, and the Scottish Sculpture Workshop, in 1990. He has also executed many public and private commissions in his career, among the former his *Bookstack*, 1992, for the

Frederick Watson, *Bookstack, Northumberland Road, Newcastle*, 1992, granite, 2.3m high x 74cm x 60cm. University of Northumbria.

exterior of the Ellison Building, Northumberland Road, NEWCASTLE; *Inside-out*, 1995, for the Tranwell Unit, Courtyard Within, Windy Nook Road, GATESHEAD; the *Way-markers and Seat*, for the Riverside South pathway, CHESTER LE STREET, 1996, and a further example of what he terms his 'still lifes', for Wingfield Art Centre, Suffolk, 2001. All of the commissions described were executed in granite, one of his favourite materials. His skill in its use was recognised by his Granite-carving Fellowship at the Scottish Sculpture Workshop, in 1990. Other recognitions for his work generally include a Northern Arts Bursary, awarded in 1991. He has lived at BIRTLEY, near HEXHAM, for many years and is a member of the Tynedale Artists' Network. Examples of his work are located in many public places throughout Britain and are held in several public and private collections.

WATSON, Hugh Thomas (fl. 19th cent.)
Landscape, figure, animal and sporting painter in watercolour; engraver; lithographer. This artist first practised at ALNWICK, from which he exhibited several landscape works at the Northern Academy, and the Northern Society of Painters in Water Colours, NEWCASTLE 1828–30. By 1833 he had moved to NEWCASTLE, where he continued in membership of the Society of Painters in Water Colours, and also became a member of the Newcastle Society of Artists. He was a regular contributor to the exhibitions of both of these societies, and also showed works at the exhibitions of the various art promoting organisations which flourished at NEWCASTLE in the 1830s, but he appears to have worked increasingly as an engraver and lithographer towards the end of this period, and on into the 1840s. His watercolour work consisted of Northumbrian and Scottish views, and a small number of animal and sporting subjects, such as his *Newcastle Races*, which is reproduced in colour as an engraving, in *Historic Newcastle*, by Frank Graham, 1976.

WATSON, James (1851–1936)
Landscape and figure painter in oil and watercolour; art teacher. Watson was born at NEWCASTLE, the son of a coachsmith and was educated locally before attending the South Kensington School of Art. On completing his training at the School he was appointed art master at Newcastle Grammar School and also became art inspector for Durham County Education Authority. He held art classes in connection with the Newcastle Municipal Evening School and at SOUTH SHIELDS, and served as vice president of the Bewick Club, NEWCASTLE. Watson was a regular exhibitor with the Club from its inception, and later the Artists of the Northern Counties exhibitions at the Laing Art Gallery, NEWCASTLE. In 1900 he sent one work to the Royal Academy, *A Cottage Garden*, and by 1903 he had started to exhibit with the Staithes Art Club, at Staithes, North Yorkshire, an area to which he had long been attracted. One of his earliest exhibited works was a study of *Old Whitby*, shown at the 'Gateshead Fine Art & Industrial Exhibition', GATESHEAD, in 1883, and on his retirement from the Newcastle Grammar School in 1919 he and his wife moved from Tyneside to Hinderwell in North Yorkshire, where he continued to paint, mainly at nearby Runswick Bay, until his wife's death in 1930. He then moved to live with his family at CULLERCOATS, but on his death was buried at Hinderwell. Watson was the great-great-nephew of John George Brown (q.v.).

WATSON, James Finlay (1898–1981)
Amateur landscape painter in oil and watercolour; commercial designer. Born at SOUTH SHIELDS, Watson moved to SUNDERLAND in 1906, where he later studied art at the evening classes run by the town's School of Art. He enlisted in the Army in the First World War, and although deprived of an eye while in action he subsequently worked for the local Gas Board for fifty years as advertising and display officer, and was able to follow his spare-time relaxation of painting and drawing. He was for many years a member of the Sunderland Art Club, and exhibited his work widely in the North East and in the Midlands, examples being shown at the Artists of the Northern Counties exhibitions at the Laing Art Gallery, NEWCASTLE, and the 'Contemporary Artists of Durham County' exhibition at the Shipley Art Gallery, GATESHEAD, staged in 1951, in connection with the Festival of Britain. Following his retirement he devoted himself entirely to art, and enjoyed one-man exhibitions of his work at Sunderland Art Gallery in 1966, and at WASHINGTON, near SUNDERLAND in 1980. Represented: Sunderland A G.

James Finlay Watson, *Derwent Valley Farm*, 1947, watercolour, 28 x 38cm. Tyne & Wear Museums, Sunderland Art Gallery & Museum.

WATSON, Mary (1875–1925)

Amateur portrait, figure and landscape painter in oil and watercolour; draughtsman. She was born at NORTH SHIELDS, the daughter of iron merchant James Watson. She was a talented artist from her childhood, and following tuition from several local artists she began to exhibit her work at the Walker Art Gallery, Liverpool, and the Bewick Club, NEWCASTLE. She later exhibited at the Artists of the Northern Counties exhibitions at the Laing Art Gallery, NEWCASTLE, contributing nine black and white drawings to the first exhibition in 1905, and a number of Continental and British landscapes, to subsequent exhibitions. She was a cousin of Ernest Procter (q.v.).

WATSON, Robert (1755–1783)

Historical, portrait and genre painter in oil. Watson was born at NEWCASTLE, and began his career in art by being apprenticed to a coach painter in the town. His master's mismanagement of the business led to its downfall, however, and Watson left NEWCASTLE, and travelling to London secured admission to the Royal Academy Schools. Here he is said to have been a model student, working hard at mastering anatomy and perspective, drawing copiously from the Antique, and visiting every collection of pictures to which he could gain access. In 1778 he was awarded the Gold Medal or Pallet of the Society for the Encouragement of Arts for the best historical drawing of the year, and showed six works at the Royal Academy, which included both portraits and historical subjects. Encouraged by this success he decided to branch out into art criticism, and in the spring of 1780 published *An Anticipation of the Exhibition of the Royal Academy*, a brochure in which he described 'with piquancy and force some well-known performances of eminent contemporary painters'. The brochure was so well received that he quickly became befriended by many of London's most influential men – among these Sir William Fordyce, Dr Samuel Johnson, and Sir Joshua Reynolds. Although settled in London, Watson paid visits to his birthplace every year. On one such visit he read of a controversy being conducted between a Dr Priestley and a Dr Price on 'Materialism'. He became so interested in this subject that in 1781 he published *An Essay on the Nature and Existence of the Material World*, a volume addressed to the two doctors. Shortly after its publication he obtained for himself an appointment as an engineer to the British Army in India, and arriving there in 1783, assisted in the defence of Fort Osnaburgh. The British garrison at the Fort was obliged to capitulate, but on 'honourable terms' obtained by Watson. He died shortly afterwards, following an attack of fever.

WATSON, Robert F (1815–1885)

Marine, coastal, landscape and portrait painter in oil and watercolour. Watson was born at NORTH SUNDERLAND, the son of a lighthouse keeper on the Inner Farne Islands, and is said to have been artistically talented from his youth, gaining a silver epergne from the Duke of Northumberland for his work when he was only in his teens. He later moved to NEWCASTLE, where he received tuition from Thomas Miles Richardson, Senior (q.v.), and later John Wilson Ewbank (q.v.), before practising as a professional artist in the town. He first exhibited his work at NEWCASTLE, showing his *The remnant of a wreck*, at the Newcastle Society of Artists' exhibition in 1836. He remained at NEWCASTLE until the early 1840s, meanwhile continuing to exhibit his work in the town, and finding a friend and patron in Tyneside poet and

Robert F Watson, *Vessels in King Edward's Bay, Tynemouth*, oil, 32.5 x 47cm. Anderson & Garland.

sailmaker, Robert Gilchrist (1797–1844). Watson and Gilchrist made several excursions in a vessel named the *Vesta*, in which the latter had an interest, calling at the Farne Islands, and Edinburgh, the poet later commissioning his friend to paint *The Vesta passing the Bass Rock*, and what is believed to have been the only portrait of Grace Darling ever executed in oil, from life. After Gilchrist's death in 1844, Watson went to London, where he commenced exhibiting at the Royal Academy and the Suffolk Street Gallery in 1845, and the British Institution in 1846. London appears to have remained his base for the next twenty years, during which period he regularly exhibited at the establishments just named, mainly showing shipping, coastal and landscape scenes, including his *Erebus and Terror under the command of Sir John Franklin, leaving the coast of Britain, on the Arctic expedition in 1845* (Royal Academy, 1849); *A Squall, the return to Shields* (British Institution, 1856), and *A Stream from the hill above Rothbury* (Suffolk Street Gallery, 1862). The last named work was exhibited by Watson during a period of residency at TYNEMOUTH, a place at which he appears to have spent much time from the early 1850s. About 1865 he settled at SOUTH SHIELDS, spending the remainder of his life in the town, and exhibiting only on Tyneside, where examples of his work were shown at the Arts Association, NEWCASTLE, from 1878, and at the city's Bewick Club, at its inaugural exhibition in the year before his death. In 1911 his works *Thrum*

Mill, Rothbury; *Sketches*; *Rainbow*, and *Table Rocks, Whitley Bay*, were shown at the South Shields Arts Club Exhibition. Represented; Grace Darling Museum, Bamburgh; Laing A G, Newcastle; North Tyneside Public Libraries; Sunderland A G.

WATSON, William Peter, RBA (d.1932)
Genre and landscape painter in oil; art teacher. He was born at SOUTH SHIELDS, and studied at the Royal College of Art, and at the Académie Julian, Paris, before practising as a professional artist and art teacher in London. He first began to exhibit his work shortly after settling in the capital, showing his *Topsy*, and *Sweet pale Margaret*, at the Royal Academy, in 1883. Later, he commenced exhibiting at the Royal Society of British Artists; the Royal Institute of Oil Painters; the Royal Birmingham Society of Artists, Birmingham; the Royal Hibernian Academy, and widely in the provinces, including the Walker Art Gallery, Liverpool, Manchester City Art Gallery, and the Bewick Club, NEWCASTLE. He showed some seventy-seven works at the Royal Society of British Artists, and was elected a member of that body in 1891. During the early part of his career in London, Watson was in charge of evening classes at the Royal College of Art, and established a considerable reputation for his work as a painter. After the turn of the century, and while continuing to exhibit in Britain, he showed work widely abroad, and several examples were purchased for overseas collections. His later

362

Royal Academy exhibits included *Day Dreams* (1889); *A Village Belle* (1897), and *When the Heart is Young* (1901). Typical exhibits at the Royal Society of British Artists were *In Sight at Last*; *A Master Mariner*; *Sunny Days*, and *An East Anglian Port*. He was a gold medallist at the Hobart International Exhibition, and participated in the Japan-Britain Exhibition, 1910, among several other overseas exhibitions. He lived at Bosham, Sussex, in his later years, dying there in 1932. His first wife, MARY WATSON (née Godfrey), was also a professional artist. Represented: National Gallery, Hobart, Tasmania, and various British and overseas collections.

WATTS, Mrs Jane (née Waldie) (1792–1826)
Amateur landscape and architectural painter in oil and watercolour; illustrator. She was the daughter of George Waldie, one of whose three homes was Forth House, NEWCASTLE. Here he, and his family, spent a great part of each year, and became friendly with the family of Thomas Bewick (q.v.), while they were living nearby. It is doubtful that Jane Waldie was born at NEWCASTLE, but she is known to have spent the first five summers of her life at TYNEMOUTH, and to have attended a boarding school at NEWCASTLE until the age of fifteen. She then attended an academy at Edinburgh, where she showed such an aptitude for drawing and painting that her father later took her on a tour of the great galleries of Italy and France, and the picturesque scenery of Switzerland and Southern Germany. On returning to England she developed into an accomplished though retiring amateur painter of landscapes and architectural pieces, contributing several works in these categories to the Royal Academy and the British Institution anonymously, until 1817, when she showed at the latter her *Tower of the Fair Gabrielle . . .*; *The Tomb of Rouseau . . .*, and *View on the coast of Northumberland; rising gale*. She again declared her name when showing her *View of Lake Albano, near Rome*, at the Royal Academy, in 1820, maintaining this practice while exhibiting at NEWCASTLE, following her marriage in 1821 to Captain George Edward Watts R N. Her brief married life was spent at Langton Grange, near DARLINGTON, where she died in 1826. Most of her exhibits at the Northumberland Institution for the Promotion of the Fine Arts 1822–1826, were Continental subjects. In addition to being an accomplished artist she was an able writer, and published at least three books.

WATTS, Kenneth (b.1932)
Urban and rural landscape painter in oil. He was born in London and although he showed a strong aptitude for drawing from an early age, and was offered a place at an art school in the capital, began work at fourteen in a Croydon shoe shop. While working there until national service at eighteen, he attended evening classes at Croydon Art School, but all but abandoned painting while serving in the army in Egypt, Kenya and Germany over the next five years. A similar situation prevailed on his return to work in London, and it was not until his marriage, and move to JARROW, near SOUTH SHIELDS, in 1961, that he began painting

seriously. His main preoccupation became urban landscape, and over the next twenty-five years he drew or painted some 200 images of JARROW, the first of which he exhibited at the Royal Institute of Oil Painters in 1969. In the following year twenty of his drawings of JARROW were shown at its twin-town, Epinay, in France, since when he has participated in many other group exhibitions, enjoyed several one-man exhibitions, and been awarded a number of prizes. His group exhibitions have included the First International Drawing Biennale, MIDDLESBROUGH, 1973; the Portland Gallery, 1973; the South Tyneside Open Art Competition, Bede Gallery, JARROW, 1989, and the Silver Longboat Competition, DARLINGTON, 1998. Among his one-man exhibitions have been those at the Moot Hall, HEXHAM, in 1972; the Serpentine Gallery in 1975; the Delagay Gallery, Cirencester, in 1979; the Bede Gallery, JARROW, 1991 and 1996, and the Customs House Gallery, SOUTH SHIELDS, in 1995. His awards and prizes have included several from Northern Arts, and other regional arts organisations. Although initially attracted to urban landscapes, Watts has, since his retirement in 1997 as a joiner, travelled widely in Northumbria and Cumbria in search of other subjects. This broadened interest in subject matter was reflected in his travelling exhibition *Coast to Coast*, shown at the Harbour Gallery, Whitehaven, Cumbria; the Customs House Gallery, SOUTH SHIELDS, and the Bluebell Gallery, NEWCASTLE, in 1999, and in his *Town & Country* exhibition, at the Mall Gallery, CROOK, in 2001. His home since 1989 has been at HEBBURN, near GATESHEAD. His work is represented in many public and private collections and has sometimes been compared with that of American artist Edward Hopper (1882–1967). [See colour plate]

WAY, William Cosens (1833–1905)
Landscape, coastal and genre painter in watercolour; art teacher. Way was born at Torquay, the son of an artist, and studied under his father until he was twenty-four. He then went to London, where he was persuaded by the fruit painter Leitch, to take his art master's certificate at South Kensington School of Art, meanwhile supporting himself by painting. After six years he obtained his certificate, and was recommended by the authorities at South Kensington, to their counterparts at NEWCASTLE, for a position as assistant master at the town's Government School of Design. Way took up his post in January, 1862, and when William Bell Scott (q.v.), two years later resigned the directorship of the School, his assistant assumed this role, retaining it for the next thirty-two years. About the same time as taking over from Scott, Way also assumed responsibility for the directorship of the School of Art at SUNDERLAND, holding this position until 1889, when his school at NEWCASTLE became affiliated to the Durham College of Physical Science. He was also for some time master of art classes at NORTH SHIELDS, and at the Grammar School at NEWCASTLE, eventually retiring from all his official teaching duties in 1895, on an annuity from the College. After leaving the School of Art, as it had then become, he practised as an artist and art teacher

William Cosens Way, *Whitby Steps*, watercolour,
45 x 23cm. Tyne & Wear Museums, Shipley Art Gallery.

at NEWCASTLE until his death. Way's influence as
an artist while he taught at NEWCASTLE was, in terms
of landscape painting, second only to that exerted by
Thomas Miles Richardson, Senior (q.v.), in the first
half of the century, and like his predecessor was
mainly in the medium of watercolour. His work
was shown widely in his lifetime, examples appearing
at the Royal Academy from 1867 until his death, and
at the New Water Colour Society (later the Royal
Institute of Painters in Water Colours); the Suffolk
Street Gallery, and at various London and provincial
galleries, for several long periods in between. He
also exhibited his work on Tyneside, showing
examples at the Arts Association, NEWCASTLE,
from 1878–1882, the 'Gateshead Fine Art & Industrial

Exhibition', in 1883, and the Bewick Club, NEWCAS-
TLE, from 1884 until the turn of the century. Ten of his
works were included in the first Artists
of the Northern Counties exhibition at the Laing
Art Gallery, NEWCASTLE, in 1905, a few weeks
after his death at his home in the city's St George's
Terrace. Represented: British Museum; Victoria
and Albert Museum; Hatton Gallery, Newcastle;
Laing A G, Newcastle; Shipley A G, Gateshead;
Sunderland A G.

WEDDELL, William (d.1878)
Cattle and landscape painter in oil; copyist. An
example of this artist's work appeared at the exhibi-
tion of works by local painters at the Central
Exchange Art Gallery, NEWCASTLE, in 1878, a note in
the catalogue of the exhibition commenting: 'W.
Weddell, a well known artist, who departed this life
during the present year, is the producer of No. 259;
this work displays fine feeling; cattle, men and trees,
all displaying the effects of wind and drenching rain.
Weddell was known among the cognescenti as the
'Morland of the North', his fidelity in copying nature
so true to the original that it was difficult to distin-
guish between Morland and Weddell-Morland'.
Nothing more is known of this artist, except that he
was a friend of John Wilson Ewbank (q.v.), in the
latter's later days on Tyneside, and that his name
appears in trade directories related to NEWCASTLE in
the 1860s as a professional artist working in the town.
A genre work, *The long grace*, was loaned to the
'Exhibition of Paintings and other Works of Art', at
the Town Hall, NEWCASTLE, in 1866, and described as
by 'Weddell'.

WEIR, Stephen (1818–1881)
Landscape painter in oil; art teacher. He was born at
NEWCASTLE, and according to his obituary in a local
newspaper, spent his early life as a shoemaker in the
town. He had been interested in painting from his
youth, however, and eventually abandoned his trade to
become a teacher at the Government School of Design,
NEWCASTLE. After leaving his teaching post he became
a full-time professional artist. Weir exhibited his work
sparingly, showing one example at the exhibition in
1852 at NEWCASTLE, staged jointly by the North of
England Society for the Promotion of the Fine Arts, and
the town's Government School of Design, and another
at the Arts Association exhibition in 1878. His obituary
claimed that he 'attained considerable eminence as an
artist', but like his son William Weir (q.v.), he does not
appear to have exhibited outside Northumbria. He may
have been related to the WILLIAM WEIR (d.1865),
who practised at NEWCASTLE in the middle of the
19th century, before moving to London, where he
established himself as a successful genre painter.

WEIR, William (1840–1881)
Landscape painter in oil. The eldest son of Stephen
Weir (q.v.), he was born at GATESHEAD, and became a
professional artist at NEWCASTLE, following some
tuition from his father. He appears to have exhibited
his work exclusively at NEWCASTLE, where among his

few known exhibits were the works he sent to the Arts Association exhibitions from 1878, until his death in 1881. A landscape work by him was, in fact, on display at the 1881 exhibition when he died, this being his *Head of Loch Achray*. He was about to take up a professional appointment in London when he died. His father predeceased him by only a few months. He may have been related to the WILLIAM WEIR (d.1865), who practised at NEWCASTLE in the middle of the 19th century, before moving to London, where he established himself as a successful genre painter.

WELCH, George W (1853–1906)
Amateur genre painter. Welch was for some twenty-eight years lay clerk to Durham Cathedral, but was throughout his life a keen amateur artist. He exhibited his work at the Bewick Club, NEWCASTLE, while living at DURHAM, showing several works associated with the Cathedral, among these *A Doorkeeper in the House of the Lord* (1890), and *A Chorister Wanted* (1891). He retired to NEWCASTLE at the early age of fifty-two, and died in the following year at GOSFORTH, near NEWCASTLE. Welch was a tenor singer of exceptional talent, and was an associate of the Royal College of Music.

WELLS, Timothy Waite (1942–1998)
Marine and landscape painter in oil and watercolour; art teacher. He was born at Greenwich, Connecticut, USA, a member of a family with long connections with the sea, and first studied art at Hartford Art School, in his native state. He later studied portraiture under Felix Dicassio, at the Phoenix School of Art, New York, and went on to continue his studies at the Porto Romano School, Florence, and at various locations in other countries, including England, France and Spain. A keen yachtsman with eventually exten-

sive experience in racing and cruising in English and North American waters, and a representative of the USA in world and international dinghy racing, Wells inevitably became interested in painting his sport in all its variety. He quickly established a reputation for his work and showed it widely in the USA. He had his first one-man exhibition at the Bruce Museum, Greenwich, in 1972, and examples were included in exhibitions of the Stamford Art Association 1973–4; at Essex, Connecticut, 1975; Greenwich Library, 1977, and on a continuous basis at the Crossroads of Sports Art Gallery, New York. Both before, and for some years after his marriage in the USA in 1966, Wells had lived in Hampshire, England. In 1985, however, he moved to KIRKWHELPINGTON, near CAMBO, and here began to vary his output of marine work by painting watercolours of Northumbrian scenery, and together with his wife Hilary, providing painting holidays with himself as tutor. Among his landscape work was a series of studies of Northumbrian castles. Wells sold his work widely in the locality, and also held a number of one-man exhibitions at HEXHAM, the first of which was at the Moot Hall, in 1988. A memorial exhibition was held at the Queen's Hall, HEXHAM, following his death in 1998, in which a wide range of his work was included, from sketches to finished oils. His daughter HEDLEY WELLS (b.1971), is also a talented artist. Many examples of his work are held in collections in Britain and the USA.

WELSH, David (b.1942)
Landscape painter in various media. He was born at NEWCASTLE and studied art at Northumbria University before taking up a career in sales and marketing. In 1997 he decided to become a full-time professional artist and in that year took part in group exhibitions at

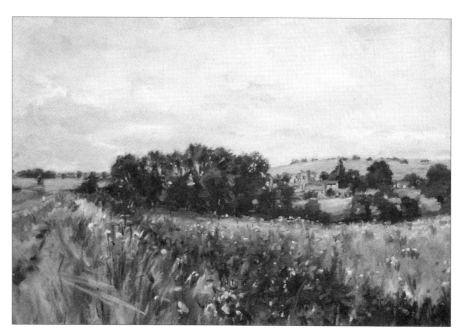

Timothy Waite Wells,
Kirkwhelpington,
Northumberland,
oil, 51 x 76cm.
Private collection.

the Dean Gallery, and the Hatton Gallery, NEWCASTLE, and enjoyed his first one-man exhibition at Narbonne, France. He has since shown his work in a number of other group and one-man exhibitions in Britain and France, among the former Browns Gallery, NEWCAS-TLE, in 1981, and the latter Antibes, France, in 1998 and 1999, and Lacoste, France, in 2000. For some years until its closure in 2002 he also showed his work at a gallery at NEWCASTLE owned with fellow artist ALAN REED (b.1961), son of Kenneth Reed (q.v.). Welsh's work has been very much influenced by that of the Impressionists and has involved him in several long visits to France to paint its landscapes. Many examples of his work have been reproduced as limited edition prints and are represented in private collections around the world. He lives at GATESHEAD and now has a gallery and studio in NEWCASTLE. [See colour plate]

WELSH, William (b.1870)

Landscape and still life painter in oil and watercolour. Welsh was born at Edinburgh, but lived from his early childhood, until the outbreak of the First World War, at NEWCASTLE. He first exhibited his work while studying at the School of Art, NEWCASTLE, showing several examples at the exhibitions of the Bewick Club. He later exhibited at the Artists of the Northern Counties exhibitions at the city's Laing Art Gallery, and on moving to Middlesex by 1919, commenced exhibiting at the Royal Academy; the Royal Institute of Painters in Water Colours; the Paris Salon, and various London and provincial galleries. The Laing Art Gallery has his watercolour, *Entrance to Fowey Harbour*.

WHARTON, Elizabeth (1757–1829)

Amateur botanical and landscape painter in watercolour. She was born at Old Park, near SPENNYMOOR, the daughter of Thomas Wharton MD, member of an old County Durham family of physicians. Her work was virtually unknown to the art world until the sale at Bonhams, London, in 1995, of a collection of her landscapes produced about 1812, and featuring North East of England and Lake District scenes in watercolour. Among these were a panoramic view of NEWCASTLE and GATESHEAD from a point just west of both, and a view of RYTON, near GATESHEAD, from the River Tyne a mile east of the village. Subsequent research indicates that she probably began painting and drawing in her youth and received instruction from a professor of art from York. This arrangement was possibly made through the famous poet Thomas Gray, who was a long-standing friend of her father, and acquainted with the professor. Much of her topographical work was executed in monochrome, but her early interest in botany led her to produce many detailed colour illustrations of British plants, which she privately assembled into several folio volumes. She spent much of her later life in DURHAM, where she died in 1829. She was buried in the graveyard of St Mary the Less, South Bailey, DURHAM. Her brother, Richard Wharton, was MP for DURHAM, 1802–04, and 1806–20.

WHEATLEY, Cecil Ross (1892–1967)

Landscape painter in watercolour; cartoonist; illuminator; art teacher. He was born at CHESTER LE STREET, the son of artist JAMES WHEATLEY, and descendant of Francis Wheatley, the Royal Academician famous for his *Cries of London*. Educated at Bede College, DURHAM, where he obtained his teaching certificate. Wheatley taught at a council school near his birthplace, then became an art master at his old College, and an assistant at the Boys' Model School, which then stood in its grounds. When the Model School closed he became art master at Whinney Hill School, DURHAM. He was later appointed headmaster of Neville's Cross Junior School in 1936. He terminated his connection with Bede College in 1950 after thirty-six years' service. In 1957 he retired from his post at Neville's Cross Junior School, where he served for twenty-one years. A pupil in his youth of Frank Thompson (q.v.), Wheatley retained a lifelong interest in watercolour painting, many of his works featuring Northumbrian and Lake District views. He was president of the Durham & District Artists Society from its foundation in 1941, until his death. One of his particular friends was Ralph Johnson (q.v.), with whom he was co-founder of the Society. Wheatley exhibited at the Artists of the Northern Counties exhibitions at the Laing Art Gallery, NEWCASTLE, for more than quarter of a century, and every year with the Durham & District Artists Society until its dissolution in 1967. Besides painting in watercolour, Wheatley was an accomplished illuminator and cartoonist. He died at DURHAM. Represented: Durham Old Town Hall.

WHEATLEY, Lawrence ('Laurie') (1907–1982)

Landscape, figure and surrealist painter in oil and watercolour; sculptor; draughtsman. Wheatley was born at SOUTH SHIELDS, and worked as a plasterer on Tyneside until the outbreak of the Second World War, when he was sent to prison at DURHAM as a conscientious objector. A keen artist from his youth he used his time in prison to produce a number of drawings of life in the institution, continuing this interest in art when he was released to carry out essential war work on the land. This included works of sculpture as well as paintings, examples of which he sent to the Artists of the Northern Counties exhibitions at the Laing Art Gallery, NEWCASTLE. During the latter part of the War, and for some time subsequently, he worked in London on blitzed buildings, also in his spare time painting, sculpting and indulging in a lifelong interest in photography. His work as an imaginative and versatile sculptor soon attracted the interest of film-makers, and he was later employed to produce a variety of models for sets all over the world, including a giant dragon for *The Purple Plain*, starring Gregory Peck, (shot in Ceylon in 1955). Other commissions included work for Walt Disney and other major film makers. In 1971, Wheatley, together with Tyneside-based filmmaker Murray Martin, visited Vincent Rea (q.v.), at the Bede Gallery, at JARROW, near SOUTH SHIELDS. Rea was then mounting an exhibition at his newly opened gallery entitled 'The Gibbeting of Wm. Jobling'. He was invited to see Wheatley's paintings, sculptures

and photographs at NEWCASTLE, this resulting in a commission to portray Jobling in a work entitled *The Caged Corpse*, and a retrospective of the artist's work at the Bede in the following autumn. Wheatley continued his work for the film industry until late in his life, dying in London in 1982. A major exhibition of his work as sculptor, painter and photographer was held at the Customs House Gallery, SOUTH SHIELDS, in 2000.

WHITE, Lt Colonel George Francis (1808–1898)

Amateur landscape and portrait miniature painter in watercolour; draughtsman; illustrator. White was born at Chatham, the son of an army officer who was descended from a branch of the White family of REDHEUGH, near GATESHEAD. Following family tradition he joined the army in his teens and in 1829 was posted to India. Here he appears to have spent much of his time sketching in the Himalayas, his resulting work later inspiring Turner and fellow artist Samuel Prout to adapt his sketches for a series of engravings which were issued in groups in 1829, 1831 and 1832, and published as *Views in India Chiefly among the Himalayan Mountains*, in 1837–8. As a result of his association with Turner in the early part of their publication White became a close friend of the artist and accompanied him when he took a boat on the Thames on October 16th, 1834, to paint the spectacular burning of the Houses of Parliament. While heading an army recruiting party in County Durham in 1837 White met ANNE GREENWELL (1814–1900), the amateur artist daughter of Thomas Greenwell, Mayor of Durham and Deputy Lieutenant of the County. The couple fell in love and eloped to Gretna Green in 1839 to marry. During their subsequent honeymoon on the Continent they both produced sketches of the scenery, Anne proving the equal of her husband in much of her work. After a brief spell in Canterbury on their return White was again posted to India, where he served during the Sutlej Campaign of 1845–6, and made many sketches which were later reproduced as colourful engravings by Ackermann. In a further tribute to his Indian work, and just before his return to Britain, his earlier sketches of Himalayan and other subjects were recreated as huge panoramas for an exhibition in London's Leicester Square. After a tour of duty in Ireland, White decided on a change of career and applied for the position of Chief Constable of County Durham. He was successful in his application, and, settling at DURHAM with his family, served as one of the most respected senior police officers in Britain from 1848 until his retirement in 1892. During his long residency at DURHAM, which ended with his death there in 1898, White, his wife Anne, and daughter ELLA JEANNE WHITE (1851–1940/1), spent much of their time sketching and painting local scenery. The substantial volume of work which they and other members of White's family produced would, however, be little known today had it not been saved from destruction following Ella Jeanne's death. A solicitor's clerk at DURHAM rescued them for posterity as they were about to be destroyed, and two examples were included in an exhibition at the Shipley Art Gallery, GATESHEAD, in 1973, prior to their acquisition by the Gallery. A substantial part of the collection from which they were acquired was sold by auction at GATESHEAD, and in London, in 1992, and examples were exhibited at the World of Watercolours exhibition, London, and at NEWCASTLE, in the following year. White was a portrait subject of Clement Burlison (q.v.), as a gift from fellow police officers several years before his retirement. A more detailed account of White's life and work, by Marshall Hall, appeared in *Durham Town & Country*, Autumn, 1999. Represented: Shipley A G, Gateshead.

Lt Colonel George
Francis White,
Family Outing to Finchale,
Co. Durham,
watercolour, 26 x 41cm.
Private collection.

WHITE, Henry (fl. late 18th, early 19th cent.)
Wood engraver. White came to NEWCASTLE from London in 1804, to complete his apprenticeship under Thomas Bewick (q.v.), following the death of his master, Lee. While with Bewick he engraved the principal designs after John Thurston, for an edition of Burns's poems published by Catnach & Davison, ALNWICK, 1808, and also handled some of the tailpieces for this work with fellow apprentices Isaac Nicholson (q.v.), and Edward Willis (q.v.). After completing his apprenticeship he returned to London, where he engraved illustrations for *Puckle's Club*, 1817; William Yarrell's *A History of British Fishes*, 1836, and Major's edition of *Walton's Angler*, 1824. According to Bewick, in his autobiographical *Memoir*,‡ White 'chiefly turned his attention, to the imitation of sketchy cross hatching on Wood, from the inimitable pencil of Mr. Cruikshanks, & perhaps some other artists in this same way – Henry White appears to have taken the lead of others who followed that manner of cutting . . .'.

WHITE, William Fitzjames, ARCA (born c.1861)
Landscape painter in oil and watercolour; art teacher. White was born at Lowick, near BERWICK-UPON-TWEED, the son of a schoolmaster, and first found employment as an elementary school teacher under the Leeds School Board. While teaching at Leeds he became interested in art, studying at the city's School of Art in his spare time. Later he was appointed a student in training at the Royal College of Art, and here he proved so successful in his studies that he was awarded several honours. On completing his studies he was appointed headmaster of Hereford School of Art, remaining there for two years before taking up the appointment as first headmaster of the new School of Art at GATESHEAD, in 1886. He remained at the School for twenty-five years, retiring in 1911, to live in Dorsetshire. While living at GATESHEAD he was a regular exhibitor at the Bewick Club, NEWCASTLE, and later the Artists of the Northern Counties exhibitions at the city's Laing Art Gallery. He also became interested in natural history illustration, and illustrated *Nests & Eggs of British Birds*, by Charles Dixon, 1896, and works of a similar nature for other collectors. He was an associate of the Royal College of Art.

WHITFIELD, Joshua (1884–1954)
Amateur landscape painter in oil and watercolour. Born at DUNSTON, near GATESHEAD, Whitfield began his working life as a costs clerk with Parsons Marine Steam Turbine Company, on Tyneside, later joining Doxford & Sons of SUNDERLAND, in the same capacity. In 1945 he was appointed commercial manager of the firm, holding this position until his retirement four years later. Whitfield was a keen amateur painter all his life, and after studying art for five years, taught at evening classes at Rutherford College, NEWCASTLE. While working at SUNDERLAND, he was treasurer of

‡ See p. 199. '*A Memoir of Thomas Bewick, Written by Himself*', edited and with an introduction by Iain Bain. Oxford University Press, 1975.

the Stanfield Art Society 1926–36; vice president of the Sunderland Art Club 1951, and secretary 1952. He exhibited his work almost exclusively in Northumbria, contributing examples to the Artists of the Northern Counties exhibitions at the Laing Art Gallery, NEWCASTLE, and to various exhibitions at SUNDERLAND and SOUTH SHIELDS. He died at EAST HERRINGTON, near SUNDERLAND. Represented: Sunderland A G.

WHITTLE, Thomas (d.1731)
Religious painter in oil; sculptor. Whittle is believed to have been the 'natural son of a gentleman of fortune', and to have taken his name from that of his birthplace, near OVINGHAM. He left home at an early age, and making his way to CAMBO, some miles distant, was engaged by a miller, remaining with his employer several years. Later, he discovered he had a talent for painting, and wandering the North of England over the next ten or fifteen years, painted several works for churches in the area, including those at HARTBURN, near CAMBO, and PONTELAND, near NEWCASTLE. He also visited Edinburgh, where he executed in stone as a joke a figure of the devil, which won him considerable celebrity when he subsequently demolished it with a hammer. His works in oil and stone have all vanished, but his work as a poet and ballad writer survives in a volume published by a school teacher at CAMBO, in 1815. Most of this work was related to Northumbrian themes, notable among which is his *The Mitford Galloway*. He died in 1731 and was buried in the graveyard of St Andrew's Church, HARTBURN, whose parish register records him as 'Thomas Whittle of East Shaftoe, an ingenious man'. EAST SHAFTOE is near CAMBO.

WILD, Rosina Beatrice (b.1898)
Amateur portrait, landscape and flower painter in watercolour. She was born at GATESHEAD, the daughter of Samuel James Wild (q.v.), and received tuition from her father, and at the School of Art, GATESHEAD, before exhibiting her work. She exhibited her work at the Artists of the Northern Counties exhibitions at the Laing Art Gallery, NEWCASTLE, from 1928, and at the Gateshead Art Society, from its foundation. Two of her works were shown at the 'Contemporary Artists of Durham County' exhibition, staged at the Shipley Art Gallery, GATESHEAD, in 1951, in connection with the Festival of Britain.

WILD, Samuel James (1863–1958)
Landscape, portrait and still life painter in oil and watercolour; art teacher. Wild was born at GATESHEAD, and studied at the schools of NEWCASTLE, GATESHEAD and SOUTH SHIELDS, and at the Royal College of Art, before practising as a professional artist. He later became an art teacher, serving at Newcastle Modern School, Leamington Secondary School, and evening classes at GATESHEAD. He first began exhibiting his work publicly at the Bewick Club, NEWCASTLE, later becoming a regular exhibitor at the Artists of the Northern Counties exhibitions at the city's Laing Art Gallery. He was a member of the Newcastle Society of

Samuel James Wild,
The Avenue, Low Fell,
Gateshead,
watercolour, 30 x 51cm.
Tyne & Wear Museums,
Shipley Art Gallery.

George Wilkinson,
Farm at Ebchester,
watercolour, 38 x 52cm.
Private collection.

Artists, and a founder-member of Gateshead Art Society, at the age of eighty-five. His earlier work was mainly landscape, but as he grew increasingly infirm he turned to portrait and still life painting. He was an exhibitor at the age of eighty-eight, at the 'Contemporary Artists of Durham County' exhibition, staged at the Shipley Art Gallery, GATESHEAD, in 1951, in connection with the Festival of Britain. His exhibits were *Ruined Hut, Saltwell*, and *Saltwell Grove*. He died at GATESHEAD. His daughter Rosina Beatrice Wild (q.v.), and a relative, William Donald Wild (q.v.), were both talented amateur artists. Represented: Shipley A G, Gateshead.

WILD, William Donald fl. early 20th cent.)
Landscape and figure painter in oil. Wild was the brother or uncle of Samuel James Wild (q.v.), and first began exhibiting his work from SOUTH SHIELDS in 1913 while living with the latter at the town's Winchester Street. His two exhibits in that year at the Artists of the Northern Counties exhibition at the Laing Art Gallery, NEWCASTLE, were his oils: *Fruit Stall*, and *Derelict*. In 1916, and living at GATESHEAD with his brother or nephew, Wild again showed work at the Laing Art Gallery, but after joining the Benwell Art Club, NEWCASTLE, he appears to have confined his exhibiting activities to the latter institution's annual exhibitions, frequently gaining praise for his work. A variety of works by Wild are known, indicating a high standard of competence as a painter. Among these are his landscapes, *View of the Bigg Market*, 1911; *The Quayside*, 1913, and *Reading the Sunday Observer*, 1915. His last known exhibit was his *Ponteland Bridge*, shown at the North East Coast Exhibition, Palace of Arts, 1929, on which occasion he exhibited alongside his relatives Samuel James Wild, and Rosina Beatrice Wild (q.v.).

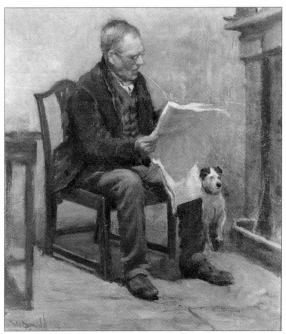

William Donald Wild, *Reading the Sunday Observer*, 1915, oil, 76 x 61cm. Anderson & Garland.

WILKINSON, George (1863–1938)

Amateur landscape painter in oil and watercolour. Wilkinson is believed to have been born near HEXHAM, and to have been adopted by a stonemason and his wife at SHOTLEY BRIDGE, near CONSETT, after being left an orphan. On leaving school he became a painter and decorator with a local company, working with his employers for thirty-five years and becoming a keen spare-time painter of views along the Derwent Valley near his home. He sent many of these views for exhibition at the Bewick Club, and later the Artists of the Northern Counties exhibitions at the Laing Art Gallery, NEWCASTLE. On leaving his employment at SHOTLEY BRIDGE Wilkinson worked as a painter and decorator at Armstrong's Naval Yard at NEWCASTLE, and took up residence in the west of the city. He remained a regular exhibitor at the Artists of the Northern Counties exhibitions at NEWCASTLE until close to his death, the *Newcastle Weekly Chronicle*, January 29th 1938, commenting that he was 'popular and well known, and his many spacious Derwent Valley and Team Valley landscapes showed he was a painter of no mean ability'. Represented: Laing A G, Newcastle.

WILKINSON, Joseph Alfred (d.1988)

Amateur landscape figure and still life painter in oil and watercolour. Wilkinson was born on Tyneside and worked as a professional interior decorator with a leading company at NEWCASTLE, painting in his spare time. During his career as a decorator in the city he was a regular exhibitor at the Artists of the Northern Counties exhibitions at the Laing Art Gallery, NEWCASTLE, and began a correspondence with many leading British artists of the day, which continued when he later retired to LONGFRAMLINGTON. These included Frank Brangwyn, Dorothea Sharpe, Francis Hodge, Sir William Russell Flint, Charles Spencelayh, and Dame Laura Knight. He also visited several of these artists to show and discuss his work, and was occasionally given examples of their work to offer him encouragement. A large collection of his sketches, watercolours, oils, and specimens of letters from the artists named, was sold at auction by Anderson & Garland, NEWCASTLE, in 1989, following his death. Most of the subjects of his work were Northumbrian scenes, but they also included views of Venice, Granada, Seville and Malaga.

WILKINSON, Joseph Wrightson (1817–1892)

Amateur marine painter in oil. He was born at GATESHEAD and after marrying the daughter of a Tyneside shipbuilder and owner became a keen painter of ships. His son, THOMAS WATSON WILKINSON (1849–1883), became a professional artist but does not appear to have exhibited his work.

WILKINSON, Samuel (d.1803)

Amateur landscape and architectural draughtsman; illustrator. Wilkinson was born at DARLINGTON, and ran a hostelry for much of his life, drawing and painting in his spare time. Most of his drawing was related to antiquarian subjects, and he is credited by George Algernon Fothergill (q.v.), in *A pictorial Survey of S. Cuthbert's Darlington*, 1905, with having produced a drawing upon which was based the 'first published picture of Darlington's most ancient building'. One of his best known views, however, is that of the town from Park Lane, published as an engraving by John Bailey (q.v.), two years after the production of his St Cuthbert's view. This view of the town was published in 1760, a section later appearing in the *History and Antiquities of the Parish of Darlington*, by William Hylton Dyer Longstaffe (q.v.), 1854. Wilkinson, who is referred to frequently in Longstaffe's book, retired from the hostelry business in 1772.

WILLIAMSON-BELL, James, SWLA (b.1938)

Wildlife and landscape painter in acrylic and watercolour; printmaker; illustrator; sculptor; art teacher. He was born at WALLSEND, near NEWCASTLE, and although successful in winning a scholarship to study art at King's College (now Newcastle University) on a part-time basis, later decided to become an apprentice draughtsman in a Tyneside shipyard. He retained a strong interest in drawing and painting, however, particularly wildlife subjects, and by 1970 had begun showing his work at the Society of Wildlife Artists' exhibitions in London. He has continued to exhibit with the Society since leaving the shipyard in 1974 to become a professional artist, and has also shown his work in many other group exhibitions. These have included the Paris Salon, 1974; the Artistes de Grande Bretagne, Paris, in 1980; Art Expo, New York, in 1989; the Seoul International Print Biennale, South Korea, in 1989; in *Whaletail Wildlife,* East African Wildlife Society, Nairobi, in 1991; the Singer &

James Williamson-Bell, *Grey Heron*, Chinese ink painting, 48 x 32cm. Private collection.

Friedlander/*Sunday Times* Watercolour Competition, the Carlisle 2 Open, and the Royal Scottish Academy, in 1994; the Royal Scottish Society of Painters in Watercolours, in 1998, and the Forestry Commission/Esso Oil exhibition of the Society of Wildlife Trust, at the New Forest, and Mall Galleries, London, in 2000. He has also enjoyed a number of one-man exhibitions, the first of which was in 1989, at Shanxi University, Taiyuan, China, in which year he also visited that country to receive tuition at Taiyuan University, in Chinese painting and printmaking. Others have followed at Durham Art Gallery, DURHAM, in 1991; Shaanxi History Museum, Xian, China, in 1998, and the Gallagher & Turner Gallery, NEWCASTLE, in 1999. He has received many awards for his work as painter, sculptor, and printmaker, the latter following his work in lithography and etching with the Charlotte Press, NEWCASTLE, in the 1970s and 1980s. During this period he taught in the Charlotte Press fine art print workshop and at the Adult Education Centre, NEWCASTLE. He has had his work reproduced as prints by the Medici Society and handles commissions for his wildlife studies on a worldwide basis, working from his studio and home at NEWCASTLE. He is a member of the Society of Wildlife Artists, the Société des Artistes Français and Bilan de L'Art Contemporain, and the Chinese Brush Painters Association of Northern Artists. His work is represented in the Pushkin Museum of Fine Art, Moscow, as well as in several university, corporate and private collections around the world.

WILLIS, Edward (fl. late 18th, early 19th cent.)
Wood engraver. Born on Tyneside, a cousin of George Stephenson, the engineer, Willis served an apprenticeship with Thomas Bewick (q.v.), at NEWCASTLE, 1798–1805. His best known work consists of his tailpiece engravings for the edition of Burn's poems published by Catnach & Davison, ALNWICK, 1808. Other tailpieces for this work were engraved by fellow apprentices Isaac Nicholson (q.v.), and Henry White (q.v.), the latter also engraving the principal designs after John Thurston. A note in Bewick's workshop engraving book, in the Laing Art Gallery, NEWCASTLE, states of Willis, at the end of his time: 'never a cross word passed between us', while in his autobiographical *Memoir*,‡ he says: 'I had a great regard for Edward Willis on account of his regular good behaviour while he was under my tuition – he has now been long resident in London'.

WILSON, George, ARCA (b.1930)
Landscape painter in oil; art teacher. He was born at JARROW, near SOUTH SHIELDS, and studied at Sunderland School of Art under Herbert Walter Simpson (q.v.), and Henry Thubron (q.v.). In 1955 he was one of several students at the School who in that year gained places at the Royal College of Art at a time when the annual national intake was only twenty-five. This evidence of the excellence of its teaching resulted in a visit in 1957 by Kenneth Allsop, who interviewed Wilson, fellow-students and staff for the celebrated *Picture Post* magazine. After leaving the Royal College of Art he took up a career in teaching art, painting in his spare time in his studio at EAST BOLDON, near SOUTH SHIELDS. He occasionally exhibited his work at the Artists of the Northern Counties exhibitions at the Laing Art Gallery, NEWCASTLE, and other exhibitions at this gallery. An excellent account of Wilson's student days under Simpson and Thubron, and the history of the Sunderland School of Art, was published by Ann Borrell in *Durham Town & Country*, Summer, 1995.

WILSON, Horace Beresford (1914–1988)
Landscape, portrait and figure painter in oil and watercolour; art teacher. He was born at MORPETH, the son of local builder and subsequently three-times mayor of the town Jonathon Wilson. After education locally he received his art training at NEWCASTLE, then took up a position as an art teacher, working in the area around Blackpool for the remainder of his career. During the Second World War he served as a lieutenant in the Royal Artillery, and several times in this period exhibited at the Artists of the Northern

Counties exhibitions at the Laing Art Gallery, NEWCASTLE. He died at MORPETH while on a visit to his home town after his retirement as art master at Kirkham Grammar School, Kirkham, near Blackpool.

Horace Beresford Wilson, *Self Portrait*, 1939, oil, 61 x 51cm. Private collection.

WILSON, James (fl. 19th cent.)

Portrait and figure painter in oil; sculptor. Wilson was a pupil of Thomas Sword Good (q.v.), at BERWICK-UPON-TWEED in the early 19th century, and later went on to practise as a portrait and figure painter in the town, until taking up photography in the 1850s. During his career as a painter he occasionally exhibited at NEWCASTLE, and Edinburgh. He showed six works at the Northern Academy, NEWCASTLE, in 1831, and one work at the Scottish Academy in the same year. Also in 1831, Wilson visited 'Mr Dunbar's Exhibition of Works of Foreign and British Sculptors', organised by sculptor David Dunbar, Senior, (q.v.), at NEWCASTLE, this perhaps deciding him to make his subsequent visit to Italy to develop his interest in sculpture. In any event, he followed his visit by carving a life-sized statue of local character James Stewart, who was credited with enormous strength and earned his living playing a violin around BERWICK-UPON-TWEED, or entertaining his listeners with tales. Wilson still owned the carving when Stewart died in 1844, and tried to dispose of it by issuing seventy shares. Each share purchaser received a small, reduced cast of the statue, and Wilson also produced a lithograph of his work. It later stood in the town's Palace Green for many years where it was gradually allowed to disintegrate. Wilson resumed exhibiting at Edinburgh in the 1840s, showing work at the Royal

Scottish Academy in 1841, 1843 and 1847. In addition to painting and producing his works of sculpture, Wilson taught drawing at BERWICK-UPON-TWEED, and is also believed to have taken pupils. Among these may have been R C TODD, who exhibited at the Scottish Academy in 1830, and John Dixon Evans (q.v.).

WILSON, Robert Arthur, ARCA SGA (1884–1979)

Landscape and subject painter in oil, tempera and watercolour; etcher; linocut artist; art teacher. Wilson was born at SUNDERLAND, and studied at the town's School of Art, and later at the Royal College of Art, and the Académie Julian, Paris, before practising as a professional artist in London. He remained based at London most of his professional life, and worked as an art instructor at London and Surrey schools for many years, in addition to handling a wide variety of artistic commissions, including mural painting, and book illustration. He did not begin to exhibit his work until quite late in life, sending examples to the Royal Academy; the Society of Graphic Artists, and to various London and provincial galleries from 1927. He contributed three works to the 'Contemporary Artists of Durham County' exhibition, staged at the Shipley Art Gallery, GATESHEAD, in 1951, in connection with the Festival of Britain. These works comprised *Cobnor Point*; *Sails near Bosham*, and *Morris Dancers in Surrey*. He was an associate of the Royal College of Art, and a member of the Society of Graphic Artists. His wife, STELLA LOUISE WILSON (née Perken), also practised as an artist, and widely exhibited her work. Represented: Victoria and Albert Museum; Sunderland A G.

WILSON, Thomas Fairbairn (1776-c.1855)

Sporting, animal, landscape, portrait and marine painter in oil and watercolour. He was born at NEWCASTLE, the son of a prosperous grocer with premises in the town's Dean Street, and by the early years of the 19th century was practising as a successful animal and landscape artist in Northumbria. Examples of his work from this period include his portrait of a six year old ox bred by Thomas Bates, of Halton Castle, near CORBRIDGE, which was engraved by Robert Pollard (q.v.) in 1808; *Roseden* (winner of the Carlisle Steeplechase in 1806) dated 1809, and a fair on the Town Moor, NEWCASTLE, which was probably his most ambitious work ever. By 1823, however, he had moved to Hull, where he continued to practise until the middle years of the century. Some of his later work consisted of portraiture, and occasional marine paintings, but the bulk consisted of animal and landscape paintings. He exhibited his work sparingly at Hull, showing examples at the Hull and East Riding Institution's 'First Exhibition of Modern Art', in 1827, and at its second exhibition in 1829. His contributions to the first of these exhibitions were his portrait of Hull artist Thomas Brooks, and several landscapes. Also from this early period in Hull, although not exhibited in his lifetime, was his *Calm off Dover*, of 1825. Another and unusual work of this period was his portrait of *Phenomenon*, a silver-laced bantam fighting cock which had won the Gold Cup at Westminster

in 1823. Showing the victor, wearing spurs and standing over his victim, it has been described as 'one of the most striking portraits of a fighting cock recorded'. Notwithstanding the infrequency with which he exhibited his work Wilson established a considerable reputation on Humberside and was, indeed, later referred to as 'Wilson of Hull'. Examples of his work have been included in several exhibitions since his death, notably the 'Working Men's Art', 'Industry and General Exhibition', Hull, 1870, and the 'Marine Exhibition', Hull, 1883. Represented: The British Sporting Trust; The Guildhall, Hull; Reading Museum of English Rural Life. [See colour plate]

WINER, Zalmon, RBA (1934–1996)
Etcher; lithographer and painter in oil, acrylic, pastel and watercolour. Born at GATESHEAD, Winer studied art and architecture at Durham University and at the Central School of Art and Design, London, before practising as a professional artist with a particular interest in etching. He exhibited his work at the Royal Academy; the Royal Society of British Artists (of which he was elected a member in 1984); the Pastel Society; the United Society of Artists; the National Society of Painters, Sculptors and Gravers/Printmakers; the *Discerning Eye*, at the Mall Galleries, London, in 1990, and in Israel, showing many examples of work with Jewish themes, including figure studies, portraits, and landscapes. He also illustrated *Haggadah* for the Exilarchs Foundation. He lived for many years in London. The Shipley Art Gallery, GATESHEAD, has his etching *Procession with holy scrolls*, set in his native town, and he is represented in various public and private collections in Britain, the USA, Australia, South Africa and Israel. Winer commonly signed his work 'Zalmon'.

WISE, Derwent (1933–2003)
Sculptor; landscape and architectural painter in acrylic and watercolour; art teacher. Wise was born at LOFTUS, and studied art at King's College (now Newcastle University). After national service, during which he also attended Farnham School of Art on a part-time basis, he took up an appointment as director of three-dimensional studies at Salford School of Art in 1960. After a period as head of sculpture at Wolverhampton College of Art he was invited back to King's College to become head of sculpture, remaining there until his retirement in 1994. From 1969 until 1990 he was also visiting lecturer and external examiner for a number of universities and polytechnics. Up until the late 1970s he worked exclusively as a sculptor. In 1969, however, he started a series of relief panels which were to consolidate a reputation as a sculptor which had already received recognition by his receiving joint first prize in the Northern Sculptors exhibition, at the Shipley Art Gallery, GATESHEAD, in 1967. These relief panels formed the main body of his work until 1982 and developed a vibrant dialogue between his love of sculpture and a deepening interest in painting which led to his renting a house near WOOLER as a base from which to explore and paint the surrounding landscape. Wise exhibited his work as sculptor and painter widely during his more than forty years as artist and art teacher, showing in group exhibitions including the Royal Academy; the Royal Scottish Academy; the Royal Society of British Artists; the Royal Institute of Painters in Water Colours; the Royal Watercolour Society; the New English Art Club, and in many London, provincial and overseas public and private galleries. He also enjoyed a number of one-man exhibitions in Britain, including those at the Hatton Gallery, NEWCASTLE; the University of York; the Stonegate Gallery, York; the Queen's Hall, HEXHAM,

Zalmon Winer,
Funeral of a Chassid I,
etching, 33 x 50cm.
Private collection.

and the Shire Pottery Gallery and Studios, ALNWICK. For his exhibition of landscapes at the latter in 2000 he chose as his title the words from Charlotte Bronte 'Speak of the North' to convey his entirely personal view of Northumberland. In 2002 he also shared an exhibition at the Shire Pottery Gallery and Studios with Brian Yale (b.1936), a fellow-student and friend while he attended Farnham School of Art during his National Service. He lived for many years at GATESHEAD. Represented: Arts Council; Darlington A G; Hatton Gallery, Newcastle; Salford A G, and various university, public and private collections.

WISHART, George Barclay (1873–1937)
Landscape painter in watercolour; architectural draughtsman. He was born at GATESHEAD, and became an engineer at Clarke Chapman & Co, in the town, painting in his spare time. In the depression of 1926 he was obliged to leave his employment as an engineer, and for the rest of his life was able to devote himself to his main interests in life of art and music. He made frequent visits to the Highlands of Scotland, and to Switzerland, to paint, but the bulk of his work featured Tyneside scenes. He exhibited his work at the Bewick Club, NEWCASTLE, from their inception, in 1884, showing *A Summer Evening at Hexham*, and later became a regular exhibitor at the Artists of the Northern Counties exhibitions at the Laing Art Gallery, NEWCASTLE. He last exhibited at the latter in 1921, showing *The Tyne from Bill Quay*, and *North Shields*. In his final years Wishart suffered eye failure

George Barclay Wishart, *Bottle Bank, Gateshead*, 1925, watercolour, 46 x 24cm. Tyne & Wear Museums, Shipley Art Gallery.

due to cataracts, and while obliged to give up painting he was still able to indulge his love of music, writing many compositions which were played by his own orchestra. He died at GATESHEAD. Represented: Shipley A G, Gateshead.

WOOD, Adam Stanley (1903–1934)
Figure and landscape painter in watercolour; illustrator. Wood was born at NORTH SHIELDS and did not take up painting and drawing seriously until he was confined to bed for many years following an influenza epidemic of 1917. During this period he took up painting and drawing with the help of his uncle, Walter Scott Wood (q.v.), proving so successful that by 1928 he was having work accepted for showing at the Artists of the Northern Counties exhibitions at the Laing Art Gallery, NEWCASTLE, and in the following year, at the North East Coast Art Club exhibition, WHITLEY BAY. Two of his Laing exhibits of 1929 were also shown at the North East Coast Exhibition, Palace of Arts, NEWCASTLE, in that year, along with a third, *The Crystal Gazers*. Wood had by then begun to sell his work, and to illustrate the *Newcastle Chronicle* with his pen drawings, but increasing ill health ultimately leading to tuberculosis cut short his promising career, and he died at NORTH SHIELDS just as he was entering his thirties. After his death his mother destroyed the remaining drawings and paintings in her possession. His watercolour of a fairground forms part of the Fenwick Collection of Circus & Fairground Material held by the Laing Art Gallery, NEWCASTLE, and was included in an exhibition on this subject in 1970. His favourite subjects, however, were the fisherfolk at CULLERCOATS, street musicians, itinerants and children. [See colour plate]

WOOD, Charles (1866–1887)
Scenic painter. He was employed as a scenic painter at the Tyne Theatre, NEWCASTLE, but drowned in the River Tyne at ELSWICK, near NEWCASTLE, while bathing.

WOOD, Frank (1904–1985)
Landscape and portrait painter in oil, watercolour and tempera; wood engraver; muralist; art teacher. Wood was born in Liverpool but moved with his family to live at SUNDERLAND in 1918. Here he studied at the town's School of Art under Richard Archibald Ray (q.v.), before taking a teaching post there in still life, landscape, pattern construction and textile printing. He became one of the most influential figures at the School, and regularly exhibited his work, showing examples at the Royal Academy; the Royal Scottish Academy; the New English Art Club; the Royal Society of Portrait Painters; the Society of Wood Engravers; the Society of Mural Decorators and Painters in Tempera, and at various public and private galleries in the provinces and overseas. He was a member of the Society of Mural Decorators and Painters in Tempera, and for some years chairman of Sunderland Art Club. One of his portrait subjects was colleague and fellow club member John Summers (q.v.), shown at the Royal Society of Portrait Painters in 1937. He and Summers frequently

Frank Watson Wood, Senior, *Berwick from the South*, 1922, watercolour, 30 x 76cm. Private collection.

shared sketching holidays. Wood had enjoyed a one-man show at the Foyle Gallery, London, by the time he was forty-four and there was a substantial exhibition of his work at Sunderland Art Gallery in 1995. Represented: British Museum; Laing A G, Newcastle; Sunderland A G.

WOOD, Frank Watson, Senior (1862–1953)

Marine, landscape, portrait and golfing painter in oil and watercolour; illustrator; art teacher. Wood was born at BERWICK-UPON-TWEED, and studied at the town's art school under James Wallace, Senior (q.v.), before attending South Kensington School of Art. On completing his studies in 1883, he was appointed second master at the School of Art, NEWCASTLE, under William Cosens Way (q.v.), remaining there until it was affiliated to the Durham College of Physical Science in 1889. He then held the post of headmaster at the School of Art, Hawick, Roxburghshire, for ten years before deciding to become a professional artist. During his period at Hawick Wood had become increasingly interested in marine painting so he decided to move to Portsmouth, where he soon obtained commissions from naval officers based at the port, via the publishing shop at the dockyard gates. One of these naval officers recommended his work to Lord Knollys, who in turn requested him to send a drawing to King Edward VII at Buckingham Palace. His Majesty retained Wood's drawing of *Portsmouth Harbour from Portisdown Hill*, this leading to further acquisitions by the king, and later other members of the Royal Family. This patronage by the Royal Family continued throughout his period working in the south of England, and his later professional career at Edinburgh. Wood first began exhibiting his work at NEWCASTLE, showing examples at the Bewick Club from 1885, until his move to Hawick. In 1889 he commenced exhibiting his work outside Northumbria, contributing to the Royal Scottish Academy; the Royal Scottish Society of Painters in Water Colours; the Glasgow Institute of Fine Arts; various provincial galleries, and in 1902 only to the Royal Academy, when his *A Border Link* was shown. His professional life as an artist was highlighted by a number of noteworthy occurrences, among these his invitation to sketch the German Fleet at Scapa Flow on its surrender in 1918, and his appointment as official artist on the Canadian tour of George VI, and Queen Elizabeth, in 1939. Although his marine paintings were purchased by five kings, three queens, princes and dukes, Wood remained much attached throughout his life to painting his birthplace, and it was one of his typical views of the town from the south side of the Tweed that the local authority presented to Princess Elizabeth, on her engagement to the Duke of Edinburgh, in 1947. BERWICK-UPON-TWEED was also one of the many Northumbrian and other subjects which he was commissioned to paint as posters and railway carriage decorations for the London North Eastern Railway in his work as a commercial artist. Wood was the father of Frank Watson Wood, Junior (q.v.), with whom he shared a studio in Paris in 1923, while attending the Académie Julian with his son. He died at Strathyre, Perth, to which he had retired from Edinburgh. Important exhibitions of work by father and son were held at Aitken Dott & Son, Edinburgh, in 1949, and at the Mainhill Gallery, Ancrum, Jedburgh, Scotland, in 1992. Although mainly known as a marine and landscape painter in watercolour, Wood's golfing scenes are among his most prized works. One of his Scottish golfing scenes sold at auction in Edinburgh for £11,000 in 2002. Represented: National Maritime Museum; Berwick Museum & A G; Dundee A G.

WOOD, Frank Watson, Junior (1900–1985)

Landscape painter in watercolour. He was born at BERWICK-UPON-TWEED, the only son of Frank Watson Wood, Senior (q.v.), and after education at public school in Devon, went to Sandhurst. From Sandhurst he joined the Indian Army, leaving it in 1923 to study art in Paris with his father, at the Académie Julian. On their return a year later he studied further at the Edinburgh College of Art and at Glasgow School of Art. He then set up a studio in Glasgow and became a professional artist. While practising at Glasgow he carried out some illustrative and commercial work, and exhibited in the city at the McLellan Gallery and James Connell & Son; also in Edinburgh at Aitken Dott & Son, and at various south of Scotland galleries.

He was also instrumental in setting up *The New 4 Group*. Following service in the Black Watch during the Second World War, Wood and his family lived for many years at Strathyre, Perthshire, where he became a leading member of the Perthshire Arts Association. He also for a period lived at Benderloch, Argyllshire, and later considered settling in the Scottish Borders. However, in the early 1960s he and his wife returned to live in Perthshire at Comrie, and here he died in 1985. Wood's work is frequently confused with that of his father because of its similarity in style, and choice of subject matter. Wood became aware of this early in his career and thereafter signed his work 'Watson Wood'. Important exhibitions of work by father and son were held at Aitken Dott & Son, in 1949, and at the Mainhill Gallery, Ancrum, Jedburgh, Scotland, in 1992. Wood Junior's son DAVID WOOD (1933–1996) was also a gifted artist.

WOOD, George Septimus (1860–1944)
Amateur landscape and coastal painter in oil and watercolour. Wood was born at NORTH SHIELDS, and worked all his life in the drapery trade in the town, painting in his spare time. He mainly exhibited his work at NEWCASTLE, where examples were shown at the Bewick Club from 1885, and the Artists of the Northern Counties exhibitions at the Laing Art Gallery from 1909. He was a founder-member of the art club at TYNEMOUTH, and regularly exhibited his work at this club. He died at WALLSEND near NEWCASTLE.

WOOD, Jacob (b.1915)
Landscape painter in watercolour and pastel. He was born at BILL QUAY, near GATESHEAD, and studied art at evening classes held at the Shipley Art Gallery, GATESHEAD. He was a member of Gateshead Art Society and regularly contributed to its annual exhibitions. He also had an exhibition at the Odeon Cinema, NEWCASTLE, and contributed two pastels to the 'Contemporary Artists of Durham County' exhibition, staged in 1951, at the Shipley Art Gallery, in connection with the Festival of Britain: *Old Cottage Rods, Yorks*, and *Country Lane, Yorks*.

WOOD, James (d.1886)
Landscape, street scene and miniature painter in watercolour. Wood practised as a professional artist at NEWCASTLE in the early 19th century and first advertised his services as a painter of portrait miniatures. Much of his work in his early career consisted of street scenes, however, many featuring ancient buildings in the town, with figures. Most of this work was small in scale and treated as vignettes, much in the manner of John Teasdale (q.v.). In the middle of the century he moved to SUNDERLAND, where he appears to have concentrated on miniature painting, but he later returned to NEWCASTLE, where he died in impoverished circumstances in 1886. Newcastle Central Library has a large collection of his local street scenes in watercolour.

James Wood, *Old Pant at the head of the Side, Newcastle*, watercolour, 29 x 23cm. Private collection.

WOOD, Robert (1852–1899)
Landscape painter in oil and watercolour; illustrator. Wood was born at Hall's Hill, near WOODBURN, in Redesdale, the son of a farmer. Following his education at a local school he was apprenticed to a joiner and builder at WOODBURN, but in 1875 he decided to move to NEWCASTLE. Here he saw two watercolours by Thomas Miles Richardson, Senior (q.v.), and after reading details of Richardson's life he decided to become an artist. Some two or three years later he purchased the business of a picture framer and gilder at NEWCASTLE, and made such a success of it that he was thereafter able to devote much of his time to painting. He first exhibited his work publicly when he showed a view of WOODBURN at the Arts Association exhibition at NEWCASTLE, in 1879. He followed this by becoming a regular exhibitor at the city's Bewick Club, one of his exhibits – a large watercolour of Bamburgh Castle – proving so attractive that it was purchased by Sir Matthew White Ridley. Shortly after this he also began to show his work outside Northumbria, examples being accepted for showing by the Royal Institute of Painters in Water Colours; the Royal Scottish Academy, and various London and provincial galleries. In 1887 he staged an exhibition of almost fifty of his drawings at NEWCASTLE, many of which featured HOLY ISLAND, off the Northumbria coastline. Wood's work also included many drawings for local newspapers and other publications. Towards the end of his life he became increasingly involved in picture dealing. He died at NEWCASTLE. His watercolour of St Mary's Island is reproduced in William Weaver Tomlinson's *Historical Notes on Cullercoats, Whitley and Monkseaton*, 1893 (reprinted by Frank Graham, 1980).

WOOD, Ruth Mary (b.1899)
Illustrator; decorative artist. She was born at SOUTH SHIELDS, and studied at Exeter School of Art; at the British Museum, and with Edward Johnson before becoming an instructor at the former, in lettering and illumination. She lived for many years at Honiton, Devon, and she exhibited an example of her work at the Wembley (1924–25), Paris and Zurich Internationals (1925–1926); the Society of Women Artists, in 1927, and the Royal Society of Artists, Birmingham, in 1934. Her work was also published in *The Revue Modern* (1927); *The Guider*; *The Girl Guide Gazette*; the *Official Year Book of the Church of England*, and *The Road*. Represented: Victoria and Albert Museum.

WOOD, Walter Scott (1867–1929)
Amateur landscape and coastal painter in watercolour; etcher. Born at NORTH SHIELDS, Scott worked as a master plumber most of his life, painting and etching in his spare time. He was a member of the North East Coast Art Club, based at WHITLEY BAY, and exhibited there and occasionally at the Artists of the Northern Counties exhibition at the Laing Art Gallery, NEWCASTLE, where typical exhibits were his watercolour *Collywell Bay*, and etching *Shields Harbour* of 1928. He was friendly with many other local artists of his period, including George Edward Horton (q.v.), and Frederick Dove Ogilvie (q.v.), and travelled the region to sketch. He was the uncle of Adam Stanley Wood (q.v.), and gave him occasional lessons in painting.

WOODHOUSE, John (born c.1800)
Portrait painter in oil; silhouette artist. Born at ALNWICK, Woodhouse was practising as a portrait painter at NEWCASTLE by his early twenties. Within a few years he had built up a considerable reputation for his silhouette work, earning from Eneas Mackenzie, in his *History of Newcastle*, 1827 (pp. 588–9), the observation that, as a 'profile painter in shade', he 'possesses, in remarkable degree, the faculty of retaining the exact forms of objects for a length of time after he has seen them. In some instances he has produced correct and striking likenesses of persons after their death.' Woodhouse practised at NEWCASTLE throughout the third decade of the nineteenth century, later moving to NORTH SHIELDS.

WORNUM, Ralph Nicholson (1812–1877)
Portrait painter in oil; art writer. He was born at THORNTON, near DURHAM, and was initially intended for the Bar. In 1834, however, he decided to make art his profession and studied for five years in Munich, Dresden, Rome and Paris. On his return to England in 1840 he settled in London, where he wrote and published his *Epochs of Painting*, and worked for some time as a lecturer in the Government Schools of Design while trying to succeed as a portrait painter. His work for the first Westminster Hall competition was selected for praise, but in 1846 he embarked on his catalogue of the National Gallery, and following his appointment that year as Keeper, he increasingly devoted his time to writing about the history and practice of art. He died in London.

WORRELL, Abraham Bruiningh van, RAHB (1787–after 1857)
Landscape, cattle and fruit painter in oil and watercolour; lithographer. He was born at Middleburgh, in the Zeeland province of Holland, where he was practising as a professional artist by 1812. He later moved to London, settling there for the next nineteen years, and exhibiting his work at the Royal Academy; the British Institution; the Old Water Colour Society (later the Royal Watercolour Society), and the Suffolk Street Gallery. In 1827 he also exhibited for the first time at NEWCASTLE, where his works appeared at the 'Exhibition of Works by the Ancient Masters', staged by the Northumberland Institution for the Promotion of the Fine Arts, and at the Institution's annual exhibition in that year. The subjects of his London exhibits were mainly landscapes with cattle, and from 1825 he was described in catalogues as a 'Royal Academician of Holland and Belgium'; this may explain the inclusion of his work *The Circumcision*, in the 'Ancient Masters' exhibition at NEWCASTLE, though his two landscapes with cattle were shown at the second exhibition with the obvious realisation on the part of its organisers that he was a living artist. Moving permanently to NEWCASTLE by 1838, Worrell showed work at the North of England Society for the Promotion of the Fine Arts, in that year, and in 1839; following this he exhibited little in the town, though he continued to exhibit in London until 1849, and sent three works to Carlisle Athenaeum in 1850. His work during his some twenty years in NEWCASTLE featured landscapes – several of which portrayed the Island of Walcheren, Zeeland, Holland; cattle studies; game and fruit. His final exhibit at the Royal Academy in 1846, was for him the rather unusual subject *Fishermen and women of Cullercoats, in the County of Northumberland*. His studio was for some years in Blackett Street, NEWCASTLE, but he appears to have spent his final years living and working in St James's Street, where he is recorded until 1857. His daughter, MISS E N VAN WORRELL, was also an artist, and exhibited her work Represented: British Museum; Natural History Society of Northumbria, Newcastle. [See colour plate]

WRAY, Peter, RE (b.1950)
Printmaker; art teacher. Wray was born at SEDGEFIELD, near DARLINGTON, and studied at St Mary's College, Strawberry Hill; Goldsmiths' College School of Art, and Leeds Polytechnic, before taking up a position at University College of Ripon and York St John, York (now York St John College), as senior lecturer in printmaking. He was elected a fellow of the Royal Society of Painter-Etchers and Engravers/Painter-Printmakers, in 1991, and has shown his work in a large number of group exhibitions, including the Cleveland Open, Chapel Beck Gallery, GUISBOROUGH, 1977; the Bankside Gallery (Whatman Prize, 1985; Barcham-Green Prize, 1986); the Royal West of England Academy, 1988; the British Printmakers, State Commission for Publishing, Moscow, 1989; the Curwen Gallery, 1995, and the National Print Exhibition, Mall Galleries, 1997. He has also had

several one-man exhibitions at the New Academy Gallery, since 1994. He has left his teaching position at the College, but continues to live at York. Represented: Cleveland Education Authority; Goldsmiths' College, and various corporate and private collections.

WRIGHTSON, Jocelyn, SWA (1888–1979)

Landscape and flower painter in watercolour. She was born at Norton Hall, near STOCKTON-ON-TEES, the daughter of Sir Thomas Wrightson, JP, Chairman of Head Wrightson; MP for STOCKTON, and later St Pancras, London. In her childhood she moved with her family to Neasham Hall, DARLINGTON, where her interest in painting was encouraged by her father. She later practised as a watercolourist, painting widely throughout Scotland and Dorset, and exhibiting her work on five occasions at the Society of Women Artists, of which Society she was a member. She painted a large number of watercolours of Cairo during a stay there in 1923, which are now in an Egyptian collection. She died at Shaftsbury, Dorset. She was the younger sister of Margaret Wrightson (q.v.).

WRIGHTSON, Margaret, FRSBS SWA (1877–1976)

Sculptor. She was born at Norton Hall, near STOCKTON-ON-TEES, the daughter of Sir Thomas Wrightson, JP, Chairman of Head Wrightson; MP for STOCKTON, and later St Pancras, London. In her childhood the family moved to Neasham Hall, DARLINGTON, and here an interest in art fostered in her by her father led to her deciding to become a sculptor. She was placed as a pupil at the Royal College of Art, and studied under Sir William B Richmond, the Royal Academician; Lanteri, and in Paris. In 1906 she had her first work accepted by the Royal Academy, *Sleeping Baby*, and from this point forward regularly exhibited her work both at the Academy, and at the Society of Women Artists. She handled many important commissions in her long working life. One of the earliest of these was a commission from the late Lord Runciman to produce a statue of a Viking landing on the Northumberland Coast, for the grounds of his home, Doxford Hall, DOXFORD. This commission was placed in 1912, but was not completed until 1925, possibly due to the interruption of the First World War, in which she served as a driver with the Womens' Auxiliary Ambulance Corps, serving in France. This statue, her largest work, was re-erected outside the new headquarters of Northumberland County Council, MORPETH, in April, 1981. Other commissions included the Lamb Memorial (the figure of a young boy) for the Inner Temple Gardens, London, and the figure St George, which forms part of the war memorial at CRAMLINGTON, unveiled in 1922. In the grounds of the family home at DARLINGTON stands another of her works, *The Slayer of the Sockburn Worm*. Some of her most notable exhibition successes occurred in her later life; at the age of eighty-six she flew to Paris at the invitation of the Société des Artistes Français to receive a medal of honour in the 1962 Salon exhibition, and she received several other recognitions. She

was a fellow of the Royal Society of British Sculptors, and a member of the Society of Women Artists, as well as being for many years a member of the Darlington Society of Arts. She died in London. Her younger sister Jocelyn Wrightson (q.v.), was also a talented artist.

Margaret Wrightson, *Viking Warrior, Council Offices, Morpeth*, 1925, bronze, figure 2.2m high. Northumberland County Council.

Y

YATES, Alan, ARBS MSDC FRSA (b.1947)

Sculptor in cast bronze and aluminium; art teacher. He was born at BISHOP AUCKLAND, and studied for his certificate of education at Durham University, before becoming an art teacher in Northumbria. He has exhibited his work at the Royal Academy; the Royal Scottish Academy; the Royal West of England Academy; Paris; Durham University; York; Grantham; DARLINGTON; Peterborough; NEWCASTLE; Edinburgh; SOUTH SHIELDS; Swansea; Stratford-upon-Avon; London, and Manchester while pursuing his teaching career. He was elected a member of the Society of Designer-Craftsmen, and a fellow of the Royal Society of Arts in 1973, and an associate of the Royal Society of British Sculptors, in 1976. He has lived for a number of years near BISHOP AUCKLAND. Represented: Grey College, Durham University.

YATES, Norman (1892–1974)

Amateur marine painter in watercolour. He was born at NEWCASTLE, and did not take up painting seriously until he had retired from his career as a mariner in his late fifties. He first went to sea aged fourteen aboard the barque *Kildalton*. He later served as officer with the Wilson Line, and as lieutenant in the RNR in the First World War in command of an anti-submarine vessel. In 1922 he joined the Humber Pilot Service, and was active in the Second World War as a Lt Commander in the Humber Examination Service, Naval Control, and from D-Day served as a Southampton and Channel Pilot with Combined Operations. He retired from the Pilot Service in 1948, and began painting watercolours of the ships on which he had sailed, or encountered in his career at sea. A display of his work was shown at Hull Central Library in 1973, and he was a contributor to the city's Ferens Art Gallery Winter Exhibition in 1972. Represented: Town Docks Museum, Hull.

YATES, Peter (1920–1982)

Landscape and figure painter in oil, acrylic, gouache and watercolour; draughtsman; printmaker. Yates was born in London, and after displaying talent as an artist while still at school became a commercial artist on Fleet Street at the age of sixteen. After work on international exhibitions in Glasgow and Paris he studied architecture under Sir Hubert Bennett, Peter Monro and Robin Day. In 1941 he served as a fireman in London and produced drawings and paintings of the great fires inflicted on the capital in the Second World War. After studying radio engineering he volunteered for the Royal Air Force, and was posted to North Wales where he made many drawings of the Snowdon Range. During his later service on the Continent he drew in Paris, Rheims, the Rhineland and Belgium. In 1945 he resumed his career as architect and commercial artist, working initially in the Ove Arup office, London. He worked on the Master Plan for PETERLEE with Berthold Lubetkin, and ran a commercial art firm in Paris through which he designed many Continental exhibitions, then in 1953 moved to NEWCASTLE to

Peter Yates, *Durham Cathedral*, 1976, oil, 46 x 46cm. Private collection.

work with city architect Gordon Ryder. During his many years as a distinguished architect in Northumbria he produced murals for Bevan House, St Pancras, London, and Beacon House, WHITLEY BAY, and a wide variety of houses, offices, laboratories and restaurants. He also made drawings in Spain, France, Italy, Greece, India, Japan, the USA and New Zealand. Yates showed his work in many group and one-man exhibitions, among the former those of the Royal Academy; the Royal Society of Painters in Water Colours; the Shipley Art Gallery, GATESHEAD, and the Hatton Gallery, NEWCASTLE. His first one-man exhibition was *Ultramarinos – a Mediterranean Odyssey*, held at the Colbert Gallery, DURHAM, in 1975. Other such events were held at the Downstairs Gallery, NEWCASTLE; the Pen Gallery, London, and the Hatton Gallery, NEWCASTLE. His exhibition at the latter in 1982 was a major retrospective consisting of paintings of England, France, Spain, Italy and Greece, and was accompanied by a catalogue introduced by Kenneth Rowntree (q.v.). His oil of Durham Cathedral, dated 1976, was included in the *Durham Cathedral Artists & Images* exhibition, at Durham Art Gallery, DURHAM, in 1993. He lived for many years at WOOLSINGTON, near NEWCASTLE, and his work is represented in many private collections throughout the world.

YATES, Richard (1886–1961)

Amateur landscape painter in oil and watercolour. Yates was born at Distington, Cumbria, and after moving to Tyneside with his family as a boy went on to become a skilled instrument maker, working for a company at NEWCASTLE. He was a keen spare-time painter and exhibited his work for many years at the Artists of the Northern Counties exhibitions at the Laing Art Gallery, NEWCASTLE, and the city's Benwell Art Club. Many of his oils and watercolours were of the suburbs of NEWCASTLE and GATESHEAD when they

Richard Yates, *Mill at Peth Head, near Blaydon*, watercolour, 23 x 41cm. Private collection.

Arthur Rousselange Young, *Warkworth, Northumberland*, watercolour, 33 x 25cm. Private collection.

were still semi-rural, but he was particularly well known for his views of the nearby River Derwent Valley. The *North Mail & Newcastle Chronicle* of November 14, 1931, said of one of his Benwell Art Club exhibits 'The Derwent Valley scene by R. Yates is almost as dainty as a Birket Foster.'

YEATMAN, Alice Mary, RDS (c.1866–after 1936)
Landscape painter in oil and watercolour; art teacher. She was born at SUNDERLAND, the daughter of a customs officer, and after private education locally and at York, studied at Heatherly's, and the Royal Drawing Society. After taking her art teacher's certificate she worked as an art mistress at schools in GATESHEAD, NEWCASTLE and SUNDERLAND, but by 1929 was describing herself as 'a painter of landscapes and interiors'. While employed as an art mistress she began exhibiting her work widely throughout Britain, showing examples at the New Gallery; the Royal Institute of Painters in Water Colours; the Royal Scottish Academy; the Bewick Club, NEWCASTLE, and later the Artists of the Northern Counties exhibitions at the city's Laing Art Gallery. She was a member of the Royal Drawing Society and lived in SUNDERLAND for many years with a studio in Fawcett Street.

YOUNG, Arthur Rousselange (1915–1994)
Landscape and coastal painter in watercolour; art teacher. He was born at NEWCASTLE, and attended evening classes in art at Armstrong College (later King's College; now Newcastle University) before taking up a career as a sign-writer and commercial artist. In 1940 he was called up into the Coldstream Guards and later transferred to R E Survey as a map draughtsman serving in India and Ceylon. In 1946 he returned to NEWCASTLE and started in business as a commercial artist, later developing it into one of the leading silkscreen printing companies on Tyneside. Young was a keen spare-time painter before, during, and after his wartime service, but did not begin to exhibit his work widely until he was in his fifties. He first exhibited with the Newcastle Society of Artists, later going on to show examples of his work in a variety of group and one-man exhibitions including among the former, the Bondgate Gallery, ALNWICK; the Chameleon Gallery. NEWCASTLE; the Dial Gallery, WARKWORTH, and those at NEWTON-ON-THE-MOOR, near ALNWICK, started by George Jude McLean (q.v.), where co-exhibitors were Malcolm Gleghorn (q.v.), and others. He also enjoyed a number of one-man exhibitions, at the Linden Hall Hotel, near MORPETH; Morpeth Library, and the Dial Gallery. Many of these later showings of his work followed his retirement from his silkscreen printing business in 1980, and his move to AMBLE with his artist wife Eleanor Mary Young (née Tully) (q.v.). Here he was able to indulge his lifelong interest in yachting, while continuing to paint signs for local shops, paint, teach art groups in the area, and take a keen interest in local environmental matters. His work is in many private collections.

YOUNG, Charles Phillips (1870–after 1951)
Landscape and architectural painter in oil and watercolour. Young was born at Dublin, but following his artistic training at King's College (later Newcastle University), he decided to remain on Tyneside to practise as an artist. He first lived at GATESHEAD, but later moved further up the Tyne Valley, living successively at STOCKSFIELD, and HEXHAM. He mainly exhibited his work at the Artists of the Northern Counties exhibitions at the Laing Art Gallery, NEWCASTLE, but also exhibited at the Shipley Art Gallery, GATESHEAD, and at Carlisle. He enjoyed a one-man exhibition at the Shipley Art Gallery, and was an exhibitor at this gallery's 'Contemporary Artists of Durham County' exhibition, staged in 1951, in connection with the Festival of Britain, showing his watercolour, *Hill Country*. He was a member of the Tyneside Art Club.

YOUNG, Eleanor Mary (née Tully) (b.1934)
Amateur landscape painter in oil and watercolour. She was born at ALNWICK and studied art at King's College (now Newcastle University) under Louisa Hodgson (q.v.), Lawrence Gowing, Roger de Grey, and Eric Dobson (q.v.). Following this she worked in a textile design studio in Manchester, and in the publicity

department of the city libraries, NEWCASTLE. A keen spare-time painter from her earliest years she has shown her work at a number of group exhibitions in Northumbria, including those held at the Bondgate Gallery, ALNWICK; the Chameleon Gallery, NEWCASTLE; the Dial Gallery, WARKWORTH, and at NEWTON-ON-THE-MOOR, near ALNWICK. She shared a two-man exhibition with her artist husband Arthur Rousselange Young (q.v.), at the Chameleon Gallery in 1986, and enjoyed a one-man exhibition at the Dial Gallery, in 1993. She lives at AMBLE. Her work is in a number of private collections.

YOUNG, John (fl. late 19th cent.)

Genre and figure painter in oil and watercolour. This artist was born on Tyneside, and practised at NEWCASTLE in the last quarter of the 19th century. He showed examples of his work at the exhibition of works by local painters, at the Central Exchange Art Gallery, NEWCASTLE, in 1878, its catalogue notes describing him as 'an artist who devotes himself to Shakespearian figure painting'. He also showed work at the 'Gateshead Fine Art & Industrial Exhibition', in 1883, but little is known of him after that date. The Shipley Art Gallery, GATESHEAD, has his oil *The Vagrant*.

YOUNG, Ralph Atkinson (fl. late 19th cent.)

Amateur landscape painter in oil and watercolour. Young worked as a commercial traveller on Tyneside in the late 19th century, and while living at NEWCASTLE, and later nearby WALLSEND, was an occasional exhibitor at the city's Bewick Club. He first began exhibiting his work at the Club in the late 1880s, and subsequently served as its honorary secretary. His exhibit at the Club in 1892 was singled out for comment in the local press, which said: 'R A Young is represented by a pretty picture of Whittle Dene, with its old mill'.

YOUNG, Thomas Bell (1900–1978)

Amateur landscape painter in watercolour. He was born at NEWCASTLE, and is said to have exhibited at the Laing Art Gallery, NEWCASTLE, while still at school, and to have received the Lord Mayor's special prize at the age of fifteen. In 1939 he moved to DARLINGTON, where he was a member of the town's Society of Arts for some thirty years, also serving on its committee. He was a member of the Border Society, and exhibited his work at the Royal Institute of Painters in Water Colours; the Artists of the Northern Counties exhibitions at the Laing Art Gallery, NEWCASTLE, and at York and Carlisle. A one-man exhibition of his work was held at DARLINGTON in 1971. Represented: Darlington A G.

Z

ZALMON – see WINER, Zalmon

John Young, *The Vagrant*, oil, 49 x 38cm.
Tyne & Wear Museums, Shipley Art Gallery.

Bibliography

Please see individual artists' entries for the titles of books, catalogues, articles, newspaper comments, etc, of particular relevance to their lives and work, and which may not be listed below.

GENERAL WORKS:

BAIN, IAIN. (edited and with an introduction by) *A Memoir of Thomas Bewick, Written by Himself*. London, 1975. *Thomas Bewick, an Illustrated Record of his Life and Work*. Newcastle upon Tyne, 1975. *The Watercolours of Thomas Bewick and his Workshop Apprentices*. London, 1981.

CHARLETON, ROBERT JOHN. *Newcastle Town*. London, 1885. Reprinted, Newcastle upon Tyne, 1978.

COOPER, LEONARD. *Great Men of Durham*. London, 1956.

FEAVER, WILLIAM. *Pitmen Painters. The Ashington Group, 1934–1984*. London, 1988.

GODDARD, T RUSSELL. *History of the Natural History Society of Northumberland, Durham and Newcastle upon Tyne, 1829–1929*. Newcastle upon Tyne, 1929.

HARDIE, MARTIN. *Water Colour Painting in Britain*. 3 vols. London, 1966. Reprinted 1969 and 1975.

HAWKES, JANE. *The Golden Age of Northumbria*. Morpeth, Northumberland, 1996.

HORSLEY, P M. *Eighteenth Century Newcastle*. Newcastle upon Tyne, 1971.

LONGSTAFFE, WILLIAM HYLTON DYER. *History & Antiquities of the Parish of Darlington*. Darlington, Co Durham, 1854.

MACKENZIE, ENEAS. *History of Newcastle upon Tyne*. Newcastle upon Tyne, 1827.

MCMANNERS, ROBERT, & WALES, GILLIAN. *Shafts of Light – Mining Art in the Great Northern Coalfield*. Bishop Auckland, Co Durham, 2002.

MEE, ARTHUR (Editor). *The King's England: Northumberland*. London, 1952; Newcastle upon Tyne, 1953. *The King's England: Durham*. London, 1953.

MIDDLEBROOK, S. *Newcastle upon Tyne: Its Growth and Achievement*. Newcastle upon Tyne, 1950. Reprinted 1968.

MORGAN, ALLAN. *A Fine and Private Place – Jesmond Old Cemetery*. Newcastle upon Tyne, 2000.

NEWTON, LAURA. *Cullercoats: A North-East Artists' Colony*. Bristol, 2003.

OLIVER, THOMAS. *A New Picture of Newcastle upon Tyne*. Newcastle upon Tyne, 1831. Reprinted, Newcastle upon Tyne, 1970.

PEVSNER, NIKOLAUS. *Buildings of England: County Durham*. Harmondsworth, Middlesex, 1953. Second edition, 1983.

PEVSNER, NIKOLAUS, & RICHMOND, IAN. *Buildings of England: Northumberland*. London, 1957. Third edition, revised by GRUNDY, JOHN, et al, 1992.

PHILLIPS, PETER. *The Staithes Group*. Nottingham, 1993.

SYKES, JOHN. *Local Records or Historical Register of Remarkable Events of Northumberland, Durham, Newcastle upon Tyne and Berwick-upon-Tweed*. Newcastle upon Tyne, 1866. Reprinted, 1973.

TOMLINSON, WILLIAM WEAVER. *Historical Notes on Cullercoats, Whitley and Monkseaton*. Newcastle upon Tyne, 1893. Reprinted, 1980.

USHERWOOD, PAUL; BEACH, JEREMY & MORRIS, CATHERINE. *Public Sculpture of North-East England*. Liverpool, 2000.

WELFORD, RICHARD. *Men of Mark 'Twixt Tyne & Tweed*. London, 1895.

WILKES, LYALL. *Tyneside Portraits*. Newcastle upon Tyne, 1971.

DICTIONARIES:

ARCHIBALD, E H H. *A Dictionary of Sea Painters*. Woodbridge, Suffolk, 1980.

BENEZIT, E. Dictionnaire de Peintres, Sculpteurs, Dessinateurs et Graveurs. 8 vols. Paris, 1976.

BROOK-HART, DENYS. *British 19th Century Marine Painting*. Woodbridge, Suffolk, 1974; *British 20th Century Marine Painting*. Woodbridge, 1981.

BRYAN, M. *Dictionary of Painters and Engravers*. First edition: 2 vols. London, 1816. Revised edition in 5 vols. London, 1903–4.

BUCKMAN, DAVID. *The Dictionary of Artists in Britain since 1945*. Bristol, 1998.

CLARK, ALAN. *Dictionary of British Comic Artists*. London, 1998.

COLVIN, HOWARD. *A Biographical Dictionary of British Architects 1600–1840*. London, 1954. Reprinted, 1978.

DEBRETT'S. *People of Today*, (ed. FOSTER SARA). London, 2002.

DICTIONARY OF NATIONAL BIOGRAPHY. London, 1885–1937.

DOLMAN, BERNARD. *A Dictionary of Contemporary British Artists*. London, 1929. Reprinted, Woodbridge, Suffolk, 1981.

E P PUBLISHING. *Royal Academy Exhibitors 1905–1970*. 6 vols. London, 1973–1982.

FIELDING, MANTLE. *A Dictionary of American Painters, Sculptors and Engravers*. New York, 1945.

GRANT, COLONEL MAURICE HAROLD. *A Dictionary of British Sculptors from 13th–20th Century*. London, 1953.

GRAVES, ALGERNON. *The British Institution 1806–1867*. London 1875. Facsimile edition, Bath, 1969. *A Dictionary of Artists 1760–1893*. London, 1884. Enlarged 1901. Facsimile edition, Bath 1969; *The Royal Academy of Arts 1769–1904*. 8 vols. London, 1905. Facsimile edition in 4 vols. Bath, 1970; *The Society of Artists of Gt. Britain 1760–1791; The Free Society of Artists 1761–1783*. London, 1907. Facsimile edition, Bath, 1969.

GROCE, GEORGE C and WALLACE, DAVID H. *The New York Historical Society's Dictionary of Artists in America, 1564–1860*. New Haven, USA, and London, 1957.

GUNNIS, RUPERT. *Dictionary of British Sculptors 1660–1851*. London, 1951. New revised edition 1964.

HALL, MARSHALL. *The Artists of Cumbria*. Newcastle upon Tyne, 1979.

HOUFE, SIMON. *The Dictionary of British Book Illustrators and Caricaturists, 1800–1914*. Woodbridge, Suffolk, 1978.

HUNT, C J. *The Book Trade in Northumberland and Durham to 1860*. Newcastle upon Tyne, 1975.

JOHNSON, JANE. *Works exhibited at the Royal Society of British Artists 1824–1893*. Woodbridge, Suffolk, 1975.

JOHNSON, J and GREUTZNER, A. *The Dictionary of British Artists 1880–1940*. Woodbridge, Suffolk, 1976.

MACMILLAN, DUNCAN. *Scottish Art in the 20th Century*. Edinburgh and London, 1994.

MCCULLOUGH, ALAN. *Encyclopaedia of Australian Art*, 1964. New revised edition, London, 1994.

MALLALIEU, HUON L. *The Dictionary of British Watercolour Artists up to 1920*. Woodbridge, Suffolk, 1976.

MALLET, DANIEL TROWBRIDGE. *Mallett's Index of Artists*. New York, 1935. Facsimile edition, Bath, 1976.

PAVIERE, SYDNEY H. *A Dictionary of British Sporting Painters*. Leigh on Sea, 1965; *A Dictionary of Victorian Landscape Painters*. Leigh on Sea, 1968.

REDGRAVE, SAMUEL. *A Dictionary of Artists of the English School*. London, 1878. Facsimile edition, Bath, 1970.

RINDER, FRANK. *The Royal Scottish Academy 1826–1916*. London, 1917. Facsimile edition. Bath, 1975.

SPARROW, W SHAW. *British Sporting Artists*. London, 1922. Reprinted 1965.

STANGOS, NIKOS (READ, HERBERT, Consulting Editor). *The Thames & Hudson Dictionary of Art and Artists*. Expanded and updated edition. London, 1994.

TURNBULL, HARRY. *Yorkshire Artists: A short dictionary*. Snape Bedale, Yorks, 1976.

WARD-JACKSON, C H. *Ship Portrait Painters*. London, 1978.

WATERS, GRANT. *A Dictionary of British Artists Working 1900–1950*. Vol 1 Eastbourne, 1975. Vol 2 (with illustrations) 1977.

WHO'S WHO IN ART. 1927–2000. Havant, Hants.

WHO WAS WHO. Vols 1-VII, 1897–1980. London.

WILSON, ARNOLD. *A Dictionary of British Marine Painters*. Leigh on Sea, 1967; *A Dictionary of British Military Painters*. Leigh on Sea, 1972.

WINGFIELD, MARY ANN. *A Dictionary of Sporting Artists, 1650–1990*. Woodbridge, Suffolk, 1992.

WOOD, CHRISTOPHER. *The Dictionary of Victorian Artists*. Woodbridge, Suffolk, 1971. Revised and enlarged edition 1978.

WOOD, JEREMY. *Hidden Talents: A Dictionary of Neglected Artists Working 1880–1950*. Billinghurst, West Sussex, 1994.

WOOD, LIEUTENANT J C. *A Dictionary of British Animal Painters*. Leigh on Sea, 1973.

CATALOGUES AND OTHER EXHIBITION PUBLICATIONS:

ART CIRCLE, NEWCASTLE UPON TYNE.
Works by Charles James Spence, 1906.

ART GALLERY, ARMSTRONG COLLEGE, NEWCASTLE UPON TYNE.
Works by Robert Jobling, 1923.

ARTS ASSOCIATION, NEWCASTLE UPON TYNE.
Exhibition catalogues 1878–1881.

BERWICK-UPON-TWEED MUSEUM & ART GALLERY.
In a Strong Light – the Art of Thomas Sword Good, 1989; *James Wallace and the Quintet*, 1995.

BEWICK CLUB, NEWCASTLE UPON TYNE.
Exhibition catalogues 1884–1895, including *Royal Jubilee Exhibition*, 1887.

BRITISH MUSEUM, LONDON.
A Noble Art – Amateur Artists and Drawing Masters (c.1660–1800), 2000.

CARLISLE ACADEMY, CARLISLE.
Exhibition catalogues 1823–1833.

CARLISLE ART GALLERY, CARLISLE.
Exhibition catalogue, 1896.

CARLISLE ATHENAEUM, CARLISLE.
Exhibition catalogues 1846 and 1850.

CENTRAL EXCHANGE ART GALLERY, NEWCASTLE UPON TYNE.
Central Exchange News Room, Art Gallery & Polytechnic Exhibition, 1870; *Works by Local Painters*, 1878; *Loan Exhibition of Local Art*, 1889; Henry Hetherington Emmerson Exhibition, 1895.

CUSTOMS HOUSE GALLERY, SOUTH SHIELDS, TYNE & WEAR.
Laurie (LaurieWheatley); *Sculptor, Painter and Photographer*, 2000; *Bob Olley. This, That…and Some of the Other*, 2000; *Church Outing*, 2001.

DARLINGTON ART GALLERY, DARLINGTON, CO DURHAM.
Catalogue of Picture Collection, 1988; *A Grand Tour – John Dobbin*, 1996.

DEAN GALLERY, NEWCASTLE UPON TYNE.
Cullercoats Revisited, 1983; *John Wilson Carmichael – The Anderson Collection*, 1991; *Byron Dawson*, 1993.

DJANOGLY ART GALLERY, UNIVERSITY OF NOTTINGHAM ARTS CENTRE, NOTTINGHAM.
Marjorie Arnfield – A Celebration of her Life and Art, 2001.

DLI MUSEUM & ART GALLERY, CITY OF DURHAM.
Birtley Aris – paintings and drawings, 1985; *The Northern Lights, Twenty-four Artists from the North East of England*, 1990.

DURHAM ART GALLERY, CITY OF DURHAM.
Durham Cathedral Artists & Images, 1993.

FERENS ART GALLERY, HULL.
Early Marine Paintings & Hull Art Directory, 1951.

FINE ART SOCIETY, LONDON.
Gerald Laing – Sculpture (1968–1999), 1999.

GATESHEAD FINE ART & INDUSTRIAL EXHIBITION, GATESHEAD.
Catalogue of 1883 exhibition.

GLASGOW MUSEUMS & ART GALLERIES, GLASGOW.
Joseph Crawhall, 1861–1913. One of the Glasgow Boys, 1990.

GRAY ART GALLERY & MUSEUM, HARTLEPOOL.
Catalogue of Permanent Collection, 1923; Various exhibition catalogues, i.e. *John William Howey*, 1925; *Seymour Walker*, 1926; *James Clark*, 1926; *Robert Leslie Howey*, 1949; *Frederic Shields*, 1983.

HARTLEPOOL ART GALLERY, HARTLEPOOL.
The Life and Career of Frank Henry Mason, 1996; *In and Around Hartlepool – Paintings by Bernard Smith*, 2000.

HATTON GALLERY, UNIVERSITY OF NEWCASTLE UPON TYNE.
Peter Yates, 1982; *Carl Lazarri – Recent Paintings*, 1989; *William Fawcus – A Retrospective*, 1992/3; *Leslie Gibson – A Northern Artist Remembered*, 1993; *Dame Catherine Cookson – A Friend of the Hatton Gallery*, 1998; *Ann Gillie*, 1999; *Dame Catherine Cookson – A Legacy*, 1999; *The Art of Mining – Thomas Hair's Watercolours of the Great Northern Coalfield*, 2000.

LADY WATERFORD HALL, FORD, NORTHUMBERLAND.
Lady Waterford Centenary Exhibition, 1983; *Louisa Anne, Marchioness of Waterford*, 1991.

LAING ART GALLERY, NEWCASTLE UPON TYNE.
Catalogue of the Permanent Collection of Pictures in Oil and Water Colours, with descriptive and biographical notes by C Bernard Stevenson, Curator, 1915; *Catalogue of the Permanent Collection of Water Colours, with descriptive and biographical notes by C Bernard Stevenson, Curator*, 1939.

Exhibitions of Works by Artists of the Northern Counties, 1905–1962.

Various exhibition catalogues 1906–2001: *Thomas Miles Richardson, Senior, and members of the Richardson Family*, 1906; *James Peel*, 1907; *Neils Moeller Lund*, 1916; *John Charlton*, 1917; *Myles Birket Foster*, 1925; *Thomas Bewick*, 1928; *Frank Thomas Carter, Thomas Bowman Garvie, George Edward Horton and John Falconar Slater*, 1934; *Ernest Procter*, 1934; *Ralph Hedley*, 1938; *William Park Atkin*, 1940; *Luke Clennell*, 1940; *Thomas William Pattison*, 1942; *Tyneside's Contribution to Art*, 1951; *Coronation Exhibitions*, 1953; *John Wilson Carmichael*, 1968; *Henry Perlee Parker*, 1969–70; *John Martin*, 1970; *Thomas Bewick*, 1978; *The Tyneside Classical Tradition – Classical Architecture in the North East, 1700–1850*, 1980; *The Decorated Glass of William and Mary Beilby, 1761–1778*, 1980; *Victorian and Edwardian Architecture in the North East*, 1981; *Luke Clennell*, 1981; *The Picturesque Tour in Northumberland and Durham, c.1720–1830*, 1982; *George Edward Horton*, 1982; *John Wilson Carmichael*, 1982; *Charles Napier Hemy RA*, 1984; *Art for Newcastle – Thomas Miles Richardson and the Newcastle Exhibitions 1822–1843*, 1984; *John Dobson, Newcastle Architect*, 1987; *Pre-Raphaelites – Painters and Patrons in the North East*, 1989/90; *Ralph Hedley – Tyneside Painter*, 1990; *A Romance*

with the North East – Robert and Isa Jobling, 1992; John Dobson, Architect of the North East, 2001.

MECHANICS' INSTITUTION, NEWCASTLE UPON TYNE.
Exhibition of Paintings and Other Works of Art, 1866.

MOSS GALLERIES, HEXHAM, NORTHUMBERLAND.
John Atkinson Exhibition, 1981; George Horton Exhibition, 1982.

NEWCASTLE SOCIETY OF ARTISTS, NEWCASTLE UPON TYNE.
First Annual Exhibition, 1835; Second Annual Exhibition, 1836; First Watercolour Exhibition, 1836.

NEWCASTLE UPON TYNE CITY LIBRARIES.
Catalogue of the Bewick Collection (Pease Bequest), 1904.

NEWCASTLE UPON TYNE INSTITUTION FOR THE GENERAL PROMOTION OF THE FINE ARTS.
Exhibition catalogues 1832–1837.

NORTH EAST COAST EXHIBITION, NEWCASTLE UPON TYNE, 1929.
Catalogue of the Palace of Arts.

NORTHERN ACADEMY OF ARTS, NEWCASTLE UPON TYNE.
Exhibition catalogues 1828–1831.

NORTH OF ENGLAND SOCIETY FOR THE PROMOTION OF THE FINE ARTS, NEWCASTLE UPON TYNE.
Exhibition catalogues 1838–1843, and with the Government School of Design, 1850 and 1852.

NORTH TYNESIDE PUBLIC LIBRARIES, NORTH SHIELDS.
George Horton, 1986.

NORTHUMBERLAND INSTITUTION FOR THE PROMOTION OF THE FINE ARTS IN THE NORTH OF ENGLAND, NEWCASTLE UPON TYNE.
Exhibition catalogues 1822–1827.

PANNETT ART GALLERY, WHITBY.
Catalogue of work on exhibition, 1966.

PEN & PALETTE CLUB, NEWCASTLE UPON TYNE.
Watercolours by John Hodgson Campbell, 1927.

SHIPLEY ART GALLERY, GATESHEAD.
Catalogue of Paintings and Drawings, 1951; Contemporary Artists of Durham County, 1951; R E McEune Bequest, 1971.

SHIRE POTTERY GALLERY & STUDIOS, ALNWICK, NORTHUMBERLAND.
Speak of the North – exhibition of work by Derwent Wise, 2000; Alan Smith Page, 2000; Derwent Wise & Brian Yale – Landscapes on the Edge, 2002.

STONE GALLERY, NEWCASTLE UPON TYNE.
John Peace, 1962; Tom Gleghorn, 1963; Drawings from the Sketchbook of the Rev George Liddell Johnston, 1970.

SUNDERLAND MUSEUM & ART GALLERY.
Nineteenth Century North East Artists, 1974; The Spectacular Career of Clarkson Stanfield, 1979.

TYNE & WEAR COUNTY COUNCIL MUSEUMS & ART GALLERIES, NEWCASTLE UPON TYNE.
Collection Handlist, Fine & Applied Art, 1980; comprising handlist to public collections in Newcastle upon Tyne, Gateshead, Sunderland and South Tyneside. Note: Now known as Tyne & Wear Museums, this organisation has been responsible for the production of all catalogues of the art galleries within these areas from 1975; i.e. Laing Art Gallery, etc.

UNIVERSITY GALLERY, UNIVERSITY OF NORTHUMBRIA, NEWCASTLE UPON TYNE.
Cornish and Spennymoor, 1999.

WALKER ART GALLERY, LIVERPOOL.
Maurice Cockrill – Paintings and Drawings 1974–1994, 1995.

WOODHORN COLLIERY MUSEUM, ASHINGTON, NORTHUMBERLAND.
Catalogue of The Ashington Group Paintings, 1992; Oliver Kilbourn – My Life as a Pitman; Catalogue of paintings at the Museum, 1992.

YORK CITY ART GALLERY, YORK.
Francis Place Exhibition, 1971.

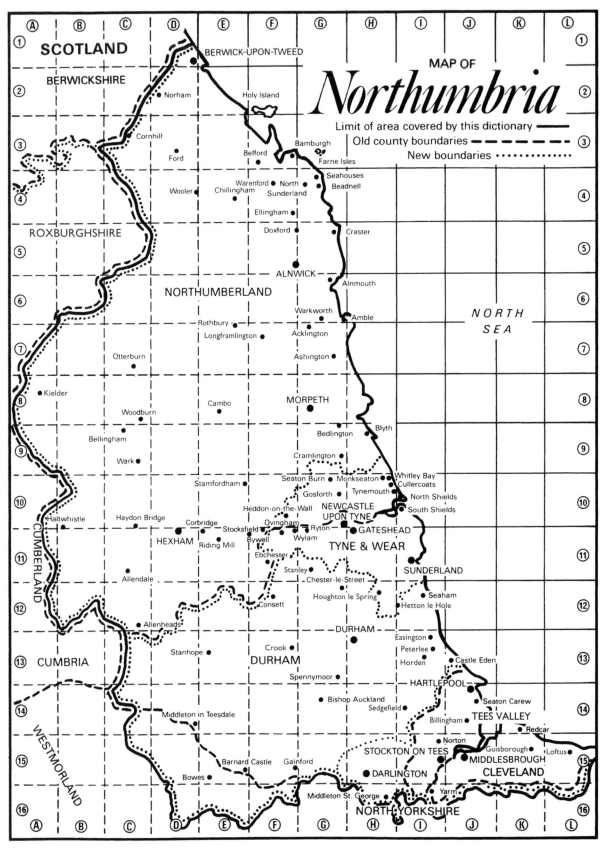

MAP OF
Northumbria

Limit of area covered by this dictionary ———
Old county boundaries – – – –
New boundaries ·············

SCOTLAND

BERWICK-UPON-TWEED

BERWICKSHIRE

Norham • Holy Island

Cornhill •

Ford • Belford • Bamburgh
Farne Isles

ROXBURGHSHIRE

Wooler • Warenford • North Sunderland Seahouses
Chillingham • Beadnell

Ellingham •

Doxford • Craster •

NORTHUMBERLAND

ALNWICK •

Alnmouth •

Rothbury • Warkworth • Amble
Longframlington • Acklington •

Otterburn • Ashington •

Kielder • Cambo • **MORPETH**

Woodburn • Blyth
Bedlington •

Bellingham • Cramlington •

Wark • Seaton Burn • Monkseaton Whitley Bay
Stamfordham • Gosforth • Cullercoats
Tynemouth North Shields

Haltwhistle • Haydon Bridge • Corbridge • Heddon-on-the-Wall **NEWCASTLE** South Shields
Stocksfield • Ovingham • Ryton UPON TYNE
HEXHAM • Riding Mill Bywell Wylam **GATESHEAD**
Ebchester • **TYNE & WEAR**

CUMBERLAND Stanley • **SUNDERLAND**
Allendale • Chester-le-Street •
Houghton le Spring • Seaham
Consett • Hetton le Hole •

Allenheads • **DURHAM** Easington •
Peterlee •
Stanhope • Crook • Horden • Castle Eden

CUMBRIA **DURHAM** **HARTLEPOOL**
Spennymoor •

Bishop Auckland • Seaton Carew
Middleton in Teesdale • Sedgefield • **TEES VALLEY**
Billingham •
Redcar •
Norton •
WESTMORLAND Barnard Castle • Gainford • **STOCKTON ON TEES** Guisborough • Loftus
Bowes • **MIDDLESBROUGH**
DARLINGTON **CLEVELAND**
Middleton St. George • Yarm •
NORTH YORKSHIRE

NORTH SEA

Acklington 7G

Allendale 11C

Allenheads 12C

Alnmouth 6G

Alnwick 5F

Amble 6G

Ashington 7G

Bamburgh 3F

Barnard Castle 15E

Beadnell 4G

Bedlington 9G

Belford 3F

Bellingham 9C

Berwick-upon-Tweed 1D

Billingham 14J

Bishop Auckland 14G

Blyth 9H

Bowes 15E

Bywell 11F

Cambo 8E

Castle Eden 13J

Chester le Street 12G

Chillingham 4E

Consett 12F

Corbridge 11E

Cornhill 3C

Cramlington 9G

Craster 5G

Crook 13F

Cullercoats 10H

Darlington 15H

Doxford 5F

Durham 13H

Easington 13I

Ebchester 11F

Ellingham 4F

Farne Islands 3G

Ford 3D

Gainford 15F

Gateshead 11H

Gosforth 10G

Guisborough 15K

Haltwhistle 10B

Hartlepool 14J

Haydon Bridge 10C

Heddon-on-the-Wall 10F

Hetton-le-Hole 12I

Hexham 11D

Holy Island 2F

Horden 13I

Houghton le Spring 12H

Kielder 8A

Loftus 15L

Longframlington 7F

Middlesborough 15J

Middleton-in-Teesdale 14D

Middleton St George 16H

Monkseaton 10H

Morpeth 8G

Newcastle upon Tyne 10G

Norham 2D

North Shields 10I

North Sunderland 4G

Norton 15I

Otterburn 7C

Ovingham 11F

Peterlee 13I

Redcar 14K

Riding Mill 11E

Rothbury 7E

Ryton 11G

Seaham 12I

Seahouses 4G

Seaton Burn 10G

Seaton Carew 14J

Sedgefield 14I

South Shields 10I

Spennymoor 13G

Stamfordham 10E

Stanhope 13E

Stanley 11G

Stocksfield 11F

Stockton-on-Tees 15I

Sunderland 11I

Tynemouth 10H

Warenford 4F

Wark 9C

Warkworth 6G

Whitley Bay 10H

Woodburn 8C

Wooler 4D

Wylam 11F

Yarm 16I

Note: Only capitalised place names in artists' entries, eg. ALNWICK, are listed above. Where it has not been possible to accommodate a place name on the map, the nearest town, city or village appears in the entry.

Exhibiting organisations

Allied Artists Association Founded 1908.

Artists of the Northern Counties These annual exhibitions organised by the Laing Art Gallery, Newcastle upon Tyne, from 1905 until 1962, were initially aimed at attracting exhibits from artists practising in the four northern counties of England. However, they quickly became popular with artists from around Britain, many of these now famous names. The exhibitions gradually eclipsed in importance those of the Bewick Club, Newcastle upon Tyne, but were themselves eventually challenged in terms of their popularity by those of the Federation of Northern Art Societies, held at the Laing Art Gallery on a bi-annual basis for many years. In addition to hosting the Artists of the Northern Counties exhibitions for more than half a century the Gallery has organised many individual and group exhibitions of Northumbrian artists' work, and has remained the premier venue for such exhibitions throughout its history.

Artists International Association Founded 1934.

Arts Association (Newcastle upon Tyne) Founded in 1878, this association held important fine art exhibitions in 1878, 1879, 1880 and 1881.

Bede Gallery Opened in 1970 after development from a former air raid shelter at Jarrow, near South Shields, Co Durham, this gallery organised important exhibitions of locally and nationally famous artists' work for the next twenty-seven years. It was succeeded by the Viking Gallery in 1997, which has continued this policy to the present day.

Bewick Club Named after Northumbria's most famous artist — Thomas Bewick – this club was founded in 1883 at Newcastle upon Tyne, and held its first exhibition in 1884. Other exhibitions were held annually for more than forty years, the club finally winding up just before the Second World War owing to dwindling membership. In its early years it was the most important exhibiting organisation in Northumbria.

Bondgate Gallery, Alnwick, Northumberland Opened in 1964, this gallery has organised many exhibitions of Northumbrian artists' work.

British Institution The Institution was established in London in 1806 as a rival to the *Royal Academy*. It survived until 1867.

British Watercolour Society This now defunct society flourished in the early part of the 20th century. Members styled: BWS.

Carlisle Academy Built in 1823, the Academy staged exhibitions until 1833.

Carlisle Athenaeum Built in 1841, the Athenaeum held fine art exhibitions in 1843, 1846 and 1850.

Darlington Society of Arts, Darlington, Co Durham Founded in 1922, this society has held annual exhibitions at Darlington Art Gallery since 1933, and is today one of the longest established art societies in Northumbria.

Durham Light Infantry Museum & Durham Art Gallery Abbreviated in the artists' entries of this dictionary to read *DLI Museum & Art Gallery*, this exhibiting venue in the City of Durham was originally launched in 1968 as the *DLI Museum & Arts Centre*. It has enjoyed a variety of names in its existence as both museum of the Durham Light Infantry Regiment and an art exhibiting venue. The art gallery has been responsible for the organisation of many important exhibitions of Northumbrian artists.

Dudley Gallery Established in London in 1865, it first specialised in watercolours; in 1867 it extended its exhibiting scope to include works in oil, and in 1872, works in black and white.

Federation of British Artists This federation was founded in 1961 to promote the visual arts in Britain. It is today the umbrella organisation for nine autonomous national art societies, and operates the Mall Galleries, London, as a venue for their annual and other exhibitions. These societies comprise: Royal Institute of Painters in Water Colours; Royal Society of British Artists; Royal Society of Marine Artists; Royal Society of Portrait Painters; Royal Institute of Oil Painters; New English Art Club; Pastel Society; Society of Wildlife Artists; Hesketh Hubbard Art Society.

Federation of Northern Art Societies Formed in 1947 by seven Northumbrian art societies, this society now has a membership of some 60 art clubs and societies throughout the region. It has held annual exhibitions throughout its history, initially at both the Shipley Art Gallery, Gateshead, and the Laing Art Gallery, Newcastle upon Tyne, but now at various venues.

Free Society of Artists Although it will be remarked later that the Society of Artists staged the first large scale exhibition of artists' work in Britain, it was in reality the Free Society which should be entitled to this claim, as the future members of the latter society seceded from the first, leaving the main body exhibiting at the same place as before. As, however, the 1760 catalogue has always been considered to belong to the *Society of Artists*, the Free Society's exhibiting life

is usually stated as having started in 1761. Like the *Society of Artists* it attracted many of the nation's leading artists both before, and after, the establishment of the *Royal Academy*. It held exhibitions almost uninterruptedly until 1783. Members styled: FSA.

Gateshead Art Society Founded in 1947, this club held its first annual exhibition in 1948 at the Shipley Art Gallery, Gateshead. These exhibitions continue to be held at this venue.

Grosvenor Gallery Although this London gallery, founded in 1877, survived for only 13 years, it became a focal point for the Aesthetic Movement of the 1880s, and a favourite of Pre-Raphaelite followers.

Hatton Gallery, University of Newcastle upon Tyne Originally the art gallery of Armstrong College (later King's College; now Newcastle University), the gallery was given its present name in 1926 in memory of Richard George Hatton for his great contribution to the teaching of art on Tyneside. It has since hosted a wide range of locally, nationally and internationally important artists' work.

International Society of Sculptors, Painters and Gravers Founded in 1898.

Lake Artists' Society Founded 1904 at Ambleside, Cumbria, this society has attracted the membership of leading British artists throughout its history. Its annual exhibitions are held at Grasmere, Cumbria.

Liverpool Academy of Fine Arts Founded 1810.

Manchester Academy of Fine Arts Founded 1859.

Mid-Northumberland Arts Group (MidNAG) This group was launched in 1963 at Northumberland College, Ashington, Northumberland, with the aim of supporting the development and enjoyment of the arts in the area. It survived for forty years and during this period was responsible for several major art exhibiting initiatives in the county involving Northumbrian artists, and publications about their work.

National Society of Painters, Sculptors and Gravers Founded 1930.

Newcastle Society of Artists Founded at Newcastle upon Tyne in 1919 for professional or amateur artists, this society held regular exhibitions at various venues in the city for a number of years. In 1982 it merged with the North of England Art Club.

New English Art Club Founded in 1886 by a body of predominantly young artists who selected works for exhibition themselves, rather than by committee, this became one of the most important art clubs in Britain, with many outstanding artists among its members. Its first exhibition was staged at the Grosvenor Gallery in 1886. Members styled: NEAC.

New Gallery Founded in London in 1888 as a splinter of the Grosvenor Gallery, this gallery attracted many of the latter's members when the Grosvenor closed in 1890.

New Water Colour Society This society was formed in 1831 as an alternative to the *Old Water Colour Society* (now the *Royal Watercolour Society*), which only exhibited the work of its own members. To avoid confusion with its predecessor it took the name of *Institute of Painters in Water Colours*, in 1863, and in 1885 was granted permission to style itself Royal. It is today based at the Mall Galleries, London, where it holds annual exhibitions of members' and non-members' work. Members styled: RI.

North East Coast Art Club Founded in Whitley Bay, Northumberland, in 1920, by John Falconar Slater and others, this club held annual exhibitions in the town for many years. It was eventually renamed the *Whitley Bay Art Club*, and closed in 1963 owing to dwindling membership.

Northern Academy of Arts Northumbria's first academy of the arts, this was established at Newcastle upon Tyne in 1828, and held exhibitions until 1831. These exhibitions were contributed to by artists from all over Britain.

Northumberland Institution for the Promotion of the Fine Arts in the North of England Established at Newcastle upon Tyne in 1822, the Institution provided Northumbria with its first fine art exhibitions. These were staged from 1822 until 1827.

Old Water Colour Society: see *Royal Watercolour Society*

Pastel Society Founded in 1898. Members styled: PS.

Royal Academy of Arts Founded in 1768, this institution has played an important part in the development of British Art for more than two centuries. Its most influential period was during the Victorian era, when its exhibitions were among the most widely discussed topics of the day. As a teaching institution, the Academy has been responsible for the early training of some of the country's best known painters, sculptors, draughtsmen and engravers. Members styled: RA.

Royal Birmingham Society of Artists Founded 1812. Members styled: RBSA.

Royal Cambrian Academy This academy was founded in 1881, and was granted a Royal Charter in 1882. Members styled: RCamA.

Royal Drawing Society Founded in 1888. Members styled: RDS.

Royal Glasgow Institute of Fine Arts Founded in 1862, its annual exhibitions attracted artists from all over Britain. It was created Royal in 1896. Members styled: RGI.

Royal Hibernian Academy This academy was founded in 1822, and has included some of Ireland's finest artists among its members. Members styled: RHA.

Royal Institute of Oil Painters Founded in 1882, this institute was shortly afterwards granted permission to style itself Royal. It is the only national art society devoted exclusively to oil painting. Members styled: ROI.

Royal Institute of Painters in Water Colours: see *New Water Colour Society*

Royal Scottish Academy Founded in Edinburgh in 1826, it received its Royal Charter in 1839. Closely modelled on the *Royal Academy*, it was not, however, until the 1850s that it established anything like the position of its English counterpart. Members styled: RSA.

Royal Scottish Society of Painters in Water Colours Founded in Glasgow in 1878, it was granted permission to style itself Royal ten years later. Members styled: RSW.

Royal Society of British Artists This society was founded in 1823 by a small group of dedicated professional artists to provide an alternative to the Royal Academy for the exhibition of their work. It held its first exhibition in 1824 at its specially designed and built gallery, the Suffolk Street Gallery, London. Its governing society was granted permission to style itself Royal in 1887. (Note that the description *Suffolk Street Gallery* is used throughout this dictionary in referring to works sent to the Society's exhibitions before 1887, and *Royal Society of British Artists*, in subsequent years.) Members styled: RBA.

Royal Society of British Sculptors Founded in 1904. Members styled: RBS.

Royal Society of Marine Artists Founded in 1939 to promote and encourage marine art this society holds annual exhibitions which are open to non-members. It was granted permission to style itself Royal in 1966. Members styled: RSM.

Royal Society of Painter-Printmakers This society was founded in 1880 as the *Society of Painter-Etchers*, for artists working in etching, engraving and mezzotint who had been denied academic status by the Royal Academy. By 1888 it had been granted permission to style itself Royal. In 1898 it was further extended to encompass engravers, becoming the *Royal Society of Etcher-Engravers*, and in 1989 acknowledged advances in technology by adopting its present title. It is today based at the Bankside Gallery, London, where it holds regular exhibitions of members' work. Members styled: RE.

Royal Society of Portrait Painters Founded in 1891 by twenty-four artists frustrated by what they perceived as the closed-shop attitude of the Royal Academy, this society was granted permission to style itself Royal in its 21st year. Members styled: RP.

Royal Ulster Academy Founded 1879.

Royal Watercolour Society This society was founded in 1804 as the *Old Water Colour Society*, by a group of mainly young artists who wished to establish an annual exhibition of the 'blossoming art of watercolour', which they felt received insufficient attention from the established exhibiting institutions, notably the Royal Academy. It was granted permission to style itself Royal in 1881, and is today based at the Bankside Gallery, London, where it holds regular exhibitions of members' work. Members styled: RWS.

Royal West of England Academy Founded in 1845.

Scottish Society of Women Artists Founded 1924. Members styled: SSWA.

Society of Artists One of the first societies in Britain to stage regular exhibitions of artists' work, this society was founded in 1760, and survived for 31 years. Its first exhibition in the premises of the Society of the Encouragement of Arts, Manufactures and Commerce, in London, has been described as the earliest large-scale exhibition of artists' work in Britain. It subsequently established its own premises, and in the eight years before the formation of the Royal Academy showed the work of the nation's leading artists; some continued to exhibit with the Society for the rest of its life. Fellows styled: FSA (before 1791).

Society of Graphic Art This society was formed in 1920 to promote work in black-and-white by British artists. Members styled: SGA.

Society of Miniaturists Founded in 1895.

Society of Mural Painters Founded in 1939.

Society of Scottish Artists Founded 1891. Members styled: SSA.

Society of Wildlife Artists This society was founded in 1964 to foster all forms of visual art based on, or representing, the world's wildlife. Its annual exhibition is the foremost event in the British wildlife art calendar. Members styled: SWLA.

Society of Women Artists This society was founded in 1855 to encourage the work of women artists. Members styled: SWA.

Society of Wood Engravers This society was founded in 1920 to encourage the art of wood engraving.

Stone Gallery Founded at Newcastle upon Tyne in 1958, this gallery held many important exhibitions of Northumbrian artists' work, until its closure in 1986.

Suffolk Street Gallery: see *Royal Society of British Artists*

Tynedale Artists' Network Although not strictly an exhibiting organisation since its establishment in 1992, the Network has been responsible for several exhibitions of members' work, as well as arranging annual tours of their studios throughout Northumberland.

University Gallery, University of Northumbria, Newcastle upon Tyne This gallery was founded in 1977, at what was then Newcastle Polytechnic, and has since pursued a policy of staging major exhibitions of work by artists of local, national and international reputation, as well as promising but less well-established artists.